A Courtier's Mirror

A Courtier's Mirror

Cultivating Elite Identity in
Thomasin von Zerclaere's *Welscher Gast*

KATHRYN STARKEY

University of Notre Dame Press
Notre Dame, Indiana

Copyright © 2013 by University of Notre Dame
Notre Dame, Indiana 46556
www.undpress.nd.edu
All Rights Reserved

Manufactured in the United States of America

Library of Congress Cataloging-in-Publication Data

Starkey, Kathryn.
A courtier's mirror : cultivating elite identity in
Thomasin Von Zerclaere's Welscher Gast / Kathryn Starkey.
pages cm
Includes bibliographical references and index.
ISBN 978-0-268-04144-1 (pbk. : alk. paper) —
ISBN 0-268-04144-X (pbk. : alk. paper)
1. Thomasin, von Zerclaere, ca. 1186–ca. 1235. W?lsche Gast.
2. Didactic literature, German—History and criticism.
3. Feudalism in literature. 4. Courts and courtiers in literature. I. Title.
PT1658.T4W3375 2013
831'.2—dc23

2013000478

∞ *The paper in this book meets the guidelines for permanence
and durability of the Committee on Production Guidelines
for Book Longevity of the Council on Library Resources.*

For Isabella and Antonia

CONTENTS

List of Figures ix

Acknowledgments xiii

Introduction:
Thomasin von Zerclaere's *Welscher Gast* and Its Images 1

ONE
Reading Knowledge: Format, Empowerment,
and the Genesis of a Reference Book 33

TWO
Vision, the Viewing Subject,
and the Power of Narrative 55

THREE
Models of Gender: Allegory, Stereotype,
and Courtly Motif 85

FOUR
Image and Elite Self-Fashioning in
the Gotha Manuscript 117

FIVE
Visuality and (Self) Reflection in
the Courtier's Mirror 139

Appendix 1:
The *Welscher Gast* Manuscripts 147

Appendix 2:
Synopsis of the *Welscher Gast* according
to the Gotha Manuscript 153

Appendix 3:
Gotha Memb. I 120 and Its Image Cycle (Figs. 1–77) 196

Appendix 4:
Images from Various Redactions of the *Welscher Gast*
and the Manesse Codex (Figs. 78–102) 352

Notes 378

Bibliography 411

Index 438

LIST OF FIGURES

Figures 1 through 77 appear in appendix 3, beginning on page 196. All of these images are from Gotha, Universitäts- und Forschungsbibliothek Erfurt/Gotha, Memb. I 120.

Fig. 1. Fol. 2r	199	Fig. 23. Fol. 22r	243
Fig. 2. Fol. 7v	201	Fig. 24. Fol. 22v	245
Fig. 3. Fol. 8v	203	Fig. 25. Fol. 25r	247
Fig. 4. Fol. 9r	205	Fig. 26. Fol. 25v	249
Fig. 5. Fol. 9v	207	Fig. 27. Fol. 26r	251
Fig. 6. Fol. 10r	209	Fig. 28. Fol. 27r	253
Fig. 7. Fol. 11v	211	Fig. 29. Fol. 27v	255
Fig. 8. Fol. 12r	213	Fig. 30. Fol. 28r	257
Fig. 9. Fol. 12v	215	Fig. 31. Fol. 28v	259
Fig. 10. Fol. 13r	217	Fig. 32. Fol. 29r	261
Fig. 11. Fol. 13v	219	Fig. 33. Fol. 29v	263
Fig. 12. Fol. 14r	221	Fig. 34. Fol. 30r	265
Fig. 13. Fol. 14v	223	Fig. 35. Fol. 31r	267
Fig. 14. Fol. 15v	225	Fig. 36. Fol. 31v	269
Fig. 15. Fol. 16v	227	Fig. 37. Fol. 32r	271
Fig. 16. Fol. 17v	229	Fig. 38. Fol. 32v	273
Fig. 17. Fol. 19r	231	Fig. 39. Fol. 33r	275
Fig. 18. Fol. 19v	233	Fig. 40. Fol. 33v	277
Fig. 19. Fol. 20r	235	Fig. 41. Fol. 34r	279
Fig. 20. Fol. 20v	237	Fig. 42. Fol. 34v	281
Fig. 21. Fol. 21r	239	Fig. 43. Fol. 35r	283
Fig. 22. Fol. 21v	241	Fig. 44. Fol. 35v	285

Fig. 45. Fol. 36r	287	Fig. 62. Fol. 55v	321
Fig. 46. Fol. 36v	289	Fig. 63. Fol. 56r	323
Fig. 47. Fol. 37v	291	Fig. 64. Fol. 57v	325
Fig. 48. Fol. 38r	293	Fig. 65. Fol. 58r	327
Fig. 49. Fol. 38v	295	Fig. 66. Fol. 60r	329
Fig. 50. Fol. 39r	297	Fig. 67. Fol. 61r	331
Fig. 51. Fol. 39v	299	Fig. 68. Fol. 65v	333
Fig. 52. Fol. 41r	301	Fig. 69. Fol. 71v	335
Fig. 53. Fol. 42v	303	Fig. 70. Fol. 73v	337
Fig. 54. Fol. 43v	305	Fig. 71. Fol. 80v	339
Fig. 55. Fol. 45v	307	Fig. 72. Fol. 89r	341
Fig. 56. Fol. 48v	309	Fig. 73. Fol. 94v	343
Fig. 57. Fol. 49r	311	Fig. 74. Fol. 99r	345
Fig. 58. Fol. 49v	313	Fig. 75. Fol. 100r	347
Fig. 59. Fol. 50v	315	Fig. 76. Fol. 100v	349
Fig. 60. Fol. 51v	317	Fig. 77. Fol. 101r	351
Fig. 61. Fol. 53v	319		

Figures 78 through 102 appear in appendix 4, beginning on page 352.

Fig. 78: Heidelberg, Universitätsbibliothek, Cpg 389, fol. 2r 353

Fig. 79: Heidelberg, Universitätsbibliothek, Cpg 389, fol. 4r 354

Fig. 80: Heidelberg, Universitätsbibliothek, Cpg 389, fol. 27r 355

Fig. 81: Heidelberg, Universitätsbibliothek, Cpg 389, fol. 31v 356

Fig. 82: Heidelberg, Universitätsbibliothek, Cpg 389, fol. 36v 357

Fig. 83: Heidelberg, Universitätsbibliothek, Cpg 389, fol. 57r 358

Fig. 84: Heidelberg, Universitätsbibliothek, Cpg 389, fol. 91v 359

Fig. 85: Heidelberg, Universitätsbibliothek, Cpg 389,
fols. 138v–139r 360

Fig. 86: Wolfenbüttel, Herzog August Bibliothek, Cod. Guelf.
37.19 Aug. 2°, fol. 9r 361

Fig. 87: Wolfenbüttel, Herzog August Bibliothek, Cod. Guelf. 37.19 Aug. 2°, fols. 9v and 105r 362

Fig. 88: Wolfenbüttel, Herzog August Bibliothek, Cod. Guelf. 37.19 Aug. 2°, fol. 21v 363

Fig. 89: Wolfenbüttel, Herzog August Bibliothek, Cod. Guelf. 37.19 Aug. 2°, fol. 23v 364

Fig. 90: Wolfenbüttel, Herzog August Bibliothek, Cod. Guelf. 37.19 Aug. 2°, fol. 35v 365

Fig. 91: Wolfenbüttel, Herzog August Bibliothek, Cod. Guelf. 37.19 Aug. 2°, fol. 36r 366

Fig. 92: Wolfenbüttel, Herzog August Bibliothek, Cod. Guelf. 37.19 Aug. 2°, fol. 36v 367

Fig. 93: Wolfenbüttel, Herzog August Bibliothek, Cod. Guelf. 37.19 Aug. 2°, fol. 43r 368

Fig. 94: Wolfenbüttel, Herzog August Bibliothek, Cod. Guelf. 37.19 Aug. 2°, fol. 70r 369

Fig. 95: Wolfenbüttel, Herzog August Bibliothek, Cod. Guelf. 37.19 Aug. 2°, fol. 70v 370

Fig. 96: Heidelberg, Universitätsbibliothek, Cpg 330, fol. 8v 371

Fig. 97: Heidelberg, Universitätsbibliothek, Cpg 330, fol. 20r 372

Fig. 98: Heidelberg, Universitätsbibliothek, Cpg 320, fol. 9v 373

Fig. 99: Heidelberg, Universitätsbibliothek, Cpg 320, fol. 21v 374

Fig. 100: Dresden, Sächsische Landesbibliothek – Staats- und Universitätsbibliothek, Mscr. Dresd. M 67, fol. 19v 375

Fig. 101: Heidelberg, Universitätsbibliothek, Cpg 848, fol. 82v, *der Schenk von Limpurg* 376

Fig. 102: Heidelberg, Universitätsbibliothek, Cpg 848, fol. 178r, *Her Bergner von Horheim* 377

ACKNOWLEDGMENTS

I am indebted to many colleagues and friends, as well as funding agencies and scholarly institutions, for providing me with the intellectual and financial support to complete this project.

Thanks go to Elaine Tennant who first introduced me to the *Welscher Gast* when I was a graduate student at the University of California at Berkeley. There I also met Horst Wenzel, whose enthusiasm for the *Welscher Gast* has been inspiring and whose mentorship and friendship have been invaluable over the years. I have also greatly appreciated Joachim Bumke's support and sage advice. He will be missed.

Many friends and colleagues have offered me invaluable feedback on this project over the past several years: Katja Altpeter-Jones, Jessica Brantley, Maria Dobozy, Jutta Eming, Joan A. Holladay, C. Stephen Jaeger, Ingrid Kasten, Ursula Peters, Sara Poor, Ann Marie Rasmussen, Eckehard Simon, Olga Trokhimenko, Haiko Wandhoff, Gráinne Watson, Horst Wenzel, and Sarah Westphal. I am grateful to my colleagues in German and in Medieval and Early Modern Studies (MEMS) at the University of North Carolina at Chapel Hill for providing an intellectually stimulating and supportive environment for my research. Clayton Koelb, Jonathan Hess, and Darryl Gless deserve special mention here.

A Courtier's Mirror would not have been completed without the assistance of Cornelia Hopf, the Director of the Handschriftenabteilung at the Forschungsbibliothek Gotha who allowed me to work with the Gotha redaction and responded promptly to my queries and requests for permissions. The staff of the Abteilung Handschriften und Alte Drucke at the Universitätsbibliothek Heidelberg was equally helpful, allowing

me to work with all of their *Welscher Gast* manuscripts despite the ongoing digitization project. Thanks also go to Falk Eisermann, then Referatsleiter for the Gesamtkatalog der Wiegendrucke at the Staatsbibliothek zu Berlin for permitting me to use his catalogue description of the Gotha manuscript before it was published.

Permissions to publish the images in this volume were obtained from the Forschungsbibliothek Gotha; Heidelberg, Universitätsbibliothek; Wolfenbüttel, Herzog August Bibliothek; and Dresden, Sächsische Landesbibliothek – Staats- und Universitätsbibliothek.

A version of the chapter on formatting (chapter 1) appeared in *Literary Studies and the Pursuits of Reading,* edited by Eric Downing, Jonathan Hess, and Richard V. Benson (Rochester, NY: Camden House, 2012). I am grateful to Jim Walker, editorial director at Camden House for permitting me to republish this material here. An initial exploration of the question of gender first saw the light of day in *Visualisierungsstrategien in mittelalterlichen Bildern und Texten,* edited by Horst Wenzel and C. Stephen Jaeger (Berlin: Erich Schmidt, 2006). First stabs at what became sections of chapter 2 appeared in *Beweglichkeit der Bilder: Text und Imagination in den illustrierten Handschriften des 'Welschen Gastes' von Thomasin von Zerclaere,* edited by Horst Wenzel and Christina Lechtermann (Cologne: Böhlau, 2002), and *Machtvolle Gefühle,* edited by Ingrid Kasten (Berlin: de Gruyter, 2010). Some initial thoughts on the significance of the mirror metaphor for Thomasin (chapter 5) first appeared in *Inszenierung von Subjektivität in der Literatur des Mittelalters,* edited by Martin Baisch, Jutta Eming, Hendrikje Haufe, and Andrea Sieber (Berlin: Ulrike Helmer, 2005).

The research and production of *A Courtier's Mirror* was funded by the Alexander von Humboldt Foundation, the College of Arts and Science at the University of North Carolina at Chapel Hill, and the National Humanities Center. Support from the Senior Associate Dean of Arts and Humanities at Stanford University Debra Satz made it possible to publish the Gotha illustrations in full color.

I would like to thank Stephen Little, editorial consultant at the University of Notre Dame Press, and the rest of the press staff, for help in guiding this project along. I am particularly grateful to Matthew Dowd whose careful editorial work has made a significant impact on

this book. The detailed critiques by the anonymous readers selected by the press were very useful, and I appreciate the time that went into writing them.

Finally, *A Courtier's Mirror* would not have been completed without the support and encouragement of my husband, Michael. This book is dedicated to our daughters whose first six years have been accompanied by this project.

Introduction

Thomasin von Zerclaere's Welscher Gast
and Its Images

This book examines the image cycle of the *Welscher Gast,* an illustrated epic-length didactic poem composed originally by the Italian cleric Thomasin von Zerclaere[1] in 1215 for a German-speaking elite secular audience residing in the region that is today overlapped by northeastern Italy, Austria, and southeastern Germany. The poem was soon transmitted throughout southern Germany and remained popular for about three hundred years.

The *Welscher Gast* is an important text for our understanding of medieval German courtly culture. It is a compendium of ethical, moral, social, and intellectual knowledge for an aristocratic lay audience at a feudal court.[2] The poem includes instruction on table manners, courtly love, self-representation and lordship, the seven liberal arts, giftgiving, justice, and other issues central to feudal society and courtly identity. Like the courtly epic, the *Welscher Gast* constructs an ideal aristocratic society in which knights and ladies are in pursuit of courtly love, social stability, and justice. Whereas the heroes of the courtly epic confront giants, dwarves, robbers, and errant knights, however, Thomasin's stalwart courtier (*biderbe man,* "good man") overcomes a wide variety of personified vices. Only by learning to recognize the vices and eschewing them can a knight, lady, or cleric become an exemplary courtier. Thomasin's goal is to inspire the entire court to live an ethical life characterized by

1

the four central courtly virtues: constancy (*stete*), justice (*reht*), moderation (*maze*), and generosity (*milte*).

In many ways, the *Welscher Gast* is paradigmatic for thirteenth-century courtly culture. The text, which explicitly addresses knights, ladies, and clerics, mirrors a historical and cultural context in which orality and literacy coexisted at court, vernacular literature was starting to be conceived as a written literature, and the aristocracy was concerned with developing a distinct courtly culture that would distinguish it from the lower classes. The *Welscher Gast* also bears testimony to the intersection of religious and secular spheres. Thomasin was a cleric whose knowledge of vernacular literature is established in his evocation of Arthurian and legendary heroes as models of exemplary behavior in part 2 of his poem.[3] He is only one of several German poets who identifies himself, or can be identified, as working in the service of the church.[4] Much research still needs to be done on how secular and religious society overlapped, but the *Welscher Gast* is clearly not unusual in its position as a clerical literary production for a secular audience.[5]

Although in one sense paradigmatic for thirteenth-century elite society and its concerns, however, the *Welscher Gast* is also unique both in terms of its specific content and its conception as an illustrated epic-length didactic poem. It is one of the first vernacular didactic treatises to be composed in the German language and for a lay audience. Furthermore, it is the first extant poem in the German vernacular to be designed as an illustrated text from the start. The image cycle contains over one hundred illustrations that are integral to the poem's pedagogical purpose: the images visualize exempla, personify abstract concepts, and provide mnemonic aids enabling the viewer to more easily commit the instruction to memory. Text and image were conceived and created together.

The illustrated poem constructs an aristocratic courtly identity, but it is concerned also more broadly with ethical behavior and political order. It upholds the traditional estates of peasant, knight, and cleric, and maintains the importance of behaving properly according to one's God-ordained lot in life. Thomasin explicitly addresses the self-representative and performative nature of the medieval court, but also the interactions between lords and peasants, knights and ladies,

and the responsibility of liege lords to behave in good faith, justly, generously, and moderately towards those dependent on them. While its instructions and examples probably seemed archaic for an audience in the fifteenth or even the fourteenth century when towns were starting to compete for power with the rural courts, and a rising burgher class had established itself as literary patrons, the poem continued to be copied and circulated until around 1500. Twenty-five extant manuscripts bear testimony to the poem's popularity particularly throughout the southeast German-speaking region of Western Europe.

Little is known about the circumstances of these manuscripts' production, but the few known patrons and historic records, such as book inventories, that establish ownership of manuscript redactions of the *Welscher Gast* suggest that a broad spectrum of elite society was interested in the poem. Some manuscripts were commissioned by urban burghers, while others were produced for upper or lesser (rural or urban) nobility; some were owned by secular households, others by ecclesiastical courts.[6] The poem thus clearly spoke not only to the feudal secular court audience for which it was produced, but also found broader appeal among the elite secular and ecclesiastical society of the Middle Ages and late Middle Ages. Fifteenth-century audiences perhaps enjoyed the poem less for its pragmatic moral instruction than for its detailed descriptions of the archaic habits and concerns of a bygone era. Rather than see their own culture depicted in the poem, fourteenth- and fifteenth-century audiences may have regarded it as a window to an earlier aristocratic culture. For an upwardly noble aristocrat or wealthy burgher, the poem would have provided considerable entertainment as well as an affirming model of elite society to which to aspire. The illustrations, as this book will show, play a key role in constructing and affirming elite identity over the 250 years of the poem's transmission.

The focus of the present volume is on the poem's visual program and an examination of how it transformed over the course of the poem's reception. Specifically, this study is concerned with what the visual presentation of the poem can tell us about the ways that the *Welscher Gast* was reconceived over the course of its transmission by audiences concerned with imagining themselves as members of an elite society. The poem was composed for the edification of a secular court audience and

focuses on a wide variety of issues including etiquette, courtship, lordship, education, and courtly ethics and virtues, presented in a manner that emphasizes practical implementation in the daily life of the courtier. Its thirteenth-century target audience was heavily concerned with developing an elite identity that distinguished it from nonnoble society, and the poem speaks specifically to that concern. Its images complement that project and help to modernize the text for a changing audience over time. The illustrated poem confirms that medieval society understood that social identity was malleable and that it was possible to fashion oneself according to a model or ideal.[7] This self-conscious process of identity formation is what I mean when I use the term self-fashioning. The *Welscher Gast* bears testimony, on the one hand, to a sustained project of elite self-fashioning starting in the first quarter of the thirteenth century, and on the other, to changing social values over the course of the poem's transmission. These social changes are reflected most clearly in the images.

This book is in two parts. Its core is this introduction and five chapters that provide contextual analysis and interpretation of the *Welscher Gast* and its illustrations. Each of the chapters addresses in turn a different aspect of elite secular identity and a different context of reception that informs the transitions that the images undergo. My thesis is that the illustrated poem participates in the construction of an elite secular identity for an audience that was concerned with distinguishing itself socially and emancipating itself from clerical society. The *Welscher Gast* was understood by its medieval audience as a source of affirmation and pragmatic instruction for the formation of this elite secular identity. As its audience shifts from rural ministerial family to urban burgher, so the staging of the poem also changes. Particularly the formatting and the images are revised and adapted to their audience's specific cultural contexts. First composed for contemplation and reflection in the pursuit of self-knowledge, the *Welscher Gast* was revised as a reference book to be used on the one hand as a resource and on the other as a window into an aristocratic society that became increasingly archaic (but clearly no less desirable as a model) as the poem was transmitted. The Gotha redaction in particular, I claim, reframes this project of fashioning an elite secular identity in terms of fourteenth-century courtly culture. The image cycle

especially is redesigned and expanded to present the viewer with models of courtly behavior and to suggest specific categories of identity formation. Furthermore, changes in formatting reveal a fundamental shift in the manner in which the poem was read. Integral to the elite society that we find modeled in the pages of the Gotha manuscript are visual and verbal literacy, gender roles, and clearly differentiated indicators of social status (estate).

The first part of the book thus focuses primarily on the 1340 redaction of the illustrated text, Gotha Memb. I 120, which I view as a pivotal manuscript in the poem's transmission. The Gotha manuscript is compared both to the oldest manuscript redaction from 1256, Heidelberg Cpg 389, as well as a fifteenth-century manuscript, Wolfenbüttel Cod. Guelf. 37.19 Aug. 2°. The Heidelberg manuscript is a crucial point of comparison because it is the oldest extant manuscript and is presumably closest to the original version. The Wolfenbüttel manuscript is similar to a group of later manuscript redactions and thus serves as representative of the text's late medieval reception. The Gotha manuscript contains the most extensive version of the image cycle, as well as the first extant version of the unusual prose foreword that was appended to the poem in the late thirteenth or beginning of the fourteenth century. It is also the first complete redaction to contain an extensive indexing apparatus that enables the viewer to use the codex as a reference tool. As my study shows, the Gotha manuscript additionally bears testimony to a radical reworking of the image cycle and formatting. This revision that the text and its images in the Gotha redaction undergo establishes its fourteenth-century audience as members of an elite reading community, and reveals important information about that community's reading practices. This manuscript is thus key not only for understanding the poem's medieval reception but also for our understanding of specific subgroups that were part of medieval vernacular literate culture.

The second part of the book is comprised of four appendices. The first provides a catalogue of all extant manuscript redactions of the *Welscher Gast*. The second presents a synopsis of the poem as it appears in the Gotha manuscript.[8] The extensive third appendix presents the illustrated pages of the Gotha manuscript. It contains a description of each illustration including transcriptions and translations of all

banderoles and labels, and reproductions of all of the illustrated folios, so that even scholars and students who are not familiar with Middle High German may have access to this important text and its remarkable visual program. The fourth appendix contains images from other manuscripts, including Heidelberg Cpg 389 and Wolfenbüttel Cod. Guelf. 37.19 Aug. 2°.

THE *WELSCHER GAST* AS A DIDACTIC PROJECT

In the thirteenth century, didactic literature in the German vernacular became widespread and was very popular as a source of edification and entertainment. For the modern reader its representation of medieval society provides a crucial point of comparison and contrast to other literary genres.

The breadth of didactic narrative forms and themes is similar in every western European medieval vernacular, but whereas didactic poems in French and Occitan proliferate already in the twelfth century, German vernacular didactic literature does not seem to appear until the thirteenth century. This thirteenth-century German corpus of didactic works intended for lay audiences includes a wide variety of genres and forms (epic-length poem, short narrative poem, poetic dialog, didactic lyric poetry, such as the *Spruchdichtung,* and so on) that address a broad spectrum of themes (love, conduct, etiquette, lordship, worldly vice, and so forth).[9] While the *Welscher Gast* was the first didactic epic-length poem in the German vernacular, its popularity and the rapid production of other didactic texts in various poetic forms soon afterward bear testimony to a thriving cultural interest in the didactic form.

That said, in the vernacular tradition of the Middle Ages didactic literature as a genre was not considered completely distinct from literature proper. All vernacular literature was expected to entertain and provide edification, be poetic and persuasive. In the courtly romance, audiences receive instruction on proper courtly behavior, fashion, and language; social institutions such as marriage (e.g., *Erec*), or feudal and dynastic relationships (e.g., *Willehalm*); and specific areas of knowledge, such as hunting (e.g., *Tristan*). When it comes to fables, exempla,

and other shorter narrative forms, it is often impossible to draw clear boundaries between entertaining and didactic literature. In this sense, almost all medieval literature is didactic literature.

A categorical difference between didactic and literary texts was probably also not initially reflected in distinct forms of reception or composition. At the beginning of the thirteenth century didactic and nondidactic vernacular poems were likely presented in similar contexts to similar effect. They may have been performed in sections, read aloud, or sung at court, or their manuscripts may have been privately viewed by their wealthy patrons. Both the courtly romance and the *Welscher Gast* are episodic and lend themselves well to being delivered in sections, both are composed in four-beat rhymed couplets, and both are composed for the entertainment and edification of a court audience.

These important similarities aside, however, didactic literature is often overtly pragmatic and generally concerned with social interaction in the here and now. Medieval didactic texts, particularly conduct books, often provide models that are to be mimicked or eschewed; they frequently moralize, persuade, threaten, and cajole their reader or listener to behave in the manner prescribed. Because of its pragmatic and pedagogical intent, didactic literature offers us a rather different perspective of medieval culture than its "literary" counterparts. If we read didactic literature at face value, then we are often led to imagine an ill-mannered society prone to excessive displays of emotion and much in need of controlling and moralizing precepts. Indeed, in his seminal book *The Civilizing Process,* Norbert Elias drew on didactic texts on table manners and courtesy to argue that medieval society was particularly violent, primitive, and badly behaved. He regarded medieval didactic works as representative of accepted social conventions that remained unchanged until the Renaissance, when a notion of *civilité* emerged that was characterized by self-control and refined expression. Elias cites the German translation of the *Disticha Catonis,* a compendium of proverbial wisdom composed originally in Latin (third or fourth century AD), as well as other medieval books of table manners and courtesy to make his point that medieval culture naively perceived their environment in terms of the opposition between "good and bad."[10] The Renaissance treatises by Erasmus, Castiglione, and others,

by contrast, according to Elias, reflect an era in which people are more refined, self-controlled, and behave in a more nuanced and deliberate manner than in the Middle Ages.[11]

However, as many scholars have shown, Elias's reading of medieval texts as a literal representation of medieval society is problematic at best.[12] First, he focuses on a select group of texts that are hardly representational of medieval didactic literature. Were he to have examined a larger corpus of didactic material, Roberta L. Krueger points out, he might have concluded instead that "medieval moralists were intensely preoccupied with attempting to shape behavior."[13] Second, many scholars have taken issue with Elias's assessment that medieval people had not yet developed the social competence to control themselves and their emotions.[14] Indeed, thanks to the work of Barbara Rosenwein and others, it is now generally accepted that it is essential to learn to read and understand medieval descriptions of social behavior both in their broader historical and in their specific literary contexts. Different genres assume different social codes.[15]

In fact, despite its pragmatic intent, didactic literature does not offer us a true reflection of medieval behavior. As Krueger succinctly puts it, "competing clerical, chivalric, and bourgeois registers may clash in a single work."[16] Prescriptive rather than descriptive, the corpus of didactic works as a whole uses various lenses to refract notions about society and social behavior and thus provides the modern reader with diverse perspectives on medieval discourses of identity. Indeed, because of its pragmatic and pedagogical intent, didactic literature offers us a view of medieval culture sometimes complementary to and sometimes conflicting with its "literary" counterparts.

The *Welscher Gast* presents us with an image of an ideal medieval court society imagined by Thomasin to be deeply invested in the virtues of constancy, moderation, justice, generosity, and all the subvirtues that go along with them. He depicts an ethical secular society that is elite in appearance and behavior and has a clearly defined social and political role in maintaining social order. This is an imagined society, but because it is one that we encounter in the courtly epic as well, it must have represented a familiar and widespread secular ideal. In contrast to the courtly epic, however, Thomasin provides his audience with pragmatic guidelines on how to achieve this ideal.

Franz H. Bäuml once characterized the *Welscher Gast* as "excessively dreary in its unremitting moralizations, accompanied by a permanently raised didactic forefinger."[17] Indeed, from the modern perspective, much medieval didactic literature seems exceedingly tedious, and moreover often seems far from being innovative or progressive.

In contrast to Bäuml's dire assessment of the poem, however, this study suggests that the *Welscher Gast* participated in a dynamic and constructive social process of identity formation for the class of ministerials in the German-speaking Middle Ages. In the thirteenth century the rise of the ministerials as a powerful political class is a specifically German phenomenon. The ministerials had a vested interest in establishing a noble identity and the *Welscher Gast,* the author of which was probably a ministerial himself, contributes in no small way to that project.

VISUALITY IN THE *WELSCHER GAST*: THOMASIN'S *BILDE*

Whether composed orally or in writing, vernacular literature of the twelfth and thirteenth centuries was composed in a historical context in which people communicated primarily by seeing, watching, and hearing each other.[18] Medieval literature abounds with descriptions of ornate material objects, architecture, clothing, gesture, and ritual. These descriptions and the material world on which they are based are indicative of a medieval society that was visually attuned and in which images, objects, and performance played a dominant communicative and ritualistic role in both secular and religious spheres of interaction.[19] Although verbal literacy was not widespread, and written culture was dominated by Latin and was the domain of the clerics, the medieval laity was visually literate: space, presence, and sensory stimuli were essential to social interaction in the secular world. Courtly society in particular was a visually oriented society, in which the choreography and representation of bodies and status was crucial for self-representation and identity. Medieval culture not only privileged sight and visual perception over other forms of reception and cognition but also gave rise to numerous discourses on visuality that may be found in the works of medieval secular poets, theologians, and scholastics alike.[20]

In the literature of the thirteenth century, we find an increased self-conscious awareness of seeing and visibility as crucial aspects of self-representation. From the lengthy descriptions of clothing and ritual to the imagination of devices that enable seeing (the mirror atop Camille's tomb in the *Eneasroman*; the magic column in *Parzival*) or cause invisibility (Siegfried's hood in the *Nibelungenlied*), vernacular courtly literature abounds with plot developments that rely on visual representation and perception.

In the *Welscher Gast*, Thomasin confirms that there is nothing natural about lordship status. In order to be recognized as a lord, one must present oneself visually and visibly as a lord—one must perform one's lordship. Thomasin dedicates a significant amount of his treatise not only to public behavior and appearance, including etiquette and comportment, but also to specific instructions for the public self-representation of ruling lords. Thomasin thus articulates much of what would have been apparent to medieval audiences of thirteenth-century literary texts: the visual is important, and courtiers had to learn to use and understand visual cues.

The *Welscher Gast* was created at a historical moment characterized by an interest in both pictorial and textual images. The thirteenth century was witness on the one hand to an explosion of visual narrative in the form of illustrated manuscripts, wall paintings, and panel paintings, and on the other the development of narrative modes and devices in vernacular literature and sermons that emphasized the visual, such as ekphrasis and exempla.[21] The *Welscher Gast* is not a highly innovative poem, but its combination of textual and visual images is novel, and it participates significantly in this rising interest in the visual. Thomasin invites his listeners and readers either to ruminate on the text or to examine its images minutely, taking example from them and learning to behave accordingly. Above all the author expects his audience to see reflected in the text and illustrations both an identifiable image of itself and an idealized image of what it might become.

The *Welscher Gast* is a courtier's mirror in the medieval sense that it provides an edifying model of ideal behavior to which its elite audience is expected to aspire.[22] The mirror was a very popular medieval genre that became particularly prominent in the thirteenth century and retained its popularity until the sixteenth century, exactly the period dur-

ing which the *Welscher Gast* was transmitted.[23] As Horst Wenzel explains: "The literary mirror presents its viewer not with a reflection as would a mirror made of metal, but with a role model. It functions as a medium of perfection that transfers a prescriptive image to the outer and inner eye. It invokes sensory and imaginary seeing, and it combines the processes of recognizing Otherness, perceiving the self, watching, and practicing self-control."[24] Thomasin intended to reach a mixed courtly audience comprised of knights, ladies, clerics, and children, and he frames his instruction in diverse ways in order to enable this audience to "see" the possibilities of living an ethical and moral life.

While the poem makes use of a highly visual language, the illustrations are often extraordinarily textual. They rely on their inscriptions, or their explication in the poem, or the viewer's ability to create a narrative that corresponds to or comments on the corresponding text. The two media overlap and intersect in complex ways, so that it becomes impossible and indeed undesirable to tease them apart.

W. J. T. Mitchell has called this kind of interplay in modern art and literature "imagetext." This term recognizes that we are dealing with two different media, but it "designates composite, synthetic works (or concepts) that combine [them]."[25] In the Middle Ages, however, images and text were not conceived as dichotomous media that might be combined, but rather as two ends of a single spectrum. In other words, to use Mitchell's term, everything was an imagetext, but some things were more textual and others more imagistic. In the *Welscher Gast,* this kind of textual and pictorial visual coding of language was simply called *bilde* (image). Michael Curschmann has referred to the relationship between text and image in vernacular medieval German culture as an "audiovisual poetic."[26] He writes: "irrespective of their own stylistic, iconographic, or intellectual traditions, texts and pictures work together in given instances to produce something larger than the sum of its parts."[27] "The most common mistake," Curschmann adds, "is to define and interpret such relationships in terms of content—as though one medium were supposed to translate from the other."[28] The *Welscher Gast* presents us with numerous examples of the ways in which this audiovisual poetic functioned in the Middle Ages. Chapters 2 through 5 of *A Courtier's Mirror* explore some of these examples to show that, while the imagetext was commonplace, it functioned on multiple levels to speak

to different audiences. Through the visual strategies embedded in the poem and its illustrations, we become witnesses to the interplay between Latin and the vernacular, between theological and secular, between literary and didactic, and between the individual and community.

The poem is a highly pragmatic treatise in which Thomasin intends to "transmit current social norms to his readers and listeners in a manner that will allow them to practice them."[29] Thomasin's pedagogical strategy for teaching his audience to behave ethically, correctly, and in a manner befitting its aristocratic status is derived, on the one hand, from his understanding of social categories and feudal hierarchy, and on the other, from his notion of how memory and imagination work, and his assumptions regarding the usefulness of images in the acquisition of knowledge. In a well-known passage he imagines different forms of reception for different audiences:

> swer niht fůrbaz chan vernemen,
> der sol da bi ouch bilde nemen.
>
>
>
> von den gemalten bilden sint
> der geboure unde daz chint
> gefrewet ofte. swer niht enchan
> versten, daz ein biderb man
> an der schrift versten sol,
> dem si mit den bilden wol.
> der phaffe sehe die schrift an.
> so sol der ungelerte man
> die bilde sehen, sit im niht
> die schrift zerchennen geschiht.
>
> ———
>
> Whoever is unable to comprehend otherwise should learn by looking at images. . . . The peasant and the child are often pleased by painted pictures. Whoever cannot understand what a good man should understand from writing is well served by images. Just like the priest looks at words, thus should the unlearned man look at images, since writing does not reveal itself to him.
>
> (1703–4, 1709–18; 1091–92, 1097–1106)[30]

Thomasin refers here specifically to "painted pictures" (*gemalten bilden*), but throughout the poem he invokes the term *bilde* (image) much more broadly to refer to role models, examples, descriptions, scenarios, thoughts, memories, imagination, and dreams, as well as painted pictures.[31] The author uses numerous visual cues to help his listeners to envision the text and remember its message. And he "illustrates" his instruction by describing exemplary scenarios that would be familiar to his readers and listeners, encouraging his audience to use their imaginations to create their own images, and instructing them to learn from the living examples and role models that they see at court.

Thomasin clearly thought about the processes of reflection and self-reflection, for he writes about it in the section of the poem that deals with the education of children:

> er sol ouch haben den mŭt,
> merchen swaz der beste tŭt,
> wan diu frumen liute sint
> unde suln sin spigel dem chint.
> daz chint an in ersehen sol
> waz ste ubel oder wol.
> siht er daz im mach gevallen,
> daz la niht von sinem mŭte vallen.
> siht er, daz in niht dŭnchet gŭt,
> daz bezzer er in sinem mŭt.

———

> He [the child] should also have the presence of mind to pay attention to everything the noblest person does, because noble people are and should be a mirror for the child. The child should see in them what is evil or good. If he sees something that pleases him, let him not forget it. If he sees something that does not seem good to him, then he ought to improve it in his mind.
>
> (1229–38; 617–626)

Thomasin thus advises the young courtier to use what he or she sees in order to create an ideal image in his or her mind's eye to which to aspire. Thomasin's use of the mirror metaphor in the specific context

of self-improvement evokes the long tradition of philosophical, theological, and scholastic debate on the mirror as a metaphor for self-knowledge.[32] But, typical for Thomasin, his particular interpretation of the mirror metaphor is pragmatic, simplified, and specific to his target audience. He invokes the mirror metaphor throughout the poem to emphasize the importance of seeing and learning by internalizing images. Thomasin's use of this metaphor to visualize for his audience the pedagogical strategy of selecting or creating a visual role model is thus not only applicable to children but suggestive for his poem as a whole. The cycle of illustrations underlines this emphasis on visuality in important ways. Among others, it provides visual elaboration or commentary on the poem, envisions the scenarios described in the poem, personifies abstract concepts such as the vices and virtues, and provides mnemonic aids to the audience.

The illustrations of the *Welscher Gast* are thus one important component of the poem's focus on visuality. The *Welscher Gast* is the first poem in the German vernacular to be designed as an illustrated text from the start. The oldest extant manuscript from 1256 contains over one hundred illustrations, and it is generally assumed that this entire cycle dates back to the composition of the poem. Adolf von Oechelhäuser, whose 1890 book was the first to examine the image cycle, suggested that Thomasin himself was responsible for its design, and most scholars agree. Regardless of their provenance, the images were considered integral to the poem throughout its transmission. Of the twenty-four extant manuscripts and fragments, at least eighteen are either illustrated or were intended to be illustrated.[33] This is in fact one of the striking and unusual features of the *Welscher Gast* material: although many early vernacular manuscripts were illustrated, it is highly unusual to have a specific cycle of illustrations associated so closely with a text that text and image were transmitted together.

THE VISUAL PROGRAM

As this study shows, the poem and its images were often designed to work in tandem to create meaning on a number of levels. Numerous

images illustrate the courtly scenarios that Thomasin describes; others translate abstract notions into concrete ideas or interactions; some take issue with the text and present the viewer with an alternative perspective. Some illustrate a single line or two of the poem, others visualize the essence of longer passages. Many of the images are moralizing; some of them are humorous. One of the dominant themes is the battle between the virtues and the vices. This is the topic of the opening illustration in the Gotha codex, but it reappears in all of the manuscripts and throughout the visual program. A few images are systematic diagrams of medieval philosophical and theological worldviews.

Most of the illustrations depict figures interacting with personified vices and virtues. The personifications are identified by means of inscriptions, a necessary aid to identifying them as their visual representation is not consistent even within the same manuscript. The allegorical personifications interact with exemplary figures taken from medieval life (the lord, the judge, the lady), history (Caesar, Pliny), and mythology (Love). Whether personification or courtier, the figures are similar in appearance: they all wear fashionable contemporary clothing, and their interaction is portrayed by gestures and inscribed banderoles containing their utterances. The images are thus simultaneously allegorical, symbolic, and narrative. Often the banderoles provide the only means by which to connect the illustration to the text. Indeed, most of the images cannot be deciphered without reading the labels or the banderoles or both.

The illustrated manuscripts and fragments of the *Welscher Gast* offer us a unique opportunity to examine manuscript illustration diachronically, since the visual program varies in style and content but not in subject.[34] Whereas revisions to the poem in the course of its transmission resulted in an improved rhyme scheme and in some cases abridged versions of the text, the content remained virtually unaltered throughout its transmission. The illustrations, however, changed in intriguing and significant ways as they were transmitted to refract or comment on their specific historical context and target audience.

In the earliest manuscripts the images have no frames or baselines so that the figures float freely, gesticulating with exaggerated hands and extended fingers. In the later manuscripts the illustrations are framed

and the figures are placed against backgrounds, or at least given base-lines on which to stand.[35] This variation may be partly if not wholly attributed to changes in artistic style. But there is also variation—in the banderoles that the illustrated figures hold, in their labels, in the constellation of figures, and in the representation of the personified vices and virtues—that cannot be explained by changes in style or aesthetic preferences. Instead, these changes suggest differing notions about how vernacular books, and specifically their illustrations, were expected to reflect on social expectations, stereotypes, and ideals. Furthermore, many of the decisions that artists made regarding format, such as whether to place the illustrations in the column of text or in the margin, and whether to orient the illustrations with the text or not, bear testimony to competing ideas about the relationship between word and image and demand different reading practices. The fluidity of the images over time suggests that the cycle was consciously and consistently reworked to satisfy new demands and criteria.

The images' variation is thus not dependent on variation in the text but instead tells its own story. As a whole, the illustrations offer a point of entry into the poem, a bridge between the feudal society represented in the poem and the diverse audiences that enjoyed it. The specific realizations of the image cycle offer us windows into the literary cultures of the German Middle Ages. The illustrated poem thus not only presents us with a unique perspective on a German-speaking court society from 1215, when the poem was first composed and its illustrations first designed, but also reveals divergent notions of status and difference throughout the medieval period. The poem's audience changed significantly over the three hundred years of the book's popularity, but it was consistent in its desire to construct a distinct elite secular identity.

Relatively little work has been done on the images of the *Welscher Gast,* or even on the poem as a whole. A few scholars have examined individual illustrations in the manuscripts of the *Welscher Gast* comparatively. The work of Horst Wenzel deserves special mention here. In a series of essays, he has focused on the variation of individual illustrations in the course of the poem's transmission. His recent book on visuality also draws heavily on examples from the *Welscher Gast* to make the argument that medieval images, like texts, were conceived with the

idea that the viewer was an integral part of them and not merely an external observer.[36] Wenzel thus views the illustrated poem as a performative space into which the thirteenth-century reader/viewer enters and is intellectually and sensually fully engaged.

Wenzel has drawn analogies between the pictorial variation in the *Welscher Gast* and the *mouvance* or *variance* in medieval redactions of texts identified by Paul Zumthor and Bernard Cerquiglini respectively.[37] For Zumthor, a medieval text's *mouvance* testified to its proximity to the medieval voice, and its dependence on a performance situation to be actualized. For Cerquiglini, a text's *variance* bears evidence of the dynamic and fluid nature of textual production in the Middle Ages. For both, textual variation implies that the notion of a text as a stable and fixed piece of writing is anachronistic for medieval literature, which is characterized by its instability or fluidity.[38] For the modern scholar, the fluidity of the medieval text means that we are often confronted with variants: shortened versions, longer versions, extensions, and divergent interpretations. The work of both Zumthor and Cerquiglini spawned a vibrant debate across medieval studies—particularly in the context of the New Philology.[39] Wenzel has argued that manuscript illustrations too are unstable and fluid.[40] Their variation is particularly apparent in the manuscripts of the *Welscher Gast* in which the same image cycle is reproduced in numerous manuscripts over an extended period of time.

In his study of a single *Welscher Gast* illustration of a ship as a metaphor of lordship (fig. 31, ill. 48), Wenzel shows that, although the corresponding passage of the poem does not change significantly, the image, which appears in ten manuscript redactions, undergoes two or three revisions in the course of its transmission. These variants, he argues, not only speak to different iconographic influences but also suggest that diverse cultural notions of lordship are at stake. The illustration is changed in order to make the textual analogy of lordship to steering a ship accessible to different audiences.[41] Wenzel thus shows that texts and their illustrations may change independently, and he offers a productive interpretive model for examining the images of the *Welscher Gast*. The variation that he identifies in individual illustrations, however, does not reflect a comprehensive reworking of the image cycle at any particular historical moment. As we will see throughout

this book, many illustrations in the cycle vary significantly over time. But the crucial changes made to individual illustrations do not all occur simultaneously. Indeed, whereas the text becomes fixed by the four- teenth century, the illustrations respond with more flexibility through- out the poem's transmission to specific historical and cultural circum- stances, and presumably also to specific requests by patrons.

The *Welscher Gast* illustrations must also have evoked (whether intentionally or not) different responses from their viewers over time. Whereas the artists of the oldest versions of the image cycle used mnemonic strategies to make memorable and often affect-inducing images that could be read on multiple levels, the artists of the younger versions of the illustrations sought more to provide images in which the viewer might see him- or herself reflected and find affirmation of his or her own elite identity. Later audiences were expected to identify with the illustrations. These changes were brought about in part by creating a narrative within individual illustrations but also by constructing so- cial categories with which viewers could identify. Gender plays a role in this context. The sex of the personifications in the earliest manuscript generally corresponds to their grammatical gender, but in the later manuscripts the personifications become more independent of lan- guage and participate more fully in the discourse on social gender roles in which the poem also engages.[42] For example, Lying (*diu luge*), a grammatically feminine vice, is personified in the 1256 Heidelberg and the Gotha redactions as a female figure (figs. 79 and 5, ill. 5), but in the Wolfenbüttel manuscript (fol. 10r), and other fifteenth-century redac- tions the same figure appears as a male courtier (figs. 96, 98).[43] The cor- responding passage in the poem depicts a young courtier lying about his association with a lady. The younger illustrations, therefore, ignore grammatical gender and present us with a more faithful representation of the scenario described in the poem. Indeed, whereas older versions of the illustrations are often highly textual in that they mimic the language and visualization strategies in the text, the younger illustrations reinter- pret the poem for a late medieval audience that was perhaps more inter- ested in social interaction, and more invested in reading the images as visual narratives that tell a story.

I will in this volume show that text and image in the *Welscher Gast* were conceived as variations of the visual coding necessary to make an

instructional treatise pedagogically effective for an elite secular audience. But the relationship between the text and its images changes as the illustrations are revised. This study thus examines how the illustrations of the *Welscher Gast* are altered over the course of its transmission to address the concerns and interests of its diverse and changing audiences. The illustrations reveal to us the ways in which medieval and late medieval audiences "read" the illustrated poem; the variation in the illustrations reflects changing relationships between text and image, which in turn offers us a window into developments in reading practices and audience expectations over the course of the poem's transmission.

CHAPTER ORGANIZATION

Although I take the entire corpus of *Welscher Gast* manuscripts into consideration, as mentioned above, I focus in this study on the 1340 manuscript Gotha, Universitäts- und Forschungsbibliothek Erfurt/Gotha, Memb. I 120, and look for comparison primarily to the 1256 manuscript Heidelberg Universitätsbibliothek Cpg 389 and to a lesser extent the manuscript Wolfenbüttel, Herzog August Bibliothek, Cod. Guelf. 37.19 Aug. 2° from the first half of the fifteenth century. While the poem remains relatively stable in content, these three manuscripts represent three stages in the transmission of the images and contain three distinct variations of the image cycle. The images of the Heidelberg manuscript are highly performative and rely on a visually literate viewer to make associations beyond the text. The Wolfenbüttel manuscript depicts scenes of lively interaction between aristocratic figures that seem to draw on notions of dramatic performance most closely connected to modern notions of representation. The Gotha manuscript is pivotal both for the transmission of the *Welscher Gast* and for the history of the medieval book in general. It features the most significant changes in the image cycle, formatting, and organization, and its revisions are taken up in almost all of the later manuscripts. The Gotha redaction is furthermore a critical document for our understanding of the history of the vernacular book in general, as it bears evidence of a fundamental shift in medieval vernacular reading practices.

One of the most significant changes to the poem in the Gotha manuscript is in its format and organization. Chapter 1 compares the Gotha manuscript with the 1256 Heidelberg redaction from the perspective of these formal revisions. The format and organization of medieval manuscripts are important visual indicators of the changing status and function of the vernacular book in medieval society. The Gotha redaction of the *Welscher Gast* is the first vernacular epic poem to contain a prose foreword. This foreword describes the poem's organization, its subdivisions, and the topics that it addresses. It also contains an indexing apparatus that allows the viewer to locate specific sections or topics in the codex. I argue that these changes in format and presentation of the poem in the later manuscript enable, and indeed require, a viewer to read the text differently. The index and foreword frame the poem as an encyclopedic work that may be used as a resource by a social group eager to associate itself with the courtly society imagined in the pages of the *Welscher Gast*. The pedagogical purpose of the poem is thus realized in the Gotha manuscript by its formal transformation into a reference work.

Chapter 2 focuses on the illustrations and the question of how they were "read," arguing that one of the catalysts for change in the visual program may have been the debates surrounding the transformation in models of seeing from an extramission model to an intromission model. Ideas about how vision works are closely related to notions about the relationship of the viewer to the image or object viewed. Thomasin addresses notions of seeing in the poem itself, but the illustrations reveal that the artists' assumptions regarding the role of the viewer vis-à-vis the illustrations were often quite different from the poet's and changed radically in the course of the poem's transmission. The illustrations, which are originally associative and layered images that function on multiple levels to create meaning and present sites of contemplation are changed over time to emphasize narrative over other forms of illustration. The later manuscripts depict dramatic scenes performed by secular elite actors similar in appearance to the audience for whom they were created. The Gotha manuscript is again pivotal in this transformation.

Chapter 3 reveals that gender plays a complex but crucial role in the way in which courtly identity is constructed in the *Welscher Gast*.

Whereas Thomasin prescribes a specific notion of gender difference in his poem, this notion is not always reflected in the illustrations of the different redactions. Instead, each artist draws on a broad spectrum of associations—from grammatical gender to religious imagery to social stereotypes or conventions. While gender is a static category in the poem, the illustrations reveal it to be a heterogeneous, nuanced, and dynamic category of identification. The Gotha manuscript is in this regard too a crucial point of transition in which one sees grammatical gender giving way to cultural notions of gender in the illustrations.

The first part of chapter 4 examines the image cycle of the Gotha manuscript with particular attention to the way in which it represents social status, particularly nobility, and emphasizes courtly motifs. Like other luxurious fourteenth-century manuscripts, the Gotha codex harkens back to a literary ideal of courtly society that was developed in the courtly romance around 1200. The image cycle of the Gotha redaction suggests that this codex was part of a concerted effort to participate in a process of aristocratic self-fashioning. More specifically, the Gotha images reframe the text to construct an ideal for noble behavior that is explicitly based on the courtly ideal of love service. The likely historical context of the Gotha manuscript suggests that it represents the growing power and consciousness of elite identity among the lesser nobility in late medieval Germany. The second part of this chapter explores this broader cultural context surrounding the manuscript's production and proposes that the manuscript represents a fourteenth-century form of literary appropriation by a ministerial family.

The concluding chapter makes the argument that the *Welscher Gast*, as a literary mirror, transforms from a site of contemplation and a source of self-recognition and self-knowledge to a mere reflection of the times. Later manuscript redactions no longer challenge the viewer or engage him or her in a project of improvement and identity formation. Instead the youngest redactions merely affirm their audience's claim to elite status.

The remainder of this introduction provides background information about the poet, the cultural context of the poem's composition, and its editorial history. These issues have generated most of the scholarship on Thomasin's *Welscher Gast,* and it is therefore essential to address

them here, although they have little bearing on my analysis of the images. The meat of my project thus begins in chapter 1.

THE POET: THOMASIN VON ZERCLAERE

Many medieval authors neither name themselves nor provide us with specific details about their social, political, and intellectual environment. Thomasin, by contrast, not only introduces himself in the prologue by name, nationality, and origin, but also litters his text with biographical references that allow us to place him both temporally and spatially. Nonetheless, there is some controversy about him, particularly with respect to his position in the church and his relationship to the court of Wolfger, the Patriarch of Aquileia (ca. 1140–1218).

In the poem, Thomasin tells us that he is an Italian native speaker from Friuli (679–81; 69–71) and that he is writing the book in a language that is foreign to him (677–79; 67–69) for an audience of "brave knights and good women and wise clerics" (*frûme ritter und gûte vrowen und wise pfaffen,* 15349–50; 14695–96). He informs us that he has already written a book of courtesy (*von der hôfscheit,*) in *wælhischen* that deals, for example, with the topic of love (1785–90; 1173–78). This book has not come down to us. Since the term "welsch" can refer to any Romance language, there has been some debate as to which language Thomasin is referring. William F. Carroll has provided the most convincing analysis of the term as it appears in the *Welscher Gast,* suggesting that Thomasin uses it interchangeably to refer to Italian, Provençal, and French, depending on context, and that its specific meaning in any given context would have been clear to his immediate audience.[44] That is, since Thomasin is Italian, the "welscher Gast" of the title presumably refers to an "Italian guest," yet when Thomasin refers to German poets strewing "welsche" words throughout their German texts, he may be referring to the many French terms that German-speaking poets such as Wolfram and Gottfried used liberally in their descriptions of courtly culture. By contrast, the enigmatic book of courtesy might have been written in Provençal, the literary language of northern Italy. There was a steady stream of Provençal poets to northern Italy, and it is in Provençal

that we find an established tradition of didactic vernacular poems on which Thomasin may have drawn.[45]

The *Welscher Gast* may be dated using an internal reference by Thomasin in which he bemoans the fact that Christ's grave has been lost for some twenty-eight years (12363–72; 11709–18). This is a reference to Saladin's conquest of Jerusalem in December 1187 and indicates that Thomasin composed the poem in 1215/16. He informs us that it took him ten months to complete his book (12932–36; 12278–82). Because, while he is writing the poem, Thomasin is not yet thirty years old (3047; 2445) he must have been born around 1186. Thomasin further informs us that he was present at one of the pope's calls to arms for the crusade (11835–40; 11183–88) and that he spent over eight weeks at the court of Otto IV in Rome when he was crowned emperor—this must have been in the summer of 1209.

Thomasin's references to his immediate environment place him at a court. He mentions that he has retreated from watching tournaments, from dances, and from interacting with ladies (12895–96; 12241–42, and 12973–74; 12319–20), to a secluded room where he is painstakingly writing his book, not for his own pleasure, but because he feels compelled to offer advice to the courtiers around him who are behaving inappropriately (12937–44; 12283–90). He draws a comparison between his current life at court and his secluded life at school (12910–11; 12256–57). This reference to his school days suggests that he was formally educated. Indeed, the poem reveals that Thomasin had broad knowledge of biblical and world history, politics, theological and philosophical thought, and courtly literature. He may have been educated at a university, but it is more likely that he received his education at a cathedral school.[46] His particular interest and skill seem to lie in reframing scholastic and clerical thought in lay terms.

This sketch of the historical person Thomasin is derived from internal references in the text. There are, however, some external historical references that may be traced to our poet as well. There are several references to the family name Zerclaere (Cerchiari, Cerclara) in the city of Cividale in Friuli, Italy. Members of the family were merchants, shippers, and notaries and must have belonged to the urban upper classes.[47] Two historical references may correspond specifically to our poet.[48] One

is a document from 1217 in the Biblioteca Civica Cividale in Friuli, which contains a reference to a "Thomasinus canonicus Aquilegensis." The second is an entry regarding the death of the church canon Thomasinus de Corclara that appears in the *Necrologium Ecclesiae Aquileiense,* in which deaths and the gifts from the deceased to the cathedral chapter of Aquileia are listed.[49] The manuscript dates from about 1300 and lists Thomasinus's death as May 11, but it does not list the year.[50] If this is indeed a reference to our poet, then it indicates that he died as a canon, but it does not tell us where he held his office, nor does it reveal to which chapter he belonged. Given the content of the poem and its intellectual foundations, most scholars assume that our author Thomasin held a position in the church and may have been a canon.

Most scholars have further placed Thomasin at the court of Wolfger, the patriarch of Aquileia.[51] Since we know more about Wolfger than we do about many of the thirteenth-century literary patrons, placing Thomasin at his court enables us to make certain assumptions about the person of Thomasin and the environment in which he lived.[52] Wolfger was a powerful politician and diplomat and had made his mark as the bishop of Passau prior to taking over the position of patriarch in 1204 at the death of Pilgrim II. Among several important diplomatic tasks, Wolfger skillfully managed the negotiations for the release of Richard Lionheart who was captured and held hostage by his enemy Leopold V on his way back from the crusade. He was an important patron of the arts and supported the poets Walther von der Vogelweide, the now anonymous *Nibelungenlied*'s author, Albrecht von Johannsdorf, and the Italian scholar Boncompagno, among others.[53] Scholars also assume that Thomasin was at Wolfger's court for over ten years by the time he wrote his poem and that he was familiar with the work of Walther von der Vogelweide. The evidence cited for this is the following passage in Thomasin's poem:

> ia ist bi mir zehen iar
> ein man, und weiz doch niht fůr war,
> ob er si ubel oder gůt
> und sprichet denn důrh sinen ubermůt
> daz der papst si ein ubel man:
> seht, wie ich mich bewarn chan.

———

Indeed, there was a man here for ten years and I do not truly
know whether he is wicked or good, but if he then exclaims in
arrogance that the pope is an evil man, then watch how I will
assert myself.

(11763–68; 11111–16)

Without naming Walther, Thomasin ostensibly cites him here as a nega-
tive example of someone who does not guard his tongue but instead
makes foolish and hateful remarks about the pope.[54]

There remains, however, a lot of uncertainty about Thomasin's posi-
tion in the church, which chapter he might have been a member of,
whether he lived in Aquileia or Cividale, and what his actual relationship
to Wolfger (or Walther) might have been.[55] Despite the uncertainties, it is
apparent that his work was intended for the kind of German-speaking
aristocratic audience that would have been present at Wolfger's court,
and would also have been found more generally in the bilingual region
in and around Friuli during this period.[56]

THE POEM: ITS LITERARY CONTEXT, INFLUENCES,
AND AUDIENCE

The literary and cultural context of the poem's composition was rich
and varied. There are numerous medieval didactic texts and traditions
on which Thomasin may have drawn.[57] In addition to the Latin literary
traditions that seem to have formed a part of Thomasin's education,
he would have been influenced by Provençal and French literature. The
Provençal literature included song but also didactic and religious po-
etry, including the moral compositions known as *ensenhamen*. These
addressed topics such as ladies' comportment, chivalry, and courtly
love. From the end of the twelfth to the end of the thirteenth century
there was much exposure in northern Italy to the Provençal poets.[58]
The French epics and romances were also well known across Europe,
and they were widely translated and imitated.[59]

Predominant in the *Welscher Gast* is the catalog of vices and virtues,
which became a popular topic for treatises in the thirteenth century.[60]

Virtues and vices were a ubiquitous topic in the clerical literature and re-
ligious sermons of the Middle Ages, and they were often personified in
literature and the visual arts. Latin and Provençal didactic literature in
particular made extensive use of personified virtues and vices. Thomasin
thus had a broad spectrum of sources on which to draw. Specific sources
that scholars have identified include Alan of Lille, Aristotle, Cicero,
Boethius, Seneca, St. Augustine, Isidore of Seville, Ambrose of Milan,
Pope Gregory I, the Bible, and others.[61]

While abundant influences may be detected, however, it is clear that
Thomasin reinterpreted his sources, sometimes dramatically, to suit his
own purposes.[62] Indeed, no direct source for the poem has been iden-
tified. As Thomasin implies in his metaphor of the poet as a carpenter
in the prologue to the poem, he used a variety of sources provided by
others to construct his own unique text:

> doch ist er ein gůt zimber man,
> der an sinem wǎrche chan
> stæin und holtz legen wol,
> da erz von rehte legen sol.
> daz ist untůgende niht,
> ob ouch mir lihte geschiht,
> daz ich in mines getihte want
> ein holtz, daz ein ander hant
> gemæistert habe, lege mit dem list,
> daz ez gelich den andern ist.

———

> Indeed, it is a fine carpenter who is able to lay stone and wood
> well and properly in his work. It is not a vice if I perhaps place
> so skillfully in the wall of my poem a piece of wood that another
> hand has formed so that it is similar to the others.

<div align="right">(715–24; 105–14)</div>

Thomasin also underlines the skill required to carefully construct such
a text:

> davon sprach ein wiser man
> 'swer gefůglichen chan

setzen in sin getiht
ein rede, die er maht niht,
der hat also vil getan,
da zwifelt nihtes niht an,
als der derz von erste vant:
der funt ist worden sin zehant.'

———————

A wise man once said, "There is no doubt that whoever is able
to incorporate into his poem a passage that he did not himself
compose has done just as much as he who first created it.
It immediately becomes his own creation."

<div align="right">(725–32; 115–22)</div>

In fact in composing his poem, Thomasin synthesized and interpreted
much contemporary knowledge about aristocratic notions of conduct
and social interaction, ethics, philosophy, and the liberal arts. The
ideas contained in the *Welscher Gast* are thus not original, but instead
represent a compendium and interpretation of conventional wisdom.
Characteristic for Thomasin's reworking of academic and scholastic
ideas is his pragmatic approach, which renders his material accessible
to a wide audience. The poem's novelty lies in Thomasin's instrumen-
talization of abstract notions of vice and virtue and his translation of
morals and ethics into a secular courtly context.

THE EDITORIAL HISTORY AND MODERN RECEPTION
OF THE *WELSCHER GAST*

As a compendium of medieval courtly culture, the *Welscher Gast* is a
crucial source for historians and an invaluable resource for medievalists.
Given its cultural importance as the first vernacular didactic treatise in
German and the first German vernacular illustrated text, it is surprising
that this poem is relatively unknown outside the academic world of Ger-
man-speaking medievalists. Even among interested students of medieval
German literature, few have read the treatise in its entirety. To be sure,
the text is not an easy read, nor does it have the poetic appeal of its ro-
mance contemporaries, such as Wolfram von Eschenbach's *Parzival* and

Gottfried von Strassburg's *Tristan*. But the poem's lack of recognition in the broader medieval studies community may have more to do with the fact that it has, until recently, never been translated in its entirety into any modern European language.

The corpus of extant manuscripts and fragments indicate that, while the content of the poem did not change radically over the course of its transmission, it did undergo numerous revisions. The oldest version appears in only two manuscripts, the earliest extant redaction from 1256 (Heidelberg Cpg 389), and a later manuscript from 1450–70 (Dresden, Landesbibliothek, Mscr. M 67). This later manuscript has been discussed in the scholarship primarily in terms of its "contamination," that is, in terms of its deviance from the version of the poem in Heidelberg Cpg 389. The manuscript fragment Bibl. Jagiellońska, Berol. mgq 978 reveals that the poem was edited and revised by the late thirteenth century. More significantly, however, sometime before the Gotha manuscript's compilation in 1340 a prose foreword was added, which provides a synopsis of the poem and functions as a table of contents. This prose foreword appears in most of the extant manuscripts that were compiled after 1340. The poem was later revised more thoroughly, in particular many passages were shortened or omitted, and variations of this revised redaction of the poem appear in the later manuscripts, including the Wolfenbüttel redaction.[63] Understanding the specific differences between particular versions of the poem is important and useful, but is not the goal of this book. As background to studying the variation in the images, however, it is important to realize that there are different stages in the poem's revision that have resulted in groups of manuscripts that are more or less related to one another. The oldest complete manuscript redaction contains the version of the poem that is least often represented in the extant manuscripts. This situation presents some fundamental problems for editors and translators, and indeed there is much controversy about which version and which lead manuscript one should use for a critical edition or a translation.

The poem was first edited by Heinrich Rückert in 1952. At that time Rückert knew of twelve manuscript redactions; he recognized that the poem had been revised, but he used as his lead manuscript Heidelberg Cpg 389, because it is the oldest one and therefore presumably, he

argued, most closely related to the text that Thomasin produced in 1215. Rückert's edition was reprinted in 1965 with an introduction by Friedrich Neumann, and although it is now out of print, scholars still rely on it as a primary source of the poem. In 1974 Friedrich Neumann and Ewald Vetter published a facsimile edition of the Heidelberg manuscript redaction, but this manuscript has recently been made available online by the Universitätsbibliothek Heidelberg.

In 1984–88, Friedrich Wilhelm von Kries published a four-volume edition using the Gotha manuscript as his lead text. By then twenty-four manuscripts and fragments were known, and von Kries's edition builds on his earlier *Textkritische Studien* but compares all of the manuscripts and provides the textual variation in an extensive critical apparatus.[64] Von Kries's edition incited much criticism from his German colleagues not only because it contains numerous mistakes, but precisely because von Kries had chosen Gotha Memb. I 120 as his lead manuscript. Joachim Bumke's particularly critical review concludes: "Only A [Heidelberg Cpg 389] retains the original wording of the poem; the rest of the entire manuscript transmission is based on a contaminated original. This means that manuscript A must be used as the basis of any critical edition."[65] Bumke's criticism is thus based on the notion that the oldest manuscript is closest to the author and therefore most authentic.[66]

Since the concerns of this study are not with reconstructing an original text but with examining the manuscript redactions in their historical contexts—particularly the Gotha manuscript—that is, with the production and reception of the manuscripts, I am not concerned with the question of which manuscript most closely approximates an author-penned original. From the perspective of manuscript studies, the Gotha manuscript is just as valid an object of study as is the Heidelberg manuscript. Indeed, as we will see, it significantly differs from its predecessor in important ways that are crucial for understanding the history of the book and fourteenth-century manuscript culture.

One of the most ambitious sections of the von Kries edition is his attempt to provide a critical edition of the image cycle. In volume 4, he reproduces the Gotha manuscript illustrations, and provides an apparatus that describes the variation in the images, labels, and banderoles

in the other manuscript redactions. He also offers a description of the illustrations and identifies their corresponding textual passages. Unfortunately the illustrations are poor quality black and white reproductions, they have been removed from the context of the manuscript page, and there are numerous mistakes in his descriptions. It is therefore difficult to reconstruct the appearance of the Gotha manuscript using his edition, and, without examining the other versions oneself, it is impossible to reconstruct the iconographic variation. The von Kries edition is now out of print.

In 2002–3, Raffaele Disanto published a two-volume edition with a commentary in Italian, using the 1256 Heidelberg redaction as his lead manuscript. The first volume contains the illustrated folios of the Heidelberg manuscript with a description of each illustration. The second volume contains a critical edition of this oldest extant version of the poem. Disanto provides corrections of the Rückert edition, and includes line numbers from the edition by von Kries, so that the reader may compare the versions in the two editions. Except for the brief descriptions of the illustrations and the concordance, this edition has been largely superseded by the digital reproduction of Heidelberg Cpg 389 provided by the Universitätsbibliothek Heidelberg.

Until 2010 there was no complete published translation of the poem. In 2004, Eva Willms published a translation of selected passages based on the Rückert edition of the Heidelberg manuscript. These excerpts give readers an impression of the poem and provide a useful basis for further study. Willms also included some images from the 1450–70 Dresden manuscript. In 2010, an English translation was finally published by Marion Gibbs and Winder McConnell. It uses the Rückert edition but adds the prose foreword from the von Kries edition. Although Gibbs and McConnell address the importance of the illustrations, they include only a single example and refer the reader to the online Heidelberg Cpg 389 redaction. It is my hope that scholars and students from the broader field of medieval studies will be able to use this translation in conjunction with my book in order to develop a better understanding of the poem and its illustrations.

The current study is not an attempt to replace the von Kries edition, nor does it aspire to replace the Heidelberg manuscript with the

Gotha manuscript as the focus of future scholarly work. My interest in the Gotha manuscript lies not in its positioning in a stemmatic diagram, nor in establishing its primacy for future editions. Rather I am interested in viewing the manuscript in its historical context as a window into aristocratic interests and concerns in the first half of the fourteenth century. The Gotha redaction lends itself well to such a study because it is a mixed manuscript that both looks back to earlier versions of the illustrated poem and forward to a new context of reception. In order to understand the unique quality of the Gotha manuscript, it is necessary to compare it to other manuscript redactions. Indeed, the manuscripts of the *Welscher Gast* offer us an excellent and rare opportunity to examine the changing conception of the book and its readership in the thirteenth, fourteenth, and fifteenth centuries.

Reading Knowledge

Format, Empowerment, and the Genesis of a Reference Book

> The reader, as opposed to the listener, "has access to the book
> as a physical object, in which all the words of a poem coexist
> at any given moment. . . . There is no external control over
> occasion, pace, or emotional response. The poem may be picked
> up or put down at any time, at any point in the story. It may
> be read slowly or quickly, one time or many times, from the
> beginning to the end or in any other sequence that seems
> attractive. . . . [A] reader has certain options a listener does not:
> he himself controls the way he receives the poet's poem."
> —V. A. Kolve, *Chaucer and the Imagery of Narrative*

Medieval secular culture was a largely oral one, but in the course of the
Middle Ages, literacy penetrated society deeply, eventually emancipating
itself from the clerical class.[1] Aristocratic courts provided a fertile envi-
ronment for the composition and enjoyment of vernacular literature
that espoused ideas associated with courtliness. The patronage of ver-
nacular literature became an important component of courtly culture.
Indeed, the beginning of the thirteenth century saw a radical rise in the
production of vernacular German manuscripts. While the patronage,
composition, and reception of vernacular epic poetry and lyric is gener-
ally recognized as integral to courtly identity, the exact relationship be-
tween medieval books and the reception of the poems that they contain

has been hotly debated. Did medieval audiences read, listen to, or watch performances of thirteenth-century vernacular German poetry? Were these early manuscripts performance tools or were they privately read? The answers to these questions probably depend on the poet, the audience, the codex, and the particular cultural circumstances. Thirteenth-century German poets composed in a literary context in which orality, aurality, and literacy overlapped, intersected, and coexisted, and they addressed this mixed context of reception in their poems.[2] Understanding medieval manuscripts and their reception, therefore, is critical for our understanding of the history of reading practices. It is also crucial for understanding the role that the medieval book may have played in the process of elite self-fashioning that is documented by the *Welscher Gast* manuscripts.[3]

Like many of his contemporaries, Thomasin von Zerclaere makes reference to oral performance and written documentation, to reading and to listening in the *Welscher Gast*. Although the poem draws on scholastic and theological discussions of the virtues and vices, its didactic content is directed toward an audience of *frûme ritter und gûte vrowen und wise pfaffen* (stalwart knights and virtuous ladies and wise clerics, 15349–50; 14695–96). That is, a mixed (male, female, and clerical) audience of the type that one might find at any medieval court.[4] As Dennis H. Green has argued, this tripartite division separates the court audience into three different overlapping forms of reception: the largely illiterate nobleman, the often literate noble woman, and the cleric who was literate in both the vernacular and Latin.[5] Although Thomasin places his poem in the context of a mixed reception by reading, listening, and looking at images, the manuscript specifically addresses the reader and guides him or her to process the poem in a particular manner. The variation in the visual design of the manuscripts suggests that different redactions were designed for diverse kinds of reading.

The poem's images, format, and layout in the manuscript redactions vary significantly over the course of its transmission, and these changes indicate how this poem, and more specifically, how these manuscripts were read.[6] Often working primarily with edited texts rather than with the manuscripts themselves, generations of scholars have frequently overlooked formatting. The visual presentation of medieval

texts, however, is a crucial aspect of their reception.[7] Illustrations may "stage" the events described in the text, in Sylvia Huot's words, but historiated or rubricated initials, script, headings, and other textual details stage the text itself.[8] Among other things, they provide a visual frame that may guide the viewer's eyes to particular passages, subdivide the text into discrete units, and indicate how a text should be recited or read. As Roger Chartier has pointed out, "The meaning of a text is not revealed only through the words used to compose it, but also through its graphic organization, from its script or typeface to its layout, from the size of the letters to the material on which the text appears."[9]

The most radical changes in the visual presentation of the *Welscher Gast* occurred between 1256 and 1340, that is, sometime between the compilation of the two oldest complete manuscript redactions, Heidelberg Cpg 389 and Gotha Memb. I 120.[10] Placed side by side, the Heidelberg and Gotha manuscripts appear to be paradigmatic examples of two stages in the development of manuscript design: Heidelberg Cpg 389 is small in format, written in verse form in a single column, and relatively unadorned;[11] Gotha Memb. I 120 is about twice as large, written in two columns of verse, and contains more ornamentation.[12] Additional changes made in the poem's manuscript presentation, however, suggest that the variation in its format and layout may not only be attributed to historical trends in vernacular manuscript design but also speak to different contexts of reception and perhaps varying attitudes toward the written vernacular poem. Two particularly striking characteristics of the Gotha manuscript are its more highly developed hierarchical and explicit indexing system and its prose foreword that functions like a table of contents. These significant addenda to the poem not only enable, but as I will argue here, demand different kinds of reading. They ultimately, I claim, give the reader control over the text, and implicitly also its content, and they can thus be regarded as empowering the reader.

The issue at the heart of this chapter, then, is to compare the visual appearance of these two codices with that which can be deciphered about Thomasin's notions of composition and reception to determine the ways in which redactors translated the poem's internal format to an external design, and reconceived the composition and reception of the

poem in its later versions. This work, ultimately, will allow us to speculate productively on some of the ways in which medieval readership of this didactic poem changed from the thirteenth to the fourteenth century. As Kolve explains in the epigraph above, the materiality of the book and its existence as an object independent of the voice open up a much broader and different range of possibilities for reception than oral performance. Redactors of texts were presumably aware of the reader's power to examine the book at will and, I argue here, responded to it by designing manuscripts that would guide the medieval reader.

THOMASIN'S AUDIENCE

Thomasin's text does not establish a clear boundary between oral performance and reading of the text, that is, between the narrator's voice and the written word. Instead, the written poem is presented as an extension of the narrator/author, a record or manifestation of his voice that has the advantage of being portable and can therefore reach a broader audience. Indeed, Thomasin refers to both himself and his poem as the Italian guest, and it is not always clear whether he is referring to himself or his book:

> Tůtsche lant entphahe wol,
> als ein gůt hůsfrowe sol,
> disen dinen welehischen gast,
> der din ere minnet vast.
> der sait dir zůhte mære vil,
> ob du si gern venemen wil.
> du hast diche gern vernůmen,
> daz von dem welehischen ist genůmen,
> daz hant bedůtet tůtsche liute.
> da von solt du vernemen hiute,
> ob dir ein welehischer man
> lihte ouch des gesagen chan
> tůtschen, daz dir můg gevallen.

German land, receive, like a good liege lady should, this, your Italian guest who cherishes your honor. He will tell you many stories of edification if you will pay attention to them. You have often enjoyed hearing that which is adapted from a Romance language that Germans have translated. And so, you are able to see today whether an Italian man might also be able to tell you something in German that pleases you.

(697–709; 87–99)

Thomasin at first seems to refer here to his poem, the *Welscher Gast*, which he hopes will be well received, but his later reference to an "Italian man" who will "speak" to his German audience suggests that the poet Thomasin himself is the subject of this passage. The repetition of the verb *vernemen*, which could refer to reading, listening, viewing, or simply understanding the text, contributes to the passage's ambiguity. Similarly in the epilogue, the Italian poet metonymically personifies and identifies with his book: "Min bůch heizet der Welsche Gast, / wan ich bin an der tůtsche gast" (My book is called the Italian guest, because I am a guest among the Germans, 15335–36; 14681–82).

Although in these and many other instances Thomasin addresses the audience directly, as would an oral performer of the poem, he also emphasizes its written documentation.[13] He refers to his book in the prologue and epilogue, and he discusses at length the process of composition by writing. In an extended and rather humorous exchange with his personified quill we find out that Thomasin has painstakingly composed his *Welscher Gast* in isolation from the court over a period of ten months (12913–33; 12259–79).[14] The quill complains bitterly about their seclusion and the hard work that he has been forced to do:

'La mich růwen, sin ist zit,'
sprichet min veder, 'swer niht git
sinem eigen chnechte
růwe, der tůt unrechte.
so han ich dir, daz ist war,
gedinet disen winder gar,

daz dů mich niht lieze beliben,
ichn můst tag und nacht schriben.
du hast verslizzen minen můnt,
wan du mich mer den zehen stůnt
zem tage pflege tempern und sniden.
wie moht ich daz so lange erliden?'

———————

"Let me rest, it is time," said my feather, "a man who does not
give his own servant a break behaves unjustly. In truth, I have
served you all this winter; you did not let me be, but rather I had
to write day and night. You have worn out my mouth, because
you are in the habit of tempering and cutting me for more than
ten hours a day. How was I able to tolerate that for so long?"

(12877–88; 12223–34)

With this exchange Thomasin establishes that he has not composed his
poem orally but in writing: the creative process is one of putting pen to
page. The repeated references to the *Welscher Gast* as a book coexist easily
alongside the many references to Thomasin's voice and the poem's oral
presentation. The direct speech, the frequent uses of the verb *sagen,* and
the dialogues inserted into the poem construct an authorial presence and
suggest orality, even in light of the poem's written composition.[15]

Images constitute a bridge between orality and literacy: because
images may be pictorial or textual, access to them is provided not only
by looking but also by listening to the text.[16] Metaphor, vivid descrip-
tion, and various other narrative strategies enable the listener to visu-
alize that which he or she is hearing.[17] Thomasin uses the word *bilde*
(image) to refer both to these imagined images and to actual pictures.[18]
And he explicitly addresses the usefulness of images for the poem's re-
ception by those who are unable to read:

swer niht fůrbaz chan vernemen,
der sol da bi ouch bilde nehmen.

.

swer niht enchan
versten, daz ein biderb man

an der schrift versten sol,
dem si mit den bilden wol.
der pfaffe sehe die schrift an.
so sol der ungelerte man
die bilde sehen, sit im niht
die schrift zerchennen geschiht.

———————

Whoever is unable to comprehend otherwise should also consider images. . . . Whoever cannot understand what a stalwart man should understand from writing is well served by images. Just as the priest looks at words, thus should the unlearned man view images, since writing does not reveal itself to him.

(1703–4, 1711–18; 1091–92, 1099–1106)

The coexistence of listening and reading reception throughout the Middle Ages has long been established, but few poets composing vernacular texts at the beginning of the thirteenth century are as explicit as Thomasin about acknowledging the multimedial nature of thirteenth-century vernacular manuscripts.[19] Thomasin thus places his poem at the nexus of orality and literacy, recognizing that both modes of reception coexisted and that the existence of a written version of a poem did not preclude its oral performance.[20] As Kolve has remarked with respect to Chaucer, Thomasin's "is a lettered art shaped by, and continually responsive to, an oral-audial environment."[21] Just as the poet Thomasin was able to move between oral performance and writing without considering these to be two opposed modes of literary production, so too did he expect his audience sometimes to listen to, and sometimes to read his book.[22]

Nonetheless although he recognizes diverse forms of reception, Thomasin emphasizes reading and seems to have had specific ideas about how and by whom his poem ought to be read.[23] His epilogue is quite specific:

swer ist oder wirt tůgenthaft,
dem gebe ich ze vriuntschaft
min bůch, daz er da mite

stiure sine schone site.
der sol ouch mit gůter getat
bezzern, swaz er hat
in minem bůche gelesen:
des sol er ermant wesen.
swer niht hat zůht und schone sit,
der sol niht umbe varn der mit.

.

dich sol ein biderbe man
můzechlichen ane sehen,
sitze uf sin schozze, daz habe ze lehen.
frůme ritter und gůte vrowen
und wise pfaffen suln dich schowen.
ob dich begrifet ein bôswicht,

.

so wirft er dich in einen schrin.
da solt du ligen bůch min,
untz du dem chomest ze hant,
dem du wirdest baz erchant
und der dich diche uber list
und dich wol handelt alle vrist.

———

Anyone who is virtuous or wishes to become so, to him I offer
my book in friendship so that he can use it to guide his fine
manners. Let him be reminded that he should also exceed that
which he reads about in my book in his good behavior. No one
who is not well bred or lacks good manners should handle it [my
book]. . . . A good man should leisurely examine you [the book].
Seat yourself on his lap; take that as your fief. Stalwart knights,
and virtuous ladies, and wise clerics should look at you. If a
scoundrel reaches for you, . . . he'll throw you into a trunk.
You must lie there, my book, until you come into the hand of
someone who will appreciate you more and who will often read
you through and will always treat you well.

(15285–94, 15346–51, 15357–62; 14631–40,
14692–97, 14703–08)

As discussed above, Thomasin mentions three groups here: knights, ladies, and clerics, and in part 2 of the poem he explicitly addresses the education of noble children. He imagines his readers having a rather intimate relationship with his book, holding it on their laps, carefully reading and rereading its pages, treating it well, and implementing its instruction. But Thomasin imagines other readers too, ones who will abuse the book by throwing it into a trunk. While admonishing audience members to listen and pay attention is conventional in thirteenth-century German literature, Thomasin addresses and constructs his ideal audience in a much more detailed (and humorous) manner than most. The *Welscher Gast* was thus apparently intended to be a useful book for upstanding aristocratic people eager to learn and improve themselves. It was clearly conceived as an educational text, but there is too little evidence to make any conclusions about how formal the educational setting of its reception was intended to be.[24] The form of reception addressed in the passage above is individual, and it is reception by reading.

As if in response to the reader's idiosyncratic access to the written text that Kolve imagines above, Thomasin emphasizes his poem's structure, repeatedly referring to its division into a prologue and ten parts in a manner that would have helped to shape the reading or listening experience. At the beginning or end of the individual parts, the I-narrator (named Thomasin) briefly summarizes the topic of the last part, offers some indication of the topic to come, and numbers the current part. For example, part 4 ends with the lines: "Hie hat ende diu vierde lere, / man sol mich noch vernemen mere" (The fourth instruction ends here, you will hear still more from me, 6327–28; 5691–92). The narrator then starts part 5 with a synopsis of the previous part and an introduction to what comes next:

Mich dunchet, ich habe lange zit
gesaget, waz tugende vreude git
und daz der tugenthafte man
nie deheine unsælde gewan.
ich zeigte, daz er sol fuhrten nicht,
swaz ungeluches im geschiht.
nu will ich iu sagen furbaz,

wie die tugende fůgent daz,
daz man ze himel chomen sol.
so han ich denne gezeiget wol,
daz niht so nůtze so tugent ist,
swer ir volget zaller vrist.

———

It seems to me that I have spoken for a long time about the joy
that virtue offers and that the virtuous man never suffered
unhappiness. I showed that he should not fear whatever
misfortune might befall him. Now I will tell you more about how
virtue ensures that one is able to enter heaven. Then I will have
shown that nothing is as beneficial as virtue for anyone who
always follows its example.

<div align="right">(6329–40; 5693–5704)</div>

Similar transitional passages appear at the beginning and conclusion of
each part and suggest that each part builds on the last. The reader or lis-
tener of the *Welscher Gast* is thus consistently reminded of the poem's
compositional structure. Indeed Thomasin clearly envisions his poem as
a coherent and carefully structured piece of work. Drawing on a familiar
trope, he refers in the prologue to the process of its construction as car-
pentry. He, the carpenter, promises to take well-constructed pieces from
other craftsmen and use them to build his poem (715–24; 105–14).[25]
The result is a coherent and stable edifice comprised of well-crafted parts
that signify as a whole.

Although the *Welscher Gast* is the first vernacular text to have inter-
nally numbered parts, it is not the first to have internal references to its
own organization.[26] Many Latin texts follow the practice of laying out
their structure in the work itself.[27] Some German vernacular genres ap-
pear to pick up this practice earlier than others. For example, the scribes
or authors of the *Kaiserchronik* and Priester Wernher's *Marienleben* also
offer internal references to their subdivision into parts.[28] Among the
thirteenth-century German vernacular epics, the closest comparable
example to the *Welscher Gast* is the *Nibelungenlied* in which the *aven-
tiure* headings appear in even the oldest manuscript redaction, suggest-
ing that these are an integral part of the poem.[29] These internal refer-

ences fulfill a variety of functions. For example, as in the case of the *Kaiserchronik,* they may divide a text into chronological sections, or, as in the *Nibelungenlied,* they may heighten suspense by delaying the progression of the narrative. They also enable the reader to easily "dip into" the story at different places and reread favorite sections.

In the *Welscher Gast,* the internal subdivision into parts allows Thomasin to organize his instructions topically and to give the poem a narrative structure with a beginning, an end, and a sense of progression, even though it has no plot. In lieu of a plot, the internal structure provides breaks and also moves the narrative along. The numbering of the parts from 1 to 10 contributes to this sense of progression. Although Thomasin places his poem in a context of reception that includes oral performance, listening, and looking at pictures, therefore, he is most attentive to readers and provides them with the tools to study his poem in a methodical and ordered manner.

ORALITY/AURALITY AND WILLFUL READING

The scribe of the 1256 manuscript redaction Heidelberg Cpg 389 acknowledged Thomasin's references to the poem's structure. The manuscript contains a visual code that underlines the internal references to subsections. Each part starts with a large decorated initial and concludes with two rubricated lines of verse that indicate the part number (see fig. 80 for an example).[30] The large decorated initials and the rubricated transitions allow the viewer to select specific parts of the poem and to orient himself while reading. Even if the reader looks only at the visually prominent rubricated verses, then he is able to immediately locate himself in the poem.

The scribe of Heidelberg Cpg 389, however, went beyond the divisions prescribed in the poem and created an additional level of organization by inserting two- to six-line rubricated initials that subdivide the ten parts and the prologue into shorter thematic passages (for example, fig. 78). These rubricated initials enable the viewer to randomly select thematically coherent subsections of the poem and, since the illustrations are inserted in the margin next to their corresponding text,

the initials also allow the viewer to identify the textual passages that correspond to images.

Heidelberg Cpg 389 is not the first vernacular German manuscript to use initials and rubrics to subdivide a text, nor to have a hierarchical division into subsections. As mentioned above, the *Nibelungenlied* is divided into sections using rubricated headings in most of the early manuscripts. Wolfram von Eschenbach's epic poems *Parzival* and *Willehalm* are notably divided into thirty-line sections, so-called *Dreißiger,* using colored initials already in their oldest manuscript redactions.[31] Unlike *Parzival* and *Willehalm,* the subsections of the *Welscher Gast* vary dramatically in length, so that, while they are thematic, it is unlikely that the author conceived these subsections as formal compositional units. It is more probable that the initials were imposed on the poem later, either by the author himself or by a scribe, and were designed as a tool for the reader or performer. The rubricated initials allow the reader to examine shorter passages selectively and to focus on specific, albeit random, topics rather than read an entire part. Barbara Frank identifies the use of initials to divide texts into passages to be recited or performed as a novel development in thirteenth-century French vernacular narrative that responds to the context of oral performance that still dominated literary culture.[32] Indeed the subdivision of the *Welscher Gast* into shorter passages makes particular sense in a recital situation in which a part would be too long to hold the interest of its listeners. In a sense, however, the subdivisions undermine Thomasin's division of the poem into ten parts because they enable a reader to ignore the larger hierarchical structure of the work and thus potentially decontextualize the thematic passages.

Sometimes the rubricated initials indicate a shift in the narrative voice and thus provide an invaluable tool for a reader attempting to maneuver his or her way through the poem, which frequently shifts between directly addressing the audience, descriptive narration, addressing the book, and internal dialogue.[33] Furthermore, the poem contains many anecdotes, historical examples, fables, and other narrative genres. These changes in genre within the poem are also often marked with a rubricated initial. The rubricated initials thus perform a multitude of tasks, but they are useful to the reader generally as they indicate not

only changes in the topic but in the form of presentation as well. At the risk of stating the obvious, these initials are useful only to a reader; they serve the listener no purpose at all.

The illustrations' layout further encourages selective but random and nonlinear (rather than exhaustive and linear) reading. They are marginal and many of them are turned on their side with respect to the text (such as in fig. 78). Although the illustrations generally appear adjacent to their corresponding textual passage, their orientation means that the viewer must interrupt the reading process in order to turn the book so that he might study the images. "Reading" the image and reading the text are thus two different processes and involve an active physical and cognitive engagement with the book. A reader might read a passage to the end (that is, to the next rubricated initial) and then examine the image in light of what he has read. Or he might interrupt the reading process to look at the image and then have to find his place again. Or perhaps he might examine the image first and attempt to make sense of it using the labels, banderoles, and associations with other familiar images before examining the text of the poem. Or a reader might present the poem while others examined the images. Or perhaps some viewers chose to "read" only the images, ignoring the written text of the poem. In whatever way a particular reader might decide to integrate the images into the reading process, the images' placement encourages him to view them on their own terms and not as contingent on or subordinate to the text.

There is no explanation in the poem or the manuscript of the thematic subdivisions nor a key, index, or table of contents that might allow us to search the poem for a specific topic. We do not know for certain how this manuscript was used, but its format, layout, and explicit organization suggest that viewers were intended to read the book from cover to cover or one part at a time, with the option to randomly select thematic subsections and illustrated passages.[34] The codex's small format raises the question whether it may have been intended for private reading, rather than recitation. Heidelberg Cpg 389 is similar in size to psalters used for private devotion in the thirteenth century, but there is too little evidence at present regarding the practice of private reading to know conclusively whether it was created for this purpose.[35]

Finally, the poem's layout in Heidelberg Cpg 389 deserves to be mentioned, as it also undergoes a transition in the later manuscript redaction. In the Heidelberg manuscript, each individual line of verse appears on its own line, and the first initial of each line is offset (figs. 78–85). This was a very common layout for thirteenth-century books of poetry across Europe and would immediately have informed the medieval reader that he or she was looking at a book of poetry.[36] Although the layout is thoroughly conventional for the thirteenth century, and its variation in the Gotha redaction is equally conventional for a fourteenth-century manuscript, the complete revision in the poem's layout nonetheless tells us something about reading practices and the way in which written text was perceived.[37] Nigel Palmer considers: "The manuscripts that give prominence to the individual line of verse as the minimal repeated unit accentuate the continuous flow of the language, presenting this as something that overrides the metrical structure of the rhyming couplets."[38] By contrast: "Those that give prominence to the rhyming couplets as the minimal repeated unit accentuate the metrical form, which for poets of the later twelfth and early thirteenth century generally stood in counterpoint to the syntax."[39] The implication is that the layout of the poem in Heidelberg Cpg 389 is somehow closer to the spoken language than that in the Gotha manuscript, in which the layout emphasizes the metrical structure of the poem's rhymed couplets (see, for example, fig. 3). The poem's layout in the Heidelberg manuscript does not offer any visual clues as to the poem's metrical structure, but encourages the reader to sound out the poem in order to identify this structure. In this sense, the Heidelberg manuscript is designed for the ear rather than the eye, and its target reader is one who translates the written text into voice. This is not to say that it was a manuscript necessarily designed for recital, but rather that the format reflects fairly closely Thomasin's mixed notion of reception in which aspects of oral performance and aural reception are integrated into the written text.[40]

In sum, the voice and the notion of aural reception seem to be incorporated into the format of Heidelberg Cpg 389. The result is a flexible document that allows diverse forms of reception but does not allow the reader to look up information. This codex seems have been designed for reading (aloud or silently) in the sense that Kolve envisions. The subdivi-

sion of the parts facilitates the reading process, but undermines the poem's narrative progression and structure. Reading the Heidelberg manuscript means making a series of choices about how one wants to approach the text and its images. The formatting invites the reader to browse the poem, selecting a textual passage or an illustration at will and in any desired sequence. It also allows a reader to select a subsection of the poem for recital that is thematically or generically coherent.

VISUAL CODING AND DIRECTED READING

Gotha Memb. I 120 was designed for more directed reading, of a private or public nature. Like Heidelberg Cpg 389, the 1340 Gotha manuscript has decorated initials and rubricated lines at the beginning and end of each of the ten parts respectively. The Gotha scribe also subdivided the parts using small rubricated initials, but he numbered these subdivisions within each part and referred to them as chapters in the prose foreword. These chapters are additionally subdivided using rubricated paraphs. Paraphs are commonly used in medieval texts to indicate the beginning of a new thought or topic.[41] The most conspicuous and significant revision to the Gotha manuscript, however, is a 610-line prose foreword that explains the poem's subdivision into parts, chapters, and paragraphs; briefly describes the contents of each part and each chapter; and uses an indexing system to key the synopses to specific textual passages (fig. 1).[42] This foreword borrows from a long Latin tradition of prologues.[43] Its novelty lies in its vernacularity, its prose form, and its pairing with the vernacular poem; the *Welscher Gast* is the first poem in the German language with a prose foreword.

At the very beginning of the prose foreword the narrator addresses the book's organization. He assures us that it is well organized: it is divided into ten parts, each part is divided into chapters, and these chapters are subdivided further into *liumt* (see below):

> Swer die materie wizzen will wa von ditze bůch sage, der vindet die materie alle gemerchet nach einander. Ditze bůch ist geteilet in zehen teil und ein ieglich teil hat siniu capitel. etlich teil hat zehen

capitel, etlichz mer, etlichz minner, unde ein ieglich capitel hat sinen liumt, etlichz vil, etlichz lutzel.

————

He who wants to know the material that this book recounts will find the subjects all noted one after the other. This book is divided into ten parts, and each part has its chapters. Some parts have ten chapters, some more, some fewer, and each chapter has its *liumt,* some many, some few.

<div align="right">(FvK 1–8)</div>

This hierarchical organization is visually encoded (fig. 1). Each part is assigned a letter (A through K), and these letters are inserted at the tops of many of the pages on both the recto and verso sides, so that a viewer is able to flip through the pages and find a specific part or easily be reminded which part he is currently reading. Marginal Roman numerals and rubricated initials allow the reader to key the foreword to specific chapters. The foreword and the indexing notation thus enable a viewer to look up a particular section of the text, to move between the synopses and the poem, to read selectively, and to quickly gain an overview of the entire work.

In the Gotha manuscript, the chapters are subdivided further by rubricated paraphs into *liumt.* The etymology and meaning of this term has not been adequately explained, but it apparently refers to something resembling a paragraph.[44] In Gotha Memb. I 120 these *liumt* are sometimes thematic subsubsections, introductory or concluding passages, or tangential asides to the topic under discussion. Sometimes the paraphs denote a change in narrative voice, particularly in dialogues. In the altercation between the poet and his quill discussed above, for example, the shift from the quill's complaint to the author's defense is marked with a paraph in the Gotha manuscript. The paraphs thus divide the text into rhetorical or intellectual units.

The rubricated initials and paraphs in the Gotha manuscript often correspond to the rubricated initials in the Heidelberg manuscript, but not always. In some cases the variation in notation may be explained by the different relationships between the poem and its images in the two redactions. In Heidelberg Cpg 389, rubricated initials were additionally

used to set off illustrated passages. In the Gotha manuscript, by contrast, the illustrations are incorporated into the text, so that textual notation no longer needs to fulfill this function. Accordingly there are several instances in which a rubricated initial appears in Heidelberg Cpg 389 but neither an initial nor a paraph appear in the Gotha redaction. For example, the first verse of an illustrated passage dealing with the vices of the tongue, *rům, spot, lůge* (Boasting, Mockery, Lying) is introduced with a rubricated initial in Heidelberg Cpg 389 (fig. 79), but in Gotha Memb. I 120 the image introduces the passage and no rubricated initial appears (fig. 5). There are also cases in which a paraph is inserted in Gotha Memb. I 120, but no initial appears in Heidelberg Cpg 389.[45] The variation in the placement of paraphs and rubricated initials in the Gotha and Heidelberg manuscripts indicates that the individual redactors had their own ideas about how the poem ought to be subdivided.[46] Manuscript format thus bears witness to scribes' interpretive intellectual work and engagement with the text.

As one example of many, figure 41 showcases the hierarchical indexing system in the Gotha codex. The heading indicates that we are in part 3, or "C." A Roman numeral identifies the beginning of chapter 13, and the paraphs subdivide the chapter further into *liumt*. The first paraph in the left column indicates the beginning of chapter 12's illustrated conclusion that nobility, justice, and courtliness go hand in hand. Chapter 13 begins with an enumeration of different forms of lust. The first paraph of this chapter marks a brief warning to those who follow their desires. The following three paraphs distinguish paragraphs on gaming, gluttony, and womanizing, respectively. The paraphs thus subdivide the chapter topically but also indicate the parallel structure of this section of the chapter in which each paragraph addresses a different manifestation of the vice of lust. The chapter divisions therefore enable the reader to identify or select a section of the poem pertaining to a general topic from the prose foreword, while the paraphs alert him to narrative structure, narrative variation, and subtopics in the poem. Furthermore, the paraphs allow the reader to correlate the amount of reading with the available time.

The subsections introduced by paraphs may range in length from four to over one hundred and fifty lines of verse. The brevity of some

of the subsections suggests that they were not introduced with a recital situation in mind. They certainly would not provide much help to a performer. But they would assist a private reader in following the structure of the text, knowing where to pause to think for a moment about a pithy four-line aphorism or maxim, or, as in the passage about different manifestations of lust discussed above, to gather his or her thoughts before moving on to the next example. The Gotha text is thus formatted with an eye to the needs of readers, and particularly private readers rather than reciters.

The illustrations in the Gotha manuscript also help to subdivide the text thematically. Most of the illustrations have been incorporated into the columns of text and, with only a single exception (fig. 38), they have been oriented to the text. This change in the illustrations' format not only allows the viewer to read the text and the image as part of a continual process but practically forces him to do so. Indeed, in contrast to Heidelberg Cpg 389, the illustrations in Gotha Memb. I 120 impose themselves on the reader and demand inspection at specific moments in the poem. They generally appear at the end of the passage to which they correspond, and thus provide a kind of synopsis of the passage, and a memory aid for what has just been read. But they sometimes appear at the beginning of a passage, and occasionally they appear to take the place of a paraph to mark the introduction of a new thematic subsection. Reading the text and reading the images thus become part of a single, mutually reinforcing act of processing the poem in the Gotha redaction.

The indexing apparatus, the prologue, the division into rhymed couplets, and the illustrations are all tools for the reader and represent an attempt to direct and perhaps even control the reader. In the epigraph to this chapter, Kolve distinguishes between the experience of listening to and reading a literary work, remarking that the reader has more control over the experience than does the listener who is dependent on the reciter or performer.[47] But while the reader of Gotha Memb. I 120 has choices, the formatting encourages a disciplined approach to the text. The reader might use the foreword to choose a specific part or chapter, and then flip through the pages to find it using the system of letters and Roman numerals. Or he might choose a part or a chapter or

a paragraph randomly, but the visually prominent indexing apparatus would nonetheless serve as a reminder of the passage's textual context. In contrast to Heidelberg Cpg 389, it is not possible to lose oneself in the Gotha codex. While the reader might attempt to read Gotha Memb. I 120 randomly, the Roman numerals and letter headings consistently remind him of his place in the larger work. The reader of Gotha Memb. I 120 could also choose illustrated sections of the poem, but the illustrations' orientation and placement make it difficult to consider the images independently of the text.

THE MEANINGS OF CHANGE

Already in the thirteenth century there was a wide variety of book formats. On the one hand, different types of hierarchical organization that developed in late antiquity and the early Middle Ages continued to be used throughout the Middle Ages. But on the other, innovative types of design, organizational apparatuses, and image cycles were created in the Middle Ages to reflect the new kinds of books being produced, new audiences, and new uses of books.[48] Scribes and artists experimented with illustration styles and *mise en page*, and they used diverse techniques to organize their material and make it accessible. The inventory of such techniques is extensive, including chapter headings, paraphs, page or chapter numbers, spaces between lines, colored ink, historiated or rubricated initials, illustrations with or without tituli, registers, marginal notations, and others;[49] indeed we still use many of these today.[50] As I have suggested, it is these formal aspects of medieval books that often tell us the most about the reception of the texts that they contain. To use the distinction that Mary and Richard Rouse have made, organizational devices can tell us whether a book was meant to be used or read.[51] But manuscript format can also offer us insight into *how* a book was used or read.

As mentioned above, both Heidelberg Cpg 389 and Gotha Memb. I 120 are quite conventional. In the Heidelberg redaction, the images are rather unusual, but the style of format is very common, particularly in Latin manuscripts, throughout thirteenth-century Europe. Because

they were largely working within the Latin tradition, thirteenth-century scribes frequently used layout and format models from that tradition when writing vernacular texts.[52] Palmer similarly identifies the Gotha manuscript as "an example of the seamless appropriation of Latin structures in the vernacular."[53] The hierarchical indexing system has its origin in the Latin scholastic tradition.[54] Palmer compares the Gotha manuscript to a redaction of the Latin didactic work *Architrenius* (Oxford, MS Jones 50, first quarter of the thirteenth century), which has a similar four-tiered system of organization using initials of various sizes and Roman numerals and concludes: "We may assume that Thomasin was familiar with Latin manuscripts of this kind and mimicked them when he created his German work."[55] Although it is questionable whether Thomasin himself was responsible for the revisions in the poem's presentation that we find in the Gotha redaction, the similarities between its organizational apparatus and those in contemporary medieval Latin manuscripts cannot be denied.

Latin manuscripts of the thirteenth century were already frequently furnished with tables of contents and registers.[56] But by the fourteenth century there was also an established vernacular context for the indexical apparatus of the Gotha codex, particularly in collections of texts. To cite only two examples roughly contemporaneous to Gotha Memb. I 120, in the *Manesse Songbook* and the *Hausbuch* of Michael de Leone we find subdivisions into books and chapters that are keyed to a table of contents using letters or Roman numerals.[57] In contrast to these collections, the *Welscher Gast* is a single poem. Since it has no plot and little narrative development, however, it similarly lends itself well to being read selectively. Although the prose foreword in the Gotha manuscript is novel, the explicit hierarchical system of organization imposed on the poem is not.

As in the Heidelberg manuscript, the layout of the poem in the Gotha redaction is also conventional. Whereas the Heidelberg manuscript emphasizes the individual line of verse as the basic unit, the Gotha manuscript stresses the rhymed couplet. The text is written in two columns in verse format; the first initial of each rhyming couplet is offset and decorated with a single red stroke. The layout of Gotha Memb. I 120 allows the reader to visually identify the beginning of a rhymed couplet

and locate himself in the metrical structure of the poem. This layout, the division into chapters and sections, the incorporation of illustrations into the narrative flow, and the explicit index all suggest that the target reader of the Gotha redaction is rather similar to a modern reader who would examine the text with his eyes and would generally consider reading to be a visual rather than aural process.[58]

For the *Welscher Gast* specifically, the change in format suggests that the poem came to be viewed as a work that needed an index. The prose foreword and the hierarchical and explicit indexing system appear in most of the later redactions of the poem. The development of these organizational devices and their consistent appearance from 1340 on are likely related to the poem's genre. The *Welscher Gast* is the first vernacular German didactic poem, but in the course of the thirteenth century, vernacular didactic literature became very popular, and by the fourteenth century it was a firmly established genre. Other manuscript redactions of the poem explicitly categorize the poem as didactic literature.[59] In the Stuttgart manuscript fragment, Landesbibliothek, Cod. poet. et phil. 2° 1, which is roughly contemporaneous to Gotha Memb. I 120, an inscription on the last page reads: "Das puch han [——] purger ze Regenspurch haissen andre schreiben den lautten ze einer pesserum MCCC und in dem XXVIII. jar" (A burgher of Regensburg had this book written for the improvement of the people 1300 and in the twenty-eighth year).[60] This inscription indicates that the poem was understood as a didactic work and commissioned for the edification of its readers.[61] The Stuttgart manuscript is a fragment, and it is missing the section that would have contained the prose foreword, but the hierarchical coding of the text is similar to the Gotha manuscript attesting that it also once contained this keyed foreword. Interestingly, the Stuttgart manuscript has yet another level of visual coding. The passages of the poem that correspond to the illustrations are rubricated. The formatting of the Stuttgart fragment thus connects the image with the text much more overtly than in Heidelberg Cpg 389, leaving little leeway for the reader to interpret the illustrations at will. But it also recognizes the narrative independence of the illustrations, allowing the reader to focus on the illustrations and have them guide his reading. By contrast, the Gotha manuscript incorporates the illustrations into the

text, thus suggesting a closer and more structured relationship between the two media.

Several of the later redactions of the *Welscher Gast* are compilations containing other didactic texts as well, thereby contextualizing the poem firmly as a didactic work.[62] While the didactic status of the *Welscher Gast* is never in question, the radical transformation of the poem's formatting that occurs between 1256 and 1340 reflects an effort to present the poem's genre visually.[63] Whereas the format of Heidelberg Cpg 389 is similar to that of Latin and vernacular poetic texts in general, the formatting in Gotha Memb. I 120 didacticizes the poem, presenting it as a reference work, and enabling the reader to use it as a pedagogical tool. Its new format makes it a useful book, rather than simply a readable one.

In sum, while Thomasin envisioned a variety of (sometimes competing) modes of reception for his text, he and his medieval redactors seem to promote specific kinds of reading practices. Thomasin imagines an ideal reader who will hold the book on his lap, and read it carefully and thoroughly. But the manuscript redactors envisioned how a reader might use the book rather differently. The changes in format of the *Welscher Gast* poem between 1256 and 1340 restage the poem from a text intended to be read and vocalized to one that may be viewed and used.

The design of the Gotha manuscript as a reference work underlines its didactic nature. Its formatting and organization might be seen as an attempt also to control the reader, limiting his options and exerting external control over the reading process. But this attempt fails, as the formal presentation of the poem opens up new possibilities for the reader who is able to examine the book in a more directed manner and use it more pragmatically, investigating specific topics that are pertinent to him and ignoring others that are not. The Gotha manuscript is thus in a sense an empowering document that gives the control of its contents to its owner. While we do not know who commissioned the Gotha manuscript, its design suggests that its owner was interested in instrumentalizing the ethical instruction in the poem. Indeed the owner probably used the book as a source of useful and pragmatic information, or as a resource for understanding the model of elite society portrayed in it.

TWO

Vision, the Viewing Subject, and the Power of Narrative

The *Welscher Gast* images offer an ideal resource for investigating image making in the Middle Ages because the same image cycle is reproduced in fourteen manuscript redactions over a 250-year period.[1] The wide range of illustration techniques and the variation between redactions bear testimony to the heterogeneity of notions of image production and reception with which individual artists or workshops were working. Some of the *Welscher Gast* illustrations seem to be attempted visual translations of the poem; some expand on brief textual references; some illustrate a single line, or synthesize the essence of a paragraph or a section; and some are diagrams. Others draw on iconographic traditions external to the text and thus encourage the viewer to make associations within a broader visual context. While on the one hand, artists copied their sources and were therefore influenced by earlier versions of the cycle, on the other, they consistently sought to modernize the illustrations and redesign them for a specific target audience.[2] Against the backdrop of multiple versions of the same image, artistic innovation and changing notions about images and their relation to texts come into high relief.[3] Similar to formatting, which we examined in detail last chapter, the images were designed and redesigned for different modes of viewing and different kinds of engagement by the viewer.

Historical and social context played a major role in artists' efforts to modernize the images.[4] In fact, most of the illustrations are altered

repeatedly to form new connections between the poem, without which the poem would have become increasingly archaic over the course of its transmission to an audience whose interests, expectations, and cultural circumstances transmuted over time.[5] Some images are altered more radically than others, and it is these that are most revealing with regard to changing medieval notions about images and texts. The image of Inconstancy, for example, is rendered so differently in the 1256 Heidelberg manuscript (fig. 81) and the 1420 Wolfenbüttel redaction (fig. 89), that if the two figures were not inscribed and did not appear next to the same textual passage, it would be impossible to identify them as the "same" image. The older manuscript depicts a lady divided into contradictory parts, while the younger manuscript contains a more naturalistic representation of a male courtier. How can we explain this variation?

As I argue in this chapter, illustrators engaged in an ongoing discourse of image making, responding to ideas about the relationships of viewer to image, image to text, and viewer to text. In Heidelberg Cpg 389 (fig. 81), the personification of Inconstancy is a commanding allegorical image that was probably designed to elicit powerful emotional responses in its viewer and thus help a viewer to commit the text and its warning about inconstancy to memory. However, the radical reworking of the image over the course of its transmission suggests that later artists considered the personification in the Heidelberg redaction incomprehensible, ineffective, or simply unfashionable, despite its extraordinarily close relationship to the poem, its arresting design, and its usefulness as a mnemonic device. The artists who translated the abstract concept of Inconstancy into a pictorial representation of the vice, I maintain, participated in a medieval discourse on apperception that was concerned with (re)evaluating how viewers looked at images and how they perceived themselves in relation to those images.[6] Throughout the poem's transmission artists presumed an active viewer who would engage with the image, but, as we will see, the quality of that engagement changes over time.

Images in thirteenth-century vernacular German manuscripts were often designed with multiple levels of meaning to be studied, interpreted, and committed to memory by a mixed audience. In the 1256 redaction of the *Welscher Gast*, the images were clearly designed for

contemplation, in other words, for a viewer to examine in conjunction with the poem, as part of a process of self-recognition, identification, and self-improvement. The images appear to have been designed for the kind of mixed courtly audience that Thomasin envisions—an audience of ladies, knights, and clerics—and could be decoded differently by clerics, educated viewers, and illiterate ones.

The illustrations in the fifteenth-century redactions, however, are not contemplative and associative. Instead they illustrate the text by emphasizing the narrative level of the image to the exclusion of other forms of illustration. In most of the images, the banderoles express the relationships between the figures, as well as their actions and intents. In the later versions of the images, the stories implied in these banderoles become more dominant and ultimately, as I will demonstrate below, they guide the viewer's interpretation of the images.[7] The focal point of these stories is someone very like the secular fifteenth-century viewer in appearance, namely, a fashionable male or female member of elite society. These figures are designed to be recognized and emulated. As Michael Curschmann has remarked, in the fifteenth century viewing manuscripts is no longer about "appropriation" of ideals by processing and working through ideas and concepts, but about "viewing and mimicking what one sees."[8] Fifteenth-century German illustrated manuscripts often contributed to a program of elite self-representation, while also affirming their owner's wealth and power.[9] As we will see in chapter 4, one may view the fifteenth-century redactions of the *Welscher Gast* in this context too. The Wolfenbüttel manuscript depicts figures enacting scenes that visualize for the viewer ethical behavior suitable for elite society. The images thus become illustrated stories that involve elite characters with which the viewer may identify or empathize, or that he or she may reject as negative examples.

The *Welscher Gast* manuscripts allow us to identify a protracted and complex process of emancipation from clerical iconography to a secularly encoded visual language that focuses on contemporary fashion and storytelling. Crucial to this process of secularization is the role of narrative structure. The 1340 Gotha manuscript documents a transitional phase in this process. The illustrations in this redaction suggest that its artist was already more interested in depicting illustrated stories

with identifiable and fashionable characters than mnemonic and asso-
ciative images. This emphasis on telling stories presupposes a particular
relationship of identification between the viewer and the image, a rela-
tionship that arises from a viewer's personal interest and engagement
with images. The variation in the *Welscher Gast* illustrations, I argue, is
thus influenced by the medieval notion, or more accurately, notions of
vision that are bound up in ideas about the viewer's relationship to the
images he sees.

A MEDIEVAL DISCOURSE OF SEEING

In the Middle Ages there was a lively discourse of seeing that encom-
passed work on memory, ekphrasis, visions, and the visual.[10] The works
of medieval secular poets, theologians, and scholastics bear testimony to
this discourse, and offer us ample evidence of the primacy given to visual
perception over other forms of reception.[11] Recent work on clothing,
gesture, memory, word and image, and manuscript design supports the
claim that medieval society was a highly visual one in which images, ob-
jects, and performance played a dominant communicative and repre-
sentative role in both secular and religious areas of society.[12] Debates re-
garding models of seeing were part of this larger concern with vision and
visuality.[13]

It has long been understood that in the Middle Ages a fundamen-
tal shift occurred in notions pertaining to how seeing functioned and
the direction in which vision transpired.[14] This was the shift from the
extramission to the intromission model of seeing.[15] According to the
theory of extramission, "the eye emits a visual ray. This ray, strength-
ened by the presence of light, goes out to encounter its visual object, is
shaped by that object, and finally returns to the eye."[16] These visual
rays, or "species," were conceived as physical entities. The process of ex-
tramission suggests that vision is an active, conscious, and motivated
act, and that it involves direct physical contact between the subject and
object of vision.[17] While the concreteness and agency inherent to this
theory of vision may be difficult for a modern reader to comprehend,
"the operation and impact of the species are uncannily like aspects of
certain modern theories—in both superficial similarities . . . and more

significant parallels. One striking similarity is the recurrence in Lacan's (and also Sartre's) theories of the gaze that is constructive and constitutive of reality, not simply a source of objective sensory input."[18]

The theory of intromission, by contrast, proposed that rays entered the eye from the object.[19] Michael Camille writes, "[T]he intromission model placed emphasis not upon the viewer, previously the beaconlike source of vision, but upon the image as the base of the visual pyramid, literally reversing the flow of the visual rays from subject to object and making the trajectory one that went from object to subject, from the image to the eye/I."[20] According to Camille, "the ultimate difference between the early and the late medieval notion of the image [is that the first, extramission] is seen as an externalization or projection of internal archetypal patterns onto the world, whereas the other is more like an inference taken from reality."[21] The distinction here lies in the relationship of the viewer to the image. In extramission the viewer actively seeks and constructs the image to be imprinted on his or her mind's eye. In intromission the viewer's relationship to the image is one of a passive receptor of visual stimuli.

As an example of the shift from extramission to intromission, Camille cites Villard de Honnecourt's renowned sketchbook drawing from the 1240s, "How to tame a lion," which contains the inscription to "note well that this was drawn from life" (*al vif*).[22] This image's inscription, regardless of its truth-value, emphasizes a new-found importance of mimesis that, according to Camille, accompanied the development of the intromission model. He writes:

> In earlier medieval image making and in the extramission theory of their apperception, the notion of likeness (similitude) was not strong because the object was always to some extent produced by the gaze. . . . Lit by the mind's eye, the image had previously not really been part of the world of things but, in a Neoplatonic sense, part of a noncorporeal realm of signification. Intromission, by contrast, placed the world of nature and the world of art on the same footing, as objects of sense, bringing the outside world within.[23]

Despite Camille's assertion that Villard's sketch may be identified as an image designed with intromission in mind, it is not generally possible

to so neatly map a transition in models of vision onto changing styles of illustration. First, the debate about the physiological, psychological, and philosophical processes of seeing was complex, heterogeneous, and certainly not limited to a discussion of two discrete and clearly defined vision models.[24] Second, although the notion of sight as an intromissive process generally superseded the earlier idea of extramission by the fifteenth century, it is a given that different models of vision coexisted and intersected for many decades.[25] There was thus no single correct and dominant theory of vision, but rather multiple competing theories that could be used to describe or problematize practices of seeing.[26] Finally, the complex debate surrounding models of vision was intellectually exclusive and elitist. It is unclear, for example, how much an artist given the task of illustrating the *Welscher Gast* would have known about these debates. These theories might have filtered down through texts or conversations to a wider audience, in which case illustrators might have been exposed to partial, overly simplified, or even incorrect ideas about vision.

Furthermore, if given the freedom to do so, an illustrator would presumably elect to design or redesign images in a manner in which he felt they would be effective and meaningful. Certainly changes in what was considered effective and meaningful relate in some way to changes in ideas about how one thought the process of seeing functioned, but it is virtually impossible to identify a direct and consistent correlation between the transformation in vision models and decisions made by illustrators to redesign certain images in the *Welscher Gast,* or any other specific vernacular manuscript. That said, these medieval notions of vision are informative, as they provide a context for considering what kind of reception the images' artists may have had in mind when creating them. In other words, although it is questionable that the models of vision were generally accessible even to the socially elite medieval audiences for these manuscripts, the variation in the image cycles can be read within the context of this broader debate about apperception. Indeed, the changes in the image cycle are evidence for artist participation in it, however unconscious that participation might have been.

Most important for the present study is the idea that the viewer's relationship to the image was in flux and a topic of debate. According

to extramission, the viewer actively constituted the image in his mind's eye based on visual stimuli. In intromission, the image, which existed in the real world, outside the mind's eye, acted on the receptive viewer. In either case, the viewer was physiologically connected to the image through the rays that enabled his sight. Whether or not a scribe knew the specifics of one or both of the vision models, or something in between, he probably thought about the relationship of the viewer to the image and the effect that a given image might have on a viewer. As we will see below, variation in the images was at least partially due to different notions of this relationship between the viewer and the image — a relationship that may have been conceived differently within a given image cycle depending on the kind of image in question.

AFFECTIVE VIEWING, ALLEGORY, AND MEMORY: THE PERSONIFICATION OF INCONSTANCY

In general, medieval notions of seeing involved more active and affective engagement than modern notions of apperception. Hans Belting writes with respect to medieval images: "the image is present in a manner independent of its medium. It does not become an image until it is animated by its viewer."[27] That is, an image only exists as an image if it is being perceived; it is the act of viewing that invests the image with significance and meaning.[28] And this process of viewing, of inscribing an image to the mind's eye, is an affective process.[29] Affective viewing has been discussed in greatest detail in the contexts of religious art, visual piety, and the relationship between the "visual and the visionary."[30] Scholars have been particularly interested, for example, in describing the performative nature of religious cult images, and the affective responses that they elicited.[31] But not only religious images were considered to have a powerful effect on their viewers. Artists who created secular images and texts also presumed that their viewers and listeners would engage sensually and emotionally with images and figurative objects.[32] As Horst Wenzel writes, in the Middle Ages, "statues and images were not merely artifacts, but rather animated beings; and this is not only the case for the religious sphere, but also in the context of courtly

culture."[33] Images were perceived as "three-dimensional bodies that invoked the senses of seeing and touch, and stimulated an affective response."[34] Throughout the Middle Ages, images were regarded as performative, present, and affect-inducing.[35]

Notions about the affective response to images influenced their design. Brigitte Buettner has remarked with respect to secular epic manuscripts that a more broadly conceived understanding derived from the art of memory tradition—that "if *imagines* were to remain effectively impressed on memory, they had to be *agentes*."[36] She explains:

> Thus figures had to be as vivid as possible, either of exceptional beauty, particular repulsiveness, or captivating eccentricity. Furthermore, strong oppositional compositions helped to turn many manuscripts into powerful epideictic means to inform the viewer, both confirming the reality of the narrative and structuring the imagination. The firm conventions regulating the rendering of figures in courtly manuscripts constantly reinforced what was morally and socially appropriate or inappropriate. Analogous in this respect to *exempla*, images could act upon the viewer, inducing the acceptance or repudiation of a positive or a negative model.[37]

The images in the oldest redaction of the *Welscher Gast,* which portray brightly colored, strange, and often contorted figures gesticulating and comporting themselves wildly, can be understood in the context of the memory arts as *agentes*. They are intended to impress themselves on the viewer's mind. As we will see, however, the later medieval *Welscher Gast* manuscripts suggest that artists moved away from the eccentric models found in the memory tradition to a more narrative model that appealed to the viewers on the basis of identification and perhaps empathy.[38] The images thus continued to evoke an affective response, but the quality of that response changed in the course of the poem's transmission.

Some images in the *Welscher Gast* cycle were changed quite radically when they were reconceived for new redactions. Curiously, one of the more inconstant images in the cycle is the personification of Inconstancy, mentioned above (figs. 81, 89). It appears in part 2, a section of the poem dealing specifically with the virtue of constancy and its corresponding vice. I contend that this image changes in response to

developing notions of the relationship between the viewer, the image, and the text. While the image of Inconstancy is unusual in the extent of its transformation, it is also paradigmatic for the kind of variation undergone by several images in the process of the cycle's transmission.

The passage that the figure of Inconstancy illustrates is addressed to lords who are directed to always present a good role model for their subjects, to remain steadfast, and to avoid the vice of inconstancy. The concepts of constancy and its antithesis, inconstancy, are extremely important in medieval German literature.[39] Part 2 of the *Welscher Gast* elaborates on the importance of the concept for the ideal ruler. Despite its clearly signaled applicability for male rulers, however, the vice is personified in the oldest extant manuscript redaction, Heidelberg Cpg 389, as a female figure. This figure is split horizontally into four parts labeled "love" (*lieb*), "sorrow" (*leid*), "yes" (*ia*), and "not" (*niht*) (fig. 81). It is an allegorical image that corresponds closely to the poem:

swaz ist ganz, mům sin æine,
unstetecheit diu ist gemæine,
wan si allenthalben wil.
si ist niht gantz und hat niht zil.
si ist in vier tæil gelæit.
ein tæil it liebe, daz ander læit.
daz dritte ia, daz vierde niht.
si ist zebrochen und zebriht

———

That which is whole must be unified; inconstancy is disunited because she wishes to be everywhere. She is not whole and has no goal. She is divided into four parts. One part is joy, the other sorrow. The third is yes, the fourth is no. She is broken and destroys [others].

(2567–74; 1965–72)

While the vice's female personification may be a result of the feminine grammatical gender of the Middle High German term *unstetecheit* (inconstancy), as we will see in chapter 3 the relationship between grammatical gender and the gender of the personifications is unstable and complex. Nonetheless, the feminine embodiment of what is identified

in the poem as a lordly male vice suggests that we are dealing with an allegorical personification. But the figure also fulfills a mnemonic function. Inconstancy's division into contradictory parts in the poem is underlined in the image by the words inserted between the figure's head, torso, hips, and legs, and the different colors used for her gown.

The figure's division into four parts presages Thomasin's later comparison of man's inconstant nature, *unstete* (inconstant), to the constancy created by God: "als diu werlt zalrest wart getan, / sie wart vil stete gemaht" (when the world was first created, it was made to be very constant, 2780–81; 2178–79). According to Thomasin, *unstete* pervades human society and is characterized by its aimlessness and fickleness. As counterexamples to man's inconstancy, Thomasin cites God's order, which is manifest in the regular alternation between night and day (2817–19; 2215–17), the seasons (2799–2810; 2197–2208), the revolution of the stars (2827–33; 2225–31), and the four elements: fire, water, earth, and air (2879–3024; 2277–2422). Thomasin's notion of constancy, which expands the traditional Latin notion of *constantia*, thus encompasses the divine orderliness of the natural world.[40]

The figure's division into four parts corresponds to the text but also has a broader significance both for the poem and for the medieval imagination.[41] This divided female personification of Inconstancy provides the viewer with a concrete visualization of the mnemonic structure described in the poem. Inconstancy's body, in contrast to Villard's lion, is not depicted as a mimetic body nor is it "part of the world of things." Instead it derives its significance only through its apperception: the viewer invests it with meaning with the help of the text and with other knowledge that he brings with him when he views it.

Four was an important number in the medieval world view: there were four elements, four directions, four seasons, four humors, the four gospels, four ages of man, and so on.[42] Chapter 5 of part 2 is devoted to the four elements (2879–3024; 2277–2422), and this passage is illustrated by a diagram depicting the elements and their relationship to one another (fig. 82). It is possible that the four-part figure of Inconstancy was designed as an antithesis to this diagram and to the description of the four elements.[43] The figure's four contrasting colors of red (the figure's flushed forehead, cheeks, and neck), blue, green, and brown corre-

spond to the four colors traditionally associated with the elements. Red, blue, green, and brown are also used in the diagram in figure 82. Indeed, the image of the divided lady has diagrammatic qualities itself, but Inconstancy's representation as a human figure invokes a much wider range of associations: the human figure is capable of eliciting a more affective response than the line diagram of the elements and is thus ultimately more effective as a memory aid.[44]

Many medieval treatises emphasize the connection between vision and memory and underline the importance of visual images for remembering text.[45] The poem's description of Inconstancy is itself a mnemonic textual image. Its seemingly redundant visualization in a picture raises questions about the relationship between actual pictorial images and mental images evoked in reading and how these are brought into dialogue with notions of vision. Mary Carruthers has pointed out that it was a "traditional pedagogical caution" not to use others' diagrams and memory images but instead to construct one's own.[46] She cites Plato's *Phaedrus*, the *Ad Herennium*, Quintilian, and especially Cicero, who all emphasize the importance of seeking and creating one's own memory images because this process is part of what makes these images memorable.[47] The ready-made image provided in the Heidelberg manuscript thus contradicts what would traditionally be considered ideal in the context of the arts of memory.

Thomasin's target audience of lay courtiers offers us one explanation why the Heidelberg artist may have felt it necessary to provide a ready-made mnemonic image. Whereas educated scholastics could construct and manipulate their own mnemonic structures and images, illiterate courtiers could scarcely have been expected to have the same training and skill at their disposal. The transposition of the mnemonic image to the page turns it into an image like any other to be viewed, internalized, and inscribed on the mind's eye, and it relieves the viewer of the task of creating his or her own image. The carefully designed illustration also helps to ensure that an uneducated viewer would commit to memory a correctly designed mnemonic aid.

Whereas, in the medieval context of image making, the image of Inconstancy in Heidelberg Cpg 389 is thus presumably less effective as a mnemonic image than one created before the inner eye by a trained

viewer, it was certainly in its own way intended to engage the viewer and make the passage memorable. The personification of Inconstancy is not an image taken from reality but, in Camille's words, it is a "projection of an internal archetypal pattern" that draws on opposing elements to elicit an affective response. The parallel textual and pictorial visualizations of Inconstancy affirm the vice's immoral nature and present the (lay) reader, listener, and viewer with a ready-made mental structure that may be used to inscribe to memory the vice's characteristics and thus learn to recognize and avoid it.

THE FRONTAL GAZE

From the perspective of medieval notions about images' presence and their relationship to the viewer, it is significant that the personification of Inconstancy gazes directly out of the page. This frontal gaze heightens the viewer's affective response to the image because it creates a visual connection between the image and the viewer and underlines the viewer's subjective experience. In his discussion of the arts of classical antiquity, Jaś Elsner distinguishes between "the frontal gaze of . . . cult icons" and naturalistic images in which figures "look away, involved in their own worlds, their own narratives and realities." The averted gazes of "[n]aturalistic images elicit a series of identifications, objectifications, narratives from us as viewers to read our way into the picture, as it were." The "arresting frontal gaze" of the cult icon, by contrast, is understood by the viewer in the context of liturgical and ritual custom and therefore has a power that extends beyond a viewer's voyeuristic intrusion.[48] Elsner's distinction between mimetic and iconic visualities is based on classical texts and images, but, as he points out, antiquity was "the mother of the Middle Ages." Particularly the "culture of sacred images and ritual-centered viewing in which art served within a religious sphere of experience was strikingly similar to the world of icons, relics, and miracles of medieval and Byzantine piety."[49] Implicit in the notion of "cult icons" is a sacred sphere within which these images were understood.

While the *Welscher Gast* is a secular text, its images, particularly in its oldest redaction, can be viewed in the broader context of religious

iconography.[50] Heidelberg Cpg 389 was probably illustrated in a monastic scriptorium by artists most familiar with the illustration of religious texts. In other words, the historical context of its production was probably a religious one. Furthermore, although the *Welscher Gast* addresses secular issues, its author was a cleric, and its catalogue of virtues and vices derived from theological discussions. The illustrations in the *Welscher Gast* are primarily personifications of virtues and vices. While their iconography drew to some extent on Prudentius's *Psychomachia*, personifications of virtues and vices were also familiar figures in Christian religious art.[51] Some illustrations, such as the ladder of virtues (fig. 55), borrow directly from religious iconography. Such crossover imagery is relatively common in medieval art.[52]

In the *Welscher Gast,* whereas many of the images reproduce interactive scenarios described in the poem, some of them, such as the figure of Inconstancy, seem to invoke associations with religious cult icons. The frontal gaze is used sparingly and to great effect throughout the image cycle in Heidelberg Cpg 389. In figure 81, Inconstancy's gaze implicates the viewer and heightens the performative and affective nature of the viewing experience. Her eyes confront and challenge the viewer, resisting any attempt to regard her with the distanced and superior gaze of the voyeur. The viewer is implicated because the frontal gaze mirrors his own. The image looks at the viewer, just as the viewer looks at the image. The figure's frontal gaze thus detracts from the viewer's autonomy and agency, making him the object of her gaze.

The illustration of Inconstancy had already undergone a significant transformation by 1340. In the Gotha manuscript, Inconstancy is still divided into four parts and labeled as a personification but she has averted her gaze and turned away from the text (fig. 20, ill. 30).[53] The younger image draws heavily on the older one, but the details that are no longer considered meaningful by 1340 are telling: in particular, the frontal gaze that implicated and challenged the viewer is missing from the younger image. Because the lady in Gotha Memb. I 120 does not meet and return the viewer's gaze, she becomes the passive object of the viewer's probing inspection. Indeed, the illustration invites the viewer to examine her unchallenged. Is it possible to detect in this variation a shift from extramission to intromission? We cannot answer this

question conclusively, but certainly the change does alter the role of the viewer who is able to examine the lady from a more impassionate and distanced perspective.

In Wolfenbüttel Cod. Guelf. 37.19 Aug. 2° (fig. 89, left column) from the first half of the fifteenth century, the scribe has preserved the description in the poem, but rejected the allegorical pictorial illustration of Inconstancy. In this manuscript the figure appears as a fashionable male courtier — it is a mimetic and naturalistic representation of a figure that might exist in the natural world and may have been "drawn from life."[54] The function of the figure in the Wolfenbüttel manuscript is a decidedly deictic one. It identifies a particular passage and appeals to the viewer to direct his gaze there. The figure is a representative of the elite society for which the poem was composed, but its purpose lies less in its iconographic significance (or lack thereof) and more in its function as a conduit between the viewer and the text. It does not mirror an internal image, nor is it in and of itself memorable or particularly significant; it is not a cult icon. The shift from an allegorical style of representation to a "naturalistic" and nonallegorical one is underlined by the change in the figure's label. In Heidelberg Cpg 389 the scribe labeled the figure with the abstract noun *unsteticheit* (inconstancy), but here the scribe has used the adjectival *unstete* (inconstant). The substantive *unsteticheit*, which is formed from the adjective *unstete* and the suffix -keit or -heit, is an abstract feminine noun. Although *unstete* may also be used as a substantive, the fact that it has no article in the image suggests that it is being used here as a nonabstract adjectival form to describe the figure's actions. The label *unstete* might still be used to identify the figure as a personification, but it is also possible that it merely either describes the figure's actions or the examples of inconstancy presented in the text toward which the figure gestures.

In Heidelberg Cpg 330 (1420), a manuscript redaction roughly contemporaneous to the Wolfenbüttel codex, we see a similar figure of a male courtier, but the label has disappeared completely (fig. 97). In its place, the male figure holds a banderole that reads: *mit unsteticheit* (with inconstancy). Throughout the image cycle, banderoles are used in a manner similar to speech balloons, and this inscription too may be interpreted as an utterance by the figure commenting on the examples of

inconstancy described in the poem. The inscription's transformation from a label to a description or an utterance supports the idea that this male courtier was not conceived as an allegorical personification but instead as an actor pointing the viewer toward an example of the vice. The complete redesign of this image in these two younger manuscripts suggests that the older image was no longer considered effective or modern enough, and that the artist felt it necessary to redesign it entirely in order to elicit the desired response from the viewer. These male figures do not engage with or challenge the viewer in the same manner as the divided lady in Heidelberg Cpg 389. Instead, their averted gazes and deictic gestures pointing toward the text acknowledge that the viewer is the active subject. In these two younger redactions, the male figures, enjoying little significance in and of themselves, guide the viewer's eyes to the text. The model selected by these artists is one from life; the figures are mimetic representations of elite young men. But other artists came up with alternative solutions to the problem of representation presented by the personification of Inconstancy.

The youngest versions of the image negotiate between allegorical and nonallegorical styles. As mentioned above, in the Wolfenbüttel manuscript (fig. 89) and Heidelberg Cpg 330 (fig. 97) we are confronted by a male courtier gesturing toward the relevant section of the text. A younger manuscript, Heidelberg Cpg 320 (1460), depicts the figure as a courtly lady (fig. 99). The words *liep* (love) and *leid* (sorrow) are inscribed on her gown and indicate the duplicity inherent in the vice of inconstancy without literally reproducing the description in the poem: the lady is not divided. She gazes directly out of the page and points the viewer away from the textual passage that describes her. Her label reads *unstet* (inconstant) and suggests that she is not a personification but instead a lady behaving in an inconstant manner. The grass beneath her feet additionally naturalizes the figure, placing her in a real world context rather than presenting her as a memory or internal image. This image modernizes the different elements of the earlier version of the image: it is both allegorical and naturalistic, it challenges and actively engages the viewer, but it is not a mnemonic image that reproduces the text. Instead the viewer must take an active role in interpreting the image with respect to the text.

The lack of comprehension or interest with which a late medieval viewer may have viewed the image conceived in 1256 is perhaps best revealed in Dresden, Sächsische Landesbibliothek–Staats- und Universitätsbibliothek, Mscr. Dresd. M 67, from the second half of the fifteenth century (fig. 100). This redaction has a special status in the history of the manuscript transmission because its images and text are most closely related to the 1256 Heidelberg redaction. It is so similar, in fact, that scholars assume that the scribe and illustrator used Heidelberg Cpg 389, or a redaction very closely related to it, as a model. The illustrator of the Dresden manuscript faithfully copies the older illustrations, but he also attempts to make sense of them for his fifteenth-century audience. The personification of Inconstancy provides us with an excellent example of the kind of changes that this illustrator deemed necessary to modernize the image cycle.

The Dresden artist has adopted the image of the divided lady, but has made important changes, placing her in an iconographic context more similar to her 1460 contemporary in Heidelberg Cpg 320. The lady's division into competing parts is suggested in this image by the contrasting yellow stripes on her red gown. As in the oldest version, the contrasting terms are included in the image, but here they appear adjacent to the figure: *ia, nicht, leit, lieb* (yes, no, sorrow, love). She is not identified as a personification—indeed she has no label at all—but she holds a banderole with the words: *der unstate bin ich komen in smerczen* (I have come from Inconstancy with great suffering, or Inconstancy has caused me great pain).[55] Instead of challenging the viewer with a frontal gaze, she averts her eyes from him and turns away from the text. The artist has thus attempted to create a story out of this image in which the young lady is not herself Inconstancy but a victim of the vice. The image no longer makes much sense with respect to the passage that it illustrates, but it tells a story of its own, a story of pain and suffering with which a viewer could identify or at least empathize.[56]

The younger versions of the divided lady are allegorical, like the oldest version, but the allegory functions differently. Whereas the image in Heidelberg Cpg 389 works by association with the words of the text and perhaps with medieval notions of world order (such as the four elements), the youngest versions of the image place the allegorical figure

within a coherent narrative structure. The image continues to elicit an emotional response, but that response changes from one of fright or aversion to one of empathy and identification.

The variation in this image can be understood in the context of changing ideas regarding the viewer's relationship to the image. Camille remarks, "This model of looking rooted in a viewing subject [intromission] . . . opened up a fundamental rift between viewer and object, a gap that did not exist when the visual rays had directly touched the object being looked at."[57] Camille has in mind the notion of the cinematic gaze, a complex relationship entered into by the cinematic viewer and the object viewed. This relationship may be characterized by mastery, by desire, by identification, or by some combination thereof. The "fundamental rift" that he identifies is created by placing the viewer in the position of the voyeur—simultaneously pulled into the image through identification and desire, and excluded from it by the image's hermetic, naturalistic design and its medial otherness. Indeed, the shift from extramission to intromission ultimately changed the perceived role of the viewing subject and his or her relationship to the image from one of contemplation and association to one of identification. While we cannot presuppose that the Dresden artist understood the physics or physiology of the intromission model, it is apparent that he was working with a notion of an active viewer who would identify with the image and attempt to place it in a coherent, recognizable, and personally relevant story. This use of narrative structure is key to the image variation that we observe in the visual program of the *Welscher Gast*.

THE POWER OF NARRATIVE

The differences between the Dresden and the 1256 Heidelberg redactions can be characterized as a change in emphasis on narrative structure and storytelling over symbol and allegory. The Dresden version of the image places what was originally a clearly allegorical figure within a narrative structure that tells a story. As in the example of Inconstancy, the stories that come to dominate many of the images are mimetic illusions of reality: they are stories in which the viewer was expected to see

him or herself and with which the viewer was expected to identify or empathize.

A second example further illustrates the growing emphasis on narrative structure over the course of the image cycle's transmission. It is the illustration of the vices of the tongue: lying, boasting, and mockery.[58] The text tells us that Boasting is the worst of villains, Mockery always accompanies him, and Lying is his second nature.[59] Thomasin makes these vices concrete in the poem by placing them in a secular context of male-female relations and social reputation. He explains: the braggart either tells the truth about his conquests, and thus breaks his oath of confidentiality to his lover; or he lies about conquests that never took place. In either case, the braggart behaves wickedly. The only thing a braggart will achieve by boasting is defamation of the lady, and he will gain no honor from it.

The 1256 illustration presents the personifications of Lying, Boasting, and Mockery, standing next to a courtly lady (fig. 79).[60] The personifications are labeled and hold banderoles containing utterances that enable the reader to interpret the image as a story.[61] Lying turns toward Boasting, placing her hand on his shoulder, and instructs him: *sprich ich han si gehabt* (Say, "I have had her"). Boasting looks directly out of the manuscript page at the viewer and proclaims: *Da ist si mir holt* (She is dear to me). Mockery looks over his shoulder at his accomplices while pointing at the lady and says: *wi si dich an chapht* (How she's gawking at you). The lady gazes directly out of the manuscript page and wonders: *zweu zeiget er an mich* (Why is he pointing at me?). On a literal level, therefore, this image presents a similar scenario to the text. It depicts a braggart who lies and boasts about his conquest. The lady is the object of the boasting, but her bewildered utterance suggests that the braggart is lying. Boasting and the virtuous lady gaze frontally out of the manuscript as if to offer the viewer a choice of whom to believe.

This image of the vices of the tongue thus depicts a man lying about his conquest. But the figures' design stages the illustration in a manner that allows us to draw a variety of associations, including connections with religious iconography.[62] The most prominent figure is Boasting. His nakedness, his gesture, his grinning mouth, and his short

hair distinguish him visually from most of the figures in the cycle and
from the other figures in this particular image as well. Nakedness is rare
in medieval manuscript illustration: it usually occurs in specific con-
texts, and it is always meaningful. Most often it signifies sinfulness and
depravity, but in certain contexts, such as the portrayal of the resur-
rected at the Last Judgment or Adam and Eve before the Fall, it signifies
innocence and purity.[63] Nakedness occurs in both contexts in the image
cycle of the *Welscher Gast.* In the Heidelberg manuscript it is clear from
the label, but also from the figure's grinning face and the company that
he is keeping, that Boasting's nakedness is a sign of his depravity. Per-
haps the most prominent location in which we see such shamelessly
naked figures is in scenes of the Last Judgment, which was a popular
theme for church portals in the twelfth and thirteenth century. A com-
mon feature of the condemned in these scenes is their nakedness, but
also their grinning faces.[64] The Fürstenportal (Prince's Portal) of the
Bamberg cathedral, for example, depicts the (clothed) sinners, grinning
widely as they are led to hell. Such scenes as this were visible to any me-
dieval churchgoer for contemplation. The figure of Boasting is there-
fore rendered in this illustration into a visual language that is already
encoded in religious iconography. This personification, which signifies
by association with medieval notions of demons and sinners con-
demned to hell, is, however, integrated in this manuscript into a secular
context through both the description in the poem and the narrative
level of the images expressed in the banderoles.

The other figures in this illustration too bear features that allow the
viewer to make associations with religious imagery. Mockery, for ex-
ample, has a very distinct visual appearance. Most of the figures in the
image cycle have homogeneous features, wavy hair, and wear no hats or
head coverings. Mockery, however, is characterized by his prominent
physiognomy—a large hooked nose and thick fleshy lips—and by his
straight, dark hair. His representation in profile emphasizes these fea-
tures, which are common attributes in medieval representations of the
infidel. His turban-like head-covering is a further indication that we are
dealing with a cultural outsider, and the stark red and white color of his
clothing provide a further contrast with the other figures in this image.[65]
Whether this figure is supposed to represent a Muslim or a Jew is not

certain; they shared many of the same iconographical features in medieval art. But it is apparent that this figure of Mockery was supposed to resonate with the medieval imagination and signify by association with such negative stereotypes. The personification of Mockery thus, on the one hand, represents a scornful courtier, but on the other, an infidel who dares to mock a virtuous Christian courtly lady.

The figure of Lying wears brightly colored clothing that clerics commonly associated with depravity and vice among the nobility, and she also wears a Jew's cap. These conical caps were particularly prominent in thirteenth- and fourteenth-century religious art in the German-speaking regions of Europe.[66] Jew's caps are often brightly colored—typically they are red or yellow—and they may be portrayed on male or female Jews. The figure of Synagoga, for example, is often portrayed wearing a Jew's cap. In the image of the vices of the tongue, Lying leans over to touch Boasting with an intimate gesture that would have suggested to a medieval audience immoral sexuality, even independent of the fact that he is naked.[67] Her immodest gestures and posture contrast with the chaste appearance of the lady on the right. Lying thus also signifies by negative association with the virtuous lady and can be understood as her antithesis.

The virtuous lady is wearing red and blue, colors associated with the Virgin Mary. But her gesture is also significant as it seems to have been a generally recognizable gesture of virtuous and courtly ladies that they hold their mantles with one hand while hooking the other through its closure. The gesture is described in medieval literature—in Gottfried's *Tristan*, for example, Isolde is described as making a similar gesture when appearing before the Irish court—and it is also portrayed in the visual arts. This gesture holds open the cloak, revealing its costly and sumptuous lining and the beautiful gown beneath.[68] Such expensive and exclusive clothing was considered a symbol of a lady's nobility. But the gesture also prevents the cloak from swinging open and revealing too much of a lady's body. It is therefore simultaneously a modest gesture that highlights a lady's comportment and her virtue. This association of this gesture with virtue can be seen in the example of two mid-thirteenth century sculptures: Reglindis in the Cathedral of Naumburg and one of the Wise Virgins on the Portal of the Magdeburg Cathedral.

As I discussed above with regard to the figure of Inconstancy, the lady's frontal gaze in Heidelberg Cpg 389 is also significant as it is a visual strategy employed often in religious iconography, particularly in the representation of cult icons. The visual associations that these figures invoke are not articulated in the banderoles or the poem but must be interpreted with the help of the labels and the broader visual culture within which the manuscript was produced. This image and many others in this version of the cycle may be read on multiple levels. They integrate courtly, religious, and even scholastic imagery, for they are frequently mnemonic images that draw on the tradition of the memory arts.[69] But they also function on a narrative level to tell a story.

The striking contrasts between these figures and their associative potential soon make way for a more unified secular aesthetic. In the Gotha redaction, Mockery has become a coifed courtly figure, and the two ladies no longer contrast starkly with one another visually (fig. 5, ill. 5). The virtuous lady no longer gazes out of the manuscript distancing herself from the other figures and appealing innocently to the viewer. Instead, she is turned toward the other figures, engaging with them. Only Boasting's short hair, frontal nudity, and unusual gesture appear to belong to a different register, or a different iconographic language.

In the later Heidelberg manuscript Cpg 330 (ca. 1420) all four figures look out of the image to the left as if addressing someone outside the frame, standing to the side of the manuscript viewer (fig. 96). The banderoles do not vary much, but this illustration nonetheless tells a slightly different story. Lying addresses an external viewer, and points to Boasting, saying: "Say that you have had her." Boasting is a naked woman. She is not holding a banderole like the other figures, but the banderole inserted next to her (rather nonsensically now) reads: "I love her." Mockery points toward the courtly lady while addressing the external viewer, saying not "See, how she's looking at me" but "Say" or in other words, "Boast, 'How she's looking at me.'" He thus tries to persuade the viewer to become the braggart. The lady on the right holds the words: "Why is he gawking at me?" The figures' gestures, the direction of their gaze, and the slight modification of the banderole thus suggest that the two male figures are addressing an external viewer and encouraging him to defame the two ladies. One lady is to be the object of

boasting about sex; the other is to be the object of boasting about her unchaste or unvirtuous gawking. Judging by the first lady's nudity, and the second one's gaze, they are guilty as charged. This version of the illustration thus depicts a scene that is comprehensible and that can be reconciled with the poem, but it is not the same scene as in the earlier versions of the image. The allegorical labels no longer make sense; neither the figures' sex nor their actions correspond to the vice they are supposed to be personifying: Lying seems to be telling the truth, while Boasting is not boasting, nor is Mockery mocking. The figures do not signify independently but only as a group or in pairs. There is no trace of religious imagery, except perhaps Lying, who may be conceived as Jewish here. This image has been redesigned as a narrative scene using a profane iconographic language. Most importantly, it addresses a viewer, drawing him into the story and implicating him in it.

In a final example of this image (Heidelberg Cpg 320) from around 1460–70, we see a different attempt to create a visual narrative (fig. 98). Lying, Mockery, and the Lady are fashionably dressed members of elite society. Boasting's nakedness has been covered by a luxurious red cloak that is fastened around his neck and strategically draped over his body. The cloak both affirms the figure's elite social status—red cloth was very expensive—and prevents indecent exposure. Boasting thus no longer shamelessly flaunts his nakedness but instead seems to be trying to hide it. Cloaks and cloaking are sometimes used in medieval German literature as a metaphor for deception, as they are in modern English. Boasting's cloak may thus be a reference to this metaphor. But it also has an effect on the visual reception of this image. It helps to integrate the figure into the scene, as he is clothed like everyone else, albeit incompletely. Furthermore, the color of the cloak visually connects him to the lady in the red dress; their glances further establish their connection; and the grass beneath the figures' feet unifies them in time and space, staging this image as a dramatic scene unfolding before our eyes.

The church portals depicting depraved sinners, the vices and virtues, Jews and Saracens, and virtuous ladies had not gone anywhere by 1460, but that visual language was obviously no longer serving as the model for this image. Instead, the artists of these later manuscripts have foregrounded narrative structure over all of the other modes of illustration that we found alongside narrative structure in the earliest version

of the image. And the story that this image now tells is a secular one in which elite members of society might see themselves represented.

TOWARD A SECULAR ICONOGRAPHY:
THE COURTIER AS CENTER OF THE COSMOS

The changes made to the image of the vices of the tongue suggest that the images emancipated themselves from clerical iconography. This process was protracted, complex, and by no means comprehensive. Yet it is nonetheless possible to identify the development of a secularly encoded visual language that focuses on contemporary fashion and storytelling. Narrative structure plays a crucial role in the process of secularization, as the emphasis on narrative ultimately enables a secular audience to use the images in a process of appropriation and identity construction. In the context of this emphasis on storytelling and the central role that elite characters come to play in the images, one illustration takes on particular significance: the ladder of virtue, which does not vary much in the course of its transmission (fig. 55). The variation that does occur, however, supports the hypothesis that these manuscript illustrations are redesigned to enable a secular elite audience to identify with them and see themselves reflected in the manuscript page.

The ladder of virtue motif was a popular means by which to incorporate man into the allegorical battle of the virtues and vices, and many versions of it appear in medieval illustration. The motif has a long iconographic tradition that scholars have traced to the *Scala paradisi* (ca. 600) by the church father John Climacus, who drew the analogy between Jacob's dream in which angels appear ascending and descending on a ladder between heaven and earth and the monk who must leave all worldliness behind to climb a similar ladder.[70] The ladder of virtue is ubiquitous in medieval ecclesiastical contexts as a visualization of the ascent toward the crown of eternal life.[71] This motif would have been immediately identifiable to a medieval audience, who would have been familiar with it from descriptions in sermons. Thomasin presents the ladder of virtue both verbally and visually. His description of it extends over three hundred lines, and the illustration corresponds exactly to the poem.

Thomasin develops the motif by placing the secular courtier at the center of the image, combining the ladder of virtue with a ladder of vice, and introducing the six qualities (*sehs dinc*) that he defines in decidedly secular terms.[72] The six qualities, which are particular to Thomasin's version of the ladder of virtue, have the potential for either good or evil: they are wealth (*riechtům*), glory (*herschaft*), power (*maht*), reputation (*nam*), nobility (*edel*), and desire (*gelust*). Thomasin introduces the notion of these six qualities already in part 2; he revisits them in part 5, in which the image appears, and then again in part 8. They thus provide one of the overarching principles between his various systems for categorizing the vices and virtues.

> Nu sage ich iu, waz alle vrist
> beidiu gůt unde ubel ist.
> gůt und ubel heizet wol,
> daz uns schaden und frumen sol.
>
>
>
> Die hacken sint riechtům, maht,
> edel, nam, gelust, herschaft.
> ———
> Now, I'll tell you what may always be both good and evil.
> [By] good and evil, [I] mean that they can [both] harm and
> ennoble us. . . . These snares are wealth, power, nobility,
> reputation, desire, and glory.
> (6551–54, 6565–66; 5915–18, 5929–30)

Thomasin imagines two ladders—one of virtue and one of vice. The six qualities, envisioned as hooks or claws, may ensnare a courtier who is aspiring to climb up the ladder of virtue toward God. The description of the actual ladder commences with its building materials. The virtuous ladder leading to the highest good requires the finest material:

> diu stiege diu da reichen sol,
> diu sol sin gemacht wol.
> die steine diu man darzů tůt,
> die suln sin wærliche gůt.

die stapfen suln gantz wesen.

.

Ein ieglich stapfel mům sin
gantz von einer tůgend

The ladder that reaches to there [the highest good] should
be well made. The stones that one uses for it should be truly
excellent; the steps should be whole. . . . Each step must be
comprised of a single virtue.

(6421–25, 6453–54; 5785–89, 5817–18)

The ladder that leads to the lowest evil, by contrast, is comprised of
sloping rungs of vices:

die staphel sint gemahet gar
von untugenden, deist war.
ein ieglich untugende hat
von dem nidersten ubel rat.
die staphel sint nider gechert,
wan ir ieglicher gert,
swer dar uf tret, daz er valle nider
und daz er nimmer chome wider.

The rungs are made entirely from vices, that is true. Each vice
is supported by the lowest evil. The rungs are turned down,
because each one wants anyone who steps on it to fall down and
never rise up again.

(6509–16; 5873–80)

The passage is structured rather typically for a mnemonic image.[73]
Once Thomasin has laid out the allegorical structure by which the
well-intentioned courtier may struggle to enter heaven and avoid hell,
he assigns content to it by labeling the rungs and identifying which
demon's hook is associated with which virtue and vice.[74] Thus, for ex-
ample, a man trying to aspire to the rungs of generosity and humility
will be ensnared and pulled down by the claws of glory and wealth to

the rungs of avarice and arrogance on the ladder of vice below. Similarly, nobility's hook will cause a man reaching for love to slip down to hatred. The fourth rung is mercy (*senfte*), and if a man aspires to this, then power's hook will pull him down to anger. If he manages to get past mercy to justice, then the snare of desire will cause him to slip down to injustice. The final rung of the ladder of virtues is truth, but reputation's snare may cause a man to fall to perjury, the lowest rung on the ladder of vices.

The illustration presents exactly the same image in a different medium, and, as mentioned above, this image remains remarkably stable over the course of its transmission. Heidelberg Cpg 389 depicts a courtier climbing up the ladder of virtues toward heaven (fig. 84). His right leg is hooked over the third rung "love" (*lieb*). The remaining rungs of virtue are labeled: "humility" (*diumut*), "generosity" (*milt*), "mercy" (*senpht*), "justice" (*reht*), and "truth" (*warheit*). Below him we see the broken and sloping rungs of the vices: "arrogance" (*vbermuot*), "lust" (*gierd*), "hatred" (*neit*), "anger" (*zorn*), "injustice" (*vnrecht*), and "perjury" (*meineid*). Six demons with long grappling hooks attempt to drag the courtier down from the rungs of virtue to the treacherous ones of vice below. The grappling hooks are labeled with the six qualities: "wealth" (*Des reihtums hak*), "glory" (*Der herschaft hak*), "power" (*Der maht hak*), "reputation" (*Nam hak*), "nobility" (*Der adels hak*), and "desire" (*Der gelust hak*). On the far left an inscription contains a demon's exclamation: "Help, I've caught him!" (*helft ich han in erwischt*). Heaven and hell are also labeled. The illustration in the Heidelberg manuscript, therefore, is highly textual not only in the sense that it is a direct translation of the description in the poem, but also in the sense that it relies on labels and inscriptions to create meaning for a viewer. While the ladder of virtues was a familiar iconographic motif, the viewer would not be able to identify the six qualities without the aid of the poem or the inscriptions.

The later illustration in the Gotha manuscript is missing some of the details (fig. 55). It portrays only four demons, two on each side of the ladder. Only the grappling hooks on the left are labeled, but with three labels: "wealth's hook" (*des richtvms hachen*), "nobility's hook" (*des adels hachen*), and "desire's hook" (*des gelustes hachen*). The Gotha

manuscript also contains the utterance by the devil: "Help, I've caught him!" It appears that the Gotha artist either forgot to label the two grappling hooks on the right, or that there was not enough space left for the inscriptions. In the later redactions, such as the Wolfenbüttel manuscript, the image contains almost all of the details of the oldest version: six demons with labeled grappling hooks and inscribed ladder rungs. Only the labels identifying heaven and hell are missing.

Indeed the representation of heaven and particularly hell are the only parts of this illustration that vary significantly. In Heidelberg Cpg 389, heaven appears as a blue cloud; hell is a ring of flames within which a devil thrusts a sinner headfirst into a cauldron as five other sinners look on. In the Stuttgart manuscript, heaven appears as a frame encircling Christ's head, which is adorned with a nimbus; hell is similarly depicted as a circle, containing the devil's head. The devil is flanked on either side by a sinner and crowned with a rat. In the Gotha image cycle, heaven is represented as a blue circle, while hell appears as a ring of fire containing a three-faced demon and two naked figures that may represent Adam and Eve. In the Wolfenbüttel manuscript and Heidelberg Cpg 320 (fol. 48r), heaven appears as a circle of clouds, while hell is a circle of flames engulfing three sinners. Later artists thus seem more interested in depicting sinners burning in hellfire, while earlier artists portrayed demons of various kinds in addition to sinners. The appearance of heaven and hell are not mentioned in the poem, so that artists were free to imagine them.[75]

In this image, Thomasin uses an ecclesiastical motif but recontextualizes it in his poem to make it relevant for his secular audience, whose virtue could be potentially threatened by the lure of wealth, glory, power, reputation, nobility, and desire. In 1215 when the poem was originally composed, these six qualities were probably understood in the context of feudal lordship: a ruler will be tempted by these social trappings of his position. Given the variation of other illustrations throughout the image cycle, the consistency of this particular illustration is surprising. One might be inclined to attribute this to the close relationship between the text and the image, but as we have seen in the case of Inconstancy, textual fidelity is not a reliable predictor of image stability. The image's consistent transmission may instead be a result of

the motif's familiarity. The personification of Inconstancy as a lady divided into four parts is particular to the *Welscher Gast*, but the ladder of virtue had a long iconographic tradition. While Thomasin combines the traditional allegory with the notion of the six qualities to give his version of the motif a particular profile and make it more relevant to his lay audience, and although he extends the image to include a second ladder of vice with sloping and broken rungs, it is ultimately still a recognizable motif.

Yet I would like to propose a further explanation for this image's resilience to change. As we have seen, the images are often redesigned over time to emphasize the narrative level that is integral to the illustrations from the beginning, and to depict members of elite society as characters in a story. In contrast to other images, such as Inconstancy, this image and Thomasin's reinterpretation of the ladder of virtue placed the secular courtier at its center from the beginning. Already in Heidelberg Cpg 389 the courtier is depicted as the center of the cosmos, and his position does not change throughout the image's transmission. The image thus did not need to be adapted because it already foregrounded secular identity in the 1256 redaction. Viewed in this manner, the revision that the representation of hell undergoes is also significant. Hell is first envisioned as a place dominated by a demon and later as a place inhabited solely by human figures who have failed to behave ethically in the secular context invoked in the image.

This chapter started by considering models of vision and what these might tell us about image variation in the *Welscher Gast*. While there appears to be no direct correlation between the revisions made to the images and these models, the notion of intromission corresponds rather well to the late medieval versions of several of the images. They are mimetic and lifelike, depicting models that a viewer might emulate and with which he could identify. In this sense, the images, like the formatting of the manuscript discussed in the previous chapter, are redesigned to be used pragmatically in the process of elite identity formation and self-fashioning.

If the audience for the *Welscher Gast* was expected to identify with the social group portrayed in the poem, to see itself among the male and female courtiers striving to eschew vice and aspire to virtuous be-

havior, then what were the dominant identificatory categories that governed the relationship between the audience and the text? And are these the same categories of identification that we find in the images? To what extent do these (textual and visual) categories change over the 250 years of the poem's popularity? Curiously, as we saw in the example of Inconstancy, one of the most fluid elements in the image cycle is the representation of gender. The role of gender as a category of identity construction is thus the focus of the next chapter.

THREE

Models of Gender
Allegory, Stereotype, and Courtly Motif

Gender is an important category in the *Welscher Gast*.[1] Thomasin prescribes differentiated gender roles and attributes specific vices and virtues to men and women.[2] He imagines a courtly society with clearly defined and gendered forms of self-expression and self-representation. The different illustrators, however, dealt with gender in various ways. As we saw in the example of Inconstancy in the previous chapter, personified vices and virtues and other allegorical figures may appear as male in one manuscript and female in the next. There is even some variation within the individual visual programs. This apparent fluidity of gender in the illustrations is surprising given the conventional and static views on gender expressed in the poem and the large corpus of courtly, spiritual, and particularly didactic texts in the Middle Ages that dictate specific gender roles. Even more surprising, however, is the image cycle's deviation from the firmly established Latin tradition in which the virtues and vices were personified as female figures.

Whereas the way in which gender is constructed in the text is conventional, and Thomasin's gender-specific instructions do not vary in the different manuscript redactions, the gender of the illustrated figures is clearly not fixed. This gender fluidity in the representation of the personifications raises questions about the role of gender and sexuality in the visual program, and in the illustrated poem as a whole. Did ideas about masculinity and femininity inform the personifications? If

so, how? Is there a didactic purpose to the gender of the illustrated personifications? Most importantly in the context of this study, what roles do gender and sexuality play in the process of elite self-fashioning imagined in the poem and its manuscripts? This chapter reveals that gender takes on a complex but critical role in the manner in which elite identity is constructed in the Gotha manuscript of the *Welscher Gast*. Moreover, the representation of gender in the Gotha manuscripts and the later redactions supports the idea that images undergo a process of secularization and narrativization. Over time, many images are redesigned to tell familiar stories of gendered interaction.

Thomasin prescribes a specific notion of gender difference in his poem, but his notion is not always reflected in the different redactions of the visual program. Instead, as this chapter argues, each artist apparently drew on a broader spectrum of associations—from grammatical gender, to allegory, to stereotypes or conventions, to historical reality. While gender is a static social category in the poem, the illustrations reveal it to be a heterogeneous, nuanced, and dynamic category of identification.

Over the past decades, work on gender in the Middle Ages has exposed a complex and heterogeneous notion of the category. Medieval literature inherited a long tradition of misogynist attitudes and discourse but developed its own notions of masculinity and femininity as well. In the context of courtly culture, the lady was portrayed as the paragon of beauty and embodiment of inner virtue. She became the focus of the concept of courtly love, a stylized social, educational, and literary ideal that incorporated notions of courtly virtue. The courtly lady was thus a social construct whose counterpart was a knight who embodied his own gender-specific catalogue of courtly virtues. But these ideals of femininity and masculinity are specific to a particular secular context—courtly culture.

The religious context generated its own competing notions of gender. Clerics may have identified women as the devil's instrument, but the cult that developed around the Virgin Mary, the recognition of female mystics, and the prominence of female religious movements speak to a more complex notion of gender within the sacred sphere of medieval society. Clerical masculinity was likewise a specific gender formation that competed with secular notions of masculinity. As Laurie A. Finke writes, gendered identity "insists on local applications

rather than global laws or principles."[3] Indeed most scholars working in the past few decades on medieval notions of gender have identified "heterogeneous and competing constructions [of gender] that are realized in specific performative practices and can be (de)stabilized."[4] Different notions of masculinity and femininity coexisted and competed in the Middle Ages, and could be invoked at will depending on the particular social context or for specific purposes.[5]

The roles for women in medieval society intersect in a complicated way with the notions of gender that we find in literary, scholastic, and religious texts. Medieval women were not generally passive creatures subject to male control, nor were they idealized and placed on pedestals as the courtly literary ideal might have us believe. Instead, women were often politically active and powerful, and they were patrons of literature who played a central role in the development of medieval literary culture. Women, like men, were active in trade and participated in most public and private areas of medieval life. The relationship between historical reality and idealized notions of gender is particularly complex when it comes to didactic literature, which always provides prescriptive models, often written by men to women, and cannot be understood as descriptive of the broader social context. Thus, gender in the Middle Ages was a nuanced, heterogeneous, and fluid category.

In the *Welscher Gast* we find different notions of gender overlapping and sometimes competing. To complicate matters further, the specific relationship between the models of gender prescribed in the poem and the representation of male and female actors in the images changes in the different manuscript redactions. The pedagogical program of the *Welscher Gast* involves embodying vices, virtues, and other abstract concepts as male and female actors, and thus making them concrete, visible, and perhaps even "objects of identification and desire."[6] For the viewer, the personifications in the image cycle function on different levels. They are, on the one hand, allegorical figures that may be identified as such by their labels, but, on the other, they are male or female characters in a visual narrative demonstrating the virtue or vice that they embody.[7] Barbara Newman has pointed out that masculine and feminine allegorical personifications should not be conflated with men and women.[8] In a group of texts that she identifies as "imaginative theology," she focuses on such female personifications as Sapienta, Ecclesia, Philosophia,

Frau Minne, and others, arguing that these are not mere personifications but goddesses. Newman's category of imaginative theology includes the wide variety of medieval vernacular texts that "engage deeply and seriously with such issues as the nature and knowledge of God, salvation, sin and grace, creation, incarnation, and so forth."[9] Characteristic of imaginative theology, according to Newman, is that "it 'thinks with' images, rather than propositions or scriptural texts or rarified inner experiences—although none of these need be excluded. The devices of literature—metaphor, symbolism, prosopopoeia, allegory, dialogue, and narrative—are its working tools."[10] The *Welscher Gast* shares certain features with the texts that Newman investigates. It too uses images of many kinds to pave a road to knowledge. But the text is neither visionary nor concerned with finding a spiritual gateway to the divine. Instead, it is firmly anchored in the secular, and its concerns are pragmatic and concrete. The knowledge that it seeks to reveal is that which is foundational to and constitutive of elite secular society and its self-image. While the poem uses many male and female personifications of virtues, vices, concepts, and ideals, I see these figures in contrast to Newman's goddesses, as allegorical figures that are also male and female actors. We will see that the representation of the personifications and the artists' selection of the masculine or feminine gender for a specific personification often reveal cultural ideas about gender.

Indeed three overlapping models of gender can be identified in Heidelberg Cpg 389, and the Gotha and Wolfenbüttel redactions. In the first model, which is most prominent in the Heidelberg manuscript, the artist generally selected the gender of his personifications according to the virtue's or vice's grammatical gender. But some inconsistencies in this practice suggest that other criteria also influenced his decisions. In the second model, seen in the Gotha manuscript, the artist has redesigned some of the illustrations and framed the poem with large-format illustrations that emphasize a specifically secular courtly notion of gender roles. These large-format illustrations in particular construct gender rather differently from the poem, but they also stand in contrast to most of the image cycle, which demonstrates a broader and less prescriptive notion of gender. As a point of contrast, in the Wolfenbüttel manuscript, the selection of gender in the illustrations was based neither primarily on grammatical gender nor on a desire to

prescribe gender roles within the context of courtly culture, although both of these models of gender still influence the design of the cycle and thus complicate its representation. Instead, the Wolfenbüttel illustrations often correspond more closely to the poem, or they depict more "realistic" or at least naturalistic scenarios. The later artists thus attempted to make sense of the older (grammatically influenced) representation of gender by, on the one hand, returning to the text, and, on the other, considering the interests and desires of their audience and changing the illustrations accordingly to provide their audience with lively and contemporary narrative scenes of interaction.

First, I will discuss the representation of gendered behavior in the poem in order to establish that Thomasin is entirely conventional in his understanding of gender and gendered behavior. Second, I turn to the catalogue of virtues and vices that Thomasin developed for his poem and examine grammatical gender to determine how much correlation there is between it and the gender of the personifications. We will see that, as the image cycle is transmitted, the representation of male and female personifications is less closely correlated to their grammatical gender. Next I turn to the seven liberal arts, which, I claim, are redesigned in each of the three manuscripts to represent different models of gender. Finally, this chapter examines the representation of gender in the Gotha manuscript specifically, making the argument that this redaction in particular provides a normative model of gendered courtly behavior. The variation in the representation of gender is important because it demonstrates both that gender was an essential factor in the concept of elite identity and that notions of gender were in flux throughout the Middle Ages. Not only did the artists of the *Welscher Gast* participate in this ongoing discourse, but this variation further reveals that even within each redaction of this didactic poem competing ideas about gender were at play.

CONSTRUCTING GENDER IN THE POEM

Most of the *Welscher Gast* does not explicitly thematize gender but implicitly addresses the education, actions, and ethics of men.[11] Part 1, however, which deals with etiquette and is targeted at children and

young people, offers gender-specific instruction for young men and ladies of the court, suggesting that Thomasin envisions a court society in which self-representation, action, and thought are gender-specific. Ingrid Bennewitz and Ruth Weichselbaum have discussed the construction of ideal masculinity and femininity in the text of the *Welscher Gast* in detail to show that Thomasin's ideas about gender difference are conservative, misogynist, and thoroughly conventional.[12] Here I focus only on the passages addressed toward young male and female courtiers in part 1 to show that Thomasin has a clear notion of gender difference and constructs a courtly society that must learn and enact those differences. Specifically, as we will see, according to Thomasin, women should be limited in their ability to act in public life, and they should constantly exert control over themselves so as to be seen and heard as little as possible.

The gender-specific instructions in part 1 fall into roughly five categories: comportment, education, literary role models, ethics, and courtship. The text addresses proper comportment: speech, attire, gestures, and manners for men and ladies. Ladies, according to Thomasin, should be seen but not heard: a lady should present herself to guests at court, rather than retreat to her bedchamber (1005–10; 391–96), but she should not speak unless she is asked to do so, and even if asked, she should speak very little; while eating a lady should refrain from speaking altogether (1079–84; 465–70). Thomasin also instructs ladies not to curse or speak loudly (1019–20; 405–6). No such constraints are placed on the speech of young men, but they are warned to keep confidences and not to gossip.[13] Men are directed to listen to what they are told, so that they do not need to be told something twice (1021–24; 407–10).

While men's speech is not disciplined to the same degree as ladies', men are instructed to control their gestures and actions. They should not gesture with their hands while speaking (1055–60; 441–46). Nor should a man set his hand on the head or shoulder of any other man who exceeds him in status (1061–64; 447–50). A man should not ride while a lady is walking (1033–34; 419–20), and he must be careful not to startle or spray a lady when he is riding (1043–46; 429–32). Men are further instructed not to walk barelegged in front of ladies (1071–72; 457–58).

Similarly, ladies are instructed to control their movements and gestures at all times. The text tells us that a lady should not cross her legs when sitting (1025–26; 411–12), she should not walk quickly or take wide steps (1031–32; 417–18). Ladies are instructed to sit upright when on horseback and to turn toward the horse's head (1035–38; 421–24), keeping their hands lowered, and holding their eyes and head still (1051–54; 437–40). A lady should never allow any part of her body to be seen naked; she should never ride without a cloak, and if she is not wearing a long tunic, then she should hold her mantel closed (1065–70; 451–56). Thomasin's instructions regarding watching and looking are also gender specific.[14] A lady should not look too intently at strange men (1014–15; 400–401), she should not look around herself, but should walk upright looking straight ahead (1073–78; 459–64). Instead of actively looking at others, a lady should passively let herself be seen.[15] Men, on the other hand, are advised to look actively at both men and ladies, albeit politely, in a courtly manner (1016–18; 402–4).

In general men are thus directed to act politely toward women and to comport themselves in accordance with their social status.[16] The instructions for women, by contrast, involve limiting the extent to which they are seen and heard—women are directed to keep their eyes lowered, be as silent as possible, completely cover their bodies, and make only controlled movements and gestures.[17] These sensory limitations are accompanied by intellectual limitations, for Thomasin distinguishes between levels of education, and the implementation of that education, for men and women:[18]

> Ein vrowe hat an dem sinne genůch,
> daz si hufsch si unde gefůg
> unde hab ouch die geberde gůte
> mit schöner rede mit chiuschem můte.
> ob si hat denne sinnes mere,
> so hab die zuht und di lere,
> erzeige niht waz si sinnes hat.
> man engert ir niht ze potestat:
> ein man sol haben chůnste vil.
> der edelen vrowen zůht wil,

daz ein vrowe habe niht vil list,
die biderb unde edel ist.
einvalt stet den vrowen wol,
doch ist reht daz ein vrowe sol
haben die lere und die sinne
daz si sich hůte vor uminne.

———

A lady is intelligent enough if she is able to be courtly and
decorous, and also behave well, demonstrating proper speech
and a chaste mind. If she has even more intelligence, then good
manners and [proper] instruction tell us that she should not
show how intelligent she is. No one wants her to be a ruler:
a man should have many skills. The breeding of noble ladies
does not require a lady who is stalwart and noble to be very
clever. Simplicity suits ladies well, but it is proper that a lady
should have the instruction and intelligence to protect herself
from malice.

(1449–64; 837–52)

With regard to education, then, Thomasin prescribes that women be
limited in their exposure to and their expression of intellectual and po-
litical discourse. The essence of Thomasin's notion of femininity is thus
limitation and control in all areas of public life.

Thomasin's lists of literary role models for young men and women
are also clearly divided along gender lines. Men should aspire to behave
like the Knights of the Round Table, or the great kings Charlemagne
and Alexander, but should not follow Keie's poor example (1653–73;
1041–61). Ladies are instructed to follow the example of Andromaches,
Enite, Penelope, Oenone, Galjena, Blanscheflor, or Sordamor, all mod-
els of virtue and honor (1641–52; 1030–40).[19] But they should not fol-
low the example of Helen of Troy who "had great beauty but little
sense" (si het vil schöne und lutzel sinne, 1438; 826).

Thomasin further outlines which central courtly values and ethics
are suitable for men and which are appropriate for ladies:[20]

Der valsch zimt niemen wol.
ein vrowe sich behůten sol

vor valsche harter denne ein man.
valsch stet den vrowen wirser an.
so stet milt allen liuten wol.
ein ieglich vrowe milt wesen sol.
doch zimt diu milt den rittern baz
danne den vrowen, wizzet daz.
diumůt zimt in beiden wol.
ein ritter und ein vrowe sol
diumůt sin. doch stet diumůt
den vrowen baz, wan ir gůt
sol sin gezirt mit der tugent,
beide an alter und an iugent.
dem ritter zimt wol frůmcheit,
den vrowen triuwe und warheit.
ein ritter zage ist enwiht,
daz valsche wip ist ouch zeniht.
der ritter arg ist gar an ere,
daz tůmbe wip an gutiu lere.
dem ritter zimt niht schalcheit,
ein vrowe sol vor unsteticheit
unde vor untriuwen sin behůt
und vor hochfart, daz ist gůt.

———————

Duplicity does not suit anyone well, [but] a lady must protect
herself from duplicity more carefully than a man. Duplicity suits
a lady worse. Generosity suits all people well. Every lady should
be generous. But you should know that generosity suits knights
better than ladies. Humility suits them both well. A knight and
a lady should show humility. But humility suits ladies better,
for their goodness should be adorned with this virtue both in
old age and in youth. Skillfulness is suitable for a knight, fidelity
and truthfulness for ladies. A cowardly knight is worthless,
a false woman is also worth nothing. A stingy knight has no
honor, the foolish woman has no good advice. Being a scoundrel
does not suit the knight, a lady should guard herself against
inconstancy and infidelity, and from pride, that is proper.

(1581–1604; 969–92)

For the most part these virtues associated with men are explicit, public, and representational: generosity, skill, bravery, and largesse are all demonstrable virtues and actions that play an important role in lordship. Women's virtues, by contrast (humility, fidelity, truthfulness) are primarily internal and require no public action.

Finally, Thomasin turns to courtship. Most of his instructions are directed toward men, whom he advises to choose a partner carefully and not be fooled by external beauty or wealth but to look for inner value (1911–36; 1304–29). A man should choose a lady whom he may serve faithfully for a long time over a woman who is too quick to show him affection (2017–32; 1410–25). Thomasin tells men that they cannot force love, nor should they try to buy love with gifts (1833–54; 1221–42). He also instructs ladies on how they ought to respond to a man's attentions: ladies should not allow themselves to be bought but should accept only small gifts from a man, such as gloves, mirrors, rings, brooches, wreaths, and little flowers, and they should not be greedy (1945–54; 1338–49). Ladies should be chaste, but both men and ladies are instructed to be faithful to their partner (1961–78; 1354–76). A lady should not give herself too quickly to a man, and a man should not pressure her to do so (1999–2040; 1392–1433). Briefly summarized, in this section on courtship Thomasin instructs women to be reserved, chaste, and faithful, and men to act sensibly and with consideration for a lady's honor.

Thomasin is the first to spell out rules of conduct for men and ladies in the German vernacular, but his guidelines for gender specific behavior are entirely conventional.[21] In this section of the poem on etiquette, court society and courtly interactions are gendered, and there is little leeway for transgression of these gender boundaries. According to the text, if one wants to be perceived as a member of elite courtly society, then one must demonstrate gender-appropriate comportment, gestures, speech, attire, political and intellectual activity, and courting rituals.

Although part 1 is rather adamant about gender-specific roles, Thomasin's catalogue of Middle High German vices and virtues does not map onto his ideas about gendered behavior with respect to the grammatical gender of the terms. Thomasin drew on Latin models, but develops a novel catalogue of virtues and vices that take a combination of

masculine and feminine grammatical genders. The grammatical gender forces Thomasin to refer to the virtues and vices as "he" or "she" in the Middle High German text, and in some cases, he develops extended personifications of them. Generosity (*milte*), for example, which he tells us above is more suitable for a man than for a woman, and which he discusses particularly in the context of lordly gift-giving, is personified extensively in part 10 as a courtly lady. Given that Thomasin developed the vernacular Middle High German catalogue of the terms that he uses, we must assume that any discrepancy between the grammatical gender of the virtues and vices and their association with men or women was not of concern to him. In the poem, Thomasin apparently perceives no contradiction in assigning Middle High German terms that take the male or female grammatical gender to vices that are typically, or exclusively, associated with the opposite sex. In the illustrations, by contrast, notions of femininity and masculinity do appear to influence the personification of virtues and vices, although grammatical gender continues to play a role as well. In fact, the poem and its images suggest that there are competing discourses of gender in the Middle Ages in which the different artists of the *Welscher Gast* redactions participated.

GENDER IN THE IMAGE CYCLE

The representation of the struggle between virtues and vices as a war of women, or at least between female personifications, had a long tradition already by the Middle Ages. It started with Prudentius's *Psychomachia* in the fifth century, and would certainly have been familiar to the artists of the *Welscher Gast* image cycle.[22] In the *Psychomachia* and other Latin treatises, female personifications of the virtues and vices have often been explained as a linguistic constraint:[23] in Latin the names for the vices and virtues were feminine abstract nouns, and their personification as female figures corresponded to their grammatical gender.[24] Thomasin certainly drew on the Latin discussions of virtues and vices by Pope Gregory I and Alan of Lille, among others, but he created a novel vernacular Middle High German catalogue of virtues and vices

in which he neither adopted the Latin terminology nor the practice of assigning grammatically feminine terms to the abstract concepts.[25] It is thus quite remarkable that in the Middle High German *Welscher Gast* we find both grammatically masculine and feminine vices and virtues that are personified as male and female figures.[26]

The variability of gender in the visual program is significant when we consider Thomasin's concern with gender difference on the one hand, and the long tradition of personifying virtues and vices as female figures on the other.[27] That is, the illustrators followed neither Thomasin's model of gendered behavior, nor did they either consistently follow the grammatical gender or mimic the Latin tradition by rendering all of the personifications female. Rather, the fluidity of gender suggests that the redactors or the illustrators considered other criteria more crucial in the selection of gender for the personifications. In fact, in the 1256 Heidelberg redaction, most of the personifications are based on grammatical gender, but even in this redaction there is some variation. In the Gotha manuscript there are even more discrepancies between the virtues' and vices' grammatical gender and their representation as male or female figures. In the Wolfenbüttel manuscript and other later redactions there are more discrepancies still. While the masculine and feminine allegorical personifications should not automatically be conflated with men and women, as I discuss in more detail below, the illustrators were clearly influenced by notions of social gender when they designed the images.

Organized alphabetically and according to grammatical gender, the personified virtues and vices are labeled in Table 1.[28] It is immediately apparent from these lists not only that the vices outnumber the virtues, but that the majority of both virtues and vices are feminine nouns in Middle High German. However, a significant number of terms are masculine and some virtues and vices, such as *gelust, gewalt,* and *ubermůt* (lust, violence, and arrogance) may take either the masculine or feminine grammatical gender.[29] Indeed grammatical gender was not as fixed in Middle High German as it is in modern German. Many of the feminine vices have the suffix -heit or -keit, which marks them as abstract feminine nouns, but there is no systematic attempt to add these or any other feminizing suffix to all of the virtues and vices.

Table 1. Personified Virtues and Vices Sorted by Grammatical Gender

Virtues	Vices
Feminine	**Feminine**
chastity (*chiusche*)	avarice/enmity (*erge*)
constancy (*stete*)	betrayal (*trougenheit*)
courtliness (*hofscheit*)	blame (*schulde*)
diligence (*unmuozze*)*	contempt/insult (*smacheit*)
faithfulness (*triuwe*)	cowardice (*zagheit*)
generosity (*milte*)	delusion (*truogenheit*)
gentleness (*senfte*)	dishonor (*unere*)
good conduct/good breeding (*zuht*)	drunkenness (*trunchenheit*)
goodness/skill/righteousness	faithlessness (*untriuwe*)
(*frumcheit*)	foolishness (*torscheit*)
honor/respect (*ere*)	glory/arrogance/pride (*herrschaft*)
humility (*diumuot*)	gluttony (*lecherheit*)
moderation (*maze*)	greed/desire (*girde*)
prudence/understanding	greed/desire/avarice (*girischeit*)
(*bescheidenheit*)	idleness (*muozze*)
security (*sicherheid*)	immoderation (*unmaze*)
truth (*warheid*)	inconstancy (*unsteticheit*)
virtue (*tugent*)	joylessness (*unfreude*)
	lechery/promiscuity/unchastity
	(*unchiusche*)
	lying (*luoge*)
	misfortune/unhappiness (*unselde*)
	power (*macht*)
	perjury (*meineid*)
	restlessness (*unmuozze*)*
	sloth/laziness (*tracheit*)
	sorrow (*unfroude*)
	treachery/wickedness (*boesheit*)
	vanity (*uppicheit*)
	vice (*untugend*)
Masculine	**Masculine**
good sense/understanding/discernment	anger (*zorn*)
(*sin*)	boasting (*ruom*)
	fame/status/reputation (*name*)
	foolishness/lack of good sense/poor
	judgment (*unsin*)
	hatred/contempt (*neit*)
	idle thought (*ungedanch*)
	mockery/scorn (*spot*)
	theft/rape (*roup*)
	usury (*wuocher*)
	wealth/power (*richtum*)

Table 1. Personified Virtues and Vices Sorted by Grammatical Gender (*cont.*)

Virtues	Vices
Neuter	**Neuter**
n/a	treachery/wickedness (*unguote*)
	misfortune (*unheil*)
	sorrow/pain/suffering (*leit*)
Mixed	**Mixed**
fear (*vorcht* [m/f])*	fear (*vorcht* [m/f])*
justice/law (*recht* [m/f/n])	inconstancy (*unstete* [m/f/n])
nobility (*adel* [m/n])*	injustice (*unreht* [m/f/n])
	lust/desire (*gelust* [m/f])
	nobility (*adel* [m/n])*
	pride/arrogance (*ubermuot* [m/f])
	violence (*gewalt* [m/f])
	whoring/whoremongering
	(*hurgelust* [m/f])

Note 1: The orthography is inconsistent in the Gotha manuscript. In this table I have resolved all diphthongs and normalized the spelling for easier recognition. The translations correspond to the context provided by the Gotha text and images. Where the manuscript offers different forms of the vice I have selected only one for inclusion in the table (e.g., *unsteticheit* and *unstete* are both used for inconstancy, but I have only included *unsteticheit* here).

Note 2: Asterisks are placed next to the terms *unmuozze, vorcht,* and *adel,* which appear as both virtues and vices in the illustrations, depending on context. While the poem tells us that the "six qualities" of "wealth" (*richtuom*), "glory" (*herrschaft*), "power" (*macht*), "fame" (*name*), "nobility" (*adel*), and "desire" (*gelust*) can all be either positive or negative depending on whether one is able to control them, they appear in the image cycle only as vices.

The use of masculine and feminine terms would allow an artist concerned with following the grammatical gender in the visual representation to depict male and female figures interacting.

The grammatical gender of the Middle High German vices and virtues does not as a rule correspond to female- or male-gendered qualities as described in the poem. For example, generosity (*milte*) which, according to Thomasin, suits knights better than ladies, is grammatically feminine and personified as a lady in the poem and the image cycle. Similarly, infidelity or deceit (*falsch*) is worse for ladies, but the vice is grammatically masculine. Thus we can see that the artists develop their

own iconographic language of gender in which male and female figures are equal actors and participate in all forms of virtuous and unvirtuous behavior.

In the visual program of the early manuscripts (Heidelberg Cpg 389, Stuttgart Cod. poet. et phil. 2° 1, and Gotha Memb. I 120) the bodies of male and female figures are not distinguished from one another anatomically, but gender is indicated by the length of clothing and hairstyle. In Heidelberg Cpg 389 the artists have contrasted long hair and long gowns with shorter hair and shorter attire to distinguish female from male figures. For example, in the representation of a young lady torn between a good and bad counselor we can identify the young lady in the middle only by her long dress that gathers in folds at the bottom, and her long hair (fol. 13r). By contrast shorter tunics and hair that is cut just above the shoulders identify her advisors as male. In the same image in the Gotha manuscript the lady's dress and hair similarly identify the figures as female and male (fig. 10).[30] But these contrasts are not always drawn so clearly, and, as we will see below, in several instances it is impossible to determine whether we are dealing with male or female personifications. In the later manuscripts, male and female figures are always distinguished from one another anatomically—female figures are endowed with large breasts and small waists—and clothing and hairstyle is gender-specific. The style of illustration in the later manuscripts thus makes it easier to identify the gender of the personifications.

FROM INSCRIPTION TO IMAGE:
GENDER DISCREPANCY IN HEIDELBERG CPG 389

The artists of Heidelberg Cpg 389 personify the virtues and vices most consistently according to grammatical gender. The few cases in which the personified figure does not correspond to its grammatical gender, however, are significant for identifying competing criteria in the images' design.[31] The exceptions may be explained by aesthetic issues, influence from other iconographic traditions, or cultural stereotypes.

The representation of Drunkenness (*trunkenheit*) as a male figure in Heidelberg Cpg 389 (fol. 195v), despite its female grammatical gender,

suggests a cultural stereotype about male drinking. In the image, which warns people not to cast aspersions about others without being fully aware of their own vices, Anger (*zorn*), Drunkenness (*trunchenheit*), and Lechery (*vnchewsse*) accompany a man who criticizes another (*Der hohfertige man*) for his pride (*wi hohfertig der ist*). In a different section of the poem that deals explicitly with drunkenness, Thomasin warns young men not to drink too much without extending the same warning to ladies. Indeed the association of drunkenness with men is fairly typical in medieval literature and is clearly a thirteenth-century cultural stereotype of male behavior. Perhaps the artist who designed this image also considered men to be more susceptible to the vice of drunkenness than women and therefore depicted it not according to its grammatical gender but according to his gendered association with the vice. This image thus conflates allegory and mimesis and suggests that, at times, the Heidelberg illustrators were thinking in social rather than allegorical terms. Interestingly, in the same image in the Gotha redaction, Drunkenness is female (fig. 72). This artist thus appears to be following grammatical gender in his personification of the vice.

Similarly, the grammatically feminine vice of Sloth or Laziness (*tracheit*) is consistently personified as male in the three instances in which it occurs in the Heidelberg redaction. It appears twice in part 1, where it illustrates the danger of laziness for children (fols. 3v, 17r). The male personification of laziness may have allowed the viewer to identify it with other representations of children in this image cycle. Throughout the image cycle in Heidelberg Cpg 389, the child (*daz kint*) is consistently portrayed as male. Even in an illustration depicting a lady's circle of life from child to young lady to old woman, the child stage is represented by a male (or gender neutral) figure with short hair and a knee-length robe (fol. 24v). However, as with drunkenness, the artist may simply have associated the vice of laziness more closely with men. Whatever the reason, these images show that even in Heidelberg Cpg 389 the grammatical gender does not always determine the gender of the personification. Laziness is personified as a male figure a third time as part of the chain of vices, in which all fourteen vices are portrayed as male, although nine of them take the feminine grammatical gender (fol. 66r; compare the image in Gotha Memb. I 120, fig. 44, ill. 69).

In another image, the vice "Idle Thought" (*vngedanch*) is grammatically masculine but personified as female (fol. 121v). The text tells us that an idle man will have impure thoughts that will leave him restless and disquieted. In the image, the "Idle Man" (*mv̊zige man*) is confronted by the female personification of Idle Thought who brings him "Idleness" (*mv̊ze*) and "Restlessness" (*unmv́ze*). Since this image addresses the fact that men who have too much time on their hands will have idle thoughts, it is not surprising that these thoughts would be most easily visualized in the figure of a woman. This image thus relies on the viewer making associations between socially constructed notions of gender and the personification.

Finally, one of the personified figures that consistently conflicts with its grammatical gender in Heidelberg Cpg 389 is the figure of Treachery (*bosheit*). Treachery appears six times in the visual program, but it is personified as a female figure only once, namely, in the opening image of the visual program, which illustrates the prologue (fol. 78). The figure stands on the far left of a group of five figures next to a figure labeled "scoundrel" (*bosvaht*). In the center an unlabeled figure generally identified as the narrator stands pointing toward the figures on either side of him.[32] On the right a second figure labeled "Treachery" (*bosheit*), depicted as a small demonic-looking male figure with spiked hair, a long pointed nose, and protruding lips, lies beneath the feet of the "righteous man" (*der frum man*). In the other four images in which Treachery appears, the vice is consistently represented by this demonic figure. It seems unlikely, however, that men were considered more susceptible than women to the vice of treachery. It is more likely that the representation of the vice as male points to the existence of a convenient and conventional iconographic model that the artists decided to adapt to their purposes.[33] The male figure of Treachery is similar in appearance to contemporary figures of heathen idols, devils, and other treacherous creatures that are often portrayed in religious imagery.[34] As we have seen in chapter 2, this is not the only image in which the artists of the Heidelberg redaction drew on religious iconography that was already well known to their medieval audience.[35] The fact that the figure is also personified both as male and as female, that is, in accordance with its grammatical gender, in this image, however, suggests that there

is some tension in the manuscript between grammatical gender and other criteria in the selection of gender for personification.

In the final and strangest exception to the grammatical gender rule in the Heidelberg manuscript, a figure labeled "the righteous man" (*Der vrum man*) appears to be female (fol. 99r, compare fig. 57). The length of the Righteous Man's tunic is consistent with the other male figures, but the long hair cascading over the figure's shoulder corresponds to the hairstyle of female figures. Since there is no difference in physiognomy and no anatomical difference apparent in the illustrations, one may reasonably assume that the illustrator made a mistake when he drew this figure's hair.

The examples that I have discussed here are the only examples in which the grammatical gender of a personified vice or virtue does not correspond to the gender of its personification in the image cycle in the 1256 Heidelberg redaction. That is, only a handful of over one hundred and twenty labeled allegorical figures do not correspond to their grammatical gender. In the majority of the personifications in Heidelberg Cpg 389, therefore, grammatical gender clearly plays a defining role in the selection of the personification's gender. The exceptions, however, suggest that some competing notions of gender play a role even in this manuscript. Interestingly, in all of the exceptions except one—the Righteous Man—vices with the female grammatical gender have been personified as male. This is significant for three reasons. First, the tendency toward male personification contrasts with the more familiar (Latin) convention of female personification. Second, this rendering balances out the Middle High German catalogue of virtues and vices, which is heavily weighted toward the feminine grammatical gender. Finally, the representation of male personifications in these illustrations contributes to creating an image cycle in which there is more interaction between the genders than there would otherwise be if the artist had been consistent about following grammatical gender.

CONSTRUCTING GENDER IN GOTHA MEMB. I 120

In the Gotha manuscript, the artist addresses gender explicitly by framing the image cycle using large-format illustrations that emphasize the

gendered norms of an idealized courtly society. Before turning to these large-format illustrations, however, I will first compare the inconsistencies in grammatical gender and the gender of the personifications in the central image cycle with those in the Heidelberg manuscript.

In Gotha Memb. I 120 there are more frequent inconsistencies between grammatical gender and the personifications' gender, which indicates that the artists considered grammatical gender to be less important as a determining criterion in designing the visual program. Similar to Heidelberg Cpg 389, in the Gotha redaction, Treachery is personified as a male demonic figure in all four images in which it appears (fig. 3, ill. 2; fig. 4, ill. 5; fig. 40, ill. 63; fig. 57, ill. 84); Idle Thought is personified as female (fig. 65, ill. 93); and the Chain of Vices is comprised of male personifications (fig. 44, ill. 69). Other examples that are particular to the Gotha manuscript in which the gender of the personifications does not correspond to the grammatical gender include the male figures "Blame" (*schulde*) and "Wickedness" (*vngv̂te*) (fig. 48). Grammatically feminine "Joylessness" (*vnfroude*) and "Unhappiness" (*vnselde*) are also personified as male (fig. 49). Finally, the personifications of Courtliness, Justice, and Nobility are all male, despite the female grammatical gender of Courtliness (fig. 41, ill. 64). In the corresponding image in Heidelberg Cpg 389, by contrast, Justice and Nobility are portrayed as courtly men, while the grammatically feminine Courtliness is identified as female by her long hair (fol. 62r). As in the Heidelberg manuscript, the artist of the visual program in the Gotha manuscript has included one rather strange discrepancy that may be attributed to error. In figure 3, illustration 2, the Righteous Man is portrayed as female.

These inconsistencies aside, the entire question of gendered representation in Gotha Memb. I 120 is problematic because it is not always possible to tell whether we are dealing with male or female personifications.[36] As mentioned above, gender is generally identified by the length of hair and clothing. Ladies have long hair that cascades over their shoulders; men's hair is shoulder-length. Ladies' gowns reach their ankles or cover their feet, while men's robes may vary from knee to ankle-length. Gender is occasionally marked by facial hair, as in the Wise Man (e.g., fig. 8, ill. 10) or by a headdress, such as the wimple worn by Avarice (e.g., fig. 6, ill. 7). But in several images it is impossible to determine whether we are looking at male or female figures.

In one image of what appears to be a pair of lovers, for example, it is unclear which partner is male and which is female, or whether the image depicts two figures of the same sex kissing (fig. 31, ill. 49). The image illustrates that good sense is paired with honor, while foolishness accompanies dishonor. In the image, Good Sense and Honor appear on the left, while the Dishonorable Man embraces Dishonor on the right. The hair and clothing of the two figures on the right are almost identical. According to the labels, the figure inscribed with "the Dishonorable Man" must be male, and "Dishonor" female, but the iconography does not support this gender distinction. Because, as we have seen, grammatical gender is not a clear indicator of a personification's gender, we are left with some uncertainty. In the same image in Heidelberg Cpg 389, by contrast, all four figures are clearly gendered: the illustration depicts two male-female pairs of lovers (fol. 50r).

Similarly in the image of the Idle Man troubled by Idle Thought discussed above, the Gotha artist has not clearly marked the gender of Idleness and Restlessness (fig. 65, ill. 93). Both figures' feet are visible, but their robes are fairly long. They have shoulder-length hair, similar in style to Idle Thought, but not quite as long. By contrast, the gender of these figures in Heidelberg Cpg 389 is much more clearly marked.[37] Several additional figures in the Gotha manuscript are not clearly gendered.[38]

Despite the variation and occasional ambiguity of gender in the visual program, the total number of male and female courtly figures and the total number of male and female virtues and vices in the Heidelberg and Gotha redactions does not vary significantly. Nor can one identify a tendency to feminize or masculinize the vices or virtues in any systematic manner over the course of the poem's transmission. In later manuscripts any correlation between the grammatical gender and the gender of the personifications seems coincidental. Consistent however, is the artists' portrayal of male and female characters interacting. Many of the images depict both male and female characters, suggesting that none of the artists conceived of separate gendered spheres but instead imagined these models of behavior to be pertinent to both men and women and in their interaction with one another. The fluidity of gender and the representation of male and female actors raise the question to what extent clearly defined gender roles are really a constituent part of the elite identity constructed in the different redactions.

DOES GENDER MATTER?

In the Gotha manuscript, the flexibility in the representation of grammatical and social gender and the sometimes ambiguous portrayal of figures suggest that the artist was not particularly attentive to language, nor did he come up with a systematic and clear alternative to the grammatical gender model. Indeed, as we saw above, in several of the images he did not emphasize gender difference at all. This supports recent work that suggests that gender may not have been a primary constituent of courtly identity, which may have been based on estate and elitism rather than sex.[39] James Schultz has pointed out that, whereas one often cannot distinguish between descriptions of male and female bodies in the medieval German epic romance, noble bodies are always distinguished from nonnoble bodies: noble bodies are instantly recognizable and are desirable regardless of gender. Schultz argues that courtly bodies are gendered through descriptions of clothing and hair but they are not sexed—that is, male and female bodies are not described as anatomically distinct.[40] Medieval desire, according to Schultz, is not based on a cross-sexual relationship but on the recognition of nobility, and the characteristics of nobility are the same for male and female bodies: pale skin, rosy cheeks, red lips, and so on. Class, he concludes, is thus a more important category for courtly identity than gender. While I concur that in literary texts courtly love is often an expression of aristophilia and appears to have little to do with sexual desire, the *Welscher Gast* shows that gender is nonetheless an important constituent of courtly identity. As we have seen, the poem is quite explicit about the importance of gendered behavior for achieving the courtly ideal it proposes. The Gotha redaction's large-format illustrations of courtly ritual that frame the text underscore the importance of gendered behavior within the context of an idealized aristocratic society.

Three large format illustrations that do not appear in Heidelberg Cpg 389 but are added to the image cycle by 1340—that is, by the time the Gotha redaction is compiled—and that frame the entire poem indicate that, in fact, the artist who created this manuscript thought distinct gender roles were crucial to his conception of courtly society. The first, an image in which virtues and vices are personified as knights, appears after the prologue and before part 1 (fig. 2). The second, an image

in which virtues are personified as courtly ladies, appears at the end of the text, and is immediately followed by an illustration of male and female personified vices holding hands and dancing around Vice who leads them on what appears to be a shawm, a musical instrument (figs. 75–76). The two large format images of knights and ladies additionally provide a response to the flexibility and fluidity of gender in the central cycle. These images indicate that the fight against vice is of importance for both men and ladies of the court, but they also make it clear that gender matters.

The two large-format illustrations that appear at the beginning and the end of the poem depict personifications of the four virtues central to courtly culture: Constancy, Moderation, Justice, and Generosity. In the first, the virtues appear as knights first paying homage to their liege lady and then fighting their corresponding vices in single combat. In the second illustration, the virtues appear as courtly ladies paying homage to Lady Virtue. Weapons lie at their feet as if the ladies had just returned from battle. In a series of four miniatures these virtues are subsequently depicted enthroned and being served by other female virtues. In contrast to the knights, who are not even provided with base lines, the ladies are closely confined within yellow frames.

The first miniature of the virtuous ladies thus mirrors the first register in the image of the knights—the same four virtues are personified, the figures are depicted in the service of Lady Virtue, and the weapons and armor point to the battle against the vices. The parallels between the two images raise the question whether these are one and the same figures. Perhaps the knights in the first image are in fact armed ladies who abandon their weapons in the second set of images. We recall that the representation of the struggle between virtues and vices as a war of women had a long tradition already in the fourteenth century.[41] Indeed, as discussed above, it is rather unusual that the virtues and vices are personified as men at all. But if the figures in the image of the knights are supposed to be female, then it is strange that they are not clearly marked as such.[42] Instead they bear all the markings of male figures, particularly in contrast to their liege lady: they are wearing conventional armor and have shoulder-length hair. The fact that the patterns on the knights' shields are different from those on the ladies' shields fur-

ther suggests that we are dealing with two differently gendered sets of personifications of the same virtues.

Nonetheless, the ladies in the second series of images are also shown with armor and weapons, which suggests that they, like the men, were engaged in battle against the vices. In the iconographic model provided by Prudentius, and probably familiar to the *Welscher Gast* artist, the female virtues and vices are armed and fighting.[43] In this illustration, however, the ladies have removed their armor and no longer bear traces of the battle. Instead they appear dressed in long, brightly colored gowns demurely performing domestic duties in the enclosed space of the court.

There are many examples of warrior women in medieval German literature, but one literary example in particular may help us to interpret this visual narrative in which the ladies' feminine courtly appearance is juxtaposed with weapons of war.[44] Wolfram von Eschenbach's heroic epic *Willehalm* (1215) offers us a particularly illuminating parallel to this illustration. Willehalm leaves his wife, Gyburg, to defend the stronghold of Orange while he rides to the city of Orleans in the attempt to win support in his war against the heathens. Left with her ladies-in-waiting and a few old men, Gyburg *[gebârt] manlich, ninder als ein wîp* (behaves in a manly way, not at all like a woman, 226,30–227,1)[45]: she orders her ladies to dress in armor and defend the besieged fortress of Orange. The ladies succeed, but the poet is very careful to reestablish conventional gender roles once the danger has passed and the fortress has been defended. When Willehalm returns to Orange and tells Gyburg about the troops that he was able to win in Orleans, Gyburg orders her ladies to erase all traces of rust and dirt from themselves, to remain silent about all of the difficulties that they suffered over the past days and weeks, to dress in their most beautiful clothing, to welcome the arriving knights, and to entertain them in a feminine manner with pretty conversation (247,1–248,8). Although Gyburg was able to transgress gender boundaries momentarily, she emphatically reestablishes gendered social norms in her preparations for the arriving knights.

Similarly in the *Welscher Gast,* the ladies at court are to be seen neither fighting nor wearing armor. Rather than portray *manlîchiu wîp* (manly women)[46] in the manner of the Prudentius illustrations, this image reestablishes any gendered social norms that may have been

placed into question by the fluidity of gender in the rest of the visual program. The ladies in the *Welscher Gast* have put down their armor and emphatically and redundantly perform the duty of serving food, which in this manuscript is represented as a female-gendered activity. The large format of these two illustrations, their prominent placement at the beginning and end of the text, and the fact that the same virtues appear in both suggest that these images and the figures' contrasting models of courtly behavior were intended to be compared and contrasted. The male figures are shown taking orders from their liege lady and fighting for her; the ladies are shown participating in a feast and serving food. These images of knights and ladies thus create a normative gendered context for all of the other images in the Gotha manuscript. Framing the poem as they do, these distinct gendered spheres of interaction are portrayed as constitutive of elite identity as it is imagined in the Gotha manuscript. These images indicate that the fight against vice is of importance for both men and ladies of the court, but they also make it clear that gender matters.

With regard to gender and sexuality, the illustration of the vices' dance provides an important contrast to the other two large-format illustrations. Dancing was an integral part of courtly life and, although detailed descriptions of courtly dance are rare, it is frequently mentioned in the courtly romance.[47] In the description of Arthur's court at the beginning of Hartmann von Aue's *Iwein*, for example, dancing is listed among the pastimes that Arthur's courtiers enjoyed on Pentecost after the feast (lines 62–72). These courtly pleasures, including conversing with ladies, archery, races, and listening to music, as well as dancing, underscore the exemplariness of Arthur's court. In the Gotha image cycle of the *Welscher Gast*, the figures' dance and their costly and colorful attire similarly highlight the emphasis on courtliness in this redaction.

The intermingling of male and female courtiers, however, represents an antithesis to the gendered, but not sexualized, behavior illustrated in the other two large-format images. Whereas these illustrations depicted the segregation of the sexes and specifically gendered roles, the dance portrays a sphere of interaction that was generally coded as sexual in medieval literature. Medieval dance scenes typically depict circles of dancing ladies or maidens, or male-female couples. All of the ver-

sions of this image in the *Welscher Gast* manuscripts combine male and female figures. In the Gotha manuscript the artist has made an attempt to alternate male and female dancers. While this has not been done entirely consistently, the artist did draw eight male and eight female figures, and most of them are flanked by at least one member of the opposite sex. This alternation of male and female dancers seems to be an innovation in the Gotha manuscript. The earlier Stuttgart fragment also contains this image, but it depicts only two female figures (Usury and Lying) dancing with fourteen male vices. In the two fifteenth-century manuscripts in which this image appears, the Heidelberg Cpg 320 and Wolfenbüttel redactions, more of the vices are personified as female than male. In Heidelberg Cpg 320, for example, all of the dancing vices except Lying and Anger are female. This variation indicates that the artists did not feel bound by the vices' grammatical gender but instead decided themselves how they would depict the dance. The alternating male and female dancers in the Gotha manuscript present the dance as it most commonly appears in courtly literature, thus suggesting that this artist was considering literary representations of dance as his model.[48] The presence of two naked figures, Vice and Boasting, that contrast starkly with the vividly attired remainder of the figures remind the viewer, however, that we are looking at vices rather than models of courtly behavior, and underscore the sexual reading of the image.

Indeed both the nakedness and the clothing depicted in the Gotha image of the dancing vices are signals of the vices' depravity. The vices' clothing, while costly in style and color, contrasts with that of the virtuous ladies in its design. Whereas both groups of figures wear bright colors, the virtuous ladies' clothing is monochrome. The vices, by contrast, wear stripes and checks, exclusive designs that moralists considered to be subversive and a sinful display of decadence.[49] This patterned clothing additionally sexualizes the dancers.[50]

The Gotha redaction, therefore, on the one hand shows a complex and heterogeneous understanding of gender, in which gender is not a fixed but rather a flexible category, and in which ambiguity is possible.[51] But, on the other, this heterogeneous representation of gender in the central image cycle is not allowed to stand on its own. Instead, it is framed and contextualized by these large-format images that anchor

the representation of male and female figures in idealized and gendered courtly norms. Any questions that might arise from the fluidity of gender in the image cycle are countered by this visual frame that allows no transgression of gender boundaries and no ambiguity about the role of men and ladies at court. Furthermore, these images support the argument that I made in the previous chapter about the image cycle demonstrating a process of secularization and a developing interest in narrative. These illustrations place the virtues in a secular narrative by representing them fighting, paying homage to their liege lady, and participating in a celebration.

Normative gender roles enacted within a secular context are further established in the Gotha illustration of the seven liberal arts, in which the arts are reinterpreted as courtly ladies, and their representative practitioners are portrayed as if in the ladies' service. The illustration is thus not only redesigned to depict a courtly ideal but also reinforces the traditional gender roles within that ideal.

THE SEVEN LIBERAL ARTS AS A MODEL
OF COURTLY GENDER ROLES

Part 7 of the poem deals with education and includes an explanation of the liberal arts and their relation to the body and the soul.[52] In the Middle Ages, the arts were typically conceived as "propaedeutic or preliminary to the study of scripture and theology."[53] For Thomasin they are directly connected to the virtues, which are "agents of the soul." The arts are not personified extensively in the poem. In the image cycle, however, they are portrayed in a series of complex individual miniatures in which a representative authority and instrument appear with each personified art. The gender of the personifications varies depending on the redaction, and the relationship between the two figures in each miniature also differs, suggesting that most of the artists considered these illustrations not only to be allegorical images of feminized abstract concepts but also representations of men and women.

In each miniature in the series, the Art and its representative hold an attribute between them (fig. 68).[54] The trivium precedes the quad-

rivium: Priscian and Grammar hold open a book to the first sentence of the *Institutiones*; Aristotle and Dialectic hold a square of opposition; Cicero and Rhetoric hold a sword and shield; Euclid and Geometry hold a figure of the first proposition from the *Elementa*; Pythagoras and Arithmetic hold a triangular chart of proportions; Milesius and Music hold a figure of perfect consonances; Ptolemy and Astronomy hold an astrolabe.[55] These attributes, as Michael Evans has pointed out, are "unconventional and peculiar to this text."[56]

The images are highly complex and function on a number of different levels. On the one hand, as Michael Stolz has argued, these images draw on scholarly discourses and would not have been accessible in their full complexity to a lay audience without substantial explanation.[57] First, the format of the images follows the model of the medieval arts of memory; these images were designed as mnemonic aids.[58] Second, a lay audience would not have been able to decipher the Latin inscriptions that appear in each of the miniatures. Third, some of the attributes and instruments used in the instruction of the arts would have been unfamiliar to a lay audience. Fourth, the authoritative scholars from antiquity would probably not have been familiar to a lay audience. Fifth, a lay audience may not have been able to comprehend the significance of the combination of allegorical and historical personages. Finally, the images present a very different perspective to the text. In the poem, Thomasin reinterprets and radically simplifies the arts for a lay audience.[59] Far from visualizing the arts in a basic and simplified manner that would have been accessible to Thomasin's target audience of courtiers, however, these images are layered with learned references that would require explication.

Yet while a learned viewer could interpret these images as allegorical representations of the arts, a less educated viewer might see in them courtly men and ladies interacting. As Elizabeth Sears has pointed out, "it is essential to remain alert to the effect that such factors as religious affiliation, education, gender, class, and ethnicity might have had on the reception of images, [and to] pay particular attention to the specific physical context in which a work functioned—who had access to it and what social and religious practices governed its use. Images and objects are seen to open themselves up, at all times, to multiple readings that are

not mutually exclusive."[60] The illustrations of the seven liberal arts indeed make use of an iconographic language that functions on different levels and that, on one level, would be readily accessible to an uneducated audience.

In the Heidelberg redaction, Grammar and Priscian are given special status by their larger size, their boldly colored frame, and their placement separate from the rest of the Arts on the left side of the page (fig. 85). The remaining Arts appear in a series of framed miniatures that appear in a column on the right side of the facing page. The variation between the Heidelberg and Gotha redactions is minor but significant both with respect to the specific emphasis on courtly motifs in the Gotha codex that I discuss in detail in chapter 4, and to my argument that the Gotha redactor was interested in gendered norms of an idealized courtly society. Whereas in Heidelberg Cpg 389 the image of Priscian and Grammar is separate from the others and distinguished by its more elaborate frame, in the Gotha redaction, the image of Priscian and Grammar is incorporated into the series of framed miniatures, so that all seven of the liberal arts are represented similarly, in the space ruled for the text columns (fig. 68). In contrast to the Heidelberg redaction, the Arts in the Gotha manuscript are consistently enthroned. In the first image Priscian is also seated on a throne across from Grammar, but in the remaining images the proponents of the arts stand with bent knees before the seated personified Arts. This motif of a male figure appearing before an enthroned lady, which is reproduced seven times in the Gotha manuscript, suggests the courtly idea and familiar image of a courtier or knight in service to his lady.[61] The bent-kneed posture of the male figures (with the exception of Priscian) supports the notion that the men are in servitude to the ladies. While in the corresponding illustration in Heidelberg Cpg 389 three of the female Arts are seated, the remaining ones appear to be kneeling or crouching in postures similar to the practitioners. The hierarchical and courtly relationship between the male and female figures depicted in the Gotha illustration is thus missing from the older manuscript redaction.

The representation of the liberal arts in the Gotha manuscript should thus not be discounted as "mere" allegorical representation, or as too complex for a lay viewer to comprehend. Instead, the artist has

created an illustration that reads on multiple levels. These figures participate in a gender discourse, and they also underline the courtly gender roles that are established in the other large-format illustrations in the Gotha manuscript. In the Gotha redaction we thus see an attempt to negotiate between language, allegory, courtly ideal, and gender within a single image.

The Wolfenbüttel redaction provides us with a useful contrast to the Gotha manuscript. In it Priscian and Grammar are also separated from the other arts; they are unframed and seated on thrones on a grassy area (fig. 94). An entire page is devoted to the remaining six arts, which are framed (fig. 95). The order of the figures has changed slightly, the older manuscripts depicted the trivium followed by the quadrivium, but in the Wolfenbüttel redaction, Geometry has been moved to the top of the column on the left. The figures hold variations of the same objects and instruments, and the Latin inscriptions vary only slightly. The most obvious change, and the one of interest here, is the shift in gender. All but one of the Arts is male (Arithmetic). In fact, one of the most fluid elements of the illustration of the seven liberal arts throughout the transmission of the *Welscher Gast* image cycle is the figures' gender. In Heidelberg Cpg 389 (fig. 85), Gotha Memb. I 120 (fig. 68), Heidelberg Cpg 330 (1420, fol. 67v), and Dresden M 67 (1450–70, fol. 65v–66r), a manuscript that is closely based on Heidelberg Cpg 389, the seven liberal arts are female. In Heidelberg Cpg 320 (1460–70, fol. 67v), as in the Wolfenbüttel redaction (figs. 94–95), all of the Arts are male except Arithmetic.[62]

Representations of the liberal arts as men are unusual but not unknown. Although he does not mention the Wolfenbüttel or Heidelberg Cpg 320 manuscripts of the *Welscher Gast*, Michael Evans has identified several cycles of the liberal arts in which male figures are used to represent the arts.[63] Evans suggests that male personifications of the arts may have come about through association with the male proponents of the disciplines that were often incorporated into the images. Whereas female representatives of the arts are thus, according to Evans, always allegorical, male figures are usually practitioners of the discipline. Following this line of reasoning, in the Wolfenbüttel and Heidelberg Cpg 320 manuscripts, the miniatures depict men teaching male students or men

engaged in scientific debate. In the fifteenth century, when these images were produced, the seven liberal arts were in fact typically the domain of male scholars and students.[64] The Wolfenbüttel and Heidelberg Cpg 320 artists thus reconceived these allegorical images of the arts as more "realistic" scenes of scholarly activity.[65]

There are several instances in the Wolfenbüttel redaction in which the personifications' genders appear to be determined by social categories and stereotypes. This was also the case in the Gotha manuscript, but in the Wolfenbüttel redaction we find a new version of this trend. For example, whereas in the Gotha manuscript the large-format frontispiece illustration of the knights represents the courtly ideal of knights serving their lady, the same image in the Wolfenbüttel manuscript suggests the social norm of knights serving a lord (fig. 87).[66] Similarly the *tv̊tsche zvnge* (the German language) was personified in Heidelberg Cpg 389 and Gotha Memb. I 120 as a female figure receiving a book entitled the *Welscher Gast* from a figure identified as a messenger (*der bote*) in the Heidelberg manuscript (fol. 2r), and as the author in the Gotha manuscript ("I wrote this" [*Tam effiticus*])[67] (fig. 3, ill. 3). In the Wolfenbüttel manuscript, however, the figure receiving the manuscript is reconceived as a male lord (fig. 86). Horst Wenzel sees in the male personification of this figure an effort to place the image in the iconographic tradition of the dedication image.[68] Michael Curschmann has criticized Wenzel's interpretation by pointing out that there were also women patrons of literature, and dedication images devoted to them. While this is undoubtedly correct, explicit references to male patrons are nonetheless more common in late medieval German literature, and although women were also important patrons of literature in the Middle Ages, the representation of the author or messenger delivering a book to a male patron is more stereotypical.[69] Moreover, Wenzel's reading of this image corresponds to the variation that we see in other illustrations, such as the seven liberal arts discussed above. Rather than an allegorical representation of the German language, this introductory image in the Wolfenbüttel manuscript has become a standard dedication image in which an author hands his book to his lord and patron. The fact that the figure is no longer labeled in the Wolfenbüttel redaction underlines the idea that the image is no longer conceived as allegorical.

In sum, the manuscript redactions of the *Welscher Gast* present us with competing ideas about gender that multiply once grammatical gender becomes less important for the selection of the personifications' gender. As we saw in the previous chapter, the illustrations in the later redactions often function by eliciting the viewer's personal identification with the figures portrayed. Instead of creating allegorical or mnemonic images that would require significant interpretive work by a viewer, or alienate or confuse him or her, the later artists, starting with the Gotha manuscript, portrayed dynamic scenes of fashionable and recognizable male and female figures interacting with one another.[70] These revised images invite the viewer to see his or her own elite culture, or at least a contemporary ideal elite culture, reflected in them. The Gotha manuscript is of particular interest because the artist appears to respond to the increasing fluidity of gender in the image cycle by redesigning and creating prominent illustrations that specifically address gender roles by visually affirming and prescribing gendered norms. These gendered norms, however, are those associated with courtly culture, and specifically courtly literature, an association that is important for the Gotha manuscript as a whole, as we will see in the next chapter.

Image and Elite Self-Fashioning in the Gotha Manuscript

For Thomasin, estate is God-given, but elite identity, which for him must have at its foundation the courtly virtues of constancy, justice, generosity, and moderation, is malleable and can be constructed. The self-fashioning of elite identity is an ongoing process of monitoring oneself and controlling one's behavior and desires. Thomasin tells us that being a good lord is hard work (3856; 3220) and that one must behave like a lord in order to be recognized as one:

> ob den herren geschiht
> ze varen in ein ander lant,
> da er lihte ist unerchant,
> ich sag iu daz da alo vil
> ůf in iemen ahten wil,
> als ůf einen der in dem lant
> ist ouch vil lihte unerchant.
> ia hat sa niht diu herschaft
> von ir selber so vil chraft,
> daz si uns zeige wer si der herre,
> er si uns nahen oder verre.

———

If a lord happens to travel to another land, where he is perhaps unknown, I tell you that there just as many will pay attention to

him as to any other person in that land who is unknown. Indeed, lordship does not have so much power in and of itself to reveal who is the lord, no matter whether he is close by or far away.

(3818–28; 3182–92)

One's identity as a lord is thus neither inherent nor universal. The illustrations indicate the pedagogical process by which the redactors of the different manuscripts expected their audience to use the *Welscher Gast* in the pursuit of this goal.

As we saw in chapters 1 and 2, the 1256 Heidelberg manuscript appears to have been created for contemplation in the pursuit of self-knowledge and self-improvement. This manuscript not only portrays an ideal version of the society for which it was created, but its images reflect on that society, creating opportunities for association and self-reflection. Its formatting encourages a process of reading excerpts, examining images, and thinking about connections both within the pages of the manuscript and to the external world. The figures portrayed in its images are bound to the language that they embody. Allegorical personifications closely align with their descriptions in the poem, providing mnemonic images to be inscribed in the mind's eye. Gender plays a role in that process: grammatically feminine concepts are translated (predominantly) into female figures, and grammatically masculine concepts into male figures, thus enabling easier recall of the virtues and vices, and specifically the Middle High German terms for them.

The Gotha manuscript functions rather differently. As I discussed in chapter 1, its formatting suggests that it was designed to be used as a reference book. From the prose foreword to the indexing to the illustrations, which are integrated into the columns of text, the manuscript is formatted and organized as a compendium of knowledge, a resource that may be used pragmatically and purposefully. Like the Heidelberg redaction, the images in the Gotha codex also draw associations to a visual language that exists outside the text, but, as we will see in this chapter, it is a language of courtly motifs that emphasize elite social status and nobility.

Indeed, as I argue, the Gotha images indicate that the manuscript's patron was concerned with constructing and affirming a particularly courtly identity and furthermore that the codex served as a vehicle for

his self-expression of that identity. The illustrations reframe the text to construct an ideal for noble behavior that is explicitly based on the literary courtly ideals, particularly love service. The insertion of this literary aesthetic of behavior and relationship belies the original intent of the conduct book, which is to eschew these models. This chapter focuses first on the representation of nobility and courtliness in the illustrations to make the case that this is a particular concern in the Gotha manuscript. Second, I place the manuscript in its likely historical context and hypothesize about why it may be formatted and illustrated in the manner it is. This chapter thus makes the case that the Gotha codex participates in a project of elite self-fashioning that is integral to its secular patron's social and political desires.

COURTLY IDENTITY AND THE *WELSCHER GAST*

As we recall, the *Welscher Gast* is a compendium of ethical, moral, social, and intellectual knowledge designed for an aristocratic lay audience.[1] But it is also a pragmatic and didactic manifestation of an ongoing discourse on courtly identity, which was primarily identified at the end of the twelfth and beginning of the thirteenth century by a particular standardized training in conduct, custom, and ethics.[2] Guiding and directing this standardization was a new ethic and ideal of aristocratic identity, rooted in Antiquity and continuing to be influential throughout the early modern period and beyond.[3] Courtly identity is perhaps most thoroughly explored in the thirteenth-century courtly romance, which abounds with descriptions of elite culture and its ceremony, clothing, education, courtship, military strategy and prowess, codes of chivalry, and so on.[4] While the concept of courtliness constructed in the Gotha manuscript is grounded in a social and educational ideal, its particular manifestation in the images invokes associations with literary motifs most prevalent in the medieval courtly romance.[5] In the context of the present study, the term "courtly" thus refers to an ideal image of elite society that is most highly developed in the literature of the twelfth and thirteenth centuries.[6] In the *Welscher Gast,* text and image mediate between this literary notion of courtliness and its social practice.

Thomasin places his poem in dialogue with courtly literature, but he has an ambivalent attitude toward it. On the one hand, he tells us that if someone is capable of higher understanding, then he or she should not waste time on courtly literature, which may contain good examples of proper behavior but is characterized by its lies (1725–46; 1113–34). On the other hand, in part 1 of the *Welscher Gast,* Thomasin refers explicitly to the heroes and heroines of courtly literature, inserting a catalogue of familiar characters and suggesting that they serve as positive role models for children and people of limited understanding, in other words, those unable to learn by reading.[7] This catalogue includes characters from historical epics based on material from antiquity (Andromache, Penelope, Oenone, and Alexander); Galliana and Karl from the epic material surrounding the figure of Charlemagne; and characters from the courtly romances (Enite, Sordamor, Blanscheflor, Gawein, Clies, Erec, Iwein, Tristan, Seigrimos, Kalogriant, and Parzival).[8] Keie and Helen of Troy are held up as negative examples.[9] Thomasin also refers to the figures of Gawein and Keie in the prologue when he introduces himself: "ich heiz Thomasin von Zerclære. / han ich Gaweins hulde wol, / von reht min Kaye spotten sol" (I am called Thomasin von Zerclaere. If I have Gawein's protection, then I don't care if Keie makes fun of me, 685–87; 75–76, 78).

Despite his condemnation of profane literature, therefore, which he refers to as mere *aventiure* (escapades), Thomasin engages with it and appropriates the heroes and heroines of this literature for his own purposes. Thomasin's reference to these heroes and heroines has inspired much scholarly discussion on the question of whether he thought that his audience should understand vernacular literature in allegorical terms, and whether this positive representation of what was commonly regarded as lies by the clerics and theologians truly represented a compromise between church doctrine and lay practice.[10] This *integumentum* debate does not concern me here. For the purposes of this study, my point is that Thomasin recognizes and engages with courtly culture, but also distances himself from it. Most importantly, his approach to courtly literature serves as a point of contrast to the Gotha codex. The Gotha redactor also placed his version of the poem in dialogue with courtly literature, but he does so in a manner that is significantly different from the poem's author.

The Gotha redaction of the image cycle suggests that courtly society was one worthy of emulation, and it directs the viewer's focus toward this profane model rather than away from it. While the Gotha artist did not depict Thomasin's catalogue of literary characters, he did portray knights, ladies, and courtly ritual, and in the dedication image he used profane iconographical motifs associated with courtly love. The Gotha redaction contains the most extensive image cycle of all the existing redactions.[11] Not including the dedication image, seven illustrations were added to the cycle sometime between the 1256 compilation of Heidelberg Cpg 389 and the 1340 Gotha redaction (figs. 2; 3, ill. 4; 38, ill. 59; 39, ill. 61; 57, ill. 83; 75; and 76, ill. 103 and ill. 104). Several of these images specifically emphasize the manuscript's interest in courtly ritual and thus support my argument that this redaction was conceived in the context of a process of elite and courtly self-fashioning. Two of these illustrations in particular highlight courtly rituals that are also central to the courtly romance: the tournament (fig. 2) and the feast (75 and 76, ill. 103). A third illustration in the Gotha manuscript depicts a circular dance (76, ill. 104). The artist also carefully distinguished aristocratic and courtly from noncourtly figures by using different physiognomy, hairstyle, and clothing. The Gotha redactor and probably also his patron thus do not appear to share the poet's ambivalent attitude toward secular courtly culture and its literary ideals but instead view this profane model as one that is worthy of admiration and emulation.

THE VISIBILITY OF ELITE IDENTITY

Central to the notion of courtly culture was the desire to socially and visually distinguish oneself from the nonaristocratic classes. Sartorial laws that forbade a person of noncourtly class from wearing bright colors, or indeed any color other than grey, were one manifestation of this desire to make class visible. The courtly romances for their part devote many lines to describing splendorous garments, feast halls, and food.[12] In the *Welscher Gast* too the illustrator has paid attention to clothing, signaling the aristocratic status of the figures by means of their colorful attire and style. In the Gotha image cycle, social status is always additionally indicated in the figures' facial features, body type, and hairstyle.[13] Indeed,

particularly in comparison with later redactions, there appears to be an interest in establishing visual markers of estate.

The poem does not discuss difference in physical appearance between members of the different estates, but it does emphasize the importance of self-representation for lords and ladies. Indeed, the entire treatise is concerned with differentiating noble from nonnoble society through social behavior, self-representation, ethics, and education.[14] Thomasin explains and emphasizes the importance of social stratification. He tells his audience that everyone was born into a particular position in society and should be satisfied with his or her role. As a practical guide to behaving in a manner appropriate to aristocratic court society, the treatise not only contains theoretical discussions of ethical behavior but analyzes real situations and relationships between different social levels even within the elite.[15] This concern with status and representation in the poem is made manifest in the illustrations of the Gotha manuscript. Only a few images portray noncourtly figures, and they are clearly differentiated from and juxtaposed to their aristocratic counterparts. One example of this juxtaposition is the image of the Wicked Man receiving Misery and Unhappiness for his violent treatment of a peasant (fig. 49). The peasant differs from the courtly figures in his attire, which consists only of a pair of loose breeches, and in his hair, which is short, dark, and straight. The aristocratic figures have shoulder-length wavy hair (often blond) throughout the visual program. Both Heidelberg Cpg 389 and Gotha Memb. I 120 use hairstyle and clothing style to distinguish the peasant in this image. In the Gotha manuscript the figure's lower status is additionally indicated by his smaller stature.

Other examples of non-courtly figures in the Gotha image cycle include the scoundrel (*boswiht*) who appears in two illustrations. In one, the figure is distinguished by his short dark hair, his representation in profile—which emphasizes his long pointed nose—and his smaller stature; in the other, he also has short, dark hair and bears a club (fig. 3, ill. 2; fig. 18, ill. 27). Similarly two illustrations depict poor men with short hair and unkempt beards wearing noncourtly attire, walking with bare feet, and carrying walking sticks (fig. 17; fig. 38, ill. 60). Beards are rare among the aristocratic figures in the Gotha codex

and are generally worn only by those specifically labeled as wise men. Noncourtly figures can thus be immediately identified, and their depiction underlines the homogeneous courtly aesthetic of their elite counterparts.

Of the seven illustrations that appear as part of the image cycle in the Gotha redaction but not in Heidelberg Cpg 389, five pay particular attention to identifying the figures' elite status through attire, hairstyle, and other motifs.[16] In one of these illustrations Diligence drives off Laziness (fig. 3, ill. 4). The two figures wear costly and socially exclusive clothing: Diligence has red hose, while Laziness wears a dramatically flowing cloak lined in yellow over a rich green tunic. The layering of different colors such as in the contrasting hues of Diligence's tunic and hose and Laziness's cloak are characteristic of noble attire.[17] Throughout the Gotha manuscript figures are portrayed wearing brilliantly colored attire in hues of yellow, red, blue, and green—colors associated with the aristocracy that identify the manuscript as a luxurious symbol of noble status.[18] Diligence and Laziness have wavy golden hair and are on horseback, seated in fine saddles. All of these details identify the figures as members of the nobility. In another illustration that appears in the Gotha cycle, but not in the earlier Heidelberg one, men who only do virtuous deeds because they are greedy for fame are juxtaposed with those who perform such deeds out of goodness and are content to go to heaven quietly (fig. 38, ill. 59). In this image too different social status is visually distinct. The virtuous poor on the right wear loose breeches and go barefoot; two of them are bearded. A virtuous lord also appears on the right. He is taller in stature and wears a fine green tunic with a broad decorative band around its hem. Over the tunic he wears a cloak fastened with a broach, and an elaborate hat used throughout the image cycle to indicate lordship status. On the left, the well-heeled knights ride their steeds to hell as the courtly musicians loudly sing their praises.

This interest in distinguishing between courtly and noncourtly figures in the Gotha manuscript is particularly apparent when we compare it to later manuscripts in which class difference is not so exaggerated.[19] In the Wolfenbüttel manuscript, for example, nonnoble figures are dressed simply or scantily, but they are not typically distinguished

from the figures surrounding them by physiognomy (such as promi-
nent noses or uneven or exaggerated features), stature, or hairstyle. In
the Wolfenbüttel version of the illustration discussed above of the vir-
tuous people about to enter heaven's gate, for example, we see four poor
people next to the lord (fig. 92, left column). The peasants have the
same hairstyles and facial features as the aristocratic figures in the
image cycle, but the men are dressed only in breeches while the single
female figure appears naked. Similarly in other illustrations of peasants
in the Wolfenbüttel redaction, such as the one in which a wealthy man
who is greedy for fame gives his cloak to a musician rather than to a
peasant who needs it more dearly, the peasant is portrayed with exactly
the same features as the wealthy man except for his clothing: he is cov-
ered only by a cloak (fig. 92, right column). Likewise, in an illustration
in which a treacherous lord directs his chamberlain to beat a peasant
who is asking for judgment, the peasant's only distinguishing features
are his simple shirt and a rather elaborate stick (fig. 88). Finally in the il-
lustration of the Wicked Man receiving Misery and Unhappiness, the
peasant, who appears on the left being abused by the wicked man is
smaller than the other figures and wears only breeches, but his hairstyle
and facial features are indistinguishable from those of the other figures
(fig. 93, bottom). Furthermore, the figure of the Scoundrel, who ap-
peared throughout the Gotha manuscript as a noncourtly figure, is re-
designed as a well-heeled courtier in the Wolfenbüttel manuscript
(fig. 86, left column). It is intriguing that the Wolfenbüttel artist distin-
guishes elite from nonelite status only by the amount of clothing the
figures wear, and not by the apparent quality of clothing nor by any
other physical characteristics. This notion that the amount of clothing
worn is the distinguishing feature in social rank suggests that the dom-
inant factor in the perception of social mobility underpinning the
Wolfenbüttel illustrations is financial wealth, since money could pur-
chase clothing. The physiognomic distinction, and the difference in
stature emphasized in the Gotha and Heidelberg redactions, by con-
trast, suggests that the notion of estate underlining these image cycles
was not limited to wealth but included other inalienable factors as well.
In the Gotha image cycle estate is conceived as a prominent, permanent,
and visible category.

COURTLY RITUAL:
THE TOURNAMENT, THE FEAST, AND THE DANCE

This emphasis on the visibility of elite status is compounded by the apparent interest in the Gotha image cycle in courtly rituals, such as knightly combat, feasting, dancing, and courtship, which were often portrayed in the visual arts in fairly standardized ways. The incorporation of these motifs into the visual program of the Gotha manuscript of this didactic poem suggests that these courtly motifs were conceived as models to be emulated by the manuscript's viewer.

These motifs are prominent in the additional illustrations that appear in the Gotha redaction but not in the 1256 Heidelberg codex, including the three large-format illustrations that frame the poem. These images were already discussed in the previous chapter in the context of their representation of gender roles. Here I reexamine them with regard to their emphasis on courtly ritual. The first illustration appears between the prose foreword and the beginning of the prologue and thus functions as the poem's frontispiece (fig. 2).[20] It depicts virtuous knights in battle against their nonvirtuous counterparts. In the top register on the left, an enthroned lady gives instruction to four knights standing before her ready for battle: "drive off the vices" (*Tribet vz die vntugende*). On the right, an enthroned lord similarly instructs four knights: "protect yourselves well against the virtues" (*Weret euch vaste der tůgende*). Their white blazons contrast in color with the black ones of the first group and indicate that the two groups of knights are opponents. Below, in a series of scenes of single combat, the virtuous lady's knights drive off the lord's knights with their long lances. The illustration thus depicts the familiar courtly motifs of vassals paying homage or receiving instruction from their liege lady (or lord) and of single combat between knightly opponents. It corresponds to the passage at the end of the prologue:

der bose man unde die bosheit
sulen hie werden so bereit,
daz si uz minem wælihischen gast,
vor den tugenden vlihen vast.

The vicious man and Treachery must be treated here in such a manner that they flee headlong from the virtues and out of my *Welscher Gast*.

(747–50)

These verses, like the image, are missing from the Heidelberg Cpg 389 redaction. The insertion of this illustration in the Gotha manuscript and its placement as a frontispiece to the poem suggest that the Gotha designer or his source elected to introduce the poem as a knightly quest to eradicate vice from court.

The labels inscribed above the enthroned figures and their knights, however, inform us that all of the figures are also allegorical personifications. Lady Virtue instructs the knights Constancy, Moderation, Justice, and Generosity, while Lord Vice commands Inconstancy, Immoderation, Injustice, and Avarice. For the cleric or educated viewer, the personification of the virtues as knights creates a bridge between secular and religious culture. Masculine dominance, demonstrative competence, and aggression are qualities not typically associated with clerics and educated men but with the secular courtly nobility, yet they are integrated here into the allegorical battle between the vices and virtues.[21] For a viewer able to read the vernacular, the allegorical meaning would also be revealed. For the illiterate viewer, however, the illustration suggests that this is a story about knightly prowess and feats of arms in the service of an overlord or lady. Although these personifications draw on a religious tradition, their iconography places them in a secular courtly context, and they may be "read" without recourse to allegory. The labels merely introduce an additional level of meaning for those able to read them.

Similarly the first large-format illustration that concludes the poem places personified virtues in a secular courtly context that emphasizes ritual and social hierarchy within the aristocratic society of the court (figs. 75 and 76, ill. 103). In the first of a series of five framed miniatures, Lady Virtue appears enthroned before four female subjects. Their labels identify them as Constancy, Justice, Moderation, and Generosity, the same virtues that are personified as knights in the first illustration. Weapons lying at the ladies' feet suggest that they have returned from a

battle against the vices. Here, however, they have victoriously discarded their weapons and armor and appear in vibrant courtly attire, participating in a celebratory feast. The four subsequent framed miniatures depict each of these virtuous ladies in turn being served by two ladies in waiting: Security and Truth serve Constancy; Good Breeding and Prudence serve Justice; Humility and Chastity serve Moderation; and Love and Fidelity serve Generosity,. As in the illustration of the virtuous knights, the artist has presented the virtuous ladies in the context of traditional courtly motifs: they wear fashionable attire and participate in the courtly ritual of the feast (rather than in single combat).

The large format of these two illustrations, their prominent placement at the beginning and end of the text, and the fact that the same virtues appear in both suggest that these images and the figures' models of behavior were intended to be compared and contrasted. Indeed, as I argued in chapter 3, they suggest a normative model of gendered courtly behavior. Here suffice it to say that the allegorical and representational levels of these two images function side by side. The labels place the poem in an allegorical tradition, but the iconography, which foregrounds elite secular ritual, frames the poem as a courtly enterprise and particularly emphasizes hierarchical aristocratic relationships.

The iconographic frame provided by these two large-format illustrations thus places the poem in the context of a notion of courtly culture that is characterized by its feudal structure, its fighting knights, its lovely ladies, its martial arts, and its feasts, a notion of courtly culture that is highly developed in medieval German literature around 1200. These illustrations further impose a narrative structure on the poem that corresponds to the narrative structure of many courtly romances, such as Hartmann von Aue's *Erec*, or Der Stricker's *Daniel von dem blühenden Tal*, in which the hero's quest and feats of arms culminate in a feast and a celebration.

An additional large-format illustration immediately follows the virtuous ladies and offers a slightly different perspective on profane courtly culture (fig. 76, ill. 104). It depicts male and female courtiers dancing together in a circle around the figure of Vice.[22] Here the accompaniment of the dance by what appears to be a shawm, a courtly instrument, and the costly clothing of the participants firmly places this dance in an

aristocratic courtly setting. Similar to the virtuous knights and ladies who are dressed in the costly armor and bright colors that identify them as noble, the vices wear bright stripes, checks, and particolored gowns and tunics, very costly colors and patterns that were spurned by the clerics but associated with the nobility.[23] The Gotha redaction of the image cycle thus concludes with yet another form of profane ritualized and performative elite behavior. Here, in contrast to the decorous feast and the knightly combat, male and female courtiers interact in a familiar manner, holding hands and dancing.

These prominent and large-format illustrations of the virtuous knights (fig. 2), the virtuous ladies (figs. 75 and 76, ill. 103), and the circle of vices (fig. 76, ill. 104) that frame the poem in the Gotha manuscript not only emphasize the visually distinct ritual practices of courtly culture, but they also stage the poem as a document about and for secular courtly society.[24] Like the text that, as we saw in chapter 1, is formatted in the Gotha redaction as a reference book, these illustrations could be regarded as pedagogic models for an elite society aspiring to emulate the courtly ideal.

THE DEDICATION IMAGE AS A MODEL OF COURTLINESS

The concluding dedication image appears only in the Gotha manuscript, and it further supports the idea that the patron specifically wished to associate himself with a (predominantly literary) courtly ideal (fig. 77). This remarkable image, completed by the same hand as the rest of the image cycle, combines a variety of courtly love motifs, suggesting that the patron was familiar with the literary and iconographic traditions of the romance and love lyric and envisioned himself in this context.

The image depicts a richly dressed man and woman beneath a limewood tree. These are the most beautifully and expensively dressed figures in the entire program of images. The man wears a long, light brown tunic over a blue chemise; long pointed shoes; and an elaborate cap lined with red. His right hand holds a long banderole, but the finger and thumb of that hand also frame an "A" that appears on his gown over his heart. He is attended by a servant dressed in red and wearing a light

brown hat lined in red—the same colors as his lord. The servant's sta-
tus in relation to his lord is indicated by his diminutive stature and his
shorter tunic. He holds the lord's hound and sword while his lord ad-
dresses the lady. She is richly and fashionably dressed in a long, red un-
dergown and a fashionable green overgown lined with ermine.[25] Her
flowing hair is adorned with a red ribbon, and her lack of head covering
indicates her unmarried status.[26] A little dog is seated behind her upon
a costly throne. Between the man and his lady are the intertwined
trunks of two limewood trees with their characteristic heart-shaped
leaves. Seven songbirds adorn its branches.

The visual themes in this image are borrowed directly from the
courtly iconography of love: the birds; the heart-shaped leaves; the
tryst beneath the limewood tree; the "A" over the man's heart, which
stands for *Amor*; and the lady's little dog, which is a symbol of her
fidelity.[27] And the banderoles confirm that we are dealing with a scene
of courtly love. The man proclaims:

> Zŭcher svezes mandel ris
> din stette in tugend hat hohen pris.
> gnad du edeler selden schrin
> ditz buch ist worden durch tugend din.
>
> ———
>
> Sugar sweet almond branch, your constancy in virtue is
> praiseworthy. Have mercy, you noble, rare treasure chest, this
> book is the result of your virtue.

The lady responds:

> Waz mŭtet me euwer hertze gegen mir
> mit tugend sol man ere zir
> niht sult ir chlagen so ser an mich
> swez ir gert daz geschicht.
>
> ———
>
> What does your heart desire from me? One should adorn honor
> with virtue. You should not prosecute me in this manner.
> Whatever you desire shall be done.

The hand gestures in this image are unusual. The man reaches out with his left hand as if trying to touch the lady, except that his palm is directed away from her and toward the viewer. This gesture suggests that he is offering her something, presumably the love represented by the "A" he is holding in his right hand. The lady holds his elbow in an equally unusual gesture in which it is unclear whether she is encouraging or discouraging his advances. This gesture seems to reflect the ambiguity of her statements. On the one hand she stresses her virtue, while on the other she informs the man that his desire will be fulfilled. In the image, the lord thus woos the lady, praises her virtue, and performs love's service in the form of commissioning this book. The lady recognizes him as a suitor and promises him that he will receive a sweet reward. It is impossible to know whether this codex was actually created or commissioned as a gift from a man to his lady, but, in any case, the patron has been depicted here, offering this book to a lady as a gesture of his love.

The illustration bears several similarities to the illustrations in the Manesse codex, (Universitätsbibliothek Heidelberg Cpg 848) containing an extensive collection of medieval song and executed in several stages between 1305 and 1340 for the wealthy Manesse family of Zurich. It contains 137 miniatures that generally depict the named poets. In these images we similarly find copious use of such motifs as limewood trees, birds, dogs, and lovers' trysts. The images also contain the singers' heraldic arms. Although the Raidenbuch arms are a later addition to the dedication image in the Gotha codex, their appearance corresponds to the models provided in the Manesse illustrations. In one miniature of *der Schenk von Limpurg*, the singer appears with his lady beneath a tree covered with birds, and his gown is decorated with the letter "A" (fig. 101). Another miniature from the Manesse songbook that is particularly similar to the Gotha dedication image is that of *Her Bergner von Horheim* (fig. 102). In this image, the singer and his lady appear beneath a rose tree. Their hands are held out toward each other; the lady carries a little dog and the man holds his sword. The inscription and the visual elements of the dedication image place it, and by extension the Gotha manuscript as a whole, squarely in the context of courtly love, a profane, ritualized literary ideal. The dedication image, which is iconographically so similar to the images in the Manesse

codex, fashions the patron as a noble minnesinger and thus affirms his courtly identity.

The Gotha images thus construct an ideal to be emulated, reflecting notions about status and courtly culture that must have been important to the patron's self-image. The images may depict literary motifs that prevailed over one hundred years earlier, but their appearance in the Gotha manuscript should not be regarded as anachronistic; instead, they give visual confirmation of the poem's ongoing relevance and validity.[28] That is, the images attest to a specific cultural conception in which the secular imagery of a literary past associated with an old and free nobility is equated with the viewer's present reality.[29]

In the Gotha manuscript, as in other late medieval vernacular profane manuscript illustrations, the images not only legitimate elite identity but also mediate between a courtly ideal and social practice.[30] Christian Schneider has argued on the basis of the fourteenth-century literary culture surrounding the courts of Prince Albrecht III of Austria and Archbishop Pilgrim II of Salzburg, that fourteenth-century didactic literature was not intended primarily to educate its readers and listeners in courtliness, but instead was intended "to create solidarity, stability, and coherence among the courtly nobility."[31] But at smaller courts at which lesser nobility were concerned with asserting their claim to elite status, such didactic works may well have fulfilled a more pedagogical purpose. Certainly the format of the Gotha manuscript, as we saw in chapter 1, would indicate its use as a practical reference work. The poem's formatting, the emphasis on the representation of elite social status, and the design of the additional illustrations in the Gotha redaction all suggest that the manuscript was part of a project of elite self-fashioning. The manuscript's background and historical environment provide us with a context for this project.

THE GOTHA MANUSCRIPT AND ITS PATRON: SPECULATIONS ON THE HISTORICAL CONTEXT

Thomasin's emphasis on self-representation and his placement of the virtues and vices in a secular courtly context only really makes sense

for an aristocratic audience. While Thomasin occasionally makes a gesture toward more impoverished classes, his target audience is the mixed group of knights, ladies, and clerics that he addresses explicitly (15349–50; 14695–96). Many of his moral instructions pertain only to the nobility and most of his examples involve interactions that would only be pertinent to an aristocratic audience.

While any suggestion regarding the patron of the Gotha codex must remain speculative, its emphasis on courtly culture, its revision as a reference work, and its history and geographical context suggest that it was created for a ministerial family.[32] The term ministerial refers to the estate of "noble bondsmen," to use John Freed's term, that came to replace the older free nobility in the thirteenth century. In the thirteenth century the rise of the ministerials as a powerful political class is a specifically German phenomenon.[33] Some ministerials had tremendous political power and wealth, and the emperor and the princes were utterly reliant on them, but they were legally bound and thus constrained in certain ways by their allegiance to a regional overlord.[34] Some ministerials were distinguished from the free nobility only by the legal contract that bound them to an overlord. Yet this legal contract bore serious consequences because it rendered them servile in the sense that they owed allegiance to an overlord, had to request permission to marry, and were not able to make independent decisions about their property. The ministerials were generally upwardly mobile, powerful, and probably concerned with establishing their elite identity despite or precisely because of their servile status. It is in this context that Thomasin's idea of a malleable elite identity that can and must be socially constructed and visually emphasized must be understood.

Ministerials and free nobles alike were patrons of literature, but ministerials seem to have been particularly enthusiastic about courtly literature and the elite culture and chivalric ideals that it espoused.[35] It has even been suggested that ministerials produced and were the audience for most of the courtly romances, which often depict them as heroes. Thomasin's immediate audience for the poem probably was the courts of the German-speaking ministerials in upper Tyrol, such as the Rodeneck family, well-known among medievalists for its commission of the famous Iwein murals at Rodenegg.[36] Indeed, it seems quite likely that precisely this level of society would have been interested in a di-

dactic work on how to aspire to the four courtly virtues of justice, con-stancy, moderation, and generosity. Of further interest would have been the question of how to live a perfect courtly life in harmony with both God and this world, and perhaps most importantly and pragmat-ically, how to represent themselves as noble elites defined more by their self-representation than by their actual political status. Thomasin's dis-cussion of the educational usefulness of courtly romance makes par-ticular sense for a ministerial audience: he recognizes the limits and the desires of such an audience while attempting to instrumentalize and didacticize the popular vernacular romances.[37]

The 1340 Gotha manuscript was compiled in an area that was cul-turally seemingly far removed from northeastern Italy where the poem was originally composed. Nonetheless, as we will see, certain similari-ties in the social climate of the region suggest that the Gotha redaction represents a form of literary appropriation by the lesser nobility, the ministerials, of courtly ideals associated with an old and free nobility.

Although we cannot identify the patron or the exact location of the Gotha manuscript's production with any certainty, an overview of the region and broader social circumstances in which it was produced will enable us to speculate further about the kind of historical and cul-tural context that produced this redaction of the poem and its images. For the details about the codex, I draw here extensively on Falk Eiser-mann's informative entry on Gotha Memb. I 120 in his catalogue on the German manuscript holdings in the Gotha Forschungsbibliothek, which traces the codex's history from the sixteenth century to its pres-ent location.[38]

An inscription inserted at the end of the poem dates its transcrip-tion to 1340. The present binding dates between 1477 and 1516 in Re-gensburg, but, as mentioned above, the scribal dialect suggests that it was written elsewhere, namely in the border area between Franconia and Swabia. Several inscriptions indicate that the scribe was familiar with writing in Latin (fig. 3, ill. 3; fig. 4, ill. 5; fig. 74, concluding lines of the text). The scribe must have been clerically trained, but we have no indication of his institutional status.[39] In the region in question, several towns and rural courts would have been possible sites for the manu-script's compilation. Without further historical evidence, however, it is impossible to place the scribe of the Gotha manuscript at a specific court

or town. The manuscript might have been commissioned at a monastic scriptorium or at one of the town chanceries in the region, or even by a scribe employed by a wealthy patron.

The identity of the manuscript's patron is equally enigmatic. A fifteenth-century inscription "Raidenbuch" at the top of the dedication image (fig. 77) along with entries on the inside of the wooden cover place the manuscript at the court of the Bavarian ministerial family Raidenbuch, which was among the lesser nobility residing in the area of southeastern Franconia. Other later inscriptions confirm that the codex was in the hands of the Raidenbuchs for at least fifty years. One entry on the inside of the wooden cover reads: 15 K 43 *Gott hatts gfiegtt / V von Raidenbůchch* (God wills it / U von Raidenbuch). Next to it, it is possible to identify a further inscription that has been partially erased: 15 V 43 *Gott Vnd din allein . . . Raidenbůchch* (God and yours alone). These inscriptions are accompanied by a pen drawing of two heraldic insignia, the Raidenbuch blazon and a second, unidentified one. Eisermann proposes that this inscription and the double insignia refer specifically to Ulrich von Raidenbuch (d. 1585) and his wife Katharina (née von Königsfeld) whose name was probably rubbed off. While Ulrich's grandfather Wilhelm von Raidenbuch had been a very powerful and influential ministerial knight, Ulrich's name is not associated with such renown. He was the last member of the Raidenbuch family to reside at the castle Affecking (today in Kelheim near Regensburg), as he sold it in 1544.[40] In 1564 Christoph von Krutschach bought the castle, and in 1593 it was in the possession of his son in law, Hans Ulrich von Königsfeld, a nephew of Katharina's whose name also appears in an inscription in the manuscript (f. 1v) and is dated 1574.[41] Although the exact details are unclear, the castle appears to have passed between related ministerial families for about one hundred years. Perhaps the codex was a part of the castle's furnishings and thus changed hands at the same time. In any case, Eisermann surmises that the manuscript passed from the Raidenbuchs to the Krutschach-Königsfelds and suggests that it was held at the castle of Affecking until the end of the sixteenth century. The codex's history may be traced with more certainty from this point forward.[42]

Despite having no evidence for the manuscript's history prior to the fifteenth century, the codex's association with the Raidenbuchs is

suggestive. They are a paradigmatic example of the kind of ministerial family that resided at courts in the region in which the manuscript was produced. Their ownership suggests that the manuscript was produced, if not for this family, then for their social equivalents. The localization of the manuscript to this region further supports the hypothesis that it was produced for a ministerial family. In the fourteenth century, eastern Franconia was politically unstable and characterized by the powerful status of its ministerials.[43] Power was not centralized, but instead many ministerial families governed small territories. From the middle of the fourteenth century the ministerial estate had flourished there, and its members strove for the reinstitution of aristocratic ethics and demanded its independence.[44]

Existing inventories indicate that many of these ministerial families owned books.[45] While few vernacular epic manuscripts appear on these lists, typical entries include collections of vernacular didactic, reference, and historical works.[46] These inventories and the manuscripts from this region that survived the peasant war suggest that "traditional notions of the nobility were upheld and the appropriate epics were well known."[47] The *Welscher Gast* seems a particularly appropriate text for this sociopolitical environment: it deals with feudal aristocratic culture, constructs an elite secular identity and preserves and prescribes a traditional vision of courtliness that would have been of interest to an aristocratic audience striving for upward mobility and social and political independence.

The illustrations too seem appropriate to the particular historical context of the manuscript that I have sketched out here in very broad strokes. As discussed above, the iconographic language that the Gotha artist used was associated with the old nobility, and particularly with its literature.[48] There was a specific interest among the ministerials and the lesser nobility in commissioning visual works of art from literary material as a means of appropriating that literary material that had traditionally been claimed by the old nobility.[49] As we have seen, the images of the Gotha manuscript do precisely that: they mimic the courtly iconography that derived from literature composed around 1200. Additionally, the image cycle emphasizes categories of identification that are highly pertinent to an upwardly mobile social group. These categories

include estate, which is identified by clothing, hairstyle, and facial features. But, as we have seen in chapters 1 through 3, it also includes gender as well as visual and verbal literacy.

The Gotha manuscript itself was obviously a status symbol: it is a large codex of 102 parchment pages measuring approximately 32 by 23.5 centimeters, and containing a cycle of over one hundred colored pen drawings, including the beautifully executed and elaborate dedication image discussed in detail above. In contrast to thirteenth-century vernacular manuscripts, which are often small in format and relatively unadorned, fourteenth-century manuscripts are frequently large and decorated in a more costly manner. These expensive manuscripts were commissioned and designed to be the possessions of a specific owner, contributed to a program of self-representation, and constituted an affirmation of wealth and power.[50] The purpose of these manuscripts was therefore often less to transmit a particular text than it was to perform a representative function, and the packaging of a text was just as important as the text itself.[51] Along with the change in emphasis on the expensive trappings of secular manuscripts in the fourteenth century came a shift in the design of the illustrations, which similarly started to fulfill a more representative function. Manuscript illustrations were often designed to reflect the specific interests of their patron. The dedication image is a clear indication that we must consider the Gotha manuscript in this context.

Literary patronage in fourteenth-century Germany often served social and political purposes.[52] In her examination of the 1334 Kassel manuscript of Wolfram von Eschenbach's *Willehalm* (Landesbibliothek 2° MS poet. et roman. I) art historian Joan A. Holladay argues convincingly that it reflects the power of its patron Heinrich, Landgrave of Hesse, and his claims to a prestigious genealogy going back to the protagonist of the epic himself.[53] This manuscript was compiled just six years before the Gotha codex, and presents us with one model for the secular context of manuscript production. Other examples are provided by the Manesse codex mentioned above, and the so-called *Hausbuch* of Michael de Leone (Universitätsbibliothek München 2° Cod. ms. 731) from the mid-fourteenth century (ca. 1345–54). This codex is yet another contemporary well-known German example of

a wealthy burgher's commission. It was originally a two-volume anthology containing a broad spectrum of texts, including collections of song by Walther von der Vogelweide and Reinmar der Alte. Only the second volume has survived; it is not illustrated. The nonnoble patrons of these latter examples probably aspired to nobility and fashioned their own elite identity in part by appropriating material associated with the courtly ideals of a bygone era. As the art historian Brigitte Buettner writes: "Then [in the Middle Ages] as today, art works were status symbols, indispensable signs of distinction that secured the owners a superior place within the social hierarchy."[54]

The Kassel *Willehalm*, Manesse, and *Hausbuch* codices are representative objects that reflect the wealth of their patrons, but also underline the notion that owning secular manuscripts was highly desirable as a sign of one's prestige. Buettner asserts, "For the noble patron, manuscripts offered not only access to knowledge; they were also objects with added value, worthy of collecting, exhibiting, offering, and exchanging."[55] The Gotha manuscript is not as elaborate or costly as the Kassel *Willehalm* codex or the Manesse codex, nor does it contain gold leaf like some of its contemporaries. But its extensive and brightly colored pen drawings, its *mise en page*, and its rubrication and index suggest that it was used both as a compendium of knowledge, and as a representative object for an upwardly mobile household. Its image cycle also supports this idea. The large-format illustrations that were added to the cycle at the beginning and the end of the poem particularly demonstrate an interest in elite courtly ritual. Its dedication image is a clear indication of the patron's personal interest in envisioning himself as a participant in courtly society as it is portrayed in medieval literature. There he appears as a poet expressing his love for his lady and surrounded by motifs associated with courtly love. This dedication image confirms that there was a personal stake in the manuscript's production and in its illustration with courtly motifs.

FIVE

Visuality and (Self) Reflection in the Courtier's Mirror

Individual redactions of texts bear testimony to intellectual engagement with them and provide us with particular interpretations.[1] Medieval manuscripts for their part are always constructed within a variety of cultural, historical, and linguistic contexts. The first contextual layer reflects the circumstances of the poetic composition: the poet, the patron, the source material, and the intended audience. Since there are no extant German medieval manuscripts that can be traced with certainty to the hand of a particular poet, however, we are always dealing with some cultural and historical remove when we examine a manuscript redaction of a particular poem. The second contextual layer is therefore the material manifestation of the text in a manuscript or manuscripts that may be historically and culturally far removed from the poem's composition. Manuscripts may have been written by one or several scribal hands; the scribes may have known much or very little about the text that they were transcribing; a manuscript may have been written in a monastic scriptorium or by a secular scribe, released from his duties in a chancery. The scribe may have followed his source faithfully or not. The source text may have been oral or written, and it may have traveled a long way from its origin. The patron may have had specific ideas about the work that he had commissioned and may have requested the scribe to make certain changes or to combine a text with others of specific interest to him in a miscellany. The scribe will almost certainly have

139

adapted the language of the text to correspond to the local dialect. If the manuscript is illustrated, then the artist may have received more or less specific instruction regarding the images, or may have faithfully or less faithfully copied an illustrated source. The format and design of a medieval book tell us how a text was read in the particular historical and cultural context in which and for which the codex was compiled.

While reception by a redactor cannot be equated to reception by an audience or a patron, manuscripts nonetheless reveal to us whom the target audience might have been, or at the very least they reveal the artists' perception of the target audience.[2] It is, in fact, only through such documentary evidence that we can hope to recover any idea of what a medieval audience was like or what such an audience found so fascinating about a compendium of knowledge and ethics for thirteenth-century courtiers. From the audience's point of view, the material staging of a vernacular medieval text, the quality and beauty of its cover, its illustrations and other adornment, and its pairing with other texts in bound codices probably influenced its reception in a way that its author could not have imagined.[3]

For most medieval German vernacular manuscripts, many of the details of their medieval contexts—their patron, their scribe, their mode of production, their reception—are unknown. For the *Welscher Gast* too, much information that would help us to understand the circumstances of its production and its continued popularity for over two hundred and fifty years remains obscure. For the most part, although we are able to roughly place specific manuscripts in particular regions of Germany at specific times (see appendix 1), we do not know who commissioned them or to what purpose. The geographical and historical context of particular manuscripts, combined with the specific choices that artists and redactors made when designing a manuscript can, however, often tell us something about its intended audience or its patron. While the text of the *Welscher Gast* does not change significantly over the two hundred years of the poem's transmission, its formatting and illustrations are much more fluid, and it is these that offer us clues as to the interests and identity of the target audience for the specific redactions. Thus while each manuscript is different, together they tell a developing story and attest to the dynamic nature of the medieval book.[4]

I have shown in the preceding chapters that the variation between the Heidelberg, Gotha, and Wolfenbüttel redactions can be attributed to a number of factors. These include changes in the sociohistorical context of the manuscripts, a developing interest in and identification with the concept of courtly culture, changes in notions about gender, changes in reading practices—particularly with regard to didactic works—and developments in ideas about the role of the viewer in apperception. These changes, I have argued, are made manifest in the illustrations and in the manuscripts' formatting. Of particular interest to me has been the Gotha manuscript, which articulates its didactic purpose and conceives elite identity rather differently from the earliest Heidelberg redaction and the later Wolfenbüttel one. Its formatting presents the poem as a reference work, and its illustrations provide models of action and interaction that recall the concept of courtliness that was developed as a social and educational ideal and fully explored in courtly literature from the late twelfth to the early thirteenth centuries.

An evocative image in the *Welscher Gast* is representative of the changes in the framing and reception of the poem and its images that I have addressed in each of the chapters of this book. It also speaks specifically to the different kinds of viewing that the particular redactions of the image cycle invoke. The image depicts a child gazing at his reflection in a mirror and contemplating what he sees. In each of the three redactions that I have focused on the image has undergone significant changes. Heidelberg Cpg 389 depicts three figures gathered around a hand mirror (fig. 83). The boy in front, dressed particolored in the contrasting hues of green and yellow, holds the mirror in his right hand and gestures upward with his left one, his index finger raised, in a teaching or speaking gesture. The artist has neglected to draw the figure's feet, but he overlaps the other two figures so strategically that their feet stand in for his own.[5] The other two boys stand behind him looking into the mirror and holding banderoles containing their utterances. The banderole on the left reads, "See how handsome he is" (*Sieh wie schon er ist*), while the one on the right contains the words, "I am more handsome than he" (*Ich bin schoner danne er*). That is, neither boy recognizes the image as a reflection of himself. Instead, one of them sees an image that he finds beautiful, while the other compares himself favorably to the image.

This illustration corresponds to a section of the poem in which Thomasin addresses lordship, making the point that lords should not listen to flatterers but should follow their own instincts, in other words, they should know themselves. In order to illuminate how foolish it is to listen to other people's lies when one knows the truth oneself, Thomasin draws the following analogy:

> Nu merct, daz swenne diu chint
> in einen spiegel sehende sint,
> daz chůmt niht von grozzem sinne,
> daz si wænent, daz dar inne
> ein chint si, daz mit in spil.
> der ist noch nærrescher vil,
> der einem andern geloubet,
> daz im niht werre in dem houbet,
> ob im daz houbet we tůt.
> da meine ich mit des herren můt,
> der da geloubet dem lôsære
> und dem volche mer falscher mere,
> denne er im selben tůt.
> wie weiz ein ander baz sinen můt?
>
> ———
>
> Now take note that when children are looking into a mirror, it is not due to their great intellect that they think that there might be a child in there who will play with them. He is much more foolish who believes someone who tells him that there is nothing wrong with his head even though he has a headache. I mean with that the lord's frame of mind who believes the lies of the flatterer and the people more than he does himself. How can someone else know his mind better than he does?
>
> (4263–76; 3627–40)

To illustrate this passage, the illustrator could have chosen to draw a man with a headache, or the lord with his flatterer, but he chose instead to depict the child gazing into the mirror as paradigmatic for the problems of seeing, recognizing, and knowing oneself.

In analogy to a ruler who does not know himself, or at least does not act on his self-knowledge, the foolish child sees his own reflection in a mirror but does not recognize himself, imagining instead that the image reveals a potential playmate. According to the poem, the children think that they see a playmate actually *in* the mirror (i.e., not merely *reflected* in the mirror): "si wænent, daz dar inne / ein chint si, daz mit in spil." The child's mistake is due to a lack of self-knowledge, which causes him to misdirect and misinterpret what he sees. In contrast to the child, the stalwart courtier must learn to recognize that he is seeing a reflection, to acknowledge his own image in that reflection, and to see an ideal version of what he might become if he follows the rules of ethical behavior outlined in the poem.

In the poem, the mirror image is thus conceived as a transforming and transformational image, the meaning of which is actively formed by the viewer.[6] As I discussed in the introduction, in part 2 Thomasin addresses the education of children, advising young aspiring courtiers to choose an older role model, an exemplary courtier who may serve as a "mirror" of ideal behavior. This mirror reflects not the child viewer but the courtly ideal to which he should aspire. But the child's role is not simply to look passively and admiringly at this ideal. Instead, he should construct his own ideal image by improving on what he sees in his mind's eye.[7] The child should thus not be the passive recipient of a viewed object but must seek out the object, actively engage with what he sees, and be transformed by it.[8] Thomasin envisions a process of self-reflection and evaluation of the self against others; a child develops socially and psychically by looking at both internal and external images and reflecting on his own actions vis à vis what he sees. Similar to the child, the stalwart courtier too should envision positive role models and improve by comparing himself to these models.

This description of the child's self-reflective learning process in the poem is similar to the process of reception that, as I have argued, is anticipated in the design of Heidelberg Cpg 389. By reading the poem and comparing himself to the ideal image depicted there, the courtier both recognizes himself and is able to improve himself along the lines of the examples that he reads about. The mirror in the passage from the poem discussed above is thus a metaphor for self-knowledge

and self-realization, and it is depicted as such in the image of the three boys in the Heidelberg redaction described above (fig. 83).[9] The three figures suggest a similar constellation to that found in other illustrations in which a courtier appears between two opposing forces, one virtuous and one unvirtuous. Here the boy holding the mirror is flanked on either side with different perceptions of the mirror image. On the one hand is the boy who recognizes an ideal courtier in the mirror image. On the other is the boy who also sees a courtier but does not identify this image as an ideal. Whereas in the poem the children simply think that they see a playmate, in the illustration the children enter into a discursive and performative relationship with the mirror image.[10] The particolored tunic of the boy holding the mirror reinforces the impression that he may be dealing with competing perceptions of the mirror's significance.

In order to understand the meaning of this image, it is necessary to combine three points that Thomasin makes in the poem. First, children do not yet have the understanding to comprehend that what they see in a mirror is a reflection. Second, the mirror image is not merely to be understood in the literal sense as a true reflection, but also as an ideal reflection of what one might become. Third, the child should look at adult courtiers as an idealized image of themselves. This illustration in the Heidelberg redaction thus provides a kind of analogy to the pedagogical strategy followed in the poem, but it is also a site for further reflection and self-reflection. Indeed the first boy's raised finger, and the mirror itself, the focal point of the illustration, which is turned toward the manuscript viewer and painted a deep black, invite the viewer to examine it him or herself and imagine what he or she might see reflected. But not all of the *Welscher Gast* artists interpreted this mirror in the same manner. In fact, the variation in this illustration is paradigmatic for the shift that I have identified in the framing of the poem from an object of (self) reflection to an object that "merely" reflects and thus affirms the viewer's identity.

In the Gotha manuscript only two boys are depicted (fig. 37). The figure in front holding the mirror points up toward it remarking on the mirror image's beauty. The second figure, whose banderole contains the words "I am more handsome than he is," points away from the mirror and toward himself.[11] In contrast to the Heidelberg image, in which the

pointing finger draws the viewer's attention to the mirror, the point-
ing finger in the Gotha manuscript directs the manuscript viewer's eye
away from the mirror to the figures themselves. The figures' clothing
no longer contrasts in color, and because the third figure is missing, the
emphasis in the image is no longer on the conflict between the two re-
sponses to the mirror image. Instead we are inclined to see two foolish
children unable to recognize themselves in the mirror. The image thus
illustrates the text, but it seems less interested in engaging the manu-
script viewer in the process of self-reflection.

In the fifteenth-century Wolfenbüttel manuscript the illustration's
meaning has been changed entirely through the revisions made to the
banderoles (fig. 90, right column). The figure holding the mirror and
gazing into it holds a banderole containing the words, "See, I'm hand-
some" (*Sich ich bin hupsch*), while the second figure's banderole reads,
"I'm more handsome than you" (*Ich bin schóner dann du*). These figures
clearly recognize themselves in the mirror; they do not see the mirror
image as an ideal, nor is there any indication that examining a mirror is
a metaphor for self-knowledge. Instead the Wolfenbüttel manuscript de-
picts two self-absorbed courtiers bickering about who is more hand-
some. All they see in the mirror is affirmation of their own beauty.

Although the poem does not change significantly in terms of con-
tent in the three redactions discussed here, the illustrator has recon-
ceived the mirror image and its apperception entirely. In contrast to the
Heidelberg image, which invokes contemplation, the Gotha manuscript
presents us with an illustration of foolish courtiers that are not to be em-
ulated but criticized for not recognizing their own noble reflections. The
Gotha illustrations thus suggest a different kind of engagement with the
mirror that coincides with the different kind of reception implicated
in the variation of the image cycle and the poem's formatting over the
course of the poem's transmission. Whereas the thirteenth-century il-
lustrations were designed to be actively interpreted, engaged with, and
internalized, the fourteenth- and fifteenth-century versions of the il-
lustrated poem were intended to be viewed, referred to, eschewed or
imitated, and identified with. The redesign of this image from depicting
a process of inner reflection to a moment of self-assertion is emblematic
for the poem's transformation over the course of the Middle Ages.

This study has examined the manuscripts of the *Welscher Gast,* and particularly the Gotha manuscript, from four different perspectives that intersect in various ways. Each of the chapters deals with a visual aspect of the illustrated poem, and each investigates changes in the formatting or illustrations over time. They all support the argument that these changes go hand in hand with developing contexts and practices of reception. Furthermore the variation in the image cycle suggests that there is a process of iconographic emancipation from scholastic and theological traditions. Whereas the oldest versions of the images require clerical training to fully understand them, the younger versions engage with contemporary viewers by depicting secular narratives in which the viewer could see an engagement with his own society and its preoccupations. The pivotal nature of the Gotha manuscript permeates these chapters as its formatting and illustrations most clearly articulate the project of self-fashioning that is at the heart of the *Welscher Gast.*

APPENDIX 1

The *Welscher Gast* Manuscripts

There are twenty-five known manuscripts of the *Welscher Gast*. Fourteen are on parchment, eleven on paper. Thirteen manuscripts contain the image cycle, although the number of illustrations varies, depending in part on how complete a given manuscript is. Four manuscripts contain spaces for illustrations but were never completed. Three fragments contain no illustrations and do not appear to have been designed to include them. The relationship of the manuscripts to one another is not entirely clear, but, as discussed in my introduction, two major strands have been identified. Descriptions of the *Welscher Gast* manuscripts have been published elsewhere in German.[1] I provide here only the very basic information about each redaction in order to give non-Germanists an overview of the manuscript transmission. The description includes the traditional designation used by scholars to refer to the manuscripts (A, G, etc.), location and date of the manuscript's compilation, the material, size, number of pages, and number of illustrations. The online Marburger Repertorium (http://www.mr1314.de/) is an essential resource that provides further information about each of the manuscripts, including a brief bibliography of research on the specific manuscripts. I have organized the manuscripts here in approximate chronological order. There is much uncertainty about some of the

1. See, for example, Neumann, "Einleitung," v–li, in which the eighteen manuscripts then known are described; Thomasin von Zerclaere, *Der Welsche Gast*, ed. von Kries, 1:48–56; and Wenzel and Lechtermann, *Beweglichkeit*, 257–65.

dates, but this overview will give the reader at least a rough idea of their distribution and chronology.

The *Welscher Gast* was known predominantly in the southeast German region. The scribal dialects of the codices range from Bavarian to east Franconian. The earliest two manuscripts can be placed in Bavaria. Heidelberg Cpg 389 has been localized to the area close to Regensburg; the Stuttgart manuscript (Cod. poet. et phil. 2° 1) from 1328 was compiled in Regensburg itself. The Gotha manuscript was compiled close by in the southeastern region of Franconia or the border region between southeastern Franconia and northeastern Swabia. There has been some disagreement as to the scribal dialects of the later manuscripts. Some scholars identify them as eastern middle German, while others have proposed that the scribal dialect is Swabian. Only two manuscripts originated in the southwest. They are the only very expensive representative manuscripts of the *Welscher Gast*: Pierpont Morgan Library G. 54, which was probably commissioned by the Trier Archbishop Kuno von Falkenstein (1362–88), and Staatsbibliothek Preußischer Kulturbesitz Berlin, Ms. Hamilton 675, compiled in 1400, which was once in the possession of Emperor Maximilian and his wife Bianca Maria Sforza. The didactic poem was therefore apparently more popular in the southeastern region of Germany than elsewhere. Frühmorgen-Voss has remarked that the popularity of the *Welscher Gast* in the southeastern region may reflect a cultural interest in illustrated didactic works.[2]

THIRTEENTH-CENTURY MANUSCRIPTS

A Heidelberg, Universitätsbibliothek, Cpg 389
 Bavaria, ca. 1256
 Parchment; 18.3 x 11.6 cm; 226 pages

2. She cites as one example the 1411 Middle High German verse translation of *Fiori di virtu*, an Italian didactic prose treatise composed around 1320 and attributed to Tommaso Leoni. The German poem was composed by Hans Vintler, a Tyrolian knight related to the family of the famous Runkelstein castle near Bolzano, Italy; it too was illustrated from the start. Frühmorgen-Voss, "Mittelhochdeutsche weltliche Literatur," 39; see also n. 83.

106 marginal colored pen drawings executed by three different hands
This manuscript is available online: http://diglit.ub
.uni-heidelberg.de/diglit/cpg389

Gr Krakow, Biblioteka Jagiellońska, Berol. Ms. germ. quart. 978
Bavaria, end of thirteenth century
Parchment; 16.3 x 23.7 cm; 1 page
One illustration

FOURTEENTH-CENTURY MANUSCRIPTS

G Gotha, Universitäts- und Forschungsbibliothek Erfurt/Gotha,
Memb. I 120
East Franconia or border region of northeastern Swabia and
eastern Franconia, 1340
Parchment; 32 x 23.5 cm; 102 pages
120 colored pen drawings (including the dedication image)

S Stuttgart, Württembergische Landesbibliothek, Cod. poet. et phil. 2° 1
Bavaria, possibly Regensburg, 1328
Parchment; 26 x 20 cm; 97 pages
92 colored pen drawings

Si Sibiu, National Archive, Colecția Brukenthal, cota GG 1-5, nr. 16,
filele 222-223
Bavarian, first half of fourteenth century
Parchment; 30.3 x 21.7 cm; 1 page
No illustrations

Wo Wolfenbüttel, Herzog August Bibliothek, Cod. Guelf. 404.9 (6) Novi
Bavaria or East Franconia, first half of fourteenth century
Parchment; 2 fragments of 2 double spaces
No illustrations

none Warsaw, National Library, cod. 8098 IV, fol. 5–6
First half of fourteenth century
Parchment; fragment of 1 double page
Two illustrations

Pe Formerly Budapest, Országos Széchényi Könyvtár, Cod.
Lat. 210 (lost)
Bavaria, mid-fourteenth century
Parchment; 28 x 22 cm; 1 page
No illustrations

Bü Büdingen, Fürstlich Ysenburg- und Büdingen's Archiv,
no shelf mark
Bavaria, second half of fourteenth century
Parchment; fragment of 1 double folio
3 colored pen drawings

E New York, The Pierpont Morgan Library, G. 54
Trier, ca. 1380
Parchment; 35.4 x 25.9 cm; 74 pages
69 illustrations

Erl Erlangen, Universitätsbibliothek, Ms. B 7
Bavarian-Franconian border, second half of fourteenth century
Parchment; 31.4 x 24 cm; 33 pages
26 colored pen drawings

F Schlierbach, Stiftsbibliothek, Hs. I 28
Bavaria, second half of fourteenth century
Paper; 21 x 29 cm; 125 pages
Spaces have been left for illustrations
Manuscript also contains the *Rossauer Tischzucht* (f. 125ra–125vb)

Tü Berlin, Staatsbibliothek zu Berlin–Preußischer Kulturbesitz,
Ms. germ. fol. 718
Second half of fourteenth century
Paper; 100 fragments of 36 pages
Spaces have been left for illustrations

Wa Watzendorf, Oberfranken, Evangelisch-Lutherisches Pfarramt,
no shelf mark
Parchment; 1 double page (lost)
East Franconia, second half of fourteenth century
No illustrations

Ma Berlin, Staatsbibliothek zu Berlin–Preußischer Kulturbesitz,
 Ms. germ. fol. 757 and Ms. 161
 Parchment; approx. 29.5 x 21.8 cm
 Ms. germ. fol. 757 consists of two long strips of parchment (Nr. 37, 38)
 and a corner fragment (Nr. 45).
 Ms. 161 consists of a fragment of a double page.
 West middle German, fourteenth century
 Illustrated (Ms. 161 contains a fragment of an illustration).

H Berlin, Staatbibliothek zu Berlin–Preußischer Kulturbesitz,
 Ms. Hamilton 675
 Southwest Germany, ca. 1400
 Parchment; 32 x 24 cm; 120 pages
 116 illustrations

FIFTEENTH-CENTURY MANUSCRIPTS

b Heidelberg, Universitätsbibliothek, Cpg 330
 Northern Bavaria, perhaps Eichstätt, ca. 1420
 Paper; 21.8 x 31.1 cm; 104 pages
 96 colored pen drawings
 This manuscript is available online: http://diglit.ub.uni-heidelberg
 .de/diglit/cpg330/

c Heidelberg, Universitätsbibliothek, Cpg 338
 Alsace, perhaps Strasburg, ca. 1420
 Paper; 29 x 19.9 cm; 288 pages
 No illustrations
 This manuscript is available online: http://diglit.ub.uni-heidelberg
 .de/diglit/cpg338

W Wolfenbüttel, Herzog August Bibliothek, Cod. Guelf. 37.19 Aug. 2°
 Swabia, first half of fifteenth century
 Paper; 31 x 22 cm; 106 pages
 118 colored pen drawings

D Dresden, Sächsische Landesbibliothek–Staats- und
 Universitätsbibliothek, Mscr. M 67
 East middle Germany, 1450–70
 Paper; 30 x 21 cm; 229 pages
 111 colored pen drawings
 The manuscript contains other primarily didactic works including:
 Boner's *Edelstein,* a collection of gnomic verse by Heinrich von den
 Teichner, two poems by Freidank, and selections from Hugo von
 Trimberg's *Der Renner.*

M Munich, Bayerische Staatsbibliothek, Cgm 340
 Bavaria or Austria, ca. 1457
 Paper; 29 x 21 cm; 224 pages
 No illustrations
 The *Welscher Gast* text is incomplete. The manuscript also contains
 selections of Otto von Passau's *Die 24 Alten* (fols. 2r–12v) and Ulrich
 von Pottenstein's *Speculum sapientiae* (fols. 13r–128v).

a Heidelberg, Universitätsbibliothek, Cpg 320
 Swabia, ca. 1460–70
 Paper; 28.4 x 39.4 cm; 102 pages
 117 colored pen drawings
 This manuscript is available online: http://diglit.ub.uni-heidelberg
 .de/diglit/cpg320/

N Nürnberg, Germanisches Nationalmuseum, Hs 86035
 East Franconia or Swabia, 1470–74
 Paper; 32 x 21.5 cm; 116 pages
 Spaces have been left for illustrations

K Karlsruhe, Badische Landesbibliothek, St. Peter pap. 25
 Bavaria, second half of fifteenth century
 Paper; 30 x 20.5 cm; 233 pages
 Spaces have been left for illustrations
 Manuscript also contains Ulrich Putsch's *Das liecht der sel*
 (133ra–217rb)

U Munich, Bayerische Staatsbibliothek, Cgm 571
 Swabia, third quarter of fifteenth century
 Paper; 31 x 21 cm; 107 pages
 98 colored pen drawings

APPENDIX 2

Synopsis of the *Welscher Gast* according to the Gotha Manuscript

Since the *Welscher Gast* does not follow a plot, but is instead a compendium of moral instruction that includes a host of examples, what follows is a thematic synopsis. I have followed the format of Gotha Memb. I 120 in providing an outline of the various topics covered in the book's ten parts and numerous chapters, so that readers may get a sense of the issues that Thomasin addresses, his style of moral instruction, and the structure of the poem as a whole. I have attempted to preserve his style, which is at times repetitive and formulaic, but can also be pithy and quite lively, and have refrained from embellishing it stylistically. I have necessarily omitted most of Thomasin's examples, which are generally concrete and to the point, and sometimes humorous. In passages in which Thomasin provides a long list of examples, I have included one or two and then added "etc." to indicate that the list continues. I have also inserted references to the images where applicable. I view this synopsis as a complement and a necessary corrective to the recent translation by Marion Gibbs and Winder McConnell, which provides a complete English version of the text and includes useful notes that explain, among other details, Thomasin's historically specific references. Gibbs and McConnell use Heidelberg Cpg 389 as their lead manuscript but they also draw on other redactions, such as the Gotha manuscript, so that their translation does not actually represent an existing Middle High German text. Furthermore, although they include a single representative illustration from the Heidelberg redaction, they do not discuss the illustrations or indicate which passages are illustrated.

153

While I have preserved the chapter divisions in the Gotha manuscript denoting them with Roman numerals, as they appear in the manuscript, the subdivision into paragraphs has not been retained. Line numbers refer to the edition of the Gotha manuscript by Friedrich von Kries (FvK) and the Rückert edition (HR) of Heidelberg Cpg 389.

Several of the abstract terms for virtues and vices may be rendered differently in English depending on context. Thus, for example, *sin* can mean sense (as in the five senses), good sense, critical judgment, discernment, or understanding; *girde* can mean lust, greed, or desire, depending on whether it is negatively or positively connoted; *erge* can mean avarice, greed, or animosity, etc. I have translated these concepts with an eye to their specific context. Gibbs and McConnell struggled with some of the same terms (Thomasin von Zirclaria, *Der Welsche Gast*, trans. Gibbs and McConnell, 14–27). Their translation appeared after I had completed my synopsis, and in several cases our readings differ. For a precise understanding of the text, it is best to consult the Middle High German original.

PROLOGUE (FVK, 611–754; HR, 1–140)

Thomasin begins his prologue by expressing the hope that his book will inspire its readers to behave properly and urges them to follow an exemplary role model. The poet promises to explain precisely what good breeding and proper behavior are, and how men and women of all ages may profit from them. Professing Italian fluency and birth in Friuli, the poet asks his readers to forgive his mistakes and to receive his work kindly. We are then informed—and provided with our first image that depicts it—that anyone who appeals to virtuous people will displease treacherous ones because the latter cannot tolerate good people (fig. 3, ill. 2). Thomasin then dedicates his book to the German-speaking lands, which he hopes will receive it like a good "lady of the manor" (*huosvrowe*) should and asks her to keep his book away from base and treacherous people (fig. 3, ill. 3). Thomasin concludes his prologue by exclaiming that he will present the vices in such a way that the virtues will be able to drive them from his book (figs. 2; 3, ill. 4).

PART 1 (FVK, 755–2308; HR, 141–1706)

I (FvK, 755–910): The "stalwart man" (*biderb man*) should not be idle. He should not stray from the right path but should instead always speak, act, and think properly. Idleness is the first vice tackled by the poet. It is to be avoided by the stalwart man and is particularly sinful for young people, as depicted in figure 4. Young people should accustom themselves to being courtly and performing good deeds, because old age will reveal the habits that they had in their youth. For their part, children should foster a feeling of humility and shame, for it will protect them from many sins. They should practice humility in three ways: by not speaking dishonorably, by conducting themselves properly, and by doing what they ought to do. A truly free person reveals humility in his actions and speech, while he who boasts, lies, and scorns others is not free. Boasting is the greatest evil, and it is never separated from mockery. Lying is always close by (fig. 5, ill. 5). If a man does not speak the truth, then he will break his oath (fig. 5, ill. 6). Shame awaits the braggart who mocks and boasts. Furthermore boasting is even more sinful for women.

II (FvK, 911–1140): The narrator next turns to noise-making and boisterousness, which he says are both difficult to tolerate and rampant among young men at fine courts. At inns, base youths drink and order to excess and are forced to leave their cloaks as payment. They then gamble for more wine and by thus attempting to avoid appearing miserly, they become guilty of gluttony (fig. 6, ill. 7). Thomasin then states that noble children should aspire to be like well-behaved knights at court, declaring that if one fails to take note of what he sees, then he will never learn to be courtly. He adds that teaching such children courtliness is like trying to teach a bear to sing (fig. 6, ill. 8). The arrogant, loud, and uncontrolled behavior at court these days inspires Thomasin to present a number of conduct and etiquette rules for courtly behavior for ladies, girls, knights, and boys.

III (FvK, 1139–92): The rules of conduct continue: noble children should not laugh much, tell secrets, or whisper.

IV (FvK, 1193–1298): Continuing with children, the reader is informed that fear will motivate a child to listen, understand, and to speak properly (fig. 7). Additionally, a noble child should always show self-restraint and behave as if a stalwart courtier were watching him (fig. 8). Good conduct and courtliness are explained to come from practice, and this section ends with the advice that children should avoid mischief and succumb neither to hatred nor anger.

V (FvK, 1299–1384): The narrator next discusses proper speech, and he suggests that those who want to speak properly should avoid gambling because it causes one to speak in an uncourtly manner and goes against the rule of good conduct. Gambling causes hatred and anger, greed, and avarice (fig. 9, ill. 11). Thomasin then declares that one should not speak too much or be too silent, and should demonstrate moderation in all things. Only virtue and discernment (*sin*) distinguish man from beast. Indeed, if a man wants to be virtuous, then discernment should guide his intention and his deeds (fig. 9, ill. 12). While innate, virtue and discernment are also the product of education. Thus, women and men should ignore base stories but learn from virtuous ones.

VI (FvK, 1385–1492): The discussion of education continues with the narrator stating that poor role models found in unvirtuous stories will pervert good breeding and ruin instruction. If a woman is pure in spirit, however, then she will not be confused when she hears contradictory advice and will be able to distinguish a proper example from an improper one (fig. 10). Women should also not enjoy listening to gossip, for a virtuous woman should feel sad if another woman behaves wickedly. Women should learn from Helen (of Troy's) misfortune, who was very beautiful but had little sense. What is more, a lady should be courteous and well mannered, and speak properly and modestly. If she has more intelligence than that, it should remain hidden as a man should have many skills, but a proper and noble lady should not. She should, however, have the good sense to protect herself from improper love as beauty, friendship, birthright, wealth, and love are worthless without good sense. Indeed, the reader is warned both in word and

image that a beautiful woman without good sense and instruction will soon lose her honor. Her beauty will inspire men to seek her favor, but her lack of good sense will cause her to do things that she should not (fig. 11, ill. 14).

VII (FvK, 1493–1606): Virtue is the next characteristic discussed by the narrator, who states that the exchange of honor for beauty is a poor trade as a woman's beauty is worthless without virtue. Using the metaphor of a bird catcher, Thomasin states that a lady signals her intention to be caught if she adorns her body but not her mind (fig. 11, ill. 15). What is more, the body and gestures always reveal one's state of mind (fig. 11, ill. 16). As every state of mind manifests itself in a particular way, it can be recognized by someone who understands these things. But one may often be misled by what one sees. Indeed, both men and women often lie. The reader is then informed that the beauty of false people runs only skin deep and that a false woman's tongue may be honey but her will is poison (fig. 12, ill. 17). Stating that, while falsity suits no one, it is worse for a lady. Thomasin then lists to which vices and virtues men and women are more prone.

VIII (FvK, 1607–1774): Ladies' beauty is described in this section as a trap that ensnares men and leads to their downfall (fig. 12, ill. 18). A beautiful woman who is loyal, constant, and gentle, however, is good and can catch men without using a net. Ladies are then told to listen to virtuous stories about virtuous ladies such as Andromache and Enide, while young men will learn from the good examples provided by Gawein, Cligés, etc. Children are once again told not to be idle but to follow the example of virtuous people, which will lead them to great honor (fig. 13). These stories provide models for children and for people who are incapable of learning any other way, but adults should disregard these stories, for they are lies. Each person should understand according to ability. The cleric and literate people are able to understand the meaning of a written word, while illiterate people look for meaning in pictures or in examples. Thomasin then expresses his gratitude to poets who have composed poems in German, because good stories are edifying, but he would prefer it if these stories contained fewer lies.

IX (FvK, 1775–1944): At this juncture, Thomasin mentions that he wrote a book of courtesy in Provençal (or Italian), in which he explained that one should face the power of love with good sense. He further states that the nature of love is to make the wise man wiser and the foolish man more foolish (fig. 14, ill. 20). Thomasin differentiates between love and "un-love," and describes correct and incorrect behavior for suitors. He states that love does not permit magic, purchase, force, deceit, or any false or sinful behavior that derives from an incorrect understanding of love. For example, if a man tries to woo a lady using wealth, then he will never know whether it is him or his money that she desires. A man unable to woo a lady using courtliness is no better than a merchant. Indeed, purchased love does not have the power of true love (fig. 14, ill. 21). This section ends with the reader learning that love is free. As such, a man brings shame upon himself when he gives gifts inappropriately or immodestly.

X (FvK, 1945–2114): Continuing with the theme of gifts, Thomasin reveals that a lady may accept the following as gifts from her suitor: gloves, a mirror, a ring, a buckle, a wreath, a flower. She should not accept anything more valuable unless she needs it, and only if she cares for her suitor more than the gifts. Ladies should also be faithful to their men, and it is most important that a lady not be false. Falsity, he explains, turns love into malice and everything that is good into something bad. Indeed, the reader is informed both in word and image that a false person's speech, gestures, and intention are contradictory (fig. 15, ill. 22). The poet then declares that a good woman should not allow any man to touch her body who does not have the right to do so. He further suggests that no courtly man should ask for more than is his due and should also serve a lady for a long time before he asks her for anything that might bring her dishonor. The reader then learns that no wicked man will dare to ask anything of a lady who is constant and virtuous. In this manner, a lady who believes that it is an honor to have men approaching her is deluded. What is more, men are informed that there is no honor at court for them if they have many lovers.

XI (FvK, 2115–2308): Continuing on the theme of women and vanity, we learn that when an old woman boasts that she gave men a lot of

trouble in her youth, she reveals her lack of virtue. Additionally, the narrator reminds his audience that while such a woman's power and beauty may decline with age, her sinfulness does not (fig. 16). Thomasin again mentions the earlier book on courtliness that he wrote for a lady in which he addressed falsity and explained how a lady should learn to recognize false lovers who will dishonor her. A woman should be able to recognize who is worthy of her love and her possessions as wealth without honor is worthless. The stalwart courtier is warned to protect his wealth from thieves and his body from false women. Ladies, on the other hand, should choose a lover who is their equal, or at least one who is virtuous, constant, and has good sense. A woman should also beware of wicked men who will slander her and the courtly man is also warned here not to slander a woman's lover. This part ends with a further reference to Thomasin's Provençal book, which addresses what is proper for virtuous women. He now proposes to explain how a man should be virtuous.

PART 2 (FVK, 2309–3164; HR, 1707–2528)

I (FvK, 2309–2438): The narrator then turns to the subject of virtue declaring that if one has not lived a virtuous life in one's youth, then he should rectify it in old age to have avoided wasting his life. Thomasin informs us that a lord provides an example to his people, and his behavior influences everyone. For example, a lord who is idle and will not pass judgment or take command both behaves unjustly and will make fools of his people. Instead, he should be a role model and guiding light for his people (fig. 17). Similarly, if a virtuous lord becomes wicked, then he is like a light that has been extinguished, which should be thrown away and replaced with a burning candle (fig. 18, ill. 25). Another way to be virtuous, the narrator tells us, is to relinquish all vice. For, if you want to sow the ground with good seed, you should first clear it well and make sure that it is free of stones and thorns (fig. 18, ill. 26). The reader then learns that a person's first task is to practice the virtue of constancy as without it all other virtues are worthless. Constancy, according to Thomasin, can best be explained by looking first at inconstancy.

II (FvK, 2439–2582): Inconstancy is shameful and harmful; it is not free but always serves vice (fig. 18, ill. 27). Inconstancy is feminized, and we are told that she constantly changes her mind; she wants everything and nothing at the same time; she does one thing today and another tomorrow. First she climbs, then she falls, she's here today, and gone tomorrow, etc. (fig. 18, ill. 28). Inconstancy is further described as like a puppy with a bell tied to its tail. It runs around to avoid the noise, and does not know that it itself is making the racket (fig. 19). Furthermore, to be constant one should limit oneself to being constant in one area. Even the cleric who owns many books should devote himself to seeking wisdom in only one of them because he will not be able to understand the meaning of all of them equally well. This section ends with the division of inconstancy into four parts: love, sorrow, yes, and no (fig. 20, ill. 30).

III (FvK, 2583–2726): Inconstancy is considered especially despicable in a liege lord because his actions determine the actions of others. Thomasin relates that a lord should be constant in all things and guard himself particularly from lying as it is treacherous if one's speech and heart are not unified. The narrator complains that, while we are dismayed if our hair is cut unevenly, we do not object if someone's heart contradicts what he says (fig. 20, fig. 31). Further, he declares that Lying and Anger are Inconstancy's children (fig. 21, ill. 32). Lying is abhorrent and carries joy in one hand and sorrow and pain in the other. One hand loves, the other hates, one caresses, the other rends apart, one gives, the other takes, etc. (fig. 21, ill. 33). The reader is then informed that a man whose shirt hangs down below his coat is a fool, and a man who wears his coat long in front and short in the back is also foolish. This analogy explains that virtuous people should ensure that their shirts and coats are even, in other words, that they fulfill their promises (fig. 21, ill. 34). A lord should look at himself from the front and the back to make sure that his hem is even (fig. 21, ill. 35). This section ends with the declaration that a lord should tell the truth and keep his promises, and his word should be written down as witness (fig. 22).

IV (FvK, 2727–2878): We are warned that, if a lord is inconstant, then his followers will also be inconstant. Turning to the beginning of the

world, the narrator explains that at the time of Creation the world was constant, but that we are to blame for the inconstancy and faithlessness that have arisen. If Adam and his children had been constant, for example, we would never suffer from cold. The world has maintained a part of its constancy, however, evidenced in the fact that everything has its season: flowers, and foliage, fruit, and grass. The constancy of the world can also be seen in the sun that shines every day and sets every evening. This is its nature. Heaven has always rotated around the earth as well as seven stars; each one has its own path from which it does not deviate (fig. 23).[1] These stars are contrasted with people who repeatedly attempt to deviate from their path and thereby demonstrate inconstancy.

V (FvK, 2879–3024): The narrator then turns to the four elements, fire, air, water, and earth, explaining that they are contradictory but also constant and complementary. While earth is dry and cold, water is cold and wet, air is hot and wet, and fire is hot and dry (fig. 24). The four elements exist below the moon and are present in man, but man is not unified by them because he is always driven to excess. The area above the moon in which the planets and the stars reside, however, is described as a sphere of constant harmony.

VI (FvK, 3025–3164): Thomasin then returns to the state of human society, describing it as the best example of inconstancy. Wherever the narrator looks he sees that fighting is destroying the world. Indeed, he states, avarice, lying, mockery, hatred, envy, and anger have displaced the virtues of fidelity and truth. Thomasin cannot locate these virtues in England, France, the Provence, Spain, Apulia, Rome, Tuscany, Lombardy, Hungary, or the German lands. Inconstancy is declared the culprit and since Thomasin sees only dissatisfaction and fighting everywhere, we must be nearing the end of the world. Therefore, the reader is encouraged to turn his heart to God and not follow inconstancy in this world, so that he may enter His kingdom when the world ends.

1. Thomasin here uses the word *stern*, which means "stars." Context makes clear that he means "planets."

PART 3 (FVK, 3165–4782; HR, 2529–4146)

I (FvK, 3165–3238): Thomasin now turns to the source of inconstancy, asking why we are so inconstant when God gave us the power over all beasts. Adam had constancy but lost it when he forfeited God's grace of his own free will. From this point on man has been born into inconstancy. What is more, since man lost his original constancy, only he has the understanding to distinguish between good and evil. For, if God forced us to be constant, then there would be no need to reward us. Instead, he gave us the freedom to choose how we want to live. Thus, Thomasin states that if someone fears God, then he should live according to His law without being forced to do so, as God will punish wickedness.

II (FvK, 3239–3312): The manuscript then returns to the seven stars in the sky that remain constant, and the four elements that reside below the moon that are contradictory in their nature. Nothing else in this world is so proud that it strives against its proper place, except foolish mankind. Inconstancy constitutes people attempting to exchange their place in this world for another. Inconstancy causes the peasant to want to be a page; it makes the page wish he were a peasant, and the cleric want to be a knight. When the knight is thrown from his saddle by a spear, he in turn wishes he were a cleric (fig. 25, ill. 39). Yet, it would seem strange to us if a hound pulled a cart while an ox hunted rabbits (fig. 25, ill. 40). This section concludes with the assertion that humankind is deluded, for if we really understood the lives of other people, we would not want to exchange our place in society for another.

III (FvK, 3312–3506): Continuing on the theme of humankind, the reader is informed that both the poor and the rich have their worries as everything is equally divided. While the poor man suffers for his poverty, the rich man is equally stricken by his wealth because it brings worry, war, anger, and hatred. Similar to the poor man, the rich man will aspire to become wealthier. This foolishness has no end, for if a man cannot be satisfied with a little, then he will enslave himself to avarice (fig. 26). Conversely, the reader learns, a man who knows how to live within his means will never be poor. For men leave their wives and children at

home and work hard for small gains when it would be better if they did less work but strove for virtue. Then they would become wealthy in virtues. The reader is then told that people must control their wealth and not be controlled by it, as a man who lets his wealth control him is a fool (fig. 27). The rationale to Thomasin lies in the fact that a man will be parted from his wealth when he dies, but he will suffer for his love of money even before his death. Enemies, fire, gambling, death, and thieves cause a rich man to suffer, but God's grace is eternal wealth. The poor have an easier path to heaven as they will reach heaven's gate before the fearful rich who come laden with their earthly possessions.

IV (FvK, 3507–3616): The reader then learns that were wealth not despicable in God's eyes, then we should abhor it for its own sake because it causes vice. Money cannot make anyone virtuous, and worldly goods do us more evil than good. The wealthy man is the example of this as he must carry two heavy burdens. The first is the desire to be even richer; that is called greed. The second is the fear that he will lose his worldly wealth. Rich men strive to be richer because they always measure themselves against people who appear to be wealthier. In actuality, they should look behind them and see how many people are poorer than they (fig. 28).

V (FvK, 3617–3702): Wealth is also harmful for poor people. The example given is that of the peasant who dreams of acquiring wealth. Having accomplished this in his dreams, he turns his mind to how he might protect his wealth and what cities and lands he might buy with it. Furthermore, he thinks only about the people who will envy him on account of his great wealth (fig. 29). Thus, many people strive and struggle the whole night through only to lose their rest and gain nothing. The rich and poor are told to accept their stations in life as both are equal and both have their worries and suffer from greed. We are then informed that the peasant would never give up his station in life if he understood the fear associated with losing one's wealth (fig. 30, ill. 45).

VI (FvK, 3703–3856): While the lord and his people have a single goal, the common people live a better life as they are unburdened by lordship. The people need to be ruled, and the lord never stops thinking

about how he will rule. People assume that he has everything he wants, but they do not recognize that he has great concerns and bears the responsibility for his people (fig. 30, ill. 46). Thomasin then questions why anyone would want to be a lord as he is constantly beset with problems and complaints, unlike the peasant. When he asks for counsel, for example, the lord is told different things by different people, and, what is more, every counselor has his own opinion and thinks he is wiser than everyone else (fig. 31, ill. 47). Furthermore, using the analogy of a captain, Thomasin explains that while a foolish man might think he would make a better lord, he would actually be incompetent as the passengers' safety depends on the captain's skill. If he has taken on more than he is able, then not only will he be lost, but all of his passengers will die too (fig. 31, ill. 48). The narrator further informs the reader that an incompetent ruler will bring dishonor upon himself and his people (fig. 31, ill. 49). This section is concluded with the assertion that lordship is not good in and of itself and that a lord should work hard to maintain his honor, as a man whose pride is greater than his virtue will fall from power.

VII (FvK, 3857–3920): Thomasin's guidance on lordship continues with his claim that it is also troublesome for someone who has never attained it. For example, a man greedy for honor will invent a plan to attain lordship, and in his dreams he becomes as pleased as if he had conquered a country. He appoints his officers as he chooses, his chamberlain keeps the crowds away from him (fig. 32), and if he wants to hunt, he is able to do so without delay, and he catches everything, even killing a bear (fig. 33). The reader is informed, however, that this dream of lordship does not last very long, for the next morning when he wakes up, everything is gone.

VIII (FvK, 3921–4090): At this juncture, Thomasin informs his readership that a powerless person is better off than a lord since anyone with power seeks to control those around him. Power corrupts to the extent that a man will give false counsel to anyone who resists him in order to win him over. Indeed, he suggests that the powerful man will have his people harm the person offering resistance, and when that person comes to complain, the man with power will deny any wrongdoing and force

the plaintiff to succumb to his power (fig. 34, ill. 52). The powerful man is wont to repeat this behavior when threatened, but no man is able to control the whole world. Thomasin cites the downfall of Alexander, Julius Caesar (fig. 34, ill. 53), Hector (fig. 34, ill. 54), the Trojans, Hannibal, and some unnamed contemporary medieval examples to illustrate the inconstancy of power. This part concludes with an inventory of the three things that man has with a contradictory nature: wealth, lordship, and power, which in turn cause spiritual poverty, dishonor, and powerlessness.

IX (FvK, 4091–4151): Power is further described as causing trouble to a man lacking it. It leads him to ponder all night how he might acquire power and what kind of punishment he could mete out to his enemies, including creating an army and going to war in his mind (fig. 35). While the next morning he will see that all of his nocturnal efforts have gone to waste, the reader is reminded that one cannot hide one's thoughts from God. One should therefore cleanse one's mind with virtue and goodness because God can see into everyone's mind and knows who is good and evil.

X (FvK, 4152–4444): A man who seeks fame is also a fool as fame does not help us when we are gone. While some desire their goodness, courtliness, and virtue to be praised irrespective of the validity of this praise, a lord should think about the truth of his reputation and should be angry if lies are being told about him. A scoundrel's praise is worthless, and our greed, avarice, and inconstancy constantly show us that we are not perfect. A man who recognizes his vices is able to improve himself (fig. 36, ill. 56), and he will further question whatever a flatterer says about him. False praise is akin to treating a doll as a child (fig. 36, ill. 57). While a child who looks into a mirror and thinks that he sees a playmate in its reflection is thought foolish (fig. 37), a man with a headache who accepts someone telling him he feels no pain is even more foolish, for how can a lord believe the flatterer and his lies more than his own mind? At this juncture Thomasin declares that if more people accepted betrayal, lying, unfaithfulness, and treachery as evil then there would be fewer liars and flatterers. A virtuous lord should be

unconcerned as to what is said about him. While a man greedy for fame worries all the time about how he might improve his life, his greed is useless because he and all of his possessions will go noisily to hell. We are then informed that it is better to go quietly to heaven than to go loudly to hell as one should do what is good and right without praise and bragging (fig. 38, ill. 59). An example is given in the lord who gives a penny to a pauper but does not care about the pauper's welfare as long as the story of his generosity is told. Similarly, people bestow clothing on those well-dressed enough, but do not give anything to the poor man who goes naked (fig. 38, ill. 60). Vice leads us to give more alms for the sake of our honor than we do on account of God, and it is something for which we will receive no award. This is further explained—and depicted—by an analogy to the foolish man who looks for pears in a cherry tree (fig. 39, ill. 61); by contrast, a man is well advised if he seeks reward where eternal reward is due.

XI (FvK, 4445–90): Greed is once again discussed, and the narrator tells us that it creates much trouble for a renowned man. Unrenowned men are also affected, however, as they think hard about how they might achieve fame and in their minds will plan a tournament that many skilled knights will attend. In his foolish thoughts, the unrenowned man will throw many of these knights, conquering them all (fig. 39, ill. 62), and his skill as a knight will be regaled all over the world. But this will all be a dream.

XII (FvK, 4491–4562): Returning to the noble man, we learn that nobility does not guarantee worthiness as no one is truly noble unless he has turned his heart and mind to good. Despite being of noble birth, a man is a disgrace to his birthright if his heart is not noble, for it dictates that he always behave properly and justly. Thomasin states that he finds it strange that any man should be proud on account of his forefather's wealth and aristocratic standing, as he should focus more on his own accomplishments. Similarly, the reader is informed that while all who follow God's command are his children, a nobleman will lose his God-given birthright if he does not follow His law. A man who loses his nobility on account of his avarice, treachery, lying, inconstancy,

lack of courtesy, and vices has made a poor trade (fig. 40). Only virtu-
ous actions can be courtly. If someone has a courtly intent, then he will
behave justly; anyone who behaves justly all the time is noble; those
who are noble are God's children (fig. 41, ill. 64).

XIII (FvK, 4563–4782): This section discusses pleasures, such as gam-
bling, eating, and falconry, and reminds the reader that if pleasures are
pursued too enthusiastically, then the right path will not be followed.
Thomasin then compares the person who considers himself unfortu-
nate because he cannot constantly do what he desires with the person
who is able to pursue his desires. The latter, he observes, is much more
unfortunate because whatever brings great joy also has the potential to
bring great sorrow. Various examples of this are then presented and
depicted such as the gambler, who does not feel better when he wins
because he knows that he could just as easily lose the next time (fig. 41,
ill. 65). Similarly, the happiness that falconry brings with it is out-
weighed by the falconer's sorrow when his bird flies away (fig. 41, ill.
66). A man's great happiness at winning a wife is also shown to turn to
sorrow if she loves another (fig. 42). The discussion then returns to
women and the admission that a woman will be good or virtuous re-
gardless of what her husband does, while a man should be steadfast
irrespective of his wife's behavior. What is more, everyone should be
chaste. Women should always be treated properly and justly despite the
courtly opinion that a man should conquer as many women as pos-
sible. A woman's disgrace is our dishonor. It is better if we leave women
to themselves and concentrate on checking our desires. Thomasin re-
minds us of his examples of desire, including the glutton who suffers
when he is denied food and dreams of having it (fig. 43). This section
concludes with the instruction that we should be aware of our thoughts,
because God can see them.

PART 4 (FVK, 4783–6328; HR, 4147–5692)

I (FvK4783–4856): We return in this section to inconstancy and the
narrator's remark that everyone seems to be striving for it. Six qualities

have the potential for inconstancy: wealth, glory, power, reputation, nobility, and desire. They are associated with particular vices and can make people dependent and unfree. The pitfalls of these qualities are then described: wealth brings greed; glory comes with pride; power causes a lack of humility; reputation/fame leads to vanity; nobility comes with foolishness; desire leads to gluttony (fig. 44, ill. 69). The reader is informed that if one aspires to be free, he should not seek out these six things because they can make him dependent. Additionally, a righteous lord should ensure that he does not become a servant of vice.

II (FvK, 4857–4952): Continuing on this theme, Thomasin declares that a lord who is too attached to wealth will become enslaved to Greed (fig. 44, ill. 70), just as a man will lose his freedom if he becomes a slave to his desires (fig. 45). What is more, he who becomes a servant to wealth, lordship, power, fame, nobility, or desire will lose his freedom in order to serve vice, and then no one will want him as a lord.

III (FvK, 4953–5232): Just as inconstancy accompanies all vices, constancy is the companion of all virtues (fig. 46). Without constancy virtue is worthless, just as constancy without virtue is nothing. Additionally, the reader is informed that a single virtue does not have the power to make someone virtuous. Rather, one must have lots of virtues and perform them constantly. Examples are provided in the good person who uses his wealth to good purpose, and will therefore not be devastated by poverty, while an evil person will keep his wealth to himself and no one will profit from it. Similarly, a virtuous man will not become prideful if he becomes a lord, but an evil man will no longer recognize his friends. If he becomes powerful, a good man will not harm anyone but will protect the poor; an evil man will avenge himself for any wrongdoing and harm those who would have been willing to serve him. If he becomes famous, a good man will strive to become better than his reputation; an evil man will become boastful. If he becomes noble, a virtuous man will aspire to having a noble spirit; an evil man will consider everyone else to be beneath him. These qualities (wealth, power, fame, and nobility) are beneficial for someone who is virtuous, but they become vices for someone unvirtuous. While a good person

turns everything that he encounters to good, the evil person turns everything to evil. The narrator reveals that if a wicked man appears to be faring well, then it is because he has not yet been punished. The reader is reminded that everyone will be judged and punished according to his actions whether in this world or the next. Because God no longer intervenes in this world by punishing or forgiving, we will suffer our fates in the next (fig. 47).

IV (FvK, ll. 5233–5464): Virtue is the only way to attain good fortune, for an unvirtuous man is always wretched, even if he rules over the world. To illustrate this, Thomasin tells us that the victim of violence is better off than the perpetrator, as God will judge the latter harshly and he will receive blame and misfortune for his action (fig. 48). Furthermore, due punishment and reward will be meted out in the next world, and the more wickedness one commits, the more unhappiness and misfortune one will receive (fig. 49). The reader is then informed that the Lord is just and the end rarely justifies the means, because God sees our intent and passes judgment based on that. The example given is the uncharitable act of providing a drunk man with more wine (fig. 50). The devil acts justly, according to the narrator, because God would not permit anything else. It is also God who gives the devil power over a wicked man or allows him to test a good man's constancy (fig. 51). The devil's power is good, but his intention is evil.

V (FvK, 5465–5598): This section begins with the narrator's insistence that the world is just, and everything happens for a reason. Both good and evil people should experience good and bad in this world, for both should have hope in God and fear Him. Furthermore, none are without sin, and those for which we do not repent in this world, we will do penance for in the next. Similarly, our fortunes in this world directly impact our lives in the next; if bad things happen to a good man, then it is in order that he will be even happier in the next world.

VI (FvK, 5599–5952): As God's will is known to no one, we cannot understand his actions. An example is given in the case of the doctor who is not questioned about his treatment if one sick man needs sweet

food and another needs sour food. In this sense, the reader is to view God like a doctor who knows what each one of us needs and, as such, anyone who questions God is a fool. Just as the doctor uses different methods to heal patients depending on the illness, so too does God treat people differently in his effort to bring them to salvation (fig. 52). Thomasin then declares that a virtuous man will not incur harm, because no one has the power to force him to abandon his virtue. He follows this up with a series of positive and negative examples of historical and biblical figures who either remained virtuous despite hardship or lived in sin. This section ends with the insight that good and evil men fear God differently since the evil man fears God's judgment, but the good man fears God's power and responds to this fear by better following His command.

VII (FvK, 5953–6182): We are then informed that a good man need not fear anything. Poverty, illness, or banishment should matter little to him because his spirit remains rich and strong and his virtue renders him perennially at home no matter how far away he is from his house (fig. 53). He should not fear imprisonment, death, or dying, for a man should not worry about how long he will live but how he spends his life. Indeed, no matter where a man dies, he will immediately be set on the path to God or the path to hell (fig. 54).

VIII (FvK, 6182–6278): Instruction then turns to the observance of mourning and the need for moderation. One ought to control one's suffering and not let it exert control. Practically speaking, a man who has just lost a friend should avoid dancing, jousting, and playing stringed instruments. If a spouse dies, then one must observe the mourning period more strictly and remain unmarried for at least a year. It is also imperative that one not misbehave and think that no one sees him, for God knows everything.

IX (FvK, 6279–6328): Readers are here informed that we will recognize our friends in the next world as an inability to see them would render paradise flawed and that is impossible. Through God we will recognize everything that is in the world.

PART 5 (FVK, 6329–7436; HR, 5693–6798)

I (FvK, 6329–6416): The section begins with the definition and subdivision of good into two separate entities. The first is God and it is always just; the second is absolute good and is comprised of the virtues that pave the way to God. Evil is also subdivided accordingly; the first evil is the devil, and the second is constituted by the vices that lead the way to him. There is a fifth category comprised of six qualities that have the potential for either good or evil: wealth, glory, power, reputation, nobility, and desire. It depends on a person's virtue whether or not these six qualities are positive or negative.

II (FvK, 6417–6540): Attaining goodness is illustrated in this section by use of the metaphor of the ladder of virtues, comprised of virtues and reaching up to the highest good. The person constructing the ladder is also required to be completely virtuous, or he will not attain the highest good. A second ladder is then discussed—one constructed entirely of vices—that leads down to the lowest evil. It has sloping rungs that will cause anyone trying to climb it to slide down to evil. Constancy is the only way to reach the highest good. Sins make one heavy and accumulating more sins makes it easier to fall.

III (FvK, 6541–6662): Discussion of the second ladder is continued here, with the devil's hooks defined as wealth, glory, power, reputation, nobility, and desire. It is these hooks that will try to pull you down from the ladder leading to the highest good (fig. 55).

IV (FvK, 6663–6878): The first ladder is once again discussed with the declaration that vice cannot lead us to God. Rather, heaven is reached only through climbing the ladder of virtues and here Thomasin lists several examples of Biblical figures who attained entrance to heaven through virtue. Everyone has more strength in one virtue than the others; no one but God is perfectly virtuous. The quickest path to hell is through wickedness as evidenced by Nimrod and Cain, who went to hell because of their evil-doing. The reader is then informed that he is delusional if he thinks that nobility, reputation, power, and glory will

give us the strength to reach God. Whether one reaches God is bound with good intention as neither the devil nor God will be swayed by material possessions. Since God knows man's character, the poor man has just as much chance as the rich man to enter heaven. Wealth in and of itself cannot secure one a place in heaven; the only path that leads to God is virtue.

V (FvK, 6879–7006): This section concerns itself with the shame that is associated with anyone who does not wish to follow God, particularly a lord on whom God has bestowed power and respect. In the old days, Thomasin states, there used to be more virtuous lords, and virtuous people were treated better. Now, however, the vices are treated better than the virtues and this is evidenced when a good man comes to court. While people pay no attention to him, they are prepared to make room for a usurer. For that reason people think that they need to be wicked if they want to get ahead (fig. 56). If people really honored virtue, there would be many knights comparable to the Arthurian knights Erec or Iwein. As it stands, however, the stalwart man is like an owl: if wicked people see him, they scream at him and stomp on him with their feet (fig. 57, ill. 83), and thus he must hide (fig. 57, ill. 84). The reader is then informed that if lords respected good people more than bad ones, then bad people would abandon their wickedness.

VI (FvK, 7007–7218): Thomasin states that this situation repeats itself in the religious world as diligent clerics are treated poorly because their lords are all in pursuit of vice. For this reason the clerics have become lazy and no longer strive for knowledge. The world is then described as topsy-turvy: it has no law and no honor, but is governed by vice. Previously, the world used to be a better place when people behaved properly. Both animals and people had everything they needed; everything had its place and received its just reward or punishment (fig. 58). The reader is then instructed to respect intelligence and those who are wise. Furthermore, both lords and bishops are given direction on how best to achieve honor. Lords should send people to school to gain better advisors, while bishops should follow God's command and his law and not allow their own ignorance to prevent them from supporting learn-

ing. This section ends with the admonition of lords who let able young people deteriorate intellectually by not sending them to school while showering gifts on the greedy people surrounding them (fig. 59).

VII (FvK, 7219–7436): The harsh treatment of the learned is further addressed here with Thomasin stating that they are treated worse than cattle. The blame is laid at the feet of the lord who ought to treat people according to their virtue to inspire others to be virtuous. The world used to be a better place because people appreciated virtue and knowledge. In today's world, however, everyone tries only to be wealthier than the next person, meaning that men fare little better than their leaders. This situation is reversible, however, for those who try to escape the chain of vices, which is wrought from wealth, desire, glory, power, reputation, and nobility. These ties bind together pride, treachery, vanity, foolishness, and desire. At its end the chain has sloth, gluttony, and drunkenness. Throughout our lives we forge this chain, which turns to steel in hell, and holds us captive there. As whoever is bathed in hell will be beaten by it, the reader is instructed to bathe now in virtue so that he may never be bathed in hell (fig. 60). This section ends with a declaration of God's power, as the reader learns that while the chain of vices pulls us down, God may pull us up with the chain of virtues.

PART 6 (FVK, 7437–9122; HR, 6799–8470)

I (FvK, 7437–7624): Virtue continues to be discussed here with Thomasin instructing his readers not to give up on their virtue. While it may be time consuming to follow the right path, it leads to the gates of eternal joy. Similarly, it may also be necessary to tolerate the power, pain, sorrow, trouble, and mockery of the vices, but in the end God will grant virtuous people happiness. Job, Moses, and David are provided here as examples of virtuous men who patiently suffered God's will and received their just reward.

II (FvK, 7625–7738): Thomasin turns here to discuss the judgment of virtue and declares only a virtuous person able to judge another good

person, as a man lacking virtue is unable to distinguish between it and vice. While a rich person will often be scornful of a poor one and the moneylender thinks himself better than the person who needs money, both are deluded. The moneylender's wealth places him only in the service of someone else who is better able to enjoy the money. He himself gains nothing from his profit except entry into hell (fig. 61). The reader is reminded here that a man should be aware that his ignominious behavior will be paid for with his child's happiness because a son must make up for his father's injustice if he does not want to incur God's wrath.

III (FvK, 7739–7946): The lack of virtue shown by the usurer begins this passage, and he is described as dead both here and in the next world as his works achieve only sorrow. A virtuous life, however, is shown to have only positive consequences in both realms as evidenced by the humble man who tolerates his fortunes in the earthly realm and gains a pleasant life in the hereafter. The prideful man on the other hand will suffer both here and when he is dead. Comparing a man without envy to an envious man, Thomasin reveals that the former will have his peace here and even greater peace there, whereas the envious person will be torn apart by restlessness and will also incur God's hatred. In this he loses his life both here and there, and it would be better if he had never been born. Similarly, a man without anger will enjoy God's mercy, while an angry man is always unhappy and will go to hell. Unchasteness, laziness, larceny and lying lead to God's wrath and eternal damnation. Someone who is virtuous on the other hand, will live well and have much joy and happiness.

IV (FvK, 7947–8236): Instruction on giving freely and avoiding greed characterize this passage and the reader learns that while people rarely accept anything from a generous man who gives justly and freely, they always take from a stingy man. As such, the miser's wealth will turn to dust. Similarly, a scoundrel does not like to touch his wealth and convinces himself to save it in case of need later saying, "I don't need it yet." Greed comes from cowardice, which in turn causes avarice. Anyone who fights for wealth is depicted as easily conquered on account of his

greed. Cowardice and avarice both produce the same result in battle (fig. 62). Someone disinterested in wealth on the other hand will profit from it once the enemy has been overcome. Therefore, the virtuous knight ought to ride under the banner of virtue to attack and destroy the enemy's army of vices. Thomasin then depicts the allegorical fight of the virtues against the vices pitting the noble and righteous knight against Pride who approaches with her armies including Lust, Power, and Immodesty, as well as Fame and Arrogance. Anger is described as the banner carrier and Foolishness is her general. Other armies of vices are led by Avarice, Lechery, and Laziness. The knight is then called to steel himself for battle and the greatest honor goes to him who conquers the vices and banishes them indefinitely (fig. 63). After the vices have been depicted, Thomasin then turns to the virtues in the knight's arsenal: Prudence, Justice, and Patience, which provide him with a banner, sword, and shield respectively. Thus armed, it is then possible to break through the front line of the vices. Once the vices have been conquered, however, there is yet more danger for the knight as he must protect himself from Boasting because it will lead to pride. Boasting, Lust, and Mockery constantly confound people, but Prudence gives people the ability to defend themselves against these three vices.

V (FvK, 8237–8684): The fall of mankind is here cited as instigating the necessity for fighting against the vices. Depicted at this point is the devil's casting out due to his evil doings and God's judgment (fig. 64, ill. 91). The reader is then reminded that it is only God's grace and a person's good deeds and intentions that will enable him to reach God's kingdom (fig. 64, ill. 92). The struggle against vice is lifelong. Instead of following Adam's example, the reader is directed to strive for virtue in this world so that we may earn our reward in the next. To overcome the devil, one is then instructed to live peacefully with everyone and direct all effort against the devil. After all, if someone had to fight against a bear, he would not suddenly sit down and count money, because he could then lose the fight. In fighting, the devil uses anger, war, hatred, greed, and usury to make man dissatisfied and restless, and he is pleased when he is able to betray us. Knights are directed to think about why they became knights in the first place and the work required to succeed

as an idle man will fall prey to idle thoughts that will rob him of his peace and make him restless (fig. 65). This accusation is leveled at both knights and clerics. To fill his office properly, a knight is instructed to work night and day for the sake of the church and for poor people. If he does not, then it would be better if he were a peasant, because he would then not be so unworthy in God's eyes. For his part, the cleric has more to do than just sing loudly. Through chastity, clean living, and good works and words, a cleric should be a role model for others and should wear the crown of virtues. Returning to the duties of the knight, the reader is informed that it befits the knight to live properly with his wife and to know his company and his servants well. The knight should treat those who are dependent on him in the same manner as he would like to be treated by his liege lord. Depicting God as our liege lord, the narrator informs the reader that if a person willingly does what he is commanded by his lord, then he reduces his indenture. For a man who enjoys doing his duty is free in spirit, while a man who does it grudgingly is a scoundrel and will remain a servant. The reader is further instructed never to command anything that goes against God and honor because both lord and servant will have to pay for their actions. All people should thank their common lord—God—for everything: the soul, life, servants, property, child, and wife. God also commands people to behave justly. In turn, if a man is good, then he should constantly strive so that all those who are subject to him also behave justly. Thomasin decrees that a lord is accountable for the actions of his people and, as such, if he makes them into thieves and usurers, then he shares their sin and their disgrace. The reader is further warned that while a person might think that he is just following his lord's orders as God is lord over all, he should fear Him, who can send his body and his soul to a place where remorse never ends. This section ends with the reminder that one should not ask a friend to do anything that goes against God and his honor. If asked, furthermore, then one serves one's friend well by refusing to do it. One should not follow evil advice.

VI (FvK, 8685–9122): In this section, the work returns to the lord who often cherishes the treacherous advisor who betrays him and becomes a thief of his soul and his honor. If the advisor counsels him to do some-

thing against God's command, then he is the devil's messenger and should be treated as such. Wealth is then depicted as the devil's trap with which he captures many birds that should fly to heaven if they do not want to end up in hell. The reader is then warned that thinking too much of wealth results in the loss of his senses and the inability to think of honor or God. If someone boasts about his profit, then he should recognize his loss, for he has chosen avarice over generosity. He has given away virtue to gain vice and thinks that he has profited (fig. 66). True wealth lies in ambivalence toward wealth and poverty, for the vices of greediness, avarice, fear, worry, trouble, and sorrow grow as one's wealth grows. The respect that comes from virtue is far worthier and longer lasting than that which comes from wealth because if a man is good and virtuous, then God will give him the strength to succeed and to acquire honor and wealth. Lords are directed not to let the light of their virtue falter as they are tasked with lighting the path to the gate of the place where the sun always shines (fig. 67). He whose torch has extinguished should light it again quickly, so that he and his people can see, because otherwise everyone will falter. Indeed, the devil loves the darkness. As the Day of Judgment will reveal what people have done, he who wants to atone for his sins should have three things in mind: fear, hope, and love. He should have hope in God, and love and fear of His command. On account of this love and fear, one should confess, show remorse, and do penance for one's sins. It is due to insufficient belief and knowledge that those who should heal are themselves sick and those who should be carrying the light prefer the dark. No one behaves according to his status: the clerics do not lead the laity as they should, nor does the laity follow. As things stand, the clerics are hurrying toward hell and the laity wants to overtake them.

PART 7 (FVK, 9123–10502; HR, 8471–9850)

I (FvK, 9123–9292): This part deals with the body and soul and the relationship between the two. Every person is depicted as created with a body and a soul and ought to derive his strength from both. The virtues are agents of the soul, whereas strength, speed, and dexterity belong to

the body. The soul is more valuable than the body, and its power greater than that of the body; every wise man knows that understanding supersedes strength. Indeed, many beasts are superior to humans in physical strength and speed, but it is critical judgment that designs the nets from which no beast can escape. Men are thus superior to beasts in intellect. Critical judgment is then described as an agent of the soul, with which God honored only angels and humans. Owing to their sinfulness, however, humans have the ability to a lesser degree than do the angels. But even that which humans have in understanding and critical judgment is of great value to them, because it enables them to follow God and the virtuous path. The reader is then tasked with remembering that God has honored him with critical judgment, and that no one in the world has such judgment except man, the angels, and God.

II (FvK, 9293–9534): This section continues the discussion of critical judgment and states that instead of using their critical abilities to look for virtue, humans have sought out only evil things, such as profit, wealth, and the deception of women. Clerics and the laity are blinded by their greed. Knights should wager their land and life for the security of poor servants, orphans, and poor women, but they do not. The cleric is equally corrupt and seeks the knight's sword in order to increase his gains and satisfy his greed. Similarly, the knight wants to read books in order to use them for gain, but it does not befit a knight to spend his nights thinking only about increasing his assets. Instead of pursuing chivalry, virtue, and justice, however, everyone turns his energies to evil and the acquisition of wealth. It is at this juncture that the reader is informed that our ability to understand comes from God, and, as such, it is foolish for us to think we have good sense but yet turn all our energies to evil. Thomasin then explains the four powers that each person possesses from which he should seek counsel. Anything that one is able to do must either go through one or all of these four powers: perception (Ymaginatio), reason (ratio), memory (memoria), intellect (intellectus). Perception and Memory are described as sisters that serve Reason and Intellect. Furthermore, Perception brings everything it perceives to its liege lady, Reason. Reason in turn assesses what is good and passes it on to Memory, while Intellect is the messenger to the angels and to God. If

someone turns his energy to profit, then he will lose these best powers, which offer him counsel on courtliness and proper behavior. He will then be left with only Perception, which every beast has. This section is concluded with the declaration that no one can acquire perfect understanding in this world; instruction awaits us in the next.

III (FvK, l9535–9714): The virtue of knowledge forms the basis of this section, and the reader is informed that, much like anyone who plays chess well will always find an equal or better competitor, so one should always try to improve one's knowledge and ability. This can be done by learning the seven liberal arts: grammar, dialectic, rhetoric, arithmetic, geometry, music, and astronomy. Grammar teaches proper speech; dialectic distinguishes truth from lies; rhetoric colors our speech beautifully; arithmetic rewards people with the ability to count; geometry teaches us to measure; music instructs us in tones; astronomy teaches the stars' nature and their path. No one is able to master all of the arts. Thomasin at this juncture lists famous scholars and theologians who were masters of particular arts, including those who appear in the illustration (fig. 68). This section ends with the narrator's assertion that he who lives properly does not tell lies, but speaks simply without treacherous intent, is active, does good deeds, and adorns himself with the virtues and understands the seven liberal arts.

IV (FvK, 9715–9832): This section reveals the two additional arts that are far superior to the others and which are not considered disciplines because it is their task to rule over the others and to teach us how to protect body and soul: Physic (*Phisica*) and Divinity (*Divinitas*). Physic instructs us how we should take care of our body. It teaches us which food and medication we should take when we are sick. Divinity teaches us how to take care of our soul, so that we do not commit sin. If we sin, it instructs us to confess so that the soul is protected. Physic also teaches the four elements and the nature of all things beneath the moon, while Divinity gives us knowledge of the heavens and the skill to recognize the angels, God, and His command. Astronomy, Arithmetic, and Geometry aid our understanding of everything that exists between man and heaven. Thomasin informs his readers, however, that Divinity, the lady

of all arts, has been lost in this world because we are too concerned with worldly fame and wealth.

V (FvK, 9833–10100): Thomasin says that he would like to speak more about the arts and their teachings, but he fears that it would be beyond the comprehension of those who have no clerical training. He states that the situation used to be different when every child could read, and lists historical and biblical kings who were well educated. Lords are then instructed to teach their children about good conduct, honor, goodness, and justice, and to avoid injustice and falsity. Education teaches one how to please God and how to live virtuously in this world and thus, Thomasin states, there is no better inheritance than an educated mind. He adds that some clerics do not provide a good example because they are able to read but they do not understand scripture. They are like peasants who enter a church and see the pictures but are not able to understand what they see. Understanding must be learned, for if an educated person commits a sin, he is better able to understand how to confess and thus place himself under God's command. Ignorance is no protection from God's judgment. A person who wants to follow God's law and eschew the devil is directed to enjoy listening to stories about God's goodness, his martyrdom, and his humility, because that will inspire him to serve God, just like thirst inspires one to think of cool water. All people should listen to God's word whether through their eyes, like clerics who read, or through their ears, like the laity who listen to sermons. If a man closes his ears to God's word, then God will not hear his prayers.

VI (FvK, 10101–10246): The constitution of the human is then elucidated, and the work describes the five doors that comprise the human body: sight, hearing, smell, touch, and taste. Everything that one can know in this world must come through one of these doors. These doors are called the senses, and they are the servants of the four inner powers that serve the soul—their queen—as counselors. While one can live without hearing, taste, smell, and sight, no one can live long without touch. Therefore, one should not harm one's sense of touch by exposing oneself to fire or cold snow. One can always awaken the senses: touch

with a beating, smell with stench, hearing with a loud noise, and taste with bitter gall. Our senses fall asleep by touching soft things, hearing sweet sounds, seeing a woman's beauty, smelling a gentle breeze, or tasting something sweet. The senses are further described as the servants of Perception, Memory, and Reason, and cannot serve well if they are asleep. Just as the lord is tasked with beating his servant if he is not doing his job properly, Reason and Perception should punish the senses for working toward their own profit. The soul furthermore should never follow the counsel of the body because the body is flawed from its fall from grace. The soul rather should give the body direction, for if it fails to do this, then the body will come to great harm.

VII (FvK, 10247–10368): The section opens with the description of the soul as like a king who, if a just ruler, will have a well cared for land. If he does not rule well, however, then his people will behave unjustly, and his idleness will result in his people avoiding work. Similarly, the reader is informed that if the soul does not rule as it should, then the body will misbehave, and both body and soul will suffer for it. The reader is then asked to consider the precise way in which man's miraculous body was created. It is cleverly constructed so that the soul is housed within it and yet has a completely different nature to the body. As such, Thomasin describes it here as God's great achievement.

VIII (FvK, ll. 10369–10502): We are told that the soul in man's body has great mastery, artistry, and power. While the body has strength, speed, and dexterity, the soul must govern these as well as the senses discussed earlier. Men and women have five things inside and five outside of their body to which the soul should always give direction. In the body are strength, speed, desire, beauty, and dexterity, while outside the body are nobility, power, wealth, fame, and lordship. If one cannot guide these ten powers with one's discretion, then they will bring a person many vices. He who is not able to control nobility, power, wealth, fame, and lordship with his good sense is described here as even more dimwitted than a beast. The reason being that, in contrast to the animal, people become proud. If you praise a stupid man or make him rich, then he will think that he is better than everyone else. A man who

is unable to control these ten things with his intellect would be better off a beast, and Thomasin here likens men with vices to beasts: a powerful man with no control is like a wolf; a man unable to control his desires is like a lazy mule, a filthy pig, a lecherous dog, or an angry marten. One more thing exists partially inside and partially outside and can be controlled with discretion and good sense: speech. Thomasin cautions that if it is not controlled within, then it comes out differently than it should. The reader is then informed that he will succeed if he uses his good sense to control all of his actions and thoughts.

PART 8 (FVK, 10503–12876; HR, 9851–12222)

I (FvK, 10503–10644): Immoderation is in this section depicted as Inconstancy's sister. As with constancy and inconstancy, moderation can be better understood if we know what immoderation is. Immoderation is described as foolishness's messenger, drunkenness's playmate, and pride's niece. It is anger's power, the glutton's mouth, avarice's lock, greed's hound, glutton's tongue, etc. In short, immoderation is the drive that excites the vices and spurs them to action. Moderation is the balance of good sense that aims to be between a little and a lot. In contrast to immoderation, moderation gives us honor and goodness, it is just, and it rules appropriately over castles and lands. It is also a measurer of everything, while immoderation cannot measure anything. It is stretched out and yet cannot measure (fig. 69). It is first expanded and then contracted. It is first the string and then the bow, and yet it is unable to find the target and shoots wide of the mark. Moderation's instruction, by contrast, is what enables us to turn vice into virtue.

II (FvK, 10645–10718): Thomasin begins this section by stating that between two vices there is always a virtue. Humility, for example, lies between pride and cowardice. While an excellent virtue, if someone has an immoderate amount of humility, then his humility will become the vice of cowardice. If someone wants to avoid cowardice, however, then he must take care not to overshoot his goal and become prideful. The reader is instructed to take the middle road and be moderate in his humility. Similarly, simplicity is described as the virtue between fool-

ishness and vainglory; generosity is between avarice and wastefulness; moderate eating is between gluttony and starvation; moderate love is between lechery and celibacy. Too much anger and excessive mercy serve neither the law nor justice. One must also beware that one practices tolerance for the sake of God and not out of sloth or cowardice.

III (FvK, ll. 10719–10826): Immoderation is here given the ability to swiftly transform a virtue into a vice, while moderation can turn a vice into a virtue. Anger, for example, is declared a terrible vice, but anger applied with discretion and moderation is a virtue. Thus, the wise man's anger comes from his goodness, but the foolish man's anger derives from arrogance. God is described as having given us both anger and love so that we would be angry with the vices and love the virtues, but man has erred and therefore values the vices over the virtues. Our foolishness has thus made both anger and love into vices. However, we can change some outcomes. For example, if pride is moderated with good sense, then it too can be a virtue. Similarly, even envy applied with moderation can be virtuous.

IV (FvK, 10827–11034): The danger of excess is tackled in this section, and the reader is reminded that nothing should be done excessively. The example described—and depicted—is church attendance. It is not good if one spends so long at church that one is unable to keep one's thoughts on God. Someone who prays too long will start thinking about other things (fig. 70). Similarly, he who has a lot to do should not spend so long in a church that it causes him to neglect other duties that serve the general good. Thomasin further reveals that people today no longer have the ability to concentrate on prayer for a long time, like the saints used to do. He who wants to follow moderation's teaching has only to ask God to lead Christianity onto the right path, to be merciful to the dead, and to enable him to do what is right and good. If one prays but does not have the will to do good deeds, however, then the prayer is worthless. One should not pray to punish one's enemies, to gain worldly power or possessions. Moderation is also essential in fasting; one should not try to be a martyr. Similarly, a man should distribute his wealth so that the poor are pleased that God gave it to them, and should thank God accordingly.

V (FvK, 11035–11220): The discussion of moderation continues with the instruction that speaking, laughing, sleeping, and being awake are all good in moderation, but anything done to excess can never be good. As one's external appearance reveals what is in one's heart, the motifs for one's heraldic arms should be selected with moderation. Thomasin here gives the example of the rise and fall of the Welf emperor Otto IV at whose court in Rome Thomasin tells us he spent more than eight weeks. Otto's insignia of three lions and a half an eagle are described as immoderate. Whereas a single lion denotes bravery, three symbolize pride. The high flight of the eagle denotes honor, but half an eagle suggests a parting or division of honor and a demi-eagle is unable to fly. For that reason, many people said that lord Otto and the kingdom are divided on account of his pride, and many strange things have happened to him in a short time. In King Philipp's time (Philipp of Swabia) it seemed at first that Otto would gain control over the empire. But then his power decreased and Philipp's increased, so that it seemed that Philipp would win the empire. Otto gained power over the entire empire on Philip's death, but now he too has died. This—to Thomasin—reveals that he who relies on worldly honor will be deceived, as a true lord always serves God.

VI (FvK, 11221–11354): The rise of Friedrich II is here provided as an example of a true lord, for when it seemed certain that he would lose Apulia, God granted him success and the German lands. Faithlessness and pride on the other hand are shown to come before a fall, as we see in the example of the Greek king, for the Greeks thought the Franks were fools, and now they must do their bidding. The Greek king also wanted to be named a saint, but the reader is informed that seven such "saints" have died in the last ten years. As such, pride is shown to lead one away from God. Thomasin instructs his readers to look to chronicles to find other examples of prideful people who came to a bad end. This section ends with the remark that every king should have a chronicle of his kingdom, and if he does not, then it is on account of his idleness.

VII (FvK, 11355–11608): Unhappiness and corruption are revealed to come from immoderation and pride, and those who choose to live unjustly will be lost. It is a deluded man who believes that God will keep a

sinner out of hell for sinning because he became a martyr. If we break God's law, we will lose His favor, as the case of Adam proves. Since we have broken many of God's commandments, the narrator remarks that his audience should be very fearful. We see on a daily basis that he who lives unjustly suffers for it, and Thomasin—utilizing the fable of the fox—states that we ought to try to improve ourselves instead of following a prideful lord. When the lion fell into a hole, all the animals came running to check on him, only to be eaten. But the fox noticed that all the tracks led into the hole but none away from it, and he stayed away. The lion is like the devil that waits with an open mouth. One should not chase sin.

VIII (FvK, 11609–11998): If someone turns his mind to immoderation then he will be cursed. The narrator explains here that more common people have been lost on account of arrogance and wickedness than have noble people only because there are more commoners than aristocrats. No one who has lived with usury, false counsel, lack of chastity, or thieving ever came to a good end. The prideful man rules differently from the way he should as he does not wish to be anyone's subject, but he should follow whomever God has appointed as ruler. Otherwise God might punish us by giving us a man who will use wickedness and pride to make us subject to him. The readers are directed to tolerate what their ruler does, whether wicked or good, as the whole world is full of dissent because no one wants to follow anyone else. God gave us a master in order to give our lives direction: that is, the pope who is the head of Christianity after God. If, out of pride, someone criticizes the pope, then he defiles Christianity. Someone criticizing the pope thinks that he will win greater respect on account of his accusations, but that reveals his foolishness. If he is relying on hearsay, then he should remember that people often lie, for the pope would do nothing that might allow the devil to get to him. The pope is supposed to banish the devil, and, as such, he should be trusted to have the good sense not to condemn himself. Since he is a man, he might make mistakes, but if he does something evil without intent, then he is innocent. This is a point that Thomasin declares people unable to accept. For example, when the pope collected money to support the crusade, he did it with the best of intentions. To accuse him

otherwise is foolishness. Thomasin states that he was present when the pope's messenger read the letter publicly. It ordered that the churches keep the money that was collected until it was decided what to do with it. The good man (Walther von der Vogelweide?) thus spoke in arrogance and without just cause when he said that the pope wanted to fill his Italian coffers with German money. Lords, judges, preachers, and poets are here tasked with choosing their words with greater caution. Lords should think about how their words will be received; preachers should speak in a manner that is easy to understand; poets should not lie. Wise men must be very careful to not make mistakes, because people listen carefully to them. People unhappy with the truth are too quick to follow a fool who gives bad advice as it is always easier to say that which some-one wants to hear. For that reason there are so many debased people around who do not counsel people to do anything other than what they like to do. It is easy to advise people not to crusade because it is expensive. Thomasin finishes this section by declaring that if one could be certain of material gain, then there would be a rush to join the crusade (fig. 71).

IX (FvK, 11999–12384): Thomasin at this juncture appeals to German knighthood to go crusading, declaring that they must fight for God and for His holy grave. Describing going on a crusade as a form of crucifix-ion and thus a means by which one may emulate Christ, he declares that martyrs go straight to God upon death. Thomasin cites the twenty-eight years since the loss of the Holy Sepulcher and claims that since then there has only been discord, anger, enmity, envy, fear, hatred, and other sorrows in Christendom. He therefore urges the reader to fight for God.

X (FvK, 12385–12484): Thomasin also calls on the noble princes of German lands to turn their thoughts and actions away from fighting at home and toward the service of the Lord. By fighting for God they will achieve true victory. He further suggests that he who denies God his service is a thief because he owes Him everything. Thomasin then ad-dresses Friedrich II, stating he should end what Emperor Friedrich I (Barbarossa) began. Three is the perfect number; since Friedrich is the third in his dynasty to go on crusade, he can aspire to bring God's com-mand to completion.

XI (FvK, 12485–12876): Thomasin now returns to the topic of immoderation and its related vice, pride. As man has no wings, he will fall if he attempts to fly. Indeed, he who perseveres in his pride will fall in five ways. First he will fall into guilt; second, he will fall from God's grace; then he will fall into hell; then he will fall physically; and finally, he will lose his honor. A proud man will fall into all kinds of vices just as the devil was guilty and fell from God's grace, and then he fell from heaven and into hell. Everyone should live in constant fear of falling, and at the top of the chain of vice is greed and then pride, which often leads to greed. If a man is prideful, then he will become greedy for wealth in order to fulfill his pride. If someone is wealthier than he, then he will be envious, angry, and will hate those who have more wealth. Anger causes him to be unjust, and he will commit falsehood, lying, and perjury. Then he will fall into hell. In this manner, the vices are described as crippling to people; they are the devil's rope with which he drags us to hell. He who wants to avoid pride should think about what he was, what he is, and what he will become. If he does that, then he may be able to whittle down his pride to a more human self-confidence. He should also remember that God desired to become man for the sake of love and humility. Although our Lord has all the virtues in perfect measure, none is more apparent than his humility. People are ultimately instructed to eschew greed, envy, worldly possessions, anger, injustice, and perjury.

PART 9 (FVK, 12877–14218; HR, 12223–13564)

I (FvK, 12877–14218): This book begins with a dispute between Thomasin and his quill. The feather complains and accuses Thomasin of becoming a hermit. It wants to stop working so hard and to rejoin the knights and ladies of the court. Thomasin promises that it won't be too much longer because he's composed eight books in as many months, and he only has two more to go. He tells the quill that he is not writing the book for his own pleasure but because he feels that he needs to respond to his surroundings and give people some guidelines on how to behave. In this part he will address Justice. The quill is silenced.

II (FvK, 13005–13238): This section begins by discussing shields once again and the avoidance of pride. Thomasin reminds us that a shield should not depict three lions and half an eagle as three lions denote excessive pride when one is enough. Similarly, while the eagle represents honor, half an eagle signifies its division. Justice is then described as being everywhere and is defined as moderation, measure, and numeration in all things. Even a lord who is God's judge on earth should fear God, for He is the Highest Judge. If Thomasin were to choose a master, he tells us that he would choose one who fears and honors God. This fear of God should be made manifest by honoring one's mother and father, teaching one's servants, loving one's fellow man, following God's command, and living peacefully with one's countrymen. One should also have pity on the poor. Before the law, poor and rich should be considered equal. Neither anger nor pity should determine a judge's actions, and his countenance should not reveal his state of mind. Poverty should similarly not disadvantage the poor man in a court of law, nor should riches give the wealthy man an unfair advantage. Unfortunately, according to the narrator, in reality things are different. If a biased lord is judging, then he will be influenced by a number of things that make him ignore justice and follow injustice, including compassion, fear, gifts, love, and hatred. That does not mean that a judge should not have compassion, however, but he should judge with a compassion that does not destroy his judgment. If someone has done something wicked and will not make amends, then he should be separated from everyone else; he should receive compassion, but he should also be punished. The judge should also refrain from anger, because if he judges out of anger, then he dispenses revenge and not justice. He should also refrain from laziness and foolishness if he wants to judge fairly. The reader is then informed that it is important to create peace in one's own land by punishing anyone who harbors thieves.

III (FvK, 13239–13348): The qualities required of a judge begin this section with the remark that he who wants to judge properly must have the courage of a lion and the eyes of an eagle, for he must withstand fear and not let bribery or bias influence his point of view. Justice is then defined as having two wings: spiritual justice and worldly justice. If one of the

two wings is missing, then injustice will result. While the two justices co-existed, law in this world was proper and clear. Since one has now given way to the other, however, the reader is informed that justice has become weak and has fallen. The abundance of heretics is blamed on the loss of meaning in the spiritual court. Thomasin then declares that while a foolish man might tell you that one should not force people to believe what is right, he would punish his own child if the child did not live how he thought the child should. However, if someone else's child does something wrong, he would never think to discipline it. The church should behave in the same way and should raise its own children and let others be raised by their own fathers. Why should the church force the Jews to do something? They do not stand in her protection. Heretics on the other hand should be forced because they became children of the church when they were baptized. If spiritual judgment does not help, then worldly judgment should step in. Similarly, if spiritual and worldly judgments do not support one another, justice will fail.

IV (FvK, 13349–13646): The reader is informed that we see treachery, avarice, anger, and envy everywhere. For that reason, envy and anger make people hate each other much like the clerics and the laity because each one of them believes that the other has it better. The cleric is envious of the knight's beautiful wife and his freedom to enjoy jousting, while the knight is envious of the cleric's comfortable life. The cleric also grows angry with greed when he sees an uneducated man acquire more wealth, whereas the layman is angry because he works hard but the priest is wealthier than he. Hatred and envy rule the day, and therefore justice has become injustice, and what is crooked has become straight, because secular and ecclesiastical courts do not support one another. The clerics and the laity have become blinded by their hatred. This is not courtly behavior. Thomasin directs his readership to consider their own faults before criticizing others. Someone who sees another's lechery should recognize his own laziness, or his anger, drunkenness, greed, or pride. He who recognizes the sins of others and criticizes them should also acknowledge his own sins and try to improve himself (fig. 72). Drunkenness, Unchastity, Anger, and Pride are Madness's children. Similarly, he who is responsible for spiritual judgment should not

judge worldly matters, and vice versa, unless he has by law both offices. The readership is then informed that no layman should ever hold an ecclesiastical court, nor should a bishop—if a duke—administer worldly justice. A lord is also tasked with travelling around his land enacting justice. If a lord loses heart, he is required to turn to God to become renewed, so that he is able to continue to govern his people and land properly. In his efforts he should be fearless and should remember that if he fights for justice with humility he will never be overcome. He who has acted against God's will should also take example from the lion that erases his tracks so that the hunter is unable to pursue him. The lord should similarly erase his sins by confession and good deeds, and he should fulfill God's command and be a good example to his people.

V (FvK, 13647–13846): A lord should also not act without thinking. Just like the newborn lion that sleeps for three days before being awoken by his father, the lord should follow three steps in counsel: he should listen, he should judge which advice is best, and he should make a decision. Then he should act quickly. The lord should listen to what the poor, the rich, the young, and the old have to say. After listening, he should think about who gave the best advice. He should not reveal which advice he plans to take too quickly or he will lose control over that advice. He is also tasked with seeking advice from someone who has experience. If they listen, then a young man and a poor man can learn more than an old man and a rich man. The lord should listen to everyone (the young, poor, rich, and old) and differentiate the fools from the wise. To illustrate this, Thomasin offers the analogy of a wooden sculpture covered with gold and jewels. While people might be attracted to such a sculpture they cannot gain much advice from it. A wise lord should further encourage the man who advises him so that he speaks without fear. One should also not pressure an advisor to speak too quickly, but allow him time to think. Advisors, for their part, should speak their minds. They should also allow the wisest man to speak first and are required to not argue amongst themselves.

VI (FvK, 13847–14066): This section begins with the declaration that sound advice is crucial for a court of law. A court of justice should be based solely on justice and should not exist for any other reason. It

should also not be based on profit, friendship, or fame. The narrator also suggests that injustice abounds when justice is not done. A lord is counseled not to threaten excessively. Thomasin relates the fable about the fate of the donkey Baldwin to illustrate the point that one should use threats only sparingly, and act on them if necessary.

VII (FvK, 14066–14218): Finally, the reader is informed that one should not believe everything that one hears, because this will result in three kinds of injustice. The first is that one will act incorrectly due to one's ignorance; the second is that one intentionally commits an injustice; the third is that one will not prevent an injustice. The first kind of injustice, which is acting in ignorance, stems from foolishness, rashness, and laziness. It can also come from anger, hatred, or love. If a lord unknowingly behaves unjustly, then he should not acknowledge it but should put it right immediately. We are told that someone who intentionally behaves unjustly often does so out of greed, fear, vanity, hatred, or envy. The man who is intentionally unjust often behaves in such a manner impulsively out of such emotions as anger, hatred, or fear. The third kind of injustice is often the result of idleness. Sometimes people do not oppose injustice because they are preoccupied with their own affairs. This is described as unwise. The reader is ultimately encouraged to assist justice in whatever way possible as it will clear the path to heaven.

PART 10 (FVK, 14219–15280; HR, 13565–14752)

I (FvK, 14219–14314): Thomasin promises his quill that he is almost finished and his last book deals with generosity. If one gives according to Justice, then one gives fairly and equally. Generosity, however, does not give equally but gives to each according to his worth. While Justice gives us joy and sorrow in its bestowing of judgment, Generosity only gives people joy. She is the virtue that makes people's lives together beautiful, whereas justice is what makes people's lives together possible. Generosity enhances justice.

II (FvK, 14315–14592): Thomasin states that Generosity was left to the end because it is the ultimate virtue and should therefore be preceded

by the others. The other virtues are, however, meaningless if they are not accompanied by Generosity. Generosity is the lady of the virtues, and, just as a lady's company precedes her leaving the chamber, so too does Generosity come last, after all of the other virtues (fig. 73). People are encouraged to be generous from their hearts—and not for the sake of gain—throughout their lives. Indeed, someone who demonstrates true generosity in his youth will have it for the rest of his life, which is a quality unique to this virtue. Generosity is constant, and, as a virtue that is always present completely in one's heart, it is truly virtuous. Similarly, a vice that fills one's heart is truly a vice. Generosity's well-tempered nature is contrasted with the vice of greed/avarice. Generosity is greed's opposite. It is a pure virtue and one should always aspire to it. Since Generosity completes the virtues and adorns youth, Thomasin has placed his discussion of her at the conclusion to his book.

III (FvK, 14593–14712): Thomasin addresses the questions of whether a person who has nothing can also be generous, and how one should give if one wants to give justly. Generosity is rooted in a noble spirit, and therefore merely giving things is not generosity. The reader is then informed that gifts may be a sign of false or true generosity. If a gift is an expression of a generous intent, for example, then it is a sign of generosity and excellence. If it is otherwise motivated, then it is a false sign. A poor man born to be generous is described in the work as like a man without a seal since no one will believe his letter because the seal is missing. For that reason people are not willing to call him generous. If a person has no means, then it is impossible for him to show his generosity. But if he has generosity in his nature, then he is no less virtuous than the man who can give evidence of his generosity by giving. Like the sun that shines above the clouds while it remains dark below them, generosity makes a poor, generous heart bright, but it is not able to show its brightness. The clouds are the poverty that darkens the light so that it is not able to shine forth.

IV (FvK, 14713–14912): Continuing on the theme of generosity, Thomasin declares that today it counts for generosity when someone gives that which he has stolen or won by other unsavory means. Due to greed, people are unable to distinguish between what is generous and

what is not. Thomasin warns that someone who does not recognize that it is not generosity when a man gives unjustly acquired goods for the sake of his reputation mistakes vice for generosity. Since generosity is a child of justice, one never finds it together with injustice. Similarly, the reader is informed that if a man gives gifts so that he will later receive something himself, then his gift is not a result of generosity but of greed. People are tasked here to consider when a gift is appropriate, who the recipient is, and what his circumstances are. For example, Thomasin suggests giving rich people rare things and poor people things that are useful to them. He advises that the man who wants to give wisely should give moderately according to his own means. He declares that the man who squanders his wealth is his own thief and will similarly rob others; in other words he will take things from others unjustly in order to give. The reader is reminded here that virtue should hurt no one; but vice is harmful. Generosity should also harm no one. Listing what various people should consider giving, Thomasin suggests that a knight may use up his whole annual income, but a prince should put something into his treasury every year so that, if he must go to war to protect his country, then he will not have to take more from his friends than his enemies. The reader is also warned, however, that hoarding wealth can lead to abuse. Lords are also told to beware that people will try to lure them with compliments into thinking that foolishness is generosity and greed is wisdom.

V (FvK, 14913–15056): The time limit involved in demonstrating one's generosity is considered in this section. If one gives quickly, then one gives a lot with a little because one prevents the recipient from feeling shame. In that sense, one gives twice as much. If a man is forced to give by begging, however, then he will not give out of generosity but to make his life easier. He who gives joyously, on the other hand, whether it be a little or a lot, gives enough, because a good heart always makes a gift appropriate. By contrast an ignoble frame of mind will make even a large gift unappealing. The reader is told to make it obvious that he likes to give and accompany his gift with his good will and intent. Generosity does not describe the man who thinks about receiving a gift in return or gives gifts in order to receive, for he is a merchant and a scoundrel, and certainly not generous. If one wants to give out of generosity, then one

should not think about how indebted the recipient is. The nature of generosity is defined as giving, while greed is taking. For that reason it is irrelevant to generosity if she is not repaid in kind. No one should stop being generous just because the recipient is ungrateful. If you stop disciplining your child because it brings you sorrow, or avoid the sea and the wind because it annoys you, then you are a complete coward. This section ends with the declaration that a noble mind should be prepared to lose and yet continue to do what is right.

VI (FvK, 15057–15238): Ungratefulness is tackled in this section and is said to stem from a man who has made a promise to give something but delays in doing so. If someone is left with only hope, then it will soon turn to ungratefulness. A promise to give should not keep the other person waiting; nor should one refrain from giving everything that was promised. Similarly, the reader is counseled to quickly forget what was given, but always remember what he has received. The giver should also be silent; the receiver should proclaim his joy. To avoid turning gift-giving into a business transaction, the generous man is implored to receive as if he had never given a gift. Similarly, a person should always think highly of that which was given to him with good intent irrespective of its size or worth. That is generosity. It is not good to feel indebted to a wicked person, but one should enjoy being indebted to a friend. The reader is further encouraged not to reciprocate too quickly in case he reveals that he does not wish to be indebted to someone. Just like a good field produces a harvest only at certain times, so too should the generous man wait for the appropriate opportunity to repay his debts and to give. If a man has nothing material that he can give, then he can still give his generous spirit. Many people are in the habit of avoiding someone who once did them a favor if they do not have the means to reciprocate. That comes from great cowardice and shows that they don't know what generosity is. This section ends with the claim that generosity makes no demands.

VII (FvK, 15239–80): The etiquette of public or private gift-giving is discussed here. Honorable gifts and courtly gifts (such as falcons or hounds) are encouraged to be given publicly, whereas anything that alleviates poverty, such as money, should be given secretly because it

does not honor the recipient but only makes his life more bearable. Thomasin instructs his readers never to give anything that might cause someone shame or harm, nor anything considered useless or meaningless. A woman should not be given weapons. Gifts that last a long time are considered best by Thomasin because the friendship with which one gives them should also be durable.

VIII (FvK, 15281–15406): Thomasin finishes his work with further instructions as to the uses of his book. A book ought to be long-lasting, and as such Thomasin offers this book to anyone who is virtuous and whose friendship he would enjoy, so that he may use it to guide his good behavior. People lacking courtesy, on the other hand, should not use the book because no teachings have the power to make virtuous those who are by nature unvirtuous. Proper behavior is deemed so important by the narrator that in spite of a person's laziness it is impossible to completely eradicate his potential for virtue if he has the good sense to behave properly. Instruction can only awaken one's good sense, however, it cannot create it. For that reason no one should give this book to his girlfriend, his liege lord or lady, or his friend unless they demonstrate some evidence of virtue.

The title of the work—the *Welscher Gast*—is explained as denoting that Thomasin is the Germans' guest. He tells his book that it is his messenger that he sends into the world. He, the book, should not board with a scoundrel. If this happens unwittingly, then he should get away as quickly as possible. The goal of the book's journey is to find righteous people: skilled knights, good women, and wise clerics who will look at it. An evil man would not look at the book for long before throwing it in a trunk. Thomasin then tells his book: "Be warned, *Welscher Gast*! You can recite the Lord's Prayer to the wolf all day long, but he'll still only answer 'lamb.'" (fig. 74). It is the same with an evil man. Whatever one says to him, it goes in one ear and out the other. This book is meant to improve a man who is constant in heart and mind. The text concludes with the formula: "I end you here: may God allow that we live an everlasting life on account of the three holy names, Father, Son, Holy Ghost. Amen." The following rubric allows us to date the manuscript's completion to August 18, 1340: "Finito libro sit laus et gloria Christo. Anno domini m° ccc° xl°. feria sexta post assumpcionem beate Marie gloriose virginis."

APPENDIX 3

Gotha Memb. I 120 and Its Image Cycle (Figs. 1–77)

THE CODEX

Gotha Memb. I 120 is housed in the Forschungsbibliothek Gotha/Erfurt. The codex comprises 102 parchment pages that measure 32 by 23.5 centimeters.[1] The text begins with the prose foreword on folio 2r and ends with a dedication image on folio 101r. The pages have been lined with ink. The area of the page covered by the two columns of script measures 23–25 by 16–16.5 centimeters. The number of lines in each column varies from 38 to 44. The evenly written text in Gothic *textualis* is the work of a single scribe who also rubricated the manuscript and inscribed the labels and banderoles of the illustrations. The first initial of each verse is offset and decorated with a stroke of red ink. This scribe also dated the manuscript on August 18, 1340 on folio 99rb: "Finito libro sit laus et gloria Christo. Anno domini m° ccc° xl°. feria sexta post assumpcionem beate Marie gloriose virginis."

The manuscript's gathering structure is entirely consistent: $(III+1)^7 +$ 11 $IV^{95} + (III+1)^{102}$. The prose foreword is written a little larger, more carefully, and with lighter ink than the rest of the text. It showcases the system of indexing and division into subsections used throughout the manuscript: parts are marked by two- to five-line rubricated initials; chapters are marked by single-line rubricated Roman numerals and

1. For a more detailed description of the codex and its history, see Eisermann, *Die Handschriften.* I rely heavily on his codicological description but have verified it in my own examinations of the manuscript.

initials integrated into the text. Within the poem the parts are marked by eight- to nine-line red or red and blue decorated initials and rubricated textual transitions. Only four large initials were completed (18vb, 24va, 35rb, 85vb). Subdivisions are marked with two- to four-line red initials, Roman numerals, and paraphs. I address the significance of these subdivisions and the indexing apparatus in chapter 1.

THE IMAGES

The present section contains all of the illustrated pages of the Gotha manuscript in addition to the first page of the prose foreword. All images in this appendix have been reproduced with the kind permission of the Forschungsbibliothek Gotha/Erfurt. It further contains descriptions of the illustrations and their relationship to the corresponding text.[2] I have included line numbers that correspond to the manuscript edition published by Friedrich von Kries (FvK). Von Kries's study is the only published edition of the Gotha manuscript, but, because it is out of print, I have also included the line numbers for the more readily available editions of Heidelberg Cpg 389 by Heinrich Rückert and Raffaelo Disanto (HR). I have additionally included von Kries's illustration numbers for easy cross reference.

Most scholars follow Friedrich von Kries in identifying 120 illustrations in the Gotha manuscript. However, von Kries's numbering system is misleading, as he typically divides large illustrations into smaller individually numbered units. His illustrations numbered 4–8, for example, are actually part of a single large illustration (fig. 2). Similarly while the individual miniatures of the seven liberal arts (von Kries 101–7) are separated by frames, I would argue that they comprise a single illustration (fig. 68). The illustrations that von Kries numbers 64 and 65 are two halves of the same image divided visually in the manuscript by an architectural element (fig. 38). Finally, like the liberal arts, the virtuous ladies (von Kries 115–19) are separated by frames, but they are clearly part of a single larger illustration (ill. 103, in both fig. 75 and 76). I identify 105 illustrations, including the dedication image.

2. For manuscript variation, see Thomasin von Zerclaere, *Der Welsche Gast*, ed.von Kries, vol. 4.

PROSE FOREWORD (FVK, 1–610)

Fig. 1: fol. 2r
First page of the prose foreword. This illustration demonstrates the tiered organizational structure of the foreword, which is actually a coded description of the entire work. Large initials identify the beginning of the descriptions of the ten parts; small initials and Roman numerals mark the beginnings of chapters. Initials inserted as headers (here "A") indicate which part the viewer is currently reading.

Fig. 1. 2r

PROLOGUE (FVK, 611–754; HR, 1–140)

Fig. 2: fol. 7v
Illustration 1 (von Kries 4–8)
In the first register, the virtues of "constancy" (*stete*), "moderation" (*maze*), "justice" (*recht*), and "generosity" (*milte*) are personified as knights paying homage to their liege lady, "virtue" (*div tůgend*), enthroned on the left. She tells them: "Drive off the vices" (*tribet vz die vntugende*). On the right, the corresponding personified vices "avarice" (*erge*), "injustice" (*vnreht*), "immoderation" (*vnmaze*), and "inconstancy" (*vnsteh*) pay homage to the personification of "vice" (*vntugend*), who instructs them: "Protect yourselves against the virtues" (*Weret euch vaste der tůgende*). In the second, third, and fourth registers, the virtuous knights pursue and unseat the vices in single combat. This illustration does not appear in the earlier manuscript (Heidelberg Cpg 389). It corresponds most closely to a brief passage that appears in the Gotha redaction of the poem but is missing from Heidelberg Cpg 389 in which Thomasin remarks that Baseness will be dealt with in such a manner that it will flee the virtues and depart from his book (747–50).

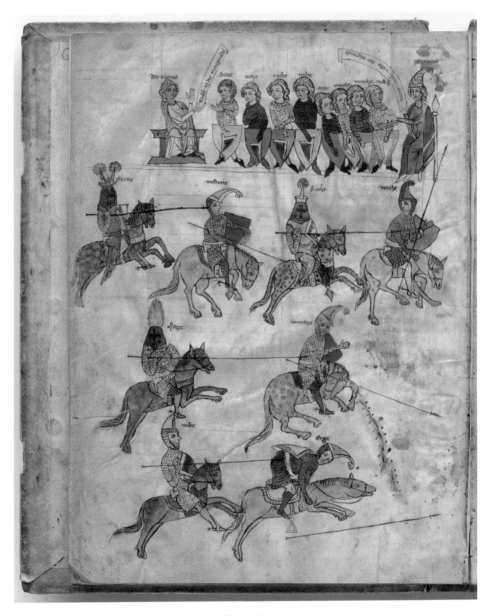

Fig. 2. 7v

Fig. 3: fol. 8v
Illustration 2 (von Kries 1)
Text summary (FvK, 689–96): Good and evil people cannot tolerate each other.
Illustration: The unlabeled central figure in blue is generally assumed to represent the narrator. He appears to be warning "the righteous man" (*der frv̊m man*) on the right about the danger of "treachery" (*bośheit*), which is personified as a courtier dressed in particolor on the far left. Treachery tells his servant "the scoundrel" (*der bośwı̊cht*) to "wreak all kinds of havoc" (*Flv̊ch allerslacht vngemach*). The scoundrel tells his master: "I am happy to do as you command" (*Ich tvn gern swaz ir gebietet*). On the right the righteous man has overcome "the scoundrel" (*der boświhte*), who now lies beneath his feet. The righteous man points out: "You are beneath my feet" (*Dv bist vnder meinen fv̊zzen*).

Illustration 3 (von Kries 2)
Text summary (FvK, 697–702): Thomasin hopes that the German lands will receive his work as a good "lady of the manor" (*hv̊sfrowe*) would because it offers much instruction on good breeding.
Illustration: A messenger delivers a codex to "the German language" (*div tv̊tsche zvnge*), personified as a courtly lady seated in an alcove in front of her castle. She asks whether Thomasin is sending it to her (*Sendet mir tomasin daz*). On the codex is written: "He is called the Italian guest" (*Der hiez wellischer gaist*). The messenger is inscribed with the Latin label: *tam effiticus* (I completed this).

Illustration 4 (von Kries 3)
Text summary (FvK, 747–50): Proper instruction will force baseness to flee from virtue and to avoid this book.
Illustration: Diligence and laziness are personified as knights. "Diligence" (*vnmv̊zz*) drives away "Laziness" (*div mv̊zze*) with his whip raised saying "out, out Laziness" (*vz v̊z mv̊zze*), while Laziness responds "Alas, is someone now attacking me?" (*Owe sol mans nv̊ an mir heben*).

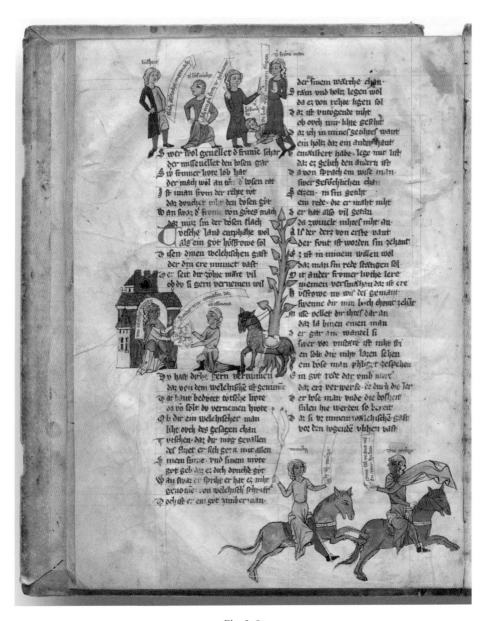

Fig. 3. 8v

PART 1 (FVK, 755–2308; HR, 141–1704)

Fig. 4: fol. 9r
Illustration 5 (von Kries 9)
Text summary (FvK, 755–74): Young people should not be lazy. If one has nothing to do, then one should always at least speak, think, and act properly.
Illustration: "Laziness" (*tracheit*) is poked from the back by "Righteousness" (*frvmcheit*) and pulled by "Touch" (*sensus tactus/Gervͤrde*). Righteousness tells Laziness, "Get up, Laziness" (*Stant vf dv tracheit*). Laziness responds: "But it is not yet day" (*Ja ist iz noch nicht tach*). The seated figure in red is labeled "Treachery" (*bôsheit*), and he encourages Laziness to: "Sleep for a while" (*Lig stille ein wile*).

Ꜣ

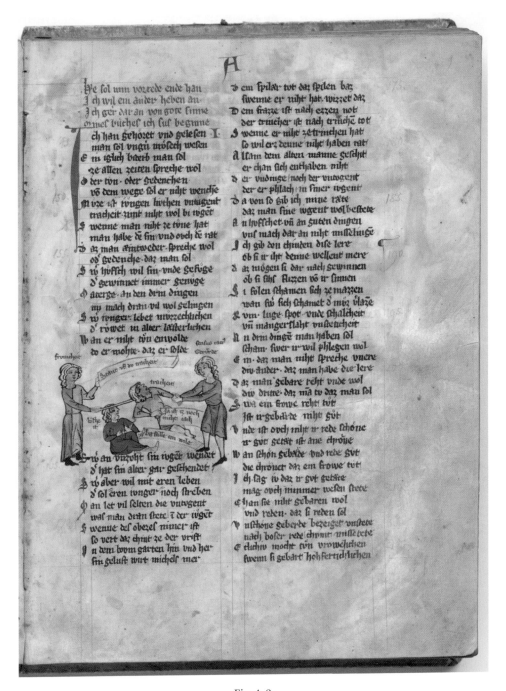

Die sol um vorrede ende han
Ich wil ein ander heben an
Ich ger dar an von gote sinne
ornes büchel ich suf beginne
ich han gehoret vnd gelesen
man sol vngü troslich wesen
Ein iglich bderb man sol
ze allen zeiten spreche wol
Der tün · oder gedencken
vo dem wege sol er niht wencke
Sin ere ist tvngen lichten vntugent
tracheit zimt wol bi twgent
Swenne man niht ze tüne hat
man habe de sin vnd ovch de rat
Daz man èintweder spreche wol
od gedencke daz man sol
Sw hüfsch wil sin vnde gefüge
der gewinnet immer genüge
Der averze an den drin dingen
im mach dran vil wol gelingen
Swo tvnger lebet vnvzehtlichen
der rowet in alter lasterlichen
Wan er niht tün enwolde
do er mohte daz er solde
Swo an vnzoht sin iveer wendet
der hat sin alter gar geschendet
Sw aber wil mit eren leben
der eren tvnger noch streben
Gan let vil selten die vntugent
was man drin stete t der twgent
Swenne des oberez nimer ist
so vert daz chint ze der vrist
In dem boym garten hin vnd har
sin gelust wirt michels mer

fronschat
Stant vf dv tracheit
tracheit
Laz tz noch niht nach
Berfalle ein wile

Der em spilar tvt daz spilen baz
swenne er niht hat · wizzet daz
Dem frazze ist nach ezzen not
der trincher ist nach trincke tot
So wenne er niht ze trincken hat
so wil erz denne niht haben rat
An dem alten manne geschiht
er chan sich enthaben niht
Der er vudruge / noch der vnvgent
der er phlach in siner iugent
Da von so gib ich mine rate
daz man sine twgent wol bestate
An hoffschet · vn an guten dingen
vnf nach dar an niht misselinge
Ich gib den chinden dise lere
ob si ir iht denne wellent mere
Daz mügen si dar nach gewinnen
ob si sich sezzen vo ir sinnen
Si solen schamen sich ze mazzen
wan siw sich schamet d miz blaze
Vmb luge spot · vnde schalcheit
vn mangerslaht vnbescheit
An dem dingen man haben sol
scham siwer ir wil phlegen wol
Eins · daz man niht spreche vnere
div ander · daz man habe die lere
Daz man gebare reht vnde wol
div dritte · daz ma tv daz man sol
Swa ein frowe reht tvt
ist ir gebaide niht güt
Vnde ist ovch niht ir rede schöne
ir güt getsit ist ane chröne
Wan schön gebäide vnd rede güt
die chröuet daz ein frowe tvt
Ich sag iw daz ir güt getsire
mag ovch nimmer wesen stete
Chan sie niht gebaren wol
vnd reden · daz si reden sol
Vnschöne gebeide bezeiget vnstete
nach boser rede chvnt wille tete
Etlichv mocht tvn vrowechhen
swenn si gebart hohfertichlichen

Fig. 5: fol. 9v

Illustration 5 (von Kries 10)

Text summary (FvK, 799–842): He who boasts, lies, and scorns others is not free. It is the law of good conduct that no one should mock anyone else, and that women and men should not lie to each other. Boasting is the greatest evil; it is never separated from mockery. Lying is always close by.

Illustration: "Lying" (*Lv̊ge*), "Boasting" (*Rv̊m*), and "Mockery" (*spot*) stand on the left; an unlabelled courtly lady stands on the right with her head turned toward the vices. Lying tells Boasting: "Say 'I have had her'" (*sprich ich han si gehabet*). Boasting replies: "I love her" (*da ist si mir gar holt*). Mockery looks at Boasting and remarks, "See how she gawks at you?" (*sich wie si dich anchapphet*). The young lady asks: "Why is he pointing at me?" (*Wes zeiget der an mich*).

Illustration 6 (von Kries 11)

Text summary (FvK, 835–38; 848–52): The law of good breeding dictates that men and women should not lie to one another; a man should keep in mind that he either speaks the truth or breaks his oath.

Illustration: A man takes an oath of faithfulness to his lady: "See my faithfulness in my hand" (*Se mein trïwe in di hant*). The lady responds: "I believe you" (*Ich gelovb dir wol*).

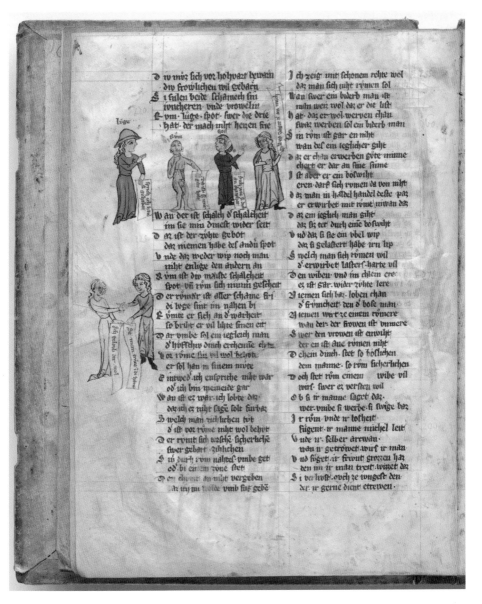

der wir sich vor hochvart bewarn
diu frowlichen wil gebarn
si sulen beide schameth sin
wucheren vnde vrowelin
c. vm luge spot swer die drie
hat der mach niht herzen sine

Lüge

Sin

Gott

Ich zeige mit schonem rehte wol
daz man sich niht rumen sol
Wan swer ein biderb man ist
man weiz wol daz er die list
hat daz er wol werben chan
swaz werben sol ein biderb man
in rum ist gar en niht
wan des ein teglicher gilt
daz er chan erwerben gute minne
chert er dar an sine sinne
Ist aber er ein bosewiht
eren darf sich rumen da von niht
daz man in haldel handel deste baz
er erwurbet mit rume niwan daz
daz ein iteglich man siht
daz si zer durch eine bosewiht
vnd daz si sie ein vbel wip
daz si gelastert habe irn lip
Swelch man sich rumen wil
der erwurbet lasters harte vil
den wiben vnd im chlein cre
er ist gar wider zuhte lere
Niemen sich baz loben chan
der frumcheit den d bose man
Niemen wurze einem romere
wau der der frowen ist vnmere
Swer den vrowen ist entwust
der en ist ane rumen niht
dechein diuch stet so boslichen
dem manne so rum sicherlichen

Wan der ist schalch d schalcheit
im sie min dinest wider seit
der ist der zuhte gebot
daz niemen habe des andrn spot
Vnde daz weder wip noch man
niht entluge den andern an
Rum ist diu meiste schalcheit
spot vn rum sich mumi gescheit
der rumar ist aller schande si
diu luge sint im nahen bi
Rumet er sich an d warheit
so brust er vil lihte sinen eit
War vmbe sol ein iegleich man
d hoschiu dinch erkenne chan
doz rume sin vil wol beholt
er sol han in sinem mvte
enweder ich entspriche niht war
od ich bin meneide gar
Wan ist er war ich lobte daz
daz ich niht sage solt furbaz
Swelch man richlichen tut
der ist vor rume niht wol behvt
der rumt sich rathse sicherliche
swer gebart zuhliehen
Swer durch rum nahtes vmbe get
od bi einem zune stet
den enwil ich niht vergeben
daz im die wilde vmb sus gebe

doch stet rum einem wibe vil
wirs swer er verstan wil
Ob si ir manne saget daz
wer vmbe si werbe si swige baz
Ir rum vnde ir toheit
fügent ir manne michel leit
Vnde ir selber arewan
wan ir getrowet wuf ir man
Vnd saget ir si wut grozzen haz
den im ir man treit wizet daz
Si ir verlust ovch ze wngese den
der ir gerne dient etrewen

Fig. 5. 9v

Fig. 6: fol. 10r
Illustration 7 (von Kries 12)
Text summary (FvK, 911–40): Some courtly children behave in a manner that ill befits their noble breeding. These base youths go to the inn and drink and order so much for their friends that they have no money left and are forced to leave their cloaks behind as payment. They then gamble for more wine and think that they are avoiding stinginess, but instead they become guilty of gluttony. Foolish children thus try to avoid one vice by embracing another.
Illustration: The child stands in the middle with his back to "Avarice" (*Erge*), portrayed as a married lady sitting on a chest and holding a purse. She says: "Look here, see what I am doing" (*Wiz hie sich waz ich tv*). The child turns instead toward "Gluttony" (*Lecherheit*), personified as a young lady. He says, "I don't want to be stingy" (*Ich wil niht arc sin*). Gluttony, who receives him with open arms, tells the cook (der choch): "Prepare a sauce for him" (*berait im ein salse*).

Illustration 8 (von Kries 13)
Text summary (FvK, 971–76): Noble children should always think about the well-behaved knights at court and aspire to be like them. If someone is not able to take note of what he sees, then he will never learn to be courtly. Teaching such children courtliness is like trying to teach a bear how to sing.
Illustration: A courtier places his hand on the head of a small bear. His banderole cannot be deciphered, but it appears to contain musical notation.

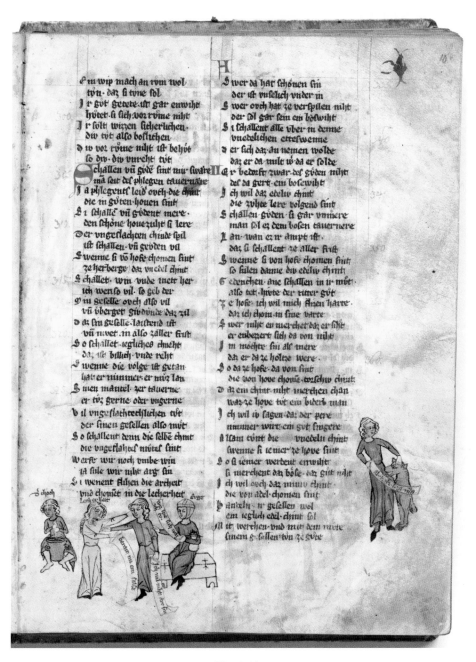

ein wip mach an rem wol
tvn· daz ſi tvne ſol
Ir gut getete iſt gar enwiht
hvret ſi ſich vor rume niht
Ir ſolt wizzen ſicherlichen·
div tut alſo boſlichen
Div vor rume niht iſt behut
ſo div div vnreht tut
Schallen vn gude ſint mu· ſwære
man ſeit daz pfleget tauernære
Ia pflegent leid ovch die diut
die in guten houen ſint
Si ſchalle vn gudent mere·
den ſchöne hovezuht ſi lere
Der vngeſlachten chinde ſpil
iſt ſchallen· vn gruden vil
Swenne ſi vo hofe chomen ſiut
ze herberge daz vuedel chiut
Schallet· win vnde mett her
ich wenſ vil· ſo geb der
Sin geſelle ovch alſo vil
vn vbergev gib dvnde daz zil
Daz ſin geſelle laſchend iſt
vn nvvet· in alſo zaller friſt
So ſchallet iegliches chmeht·
daz iſt billich vnde reht
Iwenne die volge iſt getan
hat er nimmer· er niz lan
Sien mantel zer tauerne
er tv· gerne oder vngerne
Vil vngeſlachtreliſlichen tut
der ſinen geſellen alſo mut
So ſchallent denn die ſelbe chint
die vngeflahheſ mvtel ſint
Werft wir noch vmbe win
ia ſule wir niht arg ſin
Si wenent fliehen die arheit
vnd chomet in die lecherheit

Iwer da hat ſchonen ſin
der iſt vnſelich vnder in
Swer ovch hat ze verſpilen niht
der ſol gar ſein ein boſewiht
Si ſchallent alle vber in denne
vnedelichen etteſwenne
der ſich daz du nemen wolde
daz er da mite iw da er ſolde
Er bedarf zwar· deſ guden niht
deſ da gert· ein boſewiht
Ich wil daz edeliv chint
die zuhte lere volgend ſint
Schallen gruden· ſi gar vnmere
man ſol es dem boſen tauernere
Lan· wan er iz ampt iſt·
daz ſi ſchallent ze aller friſt
Iwenne ſi von hofe chomen ſiut
ſo ſulen danne div edeliv chint
Gedenchen ane ſchallen in ir mut
alſo tut hivte der ritter gut
Ze hofe· ich wil mich fragen harte
daz ich chom in ſine varte
Swer niht eu merchet daz er ſihit
er enbezert ſich da von niht
Im mochte ſin alſe mere
daz er da ze holtze were
So da ze hofe· da von ſiut
die von hove chonu torſchu chiut
Daz ein chint niht merchen chan
waz ze hove tut ein bider man
Ich wil iu ſagen daz der pere
nimmer wirt ein gut ſingere
Alſam tunt die vnedeln chint
ſwenne ſi iemer ze hove ſint
So ſi iemer werdent enwiht
ſi merchent die boſe daz gut niht
Ich wil ovch daz mimv chint
die von adel chomen ſint
Anxeln ir geſellen wol
ein iegulch edil chint ſol
Iz merchen· vnd miu dem rate
ſinen geſellen tvn ze gute

Fig. 7: fol. 11v
Illustration 9 (von Kries 14)
Text summary (FvK, 1203–12): Fear will help children to learn to think, act, and speak properly.
Illustration: The naked child is portrayed in the center (*daz chint*). On the left, "Good Conduct" (*div zv̊ht*) tells the child: "Behave properly and well" (*Gebart reht vnd wol*). Next to her, the seated "master" (*Der meister*) thrashes the child with a switch instructing him: "Do as good conduct commands" (*Tv̊ swaz zvht gebiete*). The child responds: "With great pleasure, master" (*vil gern maister*). Fear is personified as a lady dressed in green (*div vorcht*). She stands behind the child with her left hand stretched out toward him and tells him: "Remember it well, if you want to prosper" (*Merchez wol wiltu genesen*).

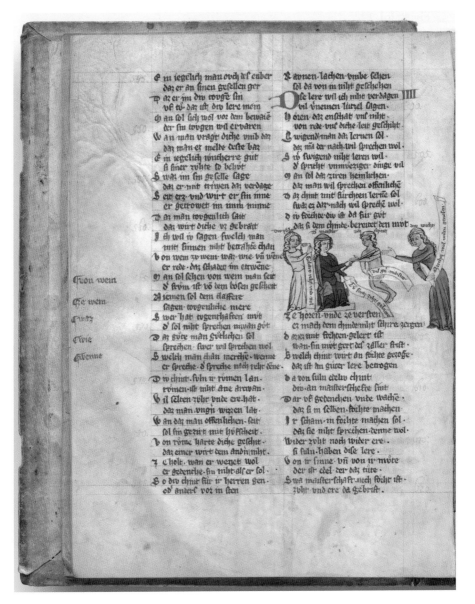

Fig. 7. 11v

Fig. 8: fol. 12r
Illustration 10 (von Kries 15)

Text summary (FvK, 1253–58): A child should always behave as if a stalwart man were watching him. This will enable him to better avoid shameful behavior, because if he starts to misbehave, then he will feel ashamed.

Illustration: An imagined "wise man" (*der wise man*) is seated on the left. The young man (*Der iv̊nchre*) inquires, "Are you there master?" (*Sit ir da maister*). The wise man responds, "I see it very well" (*Ich sihe iz vil wol*).

Note: In most of the redactions of this image, the young man's banderole reads: "Do you see that, Master?" The master's response here would correspond better to this question, but the version in the Gotha manuscript actually corresponds more closely to the text.

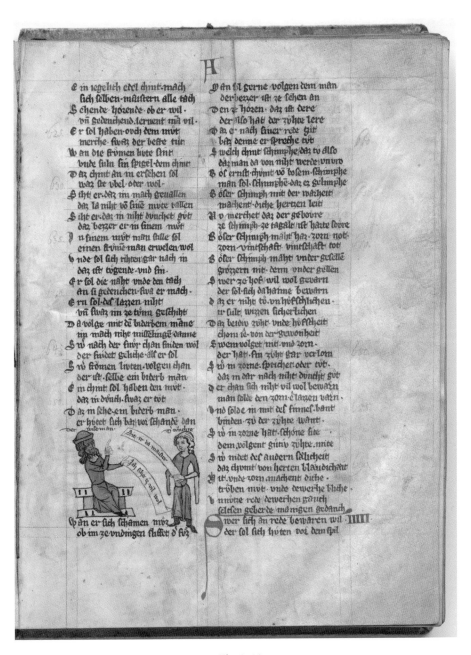



E in iegelich edel chint mach
sich selben múttern alle tach
S chende hörende ob er wil
vn gedenchend lernent man vil
E r sol haben ouch dem mvt
merche swaz der beste tút
W an die frômen lute sint
vnde suln sin spigel dem chint
D az chint an in ersehen sol
waz sie vbel oder wol
S ihte er daz im mach gevallen
daz la niht vo sinn mvte vallen
S iht er daz in niht dúnchet gút
daz bezzer er in sinem mvt
J n sinem mvt man stille sol
einen frvmen man erwelen wol
v nde sol sich rihten gar nach in
daz ist tvgende vnd sin
E r sol die næht vnde den tach
an si gedenchen swa er mach
e rn sol des lazzen niht
vn swaz im ze tvnn geschiht
D a volge mit dú biderbem mânne
im mach nihe missehinge danne
S w nach der fiur chan finden wol
der faidet geliche als er sol
S w frômen luten volgen chan
der ist selbe ein biderb man
e m chint sol haben den mvt
daz in dúnchet swaz er tvt
D az in sehe ein biderb man
er hvtet sich daz voi schande dan

der vinster man v vnder

ch an er sich schamen mvz
ob im ze vndirgen flatter d fúz



v an sol gerne volgen dem man
der bezzer ist ze sehen an
D en ze höien daz ist dere
der also hat der zúhte lere
D az er nach siner rede gút
baz denne er spreche tút
S welch chint schimphe daz tv also
daz man da von niht werde vnvro
B ol ernst chvmt vo bôsem schimphe
man sol schimphe daz ez gelimphe
B ôser schimph mit der warheit
machent diche hertzen leit
v v merchet daz der geboire
ze schimph ze tagale ist heute lôvre
B ôser schimph mäht haz zorn not
zorn vintschaft vintschaft tot
B ôser schimph mäht vnder geselle
grözzern nit dem vnder gellen
S wer ze hof wil wol gewarn
der sol sich dahinne bewarn
d az er niht vo vn hvfschlichen eu
ir sult wizzen sicherlichen
D az beidiv zúht vnde hvfscheit
chom ie von der gewonheit
S wem volget nit vnd zorn
der hat sin zúht gar verlorn
S w im zorne spricher oder tvt
daz in dar nach niht dúnchet gút
d er chan sich niht vil wol bewarn
man solde den zorn e lazzen varn
v nd solde in mit des sinnes bant
binden zv der zúhte wänt
S w in zorne hat schöne site
dem volgent gútiv zúhte mite
S w nidet des andern sælicheit
daz chvmt von herten blavdicheit
H it vnde zorn machent diche
tröben mvt vnde dewerhe bliche
v nvitze rede dewerhen gdanch
selsen geberde maningen gedanch
S wer sich an rede bewaren wil IIII
der sol sich hvten voi dem spil

Fig. 8. 12r

Fig. 9: fol. 12v

Illustration 11 (Von Kries 16)

Text summary (FvK, 1299–1322): Someone who wants to converse properly should avoid gambling because it causes one to speak in an uncourtly manner and it goes against the rule of good conduct. Even if a man loses what was his, then he shouldn't go on and on about it. Gambling causes hatred and anger, greed, and avarice.

Illustration: In the center two men, "the gambler and his companion" (*der spilere vnd sin geselle*), play dice. On the left "Justice" (*Daz recht*) holds a set of scales and announces: "He is doing you wrong" (*Er tůt dir vnrechte*). The gambler responds: "But ask him now" (*Nv frage doch in*). The other player hands his opponent an object that appears to be a red dice cup and wagers the clothes off his back saying: "He raised the stakes" (*Er hat mir fůr gesatzt*). Directly behind him, the figure of "Greed" (*girde*) tells him "Play for your coat; you will win" (*spil vf den roch dv gewinnest*). "Anger" (*zorn*) whose attribute is a sword, agrees: "Use it as your wager" (*wirf in an den chouf*).

Illustration 12 (von Kries 17)

Text summary (FvK, 1337–62): Only virtue and critical judgment/sense (*sin*) distinguish man from beast. If a man wants to be virtuous, then critical judgment should guide his intention and his deed.

Illustration: The illustration depicts the hierarchical relationship between "critical judgment" (*der sin*), "intention/will" (*der wille*), and "deed" (*daz werch*). At the top of the hierarchy is Critical Judgment, who says, "Look at me" (*Sich her zv mir*). He pokes Intention below him with a stick labeled "the barb of discernment" (*der bescheidenheit gart*). Beneath him Intention calls down to Deed: "Follow me" (*volge mir*). His stick bears the label "the barb of love" (*der liebe gart*). Deed responds "I shall do it" (*Ich sol iz tůn*).

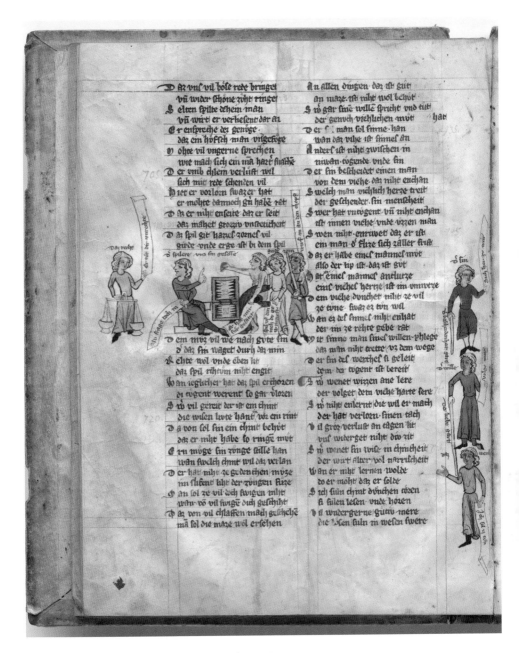

D ſz vnſ vil böſe rede bringet
vñ wider ſchöne zvht ringet
S elten ſpilte dehein man
vñ wirt er verlieſent dar an
E r enſpreche der genvge
daz ein höfſch man vngefvge
Y ohte vil vngerne ſprechen
wie mach ſich ein mā hart ſwache
D er vmb ehlein verluſt wil
ſich mit rede ſchenden vil
H iet er vorlorn ſwaz er hat
er möhte dannoch zu habe rat
D ſa er niht enſeite daz er ſeit
daz machet groziv vnſtetcheit
D az ſpil gat harze zornes vil
ſpilere vnd ſin geſelle

D em mvz vil we nach gvte ſin
d daz ſin wâget durh dā min
R ehte wol vnde eben lit
daz ſpil rihtvm niht engit
W an ieglicher hat daz ſpil erkorn
di tvgent werent ſo gar vlorn
I rô vil gereit der iſt ein chint
die wiſen livte hant vor ein rint
D a von ſol ſin ein chint behvt
daz er mhe habe ſo ringe mvt
E rn möze ſin zvnge ſtille han
wan ſwelch chint wil daz verlan
D er hat niht ze gedenchen mvze
in ſliſent niht der zvngen ſize
H an ſol ze vil doch ſwigen niht
wan vô vil ſwige dich geſchiht
D az von vil ſlaffen mach gvtliche
mā ſol die mâze wol erſehen

A n allen dingen daz iſt gvt
an mâze iſt niht wol behvt
S w gar ſine wille ſpricht vnd tvt
der genvch viehlichen mvt hat
D er ſ man ſol ſinne han
wan daz vihe iſt ſinneſ an
A nderſ iſt niht zwiſchen in
niuwan tvgende vnde ſin
D en ſin beſcheidet einen man
von dem viehe daz niht erchan
S welch man viehlich herze treit
der geſchender ſin menſcheit
S wer hat vnvgent vñ niht erchan
iſt innen viehe vnde vizzen man
S wen niht entruwet daz er iſt
ein man d ſtize ſich zäller friſt
d az er häbe eineſ manneſ mvt
alſo der tip iſt daz iſt gvt
H at eineſ manneſ antlutze
eine vichel herze iſt im vnnvtze
d ē vihe dvnchet niht ze vil
ze tvne ſwaz er tvn wil
W an er deſ ſinnel niht enhat
der in ze rehte gebe rat
W iſ ſinne man ſineſ willen pflege
daz man niht trette vz dem wege
D er ſin deſ wertheſ ſi geleit
dem ſo tvgent iſt bereit
S w wenet wizzen ane lere
der volget dem viehe harte ſere
S w niht enlernt die wil er mach
der hat verlorn ſinen tach
V il gröz verluſt an tagen lit
vnſ widerget niht ze zit
S w wenet ſin wiſe in chindheit
der wart ſtar vol narrucheit
W an er niht lernen wolde
do er mohte daz er ſolde
S ich ſvln chint dvnchen eben
û ſulen leſen vnde horen
D il vndergerne gütiv mere
die wiſen ſuln in weſen ſwere

Fig. 9. 12v

Fig. 10: fol. 13r

Illustration 13 (von Kries 18)

Text summary (FvK, 1395–1402): If a woman has a pure spirit, then she will not be swayed if she hears or sees something evil. She will be able to distinguish a proper example from an improper one.

Illustration: A lady is pulled in two directions by "the good advisor" (*der gv̊te ratgebe*) on the left and "the evil advisor" (*der vbel ratgeb*) on the right. She leans and looks toward the good advisor who tells her, "Follow virtues and honors" (*Volge tugenden vnd eren*); the evil advisor encourages her by contrast to "follow your desire" (*Volge dinem gelvste*); the lady's banderole asserts: "Beauty with virtues is good" (*schone mit tugenden ist gut*).

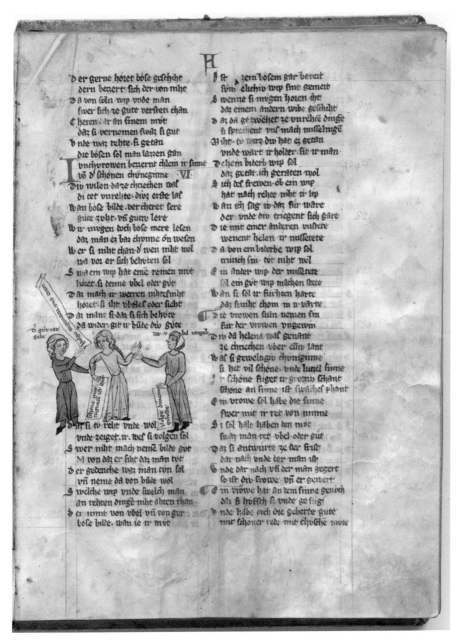

Der gerne hoeret boese geschiht
dern bezzert sich der von niht
Da von soln wip unde man
swer sich ze gute versten chan
Cerenluter an sinem muet
daz si vernemen swaz si gut
unde waz rehte si getan
die boesen sol man lazzen stan

Unsvrowen bezzerrt chlein ir sinne
vo d schoenen chüneginne
Div wilen daze chriechen wol
di tet unrehte diz erste lal
Wan boese bilde vercheret sere
gute zuht un guty lere

Wir mvgen doch boese mere lesen
daz man ez baz chvnne on wesen
Wer si niht chan d wen niht wol
wa vor er sich behvten sol
Swa ein wip hat eine reinen muet
hoeret si denne vbel oder gvet
Daz mach ir werren nihtesniht
hoeret si ihtz vbfel oder licht
Daz mane si daz si sich behvre
da wider git ir bilde div gvte

Daz si tv reht vnde wol
vnde zeiget ir wes si volgen sol
Swer niht mach neme bilde gvt
A von daz er siht daz man tvt
Der gedenche wuz man tvn sol
vn neme da von bilde wol
Swelche wip vnde swelch man
an rehten dingt niht ahten chan
Der nimt von vbel vn von gut
bose bilde wan ie ir mvt

Ist zem boesem gar bereit
svn elichiv wip sint gemeit
Swenne si mvgen hoeren iht
daz einem andern wibe geschiht
Daz da geswichet ze unrehte dinge
si sprechent vil nach missetinge
Niht tv wirz div hat ez getan
unde wart ir holder sit ir man
Dehein biderb wip sol
daz gvtarich geraten wol
Sich des frewen ob ein wip
hat nach rehte niht ir lip
Wan ich sag iu daz fur ware
der unde div triegent sich gare
Die mit einer anderen unstete
wenent helen ir missetete
Da von ein biderbe wip sol
truiich sin tut niht wol
Ein ander wip der missetvt
sol ein gvt wip machen fruit
Wan si sol ir fiurhien harte
daz fruihe chom in ir warte
Die vrowen suln nemen sin
fur der vrowen ungewin
Div da helena was genant
ze chriechen vber ellu lant
Was si gewelagiu chüneginne
si het vil schoene unde lutzel sinne
Ir schoene fuiger ir grozziu schant
schoene an sinne ist swachel phant
Ein vrowe sol habe die sinne
swer mit ir ret von minne
Si sol halt haben den muet
swaz man ret vbel oder gut
Daz si entwurte ze der frist
dar nach unde der man ist
Unde dar nach un der man gegert
so ist div frowe un er gewert
Ein vrowe hat an dem sinne genuch
da si hvfsch si unde ge fuig
Unde habe ovch die geberde gute
mit schoener rede mit chivschie muote

Fig. 10. 13r

Fig. 11: fol. 13v
Illustration 14 (von Kries 19)
Text summary (FvK, 1481–92): A beautiful woman without good sense and instruction will soon lose her honor. Her beauty will inspire men to seek her favor, and her lack of good sense will cause her to do things that she should not.

Illustration: On the left "Poor Judgment" (*Der vnsin*) says, "Do it, he is worth it" (*Tv ez er ist sin wol wert*). He is speaking to a lady holding a lily who tells the man facing her, "I would be pleased to make you happy" (*Ich tvn swaz iv lieb ist gerne*). The man reaches for her lily and says, "I ask her all the more happily" (*Ich bit si dester gerner*). Behind him his friend, or perhaps the next man in line, says: "Look how well put together and how beautiful she is" (*Sich wie wol getan si ist vnd wie schône*).

Illustration 15 (von Kries 20)
Text summary (FvK, 1499–1504): If a beautiful woman loses her honor, then her beauty will also be lost. If she adorns her body and not her mind, then she will cause her own downfall. Her adornment will signal to the bird catcher that she is willing to be trapped.

Illustration: Two hunters lie in wait with decoys to catch the colorful flying birds.

Illustration 16 (von Kries 21)
Text summary (FvK, 1515–38): The body always reveals what is in one's mind. It is not possible to hide it; gestures reveal one's state of mind. Every state of mind manifests itself in a particular way that can be recognized by someone who understands these things.

Illustration: Personification of "Sorrow" (*daz leit*).

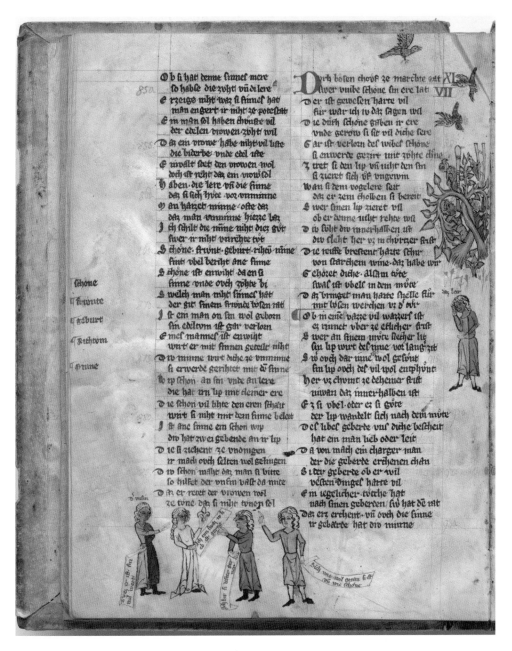

Fig. 11. 13v

Fig. 12: fol. 14r

Illustration 17 (von Kries 22)

Text summary (FvK, 1551–80): One should not always believe what one sees. A woman might be beautiful but unfaithful and ill bred. One should beware of deceitful women because they are like gilded copper. A deceitful woman's tongue may be honey, but her will is poison.

Illustration: "The duplicitous woman" (*daz valch wip*) holds both fire and water to demonstrate her split nature.

Illustration 18 (von Kries 23)

Text summary (FvK, 1615–22): Women's beauty is a trap for ensnaring fools, and it leads to a man's downfall.

Illustration: A lady holds a net in which a man has been caught.

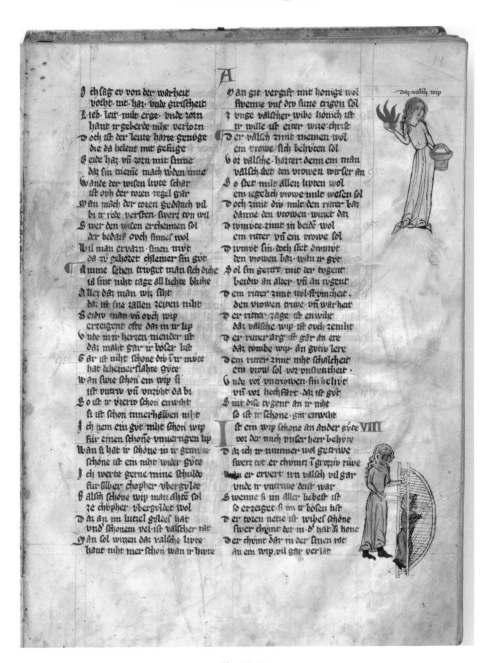

Fig. 12. 14r

Fig. 13: fol. 14v

Illustration 19 (von Kries 24)

Text summary (FvK, 1668–1670): Children should not be idle, but should follow the instruction of virtuous people, and this will lead them to great honor.

Illustration: The illustration depicts two groups of figures. On the left, the seated figure reaches out to the boy in green who appears to be suspended in mid-air. The seated figure says: "You won't get there, you Laziness" (*Dv chv̊mst dar niht dv tracheit*). The boy reaches toward the other figure in brown to his left pleading: "Help me quickly away from here" (*helfet mir von hinnen schir*). This figure responds: "Have trust and follow me" (*hab gedingen vnd volge mir*). In the group of three figures on the right, the boy in green appears again, this time in the company of "Goodness" (*frvmcheit*) and "Honor" (*Ere*). The boy tells them: "Receive me, I have come at last" (*Enphah mich ich pin ê chomen*). Goodness tells him: "Welcome dear" (*Wis willechomen liebe*); Honor says: "Give him to me" (*Gib mir in hêr*).

Note: In other manuscript versions of this illustration, the enthroned figure is labeled "Laziness" (*tragheit*), and the banderole reads "You won't get there"; but here the label has apparently been incorporated into the banderole, suggesting a slightly different reading of the image.

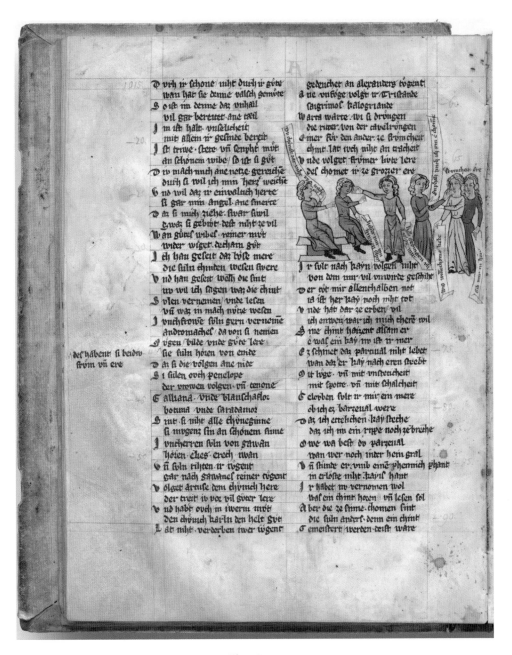

Fig. 13. 14v

Fig. 14: fol. 15v
Illustration 20 (von Kries 25)
Text summary (FvK, 1791–1812): Love makes the wise man wiser and the foolish man more foolish. It is important to control love, for if she gains the upper hand, then she will destroy one's body, soul, honor, and wealth.

Illustration: The illustration contrasts two pairs of figures. On the left, "the lover" (*der minnende man*) looks toward Love personified as a naked female archer (*Div minne*) with closed eyes. Her banderole reads: "I am sightless and blind [others]" (*Ich bin blint vnd mache blint*). The lover has been shot in the eye by her arrow and says: "You guide me well" (*Dv wisest mich wol*). On the right, "the wise man" (*Der wise man*) looks at Love whose bow and arrow are lowered. She asks him: "Well, shall I guide you?" (*Ia sol ich dich wol wisen*). The wise man holds up a yoke responding: "I had better guide you" (*Ich wise dich vil baz*).

Illustration 21 (von Kries 26)
Text summary (FvK, 1833–70): Love cannot be bought. If a man tries to woo a lady using wealth, then he will never know whether it is him or his money that she desires. If a man is unable to woo a lady using courtliness, then he is nothing but a merchant. Purchased love, however, does not have the power of true love.

Illustration: "The inconstant woman and her lovers" (*daz vnstete wip vnd ir minnere*) appear in the illustration. The woman sits in the center holding the banderole: "Love is for sale" (*an dem chovf stet di liebe*). From left to right, the deluded lovers' banderoles read: "Oh, how she presses my hand" (*Ach wie sie mir di hant drŭchet*); "What does she mean by that?" (*Waz meinet si da mit*); "She means well" (*daz ist gutlich getan*); "She is thinking of no one but me alone" (*Si trachet niemans wan min allein*).

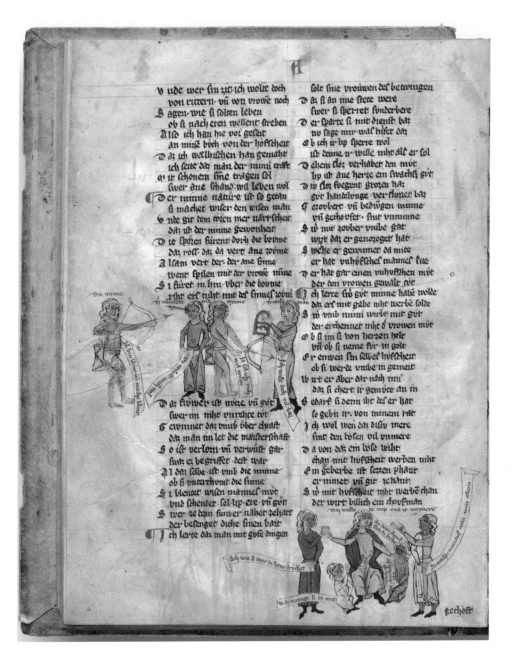

Fig. 14. 15v

Fig. 15: fol. 16v
Illustration 22 (von Kries 27)
Text summary (FvK, 1982–98): It is most important that a lady not be false. Falsity turns love into "malice" (*unminne*) and turns everything that is good into something bad, white to black, and sweetness to bitter gall. A false person's speech, gestures, and intention are contradictory. They may gesture nicely and speak sweetly, but they are ill intentioned. If someone is able to recognize falsity he will be well protected from it. *Illustration:* The unlabeled courtly lady on the left tells "the false man" (*der valsch man*), "I trust you fully" (*Ich getrowe dir wol*). He says to her, "I [pledge] my faith to this" (*des min trïwe*). "Faithlessness" (*vntrwe*) personified as a courtly lady stands behind him handing him a switch, and telling him to "reward her with this" (*Lon ir da mit*).

Vnd mit einem riche vngútem wip
mach man han vnfrôlichen lip
Jch lerte daz deheim bidirb man
niht enchert sinen mût dar an
Daz er spreche einem wibe ir gút
wan suelh wip daz getût
Ez stet ir vil bôsliche
doch stet ez wirs er vngeliche
Einem manne da; sult ir gelouben
Iwizzet daz ich ez gerner wold rôbē
ich lerte daz einer vrouwen zeme
daz si von ir frevnde neme
Th antelsroch spiegel vmgerlin
fúr spangel schapel blúmelin
Ein vrowe sol sin wol behût
daz si niht neme grôzer gút
E z en were daz sir bedurfte wol
so erloube ich ir denne daz si sol
Th einem mere vnde niht so vil
sin erzeige wol daz si wil
Daz ir der strûnt si fúr daz gút
wan anders thet si fälschen mût
Ob ir zenemen iht geschiht
mer bedarf sis denne niht
Jr út der frevnt niht lieb gar
da; sol man wizzen wol dar van
Waz ich hie vor habe geseit
ich spriche nv von der warheit
Vn stetigez mit minem rate
da; die frowen wesen state
An ir mannen wan triwschaft
hat nv ze hvfscheit chlein chraft
Daz mach falsch rúin bôse hût
vnstercheit vn vbermût
Swelh vrowe ist cheusth in ir iugent
hat si dar zû denne dise tugent
Daz si vor hochvart si behûte
vn daz si nem ir man mit gûte
Vn si in wol mit triwen holt
div ist ein stimme fúr alles golt
Daz selbe sprich ich vmb den man

lane sol er sich niht cheren an
Ander wip swer eine hat
der mach der anderen haben rat
Wir wolte lieb der vrowen ere
chónde ich iht daz in nútze were
Jch chert ez gerne an ir dienst
mir ist an einer vrouwen daz liebist
Daz si vor falsch si behút
falsch chert nimme ze vnminne vn gút
Ie vbelen dingen vn daz weize
ze swartzen mit allem sinen vletze
Ie bitter galle chert falsch di sûze
vn ze vngenaden ir schône grúve
Ivge ir gehetze ir senphte ist zorn
ir lachen wernen ir húte dorn

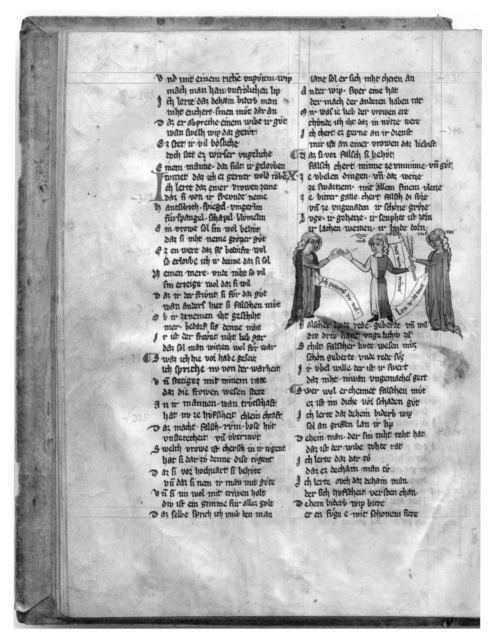

Falscher liute rede geberde vn wil
div drú hant vngeliche zal
Schilt falscher liute wesen miz
schôn geberde vnde rede súz
Jr vbel wille dar ist ir swert
daz niht niwan vngemachel gvrt
Swer wol erchennet falschen mût
ez ist im dicke vol schaden gút
Jch lerte daz dehein bidirb wip
sol an gristen lan ir lip
Dehein man der sin niht reht hat
daz ist der wibe zvhter rat
Jch lerte daz dar zû
daz ez dehain man tú
Jch lerte ovch daz dehain man
der sich hvfscheit versten chan
Dehein bidirb wip bitte
er en fúge e mit schôneu sitte

Fig. 15. 16v

PART 2 (FVK, 2309–3164; HR, 1707–2528)

Fig. 16: fol. 17v
Illustration 23 (von Kries 28)
Text summary (FvK, 2115–36): When an old woman boasts that she gave men a lot of trouble in her youth, she is revealing her lack of virtue. While such a boastful woman's power and beauty may decline with age, her sinfulness does not.

Illustration: This illustration depicts the woman's circle of life. "The old woman" (*daz alte wip*) sits in the center holding two banderoles: "I was worth something earlier" (*hie vor waz ich wert*); and "Who really pays attention to you?" (*Wer achtet vf dich reht*). On the left we see the woman as a "child" (*Daz chint*); on the right she appears as a "young lady" (*div ivnchfrowe*).

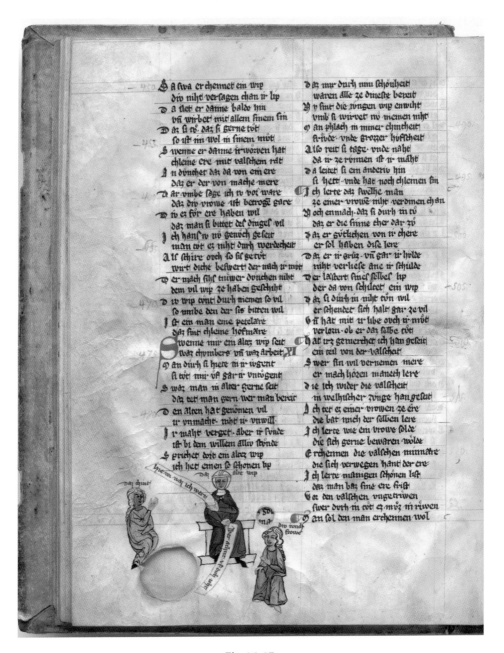

Fig. 16. 17v

Fig. 17: fol. 19r
Illustration 24 (von Kries 29)

Text summary (FvK, 2321–62): A lord's behavior affects everyone. A lord who is idle or will not pass judgment or take command will make fools of his people and behaves unjustly. He should be a role model and guiding light for his people.

Illustration: "The treacherous judge" (*der bôser richter*) wearing a cap as a sign of his authority sits looking toward his "chamberlain" (*der chamerer*) on the left whom he orders, "Drive him away from me" (*Slahe in hin von mir*). He is referring to "the poor man" (*der arme*) who kneels before him asking, "Lord, judge on my behalf" (*Herre richt mir*). The chamberlain obeys his lord, telling the poor man to "get away from my lord" (*Wichet hin von minem herren*). On the right, two courtiers stand watching the exchange. Their label explains: "They are taking a bad example from the lord" (*die nement von dem herren bôs pilde*). The courtier on the left says, "See what our lord is doing?" (*Sich waz vnser herre tůt*); the one on the right remarks, "We must also behave in the same way" (*Wir mvzzen ovch daz selbe tvn*).

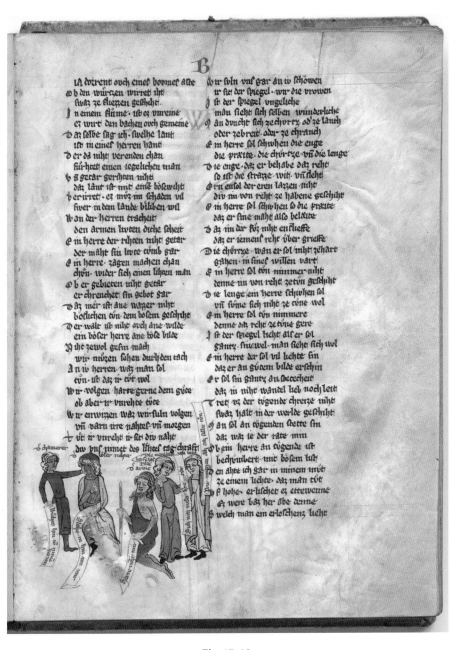

Fig. 17. 19r

Fig. 18: fol. 19v
Illustration 25 (von Kries 30)
Text summary (FvK, 2397–2412): If a virtuous lord becomes wicked, then he is like a light that has been extinguished. One should throw it away and replace it with a burning candle.
Illustration: The image depicts two courtiers; the one on the right holds a broken candle. The inscription above the figure on the left reads: "They notice that" (*die merchent daz*). The courtier on the left says: "It would be better thrown away" (*So wer iz hab baz*). The figure on the right remarks "The light is out" (*daz lieht ist erlôschen*).

Illustration 26 (von Kries 31)
Text summary (FvK, 2413–15): One must relinquish all vice, if one wants to be virtuous. If you want to sow the ground with good seed, you should first clear the field and make sure that it is free of stones and thorns.
Illustration: A farmer tills the land to prepare it for seeding. The inscription reads: "prepare yourself well" (*zow dîn wol*).

Illustration 27 (von Kries 32)
Text summary (FvK, 24392448): Inconstancy is shameful and harmful. Inconstancy is not free but always serves vice.
Illustration: "Vice" (*vntvgent*) is depicted here as a naked female figure wearing a pointed cap. She points behind her to a "scoundrel" (*bôswîcht*) toting a club and remarks, "I am happy and pleased to have him" (*Ich bin sin vro vnd gemeit*). The scoundrel says, "Here comes inconstancy" (*Da her chvmt vnsteticheit*). To the right of Vice, *vnstete* (Inconstancy) gestures toward the unlabeled personification of Unhappiness who carries "sorrow" (*leit*) on his back. Inconstancy looks toward Vice and says: "They are ready to serve you" (*die sint ze iewerm dinste berait*). Unhappiness announces: "I am carrying sorrow" (*Ich trage daz leit*). Sorrow confirms: "I'm riding unhappiness" (*Ich rîte die vnselicheit*).

Illustration 28 (von Kries 33)
Text summary (FvK, 2451–2475): Inconstancy constantly changes her mind. She does one thing today and another tomorrow. First she runs, then she goes slowly; first she climbs, then she falls.
Illustration: A courtier appears halfway up a tree holding two opposing banderoles that read: "Hold on to the branch tightly" (*hab dich vaste zem ast*); and: "Let yourself down" (*La dich her nider*).

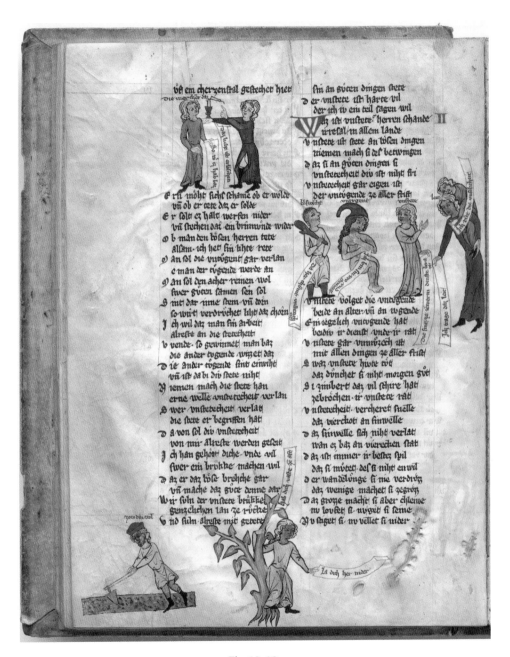

Fig. 18. 19v

Fig. 19: fol. 20r
Illustration 29 (von Kries 34)
Text Summary (2477–84): Inconstancy is like a puppy with a bell tied to its tail. It runs around in order to escape the sound of the bell, and does not realize that it itself is making the sound.
Illustration: A dog with a bell attached to its tail.

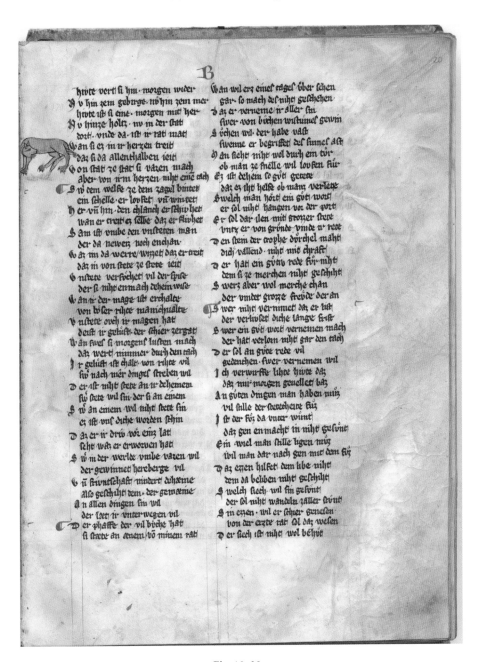

B

hivte verti sú hin· morgen wider
v hin zem gvbirge· nv hin zem mer
hivte ist sí eine· morgen mit her
v hinze holtz· nv in der stat
dorf· vnde da· ist ir rat mat
wan sí ez in ir herzen treit
daz si da allenthalben reit
von stat ze stat sí varen mach
aber von ir'm herzen niht ene mach
vnd tem welfe ze den zagel bintet
ein schelle· er lovfet vñ wintet
her vñ hin· den chlanch er schiv het
wan er treit ez selbe· daz er fliv het
sam ist vmbe den vnstaten man
der da newer noch enchan
waz im da werre· wizzet daz er treit
daz in von stete ze stete ieit
vnstete versvochet vil der slvte
der si niht enmach dehein wise
wan ir der mage ist erchalte
von bôser rihte manichvalte
vnstete ovch ir magen hat
deist ir gelüst der schier zergat
wan swes si morgens lusten mach
daz wert nimmer durch den tach
ir gelüst ist chalt· von rihte vil
siv nach mer dinges streben wil
der ist niht stete an ir dehemem
siv stete wil sin der si an einem
sv an einem wil niht stete sin
ez ist vns diche worden schin
da er ir driv vol eins lat
seht waz er erworben hat
sv in der werlde vmbe varen wil
der gewinnet herberge vil
gv frivntschaft nindert dvhæme
also geschiht dem· der gewæme
an allen dingen sin wil
der leret ir vnterwegen vil
der phaffe der vil bvche hat
si stæte an æenem· vô minem rat

wan wil erz eines tages über sehen
gar· so mach des niht geschehen
daz er vernemte ir aller sin
swer von bvchen wil timel gewin
sochen wil· der habe vast
swenne er begriffet des sinnes ast
dn siht niht wol durch ein tvr
ob man ze snelle wil lovken für
ez ist dehein so gvt gewæte
daz ez iht helfe ob man z verlæte
swelch man hôrt ein gvti wort
er sol niht hangen von der vort
er sol dar slen mit grozzer stræte
vntz er von grvnde vmbe ir rede
den stein der trophe dvrchel mahti
dich vallend· niht mit chraft
der hati ein gvti rede für niht
dem si ze merchen niht geschiht
swerz aber wol merche chan
der vinder grozze frevde der an
swer niht vernimet daz er tut
der verlivset diche lange frist
swer ein gvt wort vernemen mach
der hat verlorn niht gar den tach
der sol an gvte rede vil
gedenchen· swer vernemen wil
ich verwurfte lihte hivte daz
daz mir morgen genellet baz
an gvten dingen man haben nüz
vil stille der smwcheine tvz
ist der fvz da vnder wintt
daz gen enmachte in niht gesvnt
ein vwel man stille ligen mvz
wil man dar nach gen mit dem fvz
daz ezzen hilfet dem libe niht
dem da beliben niht geschiht
swelch siech· wil sin gesvnt
der sol niht wandeln zaller stvnt
sin ezzen· wil er schier genesen
von der ærzte rat sol daz wesen
der siech ist niht wol behvt

Fig. 19. 20r

Fig. 20: fol. 20v
Illustration 30 (von Kries 35)
Text summary (FvK, 2567–82): Inconstancy is a woman divided into four parts: yes, no, love, and sorrow. She is broken and destructive; she is incomplete and has no goal.
Illustration: The personification of "Inconstancy" (*vnsteticheit*) is a female figure divided into four parts: "no" (*nicht*), "yes" (*ia*), "sorrow" (*leit*), and "love" (*liep*).

Illustration 31 (von Kries 36)
Text summary (FvK, 2617–26): A lord should be constant in all things and should particularly refrain from lying. It is hateful if one's speech and heart are not unified. We are dismayed if our hair is cut unevenly, but we do not think it shameful if someone's heart contradicts his speech, that is, if someone is lying.
Illustration: A man holding scissors looks back at a second courtier whose hair he has cut. The shorn courtier exclaims: "Why did you cut my hair like that?" (*Wie hastů mich so beschorn*).

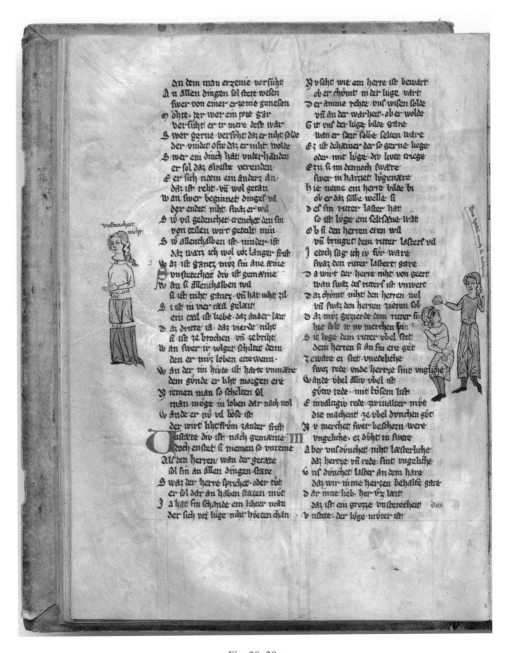

an dem man erzeine versuht
A n allen dingen sol stete wesen
swer von einer extreme genesen
h ohte der wer ein tore gar
ver suht er tr wære dest wær
S wer gerne versuht daz er niht solde
der vindet ofte daz er niht wolde
S wer ein dinc hat under handen
er sol daz ælreste verenden
E er sich næm ein anderz an
daz ist reht vn wol getan
W an swer beginnet dinges vil
der endet niht swaz er wil
S w vil gedenchet crenchet den sin
von teilen wirt geteilt min
S w allenthalben ist minder ist
daz waiz ich wol vor langer frist
W az ist ganz miz siu ane æine
unstetecheit div ist gemæine
W an si allenthalben wol
si ist niht ganz vn hat niht zil
S t ist in vier teil gelaht
ein teil ist liebe daz ander læit
d az dritte la daz vierde niht
si ist ze brochen vn ze briht
W an swer ir volget schiltet dann
den er miz loben ewe wan
A n der in hivte ist harte unmære
dem sunde er lieht morgen ein
Y iemen man so schelten sol
man muge in loben dar nach wol
w ande er niu vil bose ist
der wirt liht kr vm zander frist
u stæte div ist nach gemæine
doch enstet si niemen so unrme
all den herren wan der geræte
sol sin an allen dingen stæte
S waz der herre spricet oder tot
er sol dar an haben staten mut
I a hat sin schande ein liheer man
der sich vor luge niht hoeten chan

Y vseht wie ein herre ist bewart
ob er chvmt in der luge vart
D er æmine reher vil wissen solde
vn an der warheit ob er wolde
E tr vns der luge bilde gæte
wan er saet selbe selten wære
E z ist schæner daz so gerne liege
oder mit luge div lute triege
E zu si in dennoch swære
swer in harzeit lugenære
h ie neme ein herre bilde bi
ob er daz selbe welle si
d er sin ritter laster hat
so ist luge ein falsch lne wat
O b si den herren eren wil
vn bringet dem ritter lasters vil
J edoch sag ich iv fur wære
swaz den ritter lastert gare
D a wirt der herre niht von geert
wan swaz des ritters ist unwert
d az chvmt niht den herren wol
vn swaz den herren zieren sol
D az miz gezierde dem ritter si
hie selb ir nv merchen hin
S iu luge dem ritter ubel stet
dem herren si an siu ere get
Z ewære ez stet unedeliche
swer rede unde hertze sint ungliche
W ande ubel alliv ubel ist
gvtiv rede mit bosem list
E in slagiv rede zu tualtet nibt
die machent ze ubel dunchen got
N v merchet swer beschorn were
ungeliche ez dvht in swere
A ber vns dvnchet niht læsterliche
daz herze vn rede sint ungliche
G nc dvnchet laster an dem hare
daz wir in me herzen behalte gare
d er inne lieb her uz lært
daz ist ein grozze unstetecheit das
v nstete der luge uroter ist

Fig. 20. 20v

Fig. 21: fol. 21r

Illustration 32 (von Kries 37)

Text summary (FvK, 2631–34): Inconstancy is the mother of Lying and Anger.

Illustration: "Inconstancy" (*vnstete*) is personified as an enthroned married lady wearing a wimple and holding her children "Lying" (*lvge*) and "Anger" (*zorn*) on her lap. The banderole on the upper left, probably representing Lying's utterance, reads: "Do you see what anger is doing to me?" (*Sihestu waz mir zorn tv̊t*). The banderole on the lower right reads: "It's good for you" (*Ez ist dir gut*).

Illustration 33 (von Kries 38)

Text summary (FvK, 2646–56): Lying is abhorrent. She carries joy in one hand and sorrow and pain in the other. One hand loves, the other hates, one caresses, the other rends apart, one gives, the other takes, etc.

Illustration: "Lying" (*lůge*) stands in the center holding a flower in her right hand and a snake in her left. "Faithlessness" (*vntrı̊we*) stands behind her on the left offering the advice: "Hold it [the snake] down so he doesn't see it" (*Tv vnder daz ers iht sehe*). Lying tells the young courtier on the right, "Take the little flower" (*Nim daz blv̊mlein*). He responds, "I would like to take it" (*Ich nim iz gerne*).

Illustration 34 (von Kries 39)

Text summary (FvK, 2667–83): The larger context of this passage is that a righteous courtier should direct his actions, speech, and state of mind to a single purpose, and he should fulfill his promises. Otherwise he is a liar. Thomasin draws the analogy between lying and an uneven hem. A man whose shirt hangs down below his coat is a fool. A man who wears his coat long in front and short in the back is also foolish. Virtuous people should ensure that their shirts and coats are even, in other words, that they fulfill their promises.

Illustration: A courtier with an uneven hem stands before an enthroned lady. She directs her servant to "pull it straight" (*zivch daz gleiche*). The servant responds: "I'm happy to do that" (*Ich tv̊n ez gerne*). The man asks leave to depart: "Give me leave to depart from here" (*la mich hinnen gen*).

Illustration 35 (von Kries 40)

Text summary (FvK, 2687–88): The context is the same as above. A lord should look at himself from the front and the back to make sure that

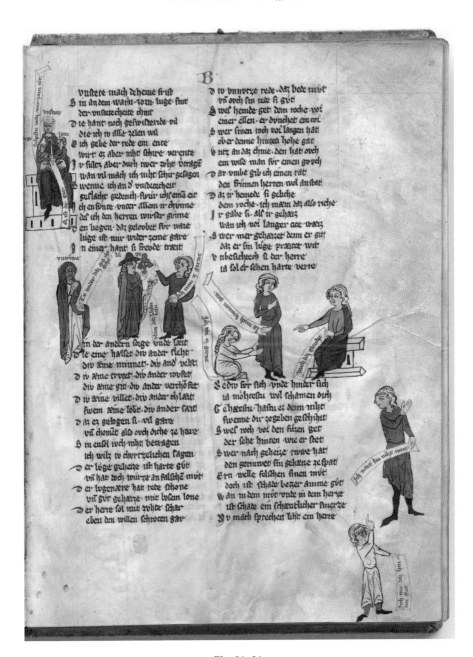

B

vnstete mach de heime si ist
$ in an dem waren zorn luge sint
der vnstete cheit es chint
$ ie hant noch gesswisterde vil
die ich iv alle zelen wil
$ e ich gebe der rede ein ente
wirt ez aber niht schiere verente
$ v sider aber durch iwer zohe verage
wan vil mach ich niht schir gesagen
$ wenne ich der vnstere cheit
zuflacht gedench funir ich ense ein
ich enfunde vnder allem ir chunne
des ich den herren wiser gvnne
$ en liegen daz gelovbet fur ware
liuge ist niur wider zeune gare
$ n einer hant si frevde treit

n der andern soige vnde leit
$ ie eine halset div ander fleht
div ame minnet div ander vehti
$ iv ame trivtet div ander rovstet
div ame gilt div ander verhoret
$ iv ame villet div ander ez slaht
swem ame lobet div ander sait
$ az ez gelogen si vil gare
vil chonne ir also ovch diche ze hare
$ m ensol ich niht betragen
ich wil iv churrzelichen sagen
$ er luge gehize ist harte gvt
vn hat doch wurze an falsche mvt
$ er wgennere hat rede schone
vil gvt gehaize mit bosen lone
$ er herre sol mit zvhte schar
eben den willen schrom gar

$ iv bunvrze rede daz bedr mvt
vn ovch sin rat si gvt
$ wel hemde get dem roche vor
einer ellen er dvnchet ein tor
$ wer sinen roch vol langen hat
ober deme hinter hohe gat
$ utz an daz chinne den hat ovch
ein wise man fur einen gouch
$ ar umbe gib ich einen rat
den frumen herren wol an stat
$ az ir hemede si gelche
dem roche ich mæin daz also riche
$ r gabe si alt ir gehaiz
wan ich vol langer æit mæiz
$ wer mer gehaizzet dem er gilt
daz er sin luge præuet wil
$ v betschecch si der herre
ia sol er sehen harte verre

$ e div bir sich vnde hinter sich
ia möhrestu wol schamen dich
$ chærstu hastu ez dem mihe
swenne dir zezeben geschihti
$ wel roch vol den hizen get
der sehe huten wie er stet
$ wer nach gehaize ruwe hat
den gemurer sin gehaize ze shat
$ rn welle folchen sinen mvt
doch ist schade bezzer aime gvt
$ an in dem mvt vnde in dem herze
ist schade ein schæntlicher smerze
$ y v mach sprechen lihte ein herre

Fig. 21. 21r

his hem is even. An uneven hem represents the lord's inability or unwillingness to fulfill his promises.

Illustration: The courtier above has an uneven hem. The man below points to it, saying, "See how that looks in the back?" (*Sich wie daz hinten stet*). The first courtier responds: "I didn't realize that" (*Ich wart sin niht inne*).

Fig. 22: fol. 21v
Illustration 36 (von Kries 41)

Text summary (FvK, 2725–26): A lord should tell the truth and keep his promises. A lord's word should be written down as witness.

Illustration: An enthroned "lord" (*der herre*) dictates to a "scribe" (*der schreiber*): "Write down my 'yes' and my 'no'" (*Schrib min ia vnd min niht*). The scribe holds a quill and a scroll containing the date: "Anno dm. M°. cc° xL [1240]".

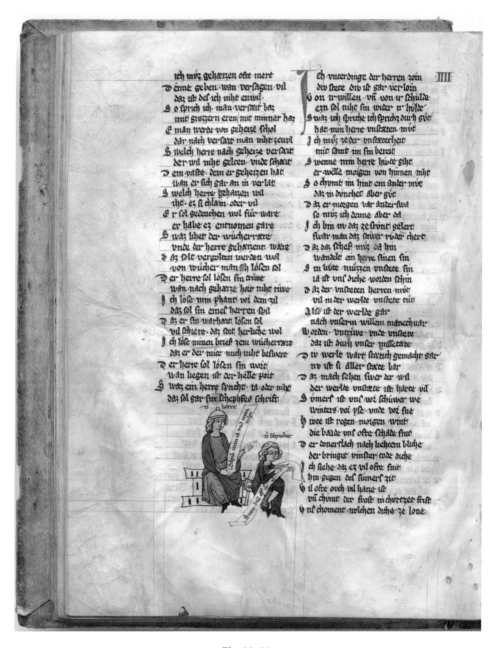

Fig. 22. 21v

Fig. 23: fol. 22r
Illustration 37 (von Kries 42)

Text summary (FvK, 2817–38): Thomasin contrasts man's inconstancy with the constancy of the cosmos. The world is constant: the sun shines on it every day and sets every night. The sun rotates around the earth. Seven stars also rotate around it; each one has its own path from which it does not deviate. Unlike us—we repeatedly attempt to deviate from our path and thereby demonstrate our inconstancy.

Illustration: A representation of the cosmos with the earth at the center, surrounded by "fire" (*fiwer*) and the stars on the concentric circles that represent their rotational paths:, "Mercury" (*mercurius*), "Moon" (*lvna*), "Venus" (*venus*), "Sun" (*sol*), "Mars" (*mars*), "Jupiter" (*iupiter*), "Saturn" (*saturnus*).

Note: The word "stars" above denotes Thomasin's use of the word *stern*. Context makes clear that he means "planets."

B

swenne vns dunchet daz wol schône

Dv werlt hât vnstete sitte
vnser vnstæte si volgen mitte
Jch getar sin wol ge iehen
lâne mohotz nimmer geschehen
were vnser vnstæte niht
vnstæte div an der werlde geschiht
V zwiv wære regen od wint
wære Adam vñ sînv chint
S ewaren stæte zwiv solt der sne
vnf würde nimmer wol chelte we
Alt ich gesprochen hân
dv div werlt zâlrest wart getân
S ie wart vil stete gemäht
daz schinet daz an daz div naht
Wert vor dem tage ze aller zit
dehéine hieze der sûmer git
Wan nâch dem winder deist wâr
div werld wer noch stete gar
Alt si wart stete gemäht
were niht vnser vnstæte chranch
D ie gut ir vil vnstætecheit
die si verchert an vnser leit
Wan ir vnstæte ir schat ir niht
der schade vns vil gar geschiht
S i gůt vns siehtům fûr gesvnt
swenn si sich wandelt zaller stvnt
Dv werlde behalect noch ein teile
der stæte daz chvmt vns zehei le
Wan wir behaltens nihtes niht
daz ist ein winderlich geschiht
A ne der werlde stæte lit
daz tegelich dinch hât sîn zit
Blůmen vñ lovb obz vñ gras
te nâch sînen ziten was
D er oberze ein fûr daz ander gat
einz chvmt enzit daz ander spat
N ach sîner zit vellet lovb vñ gras
vñ dorret daz e grůne was
D es sûmers ist lanch der tach
des winders niht sin mach

S vmers ist div hitze grôz
des frostes den winder in wider ôz
abe wir behalten deheine zit
swaz in vnserm mvote lit
E z si vbel oder ez si gůt
wir wellen volgen vnserm mvot
E rne ahtet ôf deheinen hailigen tach
swer sinen gelust verenden mach
Dv werlde hât an der stæte sîn
daz div sonne des tages schîm
V f der erden vñ nâhers vnder
des sol tvch niht nemen vnder
W an ir nature vnde ir site
ist daz si vert dem himnel mite
O si ovch wider zaller frist
daz an den bûche geschriben ist
W an daz wal ie der werlde stæte
daz der himel vmbe die erde drææt
D er siben sterne wider gânch
machet daz div erde ehrânch
W ider die sterche des himels wert
daz er si ruht hât vmbe geehert

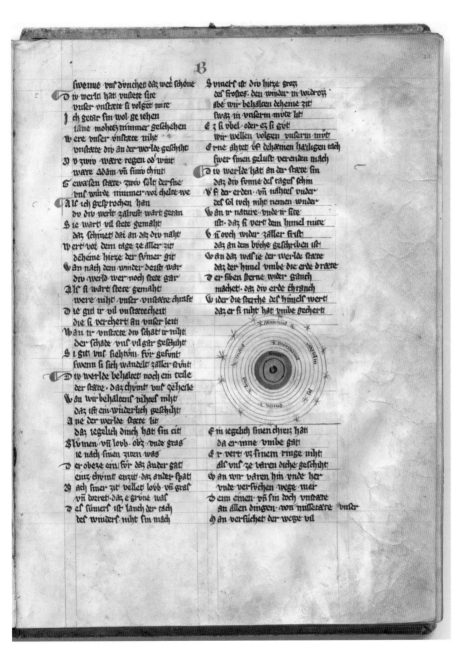

E in iegelich sinen chreiz hât
da er inne vmbe gât
E r vert vz sinem ringe niht
als vns ze varen dicke geschiht
W an wir varen hin vnde her
vnde versůchen wege mer
D em einen vñ sîn doch vnstæte
an allen dingen von missetæte vnser
O an versûchet der weze vil

Fig. 23. 22r

PART 3 (FVK, 3165–4782; HR 2529–4146)

Fig. 24: fol. 22v
Illustration 38 (von Kries 43)
Text summary (FvK, 2887–2914): The text addresses the nature of the four elements and their relationship to one another. Although creation developed from contradictory elements, these come together in the service of the whole. In contrast, man always strives against his nature. *Illustration:* The four elements appear in the circles on the left: "fire" (*vîwer*), "air" (*lŭft*), "water" (*wazzer*), and "earth" (*erde*). Their relationship to each other is expressed through half-circles on the left and numerically: "27 ter tera ter", "18 ter tera bis", "12 bis duo ter", and "8 bis duo bis". The four elements are connected with lines to the qualities on the right: "sharp" (*wechse*), "light" (*ringe*), "moveable" (*gervrich*), "dull" (*pŭllewechse*), "heavy" (*swere*), and "immoveable" (*vngerv̆rich*). Each of these qualities is joined by the semicircular lines on the right to its opposite. In order to make the relationship between the two thus connected qualities clear, these lines are labeled *widerwertich* (opposing).

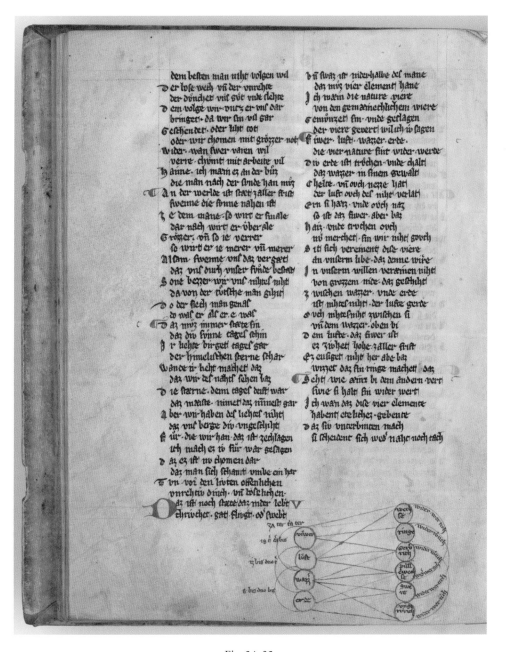

Fig. 24. 22v

Fig. 25: fol. 25r
Illustration 39 (von Kries 44)
Text summary (FvK, 3269–96): The world is constant, but people are not. Nothing else in this world is so proud that it strives against its proper place, except foolish man. He always wants to exchange his place in this world for another; that is inconstancy. Inconstancy causes the peasant to want to be a page, the page wish he were a peasant, and the cleric desire to be a knight. When the knight is thrown from his saddle by a spear, he wishes he were a cleric. No one is satisfied.
Illustration: A knight breaks his lance as he unseats another knight in single combat.

Illustration 40 (von Kries 45)
Text summary (FvK, 3297–3312): It would seem strange to us if a hound pulled a wagon and an ox chased rabbits. People who are dissatisfied and want to change their station in life are just as foolish.
Illustration: A hound pulls a cart and an ox chases a rabbit.

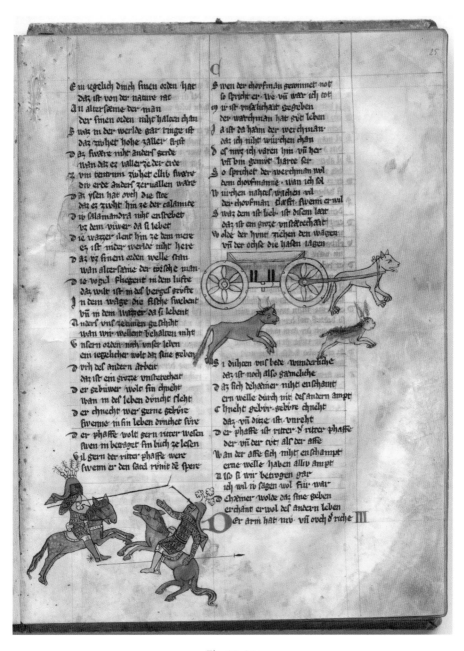

Fig. 25. 25r

Fig. 26: fol. 25v
Illustration 41 (von Kries 46)

Text summary (FvK, 3335–64): The poor and the rich man are equal. Wealth does not make anyone happy or free of care. The poor man wants money, but so does the rich man, who aspires to become even richer. This foolishness has no end. If a man cannot be satisfied with a little, then he will enslave himself to avarice.

Illustration: A man pursued by "Fear" (*vorchte*) and "Greed" (*girde*) kneels before "Avarice" (*Erge*). Fear tells the man, "We don't have anything" (*Wir haben nihts niht*). Greed assures him that "Avarice gives sweet comfort" (*Ere git gemach sůz*). The man's banderole reads: "Avarice will save me from that" (*Daz retet mir gircheit*). Avarice, sitting on a chest and holding a purse, reaches out to the man and asks "Will you be my husband?" (*Wildv mein man werden*).

Note: Where Greed states *Ere git gemach sůz*, it is clear that Thomasin intended for the first word in that phrase to be *Erge*, which means Avarice, not *Ere*, which means Honor.

ez ist alles gewalt geliche
Der ez wol mit hine ersehen chan
Ja hat niht wiser der arm man
Dem arme ist we mit der armvte
dem richen vst we mit sinem gvte
Sol man mir tht· so ist mir liet
daz div wervnge niht ist bereit
Sol aber ich tht· so ist· mir swære
daz ich niht han vn mit ich wære
Der ez alles wol ersihen wil
si habent nach geliches vil
Swer niht hat· den mnit man mhet
dem richen man abebriht
Der riche durch sin eigen gvt
mvz haben diche trvebon mvt
V clvge zorn· vnde grozzen haz
im wære deran lihte baz
Der riche durch gvt mir vil verbgon
vnivnde· die ich niht wolde tragen
Wil ez er aber vertragen niht
lat in stæine gva geshiht
Der arme man mvz haben gvt
so bedarf wol der riche hvt
Gibe gvt der arm man bite
so ist der riche gemvt da mite
Daz er vmbe helfe biten mvz
wol geliche get ir fvz
Dem armen ist we nach dem gvt
so ist noch wirser ze mvte
Dem richen wi er mvge richer si
rihtvm machet niemen sorge fri
Swer hat gewuch vn mære wol
dem hilfet sin gvt alse vil
Als der rovch hilfet den ovgen
des nach er mir nimmer gelovgen
Der ist vil arm mit grozzem gvt
swem mere zervt sin mvt
Der hat an an chlæine dinge vil
swer denne nimmer haben wil
Swelch man hat eine richen mvt
der ist niht arm· mit chlane gvt

Swen niht genvget· des er hat
des armvt nach niht werden rat
Wan boles mannes argen mvt
genvget niht dehem gvt
Der arge hiet ane lvrzel vile
moht ervoller werden sin wille
Swer niht chan mit chlæine leben
der mvz sinen lip ze sorgen geben

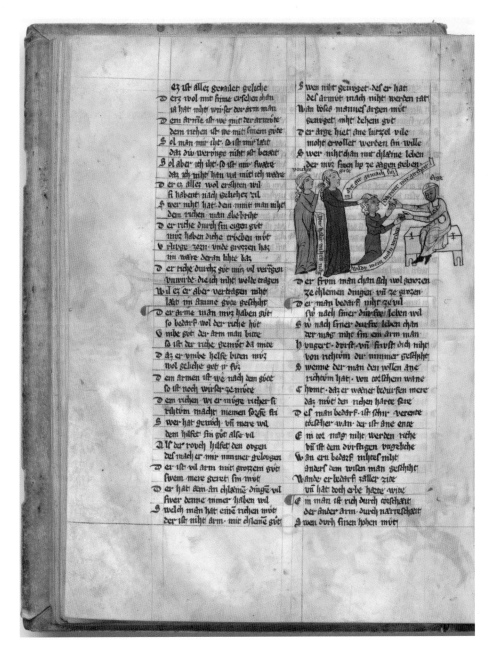

Der frvm man chan sich wol genozen
ze chlæinen dingen· vnd ze grozen
Der man bedarf niht ze vil
sw nach siner dvrftec leben wil
Sw nach siner dvrftec leben chan
der mag niht sin ein arm man
Hunger· dvrst· vn frovst dich niht
von rihtvm dir nimmer geshiht
Swenne der man dan willen ane
rihtvm hat· von welhem wane
Chvmt· daz er wænet bedvrfen mere
daz mvt den richen hærte swere
Des man bedarf· ist shir· verente
chvsher· avan· der ist ane ente
Ni tot mag niht werden riche
vn ist dem dvrftigen vngeliche
Swan ern bedarf niht mit· niht·
Anders dem wisen man geshiht
Wande er bedarf zaller zite
vn hat doch erbe hæne wite
Em man ist rich durch wisheit
der ander arm· durch narresheit
Swen durch sinen hohen mvt

Fig. 26. 25v

Fig. 27: fol. 26r
Illustration 42 (von Kries 47)
Text summary (FvK, 3451–52): People must control their wealth, and not be controlled by it. A man who lets his wealth control him is a fool. *Illustration:* "Avarice" (*Erge*) sits on the left with her hand outstretched toward the three figures approaching her. "Wealth" (*Riechtům*) kneels before her holding the end of a noose, which is tied around the neck of "the wealthy man" (*der riche*). Avarice tells Wealth, "Bring him to me" (*Zůch mirn in her*). Wealth tells the rich man: "Now follow me" (*Nu volge mir*); he responds: "I'll do it, I'll do it gladly" (*Ich tůn ich tůn gern*). Greed (*Girde*) prods him with a stick saying: "Hurry up, you'll be late" (*Ile bald dv svmest dich*).

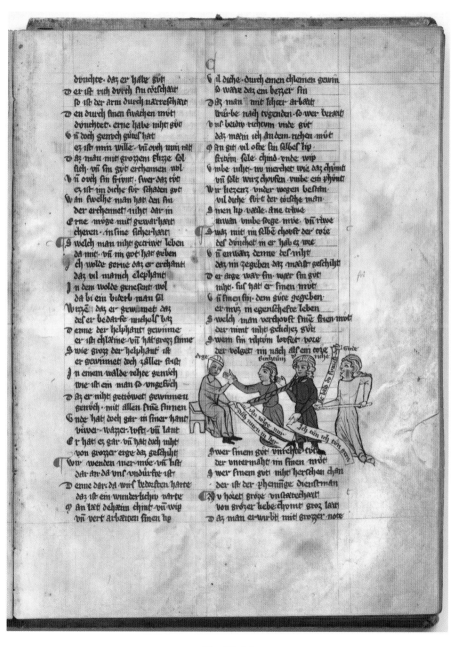

dúnchte· daz er habe gút
D er ist rich durch sin tôrscheit
so ist der arm durch nárrescheit
D en durch sinen swachen mút
dúnchtet· erne habe niht gút
G ñ doch genuoch gútes hat
ez ist min wille· vñ ouch um rat
D az man mit grozzen sizze sol
sich· vñ sin gút erthamen wol
G ñ ouch sin frivnt· swer daz tút
ez ist im diche fúr schaden gút
W an swelhe man hat den sin
der erkennet niht dar in
E rne môge mit gewarheit
cheren· in sine sicherheit
¶ S welch man niht getriwet leben
da mit· vñ in got hat geben
Ch wolde gerne daz er erkante
daz vil manich elephant
J n dem wolde genesent wol
da bi ein biderb man sol
W irze daz er gewurmet daz
des er bedarfte michuls baz
D enne der helphant gewinne
er ist chlaine· vñ hat groz sinne
S wie groz der helphant ist
er gewinnet doch zaller frist
J n einem walde rehte genúch
wie vil ein man so vngelich
D az er niht getrôwet gewinnen
genúch· mit allen sine sinnen
G nde hat doch gar in siner hant
viwe· wazzer· luft vñ lant
E r hat ez gar vñ hat doch niht
von grozzer erge da geschiht
¶ W ir wenden mer mú vñ hast
dar an da vns vndúr fre ist
D enne dar da wir bedurften harte
daz ist ein wunderlichu varte
op an lazt dehein chint vñ wip
vñ vert arbaiten sinen lip

vil dicke· durch einen chlainen gewin
so waere daz ein bezzer sin
D az man mit lihter arbeit
wurbe nach tugenden· so wer bereit
vns beidiv richtum vñde gút
daz maen ich an dem richen mút
G an gút vil ofte sin selbes lip
frivm· sele· chind· vñde wip
G mbe nihtes· iu merchet wie daz chumt
vñ solt wirz chosen vmbe ein phunt
W ir hietenz vnder wegen bestan
vil dicke kirt der tôrsche man
S inen lip vaile· ane triwe
anwan vmbe saige mue· vñ riwe
¶ S waz mit im selbe chouft der tôre
des dúnchet in er hab ez me
G ñ enwan· denne des niht
daz im zegeben daz maeist geschiht
D er arge war sin· wer sin gút
niht· sul hat er sinen mút
G ñ sinen sin· dem sure gegeben
er muoz in egenscheftre leben
S welch man verhovft sine swern mút
der nimt niht geschiez gút
S wem sin rihtum loukit· vore
der volget im nach als ein tore

S wer sinem gút vnterche tut
der vntermaht im sinen mút
S wer sinem gút niht herschan chan
der ist der phennige dienstman
¶ W v hoeret groze vnstatecheit
von grozer liebe chumt groz lait
D az man erwirbit mit grozer note

Fig. 27. 26r

Fig. 28: fol. 27r

Illustration 43 (von Kries 48)

Text summary (FvK, 3559–79): Even when a man is wealthy enough he will think that he needs to be wealthier still because he will see some-one richer than he. There will always be someone richer, so his greed will never end. He should look behind himself and see how many peo-ple are poorer than he.

Illustration: The illustration depicts five figures and makes most sense if read from right to left. Only the figure on the right is labeled—"the wise man" (*der wise*)—and he says, "I must acquire wealth" (*Ich mv̊z vmb gůt trachten*). He is the object of the next man's envy who says: "If I only had as much as he" (*het ich so vil als der hat*). The third figure in green re-marks: "If only he would look behind him" (*mach der sehen hinder sich*). The next figure agrees: "Then he would see that we have nothing" (*So siht er daz wir nihten han*). Finally the figure on the far left concludes: "He is not able to understand that" (*Des enchan er niht versten*).

Note: The label "the wise man" is a scribal error. According to the text and the banderoles that the figures hold, this figure should be labeled "the rich man." In Heidelberg Cpg 389, the figure is labeled *Der richest under den* (the richest among them).

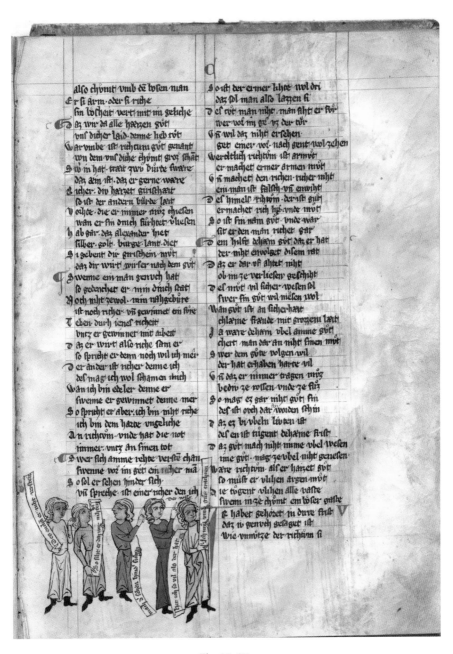

also chvmt· vmb dē losen man
Er si arm· oder si riche
sin loscheit· vert mit im geliche
az wir dz alle hærzen gvt
vns dicher laid· denne ich rvt
War vmbe ist· richtvm gvt genant
wn dem vns diche chymt groz schat
Sob in hat· trait zwv dvrte swære
daz am ich· daz er gerne wære
Richer div hærzet girischart
so ist der andern bürde leit
Volhte· die er nimmer mvz chiesen
wan er sin dmch fürhtet vliesen
Hab gar· daz alexander htet
silber· golt· burge lant diet
Si gebent dir girischem mvt
daz dir wirt aviser nach dem gvt
Swenne ein man genvch hat
so gedenchet er· min dmch scat
Noch nicht zewol· min nahgebure
ist noch richer· vnt gewinnet ein sorie
Teben durch ienes richeit
vntz er gewinnet mit arbeit
Daz er wirt also riche sam er
so spricht er dem noch wil ich mei
Der ander ist richer denne ich
des mag ich wol schamen mich
Wan ich bin edeler denne er
siweme er gewinnet denne mer
So spricht er aber ich bin nicht riche
ich bin dem hærzte vngeliche
An richtvm· vnde hat die not
immer· vntz an sinen tot
Swer sich amme rechte verste chan
siwenne vor im get ein richer mā
So sol er sehen hinder sich
vnt spreche ist einer richer den ich

Oist der ermer lihtē wol dri
daz sol man also lazzen kl
Des rot man nicht· man sicht er fvr
wer wol im ge nz dar tvr
Ist wil daz nicht erfehen·
geb einer vol· nach gent wol zehen
Werclich richtvm ist armvt
er machet ermer armen mvt
Nu machet· den richen richer nicht
ein man ist falsch· vn enwicht
Des hymels richtvm der ist gvt
ermachet rich hie vnde mvt
So ist sin næm gvt· vnde war
sit er den man richer gar
Dem hilfet dehiem gvt daz er hat
der nicht envolget disem rat
Daz er dar vff achtet nicht
ob im ze verliesen geschiht
Des mvt vil sicher wesen sol
swer sin gvt wil mezen wol
Wan gvt ist an sicher hart
chlæme frævde mit grozem lart
Ja wære dehiem vbel amme gvt
chert man dar an nicht sinen mvt
Swer dem gvte wolgen wil
der hat erhaben harte vil
Sun daz er nimmer tragen mvz
bediv ze wollen vnde ze siuz
So mag ez gar nicht gvti sin
des ist ovch dar wonden schin
Taz ez bivbeln lizan ist
des en ist tigent dehiame frist
Daz gvt mach nicht nimme vbel wesen
nine gvt mag ze vbel nicht genesen
Wære richtvm als er haizet gvt
so muste er vllihen argen mvt
Die tigent vlchen alle vaste
siwem in ze chymt ein boser gaste
Es haber geheizet· in dure frist
daz iv genvch gesaget ist
Wie vnnvtze der richtvm si

Fig. 28. 27r

Fig. 29: fol. 27v

Illustration 44 (von Kries 49)

Text summary (FvK, 3629–72): The poor man imagines that he is rich, and when, in his mind, he has great wealth, he starts to construct tremendous palaces and many lands. He then imagines how he might protect his palace so that he never has to fear an attack. And he thinks about the people who will envy him on account of his great wealth.

Illustration: The illustration depicts the poor man's imagined life. The "wealthy man in thought" (*der riche man mit gedanchen*) sits on a throne and turns toward "the flatterer" (*der loser*) on the left saying: "How they envy me" (*wie mich di nident*). He is referring to "the envious ones" (*Die nidere*) on the right. The first envious one dressed in yellow remarks: "I could never gain anything" (*Ichn enchond ni niht gewinnen*), while the second one points at the rich man and asks: "How did he get rich a short while ago?" (*Wie der worden chv̊rtzlich ist riche*). The flatterer responds: "People envy good people" (*Man nidet frv̊m leute*).

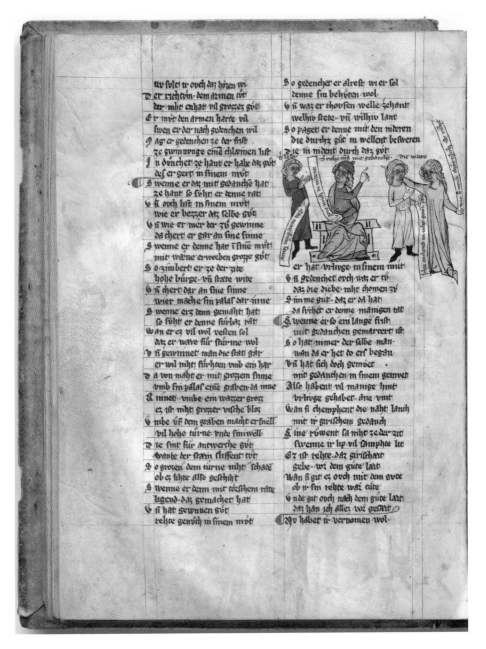

Fig. 29. 27v

Fig. 30: fol. 28r
Illustration 45 (von Kries 50)
Text summary (FvK, 3691–3702): The rich and poor should both accept their stations in life. Both are equal and both have their worries. Both poor and rich suffer from greed. But only the rich man suffers from fear (that he will lose his wealth). The poor man would not give up his station if he realized what it would mean to be rich.

Illustration: "The rich man" (*der riche man*) stands holding "Fear" (*vorcht*) and "Greed" (*Girde*). Fear tells the man, "Someone is counting on your wealth" (*Man retet vaste vf din gůt*). Greed tells him, "You have no profit" (*Dv hast niht gewinnes*). On the right, a barefoot man asks: "How long will I be poor" (*wie lange sol ich arm si*). Greed (*girde*) stands behind him urging him to "try hard to get rich" (*wirb vaste vmb gůt*). On the left an unlabeled figure who, judging by his beard and grey hair, represents the wise man, watches the scene and remarks: "fear accompanies wealth" (*vorcht is bi richtům*).

Illustration 46 (von Kries 51)
Text summary (FvK, 3703–18): The lord and his people have a single goal. The people live better than their lord who has many worries. The people need him to rule, and he must constantly think about what is best for them. People assume that he has everything he wants, but they do not recognize that he has great concerns and bears the responsibility for his people.

Illustration: "The rich man" (*Der riche man*) on the left is flanked by two smaller figures. In the center of the image the female figure in yellow points to the lord and remarks to the group of "people" (*daz volch*) watching him: "See how they carry him" (*Seht wi man den treit*). The people hold banderoles that read: "He has whatever he wants" (*da hat er swaz er wil*), and "Hey, I wish I were a lord" (*hey wer ich ovch ein herre*).

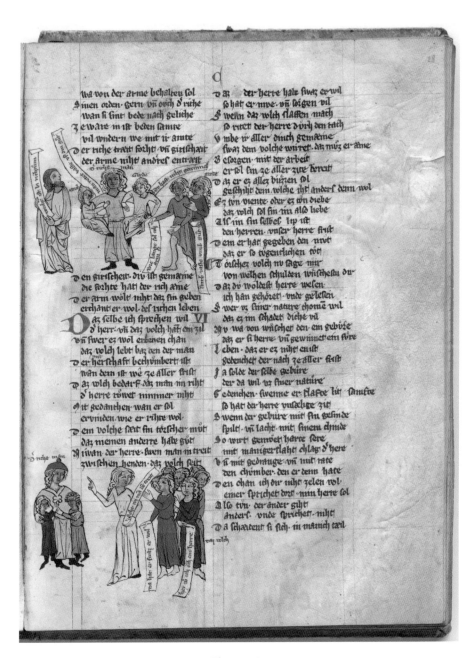

Fig. 30. 28r

Fig. 31: fol. 28v
Illustration 47 (von Kries 52)
Text summary (FvK, 3733–70): In contrast to the peasant, the lord has a lot of worries. When he asks for counsel, one person will tell him one thing while another tells him something else. Everyone has his own opinion and thinks that he is wiser than everyone else.
Illustration: "The lord" (*der herre*) asks "the landholders" (*die lantrechten*) for their advice, but they give him contradictory responses. They are influenced by personal interest, and one of them even tries to bribe him. On the left, the lord says: "I ask you about him" (*Ich vrag dich sin*). The landholders respond in turn: "He should have protection" (*er sol haben sinen gwer*); "Remember that you are my nephew" (*gedench daz min neve bist*); "You were always my friend" (*dv wer ie min frivnt*); "I'm giving the third opinion" (*Ich gib di dritten vrteil*); and "I'll give you ten marks for it" (*darvmb geb ich dir zehen march*).

Illustration 48 (von Kries 53)
Text summary (FvK, 3771–86): A foolish man might think that if he were lord, then he would do things better. But he would be incompetent. The passengers' safety depends on the captain's skill. If he has taken on more than he is able, then not only is he lost, but also all of his passengers will die.
Illustration: The illustration depicts a boat with five passengers and a bearded captain. The banderole says: "If he fails, we'll all be dead" (*er versag wir sin all tod*).

Illustration 49 (von Kries 54)
Text summary (FvK, 3787–94): An incompetent ruler will bring dishonor upon himself and his people. If a man desires great honor but he does not have the sense or discernment to use it properly then it will bring him dishonor.
Illustration: Two couples are depicted: "Discernment" (*der sin*) is paired with "Honor" (*div ere*), and "the dishonorable man" (*der vnerhaft*) embraces "Dishonor" (*div vnere*). On the left Discernment points to the other couple and remarks, "He is troubled with dishonor" (*er ist bechvmbert mit vnere*). Honor asks: "Do you see what he's doing?" (*sihstu waz er tvt*). On the right the dishonorable man proclaims: "I love you a lot" (*dv bist mir harte lip*). Dishonor responds: "Embrace me, my dear" (*vmbevah mich lieplichen*).

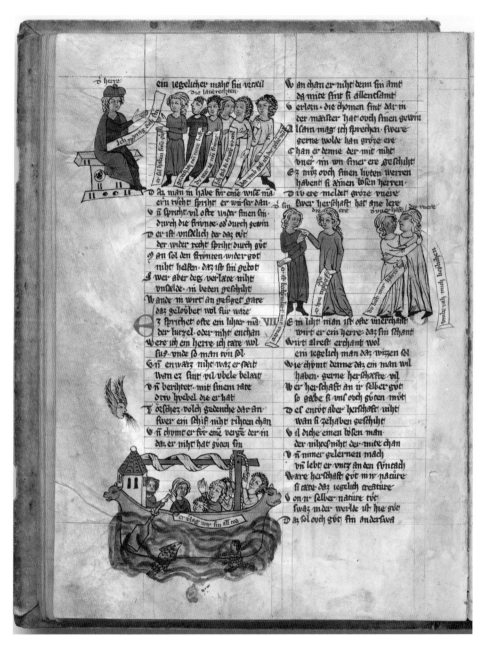

Fig. 31. 28v

Fig. 32: fol. 29r
Illustration 50 (von Kries 55)
Text summary (FvK, 3861–82): When a man greedy for honor imagines himself to be a powerful lord, he appoints his imaginary officers as he chooses. And he dreams about how the chamberlain will keep the peasants away from him.

Illustration: The enthroned figure is the man imagining himself as a lord, "the lord in thought" (*der herre mit gedanchen*). His swordbearer stands on the right dressed in a particolored tunic. On the left "the chamberlain" (*der chammerer*) threatens "the people" (*daz volch*) with a club, telling them, "Leave my lord alone" (*vf hőr von mime hern*).

daʒ vnrer iſt harʒ da
v ñ ovch hie· ſwa eʒ iſt
eʒ machet harʒ ʒe aller friſt
ð er envol herſchaft niht
wan ob den herren geſchiht
ʒ er varen· in ein ander lant
da er lihte iſt vnerchant
J ch ſag· iv daʒ· daʒ alſo vil
vſ in iemen ʒhoen wil
A lſ vſ einen der in dem laute
iſt ovch vil lihte vnerchante
J a hat ſa niht div herſchaft
von ir ſelber ſo vil chraft
ð aʒ ſi vns ʒeige· wer ſi der herre
er ſi vns nahen· oder verre
h An mir vns ſagen ſeht· wol er iſt
wan div herſchaft hat niht ð liſt
ð aʒ ſi vns ſage wer er ſi·
ſi wil· in halt vil nahen bi
ð a von dunchet ſi mich niht ʒe gvte
warvmbe denne deſ iemen mvte
ð aʒ er wolde han grozze ere
die hohen turne die vallent ſere
J ſt div grontfeſt niht harte wol
alſo geſchiht dem der hoher mote
ð enne ſin ſtorm keit· muge er tragẽ
der vellet lihte vnder den wagen
ð ie grozen ſteine vſ dem berge
walget nut chreſte herch ʒer erde
ð ie ſteine die vſ der elken ſint
die ligent ſampht· merche daʒ ð wit
ð er ſchoret die lohen tovme veſte
daʒ er ʒerbrichet vil gar ir eſte
ð em chlaмen wuret niht ſo vil
der ſich nach winde neigen wil
A lſo ſprich ich daʒ man ſol
vnder den herren leben wol
Wan der herre hat ʒe ſchaffen vil
ob er mit eren leben wil
V on vrluge· wirt eiſ herren mvot
vñ von angeſten· dicke gemvot

v ñ alſ ich iv han geſaret
er lebet mit grozer arbaet
J ch han geſaret ein lange ʒit
waʒ chvnbert herſchafte git
A v horet ovch wie ſi dem man
bechvnbert· der ſi nie gewan
S wenne ein gir ſcher man nach ere
dar an gedenchet harte ſere
E r vindet er einen luſtgen rat
alſ er in erwiſchet hat
ſ o iſt er alſo fro ʒehant
ſam er erworben hab ein lant
J n dvnchet er habe ſwtʒ er wil
er hat ere· vñ herſchafte vil
E r hat ſin lant harte wol
alſ er von rehte haben ſol
E r iſt wol chome gar an ere
daʒ ſchenche ampt· lihet er
V n war ʒe trihſazen ſi gvte
daʒ ſtift er gar in ſinem mvte
ſ in ampt verluiſet denne
der gvt der inne waʒ etrwenne
E r git eʒ ſwem erʒ geben wil
wan er hat denne harſchafte vil
ſ o gerit die chamerere vmb in

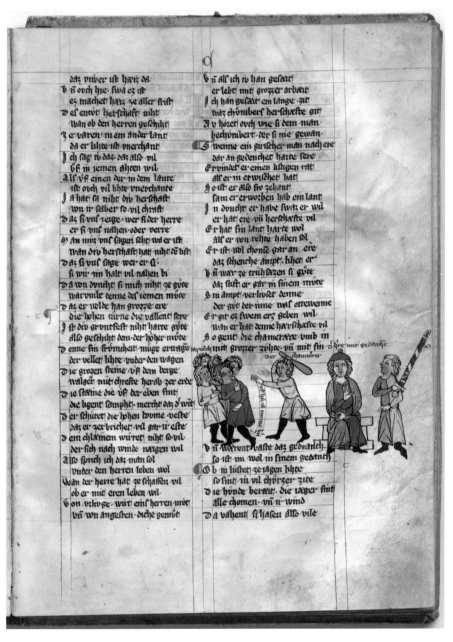

Vñ warent haſte daʒ gedrnch
ſo iſt im wol in ſinem gedanch
O b in hiebet ʒe iagen lihte
ſo ſint iv vil chvrʒer ʒite
ð ie hvnde bereat· die iager ſint
alle chomen· vñ iv wind
ð a vahent ſi haſen alſo vile

Fig. 32. 29r

Fig. 33: fol. 29v
Illustration 51 (von Kries 56)

Text summary (FvK, 3883–96): The theme continues from above. In his imagination this greedy man wants to hunt, and the dogs are quickly made ready and then the hunters appear. They catch so many hares that they are not able to carry them; a wild boar causes the dogs some problems, but it too is killed; a stag is caught; and finally the man himself kills a bear with his spear.

Illustration: This illustration also depicts an imagined scene. In his fantasy, the man who imagines himself to be a lord also imagines a bear hunt in which he successfully kills the bear. The figure in front wearing yellow says: "Let me kill him on my own" (*lat mich in eine toten*). His companions ask "Shouldn't we help you?" (*sul wir iv iht helfen*).

daz er ze tragen ist ze vile
Ein eber chvmbet vast die hvnte
die in ze chomt ze der stvnte
Er bringet die hvnte in groze not
doch wirt ovch er ze tvngest tot
Da wurt mit sinen hornen langen
mit gedanchen ein hirz gevangen
Ze tvngest stehet der selbe herre

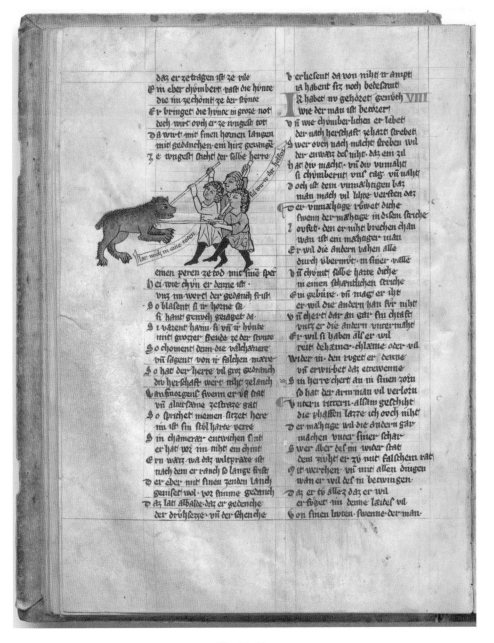

lat mich in ane rvren

Lat wert die hetze

einen peren ze tod mit sime sper
Hei wie chvn er denne ist
vnz in werct der gedanch frist
So blasent si ir horne sa
si hant genvch gejaget da
Si varent havm si vn ir hvnte
mit grozer freude ze der stvnte
So chomet dem die valschenare
vn sagent von ir valschen mare
So hat der herte vil grvz gebranch
div herschaft wert niht zelanch
Wan snorgent swenn er vz dat
vn allvrsone zestraze gat
So sprichet niemen sitzet herre
in ist sin stol harte verre
Sin chamerar entwichen sint
er hat vor im niht ein chint
Ern wat wa dat wiltprate ist
nach dem er ranch so lange frist
Der eber mit sinen zenden lanch
geniset wol vor stimme gedanch
Dz lat albalde daz er gedenche
der druhszezze vn der schenche

Der erliesent da von nihte ir ampt
ja habent siz noch bedechant
Ir habet nv gehoret genveh VIII
wie der man ist betoret
Vn wie chvmberlichen er lebet
der nach herschaft zehart strebet
Swer ovch nach macht streben wil
der entwarz des niht. daz em zil
Hat div macht. vn div vormaht
si chvmberut vns tag. vn naht
Doch ist dem vnmahtigen baz
man mach vil lihte versten daz
Der vnmahtige rowet diche
swenn der mahtige in disen striche
Jouset. den er niht brechen chan
wan ist ein mahtiger man
Er wil die andern vahen alle
durch übermvt in siner valle
Vn chvmt selbe harte diche
in einen schantlichen striche
Sin gebiute vn mag er iht
er wil die andern han für niht
Vn chert dar an gar sin chtaket
vntz er die andern vnterniahet
Er wil si haben all er wil
reit dehamer chlæme oder vil
Wider in den roget er denne
vil erwirbet dez etewenne
Sin herre chert an in sinen zorn
so hat der arm man vil verlorn
Vnter rittern alsam geschiht
die phaffen lazze ich ovch niht
Der mahtige wil die andern gar
machen vntar siner schar
Swer aber des im wider stat
dem nihtet er zo nut falschem rat
Er wirchen vn mit allen dingen
wan er wil der in betwingen
Daz er tv allez daz er wil
erfoget im denne laidel vil
Von sinen lvten swenne der man

Fig. 34: fol. 30r
Illustration 52 (von Kries 57)
Text summary (FvK, 3949–66): Powerful people want to control everyone. If a man resists a man with power, then the powerful man will give him false counsel in order to force him to do his will. The powerful man will have his people harm anyone who resists his power, and when someone comes to complain, the powerful man will tell him he knows nothing about it. And he will force the plaintiff to succumb to his power.
Illustration: "The plaintiff" (*der chlait*) kneels before "the judge" (*der richter*) complaining: "Lord, they did thus to me" (*herre also hant si mir getan*). The enthroned lord holds two banderoles. The first, which he holds toward the plaintiff, reads: "I will make amends for it" (*Ich widerschaf ez wol*). The second banderole, however, which he holds toward his servants, reads: "I'll treat him worse" (*Ich wil im wirser tvn*). His servants remark: "Then he will serve you more readily" (*So dienet er iv gerner*).

Illustration 53 (von Kries 58)
Text summary (FvK, 4013–23): Human power is fleeting. When the powerful lord thinks he has conquered all those who resisted him, he will always find more people who rise up against him. This was the case with Julius Caesar, who conquered much of the world, but his power did not help him when he returned home. He lived only two years and then completely lost his power. When he thought he was secure, he was killed.
Illustration: This illustration depicts the murder of Julius Caesar by Brutus and Cassius. The three figures are labeled.

Illustration 54 (von Kries 59)
Text summary (FvK, 4024–26): A further illustration of the fleetingness of human power is Hector's sorrowful end.
Illustration: Hector (*hector*) is dragged around the city of Troy (*Troye*).

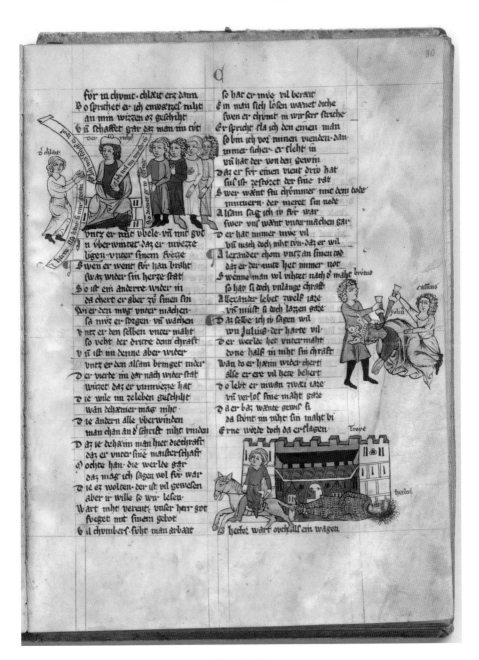

für in chumt· chlawr erz dann
Do sprichet er ich enwarzel niht
an min wizzen ez geschiht
vñ schaffet gar daz man in tot

untz er nach vbele· vñ nut gut
n vber wmdet daz er mueze
ligen vnter sinem vveze
Swen er wænt fvr han braht
swaz wider sin herze stat
So ist ein anderre wider in
da chert er aber zu sinen sin
vñ er den mvg vnter machen
sa untz er sorgen· vñ wachen
vntz er den selben vnter maht
so veht der dritte denn chraft
v st in denne aber wider
vntz er den alsam bringet nider
Der vierde in dar nach wider stat
wizzet daz er vnmveze hat
Die wile in zeleben geschiht
wan dehæiner mag niht
Die andern alle vberwinden
man chan an der schrift niht vinden
Daz die deheim man hiet diechraft
daz er vnter sine maisterschaft
Mochte han· die werlde gar
daz mag ich sagen wol fvr war
Ob ez wolten· der ist vil gewesen
aber ir wille so wir lesen
Wart niht vereint· vnser herr got
fveget mit sinem gebot
Bil chumbers· svht man arbeit

so hat er mve vil berait
êm man sich lösen wænet diche
swen er chumt in wirserr striche
Er sprichet· sla ich den einen man
so bin ich vor minen vienden· dan
unmer sicher· er sleht in
vñ hat der von den gewin
daz er fvr einen vient driv hat
sus ist zestöret der sine rat
Swer wænt stu chünner mit dem tode
müntern· der meret sin node
Alsam sag ich iv fvr war
swer vns wænt vnder machen gar
er hat unmer mve vil
vñ nach doch niht tun· daz er wil
Alexander chom vntz an sinen tod
daz er der niute hiet unmer not
Swenne man wl vihten· nach der maht
so hat si doch vnlange chraft
Alexander lebet zwelf iare
vñ müst si doch lazzen gare
Daz selbe ich iv sagen wil
von Julius· der harte vil
der werlde hiet vnter maht
doch half in niht sin chraft
Wan do er hæim chom wider chert
alse er ere vil here behert
Do lebt er niwan zwei iare
vñ verlos sine maht gare
Da er daz· wænte gewis si
da stvnt im niht sin maht bi
Erne wörde doch da er slagen

Hector wart ovch alse ein wagen

Fig. 35: fol. 31r

Illustration 55 (von Kries 60)

Text summary (FvK, 4091–4110): Power is troublesome for a powerless man. A powerless man will happily imagine that he might acquire power through marriage or other means. Then he will imagine what harm he might do to his enemies; in his mind he will create a great army, and his enemy will have no defense.

Illustration: The illustration depicts two armies fighting. The knights on the left clearly have the upper hand. On the right, all of the opposing knights but one are lying in a heap on the ground.

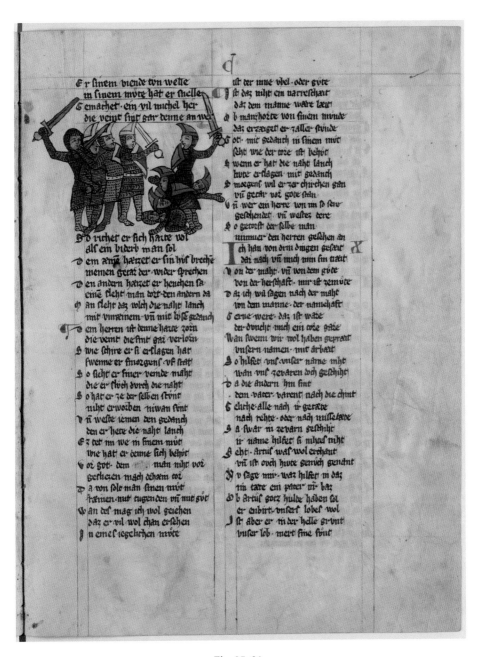

Er sinem viende ton welle
in sinem mvte hat er snelle
s emachet ein vil michel her
die veint sint gar denne an wer

So richtet er sich harte wol
als ein biderb man sol
d em anze hazzet er sin hus breche
meinen gerat der wider sprechen
d en andern hazzet er heuchen sa
eime vlehet man wol den andern da
sh an sleht daz solch die nähte lanch
mit vnreinen vn mit lose gedanch
sem herren ist denne harte zorn
die veint die sint gar verlorn
s we schire er si erflagen hat
swenne er smorgens vf stat
so sieht er siner veinde naht
die er slioch durch die naht
so hat er ze der selben stvnt
niht erworben niwan svnt
d ü welte iemen den gedanch
den er hete die nähte lanch
Ez tet im we in sinem mvt
wie hat er denne sich behvrt
oz got dem man niht vor
gerheten mach dehain tor
d a von sol man sinen mvt
hämen mit tugenden vn nut gvt
wan des mag ich wol geiehen
daz er vil wol chan erlehen
In eines iegelichen mvte

ist der mve vbel oder gvte
ist daz niht ein narrescheit
daz dem manne wær leit
ob manz horte von sinem munde
daz erzæiget er zaller stvnde
ot mit gedanch in sinem mvt
seht wie der tore ist behvt
wenn er hat die nähte lanch
lvte erslagen mit gedanch
smorgens wil er zer chirchen gan
vn gerat vor gote stan
vn wer ein herre von im so sere
geschendet vn walter tere
so getrvst der selbe man
nimmer den herren gesehen an
Ich han von drin dingen gesait
daz nach vn mich nim sin træit
von der mäht vn von dem gvte
von der herschaft mir ist zemvte
daz ich wil sagen nach der maht
von dem manne der namehaft
s eine wære daz ist wære
der dvncht mich ein tore gære
Wan swem wir wol haben gepræt
vnsern namen mit arbeit
so hilfet vns vnser næme niht
wan vns zevaren doch geschiht
d a die andern im sint
den vater varent nach die chint
e erbe alle nach ir geræte
nach rehte oder nach misseteæte
s a swar in zevarn geschihet
ir næme hilfet si niehtes niht
sh eht artus was wol erkant
vn ist ovch hiwte gemich genant
Nu sage mir waz hilfet in daz
nu tæte ein pater ui daz
ob artus gotz hulde haben sol
er erbirt vnsers lobes wol
Ist aber er in der helle grvnt
vnser lob mert sine svnt

Fig. 35. 31r

Fig. 36: fol. 31v
Illustration 56 (von Kries 61)
Text summary (FvK, 4219–36): Greed, avarice, and inconstancy show us that we are not perfect. A man who recognizes his vices is able to improve himself. And he will not immediately believe whatever a flatterer says about him.

Illustration: The flatterer (*Der lôsere*) on the left tells the lord (*der herre*): "You are perfectly virtuous" (*Ir sit an tvgenden volkomen gar*). The lord responds with a gesture over his shoulder at the three personified vices standing behind him: "My vices don't agree" (*Min vntugent giht dez niht*). "Greed" (*Girde*), "Avarice" (*erge*), and "Inconstancy" (*vnstete*) respond to the lord in keeping with their nature. Greed complains: "We need more wealth" (*wir bedurfen mer gvtes*); Avarice says: "I give enough to my servants" (*Ich gib gnvch minen chnechten*); Inconstancy tells the lord: "He should be pleased to be your subject" (*er sol iv gern sin vndertan*).

Illustration 57 (von Kries 62)
Text summary (FvK, 4237–52): A stalwart man should think about whether the rumors about him are truth or lies, and he should be angry if they are lies. False praise is like claiming that a doll is a child. The stalwart man should show his displeasure by putting the doll away and saying that the flatterer is a scoundrel.

Illustration: The illustration depicts a kneeling man holding a small figure out to an enthroned lord. The lord asks: "Is that a doll?" (*Ist daz ein tochke*); the man kneeling lies: "It is a beautiful child" (*Iz ist ein schône chint*).

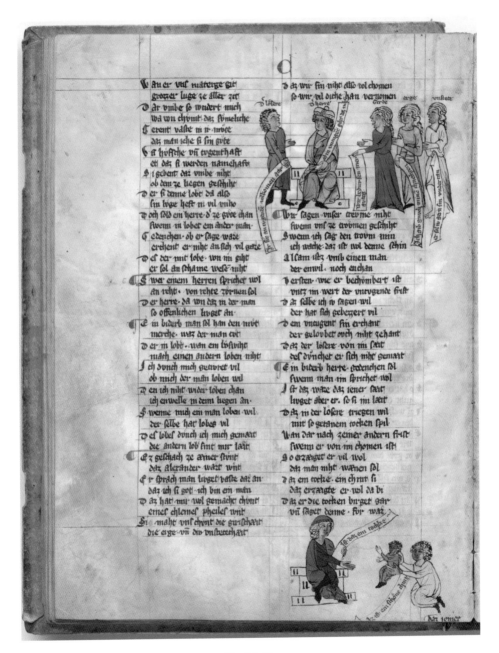

Fig. 36. 31v

Fig. 37: fol. 32r

Illustration 58 (von Kries 63)

Text summary (FvK, 4263–88): This passage addresses false praise and warns the stalwart courtier to put an end to any lies being circulated about him. Thomasin compares the lord who believes false praise with a foolish child who looks into a mirror and thinks that he sees a playmate in its reflection.

Illustration: Two children gaze into a hand mirror. The first child remarks: "See how handsome he is?" (*Sich wie schon er ist*). The second one responds, pointing toward himself: "I'm more handsome than he is" (*Ich pin schŏner denne er*).

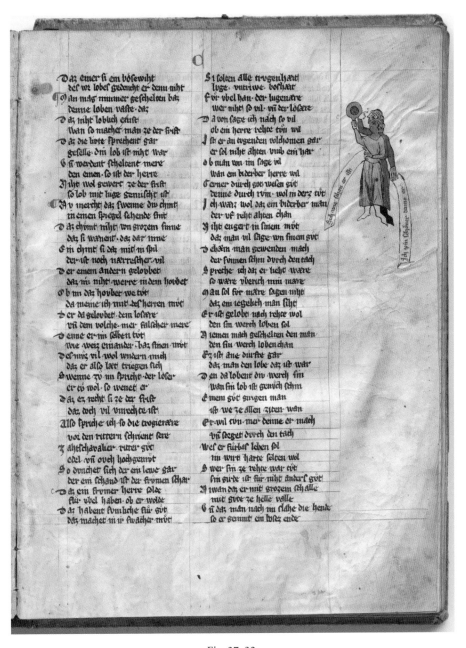

Fig. 37. 32r

Fig. 38: fol. 32v

Illustration 59 (von Kries 64–65)

Text summary (FvK, 4323–49): If a lord is virtuous, then he should not care what people say about him. A man greedy for fame wants to do more than he is able, and he worries all the time about how he might improve his life. But his greed is good for nothing: he and all of his possessions will go to hell with a great clamor. It is better to go quietly to heaven than to go loudly to hell. One should do what is good and right without praise and bragging.

Illustration: The illustration juxtaposes the greedy lords accompanied by music and excitement as they enter hell with the good people whose deeds speak for themselves and who are ushered quietly into heaven. A devil stands on the far left in the gate to hell clutching a man in red. The group standing directly before hell's gate is labeled "the criers" (*Die crogyrere*) and "the musicians" (*Die spilleute*). These figures hold banderoles that read: "Hurrah, good knights!" (*zahzevalier ritter gůt*) and "noble and high spirited!" (*Edel vnd hoch gemv̊t*). On the right, heaven is represented by the blue circle ringed with red, yellow, and beige. Its gate stands open. The bearded man about to enter looks back and says: "Come thus to me" (*Get so her zv mir*). He is one of "the poor people" (*Daz arm volch*) being ushered into heaven. To the left of the poor people is a lord holding a banderole that reads: "We should go without noise" (*Wir suln ane schal varn*).

Illustration 60 (von Kries 66)

Text summary (FvK, 4355–76): If a lord does something only so that he becomes renowned, then his virtue has led to vice. Unfortunately many people do more for their own fame than they do on account of virtue. A greedy man will give a penny to a pauper but will not care how he fares as long as the pauper tells others about his generosity. People do not give anything to the poor man who goes naked, but they generously bestow clothing on those who are well dressed enough.

Illustration: A man who is "greedy for fame" (*des rvmes girich*) gives his cloak to a musician who is able to sing his praises. The musician is labeled a "flatterer" (*der loter*). "The poor man" (*der arm man*) on the right begs: "Lord, give me a penny for the grace of God" (*herre gib mir einen pfennich durh got*). The greedy lord tells him: "I'll give you nothing" (*Ich gib dir nichtz*).

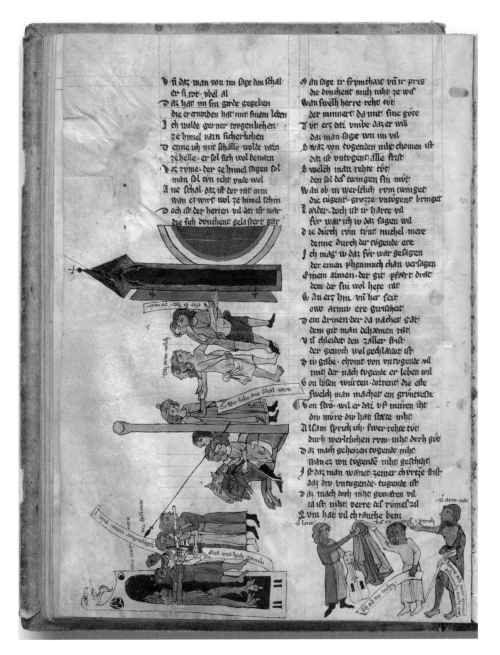

Fig. 38. 32v

Fig. 39: fol. 33r
Illustration 61 (von Kries 67)
Text summary (FvK, 4431–44): A man should not expect reward for vice but should seek eternal reward where reward is due. It is foolish to search for something in the wrong place; a man who looks for pears in a cherry tree is a fool.
Illustration: The illustration depicts two men, one sitting in a cherry tree and the other standing below. The one at the base of the tree asks the other to "hand him down a pear" (*Gib mir der pirn her abe*). The other man responds: "But they are cherries; you can see that" (*Ia sint iz chersichge daz sihstu wol*).

Illustration 62 (von Kries 68)
Text summary (FvK, 4445–90): Greed is a dangerous vice for a man seeking fame. Such a man might think that if he does something really good, then people will talk about him. In his imagination, he will plan a tournament, which many skilled knights will attend. In his mind, he will throw so many of these knights that he will win the tournament and his skill as a knight will be regaled all over the world.
Illustration: The illustration depicts the imaginary tournament. The man who is a "lord in thought" (*der herre mit gedanchen*) appears as a knight single-handedly unseating two opponents.

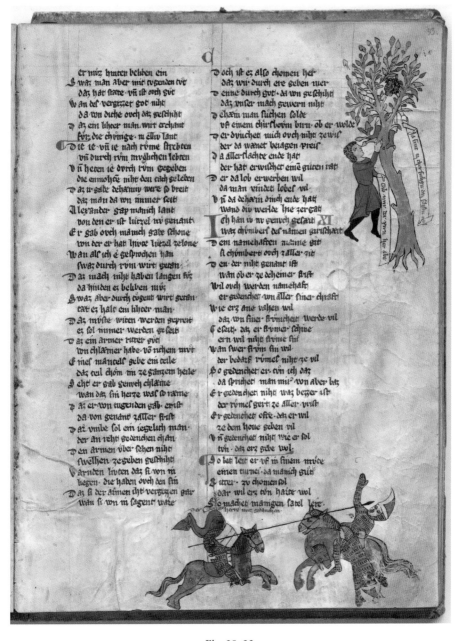

er muz hinter beliben ein
Swaz man aber mit tugenden tůt
daz hat state vñ ist ovch gůt
Wan des vergizzet got niht
da von dicke ovch daz geschiht
Daz ein liher man wirt erchant
fvr die chunige in ellû lant
Die ie vñ ie nach rvme strebten
vñ durch rvm mvghlichen lebten
Dû heten ie dvrch rvm gegeben
die enmochte niht den tach geleben
Daz ir gabe dehainiu were so breit
daz man da von nimmer seit
Alexander gap manich lant
von den er ist luzzel nů genant
Er gab ovch manich gabe schone
von der er hat luve luzzel zelone
Wan als ich e gesprochen han
swaz durch rvm wirt getan
Daz mach niht haben langen frist
da hinden ez beliben muz
Swaz aber durch tvgent wirt getan
taet ez halt ein liher man
Daz mvste witen werden gepreit
ez sol immer werden geseit
Daz ein armer ritter gvt
von chlaemer habe vô richem mvt
Eines mantels gebe ein teile
daz teil chôm in ze ganzem heile
Icht er gab gerwch chlaine
wan daz sin herze was so raine
Daz er von tugenden gab ernst
da von genant zaller frist
Daz vmbe sol ein iezlich man
der an reht gedencken chan
Den armen vber sehen niht
swelhen ze geben geschiht
Darnden liuten daz si von rů
legen die haben ovch den sin
Daz si der armen iht vergezzen gar
wan si von rů sagent ware

Doch ist ez also chomen her
daz wir durch ere geben mer
denne durch got da von geschiht
daz vnser nach gewern niht
Chaem man suchen solde
vf einem churboum birn ob er wilde
der dvuchet mich ovch niht zewis
der da wanet beiagen preis
Da aller slachte ende hat
der hat erwischet eine grůten rat
Der da lob erwerben wil
da man vindet lobes vil
Dû da dehein dinch ende hat
wand div werlde hie zergat
Ich han iu nv gerwch geseit
waz chumbers des namen gerischeit
Dem namehaften nande git
si chumbert ovch zaller zit
Den der niht genant ist
wan ob er ze dehainer frist
Wil ovch werden namehaft
er gedenchet von aller sina chraft
Wie erz ane vahen wil
daz von sinen frvmcheit werde vil
Geseit daz er frvmer schine
ern wil niht frvme sin
Wan swer frvm sin wil
der bedarf rvmes niht ze vil
So gedenchet er vñ ich daz
da sprichet man mir von aber baz
Er gedenchet niht waz bezzer ist
der rvmes gert ze aller vrist
Er gedenchet ofte daz er wil
ze dem houe geben vil
Dû gedenchet niht wie er sol
tvn daz erz gabe wol
So bat leut er vf in sinam mvde
einen turnei da manich gůt
Ritter zů chomen sol
dar wil erz tvn haiterlich
So machet mangem tavel leite
herre mit gedanchen

Fig. 39. 33r

Fig. 40: fol. 33v

Illustration 63 (von Kries 69)

Text summary (FvK, 4531–50): Since nobility does not derive from privilege but only from proper actions and thoughts, a man will lose his nobility if he gives himself over to vice.

Illustration: The tall figure on the left is almost naked—the three personified vices "Treachery" (*bôsheit*), "Lying" (*lv̊ge*), and "Inconstancy" (*vnstete*) are stripping him of his clothing. Treachery's banderole reads: "Let's pull his nobility completely off him" (*zihe wir im sin adel gar abe*). Lying tells the man, "You must leave your nobility here" (*dv mvst din adel hie lazzen*).

siner welschen gedanche sper
Niemen mach zo in geliche
si muzien in alle entwichen
Warra wie sin frumcheit
ist in der werlde umbe gesat
Sie redent ouch gemeinliche
daz sin zwiuel ste hiuschliche
Sin wasemuch ist harte rich
nu ist niemen da geliche
Sin vel daz verst harte wol
Sin harnasch stet im als er sol
Sin ysenhosen umbe die bein
die sint ze groz noch ze clein
Hey wie der selbe man
sinu ben horen chan
Niemen ruret in da geliche
er ist aller frumcheit riche
Des dunchet in an sinem mut
daz waz ein troum harte gut
Der adel uns alsam chan XII
machen arowme swelch man
Edeler denne ein ander ist
er wænet sin truwer zaller frist
Ist truget sich dar an
niemen ist edel denn der man
Er sin herze vn sin gemute
hat gecheret an rehte gute
Ist ein man wol geborn
vn hat sines mutes adel verlorn
Ich chan iu sagen wol fur war
in schendet sin geburt gar
Wan swer wol geborn ist
sin geburt gert zaller frist
Daz er wol vn reht tu
ob er sich niht twinget dar zu
So hat er deme lasters mere
sin geburt minuert sin ere
Des wundert ouch mich harte vil
daz dehein vrum man wil
Durch siner vordern gut
vn durch ir edel haben uber mut
Mach er selbe tun daz

da von er muge herzen baz
Von im selbe edel denne von im
daz duche mich ein bezzer sin
Vaterhalben ist ein iegelich man
edel der ez versten chan
Swer sin geburt behalten wil
der hat adels harte vil
Die sint alle gotes chint
die sin gebot leistende sint
Swer niht enleistet sin gebot
der hat daz adel daz im got
Hab von sinen schulden verlorn
vn hat im dar zu erchorn
Einen vater der unedel ist
von sinem ubel zaller frist
Swer sinen edelen vater lat
sin adel er verwochet hat
Got hat uns alle geschaffen
vn hat sinel willen chraft
Ze werlde braht daz ist war
da von si wir sinu chint gar
An den der ez verwocht hat
mit siner ubelen getat
Hie bie moht er merchen wol
daz niemen edel herzen sol
Wan der der rehte uit
swer aber hat vnrehten mut
der en muz ane tugende leben
vn hat sinen edeltum gegeben
Durch der unrogende minne
daz chumt von chrauchem sinne
Er hat bosen chouf getan
der sines adels ist worden an
Durch erge vn durch bosheit
durch luge vn durch unsterecheit
Durch unzuht vn durch untugent
ez si in alter oder in iugent

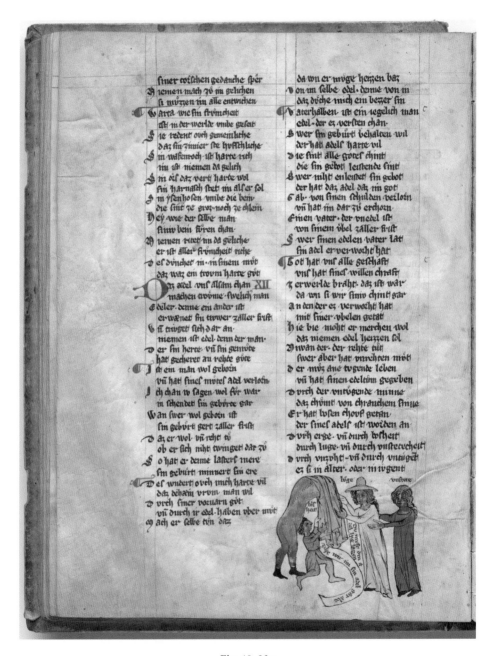

Fig. 40. 33v

Fig. 41: fol. 34r
Illustration 64 (von Kries 70)
Text summary (FvK, 4551–62): The three virtues of courtliness, justice, and nobility go hand in hand. If someone has a courtly intent, then he will behave justly; anyone who behaves justly all the time is noble; those who are noble are God's children.

Illustration: The three personified virtues of "Courtliness" (*hofscheit*), "Justice" (*recht*), and "Nobility" (*adel*) hold hands in a circle. The figures are surrounded by two inscribed circles. In the outermost circle, we read: "Courtliness behaves justly" (*hofslichen tut recht*); "Justice does what is courtly" (*recht tvt hofschlichen*); "nobility does what is courtly with justice" (*adel tut hofslichen mit reht*). In the inner circle the scribe has written: "Justice does what is courtly" (*recht tut hofslichen*); "nobility behaves justly" (*adel tvt recht*); "courtliness behaves nobly" (*hofscheit tut edelichen*).

Illustration 65 (von Kries 71)
Text summary (FvK, 4585–96): In gambling, the loser is unhappy because he realizes his loss and his foolishness, but the winner is also unhappy and is unable to rejoice in his winnings because he realizes that he could suffer the same fate as the loser. The broader context is that each person has desires, but he should not constantly pursue them, because it will not make him happy.

Illustration: The illustration depicts three men playing dice. "The player" (*der spîler*) on the left has already lost his shirt and shoes. He acknowledges his foolishness by exclaiming: "Alas I'm a fool and a blind man!" (*We ich tôr vnd blinter*). "The winners" (*die gewinner*) sit on the right gesturing toward the loser. The figure in red turns to the one in green and says: "See how he tears at himself" (*Sich wie er sich rov̊fet*).

Illustration 66 (von Kries 72)
Text summary (FvK, 4603–6): The happiness that falconry brings with it is outweighed by the falconer's sorrow when his bird flies away. The context is the same as above.

Illustration: A falconer stands holding a chicken leg as bait for his falcon that is flying away. He tries to lure the bird with the call "Sohtsche sohtsche."

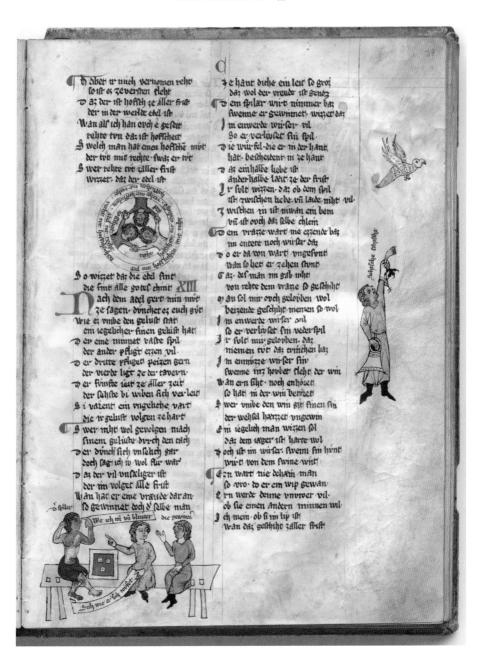



ch aber ir nuoch vernomen recht
so ist ez zeverstan flecht
daz der ist hofisch ze aller frist
der in der werlde edel ist
Wan als ich han ouch e geseit
rehte tvn daz ist hofscheit
S welch man hat einen hofschen mvt
der tvt mit rehte swaz er tvt
S wer rehte tvt zaller frist
wizzet daz der edel ist

S o wizzet daz die edel sint
die sint alle gotes chint
N ach dem adel gvot min mvt
ze sagen dvnchet ez euch gvot
Wie er vmbe den gelust stat
ein iegelicher sinen gelust hat
D er eine minnet vaste spil
der ander pfligt ezzen vil
D er dritte pfliget beizen gern
der vierde ligt ze der tavern
D er fvnfte ivt ze aller zeit
der sehste bi wiben sich verleit
S i varent ein vngeliche vart
die ir gelust volgen ze hart

S wer niht wol gevolgen mach
sinem geluste durch den tach
D er dvncht sich vnselich gar
doch sag ich iv wol fur war
D az der vil vnsæliger ist
der im volget alle frist
W an hat er eine vreude dar an
so gewinnet doch der selbe man



ze hant diche ein leit so groz
daz wol der vreude ist genoz
D em spilar wirt nimmer baz
swenne er gewinnet wizzet daz
I n enwerde wirser vil
so er verliuset sin spil
D ie wurfel die er in der hant
hat bescheident in ze hant
D az einhalbe liebe ist
anderhalbe læit ze der frist
I r sult wizzen daz ob dem spil
ist zwischen liebe vn læide niht vil
Z wischen ru ist anwan ein bein
vn ouch daz selbe chlein
D em vrazze wart nie erzende baz
in entete noch wirser daz
D o er da von wart vngesvnt
wan so het er zehen stvnt
G az des man im gab niht
von rehte dem vrazze so geschiht
D er sol mir ouch gelouben wol
beizende geschilt niemen so wol
I m enwerde wirser vil
so er verliuset sin veder spil
I r sult mir gelouben daz
niemen tvt daz trinchen baz
I n einwizze wirser stiv
swenne im z hovbet flehet der win
W an er in siht noch enhoret
so hat in der win betoret
S wer vmbe den win sitzt sinen sin
der wehsel harzret vngewin
E in iegelich man wizzen sol
daz dem zager ist harte wol
D och ist im wirser swem sin hvnt
wirt von dem swine wunt

E in wart nie dehain man
so vro do er ein wip gewan
E rn werde deime vnrvwer vil
ob sie einen andern minnen wil
I ch mein ob si min lip ist
wan daz geschiht zaller frist

Fig. 41. 34r

Fig. 42: fol. 34v
Illustration 67 (von Kries 73)
Text summary (FvK, 4619–34): A man's great happiness at winning a wife whom he loves will be converted to even greater unhappiness if she loves another. Whatever brings great joy also has the potential to bring great sorrow.

Illustration: On the left we see a man in red drawing the husband's attention to the wife's actions: "Do you see what your wife is doing?" (*Sihestů waz din wip tůt*). The husband responds: "Woe is me, he loves her" (*We mir si ist im holt*). On the right the wife and her lover stand facing each other. The lover touches her face and asks: "Is your husband watching that now" (*Sehe nv daz din man*). The wife responds: "Alas, may God forgive me" (*owe dez erlazze mich gồt*).

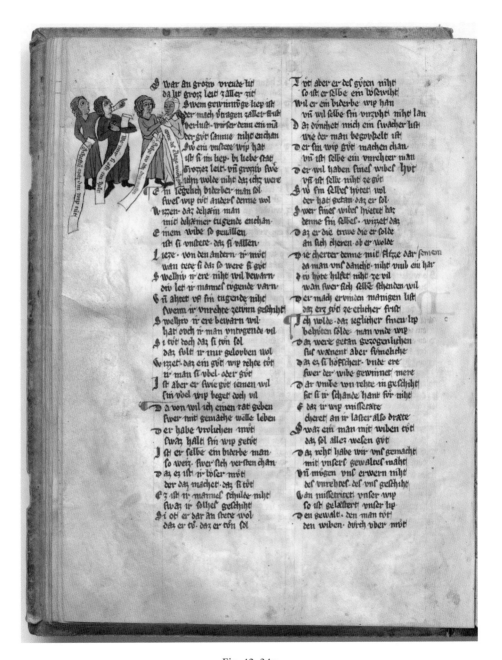

war an grozıv vreude lıt
da lıt groz leıt zaller zıt
Swem gewınnt ge lıep ıſt
der mach vtragen zaller ſtůt
verluſt · wirſer denne ein má
der gůt ſamne nıht enchan
Swer vnſtere wıp hat
ıſt ſi ım lıep · bi lıebe ſtat
Grozter leıt · vñ grozıv ſwe
nıhtn wolde nıht daz ıchz were
Ein ıeglıch bıderber man ſol
ſwer wıp wıl anderſ denne wol
Wızzen · daz dehaein man
mıtt dehaeiner tugende enchan
Einem wıbe ſo geuallen
ıſt ſi vnſtere · daz ſi vallen
Lıeze · von den andern ıı mvt
wan tete ſi daz ſo were ſi gůt
Swelhıv ıı ere nıht wıl bewarn
dıv leıt ıı manneſ tugende varn
Gıı ahtet vf ſın tugende nıht
ſwem ıı vnrehte zetůn geſchıht
Swelhıv ıı ere bewarn wıl
hat ovch ıı man vntugende vıl
Sı tůt doch daz ſi tůn ſol
daz ſult ıı mır gelovben wol
Wızzet · daz ein gůt wıp rehte tůt
ıı man ſi vbel · oder gůt
Iſt aber er ſwie gůt lernen wıl
ſın vbel wıp begert doch vıl
Da von wıl ich einen rat geben
ſwer mıt gemache welle leben
Der habe vrolıchen mvt
ſwaz haelt ſın wıp gůt
Iſt er ſelbe ein bıderbe man
ſo weız ſwer ſich verſten chan
Daz ez ıſt ıı vbſer mvt
der daz machet · daz ſi tůt
Ez ıſt ıı manneſ ſchulde nıht
ſwaz ıı ſolheſ geſchıht
Sı oft er dar an ſtete wol
daz er tů · daz er tůn ſol

Tůt aber er des gůten nıht
ſo ıſt er ſelbe ein boeſewiht
Wıl er ein bıderbe wıp han
vñ wıl ſelbe ſın vnzuhtt nıht lan
Daz dvnchet mich ein ſwacher lıſt
wıe der man begovkelt ıſt
Der ſın wıp gůt machen chan
vñ ıſt ſelbe ein vnrehter man
Der wıl haben ſineſ wıbeſ hůt
vñ ıſt ſelbe nıhtt ze gůt
Sw ſın ſelbeſ hůtet wol
der hat getan daz er ſol
Swer ſineſ wıbeſ hůetet baz
denne ſin ſelbeſ · wızzet daz
Daz er die trıwe die er ſolde
an ſich cheren · ob er wolde
Die cherter denne mıt · ſı tze dar ſomem
da man vnſ danchet · nıht vmb ein har
Der hůte hılfet nıht ze vıl
wan ſwer ſich ſelbe ſchenden wıl
Der mach erwınden manıgen lıſt
daz erz tůt ze erlıcher frıſt
Ich wolde · daz ıeglıcher ſineu lıp
behůten ſolde · man vnde wıp
Daz were getan gezogenlıchen
ſuſ waenent aber ſoemchlıche
Daz ez ſi hofſcheıt · vnde ere
ſwer der wıbe gewınnet mere
Der vmbe von rehte in geſchıht
ſır ſi ıı ſchande hant für nıht
Ez daz ıı wıp miſſerate
cherert an ıı laſter alſo drate
Swaz ein man mıt wıben tůt
daz ſol aller weſen gůt
Daz rehte habe wır vnſ gemachet
mıt vnſerſ gewalteſ mahte
Vñ mogen vnſ erwern nıht
des vnrehteſ · deſ vnſ geſchıht
Wan miſſetricet · vnſer wıp
ſo ıſt gelaſtert · vnſer lıp
Den gewalt · den man tůt
den wıben · dvrch vber mvt

Fig. 42. 34v

Fig. 43: fol. 35r
Illustration 68 (von Kries 74)
Text summary (FvK, 475356): The glutton provides us with an example in which we see how destructive desire can be. He suffers when he imagines having food but is denied it.

Illustration: "The glutton" (*Der fraiz*) points to a table laden with food. He exclaims: "Alas, if only I could have some of that food" (*Owe het ich der speise ein teil*).

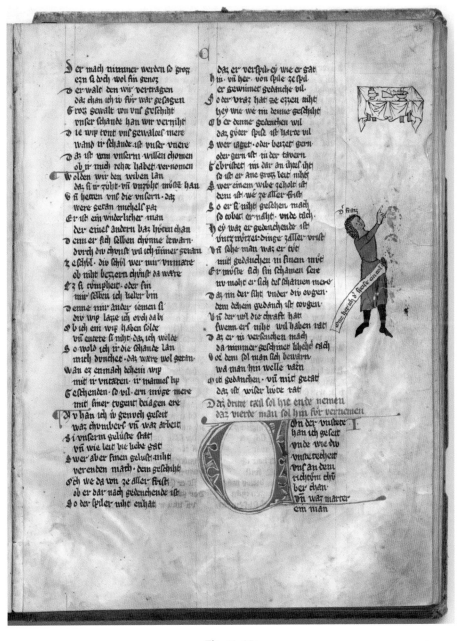

er mach nimmer werden so groz
ezn si doch wol sin genoz
er walde den wir vertragen
daz chan ich iu fur war gesagen
Groz gewalt von vns geschiht
vnser schande han wir verniht
Die wip tvnt vns gewalces mere
wand ir schande ist vnser vnere
Ez ist vmb vnsern willen chomen
ob ir mich reht habet vernomen
Wolden wir den wiben lan
daz si ir zuht vnd vnzuht mohte han
Si hetten vns die vnsern daz
were getan michalt paz
Er ist ein widerlicher man
der eines andern baz hoeren chan
Dem er sich selben chvnne erwarn
durch diu chvnst wil ich ummer gevarn
Zescheltdiu schol wer mir vnmaere
ob niht bezzern chvnst da waere
Ez si toerpheit oder sin
mir selben ich helter bin
Denne mir ander iemen si
diu wip lazte ich ovch da bi
Ob ich ein wip haben solde
vn euarte si niht daz ich wolde
So wold ich ir die schande lan
mich dunches daz waere wol getan
Wan ez enmach dehein wip
mit ir vntaten ir mannes lip
Gescheinden so vil ern muge mere
mit siner tugent bejagen ere

Nv han ich iv genvoch geseit
waz chvmbers vn waz arbeit
Si vnserm gelüste stat
vn wie leit die liebe gat
Swer aber sinen gelust nimt
verenden mach dem geschiht
Ovch we da von ze aller frist
ob er dar nach gedenchende ist
So der spiler niht enhat

daz er verspil ez wie er gat
hin vnd her von spile ze spil
er gewinnet gedanche vil
Oder vraz hat ze ezzen niht
hey wie we im denne geschiht
Ob er denne gedenchen wil
daz goter spile ist harte vil
Swer lazet oder bezzet gern
oder gern ist in der tavern
Gebristet im dar an ihtes iht
so ist er ane groz leit niht
Swer einem wibe geholt ist
dem ist we ze aller frist
So er si niht gesehen mach
so tobet er nahtes vnde tach
Hey waz er gedenchende ist
vmb mörzet dinge zaller vrist
Vn sihe man waz er tuot
mit gedanchen in sinem muot
Er müste sich sin schamen sere
nu mohte er sich des schamen mere
Daz in der siht vnder div ougen
dem dehein gedanch ist verborgen
Vn der wol die chraft hat
swem ers niht wil haben rat
Daz er mit verdanchen mach
da nimmer geschiner liche tach
Vor dem sol man sich bewarn
wa man hin welle varn
An gedanchen vn mit getat
daz ist wider luite rat

Daz dritte teil sol hie ende nemen
daz vierde man sol hin für vernemen

On der vnkivsche
han ich geseit
vnde wie du
vntervehent
vns an dem
rich vnd chvs
ber chen
vn waz marter
ein man

PART 4 (FVK, 4783–6328; HR, 4147–5692)

Fig. 44: fol. 35v
Illustration 69 (von Kries 75)
Text summary (FvK, 4811–36): The six qualities of wealth, nobility, reputation, glory, desire, and power are connected with certain vices and can make people dependent and unfree.
Illustration: The illustration depicts "the chain of vices" (*der vntugende cheten*). The six qualities provide the links between the vices. The large figure in red supporting the column of figures is unlabeled here. In other manuscript redactions it is labeled "Vice" (*untugend*). This figure holds four vices in front of him: "Laziness" (*Tracheit*), "Lechery" (*Lecherheit*), "Drunkenness" (*Trvnchenheit*), and "Whoring" (*hv̊rgelust*). Extending upward behind Vice is a column of ten figures resting on each other's shoulders. Starting from the bottom, they are "Desire" (*gelv̊st*), "Nobility" (*adel*), "Foolishness" (*Torscheit*), "Reputation" (*name*), "Vanity" (*vppicheit*), "Power" (*macht*), "Contempt" (*smacheit*), "Glory" (*herrschaft*), "Arrogance" (*vbermůt*), "Wealth" (*richtům*), "Lust" (*girscheit*).

Illustration 70 (von Kries 76)
Text summary (FvK, 4857–68): A lord who is too attached to wealth will become Greed's servant and will have to serve her.
Illustration: "The wealthy man" (*der riche*) rests his weight on "wealth" (*richtv̊m*), similar to the chain of vices described above. The two figures are sitting below (at the feet of) "Greed" (*girde*).

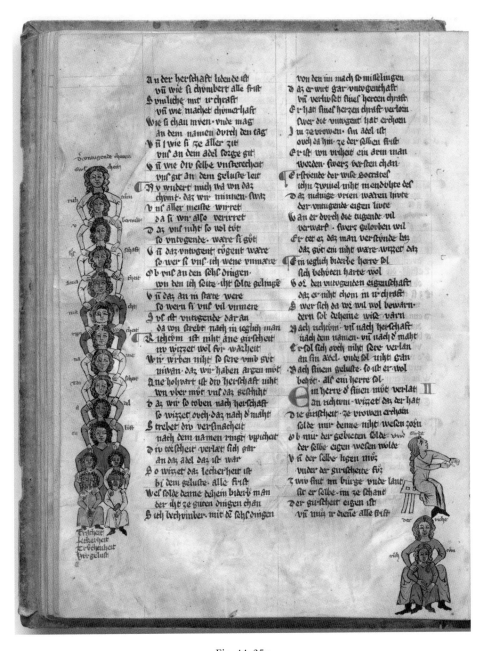

Fig. 44. 35v

Fig. 45: fol. 36r
Illustration 71 (von Kries 77)

Text summary (FvK, 4919–52): When a man is a slave to his desires, he loses his freedom.

Illustration: An enthroned lady holding a whip orders the kneeling man before her to "pull off the shoe immediately" (*zv̊ch hin di schv̊ schiere*). The man responds: "With pleasure, my dear Lady" (*vil gerne liebe frauwe*). The two men behind him watch this and comment. The first asks: "Is he supposed to be my friend?" (*Solde der min genȯz si*). The second exclaims: "God forbid that it should happen!" (*Nv̊ne welle got daz iz gesche*).

e

¶ wer an herschaft vlat den müt
daz en ist niht güt
Wan er ist egen der hohvart
er hat sich gescheidet ze hart
Z wirs ist im deheim dienstman
sit er selbe niht enchan
ff lichen der hohverte eigenschaft
er hat niht stetes herren chraft
S ist er so lebet· unde tot
vñ dienet der uber müt
S wer sich verlat an die maht
der hat ouch stetes herren aht
h erlorn· unde muz töslich
dienen· eigen schalche gluch
d er vrowen versmahet
er si im liep oder leit
d az molte im versmahen daz
het er sin· witzet daz
J m mohte ouch daz versmahen wol
daz in der valant riten sol
S ime vrivnt mögen im gehelfen niht
swaz im ze liden geschiht
V on siner vrowen· swaz si im tot
daz müz in aller dvnchen güt
S wer dem namen volgen wil
der dienet der vntugende vil
D ie wir da heizzen vpriheit
wa hilfet daz· hat er breit
B amen sit er eigen ist
vñ müz ouch dienen alle frist
E iner vrowen· div vnstete
ist· an aller ir gerete
¶ S wer sich an sin adel verlat
die torscheit· der ze vrowen hat
W an im versmahet zelernen niht
ich wæne· von im werde niht
d chem lant berihtet wol
der niht lernet· daz er sol
h ir were sin adel vil vnmaere
swa mit dem dinge lechnubert wære
W az frvmt daz disen· oder den

ob edel was sin alter en
S it er selbe ze dirre frist
der torscheit eigen ist
S wer die sule uz nemen wil
des dahel bliber da niht vil
S wer selbe ist en boswiht
der hat siner vol varn adel niht
¶ S wer dem gelucke volgen wil
der hat vrowen harte vil
Z racheit vnde· leckerheit
hvrgelust· vnde trvnchenheit
D ie habent· vber in gwalt
er ist ir erbe eigen halt
W ie wil der ein herre sin
dem da herscheit· meit vnde win
S wer trvnchen wirt von vrinelschraft
der ist wol in wines eigenschaft
W ie aber der selbe alle frist
mit dem dinge vmvzich ist
W az er ezze· der ist ouch
der leckerheit ein waver gouch
W ie aber der· der alle zit
mit beine· vber beine lit
d er ist ein schalch der tracheit
er mach der vrowen sin gemeit
B uln aber die vri wesen
die ane wip niht mögen genesen
h ñ die niht habent so vil chraft
sine müzzen zu wibes schaft
I den· vnde gar ir gebot
die machent· vz in selben spot
D ie alle wege ligen müzzen
vnder enes wibes kezzen
W ie mohte nur gebiten der
den dvrch ein wip hat so ser

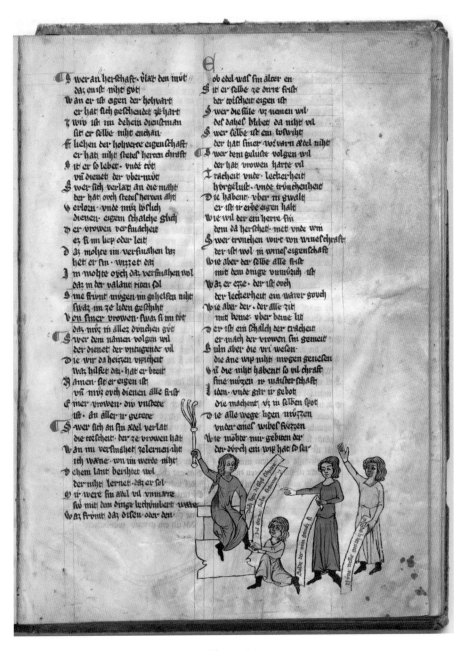

Fig. 45. 36r

Fig. 46: fol. 36v

Illustration 72 (von Kries 78)

Text summary (FvK, 4971–75): Constancy is Virtue's counselor. Without Constancy, there can be no virtue.

Illustration: Virtue (*tvgent*) is enthroned with Constancy (*Stette*) standing to her right. Constancy advises Virtue: "I counsel that you be always constant" (*Ich rat iv daz ir stete sit alzeit*). On the right (Virtue's left) the three virtues "Humility" (*divmv̊t*), "Chastity" (*chivsche*), and "Generosity" (*milte*) ask Virtue variations of the same question: "Lady, what do you command us to do?" (*frawe waz gebietet ir vns*); "What does our Lady command?" (*waz gebiv̊t vnser frawe*); "What does my Lady Virtue command" (*Waz gebivtet min frowe tv̊gent*). Virtue instructs them: "I command you to be constant" (*Ich gebiet ev steticheit*).

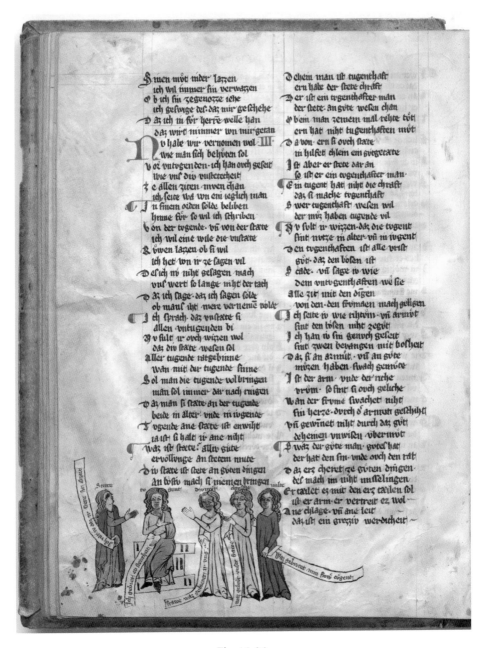

men müt nider lazzen
ich wil immer fin verwazzen
Ob ich hu zegenozze iehe
ich gesinge des daz mir geschehe
Daz ich in für herre welle han
daz wirt nimmer von mir getan
Nv hale wir vernomen wol IIII
wie man sich behüten sol
Vor vntvgenden ich han ovch geseit
wie vns div vnsterecheit
Ze allen ziten mven chan
ich feite wa von ein iegluch man
In finem orden solde beliben
hinne für so wil ich schriben
Von der tvgende vnd von der stæte
ich wil eine wile die vnstæte
Rvwen lazzen ob si wil
ich het von ir ze sagen vil
Des ich nv niht gesagen mach
vns werti so lange niht der tach
Daz ich sage daz ich sagen solde
ob maus iht mere vernemë wolde
Ich sprach daz vnstæte si
allen vntvgenden bi
Jv svlt ir ovch wizzen wol
daz div stæte wesen sol
Aller tugende rttgebinne
wan mit dir tugende finne
Sol man die tugende wol bringen
man sol immer dar nach ringen
Daz man si stæte an der tugende
beide in alter vnde in iugende
Tvgende ane stæte ist enwiht
ia ist si halt ir ane niht
waz ist stæte allv güte
ervollunge an stetem mute
Div stæte ist stæte an güten dingen
an bösiv mach si niemen bringen

Dchein man ist tugenthaft
ern habe der stæte chraft
Der ist ein tvgenthafter man
der stæte an güte wesen chan
Bein man zeinem mal rehte tüt
ern hat niht tugenthaften müt
Da von ern si ovch stæte
tin hilfeti chlein ein swgeræte
Ist aber er stæte dar an
so ist er ein tvgenthafter man
Ein tugent hat niht die chraft
daz si mache tvgenthaft
Swer tvgenthaft wesen wil
der mv haben tugende vil
Hv solt ir wizzen daz die tvgent
sint nvtze in alter vnd in ivgent
Den tvgenthaften ist alle vrist
güt daz den bösen ist
Schade vnd sage iv wie
dem vntvgenthaften we sie
Alle zit mit den dingen
von den den frümigen mach gelingen
Ich sære iv wie richtvm vnd armüt
sint den bösen niht zegüt
Ich han iv fin genvch geseit
sint zwen bevangen mit boßheit
Daz si an armüt vnd an güte
müzen haben swach gemüte
Ist der arm vnde der riche
vröm so sint si ovch geliche
Wan der frvme swachet niht
fin herze durch der armüt geschiht
vñ gewinet niht durch daz güt
dehemen vnwizen vbermüt
Swa der güte man güten hat
der hat den sin vnde ovch den rat
Daz erz cheret ze güten dingen
des mach im niht misselingen
Er tailet ez mit den erz tailen sol
ist er arm er vertreib ez wol
Ane chlage vnd ane leit
daz ist ein grozziv werdicheit

Fig. 46. 36v

Fig. 47: fol. 37v
Illustration 73 (von Kries 79)

Text Summary (5181–98): Everyone will be judged and punished according to his actions. God used to tolerate no sinning but would punish people for their wicked deeds immediately. He would absolve people of their sins. But now that he does not intervene in this world, we will suffer a worse fate in the next.

Illustration: In the center of this illustration, a man with a club threatens to beat another man, who cries out: "Sir, don't kill me" (*Herre en totet mich niht*). Two angels fly down from above. The one in front holds a switch and proclaims: "I want to punish him" (*Ich wil in zuchtigen*). The second angel holds him back with the reminder: "Our Lord does not want that" (*Vnser herre en wil des niht*). Two demons below clutching grappling hooks are waiting to pull the man who is to be punished into hell. In reference to the angels, the demon on the left says: "He won't let him be punished" (*Er let in niht zvchtigen*). The one on the right responds: "Then he'll be given to us" (*So ist er vns gar beschert*).

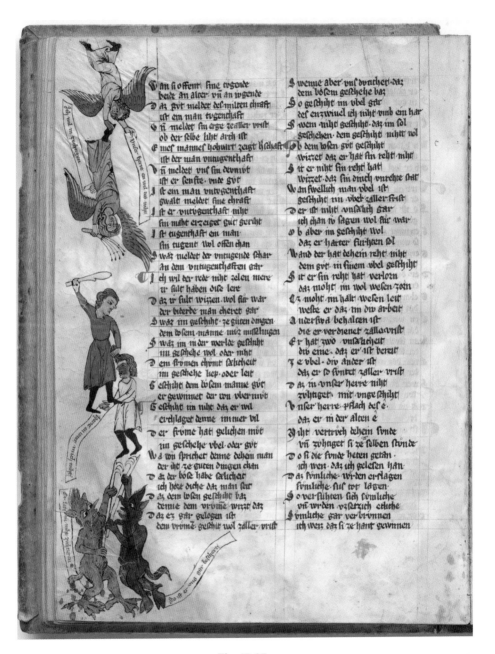

Fig. 47. 37v

Fig. 48: fol. 38r
Illustration 74 (von Kries 80)

Text Summary (5240–70): A perpetrator of violence is worse off than his victim, for God will judge him harshly. Only the perpetrator, and not the victim, will receive blame and misfortune for his actions.

Illustration: "The violent man" (*Der gewaltigere*) is enthroned on the left. "Wickedness" (*vngv̊te*) hands him "Blame" (*schulde*) and "Misfortune" (*vnheil*). The violent man complains: "You are giving me the blame" (*dv gist mir div schvlde*).

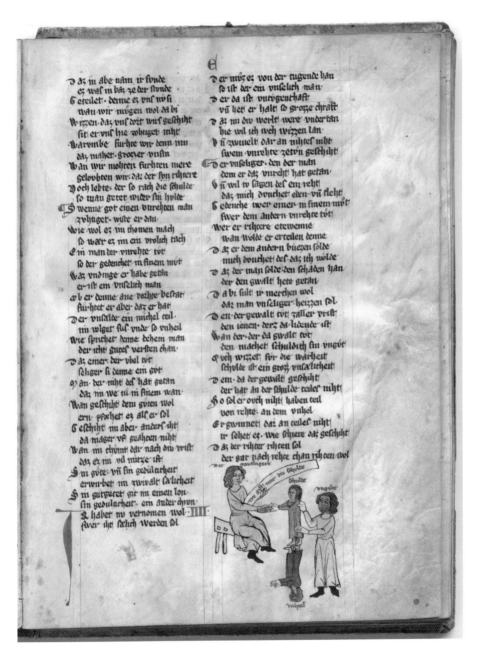

daz in abe nam ir ſvnde
ez was in baz ze der ſtvnde
G ereilet · denne ez vns nv ſi
wan wir mvgen wol da bi
Wizzen daz vns dort wirt geſchiht
ſit er vns hie zvhtiget niht
Warvmbe fvrhte wir denn in
daz maher · groezer vnſin
Wan wir mohten fvrhten mere
Gelovbten wir daz der ſyn richere
J och lebte · der ſo rach die ſchulde
ſo man getet wider ſin hvlde
S wenne got einen vnrehten man
zvhtiget · wiſte er dan
Wie wol ez in thvnen mach
ſo waer ez im ein vrolich tach
E in man der vnrehte tvt
ſo der gedenchet in ſinem mvt
Waz vndinge er habe getan
er iſt ein vnſelich man
O b er denne ane vorhte beſtat
fvr-hvet er aber daz er hat
D er vnſelde ein michel teil
in wilget ſuſ vnde ſo vnheil
Wie ſprichet denne dehem man
der reht gvtes verſten chan
D az einer der vbel tvt
ſelger ſi denne ein gvt
O y an der niht des hat getan
daz im we tů in ſinem wan
Wan geſchiht dem gvten wol
ern pfæhet ez alſ er ſol
G eſchiht im aber anders iht
da maier vſ geahten niht
Wan im chvnnt dar nach div vriſt
daz ez im vil nvtze iſt
H in gvte · vn ſin gedulticheit
erwirbet im zwivalt ſælicheit
H in gutzrecht git im einen lon
ſin gedultecheit · ein ander chron
R habet nv vernomen wol · IIII
ſwer iht ſælich werden ſol

D er muz ez · von der tugende hān
ſo iſt der ein vnſelich man ·
D er da iſt vnvgenthaft
vñ het er halt ſo groze chraft
D az im div werlt were vndertān
hie wil ich woh wizzen lān
V ñ zwivelt dar an nihtes niht
ſwem vnrehte zetvn geſchiht
D er vnſeliger · den der man
dem er daz vnreht hat getān
G vñ wil iu ſagen des ein reht
daz mich dvnchet eben · vñ ſleht
G edenche iwer einer in ſinem můt
ſwer dem andern vnrehte tvt
Wer er rihtere etewenne
wan wolde er erteilen denne
D az er dem andern bvezen ſolde
mich dvnchet des daz ich wolde
D az der man ſolde den ſchaden hān
der den gwalt hete getān
D a bi ſult ir merchen wol
daz man vnſeliger heizzen ſol
D en der gewalt tvt zaller vriſt
den ienen · derz da lidende iſt
Wan der · der da gwalt tvt
den machet ſchuldich ſin vngůt
E vch wizzet fvr die warheit
ſchvlde iſt ein groz vnſælicheit
D em · da der gewalt geſchiht
der hat an der ſchulde teiles niht
H o ſol er ovch niht haben teil
von rehte · an dem vnheil
E r gwinnet dar an teiles niht
ir ſehet ez · wie ſchiere daz geſchiht
D az der rihter richten ſol
der ſat nach rehte chan richten wol

Fig. 48. 38r

Fig. 49: fol. 38v
Illustration 75 (von Kries 81)
Text summary (FvK, 5285–88): The more wickedness one commits, the more unhappiness and misfortune one will receive.
Illustration: "The wicked man" (*der vngŭte man*) is depicted on the left, pulling the hair of a smaller shirtless figure. He looks over his shoulder at the figures arriving and asks: "What are you bringing me?" (*Waz bringet ir mir*). The man in front responds: "Joylessness and Misfortune" (*Vnfrevde vnd vnselde*). The second man repeats: "We're carrying Joylessness and Unhappiness" (*Wir tragen vnfrovde vnd vnselde*). Between them they carry a long stick over which are thrown the bodies of "Joylessness" (*vnfrovde*) and "Unhappiness" (*vnselde*).

¶ Ez sprichet lihte ein vuiltouuch man
vnser herre sorne sich daz an
Daz er vertreit so lange zit
daz ein guti man lit
Oder eines vbelen mannes für
wan er im immer dienen muz
Nein·er sorvet sich niht dar an
er hilfet niht den vbelen man
Vñ wirret ovch dem goten niht
swie lange so ez hie geschiht
Daz ez got vertragen wil
wan er hat des lones zil vñ vil
Der ietwederem zinnt wol
dar nach vñ er im geben sol
So wenne der vbel ie mere tot
so nu ie mere bringet sin vngvt
Vnreude· vnde vntælicheit
daz wizzet für die warheit

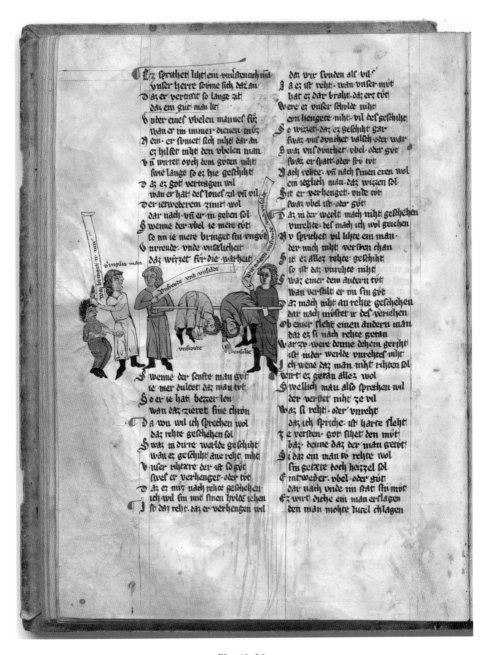

So wenne der senfte man got
ie mer dultet daz man tot
So er ie hat bezzer lon
wan daz zieret sine chron
Da nu wil ich sprechen wol
daz rehte geschehen sol
Swaz in dirre werlde geschiht
wan ez geschiht ane reht niht
Vnser rihtære der ist so got
swes er verhenget· oder tot
Daz er mir nach rehte geschehen
ich wil sin mit sinen hulde iehen
Ist daz reht· daz er verhengen wil

daz wir sunden alle vil
Ia ez ist reht· wan vnser mvt
hat ez dar braht· daz ez tot
Were ez vnser schulde niht
ein hengente niht·vil des geschiht
So wizzet·daz ez geschiht gar
swaz vns dunket valsch·oder war
Swaz vns dunket·vbel oder got
swaz er spat·oder fro tot
Iach rehter·vñ nach sinen eren wol
ein ieglich man·daz wizzen sol
Hit er verhenget·vnde tot
swaz vbel ist·oder got
Daz ni der werelt mach niht geschehen
vnrehte· des mach ich wol iehen
Vn sprichet vil lihte ein man
der mich niht verstan chan
Hit er allez rehter geschehen
so ist daz vnrehte niht
waz einer den andern tot
wan verstilt er im sin got
Daz mach niht an rehte geschehen
er nach miffet ir des veriehen
Ob einer sleht einen andern man
daz si si nach rehte getan
War zv were denne dehein gerihti
ist in der werlde vnrehtes niht
Ich wene daz man niht rihten sol
wirt ez getan allez wol
Swellich man also sprechen wil
der verstat niht ze vil
Waz si rehti·oder vnreht
daz ich spriche·ist harte sleht
Ze versten·got sihet den mvt
baz·denne daz der man getot
Si daz ein man tot rehte wol
sin getæte doch heizzel sol
Entweder·vbel oder got
dar nach vnde im stat sin mvt
Ez wirt dicke ein man erslagen
den man mohte lucel slagen

Fig. 49. 38v

Fig. 50: fol. 39r
Illustration 76 (von Kries 82)

Text Summary (5383–96): The ends do not justify the means because God sees our intent and passes judgment based on it. If a man knows that another man is drunk and yet gives him wine, then he is not behaving charitably.

Illustration: The illustration depicts an evil action that is based on hateful intentions. The two figures on the left are trying to get the one on the right drunk. The figure in yellow tells his accomplice: "Make him drunk" (*Mache in trv̊nchen*). The figure holding the wine cup tells his victim: "Drink it all" (*Trinch vaste*). The figure on the right responds: "Give me something to drink, by God." (*Gib mir lv̊* [sic] *trunchen durh got*).

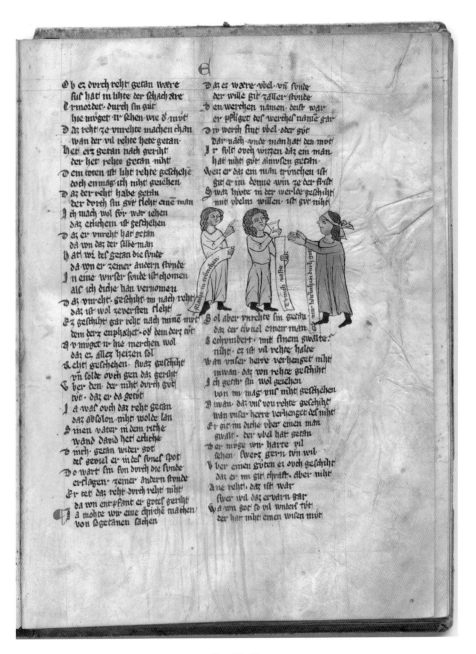

Ob ez durch reht getan wære
sus hat in lihte der schach tære
Ermordet durch sin gut
hie muget ir sehen wie der mut
Daz reht ze vnrehte machen chan
wan der vil rehte hete getan
Het erz getan nach gerihte
der het rehte getan nihte
Dem toten ist liht rehte geschehe
doch enmag ich niht gesehen
Daz der reht habe getan
der durch sin gut slehe eine man
Ich mach wol for war ichen
daz etelichem ist geschehen
Daz er vnreht hat getan
da von daz der selbe man
Hatt wi des getan die svnde
da von er zeiner andern stvnde
In eine wirser svnde ist chomen
als ich diche han vernomen
Daz vnreht geschiht im nach reht
daz ist wol zeversten sleht
Ez geschiht gar reht nach mime mut
dem der z enphahet od dem der z tut
Sv muget ir hie merchen wol
daz ez allez heizen sol
Rehti geschehen swaz geschihte
vn solde ovch gen daz gerihte
Aber den der niht durch gut
tut daz er da getut
Ja was ovch daz reht getan
daz absolon niht wolde lan
Sinen vater in dem riche
wand david het etliche
De mch getan wider got
des geviel er in des sones spot
Do wart sin svn durch die svnde
erslagen zeiner andern stvnde
Er tet daz reht durch reht niht
da von entpfant er gotes gerihte
A mohte wir eine chiche machen
von sogetanen sachen

Daz ez wære vbel vn svnde
der wille git zaller stvnde
De en werchen namen deist war
er pfliget des werches name gar
Sv werth sint vbel oder got
dar nach vnde man hat den mut
Ir solt ovch wizzen daz ein man
hat niht got annvsen getan
Swer er daz ein man trvnchen ist
git er im denne awin ze der frist
Swar hivte in der werlde geschiht
mit vbeln willen ist gvt niht
Sol aber vnrehte sin getan
daz der tivuel einer man
Schvndert mit sinem gwalte
niht ez ist vil rehte halte
Wan vnser herre verhenget niht
invan daz von rehte geschiht
Ich gerihte sin wol gesehen
von mir mag vns niht geschehen
Biwan daz vns von rehte geschiht
wan vnser herre verhenget des niht
Er git im diche vber einen man
gwalt der vbel hat getan
De er muge vns harte vil
schaden swerz gerin tun wil
Vber einen guten ez ovch geschiht
daz er im git schraft aber niht
Ane rehte daz ist war
swer wil daz daz er warn gar
Da von got so vil vndert tut
der hat niht einen wisen mut

Fig. 51: fol. 39v

Illustration 77 (von Kries 83)

Text Summary (5397–5441): The devil is able to act only with God's permission. The devil acts justly because God would not permit anything else. God often gives him power over a wicked man or allows him to test a good man's constancy.

Illustration: A sitting man is depicted. Behind him a demon holds a huge sledgehammer aloft as if to strike him. Holding him back, however, is the hand of God, which holds a chain that prevents the demon from using the hammer.

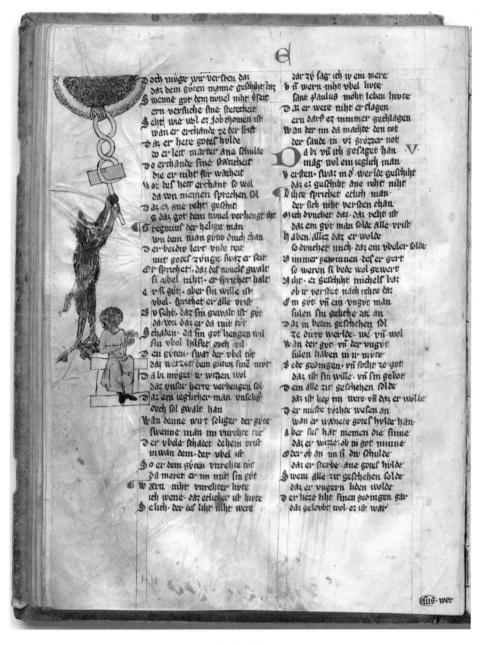

e

och mvge wir verſten daz
daz dem gvten manne geſchiht · daz
S wenne got dem tuivel niht ⸱ vſeit
ern verſuche ſine ſtarcheit
S eht wie wol ez Iob chomen iſt
wan er erchande ze der friſt
D az er hete gotel hvlde
do er leit marter ⸱ ana ſchulde
D o erchande ſine ſtarkheit
die er niht fur warheit
V or des het erchant ſo wol
da von niemen ſprechen ſol
D az ez ⸱ ane rehte geſchiti
G daz got dem tuivel verhengt ihr
S regoriul der heilige man
wn dem man gvtu dinch chan
D er beidiv leirt ⸱ vnde teit
mit gotel zvnge · ſwaz er ſeit
Er ſprichet · daz del tuivele gwalt
ſi vbel tihti · er ſprichet halt
e r ⸱ ſi gvt · aber ſin wille iſt
vbel · ſprichet er alle vriſt
Z u vſcht · daz ſin gewalt iſt · got
da von daz er da tuit tot
S chaden · da ſin got hengen wil
ſtu vbel hilfet ⸱ ovch vil
e n gvten · ſwaz der vbel tot
daz wirzeit dem guten ſin ⸱ nrot
D a bi mvgt ir · wizzen wol
daz vnſer herre verhengen ſol
D az ein teglicher man · vnſelig
ovch ſol gwalt han
V an denne wirt ſeliger der gvte
ſwenne man in vurchte tut
D er vbele ſchadet dehem vrit
niwan dem · der vbel iſt
S o er dem gvten vnrehte tot
da merct er · in niht ſin gvt
W arn niht vnrehter livte
ich wene · daz etlicher iſt livte
S elich · der del liht niht were

dar zv ſag ich iv em mere
b ſi wern niht vbel livte
ſant Paulus moht leben hivte
D az er were niht er clagen
ern darf ez nimmer gechlagen
Wan der in da maehte den tot
der ſande in vz grozzer not
D a bi vn ich geſaget han
mag wol ein teglich man
V erſten · ſwaz m dr werlde geſchiht
daz ez guſtihit ane rehte niht
D iche ſprichet etlich man ·
der ſich niht verſten chan
O ich dvnchet daz · daz rehte iſt
daz em gvt man ſolde alle vriſt
H aben allez daz er wolde
ſo dvnchet mich · daz ein vbeler ſolde
N immer gewinnen del er gert
ſo weren ſi bede wol gewert
Z iht · ez guſchiht michelf baz
ob ir verſtet nach rehte daz
E in gvt · vn ein vngvt man
ſulen in gelvche dn an
D az in beden geſchehen ſol
ze dirre werlde · we vn wol
Wan der got · vn der vngvt
ſulen haben in ir mvte
S ede gedingen · vn foiht ze gotl
daz iſt ſin wille · vn ſin gelot
D em alle zit geſchehen ſolde
daz iſt liep im were vn daz er wolde
D er muſte rehter weſen ſn
wan er wanere gotel hvlder han
A ber ſus hat niemen die ſinne
daz er wizze · ob in got minne
O der · ob an in ſi dw ſchulde
daz er ſterbe · ane gotel hvlde
S wem alle zit geſchehen ſolde
daz er vngern liden wolde
D er hieze liht ſinen gedingen gar
daz gelovbt wol ez iſt war

Fig. 52: fol. 41r
Illustration 78 (von Kries 84)

Text Summary (5725–42): Just as the doctor uses different methods to heal patients depending on the illness, so too does God treat people differently in his effort to bring them to salvation. A doctor might heal a sick man using thirst, hunger, or fire; he might bind him to a wall and cut him; he might tug a man's beard and hair so that he does not sleep too much, or enable him to sleep better.

Illustration: A doctor treats two different patients. On the left "the sick man" (*der siche*) lies in bed, and the doctor (*Der artz*) touches his shoulder telling him, "Sleeping is unhealthy for you" (*Dir ist daz slafen vngesvnt*). On the right "the sick man" (*der siche man*) is bound to a thick stake while the doctor (*Der artzet*) performs surgery.

e

Als ich gesprochen han·
Wirn wizzen warumbe ein man
Sprechet · welle spise suezze
der ander sure haben in vezze
Vñ wellen wizze wa von der
habe so vil · der ander mer
Vñ sprechen hete du daz
ez wer an im gestatter baz
Got hat wunderlich getan
daz er den armen wil verlan
an armuit · unde der boswiht
ist riche · daz solde got tun niht
Hie schinet unser narrischeit
swem uns der arzat vor leit
Daz er stidet uf die wunden
wirn gewirren ze den stunden
Sie ihr sprechen · daz er ubel tu
wir lazen in einen der zu
Daz er tu swaz er wil
wir gewirren mihr schlagen vil
Wie getar denne dehein man
wider den schlagen der da chan
Ein teglich sele erzen wol
dar nach vil er si erzen sol
Etlich man hat den muit
daz im richtum niht er guit
Wan er wirde tump wer er rich
ein ander ist dem vugelich
An sinem willen vñ an sine muit
dem ist der richtum guit
Dem dritten ist er ungesunt
habe nutze zaller stunt
Wan er were lihte ze noetlich
were er dan gesunden gelich
So ist dem vierden zaller vrist
guit · ob er wol gesunt ist
Wan er chert sinen gesunt
ze guten dingen alle stunt
Daz weiz allez got wol
der niht tut · niwan daz er sol
Da von sol niemen han den muit
daz er spreche · daz got tut

Ander · denn er von rehte solde
Wan suer sich daz an nemen wolde
Daz er die lute erchaute daz
denne got · der wer torisch wizze daz
Wil siehz der an nemen niht
dem da ze sprechen geschir
Got solde dem geben selicheit
disem hep· dem andern leit
Ja weiz got wol wem er sol geben
unsolicheit· oder seligez leben
Got· der erzent uns alle vrist
dar nach vñ unser siechtum ist
Welle wirz niht han ver got
swem er uns erzent unserin muit
Vñ wellen sprechen daz
daz er mohte tun baz
Wir mögen wol von unserm muit
triben den edelen arzat got
Vñ gwinnen nimmer mere
deheinen mit also guoter lere
Ein arzt der wol erzen chan
der erzent dicke einen siechen man
Sit dürste mit hunger vñ mit praut
er bruoet in uf ze einer want
Er snidet· vñ stichet in vil hart
einem andern touer er sine bart
Suer sin har· wan er wil
daz er niht enslafe vil
Vñ lat in hiurugern niht
wir sehen wol daz ez geschiht
Alsam unser herre tut
swenne er erzent unsern muit
Er erzent den mit selicheit
den andern erzent er mit leit
Er erzent uns zemer teglische vrist
dar nach vñ unser siechtum ist
Dai umbe sol ein teglich man
der sich ze guote versten chan

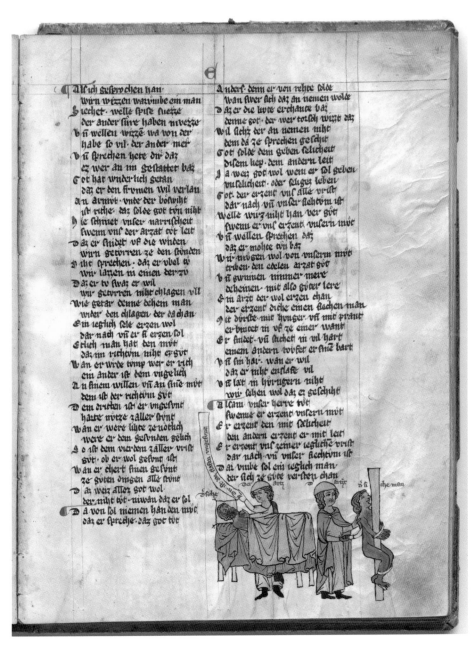

Fig. 52. 41r

Fig. 53: fol. 42v

Illustration 79 (von Kries 85)

Text Summary (5973–84): A good man should not fear anything. He should not fear poverty because his spirit is rich. He should not fear illness, for it will cause his spirit to become even stronger. He should not fear banishment because a good man who does not abandon virtue is always home, no matter how far away he is from his house.

Illustration: "A lord" (*ein herre*) exiles a man—"I banish him immediately" (*Ich tůn in in di achte zehant*)—while his "people" (*daz volch*) take note: "He has been banished" (*Er ist zv achte getan*). The banished man, the figure in yellow on the far right, departs but tells "his virtues" (*Sin tůgent*), "Come with me my cherished virtues" (*Vart mit mir mein vil lieben tugende*). His virtues respond: "We won't leave you." (*Wir enchůmen von dir niht*).

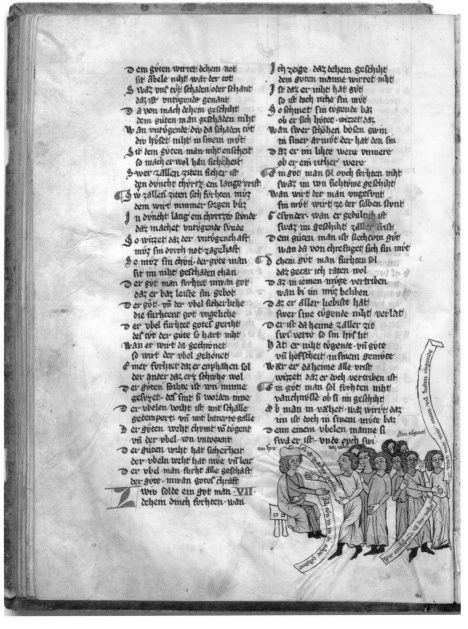

D en gůten wirret dehein not
sit Abele niht war der tot
S waz vns tůt schaden oder schant
daz ist vntvgende genant
D a von mach dehem geschiht
dem gůten man geschaden niht
W an vntvgende div da schaden tůt
div höset niht in sinem můt
I st dem gůten man niht enscheit
so mach er wol han sicheheit
S wer zallen ziten sicher ist
den dvncht chvrtz ein lange vrist
I v zallen ziten sich fvrhten můz
dem wirt nimmer sorgen bůz
I n dvncht lang ein chvrtzv stvnde
daz machet vntvgende svnde
S o wizzet daz der vntvgenth aft
můz sin dvrch not zagelhaft
S o mvz sin chvni dar gvte man
sit in niht geschaden chan
D er gvt man forhtet immer got
daz er daz leiste sin gebot
D er gvt vn der vbel sicherliche
die fvrhtent got vngeliche
D er vbel fvrhtet gotes gerihti
des tůt der gůte so hart niht
W an er wirt da gechrönet
so wirt der vbel gehönet
E mer forhtet daz er enphahen sol
der ander daz erz schiwe wol
D er gvten forhte ist von minne
gesvzet des sint si worden inne
D er vbelen vorht ist mit schalle
getemperti vn mit bitervte galle
D er vbel wrhte chvmt von vntvgent
vn der vbel von vntvgenti
D er gůten wrht hat sicherheit
der vbeln wrht hat mve vn leit
D er vbel man fvrht alle geschaft
der gvte inwan gotes chraft
Wiv solde ein gvt man VII
dehem dvrch fvrhten wan

I ch zeige daz dehem geschiht
dem gvten manne wirret niht
I st daz er niht hat gvt
so ist doch riche sin můt
S o schmet sin tvgende baz
ob er sich höret wizzet daz
W an swer schöheti bösen gewin
mit siner armůt der hat den sin
D az er im lihte were vnmere
ob er ein richer were
G m gvti man sol ovch forhten niht
swaz im von sieldvne geschiht
W an wirt der man vngesvnt
sin můt wirt ze der selben stvnt
E cbynder wan er gedultich ist
swaz im geschiht zaller vrist
D em gůten man ist siechtvm gůt
wan da von chrefniget sich sin můt
E chein gvt man fvrhten sol
daz getar ich raten wol
D az in iemen mvge vertriben
wan bi im můz beliben
D az er aller liebiste hat
swer sine tvgende niht verlat
D er vbel da heime zaller zit
swo verre so sin hof lit
H ati er niht tvgende vn gvte
vn hofscheit in sinem gemvte
W er er da heime alle vrist
wizzeti daz er doch vertriben ist
E m gvt man sol forhten niht
vanchmvsse ob si im geschiht
D b man in vahet waz wirt daz
im ist doch in sinem můte baz
D enn einem vbelen manne si
swa er ist vnde ovch swi

Fig. 54: fol. 43v

Illustration 80 (von Kries 86)

Text Summary (6115–22): Every land has a path to God and a path to hell. A man should not worry about how long he will live, but how he lives. No matter where a man dies, he will immediately be set on one of the two paths.

Illustration: The illustration depicts earth in the center with "heaven's path" (*Des himels wech*) leading up and "hell's path" (*der helle wech*) leading down.

an vert vmbe gar die vrist
die man in dirre werlde ist
Aber man sol wizzen· swenne
man stirbet· so vert man heim denne
Er solt dar vmbe furhten niht
ze harte· daz im we geschiht
Wan im die zit verget vil drate
ist daz er grozen siechtvm hat
Ob aber sin siechtvm chlein ist
so vertreit erz wol die frist
Entweder er den siechtvm verlat
oder der siechtvm von im gat
Man sol den siechtvm furhten wol
der einen man niht lazzen sol
Vn den man niht enlat
swenn er in erwischet hat
Onde der doch ist so groz
daz in dehein er ist genoz
Den sol man furhten zaller stunt
man vindet in der helle grunt
Em man sol erahten niht
wie lang im ze leben geschiht
Er sol halt erahten daz
wie er lebe· er tut vil baz
Ein ieglich man hat wol den sin
daz er weiz· daz er mvz da hin
Swaz er tut vbel oder gut
doch vert der baz· der rehte tut
Er sol den tot niht furhten hart
er sol er furhten mer die vart
Die er nach tode· varn sol
hat er hie niht gelebt· wol
Er sol ovch dar vf ahten niht
wa er sterbe· swa im geschiht
Ie gelten sin schulde· ez ist gut
er sol bereiten sinen mut
Daz er moge gelten wol
swa er ist· wan er sol
Gelten· daz im ist gegeben
swa der man mach geleben
Da nach er ovch sterben wol

tot er daz er tun sol
Der weg in allen landen ist
der hince got vert zaller vrist
Der weg in allen landen lit
der hince helle vert alle zit
Swa der man sterben sol
da stirbt· er vbel oder wol
Swa er stirbet· er wirt zehant
ze ruwe· od ze vnruw gesant
Doch spricht dicke ein man
der fur war niht versten chan
Ob ich da henne sterbe niht
liht daz mir niht geschiht
So grozru not ze minem tot
als reht were· daz ist ein not
Ich sag iv daz ein gut man
der sol ahten niht dar an
Wan swie er chunt hince got
er ist geeret von sinem gebot
Aber die gar ir tage sint
an ir hohverte gewesen blint
Die suln zem tode niht gesehen
waz in der von moge geschehen
Dawn stellen si ahten daz
daz man si ere zem tode baz
Denne man ein andern man tu
wan daz gehoret ovch dar zu
Si suln ir grap machen schone
wan si hant niht gezurdez chrone
Ob si selben sint gemeine
so sin erwelt vz ir steine
Der machet ein diche holzes grap
der selbe varn mvz hin ap
Er ist liht in der helle grunt
des grap hohe ist ze oure stunt
Des grap hie vil hoher hat
vil ahter ze helle vinster gat
Des grap hie nv nider ist
der ist liht hoh ze oure vrist
Den toten mach gewerren niht
swaz in an sinem libe geschiht

PART 5 (FVK, 6329–7436; HR, 5693–6798)

Fig. 55: fol. 45v
Illustration 81 (von Kries 87)

Text summary (FvK, 6417–6634): The virtuous ladder leads to the highest good; the treacherous ladder of vices leads to the lowest evil. The steps of the virtuous ladder are well made, while those of the unvirtuous ladder are slippery and broken. Through virtue it is possible for one to gain access to heaven, but once one has set foot on the unvirtuous ladder, one will easily slip down to hell. The six qualities of wealth, glory, power, reputation, nobility, and desire are like devil's hooks that can pull a man down from the ladder of virtues to the ladder of vices.

Illustration: A male courtier climbs up the ladder of virtues toward heaven. Below him is the broken ladder of vices that leads to hell. Four devils hold long hooks and try to pull him down to the ladder of vices. The rungs of the ladder of vice are labeled: "pride" (*v̊bermv̊t*); "greed" (*Girde*); "hatred" (*Nit*); "anger" (*zorn*); "injustice" (*vnrecht*); "perjury" (*meineid*). Hell is depicted as a black circle ringed in red containing two figures, possibly Adam and Eve, and a three-faced devil. The demon on the far left says: "Give me a hand! I've got him!" (*helfet ich han in erwischet*). The demons' hooks are labeled: "the hook of wealth" (*des richtv̊ms hachen*); "the hook of nobility" (*des adels hachen*); and "the hook of desire" (*des gelustes hachen*). Missing are the hooks of glory, power, and reputation. The virtuous ladder rungs are: "humility" (*divmut*), "generosity" (*Milte*), "love" (*Liebe*), "gentleness" (*Senfte*), "justice" (*Recht*), "truth" (*warheit*).

den guten vn den vbeln niht
wan in da von leit geschiht
S vz sint si vbel vn gvt
dar nach als ist des mannes mvt
D er machtich ist vnde riche
daz gelovbet werliche
S wer sin reht war tot
der gelust ist vil selten gvt
W an er in dem libe ist
vn zvhet ze vndingen alle vrist
O haber vnz welt so vernemen
daz ir gelust weldet nemen
S vr den willen so were er gvt
dar nach als were des mannes mvt
O an solz also versten niht
wan der gelust ist enwiht
D u bezzert noch dicke ene man
der wol der wider striten chan
D es nideristen vbels bereitschaft
sint die sehse er hat die chraft
D az er da mit zihet alle zit
den vbeln da er selbe lit
Wie daz allez geschehen sol
daz wil ich sagen merchet wol
O tz seit nun sin vn ovch ist mvt
swaz hinne dem oberisten gvt
G eiten sol daz mvz fur war
wesen vz erwelt gar
O w stiege div da reiten sol
div sol sin gemacht wol
D ie steine die nia darzv tvr
die suln sin gar lichen gvt
D ie stapfen soln gantz wesen
dar zv sol man gvt den erlesen
D ie tvgende mvzen sin die stiege
ob teinen spreche dar ich liege
D er sage waz si ser lich gvt
ob er denne daz getvt
S o mvz er sagen vol fir war

daz die tugende gvt sint gar
W an niht anders nider werlde ist
daz gar si gvt alle vrist
S o mach ovch niht gereichen dar
zem oberisten gvt wizzet daz
D az swære daz mvz ziehen nider
vn chvmt vn siner chraft niht wid'
D az vbel erreichet niht daz gvt
daz ander swich an sinem mvt
D az ringe zwht ioh alle vrist
ein gvte bi der andern ist
S o ist ovch reht daz alle zit
daz ein vbel bi dem andern lit
N v habet ir vernomen wol
wa von ein man machen sol
F in stiege div zem oberisten gvt
chomen mvge swer hat den mvt
D az er dar vf chomen wol
der mvz gedenchen harte vil
Wie er die stiege machen sol
daz er dar vf gestige wol
F in ieglich stapfel mvz sin
gantz von einer tvgend daz ist min
Wille vnde ovch min rat
so man dar vf denne gat
S o mach man varn sicherlichen
doch sol man varn stetlichen
S wer die stiege machen wil
der sol ovch sich des vliezzen vil
D az die vntvgende chomen niht
dar zv wan ob daz geschiht
S o nement daz in iren mvt
daz si ze dem oberisten gvt
N immer wol gereichen mach
ia sol div naht vn der tach
N immer in ein ander chomen
ich han es ovch nie vernomen
D az ez tach were vmb mitte naht
wan div vinster hat die maht

Fig. 55. 45v

Fig. 56: fol. 48v
Illustration 82 (von Kries 88)
Text summary (FvK, 6935–56): In the old days, there used to be more virtuous lords, and virtuous people were treated better. Now the vices are treated better than the virtues. When a stalwart man comes to court, people pay no attention to him, but if a usurer comes to court, then the stalwart man will have to make room for him. For that reason people think that they need to be wicked if they want to get anywhere. *Illustration:* Vice bestows (false) honor upon its people. "Vice" (*Vntugend*) is personified as a naked figure with a pointed cap. Vice tells the men standing before him: "Come to me, if you want honor" (*Chv̊met zv mir welt ir ere*). The first four figures facing Vice vie for attention: "I asked before you" (*Ich han e gevodert danne dv̊*); "allow me to be treacherous" (*Lihet mir daz ich arch si*); "flattery makes me worthy" (*Lôsen tůt mich wert*); "Then give me the profit" (*So verlihet mir den wůcher*). The man on the right complains, "Alas, they are all pushing in front of me" (*Owe mir, si dringent mir alle fůr*).

Nv han ich iv geseit wol
wa von man tugende nuien sol
wan unser gemeiner herre
minnet die tugend harte sere
In teglich moht sich sin schame vil
der dem herren niht volgen wil
Der mach sich sin aber schame tuere
dem got hat gegebe maht vn ere
Ob er dem herren niht volge wil
der im hat gegeben ere vil
Vnser herre git diche ere
dem der sich selben schendet sere
Der selbe mach ouch niht herr sin
des ist dar an wol worden schin
Daz er dem herren niht volge wil
der uns git herschefte vil
Sw er sinem herren nimt sin reht
so mag ouch er ze sinem chnecht
Chein reht von rehte han
wie mohte denne d selbe man
Sou rehte sin ein landes herre
d daz verworht hat so verre
Daz er an sinem eigene chnecht
niht von rehte mag haben reht
Sw sine herschaft also hat
daz er niht nach rehte gat
Der hat mir unrehte sin herschaft
vn tut gewalt ouch sin chraft
Er tut uns gewaltes vil
der uns von gote scheiden wil
Daz tut ein ungerehter herre
der scheidet uns von gote verre
Mit siner untugende chraft
machet er uns untugenthaft
Weizgot der herren der ist vil
fur war ich iv daz sagen wil
Die uns machent untugenthaft
mit ir untugende chraft
Da von mach nie niht vmden hivte
als tugenthafte livte

Als mam mie bevor vant
daz wil ich iv sagen zehant
Die herren warn tugenthaft
do liebte den andern tugende chraft
Daz si lebten nach der tugende
beide in alter. vn in iugende
Nv habent si vercheret ir site
da umbe wir beliben mite
In teglich man tut gern daz
da von er wirt gehandelt baz
Man handelt tugenthafte livte
bi alten ziten baz denne hivte
Da von wir beu si nach tugenden
nv handelt man daz die untugenden
Denne die tugende daz ist war
da von dringen wir alle dar
Chvmt ze hove ein biderbe man
den wil der herre niht sehen an
Chvmt aber dar ein bosewiht
der chonnt von dan an ere niht
Ob ein frum man ze hove were
chome denne dar ein wecherere
Man het den biderben man fur niht
als der bose herre gesiht
Den wecherere richen
dem woz der biderbe euewrichen
So gedocht ihte etelswer
wer ich nv riche alsam der
So moste man mich eren ouch
sus hat man mich fur einen gouch
Swie biderbe vn swie wise ich bin
ich wil eheren du gewin
Mein sin vnde minen muot
ich sehe wol daz er tut
Swaz er wil. der got hat
man hoeret gerne singen rat

Fig. 56. 48v

Fig. 57: fol. 49r
Illustration 83 (von Kries 89)
Text summary (FvK, 6975–88): The stalwart man is like an owl; if wicked people see him, they scream at him and stomp on him with their feet.
Illustration: Three birds and an owl appear in the left margin.
Note: Von Kries considers this and the following illustrations to be a single illustration. Although the images illustrate the same passage, however, they are not visually integrated. I have therefore numbered them separately.

Illustration 84 (von Kries 89)
Text summary (FvK, 6975–88): Stalwart people must remain hidden, for if they are found, they will be mocked.
Illustration: The stalwart man overcomes a scoundrel, but incurs Treachery's hatred for doing so. The three men standing in front of "Treachery" (*bôsheit*) are "Ir dinstman" (its vassals). Treachery tells them "Avenge me on him, my servants" (*rechet mich an im min dinstman*). The three vassals look or gesture toward "the virtuous man" (*der frům man*) on the right. They exclaim: "He thinks he is doing good" (*Nv wenet er gar wol tůn*); "Do you see what he wants to do?" (*Sihstů waz er tvn wil*); "Do you see, lord, what he is doing?" (*Sehet ir hern waz tuᵉt er*). The righteous man stands atop the scoundrel, holding him down with a long pointed stick. The figure on the ground is inscribed: "the scoundrel lies here" (*der bôswîcht liget hie*). The virtuous man tells him: "You must lie still there" (*Dv můst da stille ligen*).
Note: The manuscripts differ significantly in the positioning of the virtuous man. In most of the redactions, he is depicted lying on the ground beneath the scoundrel's feet.

ich muz werden ein dolwiht
ich erwurbe mit frumicheit nv niht
daz chumit von der herren schulde
ich wil verliesen niht ir hulde
dar vmbe daz ich spriche daz
ich wolde daz si teten baz
da ist nv hier eck vil ovch gawein
parsifal vnde ywain
ich weiz sie vnder daz geschiht
da von daz wir haben niht
Artusen in dehemem lande
lebt er wir funden in ane schande
In der werlde noch ritter gnvch
die so frvm wern vn so gefuch
daz man si mohte herzen ywan
suf hat gesaget mir min wan
Sit ir war ich iv daz sagen wil
man funde noch der ritter vil
die ovch an der tugende weck
vil mohten wol erstatten creck
WA sint si verborgen denne
daz man si niht vindet erwenne
Die frvmen sint verborgen gar
daz gelovbet wol fur war
H wie er niht verborgen ist
so honet man in doch alle vrist
Der bosen lvte ist so vil
daz sich der frvme niht zeigen wil
Urzet daz der biderbe ist
gesueht der bosen volen alle vrist
Ob si sehen den biderben man
si schieren nit alle geliche an
So ni treten vf in mit dem fure
nv sehet ob er sich bergen mvze

Ob si die herren vinden wolden
so sagt ich iv daz si solden
Eren tugenthaften lvte
so funde man si vil lihte hvte
Die des vil wol weren wert
daz man ir frvnde hie begert
Ir liezen den bosen ir bosheit
tete man in dar vmbe leit
Em man tete dicke daz er solde
ob man in dar vmbe eren wolde
Die herren mohten geschaffen wol
daz man tete daz man sol
Wie mohten si getvn daz
da erten die frvmen baz
Denne die bosen wizzet fur war
so liezen si ir bosheit gar
Daz des nv alles niht geschiht
des sint die herren ane schulde niht
Daz ich von den ritti han geseit
daz sol man von der pfafheit
Ovch versten deheiner niht
nach hoher chvnste werben vil
Jv warvmbe tvnt si daz
da handelt man si lvtzel desder baz
Ob si nach chvnste wolden streben
so mohten si niht wol geleben
Dar nach vn ir herre lebt
der mwan nach vntugend strebt
Ein ieglich man vern mvz
nach sines herren vntugende fvz
Wil er vern im gewarten iht
oder er gibt im nihtel niht
Varvmbe solde denne ein man
ge schule varn fit er chan
Wol vntvgenthaft wesen
wer solde da von ze schul lesen
Man lernet toscheit da heim wol
da mite man ze hove sol
Werben pfarre vnde pfrunt
seht wie vol die bischoffe tvnt

Fig. 57. 49r

Fig. 58: fol. 49v
Illustration 85 (von Kries 90)

Text summary (FvK, 7045–7124): The world is topsy-turvy; it has no law and no honor, but is governed by vice. The world used to be a better place: the lord and the page did what they were supposed to do; both animals and people had everything they needed; everything had its place and received its just reward or punishment.

Illustration: Animals and fools are given preferential treatment at court. On the left the enthroned "lord" (*Der herre*) asks the ox: "Whom do you want to speak on your behalf?" (*Wen wiltu zve vorsprechen*). The two men behind the ox negotiate its ownership: "I'll take the ox from you" (*Den ochsen ich wol neme von dir*); "You made a good decision" (*Dv hast recht getan*). The next figure in yellow pushes ahead of the bearded "wise man" (*der wise man*): "Let me go first, old fool" (*La mich für alter tor*). The wise man watches all this and remarks: "The world is like this now" (*Also stet nv div werlt ze diser zit*).

H wer si sin die da gebent
churchen· den die also lebent
H eht da mit hant si gemachet
daz nimen uf chunst wachet
B wer sinen herren lobet· vil
swaz er tut· flasse swemme er wil
D er ist höflich· vnde gefich
dem sol man geben ovch gvvch
D er ia herre sprechen chan
der ist nv ein biderbe man
H eht daz hat die pfaffen gar·
trage gemachet· für war
D si an der chvnst verderbent
wan si da mit lucel werbent
H eht daz ist gar der herre schulde
ich hanz gesprochen in ir hulde
Wa ist nv Aristotiles
Zeno· vnde parmenides
Wa ist nv Anaxagoras
plato· vnde ovch piragoras
J v wizzet daz mich dvnchet des
vn lebit hivte Aristotiles
J n entsere dehein ander
chvnich· daz im Alexander
Z e ern tet· die wile er lebet
swer selbe gern nach ern strebt
D er minnet ovch biderbe liute
die wisen· vn biderbn sint hivte
A ne lob· vnde ane pris
den wisen hat der vnwis
H it siner chraft gemidert sere
der bosen· ist so vil mere
D az die frvmen sint enwiht
der bose ist wert· daz geschiht
D a von· daz div hohen tanne
sint in daz mos gediget vo danne
D iz mos graf ist gestigen
vfi daz geburge· nv muze ligen
D ie geslachten bovme nider
daz ist geschehen stvnt sider
D iv werlt stet ane zerihte

vn due ere· daz geschiht
V on div· daz man ist den bösen holt
die vnedelen steine sint in daz golt
G et in die vingerlin gestrongen
edel steine sint vf gedrongen
D ie schamel die da solen ligen
vnder den benchen die sint gestigen
V f die benche· div banch ist
vf dem tische· nv lange vrist
D er vnwise· wise zvnge hat
der wise chan niht geben rat
S ör den Alten dringet der junge
daz vile hat menschen zvnge
G egriffen· wenet sprechen wol
ein ieglich man der sol
H inne für sine zvnge han
stille· vn sol daz vihe lan
R eden· daz ist nv worden reht
der herre sol eren ovch den chneht
D ie ritter suln genze fizen
von rehte die loter riten mvezen
D er helige wissage versprach
daz er die schache riten sach
D o die herren wusten gen
daz sol man also versten
D az die bösen habent ere
vn sint· die frvmen gemidert sere
D az ist nv alles werdan schin
war vmbe sol daz also sin·
D a hat der vntugenthaft
leider· inder werlde meisterschaft
W ie· habt ir mich niht vernomen
daz die berch bovme sint chomen
H er abe zem mos· do daz mos graf
die inden in dem mose was
V fi do die schamel nider lagen
vfi do wir hoher tische pflagen
V fi in derre benche· wizzet daz
daz div werlt do stvnt laz
D o tet der herre· vnde der chneht
daz si solen tvn von reht

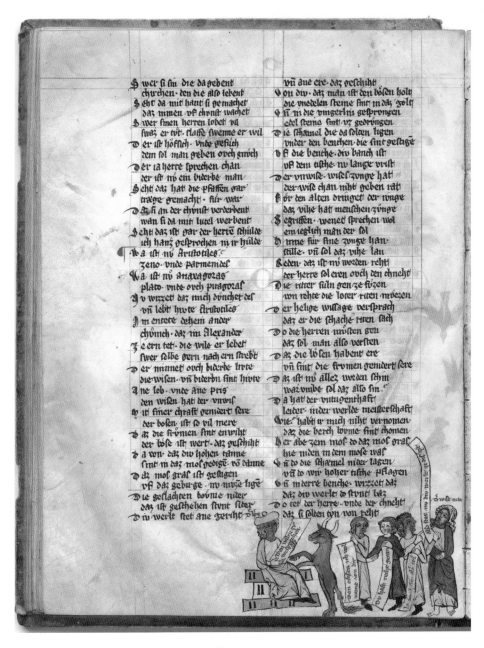

Fig. 58. 49v

Fig. 59: fol. 50v
Illustration 86 (von Kries 91)
Text summary (FvK, 7179–7218): Lords let able young people deterio-rate intellectually by not sending them to school. Instead of investing in the education of young people, they throw gifts and money at the greedy people surrounding them.
Illustration: "The lord" (*der herre*) pours money into the mouth of a courtier. The banderole between them reads: "If he needs it, I don't give it to him" (*bedorft ers ich gebe im nicht*). "Greed" (*di gierde*) stands on the left, encouraging the nobleman: "Open up really, really wide" (*Gien vil vaste wit vf*). On the right "the needy man" (*der bedŏrfende*) asks for help but is ignored: "Lord, give me some too" (*Herr gebet ovch mir*).

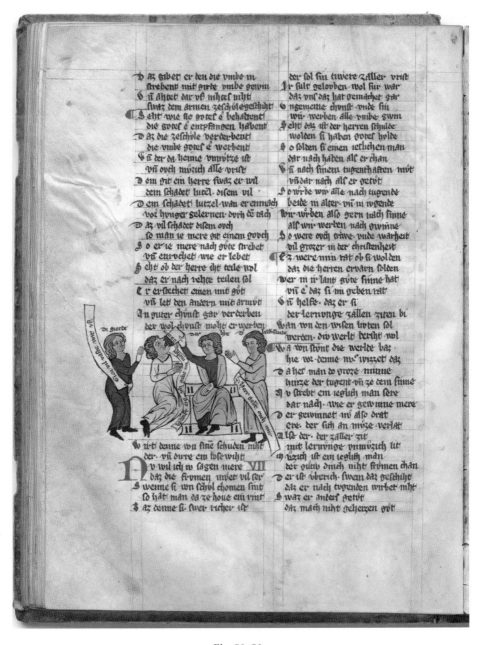

daz gibet er den die vmbe in
strebent mit gůte vmbe gewin
G+ ahtet dar vn nihtes niht
swaz dem armen zeschůt geschiht
C+S ehtt wie sie gotes e behaltent
die gotes e entpfangen habent
D az die zeschůle verderbent
die vmbe gotes e werbent
G+ ist der da hinne vnnvtze ist
vn ouch můzich alle vrist
D em git ein herre swaz er wil
dem schadet lutzel disem vil
D em schadet lutzel wan er enmach
vor hunger gelernen doch tu tach
D az vil schadet disem ouch
so man ie mere git einem gouch
J o er ie mere nach gůte strebet
vn entvelschet wie er lebet
H eht ob der herre dit teile wol
daz er nach rehte teilen sol
E r ersteehet einen mit gůt
vn leit den andern mit armůt
J n guter chrust gar verderben
der wol chrust mohte er werben

der sol sin tiuere zaller vrist
Jr sult gelovben wol fur war
daz vns daz hat gemachet gar
G+ ngemeine chrust vnde sin
wir werben alle vmbe gwin
J ehtt daz ist der herren schulde
wolden si haben gotes hulde
S o solden si einen reichen man
dar nach haben als er chan
V+ nst nach sinem tugenthaften můt
vn dar nach als er getůt
J o wir de wir alle nach tugende
beide in alter vn in iugende
V+ir wirben also gern nach sinne
als wir werben nach gwinne
S o were ouch trawe vnde warheit
vil grozer in der christenheit
Ez were min rat ob si wolden
daz die herren erbarn solden
wer in ir lant gůte sinne hat
vn e daz si im geben rat
G+ n helfe daz er si
der lerunge zallen ziten bi
Wan von den wisen wirten sol
werden diu werlt berihte wol
Wa von stůnt die werlde baz
hie we denne mc wizzet daz
D a het man do groze minne
hinze der tugent vn ze dem sinne
J v strebt ein ieglich man sere
dar nach wie er gewinne mere
D er gewinnet im also drat
ere der sich an můze verlat
A lse der der zaller zit
mit lerunge vnmůzich lit
M ůzich ist ein ieglich man
der gůtu dinc niht strůmen chan
D er ist oberich swan daz geschiht
daz er nach tugenden wirbet niht
S waz er anders getůt
daz mach niht geherzen gůt

Wirt denne von sine schuden niht
der vn dure ein bose wiht
N v wil ich iu sagen mere VII
daz die frumen immer vil ser
S wenne si von schůl chomen sint
so hät man da ze houe ein rint
D az denne si swer richer ist

Fig. 60: fol. 51v
Illustration 87 (von Kries 92)
Text summary (FvK, 7359–7400): The chain of vices is wrought from wealth, desire, glory, power, reputation, and nobility. These ties bind together pride, contempt, vanity, foolishness, and desire. The chain has sloth, gluttony, and drunkenness at the end. Throughout our lives we work this chain, which turns to steel in hell, and holds us captive there. Whoever is bathed in hell will be beaten by it. We should bathe now in virtue so that we will never be bathed in hell.

Illustration: A man is held captive with a noose made of vices and is being bathed by a group of demons. The demon on the left is inscribed with the label *div weitze* (the wheat). This demon pours fire from his cauldron over the naked man. A demon of smaller stature bites the man while a two-faced demon holds the noose. The rope is labeled with the vices and the ties that bind them together: "avarice" (*girscheit*), "pride" (*vbermůt*), "contempt" (*smacheit*), "vanity" (*vppicheit*), "foolishness" (*tŏr-scheit*), "desire" (*gelvst*), "wealth" (*richtům*), "glory" (*herschaft*), "power" (*macht*), "reputation" (*name*), and "nobility" (*adel*). It appears to be woven together from four strands, which are "laziness" (*Tracheid*), "gluttony" (*Lecherheid*), "drunkenness" (*Trůnchenheid*), and "whoring" (*Hůrgelust*).

Note: The inscription *div weitze* is probably a scribal error; in any case it is unique to the Gotha manuscript. Heidelberg Cpg 389 has the label "hell's bath" (*der helle bat*); most other manuscripts have no inscription.

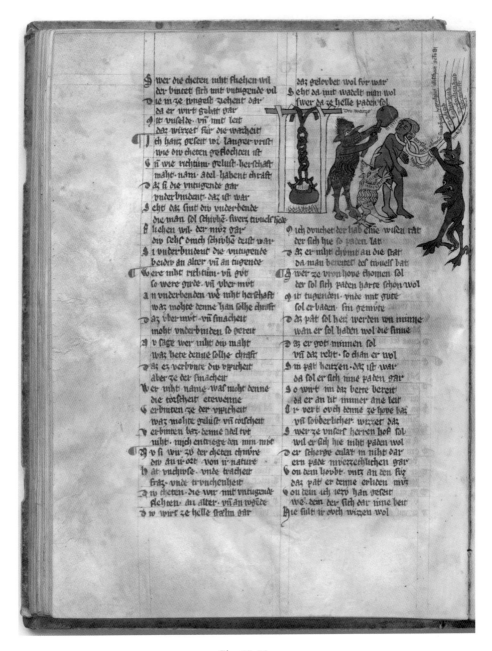

swer die theten niht fliehen wil
der vintet sich mit vntugende vil
Die in ze jungest ziehent dan
da er wirt schuldic gar
Ist vnselde vñ mit leit
daz wizzet für die warheit
Ich hanz gereit wol langer vrist
wie diu theten geflochen ist
Su wie richtum gelust herschaft
mahte nam adel habent chraft
Do si die vntugende gar
vnder bindent daz ist war
Seht daz sint diu vnder bende
die man sol schiuhen swers tvuele hede
Fliehen wil der muz gar
diu reht durch schiuhe teils war
Si vnder bindent die vntugende
beidiv an alter vñ an tugende
Were niht richtum vñ gut
so were grude vñ uber mut
An vnder benden wer niht herschaft
waz mohte denne han solhe chraft
Daz uber mut vñ smacheit
moht vnder binden so gereit
Iv sage wer niht diu maht
waz hete denne solhe chraft
Daz ez verbunte diu vppicheit
aber ze der smacheit
Wer niht name waz moht denne
die torscheit etewenne
Gebruten ze der vppicheit
waz mohte gelust vñ torscheit
Gebruten baz denne adel tot
niht mich entriege den min mut
Iv si wir zv der theten chvmre
div an iv ort von iv nature
Hat vnchivsche vnde tracheit
fraz vnde trvnchenheit
Div theten die wir mit vntugende
fliehen an alter vñ an ivgede
Div wirt ze helle stalin gar

daz gelovbet wol für war
Seht da mit wandelt man wol
swer da ze helle paden sol
Dv warze
Mich dvnchet der had ebie wisen rat
der sich hie so paden lat
Daz er niht chvmt an die stat
da man bereitet des tivuels bat
Swer ze vron hove chomen sol
der sol sich paden harte schon wol
Mit tugenden vnde mit gute
sol er baden sin gemute
Daz pat sol heiz werden von minne
wan er sol haben wol die sinne
Daz er got minnen sol
vñ daz reht so chan er wol
Sin pat heitzen daz ist war
da sol er sich inne paden gar
So wirt im daz bette bereit
da er an lit immer ane leit
Ir vert ovch denne ze hove baz
vñ lobberlicher wizzet daz
Swer ze vnsers herren hof sol
wil er sich hie niht paden wol
Der scherge culat in niht dar
ern pade vnverzellichen gar
Von dem lovbt mitz an den fiz
daz pat er denne erliden muz
Von dem ich iezv han geseit
we den der sich dar inne beut
Hie sulti ir ovch wizzen wol

PART 6 (FVK, 7437–9122; HR, 6799–8470)

Fig. 61: fol. 53v
Illustration 88 (von Kries 93)

Text summary (FvK, 7658–7718): The moneylender thinks himself clever and stalwart, and superior to the person who needs money, because he is capable of making a profit, but he is deluded. The moneylender's wealth only places him in the service of someone else who is better able to enjoy the money, for he becomes the rich man's treasurer and must submit to his command. He himself gains nothing from his profit except entry into hell. The narrator speaks directly to the moneylender, accusing him of being foolish and unvirtuous.

Illustration: "The money-lender" (*Der wůcherrer*) stands with his hand in his purse; a second man in yellow stands before him with his index finger raised. This figure in yellow may represent the narrator who scolds the usurer.

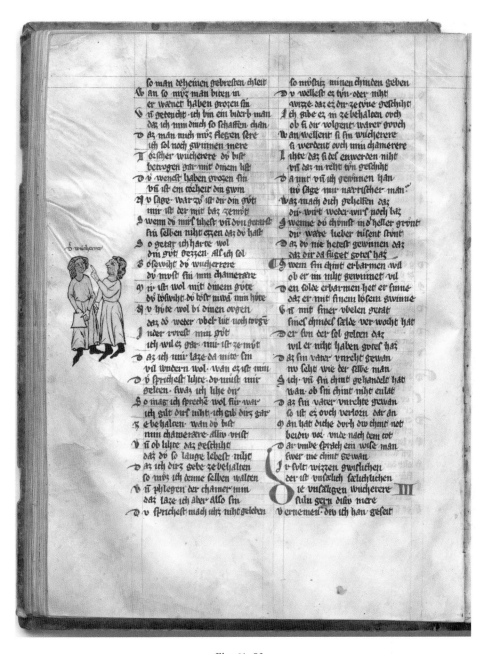

so man deheinen gebresten chleit | so müstu minen chinden geben
Ab an so muz man biten in | Du wellest ez tun oder niht
er wænet haben grozen sin | awirze daz ez dir ze tune geschihet
Nu gedenche ich bin ein biderb man | Ich gibe ez in ze behalten ovch
daz ich min dinch so schaffen chan | ob si dir volgent wærer grouch
Daz man mich mir flegzen sere | Wan wellent si sin wücherere
ich sol noch gwinnen mere | si werdent ovch min chamerere
Er sprach wucherere du bist | Ich ahte daz si del enwerden niht
betrogen gar mit dinem list | vil daz in reht tun geschiht
Du wenest haben grozen sin | Da mit vñ ich gewinnen han
vñ ist ein ticheit din gwin | nu sage mir nærtlicher man
Nu sage war zu ist dir din güt | Waz mach dich gehelfen daz
mir ist der mit daz zemüt | du wirt weder arm noch biz
Ich weiz du mir lihest vñ dvn geraist | Je wenne du chümst ins der heller grunt
din selben niht ezzen daz du hast | du wære lieber tusent stunt
So getar ich harte wol | Daz du nie hetest gewinnen daz
din güti bezzen als ich sol | daz dir da fueget gotel haz
Boseswiht du wuchertere | Jch wen sin chint erbarmen wil
du müst sin min chamerære | ob er in niht gewinnet vil
Nu ist wol mit dinem gote | Den solde erbarmen het er sinne
du tosewiht du bist niwa min hüte | daz er mit sinem losem gwinne
Du biste wol bi dinen ougen | Git mit siner vbelen gerat
daz du weder vbeliut noch touge | sines chindel sælde verwocht hat
Inder rvrest min güt | Der sun der sol golten daz
ich wil es gar mir ist ze müt | wil er niht haben gotel haz
Daz ich mir laze da mite sin | Daz sin vater vnreht gewan
vil wundern wol wan ez ist min | nu seht wie der selbe man
Du sprichest lihe du müst mir | Sich vñ sin chint gehandelt hat
gelten swaz ich lihe dir | wan ob sin chint niht enlat
So mag ich spreche wol für war | Daz sin vater vnrehte gewan
ich gut duf niht ich gib dirz gar | so ist ez ovch verlorn dar an
Ze behalten wan du bist | Ei an hat diche dorh du chint not
min chamerære alliu vrist | beidiv vor vnce nach dem tot
Nu ob lihte daz geschiht | Dar vmbe sprach ein wise man
daz du so lange lebest niht | swer ime chint gewan
Daz ich dirz gebe ze behalten | Ir solt wizzen gwisluchen
so nuz ich denne selben walten | der ist vnsælich saluchluchen

§ Die vnsæligen wücherere ||| III
Nu phlegen der chamer min | sulu gen disw mere
daz laze ich aber also sin | vernemet div ich han gesett
Du sprichest nach uhz niht geleben

Fig. 61. 53v

Fig. 62: fol. 55v
Illustration 89 (von Kries 94)

Text summary (FvK, 7994–8000): The greedy man is fearful of losing his wealth. Greed comes from cowardice; fear causes avarice. Anyone who fights for wealth will be easily conquered, and he will lose both himself and his wealth on account of his greed. Cowardice and avarice both produce the same result in battle.

Illustration: Two knights appear in battle flanked by "Greed" (*Div gierde*) and "Cowardice" (*zagheit*). On the left, Greed tells her knight: "Take the horse and flee" (*nim daz ros vnd flivch*). On the right, Cowardice clutches the knight's wrist and tells him: "Flee, you are dead" (*flivch dv bist tod*).

F

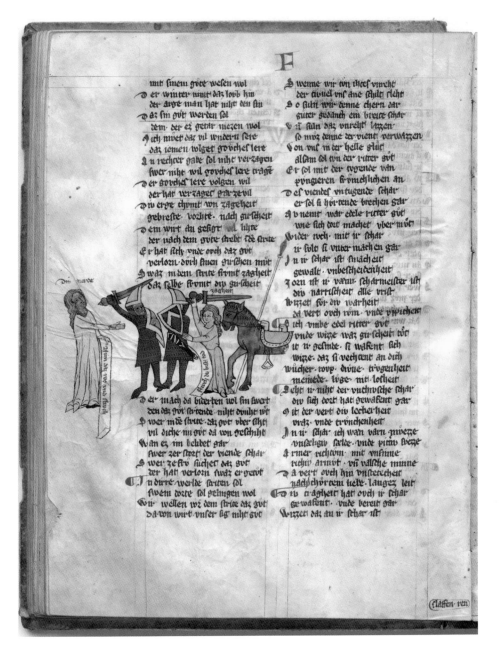

mit sinem grôce wesen wol
D er winter nimt daz loub hin
der arge man hat niht den sin
D az sin gut werden sol
dem der es getar mezen wol
J ch muet daz vil wunder ū sere
daz iemen volget grôches lere
D u rechter gabe sol niht verzagen
swer niht wil grôches lere tragen
D er grôches lere volgen wil
der hat verzaget gar ze vil
D iu erge chumt von zageheit
gebreste vorhte nach gurscheit
D em wirt du gesigt wil lihte
der nach dem gute strebt der strite
E r hat sich vnde ovch daz gut
verlorn dorh sinen gurschen mut
S waz in dem strite stirmt zagheit
daz selbe stirmt diu gurscheit

D er mach da bewerten wol sin swert
den daz gut stirtende niht dunket wirt
S wer mite strite daz gut vber sthet
vil dicke in gut da von geschiht
W an es im belibet gar
swer zer storzt der viende schar
S wer ze stv suchet daz gvt
der hat verlorn swaz er gevut
J n dure werlde striten sol
swem dorte sol gelingen wol
G u wellen wi dem strite daz gut
da von wirt vnser sig niht gvt

S wenne wir vō thces vurcht
der tiuvel vns āne schilt fecht
S o suln wir denne chern dar
guter gedanch ein breite chor
V ū suln daz vurehtī lazzen
so muz denne der viende verwazzen
V on vns in der helle glut
alsam sol tvn der ritter gut
E r sol mit der tvgende vān
pvngieren stvurnelichen an
D es viendes vntugende schar
er sol si hortende brechen gar
A v nemt war edele ritter gut
wie sich dut machet vber mut
wider rech mit ir schar
ir solt si vnter mach en gar
J n ir schar ist knaeh eit
gewalt vnbescheidenheit
J oen ist ir varū scharmeister ist
div narrischeit alle vrist
W izzet for diu warheit
da vert ovch rom vnde vppicheit
S ich vnde edel ritter gut
vnde wizze waz gurscheit tot
ir ir gesinde si wakent sich
wizze daz si verchant an dich
wücher roup divne trvgenheit
meineide löge mit lostheit
D eht ir niht der vuchvsche schar
diu sich dort hat gewakent gar
O ist der vert div lecker heit
vraz vnde trvnchenheit
J n ir schar ich wan varn zwezze
vnsælign sælde vnde pittv swezze
A rmer richtvm mit vnsinne
richiv arnvt vn valsche minne
D a vert ovch hin vnrecehcer
nach chvrcem ziele langez leit
G u tragheit hat ovch ir schar
ge wakent vnde bereit gar
W izzet daz du ir schar ist

Fig. 62. 55v

Fig. 63: fol. 56r
Illustration 90 (von Kries 95)

Text summary (FvK, 8079–90): He who calls himself a knight, like any virtuous man, should now prepare himself for battle against the vices. No one can win greater honor than he who succeeds in conquering vice. Of what good is it if one has conquered a city or a land? Knight-hood is not merely about breaking spears; true knighthood means conquering the vices and not letting them return.

Illustration: "The wealthy and virtuous man" (*Der riche gûte*) on horse-back conquers "the vices" (*Di vntŭgende*). The vices lie piled in a heap with their eyes closed. The banderole reads: "We'll never rise again" (*Wir enchŷmen nimmer mer auf*).

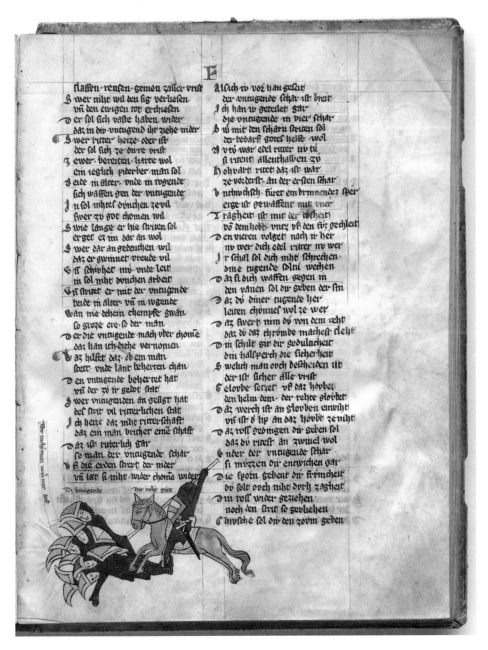

F

flaſſen· renſen· gemen zaller vriſt	Alſich tv voꝛ han geleit
S wer niht wil den ſig verlieſen	der vntugende ſchar iſt breit
vñ den ewigen tot erchieſen	I ch han tv geteilet gar
D er ſol ſich vaſte haben wider	die vntugende in vier ſchar
daz in div vntugend iht ziehe wider	S tv mit den ſcharn ſtriten ſol
S wer ritter heiꝛe oder iſt	der bedarf gotes helfe wol
der ſol ſich ze dirre vriſt	A tv war edel ritter tv til
Z ewer· bereiten· harte wol	ſi richti alleuthalben zv
ein regtlich piderber man ſol	H ohvarti ritet daz iſt war
B eide in alter· vnde in tugende	ze voꝛderſt· an der erſten ſchar
ſich waffen gen der vntugende	V nthwchſch· furet ein brinnendez ſper
I n ſol nihtes dvnchen ze vil	erzt iſt gewaffent mit vner
ſwer zv got chomen wil	T ragheit iſt mit der toꝛheit
S wie lange er hie ſtriten ſol	vo dem hobt· vnez vf den fz gechleit
er ger ez im dar an wol	D en vieren volget nach tv her
S wer dar an gedeuchen wil	nv wer dich edel ritter nv wer
daz er gwinnet vreude vil	I r ſchal ſol dich niht ſchrechen
G ſt ſchivher mi· vnde leit	dine tugende ſoltu wechen
ti ſol niht dvnchen arbeit	D az ſi dich waffen ſegen in
E ſ ſtriret er mit der vntugende	den vanen ſol dir ſchriben der ſin
beide in alter· vñ in tugende	D az dv diner tugende her
Wan nie dehein chempfe gwan	leiten chvnneſt wol ze wer
ſo groze ere· ſo der man	D az ſwerh nim dv von dem reht
der die vntugende nach oder chonie	daz dv daz chrvmbe macheſt ſleht
daz han ich dir he vernomen	D in ſchilt ſir dir gedulacheit
V az hilfet daz· ob ein man	din halſperch die ſicherheit
ſtrit· vnde lant beheeren chan	S welch man ouch beſcheiden ût
D en vntugende beherret hat	der iſt ſicher alle vriſt
vñ der zv tr ſelbſ ſtat	F elovbe ſetzet· vf daz hovbet
S wer vntugenden an veſtgt hat	den helm den· der rehte glovbet
des ſtirt vil ritterlichen ſtat	D z werch iſt an glovben entwiht
I ch heiꝛe daz niht ritter ſchaft	vñ iſt ó lip an daz hovbt ze niht
daz ein man bircher eine ſchaft	D az voll groꝛmgen dir ſchen ſol
D az iſt ritterlich far	daz dv riteſt· an zwivel wol
ſo man der vntugende ſchar	V nder der vntugende ſchar
N & die erden ſtreyt· dar nider	ſi müzzen dir entwichen gar
vñ læt ſi niht wider chonie wider	Die ſpotn gebent dir frömcheit
	dv ſolt ouch niht dvrh zagheit
Di vnrigende Der rehte gúte	D in voll wider ze ziehen
	noch den ſtrit ſo zvliehen
	C hvſche ſol dir den zovm geben

Fig. 63. 56r

Fig. 64: fol. 57v
Illustration 91 (von Kries 96)
Text summary (FvK, 8271–8302): The devil was cast out due to his evil actions and God's judgment.
Illustration: An angel uses a long fork labeled "God's judgment" (*Gotes gerichte*) to push "the devil" (*Der valant*) down toward a blue demon and the hellfire burning below. The demon pulls the devil down using a tightly twisted noose labeled "his evil" (*Sin v̊bel*).

Illustration 92 (von Kries 97)
Text summary (FvK, 8309–38): God's grace and a person's goodness will enable him to reach God's kingdom.
Illustration: "God's Grace" (*Gotes gnade*), an enthroned and crowned figure within a circular frame receives "the good man" (*Der gůte*) and "the good woman" (*Div gůte*).

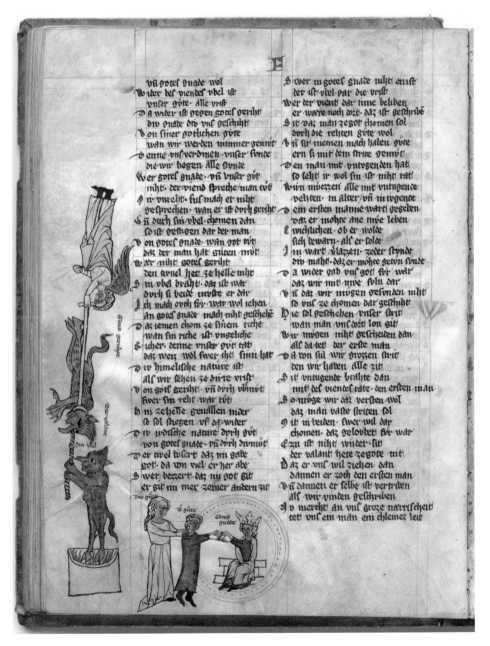

vñ gotes gnade wol
W ider des viendes vbel ist
vnſer gvte· alle vriſt
D a wider ist gegen gotes veriht
div gnade dľ vñſ geſchiht
V on ſiner gotlichen gvte
wan wir werden nimmer gemvt
d enne vns verdinen vnſer ſvnde
die wir begen alle ſtvnde
W er gotes gnade· vñ vnſer gvt
nihte· der viend ſpreche man tvt
y niͮ vnreht· ſuſ mach er niht
geſprechen· wan er iſt dvrh geriht
C ſi dvrh ſin vbel chomen dan
ſo iſt geſtigen dar der man
V on gotes gnade· wan got dvt
daz der man hat gvten mvt
W ær niht gotes geriht
den twivel het ze helle niht
S in vbel braht· daz iſt war
dvrh ſi beide twiſte er dar
J ch mach ovch fir war wol iehen
an gotes gnade mach niht geſchehe
D az iemen chom ze ſinen riche
wan ſin riche iſt vngeliche
F ulcher denne vnſer gvt tvt
daz weiz wol ſwer iht ſinn hat
D iv himeliſche nature iſt
alſ wir ſehen ze dirte vriſt
v on got geriht· vñ dvrh vbmvt
ſwer ſin reht war tvt
h in ze helle gruwllen mder
ſo ſol ſtechen vf dz wider
D iv wvdiſche nature dvrh gvt
von gotes gnade· vñ dvrh diviвt
D er twel iwirt daz niv gale
got· da von viel er her abe
S wer bezzert daz niv got gib
er ſit niv mer zeiner anderu ziͮ

S wer iu gotes gnade niht enist
der iſt vbel gar die vriſt
W er der vient dar inne beliben
er were noch dort· daz iſt geſchribe
S it daz man ze got chomen ſol
dvrh die rehten gvte wol
A ſt fir niemen mach halen gvte
ern ſi mit dem ſtrite gemvt
d en man mit vntvgenden hat
ſo ſeht ir wol ſin iſt nihte rat
W in inbezzert alle mit vntvgende
vehten· in alter/vñ in ivgende
d em erſten manne wart gegeben
daz er mohte ane mve leben
L wichliche· ob er wolde
ſich bewarn· alſ er tolde
J nn wart blazzen· zeder ſtvnde
div maht· daz er mohte getvn ſvnde
D a wider gab vns got fri· war
daz wir mit mve ſvln dar
V ſt daz wir mvgen verſvnden niht
ſo vns ze chomen dar geſtiht
H ie ſol geſchehen vnſer ſtrit
wan man vns dort lon git
W ir mvgen niht geſcheiden dan
alſ da tet der erſte man
A von ſvl wir grozzen ſtric
den wir haben alle zit
S it vntvgende brahte dan
mit des viendes rate· den erſten man
S o mvge wir daz verſten wol
daz man vaſte ſtriten ſol
y it niv beiden· ſwer wil dar
chomen· daz gelovbet fir· war
C zu iſt nihte wider ſit
der valant hete ze gote nit
D az er vns wil ziehen dan
dannen er zoch den erſten man
V ſi dannen er ſelbe iſt vertriben
alſ wir vinden geſchriben
y v mercht an vns groze nærriſcheit
tet vns ein man ein ſhlemez leit

Fig. 64. 57v

Fig. 65: fol. 58r
Illustration 93 (von Kries 98)

Text summary (FvK, 8449–52): An idle man will fall prey to idle thoughts that will make him restless and dissatisfied.

Illustration: "The idle man" (*Der mv̊zige man*) sits enthroned on the right. "Idle Thought" (*vngedanch*) appears before him as a lady dressed in blue. She tells the man: "Behold, that's what you get from me" (*Sich daz hastů von mir*) and gestures over her shoulder to the figure of Idleness (*Mv̊ze*), who carries Restlessness (*vnmv̊zze*) over her shoulder. Idleness remarks: "See, that's what I'm bringing you" (*Se daz bring ich dir*).

W ir flizzen vns immer danne
daz wirz gulte dem selben manne
O it grozzern od mit glichem leib
vn haben hier an er achten
O az wir vns erwern niht
daz vns der vil volwicht
S wer ze helle ziehen wil
da man vindet leides vil
V n da man immer ane bíz
mit not lebende sterben míz
I ch han gelesen vn vernomen
swer den vallant wil vb komen
er sol mit allen liuten wol
leben als er leben sol
E r sol niht ehrenchen sin chraft
mit deheiner andern vientschaft
S wer vberchunt sin emel mit
der hat verendet allen strit
I ch rate ieglichem ritter geert
vntz in des tiuvels strit wert
O az er niht anders tun sol
wan so mach er gestriten wol
S wer mit einem pern striten solde
ich wæne niht daz er wolde
P heinunge zelen ze der zit
wan er verlür liht an dem strit
er tiuel fuget alle vrist
daz der man vnnuzich ist
O it zorn mit vnluge vn mit haz
mit gude mit wucht daz er daz
in zu chome ze der vrist
swenne er vngewarnt ist
S wenne wir solten wehren daz
so ir ret vns vil dicke daz
G ot des ist der vieint vro
swenn er vns denne tr uget so
O er vihtet niht nach ritters reht
der den armen man sleht
N u der in mit sin gut
der hat vnritterlichen mut
G edenchet ritter an iwern eiden
warvmbe sit ir ritter worden

vnd flaffen weiz got wir sit
da vn daz en man gern lit
H olde er dar vmbe ritter wesen
ihn hauz gehoret noch gelesen
W enet ir dar vmbe ritter sin
dvrch gvte spise vn dvrch gvten win
O ar an sit ir betrogen gar
la zzet daz vibe gern daz ist war
O vch chlader vn dvrch schöne gesmid
sit ir niht ritter swerz gid
E wem gebüren er wirst niht hin
la hat der gouch wol den sin
O b man im eine schellen bünde an de tiz
daz er si hin tragen miz
S wer wil ritters ampt pflegen
der miz mer arbeit legen
A n sine für denne an ezzen wol
mer ze trine er haben sol
O enne tragen schöne gewant
vn vörn swigende div lant
O er mach niht ritters ampt pflegen
der sich wan wil in senfte legen
S welch man wirzich ist
der ist vnwirdich zaller vrist
W an er gedenchet lihte daz
daz in wære howende daz
O ehein man sol wirzich sin
swer wirzich ist der macht schin
O az wirze dicke vn wirze bringet
so er mit vngedauchen ruget

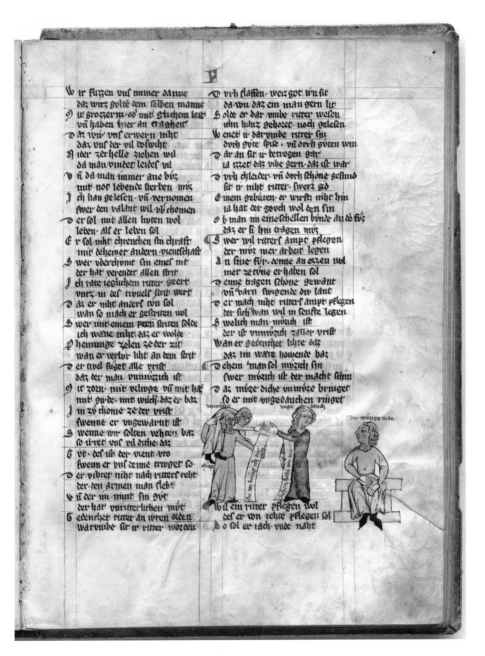

N u il ein ritter pflegen wol
des er von rehte pflegen sol
S o sol er tach vnde naht

Fig. 65. 58r

Fig. 66: fol. 60r

Illustration 94 (von Kries 99)

Text summary (FvK, 8717–70): If someone boasts about his profit, then he should recognize his loss, for he has chosen avarice over generosity. He has given away virtue to acquire vice and thinks that he has profited from it.

Illustration: A lord sits enthroned in the center of the illustration and is approached from the left by the virtues "Justice" (*Recht*) and "Generosity" (*milte*), and from the right by the vices "Greed" (*Girde*) and "Injustice" (*Vnrecht*). Justice holds scales, and she and Generosity carry between them a stick on which is hanging a circular frame containing a plant or the image of a garden. Greed and Injustice hold a stick with four money bags hanging from it. Injustice also holds a set of scales. Below these vices is a circular gate to hell in which we see a demon's profile. Generosity asks the lord, "Do you want me to prepare you?" (*Wiltu daz ich dir bereit*). The lord points toward Greed and Injustice and responds, "I have given it on account of that" (*Ich han iz durch daz gegeben*). Greed tells the lord "Go to your room" (*Ginch her in deine chammerr*). The sense seems to be that the lord is receiving wealth on account of his greed and has chosen to follow this path, which will lead him into hell, rather than be generous and just and thus enter into paradise.

Note: In Heidelberg Cpg 389, the object or image in the circular frame is labeled "paradise" (*daz Pardise*). Where the lord responds to Generosity, Heidelberg Cpg 389 contains the inscription: "I have asked for it on account of that" (*ich hanz durch daz gebeten*). The rather drastic variations that this illustration undergoes in the course of its transmission suggests that it was not entirely comprehensible to the medieval artists reproducing it.

er sinem herren git die lere
daz er hie mit arbeit
daz er chere sinen mvt
Erwirbet · daz in dort ver
an erge · vñ wie er daz gvt
immer in iener welte geschee
en liuten mvge abe gebrechen
an als ich sprach · swer an gewin
er sol sich niht so swechen
hat verlazzen sinen sin
daz er behalte solhen rat
er hat hie · vñ dort not
der niht wan gvscheit hat
vñ ist ovch lebendiger tot
swa er mit rehte gi mvge genezzen
ñ dvnchet sich doch der samnere
da nem · es nach vñ niht gezeme
wise · vnde der wucherere
swaz wir nemen mit vnrehte
Eselle dv hast armen sin
halt vnserm eigen chnehte
an dv west cheren an gewin
dv solt vs richen alten chleine
ſ v sag mir · wa ist din list
wan er ist des tivels werzstein
es schmet wol daz verslizen ist
in netze · vnde sin weder spil
ſ ines sinnes sinde gar
er vehet da mit vogel vil
wan din gewin chvmt
ie zehnmel fliegen solden
ſ aber verlust wol herzen mach
ob si zehelle niht varn wolden
daz sehe wir vol dvrch den tach
vil · vns werzet din scharpfer list
ſ o dv dich romest von gewinne
daz wir sinden alle vrist
so soldestu haben ovch die sinne
ir chvndicheit · nach dir gvt
ſ o dv erchaust dine slust
dv gist vns vil lustigen mvt
so heziku dines romest gelust
swer werzt sin merzer wizzet daz
wan dv hast din milte verlorn
daz es sinder ein wile baz
vñ hast dir die erge erchorn
ntz in dir sinde vellet gar
ie tugende vmb vntugend regele
also sage ich iv fvr war
vñ wenest nach gewinne streben
swer verlat an gewin
der werzet so harte sinen sin

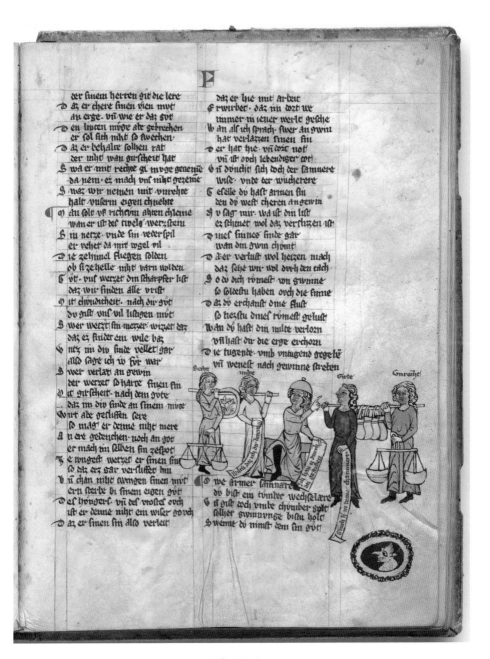

It gvtscheit · nach dem gote
daz in dir sinde an sinem mvte
wirt abe gesluzzen leire
so mag er denne niht mere
an ere gedenchen · noch an got
er mach in selben sin zespot
ze iungest werzet er sinen sin
so daz er gar verslizzet in
vñ chan niht avingen sinen mvt
ern sterbe bi sinem eigen gvt
ſ es hungers · vñ des vrostes ovch
O we armer samnære
ist er denne niht ein wiser gvch
dv bist ein tvmber wechselære
daz er sinen sin also verleit
ſ gilt doch vmbe chvnber gvlt
solher gvinunge bistu holt
swenne dv nimst dem sin gvt

Fig. 66. 60r

Fig. 67: fol. 61r
Illustration 95 (von Kries 100)

Text summary (FvK, 8893–8916): Lords should not let the light of their virtue falter, because they are the ones who are supposed to illuminate the path to the place where the sun always shines. He whose light has gone out should light it again quickly, so that he and his people can see, because otherwise everyone will stumble.

Illustration: The light bearer holds a candle and lights the way to heaven's gate through which we see a blue circle ringed in red and green. He tells "the people" (*daz volch*) to "mind the pit" (*hv̊tet euch vor der grvbe*), a black circle that invokes the passage to hell that we have encountered in other illustrations. The people ask him to "illuminate so that we can see" (*Livht vf daz wir gesehen*).

F

der hat wol der tugende tach
o on der vntugende nahti gescheit
swem ez si liep oder leit
o er nach gestrochen niht zehant
wan er hat lieht zv siner vart
J ch han der harte vil gesehen
swenne in schade ist geschehen
a n dem libe oder an dem gvte
daz si habent so trvben mvt
o az si weynent daz ir niht
got gerveche daz geschiht
J n ze grozer vnselicheit
mvgen si gedencken waz arbeit
D ie heiligen liden vn welch not
vn waz marter vil welhen tot
o si waz armvt vn welch schande
dabi nach man versten zehande
o az vnselde groziv selde ist
swer si mit gvte enpfehet alle vrist
J a wolde ovch vnser herre got
liden armvt vnde spot
o vrst hunger vrost vnder not
er wolde ze vngelt ligen tot
o er vns allen git daz leben
swem er richtvm niht wil geben
o ist leit leben armelichen
als er ez selbe gwislichen
E r mohte sin harte vro wesen
wil er gelovben daz wir lesen
S wen er handelt als sich
zvrnet er des wundert mich
S ws hie mit im sin lider die not
der leben mit in wol sder ist tot
J v wil ich raten den herren allen
daz si daz licht niht lazen vallen
W an sie suln vns kvlten we
vntz si vns bringen fvr daz tot
o a timner ist der sinne schin
si mvgen gein da inne sin
S wes lieht aber erloschen ist
ein zvnde ez in chvrzer vrist
o vn habe ez vf vil wundern ho

wan so sieht er vn wir also
o az vn tot er des niht schier
so veller er vn valle wir
o on rehte viel der in die grvbe
der sin lieht niht vf enhvbe
o on rehte der in dem graben liti
der naheret rieht alle zit
o iv vnster ist den vianden liep
bi vinster naht stilt der diep
o i der vaht tvt mir vil
daz man des tages niht tvn wil
S waz man nahtes tvn mach
daz melder gar der lieht tach
o il dicke man der naht schaut
bi dem tage wol bewint
a lso sage ich iv fvr war
der vngest tach der melder gar
S we man ny getvn nach
er wvrt ein smichelicher tach
W an die svure die man hat
vn die man ane bihte lat
o ie werdent denne gar vf getan
so mohte man kheir wizzen lan
o si mit immerme schande sin svnde
einem manne ze dirre stvnde
o an sol haben wir den ovgen
offenlich vnde tovgen
D iv dinch swer wil bihte han
daz dvnchet mich wol getan
o ozht gedinge vnde minne
wan swer wil bihte tvn mit sinne
o er sol gedinge han ze got
voht vnde minne dvrh singebot
o er gvte gelovbe git
vns div dvrich drip dinch alle zit
G elovbe wir die grozzen not
vn daz er dvrch vns leit den tot
o az mach vns geben groze minne
ob wir dar cheren vnser sinne
G elovbe wir daz er zebrach
die helle vn erstvnt dar nach
o az mach vns wol gedinge geben

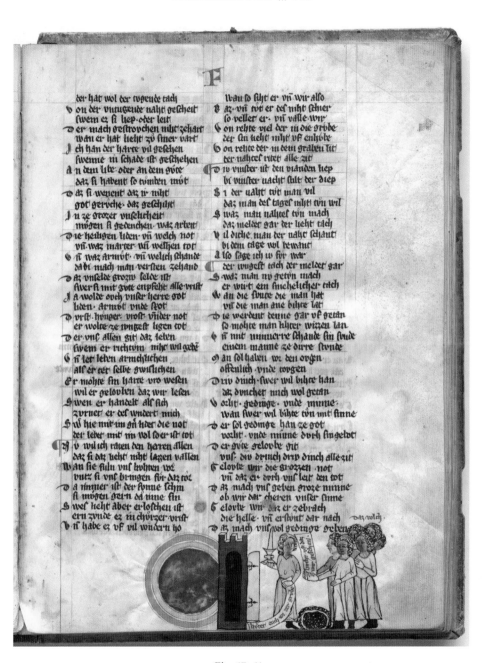

Fig. 67. 61r

PART 7 (FVK, 9123–10502; HR, 8471–9850)

Fig. 68: fol. 65v
Illustration 96 (von Kries 101–7)
Text summary (FvK, 9567–9610): We can improve by learning the seven liberal arts. They are grammar, dialectic, rhetoric, arithmetic, geometry, music, and astronomy. Grammar teaches proper speech; dialectic distinguishes truth from lies; rhetoric colors our speech beautifully; arithmetic rewards people with the ability to count; geometry teaches us to measure; music instructs us in tones; astronomy teaches the stars' nature and their paths. No one has mastered all of the arts, but each art has its masters. Thomasin lists famous scholars and theologians who are associated with particular arts.

Illustration: The series of framed miniatures depict the seven liberal arts. In each a representative historical figure is portrayed on the left while a personification of the art appears on the right. The two figures hold a symbolic attribute between them:

Priscian (*Priscianus*) and Grammar (*Gramatca*). The two figures hold a book open to the first sentence of Priscian's *Institutiones grammaticae*; it reads *Phylosophi diffiniunt.*

Aristotle (*Aristotiles*) and Dialectic (*Dyaletica*) hold a square of opposition.

Tullius (*Tulius*) and Rhetoric (*Rethorica*) hold a sword and shield, which symbolize the battle of words. The inscription above the shield reads *age et defende.*

Euclid (*Euclydes*) and Geometry (*Geometria*) hold a figure of the first proposition from the *Elementa*. The inscription reads *Supra lineam datam triangulum equilateram constituere.*

Pythagoras (*Pytagoras*) and Arithmetic (*Arismetica*) hold a triangular table of numbers. The inscription reads *De dupla nascitur equalatera.*

Milesius (*Milesius*) and Music (*Musica*) hold a table of intervals.

Ptolemy (*Ptolomeus*) and Astronomy (*astronomia*) appear crowned and holding an astrolabe. The inscription reads *Accipe solis altitudinem ascensum et considera.*

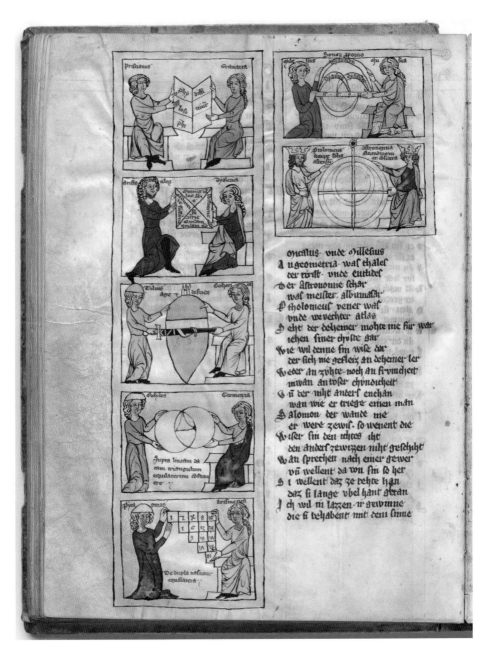

oncalus· vnde Gillesius
A ug̃eometria was Thales
der torst· vnde eũthes
D er Astronomie schar
was meister· albumassar
P tholomeus vener was
vnde wewehter Atlas
D eht der delemer mohte me für war
zehen siner chorste gar
W ie wil denne sin wise dar
der sich me gesteiz an deheiner ler
W eder an zuhte noch an si vnchert
mwan an toser chundicheit
S ũ der niht anders enchan
wan wie er triege einen man
S alomon der wande me
er were zewis· so wenent die
W iser sin den rehtes iht
den anders zewizen niht geschiht
W an sprechen nach einer gewer
vũ wellent da wn sin so her
S i wellent daz ze rehte han
daz si lange vbel hant getan
I ch wil mi lazzen ir gewinne
die si behabent mit dem sinne

Fig. 68. 65v

334 ||| Appendix 3

PART 8 (FVK, 10503–12876; HR, 9851–12222)

Fig. 69: fol. 71v
Illustration 97 (von Kries 108)

Text summary (FvK, 10605–8): Moderation measures everything; immoderation does not have the power to measure anything. It is stretched out and yet cannot measure. It is first expanded and then contracted.

Illustration: The illustration depicts four figures measuring a bolt of material. "Faithfulness" (*Triuwe*) and "Moderation" (*Mazze*) on the left are juxtaposed with "Faithlessness" (*vntriuwe*) and "Immoderation" (*vnmazze*) on the right. Moderation measures the material in good faith, while Immoderation tries to cheat. Moderation holds a measuring stick saying, "I'll measure it properly" (*Ich mezze im rechte wol*). Faithfulness says, "I want to give him what he has a right to" (*Gib im wol sein recht daz wil ich*). On the right, Faithlessness tells Immoderation, "Over reach with your hand" (*vbergreif mit der hant*); Immoderation tells her, "Be quiet so that they don't hear that" (*Swieg daz siez icht hŏren*). On the far right the figure of "Immoderation" (*vnmazze*) appears again, embodying extremes in movement from stretching too high, to bending too low, etc.

v uftere eine fwefter hât
ichn mach niht haben rât
J ne fage ir fide vñ ir maht
ir gewerſt vñ wie fie fi gerlaht
er vnftere fwefter iſt
diu vnmâze zaller vrift
v nmâze mach niht ftete fin
daz iſt vil dicke worden fchin
J ch fagte von der vnftetecheit
do ich von der ftete hett gefeit
A lfam ich lie ouch niht verlâze
ichn fage iu von der vnmâze
W an fo erchennet man defte baz
die vnmâze wizzet daz
v nmâze iſt der nachrifcheit
tot vnde der trinchenheit
f pil vnde der uber muot
niftel fwer fin war tut
v nmâze iſt des zornes chraft
vnmâze hat niht menfchaft
v nmâze iſt des vrâzzes muot
der erge flôz der girde huot
W an fi licher vñ laget
daz der guote wol behaget
W izzet fur die wârheit
fi iſt ouch zunge der lecherheit
v nmâze iſt des nides vergrift
wan daz fagt vns diu fchrift
f wer nides vnmâzlichen
der totet fich felben ficherlichen
v nmâze iſt wrhos d' zagheit
vñ ein flâz der tracheit
J uch fol des niht nemen wunder
vnmâze iſt d' vnchiufche zund
J ch wiz iu fagen chorzlichen
ir fult wizzen ficherlichen
v nmâze iſt der vntugende fchar
gart wan fi ment gar
f ſi wechet die vntugende
beide an alter vñ an tugende
d az iſt der vnmâze maht

daz fi niut uber ir chraft
az iſt der vnmâze fite
fi wolgert der vntugende mite
o iſt ir gewerft daz
vnfelicheit vnde gotel haz
v nmâze diu iſt âne zil
fi heizet lutzel vñ zevil
er iſt felicher vñ verwazzen
der fin durch niht chan gemazzen
iu mâze fol fin an allen dingen
von d' mâze mach niht miſlinge
er iſt gar ein vnfelich man
der fin gewerte niht mezzen chan
W izzet daz diu mâze iſt
der finnel wage zaller vrift
iu rehte mâze hat ir zil
en zwifchen lutzel vñ vil
f wer mit der mâze chan mezzen wol
der tut ez allez daz er fol
e an fol mezzen nach finer chraft
vnmâze iſt âne uber maht
e an fol mezzen groz vñ chleine
diu rehte mâze fol fin gemeine
e rlieze wir mâze wagezal
daz iſt an rehte ein michel val
iu mâze gibt vns ere vñ gib
vnmâze iſt âne uber muot
ie mâze behalcet vñ gît nach reht
den herren machet vnmâze chnehte
iu mâze rihcet burge vñ lant
vnmâze bringet fchaden vñ fchant
iu mâze mizzet aller flahte
vnmâze hat niht die mahte
az fi mezze ihres iſt
fi iſt geftrechet vñ mizzer niht

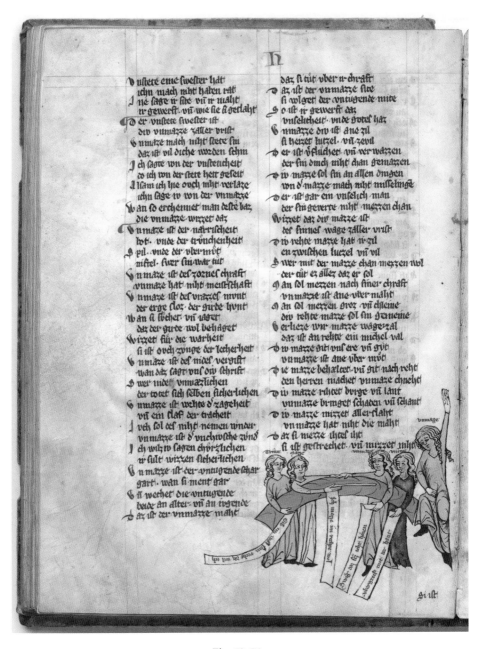

Fig. 69. 71v

Fig. 70: 73v
Illustration 98 (von Kries 109)
Text summary (FvK, 10839–50): Even though it is good to go to church, it is not good if one spends so long there that one is unable to keep one's thoughts on God. Someone who prays too long will start thinking about other things.

Illustration: A man is unable to concentrate on his prayer, because he is thinking of a dance that he wishes to attend. He kneels before an altar as if to pray, but his head is turned back toward the figure standing behind him touching his shoulder. The standing figure says: "Well, let's go to the dance" (*Wol dan zedem tantze*); the kneeling man responds: "Pray a little longer" (*beite eine wile noch*).

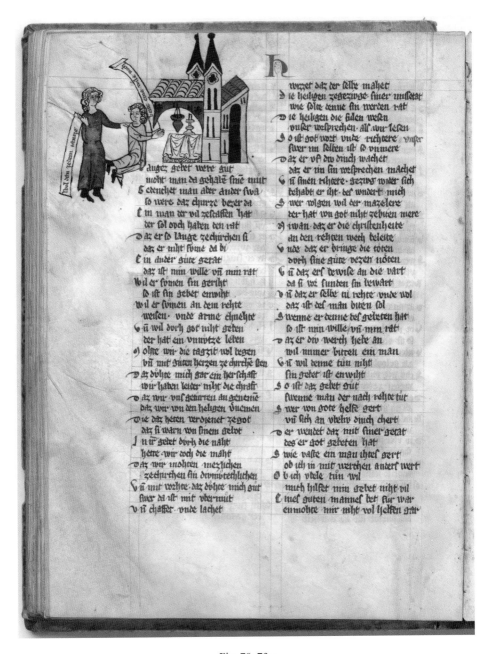

Fig. 70. 73v

Fig. 71: fol. 80v
Illustration 99 (von Kries 110)

Text summary (FvK, 11965–82): It is easy to advise people to not go on a crusade because it is expensive. The crusade taxes are a burden. If one could be certain of material gain, then there would be a rush to go.

Illustration: A captain is ready to cast off while a crowd of people vies for a place on his ship. Behind the ship is a chest full of gold—representing the treasure that people think they will gain while on crusade. The captain tells them: "Begone, there are too many of you" (*habet vf iewer ist ze vil*). Two of the figures on land hold purses and respond: "Yes, but I was here first" (*Ja bin ich der erste gewesen*), and "In truth, I'm not staying here" (*entriwen ich bleibe hie nicht*).

der betorfte wol grozes sinnes
der vns daz er wern wolde
daz man dar niht varn solde
q an mach vns ouch daz rate wol
daz man dar zo niht helfen sol
d w stivre ist vns vil vnmere
da von der bvtel wirt lere
s olde ein phenninch zehe bringe
man sehe eine fvr den andn drige
d it ir pigvrteln alle dar
si wrden vz geschuttet gar

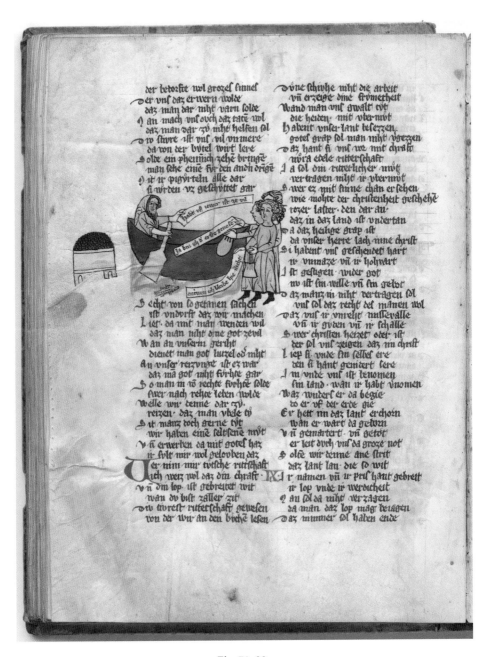

S echt von so getanen sachen
ist vndvrft daz wir machen
L iet da mit man wenden wil
daz man niht dne got zevil
W an an vnserm gerihte
dienet man got lutzel od niht
A n vnser rerzvnge ist ez war
daz na got niht fvrhte gar
S o man in zo rechte fvrhte solde
swer nach rehte leben wolde
Welle wir denne dar czy
reizen daz man vbele ty
s it manz doch gerne tyt
wir haben eine seltsene nvt
V n erwerben da mit gotes haz
ir svlt mir wol gelovben daz
U er nim mir twsche ritischaft
ich werz wol daz din chrast
vn din lop ist gebreitet wit
wan dv bist zaller zit
d w twrest ritterschaft gewesen
von der wir an den biche lesen

dvne schivhe niht die arbeit
vn erzeige dine frvmecheit
Wand man vns gwalt tvt
die heiden mit vbermvt
h abent vnser lant besetzen
gotes grap sol man niht vgrezzen
d az hant si vns awe mit christ
mvra edele ritterschaft
I a sol din riterlicher mvt
vertragen niht ir vbermvt
s wer ez mit sinne chan er sehen
wie mohte der christenheit geschehe
grozer laster den dar an
daz in daz land ist vndertan
w a daz heilige grap ist
da vnser herre lach mine christ
S i habent vns geschendet hart
ir vmuaze vn ir holuart
I st gesugen vnder got
nv ist sin wille vn sin gebot
d az manz in niht vertragen sol
vns sol daz recht des manen wol
d az vns ir vnreht misseualle
vn ir gvten vn ir schalle
S wer christen heizet oder ist
der sol vns zeigen daz in christ
L iep si vnde sin selles ere
den si hant geniaret sere
J m vnde vns ist benomen
sin land wan ir habt vnomen
Waz wunder er da begie
do er vf der erde gie
E r hett in daz lant erchorn
wan er wart da geborn
v n gemartert vn getot
er leit dvrch vns da groze not
S olde wir denne ane strit
daz lant lan die so wit
J r namen vn ir pris hant gebreit
ir lop vnde ir werdicheit
q an sol da niht verzagen
da man daz lop mage betiagen
d az mmmer sol haben ende

Fig. 71. 80v

PART 9 (FVK, 12877–14218; HR, 12223–13564)

Fig. 72: fol. 89r
Illustration 100 (von Kries 111)
Text summary (FvK, 13415–42): He who wishes to criticize others should first consider his own faults. Everyone would be courtly if we were able to identify flaws in ourselves as easily as we are in others. Someone who sees another's vices should recognize his own laziness, or his anger, drunkenness, greed, or pride. He who recognizes the sins of others and criticizes them should also acknowledge his own sins and try to improve himself.

Illustration: An enthroned man criticizes the faults of "the proud man" (*Der hochvertige man*): "How proud he thinks himself to be" (*wie hochvertig der sich dv̊nchet*). He does not notice his own vices standing next to him. "Anger" (*zorn*) raises his sword, saying: "I'm warning you about me" (*Ich erman dich min*); "Drunkenness" (*trv̊nchenheit*) stretches her club out toward him and remarks: "I'm also here with you." (*Ich bin ovch hie mit dir*). "Unchastity" (*vnchivsche*) pokes him with a long stick, assuring him: "I'll never leave you" (*Ichn chv̊me nimmer von dir*).

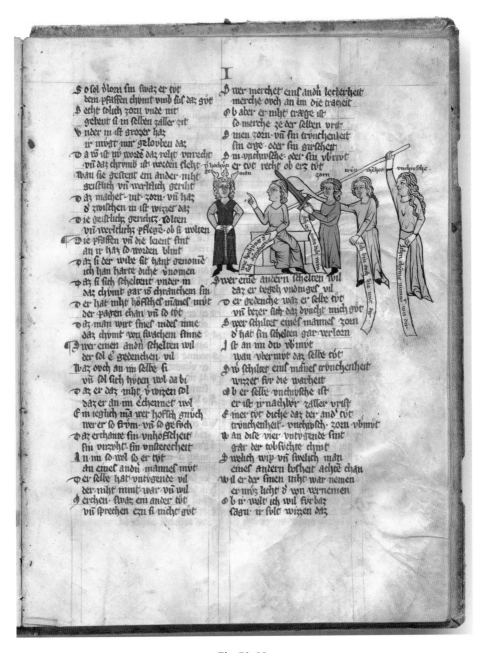

I

So sol vlorn sin swaz er tvt
dem pfaffen chvmt vmb sust daz got
Ist etelich zorn vnde nit
gebevt si in selben zaller zit
Vnder in ist grozer haz
ir mvgt mir geloubn daz
Da vo ist vn wrde daz rehte vnrehte
vn daz chrumb slit werden slehte
Wan sie streitent ein ander niht
geistlich vn werltlich gerlht
Daz machet nit zorn vn haz
d zwischen in ist wizzet daz
Die geistlich gerihte woltent
vn werltlichz pflegt ob si woltent
Die pfaffen vn die leient sint
an ir haz so worden blint
Daz si der wibe sit hant genomie
ich han harte dicke vnomen
Daz si sich scheltent vnder in
daz chvmt gar vo chranchem sin
Er hat niht hofschel mannes mvt
der pagen chan vn so tvt
Daz man wirt sines mdes inne
daz chvmt von swachem sinne
Swer einen andn schelten wil
der sol e gedenchen vil
Waz ovch an im selbe si
vn sol sich hvten wol da bi
Daz er daz niht v wizen sol
daz er an im echennet wol
E in ieglich ma wer hofsch gnuch
wer er so frvm vn so gefuch
Daz erchante sin vnhofschheit
sin vnzvht sin vnderecheit
A n im so wol so er tvt
An einel andn mannes mvt
Der selbe hat vntvgende vil
der niht nimt war vn wil
Berchen swaz ein ander tvt
vn sprechen ezn si niht gvt

Swer merchet eins andn lecterheit
merche ovch an im die trageit
Ob aber er niht trage ist
so merche ze der selben vrst
Sin zorn vn sin trvnchenheit
sin erge oder sin gurscheit
Sin vnchvsche oder sin vbmvt
so hochn er tvt recht ob erz tvt
Swer ein andern schelten wil
daz er begeh vndinges vil
Er gedenche waz er selbe tvt
vn bezer sich daz dvncht mich gvt
Swer schiltet eines mannes zorn
d hat sin schelten gar verlorn
Ist an im div vbmvt
wan vbermvt daz selbe tvt
Sw schilter eins manes trvnchenheit
wizzer fir die warheit
Ob er selbe vnchvsche ist
er ist vnachlor zaller vrist
E mer tvt dicke daz der andr tvt
trvnchenheit vnchvsch zorn vbmvt
Wan dise vier vntvgende sint
gar der tobsvchte chint
Swelich wip vn swelich man
eines andern bosheit achten chan
Wil er daz sinen niht war nemen
ernmvz licht d von vernemen
Ob ir welt ich wil fir baz
sagn ir svlt wizen daz

Fig. 72. 89r

PART 10 (FVK, 14219–15280; HR, 13565–14752)

Fig. 73: fol. 94v
Illustration 101 (von Kries 112)
Text summary (FvK, 14343–52): Generosity is the lady of the virtues. Just as a lady's company precedes her leaving the chamber, so too does Generosity follow all of the other virtues.
Illustration: "Generosity" (*Div milte*) follows the group of "virtues" (*div tůgende*) as they leave the castle.

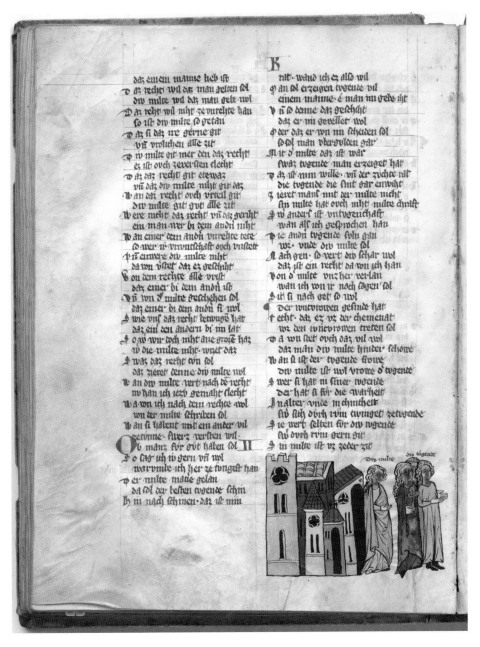

daz einem manne lieb ist
D az rechti wil daz man selten sol
div milte wil daz man gele wol
D az rehte wil mht ze vnrehte han
so ist div milte so getan
D az si daz ir gerne git
vnt vrolichen alle zit
ch iv milte git mer den daz rechti
ez ist ovch zeversten clecht
D az daz rechti git etewaz
vn daz div milte niht git daz
W an daz rechti ovch vrteil git
div milte git gvt alle zit
W ere mht daz rechti vn daz geriht
ein man wer bi dem andri mht
W an einer den andi vnrehte tete
so wer ir vrvntschaft ovch vnstete
vn ernere div milte mht
da von vbet daz ez geschiht
V on dem rechte alle vrist
daz einer bi dem andri ist
vn von d milte geschehen sol
daz einer bi dem andri si wol
Swie vns daz rehti betwngt hat
daz ein den andern bi im lat
So av wir doch mht ane grose haz
ab die milte mht wnet daz
S waz daz rechti vns sol
daz zeret denne div milte wol
W an div milte wert nach de rechti
nv han ich iezt gemaht clecht
W a von ich nach dem rechte wol
von der milte schriben sol
W an si halent mit ein ander vil
O getvnne. swerz versten wil
Ob manz fvr gvt haben sol
D o sag ich iv gern vn wol
war vmbe ich her ze tvngest han
D er milte matie golan
da sol der besten tvgende schin
I h in nach schinen daz ist min

rat. wand ich ez also wil
daz an sol erzeigen tvgende vil
einem manne e man in gede ist
V nd so danne daz geschiht
daz er mit gevellet wol
daz der daz er von in scheiden sol
so sol man vbersvlden gar
M it d milte daz ist war
swaz tvgende man erzeiget hat
D az ist min wille vn der zvchte rat
die tvgende die sint gar entwiht
z zeret manl mit der milte niht
sin milte hat ovch mht milte chraft
S w anders ist vntwnchaft
wan als ich gesprochen han
D ie andri tvgende soln gan
wir vnde div milte sol
A ch gen so vert div schar wol
daz ist ein recht da von ich han
V on d milte vnz her verlan
wan ich von ir noch sagen sol
S it si nach get so wol
D er vntvrowen gesinde hat
t echt. daz ez vz der chemenat
wir den vntvrowen treten sol
D a wu stet ovch daz vil wol
daz man div milte hinder schone
W an si ist der tvgende kvone
div milte ist wol vrone d tvgende
S wer si hat in siner tvgende
der hat si fvr die warheit
I n alter vnde in schinheit
div sich dvrch ivn tvrngeit zetvgende
S ie wert selten fvr div tvgende
div dvrch ivn gern git
S in milte ist vz zeder zit

Fig. 74: fol. 99r
Illustration 102 (von Kries 114)
Text summary (FvK, 15367–70): Thomasin addresses his book, telling it to keep away from wicked people, who will not be able to use it properly. He exclaims: "Be warned, *Welscher Gast*! You can recite the Lord's Prayer to the wolf all day long, but he'll still only answer 'lamb.'"
Illustration: An enthroned teacher holds a whip and a tablet containing the Lord's Prayer (*pater noster*) and is trying to teach a wolf to say the prayer. He tells the wolf, "Say it quickly" (*Sprich an drat*). The wolf, however, is much more interested in the sheep behind him, and says only, "Here, lambie, lambie!" (*lamp lamp her*).

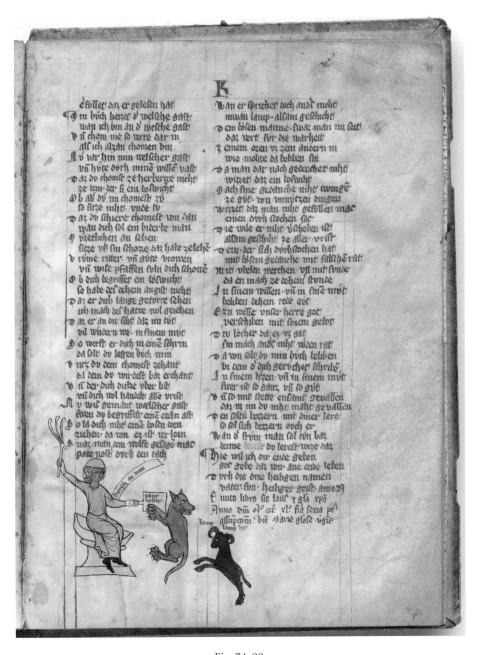

Fig. 74. 99r

Fig. 75: fol. 100r
Illustration 103 (von Kries 115–17)
Illustration: As in the illustration of the seven liberal arts, these miniatures were designed as a series:

"Virtue" (*Div tugend*) is enthroned and receives her virtues: "Constancy" (*Stete*), "Justice" (*Recht*), "Moderation" (*mazze*), and "Generosity" (*milt*). These are the same virtues personified as knights in the first illustration of the cycle.

"Constancy" (*Setete*) sits at the table and is served by "Security" (*Sicherheid*) and "Truth" (*warheid*).

"Justice" (*Daz recht*) sits eating at the table and is served by "Good Breeding/Courtliness" (*zůcht*) and "Discernment" (*bescheidenheit*).

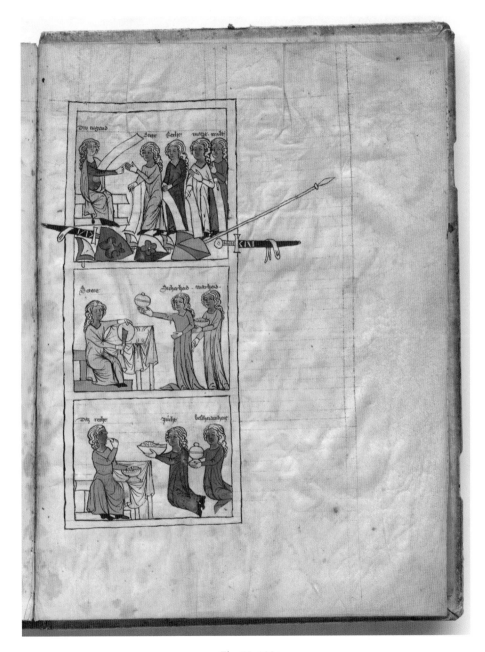

Fig. 75. 100r

Fig. 76: fol. 100v
Illustration 103 continued (von Kries 118–19)
Illustration: The series of framed miniatures continues:
"Moderation" (*mazze*) is served by "Humility" (*Divmůt*) and "Chastity" (*chivsche*).
"Generosity" (*Milte*) is served by "Love" (*liebe*) and "Faith" (*triwe*).

Illustration 104 (von Kries 120)
Illustration: The final illustration in the cycle depicts the circle of vices holding hands and dancing around the personification of "Vice" (*Vntugent*) who blows a horn in the center. Going clockwise from the top the vices are: "Lying" (*lůge*), "Boasting" (*rům*), "Injustice" (*vnrecht*), "Drunkenness" (*trunchenheid*), "Thievery" (*Rovp*), "Violence" (*gewalt*), "Immoderation" (*vnmazze*), "Pride" (*vbermůt*), "Betrayal" (*trůngenheit*), "Whoremongering" (*hůrgelůst*), "Inconstancy" (*vnstete*), "Greed" (*girde*), "Avarice" (*erge*), "Usury" (*wůcher*), "Hatred" (*Neit*), and "Anger" (*zorn*).

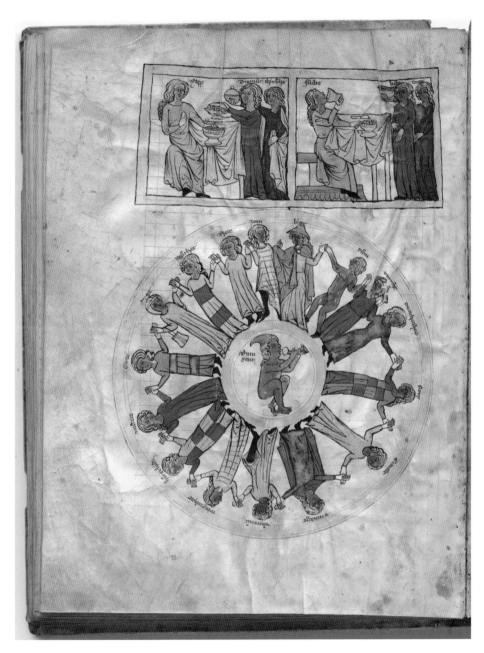

Fig. 76. 100v

Fig. 77: fol. 101r
Illustration 105

Illustration: This illustration is unique to the Gotha codex. It is a dedication image. The man proclaims: "Zůcher svezes mandel ris / din stette in tugend hat hohen pris. / gnad du edeler selden schrin / ditz buch ist worden durch tugend din." (Sugar sweet almond branch, your constancy in virtue is praiseworthy. Have mercy, you noble, rare treasure chest, this book is the result of your virtue.) The lady responds: "Waz můtet me euwer hertze gegen mir / mit tugend sol man ere zir / niht sult ir chlagen so ser an mich / swez ir gert daz geschicht." (What does your heart desire from me? One should adorn honor with virtue. You should not prosecute me in such manner. Whatever you desire shall be done.)

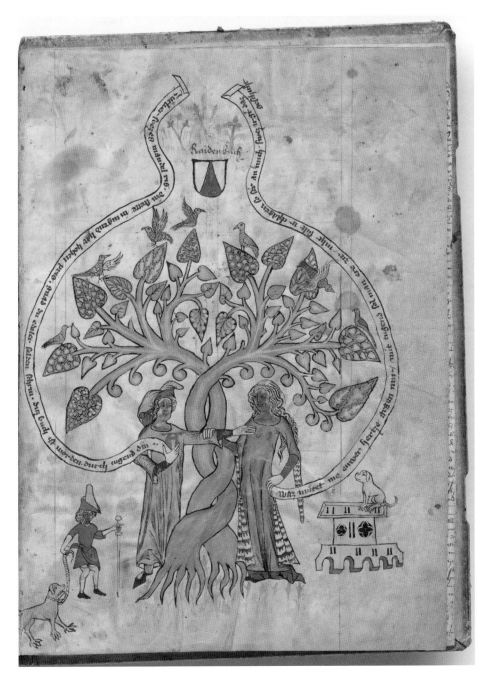

Fig. 77. 101r

APPENDIX 4

Images from Various Redactions of the *Welscher Gast* and the Manesse Codex (Figs. 78–102)

The previous appendix presented the image cycle from Gotha Memb. I 120, housed in the Forschungsbibliothek Gotha/Erfurt. This appendix presents images from a variety of other manuscript versions of the *Welscher Gast* as well as two illustrations from the Manesse Codex (Heidelberg, Universitätsbibliothek, Cpg 848) that serve as points of comparison for the Gotha dedication image. The illustrations have been discussed in the chapters above, and are presented here for ease of reference. All images in this appendix are identified in their captions and are reproduced with the permission of the respective institutions in which they are held.

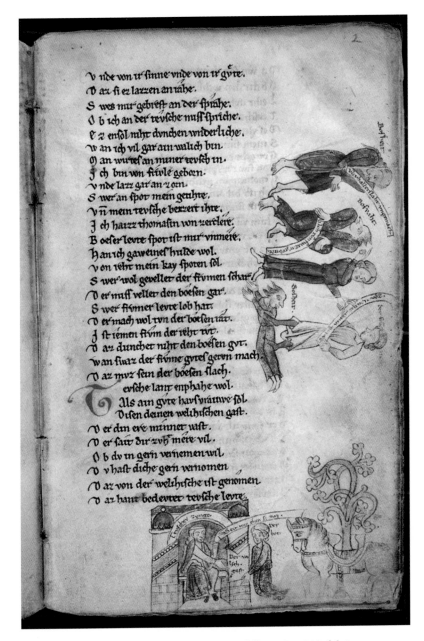

Fig. 78. Universitätsbibliothek Heidelberg Cpg 389, fol. 2r

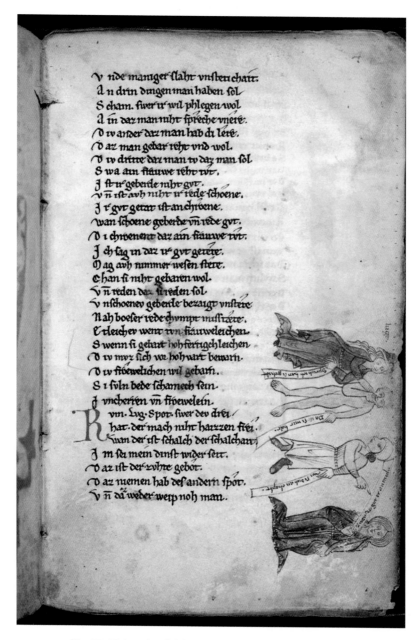

Fig. 79. Universitätsbibliothek Heidelberg Cpg 389, fol. 4r

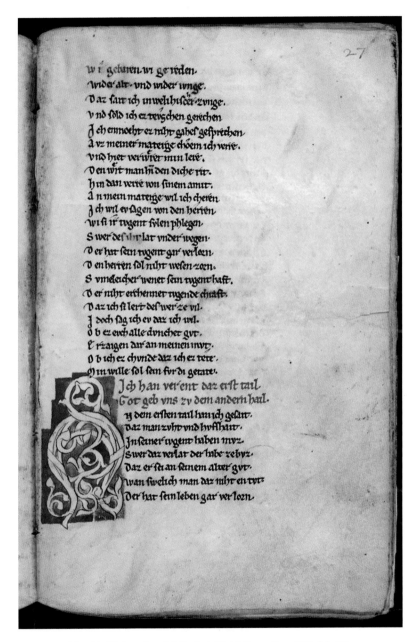

Fig. 80. Universitätsbibliothek Heidelberg Cpg 389, fol. 27r

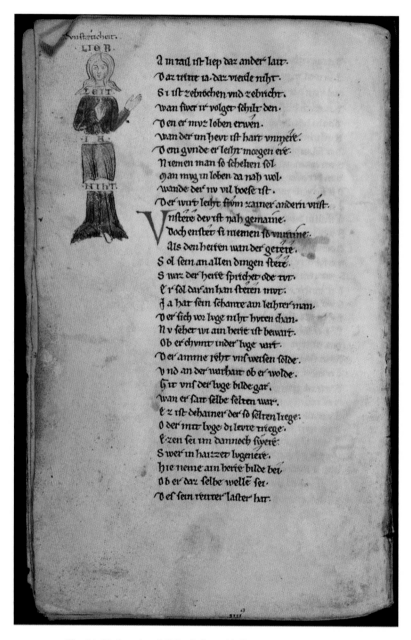

Fig. 81. Universitätsbibliothek Heidelberg Cpg 389, fol. 31v

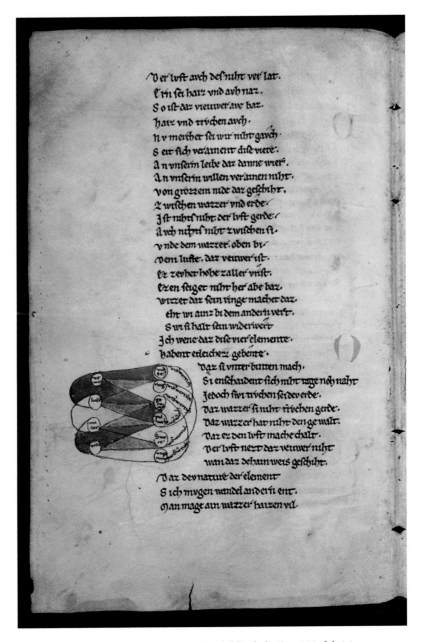

Fig. 82. Heidelberg, Universitätsbibliothek, Cpg 389, fol. 36v

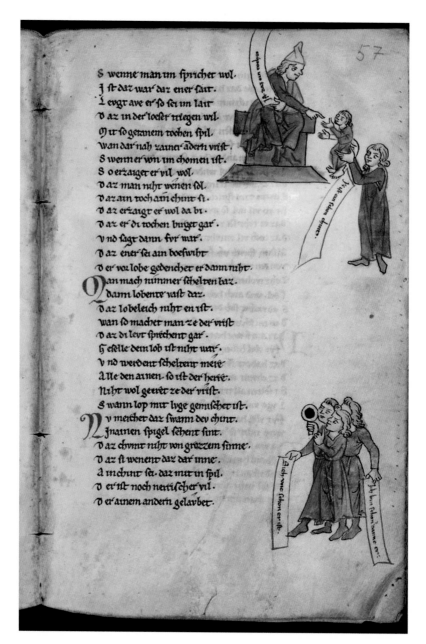

S wenne man im spricher wol.
J st daz war daz ener sait.
L evgt ave er so sei im lait
v az in der loeser triegen wil.
m ir so getanen tochen spil.
wan dar nah zainer adern vriet.
S wenner won im chomen iet.
S o erzaiger er vil wol
v az man niht wenen sol.
v az ain tochain chint si.
v az erzaigt er wol da bi.
v az er di tochen burgt gar.
v nd sagt dann fur war.
v az ener sei ain boeswiht
v er vor lobe gedenchet er dann niht.
m an mach nimmer schelten daz.
v ann lobentz vast daz.
v az lobeleich niht en iet.
wan so machet man ze der vriet
v az di levt sprechent gar.
g eselle dein lob iet niht war.
v nd werdent scheltent mere
a lle den ainen so iet der herre.
niht wol geeret ze der vriet.
S wann lop mit luge gemischet iet.
m v meither daz swann dev chint.
J nainen spigel sehent sint.
v az chunt niht von grozzem sinne.
v az si wenent daz dar inne.
a in chint sei daz mit in spil.
v er iet noch nerrischer vil.
v er ainem andern gelavbet.

Fig. 83. Heidelberg, Universitätsbibliothek, Cpg 389, fol. 57r

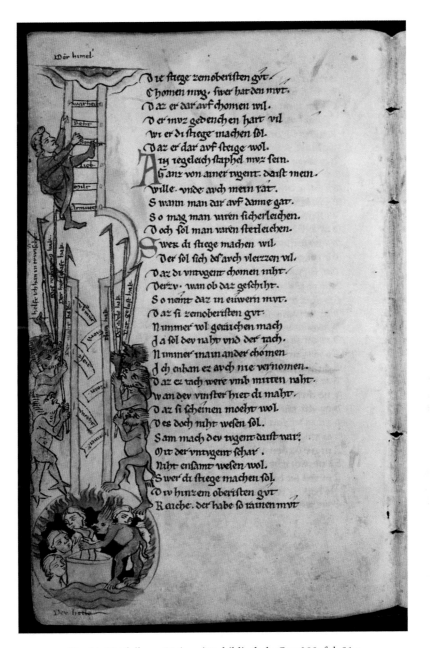

Fig. 84. Heidelberg, Universitätsbibliothek, Cpg 389, fol. 91v

Fig. 85. Universitätsbibliothek Heidelberg Cpg 389, fols. 138v–139r

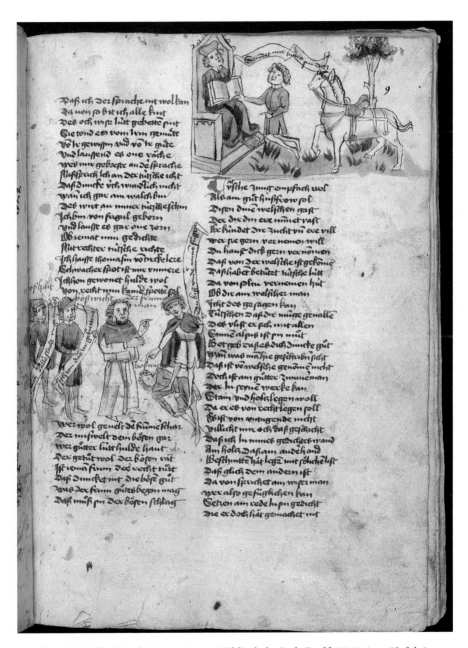

Fig. 86. Wolfenbüttel, Herzog August Bibliothek, Cod. Guelf. 37.19 Aug. 2°, fol. 9r

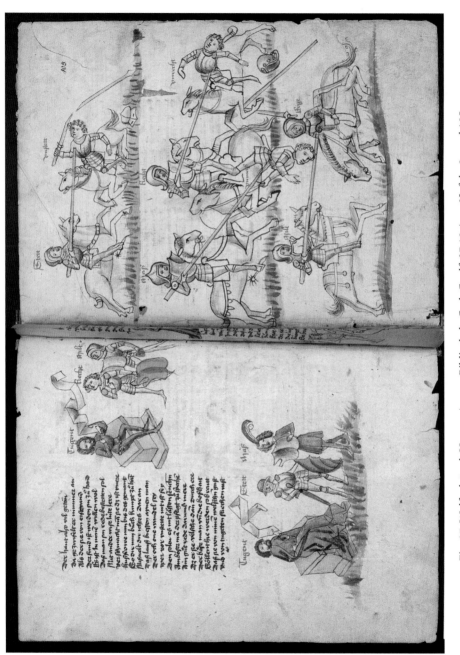

Fig. 87. Wolfenbüttel, Herzog August Bibliothek, Cod. Guelf. 37.19 Aug. 2°, fols. 9v and 105r

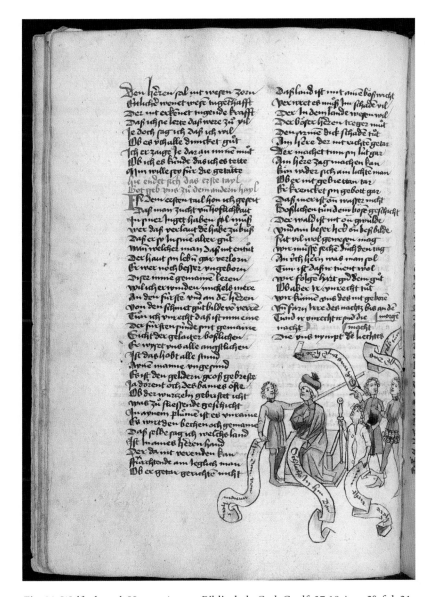

Fig. 88. Wolfenbüttel, Herzog August Bibliothek, Cod. Guelf. 37.19 Aug. 2°, fol. 21v

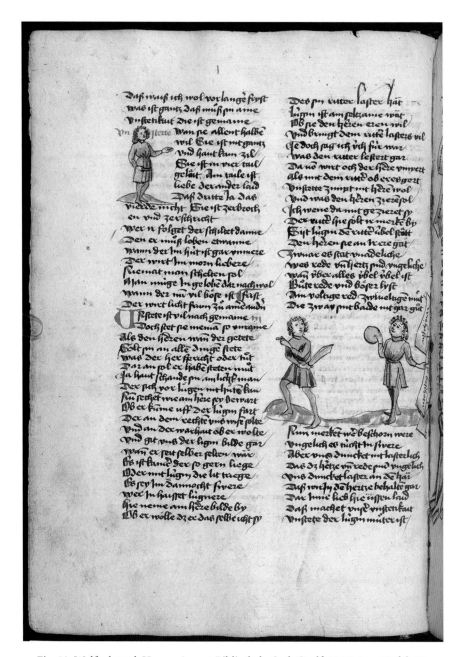

Fig. 89. Wolfenbüttel, Herzog August Bibliothek, Cod. Guelf. 37.19 Aug. 2°, fol. 23v

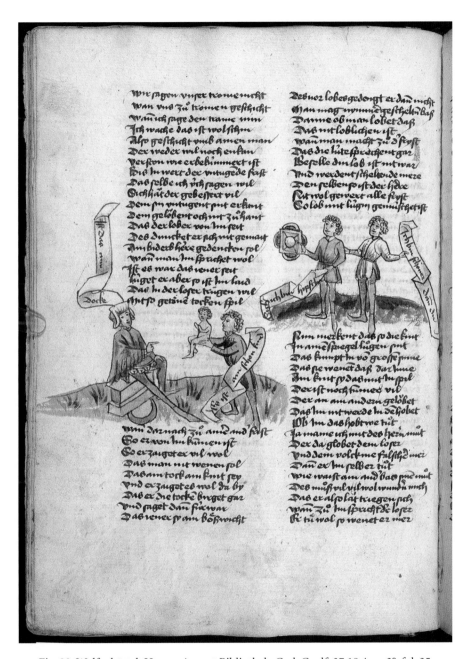

Fig. 90. Wolfenbüttel, Herzog August Bibliothek, Cod. Guelf. 37.19 Aug. 2°, fol. 35v

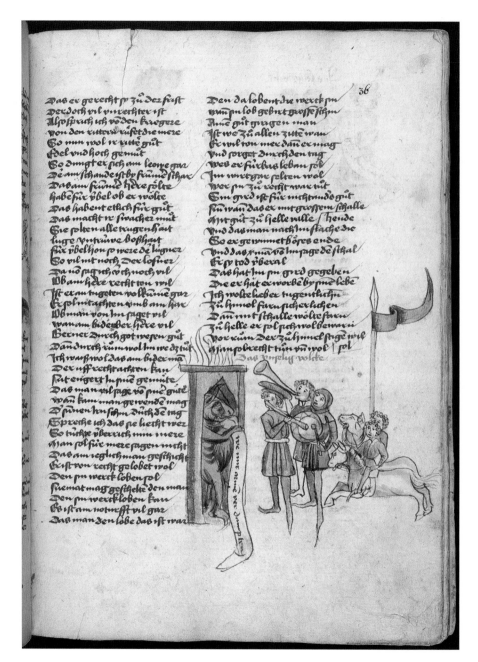

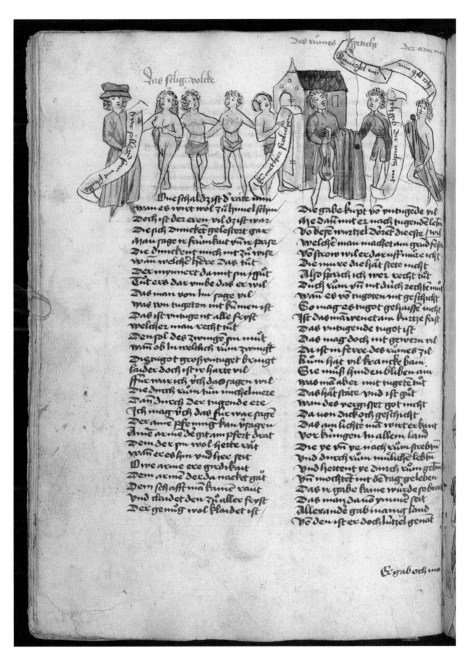

Fig. 92. Wolfenbüttel, Herzog August Bibliothek, Cod. Guelf. 37.19 Aug. 2°, fol. 36v

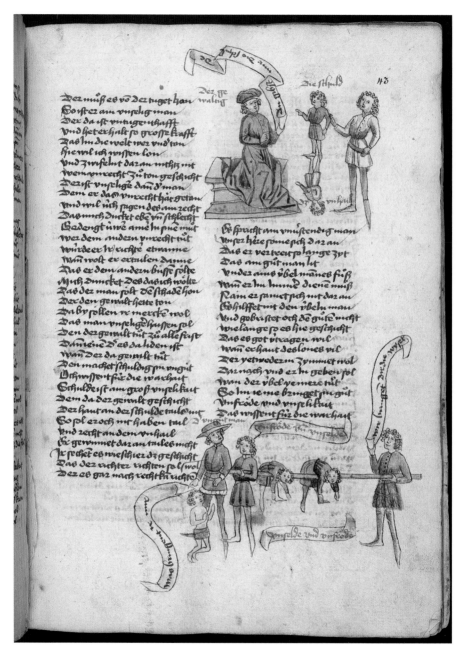

Fig. 93. Wolfenbüttel, Herzog August Bibliothek, Cod. Guelf. 37.19 Aug. 2°, fol. 43r

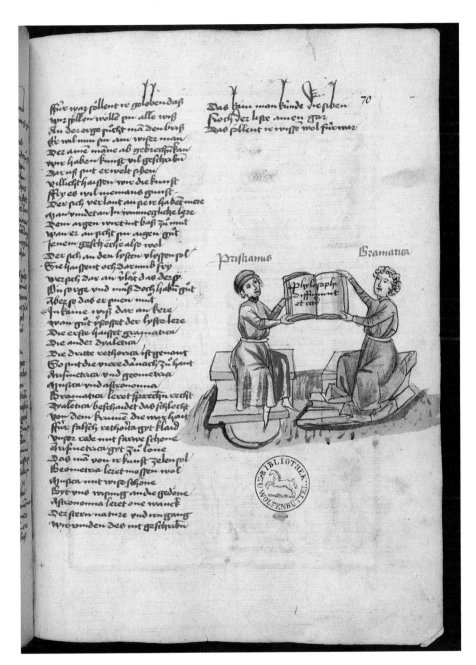

Fig. 94. Wolfenbüttel, Herzog August Bibliothek, Cod. Guelf. 37.19 Aug. 2°, fol. 70r

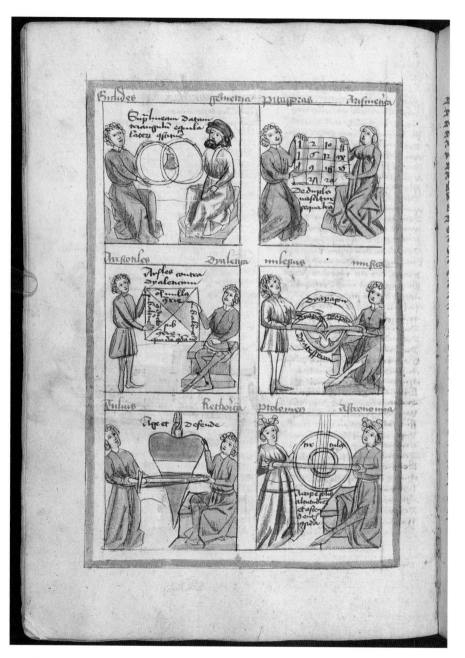

Fig. 95. Wolfenbüttel, Herzog August Bibliothek, Cod. Guelf. 37.19 Aug. 2°, fol. 70v

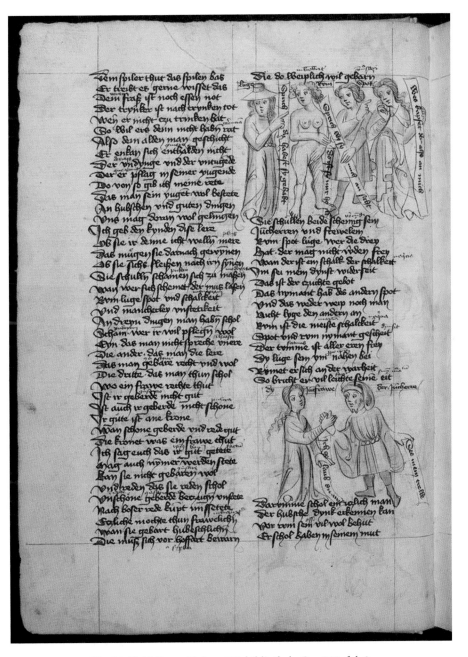

Fig. 96. Heidelberg, Universitätsbibliothek, Cpg 330, fol. 8v

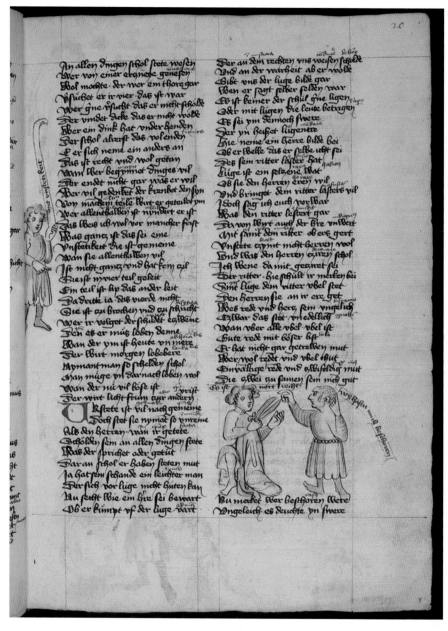

Fig. 97. Heidelberg, Universitätsbibliothek, Cpg 330, fol. 20r

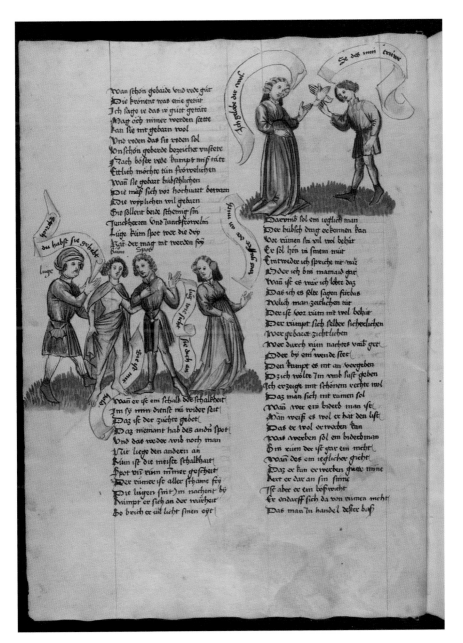

Fig. 98. Heidelberg, Universitätsbibliothek, Cpg 320, fol. 9v

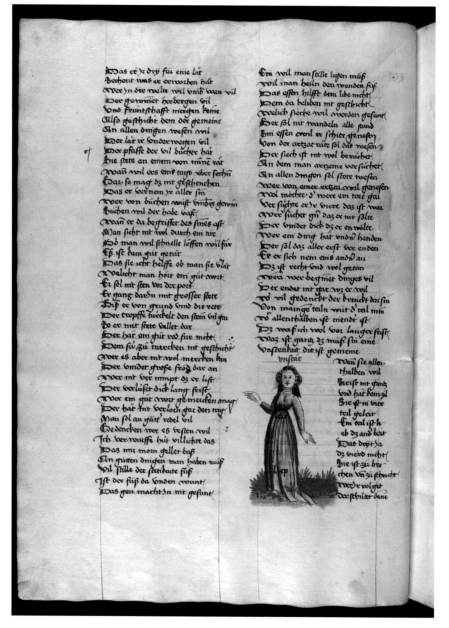

Fig. 99. Heidelberg, Universitätsbibliothek, Cpg 320, fol. 21v

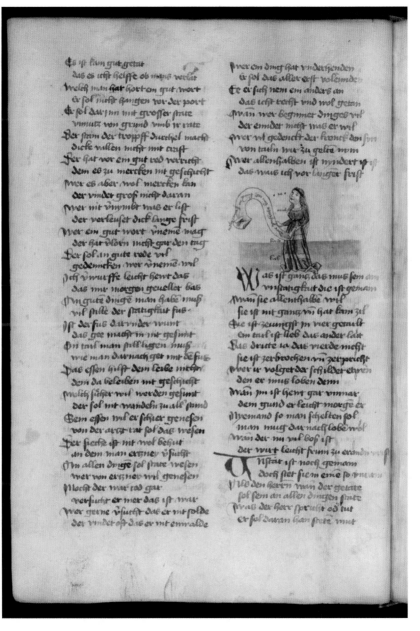

Fig. 100. Dresden, Sächsische Landesbibliothek–Staats- und
Universitätsbibliothek, Mscr. Dresd. M 67, fol. 19v

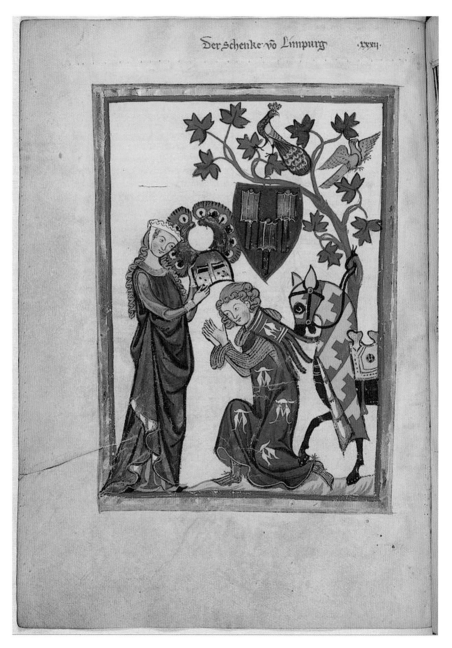

Fig. 101. Heidelberg, Universitätsbibliothek, Cpg 848, fol. 82v, *der Schenk von Limpurg*

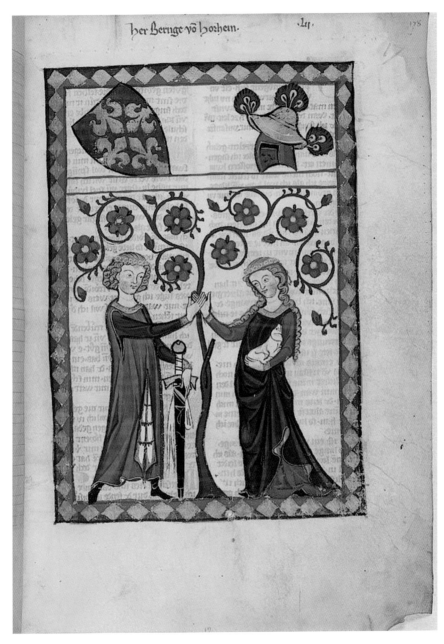

Fig. 102. Heidelberg, Universitätsbibliothek, Cpg 848, fol. 178r, *Her Bergner von Horheim*

NOTES

Introduction

1. Thomasin refers to himself as "Thomasin von Zerclaere," and most of the scholarship on him and his text has adhered to this spelling of his name. Some English-language scholarship, including the recent translation by Gibbs and McConnell, refer to the author as "Thomasin von Zirclaria." I have elected to use the version of the name that appears most commonly in the scholarship, and that Thomasin himself uses.

2. The extent to which the *Welscher Gast* is informed by its specific historical and sociological context in the upper Tyrol in 1215 has been much debated. Röcke, *Feudale Anarchie,* attempts to contextualize the poem in the historical reality of Friuli. Cormeau, "Tradierte Verhaltensnormen," examines part 10 of the work and comes to the more nuanced conclusion that Thomasin was informed by his particular historical circumstances but that much of his treatise is based on a long tradition of works on the virtues and vices.

3. Thomasin's reference to the heroes of profane literature has inspired much scholarly discussion on the question of whether Thomasin thought that his audience should understand vernacular literature in allegorical terms, and whether this positive representation of what was commonly regarded as lies by the clerics and theologians truly represented a compromise between church doctrine and lay practice. See, for example, Huber, "Höfischer Roman," and "Zur mittelalterlichen"; and Haug, "The Truth." Dallapiazza, "Artusromane," notes that Thomasin does not portray the legendary heroes of medieval epic in entirely positive terms.

4. Bumke, *Mäzene,* 70–71.

5. See, for example, the essays in Palmer and Schiewer, eds., *Mittelalterliche Literatur.*

6. The two fourteenth-century manuscripts for which we know the patrons offer us some indication of the spectrum and diversity of interest in the poem. The Stuttgart manuscript, Württembergische Landesbibliothek, Cod. poet. et phil. 2° 1 (1328/58), for example, was commissioned by a burgher of the city of Regensburg (see Irtenkauf, *Stuttgarter Zimelien,* 56). The New York manuscript, Pierpont Mor-

gan Library, G. 54 (ca. 1380) was commissioned by Kuno of Falkenstein, the arch-bishop of Trier. For a selected bibliography of scholarship on these and other *Welscher Gast* manuscripts, see the entries in the Handschriftencensus: http://www .handschriftencensus.de/.

Documented owners of *Welscher Gast* manuscripts include the Benedictine abbey Mosach (today Moggio di Sopra in Friuli), which listed the *Welscher Gast* in their 1250 book inventory, and Emperor Maximilian I and his third wife Bianca Maria Sforza, who owned the Berlin manuscript Hamilton 675 (ca. 1400). Maxi-milian was very interested in literary patronage and probably owned many books, but it is tempting to see his possession of the *Welscher Gast* in the context of his ro-manticized "autobiographical" literary creations, *Theuerdank* and *Weißkunig.* Like these ambitious projects, the *Welscher Gast* could participate in a project of aristocratic self-fashioning. While the reasons for Maximilian's ownership of the *Welscher Gast* must remain speculation, it is clear that the poem not only spoke to the feudal secular court audience for which it was produced, but also found broader appeal among the elite classes of medieval and late medieval society. Fur-ther owners include the Austrian noblewoman Elisabeth of Volkensdorff who listed a manuscript in an inventory of her books (first half of the fifteenth cen-tury). For a translation of Elisabeth of Volkensdorff's book list and a brief bibli-ography, see Rasmussen and Westphal-Wihl, *Ladies, Whores, and Holy Women,* 97–109. Additionally the Bavarian magistrate Jacob Püterich of Reichershausen (1400–1467) mentioned a *Welscher Gast* manuscript in the inventory of books included in his *Ehrenbrief* for the Countess of the Palatinate and Duchess of Aus-tria, Mechthild. A further reference to a manuscript appears in the 1434 inven-tory of books kept in the church of the Ordensburg in Königsberg (today Kalin-ingrad). On patronage and historical references to ownership of *Welscher Gast* manuscripts, see von Kries, *Textkritische Studien,* 67–68, and his more recent list of historical references to manuscripts in Thomasin von Zerclaere, *Der Welsche Gast,* ed. von Kries, 1:63.

7. This in contrast to Greenblatt, *Renaissance,* 1–3, who regards the notion of self-fashioning as a peculiarly sixteenth-century phenomenon.

8. My thematic synopsis identifies what topics are illustrated. Synopses in German with different emphases are available in Diestel, "Der Wälsche Gast"; Thomasin von Zerclaere, *Der Welsche Gast,* ed. von Kries, 1:14–45.

9. The standard studies include: Sowinski, *Lehrhafte Dichtung,* and Boesch, *Lehrhafte Literatur.* See also Bumke, *Geschichte der deutschen Literatur,* for a sur-vey of thirteenth-century didactic texts.

10. Elias, *Civilizing,* 50.

11. Elias, *Civilizing,* 56–67. See also Krueger, "Identity Begins at Home," 21, for a discussion of Elias.

12. C. Schneider, *Hovezuht,* 18–24, provides a succinct summary of Elias's notion of the civilizing process and its critiques.

13. Krueger, "Identity Begins at Home," 22.

14. Rosenwein, "Worrying about Emotions."

15. See the essays in Jaeger and Kasten, eds., *Codierungen*; Rosenwein, ed., *Anger's Past*; and Althoff, *Spielregeln*.

16. Krueger, "Identity Begins at Home," 21.

17. Bäuml, review of *Feudale Anarchie*, 854.

18. See Holsinger, "Analytical Survey 6," for an excellent survey of how notions of performance can help us to understand the ways in which medieval literature was received.

19. See, for example, the work by Michael Camille on manuscripts and their illustration including "The Book of Signs," "Seeing and Reading," and *Mirror in Parchment*; and Mary Carruthers's work on memory: *The Book of Memory* and *The Craft of Thought*.

20. Starkey and Wenzel, eds., *Visual Culture*; Wenzel, *Hören und Sehen*, esp. 338–413. Wenzel, "Visualität." See also Wandhoff, *Der epische Blick*; Bumke, "Emotion und Körperzeichen"; Müller, "Visualität"; Philipowski, "Geste und Inszenierung"; and Hübner, *Erzählformen*.

21. The art historian Brigitte Buettner writes: "it was precisely during the thirteenth century that the volume of visual narrative increased dramatically: the proliferation of illuminated manuscripts, panel paintings, and wall paintings, as well as the development of exempla inserted into sermons and of vernacular allegorical prose, were roughly coeval and possibly related phenomena." Buettner, "Profane Illuminations," 79.

22. Thomasin does not specifically refer to his book as a mirror, but it fits into the generic category nonetheless. The *Lexikon des Mittelalters* divides mirrors into three categories: (1) works that represent the history of the world and its salvation; (2) works that lead the reader to self-knowledge and demonstrate the path to moral, spiritual, and social improvement; and (3) works that present excerpts from older works. Roth, "Spiegelliteratur," col. 2101. Cited also in Wenzel, *Spiegelungen*.

On the concept of the mirror in the Middle Ages, see Teuber, "Per speculum," 20–24. See also Wenzel, *Spiegelungen*, esp. 86–90, where he argues that the text takes on the function of a mirror that reflects an ideal to be emulated by the reader. On Thomasin's use of the mirror metaphor to thematize self-perception, see Starkey, "Thomasins Spiegelphase."

The first book in German that uses the term "mirror" in its title may be the *Sachsenspiegel*, a legal treatise composed by Eike von Repgow around 1230. On the *Sachsenspiegel* and the German context of the genre of the mirror, see Wenzel, *Spiegelungen*, 84–85.

23. Grabes, *Speculum*, 21, documents the number of books with the word "mirror" in their title and makes the point that these titles increase dramatically in the thirteenth century, and then decrease again in the sixteenth century before disappearing almost completely in the seventeenth century.

24. Wenzel, *Spiegelungen*, 90: "Das Buch als Spiegel liefert seinem Gegenüber also nicht etwa ein Ab-Bild wie ein Schminkspiegel aus Metall, sondern das Vorbild eines Anderen, es fungiert als Medium der Vorbildlichkeit, das als modellierende Vor-schrift das äußere und das innere Auge anspricht, sensorisches und imaginatives Sehen, Fremdwahrnehmung und Eigenwahrnehmung, Beobachtung und Selbstkontrolle miteinander verbindet."

25. Mitchell, *Picture Theory*, 89n9.

26. Curschmann, "Pictura," 219.

27. Curschmann, "Imagined Exegesis," 169.

28. Curschmann, "Imagined Exegesis," 169.

29. Cormeau, "Tradierte Verhaltensnormen," 277: "Anders als fiktive Literatur ist Thomasins Moraldidaxe direkt handlungsbezogen; er will die geltenden sozialen Normen seinem Publikum anwendbar vermitteln."

30. The Middle High German text here and throughout is cited from the von Kries edition, vol. 1. The first set of verse numbers refers to the von Kries edition of Gotha Memb. I 120 (FvK). The second set refers to the most well-known and commonly cited edition of Heidelberg Cpg 389 edited by Rückert (HR). I have chosen to cite the von Kries edition because he uses Gotha Memb. I 120 as his lead text and therefore includes the prose foreword. I have included the line numbers from the Rückert edition because it is the more widely cited source, and it is generally more readily available. Translations from the Middle High German are my own unless otherwise noted.

31. On Thomasin's use of the word *bilde*, see Starkey, "From Symbol to Scene"; Brinker-von der Heyde, "Der 'Welsche Gast.'"

32. Bartsch, "The Philosopher"; Wenzel, *Spiegelungen*.

33. Of the 24 extant manuscripts and fragments that range in date from the thirteenth to the sixteenth century, 14 are illustrated and 4 contain spaces for illustrations that were never completed. Four additional fragments are so short that it is impossible to determine whether they were illustrated. This leaves only two fifteenth-century manuscripts that we can say with certainty were never intended to be illustrated. One of these, a late Alsatian manuscript from the first third of the fifteenth century, contains captions written in red and inserted into the text that correspond to 65 of the images (Heidelberg, Universitätsbibliothek, Cpg 338). The single remaining unillustrated version of the text is incomplete (it includes only the first 8,375 lines) and is incorporated into an anthology of Bavarian origin from around 1457 (Munich, Bayerische Staatsbibliothek, Cgm 340).

34. For an edition of the text with a discussion of the manuscript variations and their illustrations, see Thomasin von Zerclaere, *Der Welsche Gast*, ed. von Kries. For the most recent discussion of the variations in images in the *Welscher Gast*, see Wenzel and Lechtermann, eds., *Beweglichkeit*.

35. For example, manuscripts W, U, and a (see under "Fifteenth-Century Manuscripts" in appendix 1).

36. Wenzel, *Spiegelungen*.

37. Wenzel, "Die Beweglichkeit."

38. Paul Zumthor's work in the area of manuscript variation received wide acclaim. See, for example, Zumthor, *Oral Poetry*, and "The Text." Bernard Cerquiglini, *Éloge*, follows a similar line of argumentation, using the term *variance* to denote the variation in medieval texts. Arguing that the variation found in medieval manuscripts is an essential quality of the medieval vernacular tradition, Zumthor asserts that the differing versions should not be regarded as corruptions of an original master text, but as part of a continual process of modification and recreation he calls *mouvance*.

39. For an excellent survey of some of the recent scholarship on the orality/aurality of the text, see Holsinger, "Analytical Survey 6." The German perspective on this debate is perhaps best represented in the work of Joachim Bumke, Jan-Dirk Müller, and Horst Wenzel. Bumke's foundational essay, "Der unfeste Text," argues that multiple versions of vernacular epic narrative coexisted when the texts were first committed to the page, and that these texts only became fixed in the course of the fourteenth century. Jan-Dirk Müller, "Vorbemerkungen," xv, n. 2, similarly notes that the modern notion of a stable, author-produced text is anachronistic for the Middle Ages and reminds us that these texts were not primarily read but were also performed, so that each performance provided medieval audiences with yet another variant. Tervooren and Wenzel, eds., *Philologie*, contains a collection of responses to the New Philology debate by German medievalists.

40. Wenzel, "Die Beweglichkeit," 234.

41. Wenzel, in "Die Beweglichkeit," 234, writes: "Korrespondiert die Beweglichkeit der Bilder mit den Veränderungen der Texte oder ist die 'variance' der Bilder durch soviel Selbstständigkeit gekennzeichnet, daß das Bildmaterial den Deutungsspielraum der Texte im Sinne eines korrespondierenden, relativ eigenständigen Mediums erweitert?"

42. See Starkey, "Das unfeste Geschlecht."

43. Starkey, "From Symbol to Scene."

44. Carroll, "'Der Welsche Gast.'" Carroll also provides a synopsis of the debate with bibliographical references.

45. See Crosland, "Italian Courtesy Books," esp. 503.

46. Teske, *Thomasin*, 50–58.

47. The spelling of the name Zerklaere varies. See Teske, *Thomasin*, 41–49, for an account of the references to the name.

48. Thomasin von Zerclaere, *Der Welsche Gast*, ed. von Kries, 1:3–4.

49. See Scalon, *Necrologium*.

50. "Thomasinus de Corclara canonicus obiit qui dedit fratribus curiam unam in Aquilegia" (The canon Thomasinus of Corclara is dead, who gave the brothers a meeting place in Aquileia). Cited from Thomasin von Zerclaere, *Der Welsche Gast*, ed. von Kries, 4:44. Abbreviations have been resolved. See ibid., 1:3–6, for a discussion of other possible historical references to Thomasin. Cormeau, "Thomasin," col. 896, summarizes these historical references. See also Neumann, "Einführung," 9.

51. See, for example, Cormeau, "Thomasin," and Schiewer, "Thomasin von Zerclaere."

52. For a brief synopsis of the status of the patriarchy and Wolfger's political standing, see Willms translation and edition of Thomasin von Zerclaere, *Der Welsche Gast*, 4–5. See also Boshof and Knapp, eds., *Wolfger von Erla*.

53. See Teske, *Thomasin*, esp. 13–40; Bumke, *Mäzene*, passim.

54. The criticism of Walther continues in ll. 11842–52; 11191–11200.

55. See Marchal, "Domkapital," on the role of canons in the thirteenth century. See Rocher, "Thomasin von Zerclaere," 940–47, 38. In Aquileia at the beginning of the thirteenth century there were three collegiate churches with their own chapters: San Stefano, San Felice, and Santa Maria. Rocher has looked into the identity of the canons of these churches during the period when Thomasin was composing the *Welscher Gast* and comes to the conclusion that none of them was our Thomasin. He suggests that, since Wolfger actually lived in Cividale and not Aquileia, Thomasin attended school, became a cleric, and finally became a canon there. See Willms introduction in Thomasin von Zerclaere, *Der Welsche Gast*, 2–3 for a brief synopsis of the debate regarding Thomasin's affiliation with Wolfger.

56. Willms writes: "Wenn nicht neue Quellenfunde hier Klarheit schaffen, muß man einstweilen das Kanonikat um 1215 für ebenso ungesichert halten wie die Zugehörigkeit zur unmittelbaren Gefolgschaft Wolfgers, und selbst hinsichtlich des Klerikers können wir nicht sicher sein, basiert die Zuschreibung doch auf der unbeweisbaren Annahme, daß nur ein solcher ein Werk dieser Art verfassen würde und verfassen konnte. Außer Frage steht nur, daß Thomasin ein Publikum im Auge hat, wie man es, soweit wir wissen, sicher am Hof des Patriarchen, aber auch sonst unter dem Friauler Hochadel, hat vorfinden können." Thomasin von Zerclaere, *Der Welsche Gast*, 4.

57. Whereas didactic poems in French and Occitan proliferated already in the twelfth century, German vernacular didactic literature seems to first appear in the thirteenth century. The thirteenth-century German corpus of medieval didactic works intended for lay audiences includes a wide variety of genres (epic-length poem, short narrative poem, poetic dialog, *Spruchdichtung*, etc.) that address a broad spectrum of themes (love, conduct, etiquette, lordship, worldly vice, etc.). For more information on the German didactic tradition, see Sowinski, *Lehrhafte Dichtung*, and Boesch, *Lehrhafte Literatur*. See also Bumke, *Geschichte der deutschen Literatur*, for a survey of thirteenth-century didactic texts.

58. Crosland describes a "constant stream of Provençal poets" that "flowed into the northern provinces of Italy." They were well received at the Italian courts, and the ideals and literary forms of Provençe were freely imported into Italy, where they became the fashion amongst the Italian writers. These latter not only copied the poetry of the Provençal poets, but they themselves frequently wrote in Provençal, and the consequence was that a kind of school of Provençal poetry was formed in the North of Italy. Crosland, "Italian Courtesy Books," 503.

59. Gaspary, *Geschichte*, 113–14.

60. Newhauser, *Treatise*.

61. Cora Dietl, in "Aristoteles," has argued that Thomasin's notion of moderation (*maze*) was influenced by Aristotle's *Nicomachean Ethics*. Traub, *Studien zum Einfluß*, traces Thomasin's representation of concepts of constancy (*stete*), justice (*reht*), and generosity (*milte*) back to Cicero's *De officiis*. The first editor of the *Welscher Gast*, Heinrich Rückert, in Tomasin von Zerclaere, *Der Wälsche Gast*, identified influences from John of Salisbury's *Policraticus*, among other texts. See also Rocher, "Die ars oratoria," and Diestel, "Der Wälsche Gast." Rücker, *Mâze*, has argued that Thomasin was partly influenced in his discussion of the virtues by Isidore of Seville's *Book of Sentences*. Resler, "Thomasîn," 136, provides an extensive list of influences on Thomasin's text including the Bible, Boethius, Cicero, Seneca, Horace, St. Augustine, Isidore of Seville, Ambrose of Milan, and Pope Gregory I.

62. One of his sources was the *Moralium dogma philosophorum*, a popular twelfth-century book on ethics attributed to William of Conches, but Thomasin's particular understanding of the virtues and their hierarchy differs significantly from this source. On the importance of the *Moralium dogma* for Thomasin's poem, see Teske, *Thomasin*, 188 ff., 164. Christoph Huber has investigated to what extent Thomasin drew specifically on the catalog of vices and virtues in Alan of Lille's *Anticlaudianus*, but he concludes that while influences can be detected, they are diffuse; see Huber, *Die Aufnahme*, esp. chap. 1. According to Huber, Thomasin's borrowing is limited to external details of the battle between the virtues and the vices. See also Cormeau, "Tradierte Verhaltensnormen," 291–92. See also Göttert, "Thomasin," who places the text in the broader context of medieval and classical ethical literature.

63. Friedrich von Kries's *Textkritische Studien zum Welschen Gast Thomasins von Zerclaere* attempts to offer a detailed analysis of the variations between the manuscripts and stemmatic diagrams that show the relationships of the manuscripts and the redactions to one another, but it has been heavily and thoroughly criticized for its many errors.

64. Von Kries justified his privileging of the Gotha manuscript in two ways. First, the Gotha manuscript contains the largest number of illustrations. Second, and more problematically, von Kries traces the improved version of the poem that it contains to Thomasin himself, arguing that the poet revised his own poem and added the prose foreword. Von Kries bases his argument on two observations. The first is the notion that Friedrich Ranke first proposed in 1908 (Ranke, *Sprache und Stil*, 70 ff.), namely, that Thomasin himself was responsible for the prose foreword that appears in most of the manuscripts. This foreword is missing, however, in Heidelberg Cpg 389. This led Friedrich Neumann (Neumann, "Einleitung", xxviii; see also Neumann, "Einführung," 55) to conclude that Thomasin added the foreword to a "second edition of his text" that appears in the later redaction in the Gotha manuscript. The second observation has to do with the poem's rhyme scheme. As the oldest version of the poem progresses, its rhyme scheme improves.

Von Kries argues that the revisions made to the poem in the Gotha manuscript are consistent with those made over the course of the poem in Heidelberg Cpg 389. This leads him to conclude that when Thomasin completed his poem, he went back to the beginning and revised it according to the improved rhyme scheme that he had developed while composing his first draft.

65. Bumke, Review of *Thomasin von Zerclære.*

66. Given Bumke's more recent work on textual fluidity and variants, I suspect that he might today reevaluate his critical assessment of von Kries's decision to edit the Gotha manuscript. See Bumke, "Der unfeste Text," and *Die vier Fassungen.*

ONE. Reading Knowledge

1. See Green, "*Vrume rîtr.*"

2. Green, *Medieval Listening,* and "*Vrume rîtr.*" See also Chinca and Young, "Orality," esp. 3–8.

3. A version of this chapter with a slightly different emphasis appears in Starkey, "The Question."

4. Thomasin's target audience comprised male and female courtiers. For the sake of simplification, I have used the masculine pronoun throughout when referring to the "reader" or "listener." It is beyond the scope of this chapter to elaborate on gendered reading practices in the Middle Ages in general, or to determine whether the historical audiences of the manuscript redactions actually included men and women. For an overview of women as readers and patrons of literature, see Green, *Women Readers,* and Grundmann, "Die Frauen."

5. Green, "*Vrume rîtr.*" There is an extensive debate about levels of literacy among lay people. See for example, Grundmann, "Litteratus-illitteratus", 4–5, which makes the case that few lay people were able to read and write the vernacular; Turner, "The *Miles,*" proposes that lay literacy was more common than Grundmann suggests.

6. For descriptions of the manuscripts, see Thomasin von Zerclaere, *Der welsche Gast,* ed. von Kries, vol. 1; Wenzel and Lechtermann, eds., *Beweglichkeit,* 257–65; and appendix 1 in the present volume. Judging by the extant manuscripts and fragments, the poem was revised twice in the course of its transmission. See under the heading "The Editorial History and Modern Reception of the *Welscher Gast*" in the introduction to the present volume for details. Suffice it here to recall that the manuscripts at the focus of this chapter, Heidelberg Cpg 389 and Gotha Memb. I 120, thus contain two slightly different versions of the poem. However, since the editorial changes do not significantly alter the poem's content, this variation does not play a role in the present chapter. The poem was later revised more thoroughly, and variations of this re-revised redaction of the poem appear in the remaining nineteen manuscripts. For a detailed analysis of the relationships

between the poem's redaction in different manuscripts, see von Kries, *Textkritische Studien,* and Thomasin von Zerclaere, *Der welsche Gast,* ed. von Kries,1:69–86.

7. Chartier, "Die Weltgeschichte," 9. See also B. Frank, *Die Textgestalt,* and "Zur Entwicklung." Frank's book and essay include useful bibliographies of other important work on textual format.

8. Huot, *From Song to Book,* 3.

9. Chartier, "Die Weltgeschichte," 8.

10. Manuscript fragments that predate or are roughly contemporaneous to Gotha Memb. I 120 are the one-page fragments: Krakow, Ms. germ. quart. 978 (end of thirteenth century); Wolfenbüttel, Cod. Guelf. 404.9 (6) Novi (first half of fourteenth century); Sibiu, National Archive, Colecţia Brukenthal, coda GG 1-5, nn. 16, filele 222-223 (first half of fourteenth century); and the 97-page fragment Stuttgart, Cod. poet. et phil. 2° 1 (1328 or 1359).

11. The codex comprises 226 parchment leaves that measure 17.4–18.3 x 11.2–11.6 centimeters (approximately half the size of the Gotha codex). Each page contains about thirty-two lines of verse. The size of the text column is 13.5 x 4.0–5.9 centimeters. The margins are therefore quite generous, leaving plenty of space for illustrations. For a detailed description of the manuscript, see K. Schneider, *Gotische Schriften, Textband,* 173–75; *Tafelband,* fig. 95. See also the introduction to the facsimile Thomasin von Zercleare, *Der Welsche Gast,* ed. Vetter and Neumann, and the online description of the Universitätsbibliothek Heidelberg at http://digi.ub.uni-heidelberg.de/sammlung2/werk/pdf/cpg389.pdf. For a brief bibliography of scholarship on the manuscript, see the online entries at the Universitätsbibliothek Heidelberg, above, and the Marburger Repertorium Deutschsprachige Handschriften des 13. und 14. Jahrhunderts: http://www.mr1314 .de/1241.

12. The codex comprises 102 parchment pages that measure 32 x 23.5 centimeters. It is written in a two-column format with the number of lines in each column varying from thirty-eight to forty-four. The columns of writing cover an area that measures 23–25 x 16–16.5 centimeters. For a detailed description of the manuscript, see Eisermann, *Die Handschriften.* I am deeply indebted to Falk Eisermann for allowing me to work with his entry pre-publication. It is now available online at http://www.manuscripta-mediaevalia.de/hs/projekt_gotha.htm. The layout of the Gotha manuscript resembles that used for the vernacular Romance epic in the thirteenth century. On the development of layout in the Romance tradition, see B. Frank, *Die Textgestalt,* and "Zur Entwicklung," 70.

13. On references to reading and listening more generally in medieval German literature, see Green, *Medieval Listening.*

14. In keeping with other thirteenth-century representations of composition, he portrays himself with pen and knife in hand, and depicts the writing process as an arduous one. Saenger, "Silent Reading," 388–90.

15. Ursula Peters questions whether "the images in these manuscripts really do generally indicate the original orality of the composition and reception pro-

cesses," suggesting instead that "characteristic markers of orality . . . underline the fact that orality is a fiction." Peters, *Das Ich*, 80.

16. See Wenzel, *Hören und Sehen*, "Audiovisualität," and "Systole—Diastole." See also Coleman, "Aural Illumination," which deals with the aural reception of images in the late Middle Ages.

17. For a survey of work on visualization strategies in medieval German art and literature, see Wenzel and Jaeger, eds., *Visualisierungsstrategien*.

18. Starkey, "Visual Culture," 2–3.

19. On what he calls "the intermediate mode of reception" for vernacular German literature, see Green, *Medieval Listening*, 169–230; for a discussion of Green's work in the context of the ongoing debate about orality and literacy, see Chinca and Young, "Orality."

20. For a brief overview of the discussion of the intersection of literacy and orality in the Middle Ages, see Chinca and Young, "Orality."

21. Kolve, *Chaucer*, 15.

22. Kolve, *Chaucer*, 15. Kolve continues, "Even those royal or noble patrons whose favor was most important to him as a professional poet could be found now listening to his work in company, now reading alone." On the coexistence of different forms of reception and their relevance for memory, see Wenzel, *Hören und Sehen*.

23. Thomasin is not alone in his emphasis on reading. Some medieval German authors appear to have felt that readers would have a better understanding of the complexity of their works. See Green, *Medieval Listening*, 171–72, 196.

24. The question whether it was composed as a schoolbook must remain open. On the role of medieval German didactic texts in the Latin school culture, see Henkel, *Deutsche Übersetzungen*, esp. 86–92.

25. See, for example, Harant, *Poeta Faber*; Obermaier, *Von Nachtigallen*, and "Der Dichter."

26. Palmer, "Kapitel und Buch," 63–67.

27. Palmer, "Kapitel und Buch," 59–60.

28. Palmer, "Kapitel und Buch," 62–65.

29. On the headings in the *Nibelungenlied*, see Lohse, "Die Aventiurenüberschriften."

30. The prologue concludes with four rubricated lines of verse. On the development of the use of rubrics in German and French medieval manuscripts generally, see Backes, "Geordnete Texte."

31. See, for example, the *Willehalm* manuscript fragment Munich, Cgm 193, III, and Nuremberg, Germanisches Nationalmuseum, Graphische Slg., Kapsel 1607, Hz 1104–1105 (ca. 1270); and the *Parzival* manuscript St. Gallen, Stiftsbibliothek, Cod. 857 (second third of the thirteenth century).

32. B. Frank, "Zur Entwicklung," 70.

33. This technique is used by the scribe of the *Willehalm* fragment Munich, Cgm 193, III, and Nuremberg, Germanisches Nationalmuseum, Graphische Slg., Kapsel 1607, Hz 1104–1105, as well. See Starkey, *Reading*.

34. The formal presentation of the poem in Heidelberg Cpg 389 also resembles the presentation of courtly epic poems in other thirteenth-century vernacular manuscripts.

35. Palmer raises the question whether small format books might be connected to lay ownership and private reading practices, but comes to a similarly indeterminate conclusion. See Palmer, *German Literary Culture*, 14. See also Scholz, *Hören und Lesen*; compare the reviews of Scholz by Bumke, esp. p. 118, and Henkel, esp. p. 218. On private reading, see also Curschmann, "Hören-Lesen-Sehen," and Green, "On the Primary Reception."

36. As Paul Gehl points out in reference to Italian manuscripts, "The rigid left margin and the ragged right would have told any medieval reader at a glance that the work is poetry." Gehl, *A Moral Art*, 61.

37. Palmer, "Manuscripts," 90. On conventions of layout for vernacular epic poetry, see also B. Frank, "Zur Entwicklung," 70. Her focus is on Romance literature, but many of the conventions and developments she cites pertain also to the German tradition.

38. Palmer, "Manuscripts," 90.

39. Palmer, "Manuscripts," 90.

40. Paul Zumthor, Walther J. Ong, and others have argued extensively that the medieval manuscript is inherently vocal. See Zumthor, *Oral Poetry*, and "The Text"; Ong, *Orality*. See also Wenzel, *Hören und Sehen*; Taylor, *Textual Situations*; Green, "Terminologische Überlegungen." Chinca and Young, "Orality," 4, conclude that "there is no pure literacy and no pure orality in the Middle Ages."

41. Saenger, "Silent Reading," 392.

42. Thomasin von Zerclaere, *Der welsche Gast*, ed. von Kries, 1:70, follows Neumann, "Einleitung," xxviii, in suggesting that Thomasin himself revised the text and added the prose foreword. Although there is no concrete evidence that Thomasin was involved, whoever composed the register knew the poem well and was able to mimic its style.

43. Palmer, "Kapitel und Buch," 68.

44. See Palmer, "Kapitel und Buch," 69.

45. For example, in the section on conduct in part 1, the lines *Ein iunchfrowe sol senftichlich* (1019; 404) and *Wil sich ein vrowe mit zuht bewarn* (1065; 451) are marked with paraphs in Gotha Memb. I 120 (10v) but not in Heidelberg Cpg 389 (7rv).

46. Similarly B. Frank, "Zur Entwicklung," 71, has noted that in the French tradition the subdivision of texts often varies from manuscript to manuscript. This variation reveals the active role that scribes took in staging a text in a particular redaction.

47. Kolve, *Chaucer*, 17.

48. See Parkes, "The Influence."

49. See Parkes, "The Influence," 118–22; and Rouse and Rouse, *Preachers*, 7–36.

50. Rouse and Rouse, "*Statim Invenire*," 209: "The utility of the devices of layout worked out in the twelfth century is evident: we still use virtually all of them today, save that we have moved the marginalia to the foot of the page. And whenever one has occasion to turn directly from use of a well laid-out twelfth- or thirteenth-century manuscript to look for something in the exceptional modern printed text that does not have, for example, running headline or clear paragraph divisions, one has an annoying sense of lost ground."

51. See Rouse and Rouse, "The Development."

52. B. Frank, "Zur Entwicklung," 69.

53. Palmer, "Kapitel und Buch," 69: "Thomasins Werk ist in erster Linie als Beispiel für die lückenlose Übernahme lateinischer Strukturen in die Volkssprache zu werten." Palmer thus assumes that the hierarchical organization in Gotha Memb. I 120 goes back to the author. On the practice of transferring Latin formatting traditions to vernacular texts, see also B. Frank, "Zur Entwicklung," 69.

54. Palmer, "Kapitel und Buch," 67.

55. Palmer, "Kapitel und Buch," 69–70: "Wir dürfen annehmen, daß Thomasin lateinische Handschriften dieser Art gekannt und in der Konzeption seines deutschen Werks nachgeahmt hat."

56. For example, Rudolf von Ems, *Alexander*. See Palmer, "Kapitel und Buch," esp. 70–71. On the Latin tradition and the introduction of organizational apparatuses, see Parkes, "The Influence," and Rouse and Rouse, "The Development."

57. Universitätsbibliothek Heidelberg Cod. Pal. germ. 848 (*Manesse Songbook* [1305–40]); Universitätsbibliothek München 2° Cod. ms. 731 (*Hausbuch* of Michael de Leone [1355]).

58. The Gotha manuscript was probably designed with private reading in mind, but the codex may nonetheless have been used for recitals. Coleman, *Public Reading*, 88–108, has argued that in the fourteenth and fifteenth centuries in France and England, public recitals from a manuscript were more common than private reading. She tells us that educated people able to read for themselves often preferred recitals, which enabled them to participate in a shared literary experience. On silent reading in the fourteenth century, see Saenger, "Silent Reading," 390–93; 406–8.

59. On medieval notions of genre and the importance of context see Grubmüller, "Gattungskonstitution," and Egidi, "Minnelied."

60. There has been some controversy over the date of the manuscript's compilation, as one of the illustrations contains the inscribed date 1359. See Irtenkauf, Krekler, and Dumke, *Codices poetici*, 3–4. See also the entry in the online resource Marburger Repertorium.

61. See Peters, *Literatur in der Stadt*.

62. For example, Schlierbach, Stiftsbibliothek, Hs. I 28 (end of fourteenth century) also contains the *Rossauer Tischzucht*; Dresden, Sächsische Landesbibliothek–Staats- und Universitätsbibliothek, Mscr. Dresd. M 67 (1450–70) also contains Ulrich Boner's *Edelstein*, a collection of gnomic verse by Heinrich von

den Teichner, two poems by Freidank, and selections from Hugo von Trimberg's *Der Renner*, Karlsruhe, Badische Landesbibliothek, St. Peter pap. 25 (second half of the fifteenth century) contains Ulrich Putsch, *Das liecht der sel.*

63. The Stuttgart redaction suggests that this transition has already taken place by 1328. Unfortunately that redaction is a fragment, so it is unclear whether the manuscript originally contained a prose foreword.

TWO. Vision, the Viewing Subject, and the Power of Narrative

1. Of the twenty-five manuscripts and fragments of the *Welscher Gast,* four are too fragmentary to determine whether they were illustrated, and four contain spaces for illustrations that were never completed. Only two redactions were obviously designed as nonillustrated versions of the poem: Munich, Bayerische Staatsbibliothek, Cgm 340 (ca. 1457), and Heidelberg, Universitätsbibliothek, Cpg 338 (ca. 1420). The so-called manuscript fragment Berlin, Staatsbibliothek zu Berlin–Preußischer Kulturbesitz, Ms. germ. fol. 757 is actually a group of small fragments from two or three different manuscript redactions, so that the total number of twenty-five manuscripts to which scholars traditionally refer is misleading.

2. Under the rubric of *Beweglichkeit der Bilder,* Horst Wenzel has repeatedly made the case that the variation in the image cycle of the *Welscher Gast* over the course of its manuscript transmission reflects changing cultural notions and contexts. See Wenzel, "Die Beweglichkeit," and Wenzel and Lechtermann, eds., *Beweglichkeit.*

3. Noel, "The Utrecht Psalter," develops a convincing methodology for examining the Utrecht Psalter and its "copies" that is also relevant for the present study.

4. Wenzel, "Der Dichter"; Saurma-Jeltsch, "Textaneignung." The illustrations' visual contexts can influence the interpretation of the poem, and it is therefore important, as Curschmann, "Interdisziplinäre Beweglichkeit," 857, has pointed out, to consider the illustrations not only in relation to the text but also to other images. Wenzel, "Die Beweglichkeit," follows this approach.

5. Saurma-Jeltsch, "Textaneignung," 44. She writes: "Das Bild steht nicht einseitig in einem Dienstleistungsverhältnis zum Text, sondern bildet mit diesem gemeinsam Teil eines Diskurses zwischen Gruppen und Individuen und der Schriftlichkeit insgesamt. Beide Elemente gehören in den größeren Bereich der Kommunikation und reflektieren deren zeit-, gruppen- und individualspezifischen Wandel."

6. Starkey, "Affektives Sehen," is a preliminary investigation of the medieval models of seeing and their potential effect on the variation in the images of the *Welscher Gast.*

7. I define the terms narrative and story along the line of Genette, *Narrative Discourse,* who writes: "*narrative* refer[s] to the narrative statement, the oral or

written discourse that undertakes to tell of an event or series of events." In contrast, the story is "the succession of events, real or fictitious, that are the subjects of this discourse" (25); "*narrative* [is] the signifier, statement, discourse or narrative text itself"; "*story* [is] the signified narrative content"; "*narrating* [is] the producing narrative action; the event that consists of someone recounting something" (26–27).

8. Curschmann, "Wort-Schrift-Bild," 730. He writes: "Es geht nicht mehr um Aneignung durch Verarbeitung, sondern um Ablesen und Nachahmung."

9. Saurma-Jeltsch, "Neuzeitliches," 105. See also Stamm-Saurma, "*Zuht* und *wicze*," 62–65.

10. Starkey and Wenzel, "Visuality," and Starkey and Wenzel, eds., *Visual Culture.*

11. For example, Thomas Aquinas, *Commentary*, lectio 14 on bk II, par. 417, states that: "the sense of sight has a special dignity; it is more spiritual and more subtle than any other sense"; cited and translated in Carruthers, *The Book of Memory,* 54. On the importance of seeing more generally, see Schleusner-Eichholz, *Das Auge.* See also Nelson, ed., *Visuality.*

12. See, for example, the work by Camille on manuscripts and their illustration, including *Mirror in Parchment*; and Carruthers, *The Book of Memory*, and *The Craft of Thought.* See also Lentes, "Inneres Auge"; Schreiner, "Soziale, visuelle"; Wenzel and Jaeger, eds., *Visualisierungsstrategien.*

13. See, for example, Akbari, *Seeing.*

14. Camille, "Before the Gaze," 204.

15. Lindberg, "Alhazen's Theory." For a survey of these models of vision in the thirteenth and fourteenth centuries, see Akbari, *Seeing*, and Tachau, "Seeing as Action".

16. Hahn, "*Visio Dei*," 174.

17. Nelson, "Descartes's Cow," 5.

18. Hahn, "*Visio Dei*," 175. See also Bryson, "The Gaze," and Benson, "Freud". See also Starkey, "Thomasins Spiegelphase."

19. Simon, *Der Blick*; Lindberg, "Alhazen's Theory."

20. Camille, "Before the Gaze," 206.

21. Camille, "Before the Gaze," 206–7.

22. Camille, "Before the Gaze," 206.

23. Camille, "Before the Gaze," 206–7.

24. For an overview of the complexity of this debate, see Lindberg, "Alhazen's Theory," and Akbari, *Seeing*, 21–44. Tachau, "Seeing as Action," 338, concludes with regard to the paradigm of vision: "Like all such paradigms, this one . . . remained subject to debate, to misunderstanding, to refinement, to correction, and to popularization in many literary and artistic media."

25. Lindberg, "Alhazen's Theory." In fact, as Nelson, "Descartes's Cow", 9, has pointed out, there are Americans who still believe in the theory of extramission. See, for example, Winer and Cottrell, "Does Anything."

26. Macho, "Narziß," 1: There was no "principally correct or incorrect theory of seeing, but merely *theories* of seeing that facilitated or obviated specific practices and techniques of seeing—from religious rituals to optical devices."

27. Belting, *Bildanthropologie*, 30: "das Bild ist auf andere Weise anwesend, als es sein Medium ist. Es wird erst zum Bild, wenn es von seinem Betrachter animiert wird."

28. Belting, *Bildanthropologie*, 12: "Wir selbst sind der Ort der Bilder" (We ourselves are the site of images).

29. Collins, *Reading*, x, similarly asserts that "verbal and visual images derive their affective power from their relation to mental imaging."

30. See, for example, Belting, *Das Bild und sein Publikum*, and *Bild und Kult*; Hamburger, *The Visual*; and Biernoff, *Sight and Embodiment*. Newman, "What Did It Mean," offers a survey of medieval discussions of visions. On medieval visual piety see G. Frank, "The Pilgrim's Gaze."

31. See, for example, Belting, *Das Bild*, and *Bild und Kult*. See also Dietrichs, "*Terribilis.*" On the use of the conventions of cult images by secular rulers, see Marek et al., eds., *Bild und Körper*, 15–16; Bredekamp, *Repräsentation*. On the response to religious imagery across cultures and time, see Freedberg, *The Power*.

32. See for example Luyster, "Time, Space."

33. Wenzel, *Spiegelungen*, 28: "[Im Mittelalter] waren Statuen und Bilder nicht pure Artefakte, sondern beseelte Gegenüber; und dies gilt nicht nur für den religiösen Raum, sondern auch im Raum der höfischen Kultur."

34. Wenzel, *Spiegelungen*, 28: "Bildkörper, die Gesichts- und Tastsinn gleichermaßen adressieren und die Affekte in Erregung setzen. "

35. This is, of course, not particular to the Middle Ages. See Freedberg, *The Power*.

36. Buettner, "Profane Illuminations," 83.

37. Buettner, "Profane Illuminations," 84.

38. On the importance of empathy in the reception and production of literature, see Keen, *Empathy*. Barthel, *Empathie*, offers an overview of medieval notions of empathy. See also Breger and Breithaupt, eds., *Narrative Empathy*; and Breithaupt, *Kulturen*.

39. On the concept of *unstete* in the *Welscher Gast,* see Klare, "Thomasins," and Thomasin von Zirclaria, *Der Welsche Gast*, trans. Gibbs and McConnell, 18. On the concept of constancy more generally in medieval German literature, see McConnell and Ehrismann, "*stæte.*"

40. On Thomasin's notion of *stete* and the Latin tradition, see Huber, *Die Aufnahme*.

41. On the intersection of medieval notions about four elements and the representation of the human body, see Blume, "Körper."

42. Meyer and Suntrup, *Lexikon*, Sp. 332–404.

43. Meyer and Suntrup, *Lexikon*, Sp. 332–404. I would like to thank Thomas Cramer for pointing out the association between the four colors of the divided

lady with the colors associated with the four elements. The figure of Inconstancy itself becomes a kind of diagram that stands in contrast to the line diagram of the elements. On the significance of bodies in and as diagrams, see Bogen, "Der Körper."

44. On diagrams, see Evans, "The Geometry." On making images memorable, see Carruthers, *The Book of Memory*.

45. Carruthers, *The Book of Memory*.

46. Carruthers, *The Book of Memory*, 145.

47. Carruthers, *The Book of Memory*, 64, 108, 145, 146, 152, 256, 274–75, 306n83.

48. Elsner, "Between Mimesis," 59–60.

49. Elsner, "Between Mimesis," 46.

50. As Alexander, "Iconography," repeatedly stresses, the secular and religious, ecclesiastical and lay are in any case inseparable in the Middle Ages.

51. Katzenellenbogen, *Allegories*.

52. Barbara Newman, in "Love's Arrows," 263, defines this practice of creating crossover images as "the intentional borrowing and adaptation of courtly themes in devotional art and vice versa." See also Newman, *God and the Goddesses*, chap. 4. In general, as Jonathan J. G. Alexander, in "Iconography," 5, has pointed out, "the secular and the religious overlapped and interacted in every way and at every level in medieval art as in medieval society."

53. In the Stuttgart manuscript, the images of which probably date to 1328, the illustration is missing entirely. While it is difficult to draw any conclusions from its absence, it is nonetheless interesting that this is the only illustration missing from part 2 of the poem, and this may suggest that the artist deemed the figure to be completely superfluous given its detailed textual description. Alternatively the illustrator may have considered this subject too difficult to illustrate or the image too complicated to copy.

54. Camille, "Before the Gaze," 207.

55. Similarly in Heidelberg, Universitätsbibliothek, Cpg 338, a manuscript from around 1420 that contains no illustrations, the scribe has added two rubricated verses that fulfill the role of subdividing the text. These read: "Dis seit von unstetikeit und von liep und leit" (This tells of inconstancy and of love and sorrow).

56. As Baskins, in "Gender Trouble," 15, points out in her study of Boccaccio's tale of Nastagio and its redaction in fifteenth-century wall panels, "Spectators do not necessarily restrict their identification to protagonists of the same biological sex or cultural gender but rather they may strategically identify across gender through motives of disavowal, compensation, renunciation or pleasure."

57. Camille, "Before the Gaze," 208.

58. Starkey, "From Symbol to Scene," is a preliminary investigation of this image and its transformation.

59. The text tells us that anyone engaging in these vices is not free (831–32; 217–18). I have translated the term *Ruom* here as Boasting. The term is ambiguous,

as it means on the one hand reputation, and on the other boasting—as in the expressions *sich ruomen* (to boast) or *ruomære* (braggart). Since the excursus on *Luge, Ruom*, and *Spot* comes in the section of the text devoted to speech and forms of speaking, it seems likely that Thomasin refers here to the vice of "boasting," rather than to reputation. Yet the ambiguity that would have been apparent to a medieval poet and audience does bear some relevance for the continuation of this passage, and potentially for the illustrations as well. Boasting and the issue of one's reputation both play a role in this passage. A good man needs to guard his reputation, and should therefore not engage in boasting.

60. The first analysis of the *Welscher Gast* images in 1890 by Adolf von Oechelhäuser (*Der Bilderkreis*) set the stage for further studies of word and image in the codices. He writes: "Wir sehen vier einzelne Nebenfiguren nebeneinander stehend in Vorderansicht; zuäusserst links die *luge* als reich gekleidetes Weib mit einer Art Judenhelm auf dem Kopfe; sie wendet sich mit schmeichelnder Gebärde (*Sprich ich han si gehabt*) zu einem neben ihr stehenden, völlig unbekleideten Jüngling, dem *ruom*, der listig überlegend (*Da is si mir holt*) die Hand ans Kinn gelegt hat. Weiter rechts der *spot*, als häßlicher Mann, den Kopf nach links gewandt (*wi si dich an chapht*) und mit der Rechten nach der anderen Seite zeigend, wo sich ein 'schönes Weib,' darüber verwundert (*zweu zeiget er an mich*) zeigt." Oechelhäuser concludes, "Der Vorgang ist nicht recht deutlich, aber mit Hilfe der Spruchzettel immerhin verständlich ausgedrückt" (18).

61. Boasting's label is missing, but since the edge of the page is badly worn, it was probably rubbed off.

62. The labels allow us to identify these figures as allegorical personifications of the vices. While in the thirteenth century there was no standard iconography of the vices and virtues, they were very familiar figures in Christian religious art and frequently appear in cathedral portals, among other prominent locations. Katzenellenbogen, *Allegories*.

63. Buettner, "Profane Illuminations," 86–87.

64. On smiling, and particularly representations of smiling women, in medieval German culture, see Trokhimenko, "Keeping up Appearances."

65. On turbans and other head-coverings, see Mellinkoff, *Outcasts*, and *Averting Demons*.

66. Mellinkoff, *Outcasts*.

67. Buettner, "Profane Illuminations," 84, points out with respect to the spacing of figures in thirteenth- and fourteenth-century manuscripts that personages were generally portrayed in discrete spaces: "Overlaps between figures were kept to a minimum, except when artists wanted to signify multitudes or states of chaos, such as battles, or murders or sexual intimacy."

68. Bumke, *Höfische Kultur*, 1:195–96.

69. On crossover images in medieval art see Newman, "Love's Arrows," 263, *God and the Goddesses*, chap. 4.

70. Katzenellenbogen, *Allegories*, 22: "It is his task first of all to overcome his sinful desires, then to achieve the virtues, if he wishes to attain in the end the topmost rung and there join the Pauline trinity of virtues, Faith, Hope and Charity." See 22–26 and the accompanying images for examples of the motif of the ladder of virtue.

71. Jeffrey Hamburger, in his *Rothschild Canticles*, and Adolf Katzenellenbogen provide numerous examples of the motif, which I will not go into here. To name only one of many examples, Herrad of Hohenbourg uses it in her *Hortus deliciarum* (1167–85), an illustrated compendium of knowledge compiled for her religious community at the Hohenbourg Abbey, to represent the "ascent of virtue and the exercise of holy sanctity that obtain the crown of eternal life." Herrad, *Hortus deliciarum*, 1:352–53: "ascensum uiritutum et religiosum sanctitatis exercitium quo eterne uite corona adipiscitur." Translation and citation in Hamburger, *Rothschild Canticles*, 65 and 259n34. In Herrad's version of the motif, angels assist the female personification of Charity to attain divine reward represented by a crown held by the hand of God. See Hamburger, *Rothschild Canticles*, 49, for a discussion of the motif and other examples. Herrad extends the iconographic motif by representing laymen, women, and clerics striving upwards. Katzenellenbogen, *Allegories*, 24.

72. Focusing on Thomasin's discussion in part 8, Cora Dietl takes great pains to show that Thomasin derived his notion of the six qualities from Aristotle's *ethica vetus*, but, as she concludes, he completely revises Aristotle for his own purposes. Dietl, "Aristoteles."

73. Carruthers, *The Book of Memory*.

74. Schüppert, "Bildschichten," sees in Thomasin's *explicatio* of the ladder similarities to the narrative strategies used in sermons. She cites Berthold von Regensburg as an example, who uses an image to help structure a text and enable his congregation to better commit it to memory. But memory images were widespread. Mary Carruthers, *The Book of Memory*, has discussed numerous such examples of images used for memorization in scholastic and theological contexts.

75. Oechelhäuser, *Der Bilderkreis*, 56, first noticed the variation in the representation of hell in the *Welscher Gast* manuscripts.

THREE. Models of Gender

1. An earlier foray into the question of gender in the *Welscher Gast* that includes some of the material that appears in this chapter is Starkey, "Das unfeste Geschlecht." I follow here the convention of distinguishing between gender, which is socially constructed, and sex, which is biological. Since there is no indication in the images that we are dealing with cross-dressing figures, the gender of the figures, which is indicated through clothing and hairstyle, is correlated with their sex. The

question to what extent sex is also socially constructed is not at issue here. Butler's seminal book, *Gender Trouble,* first problematized the notion of a sex-gender dichotomy, emphasizing that sex, which appears to be pre- or extradiscursive, is really dependent on particular gender constructions. The assumption that sex is a natural phenomenon, she points out, tends to veil the fact that it is socially constructed. Butler's work threw open a whole new area of inquiry. In medieval studies, it gave rise to important work on the ambiguity of sex in literary texts and raised questions about the relevance of this ambiguity for cultural constructions of gender. See, for example, Clover, "Regardless of Sex"; Haag, "Das Ideal"; Gaunt, *Gender and Genre,* esp. 234–85; and Bennewitz, "Der Körper der Dame". For an excellent discussion of Butler and theories of gender in medieval studies, see Klinger, "Gender-Theorien." A third category of relevance here is grammatical gender.

2. See Weichselbaumer, "Normierte Männlichkeit."

3. Finke, *Feminist Theory,* 9.

4. Klinger, "Gender-Theorien," 272.

5. See, for example, the following collections of essays on masculinity: Lees, ed., *Medieval Masculinities*; Cohen and Wheeler, eds., *Becoming Male*; Dinges, ed., *Hausväter*; Baisch, et al., eds., *Aventiuren des Geschlechts.* On medieval sexuality, see Lochrie, McCracken, and Schultz, eds., *Constructing Medieval Sexuality.*

6. Newman, *God and the Goddesses,* 2–3.

7. The abstract concepts are not always embodied as extended personifications in the text, so that it is often difficult to determine whether Thomasin conceived of them as personifications or was merely bound by grammatical gender to refer to certain virtues and vices as "he" or "she." As de Boor, "Fortuna," 312, wrote in 1975: "Die Scheidung zwischen bloßer Metaphorik als sprachlicher oder dichterischer Verbildlichung einer gestaltlos wirkenden Macht und ihrer Personifizierung in einer gestalteten Figur ist in der Forschung nicht genügend beachtet worden." This is still the case today; although Newman, *God and the Goddesses,* has addressed this distinction productively, more work could be done.

8. Newman, *God and the Goddesses.*

9. Newman, *God and the Goddesses,* 298.

10. Newman, *God and the Goddesses,* 298.

11. In the text, the grammatical system is asymmetrical, that is, the unmarked pronominal gender is masculine. While a masculine form may therefore refer to a male or a female individual, a feminine form refers only to a female individual. Thomasin generally uses masculine forms (e.g., pronouns) when he describes scenarios for his mixed audience of ladies, knights, and clerics. In part 1, by contrast, Thomasin uses feminine forms and addresses women explicitly. See Forer, "Genus und Sexus," esp. 39. On grammatical gender, see also Bussmann, "*Das* Genus."

12. Bennewitz and Weichselbaumer, "Erziehung zur Differenz." On masculinity in the *Welscher Gast,* see Weichselbaumer, *Der Konstruierte Mann.*

13. On gender difference in Thomasin's instructions for speaking, see Weichselbaumer, *Der Konstruierte Mann,* 77–79.

14. On disciplining the female gaze, see Bennewitz, "Körper der Dame", 227.
15. Weichselbaumer, *Der Konstruierte Mann*, 77.
16. See Bennewitz and Weichselbaumer, "Erziehung zur Differenz."
17. See Bennewitz, "Körper der Dame." Bennewitz argues that didactic texts for women were concerned with making the female body invisible. She identifies three steps in this process: "die Ver-Hüllung des Körpers" (the hiding of the body), which results in reducing women's freedom of movement and making them less noticeable; "die räumliche Einschränkung" (spatial limitation), which includes instructions about walking, riding, physical contact (particularly with men); and "die sensuelle Einschränkung" (sensual limitation), which includes regulations on speaking, listening, and looking (225). See also Bennewitz and Weichselbaumer, "Erziehung zur Differenz", 45.
18. Bennewitz and Weichselbaumer, "Erziehung zur Differenz," 46. Ruff, *Der Wälsche Gast*, 38, notes the similarity to Andreas Capellanus, namely that "Geist ist . . . nicht unbedingt gefragt; im Gegenteil, denn wenn die intellektuellen Fähigkeiten einer Dame über das übliche Mass hinausreichen, so soll sie das nicht zeigen."
19. All of these exemplary figures are loyal, patient, selfless, and brave women identified in large part through their relationship with idealized mythological, legendary, historical, or Arthurian heroes. Andromache is Hector's wife, Penelope is Odysseus's wife, Oenone is Paris's lover, Galjena is Charlemagne's wife, Enite is Erec's wife, Sordamor is Gawein's sister, and Cligès's mother, Blanscheflor, is either the heroine of *Flore und Blanschflur* or the lover of Chrétien de Troyes' Perceval. Included in the catalogue is one unidentifiable name that appears differently in each manuscript redaction. In Gotha Memb. I 120 the name is Botinia, in Heidelberg Cpg 389 it is Sucinia, etc. See Haug, "Fiktionalität," 233; and Düwel, "Lesestoff," esp. 73–74. On the identification of "Botinia," see Neumann, "Einführung," 18; Pfeiffer, *Freie Forschung*, 59, argues that the name refers to Lavinia. Von Kries considers Pfeiffer's reading to be the most credible explanation; see Thomasin von Zerclaere, *Der Welsche Gast*, ed. von Kries, 1:16.
20. Bennewitz, in "Körper der Dame," writes: "In einer direkten Gegenüberstellung werden den beiden Geschlechten darüber hinaus zentrale höfische Werte in differenzierter Form zugeordnet," 227n14. Ruff, *Der Wälsche Gast*, 40, suggests that since this gender-specific list of virtues and vices is presented in the context of instructions on love, these virtues and vices are particularly applicable in relationships between men and women and are not general categories.
21. See Bennewitz, "Körper der Dame"; Bennewitz and Weichselbaumer, "Erziehung zur Differenz"; Bumke, *Höfische Kultur*; Klapisch-Zuber, ed., *Silences*. On constructing gender and sexuality in the Middle Ages, see the introductions and essays in Lees, ed., *Medieval Masculinities*; Lochrie, McCracken, and Schultz, eds., *Constructing Medieval Sexuality*; and Baisch et al., eds., *Aventiuren des Geschlechts*.
22. See Katzenellenbogen, "Die Psychomachie"; O'Reilly, *Studies*, esp. 1–82.

23. More recently Nugent, "*Virtus* or Virago," 13, has argued that "gender is strongly embedded in the overall conception of the work," and that the personification of the virtues and vices as women is not just due to their grammatical gender but also firmly embedded in gendered stereotypes that pervade the text. Nugent also argues that the virtues and vices in the *Psychomachia* are actually transsexual, female bodies that take on the characteristics of men.

24. Scholars have often assumed that grammatical gender should determine the gender of the medieval personifications of the vices and virtues. See Newman, *God and the Goddesses*, esp. 35–37 for a discussion of the grammatical theory of personification. Newman gives some credence to the theory, but asserts that "it is far from being a full and adequate explanation" (36).

25. On the influence of Alan of Lille on Thomasin's *Welscher Gast,* see Huber, *Die Aufnahme.*

26. As Clover, "Regardless of Sex," has remarked with regard to male and female bodies in Old Norse sagas: "the difference was conceived less as a set of absolute opposites than as a system of isomorphic analogues, the superior male set working as a visible map to the invisible and inferior female set" (377). See also Bennewitz, who, in "Zur Konstruktion," takes issue with Thomas Laqueur's one-sex-model.

27. On grammatical gender and personification of Lady World, see Stammler, *Frau Welt,* esp. 35–40.

28. I have included only abstract terms that refer to the concepts that Thomasin presents as vices and virtues. Several other labels identify figures as the scoundrel (*der bôswicht*), the righteous man (*der frŭm man*), the German language (*div tŭtsche zvnge*). For some of the terms it is difficult to find a single appropriate English equivalent. Some terms, such as *hohvart*, which can be translated as "pride" or "arrogance," are best translated differently depending on context. On the difficulties of translating Thomasin's terms, see Thomasin von Zirclaria, *Der Welsche Gast,* trans. Gibbs and McConnell, 14–28. Some of the terms may be interpreted either as positive or negative qualities depending on context. For example, *herrschaft* may be translated as "glory" or "arrogance," depending on whether it is a positive quality or a vice. Many of these concepts are discussed in the context of courtly culture in Ehrismann, *Ehre und Mut.*

29. Lexer, *Mittelhochdeutsches Wörterbuch*; Benecke, *Mittelhochdeutsches Wörterbuch.*

30. Although these distinctions appear now to be relatively clear, at an earlier stage of my work on the *Welscher Gast* I had not done a comprehensive study of the representation of gender and erroneously identified the figure of the treacherous advisor as a female figure wearing a headscarf in "From Symbol to Scene." I would like to thank Elke Brüggen for pointing out to me that this figure's head-covering is, in fact, a cap often worn by male figures in manuscript illustrations.

31. Katzenellenbogen, *Allegories,* discusses the visualization of the virtues and vices from antiquity through to the Middle Ages. Katzenellenbogen ends his

monograph with a discussion of the virtue and vice cycle of Notre-Dame, and an appendix that addresses the influence of this cycle that was copied starting around 1230 (albeit not with complete success) The figurative representations of the virtues and vices were not used for the earliest extant manuscript of the *Welscher Gast*, nor were such typological representations used in the later versions of the text. On the representation of virtues and vices, see also Camille, *The Gothic Idol*, esp. 9–17. See also the entries on "Tugend", "Laster", and "Personifikation" in the *Lexikon Christlicher Ikonographie.*

32. Curschmann, "Volkssprache und Bildsprache," and Wenzel, *Hören und Sehen.*

33. This is famously also the case with the orchard scene in *Tristan.* See Curschmann, "Images of Tristan."

34. Camille, *Gothic Idol.*

35. Wenzel, "Der Dichter," has a different explanation for the change in gender in the image in Heidelberg Cpg 389. He suggests that the juxtaposition to the figure of the virtuous man motivated the representation of Treachery as a male figure. Since, however, male and female figures are often juxtaposed in the image cycle, I don't find this explanation to be entirely convincing. See Starkey, "From Symbol to Scene."

36. Curschmann, "Interdisziplinäre Beweglichkeit," 856, notes this ambiguity in his critical review of Wenzel and Lechtermann, eds., *Beweglichkeit.*

37. In Heidelberg Cpg 389, the edge of the folio is cut and with it the hair of *unmuozze*, so that it is now impossible to tell for certain whether the figure was conceived as male or female in the earlier version of the image; the figure of *muozze*, however, is unambiguously female.

38. Other examples of ambiguous figures in the Gotha redaction include the personified figure of Inconstancy, which appears a few times in the visual program and is sometimes portrayed as male and sometimes female. In one image, however, the gender is ambiguous (fig. 36, ill. 56). This illustration depicts an enthroned lord seated between a flatterer on the left and the personified vices of Greed, Avarice, and Inconstancy on the right. While Greed and Avarice are unambiguously identified as female by the length of their hair and gowns, the figure of Inconstancy seems caught between the masculine and feminine ends of the spectrum—its hair is uneven in length, and its tunic is half long and half short. In Heidelberg Cpg 389, the image is similarly ambiguous. Since, according to Thomasin, Inconstancy is comprised of opposites, this ambiguity may be intentional.

39. See Schultz, *Courtly Love*; see also Klinger, "Gender-Theorien."

40. Schultz, *Courtly Love*, 97: "Men's clothing extended only partway down the leg and the leg coverings fitted very closely so that the contours of men's legs were clearly visible. As a result shapely legs came to be regarded as a hallmark of masculine beauty. . . . Of course legs in themselves are not particularly male. Thus one cannot say that men's clothes reveal a sexed body. Rather, men's clothes create

a gendered body. Exposing the legs turns the body into a man's, since the body with visible legs can only be a man's. It is the clothes not the legs that make the body masculine."

41. See Katzenellenbogen, "Die Psychomachie."

42. It would be interesting to see whether women who distinguish themselves in medieval literature by fighting like men are generally depicted as male or female. In the fragment of Wolfram von Eschenbach, *Willehalm*, Nuremberg Hz 1104rv and Munich, Cgm 193, III, fol. 4r (1270s), Gyburg's armor covers any features that would allow us to identify her visually as a woman.

43. See Katzenellenbogen, "Die Psychomachie"; O'Reilly, *Studies*, esp. 1–82.

44. See Haag, "Das Ideal." On warrior women in French medieval literature, see Solterer, "Figures of Female Militancy." On cross-dressing in general, see, Hotchkiss, *Clothes*; for many important examples of cross-dressing in medieval literature see Feistner, "*manlîchiu wîp, wîplîchiu man*."

45. Wolfram von Eschenbach, *Willehalm*, ed. Heinzle.

46. See Haag, "Das Ideal" for the theological discussion in the Middle Ages of the *manlîchiu wîp*, the manly woman, who is able to reject her womanliness and act in a morally and ethically superior manner—like a man.

47. According to the work of Mullally, *The* Carole, who draws on references in French literature to distinguish between different forms of medieval dance, the dance depicted in this image may be a carole, a dance performed in a circle usually to the accompaniment of the dancers' singing. But it may also be a *hovetanz*, a form of social dance that was accompanied by wind instruments and was popular in Germany in the fourteenth century. Mullally, "Houes Danses," 32, distinguishes between the *hovetanz* and the carole based on the presence or absence of accompaniment by musical instrument. For my purposes it is not essential to determine which dance is portrayed here, and in any case the iconography of dance—as Mullally, *The* Carole, 93–100, has shown—is typically not a realistic portrayal of actual historical dance forms.

48. Mullally, *The* Carole, 41–43.

49. On negative associations in the Middle Ages with striped cloth, see Pastoureau, *The Devil's Cloth*, esp. 7–18.

50. The sartorial contrast between the virtues and the vices in the large-format illustrations is missing from the Stuttgart manuscript in which both the virtuous ladies and the vices wear monochrome clothing. This comparison with the Stuttgart manuscript suggests that it is a particular innovation of the Gotha manuscript to differentiate the representation of the vices from the virtues by using the categories of sexuality, as opposed to gender, and introducing differentiated types of courtly attire to express sexuality.

51. See Clover, "Regardless of Sex," and Laqueur, *Making Sex*.

52. On Thomasin's notions regarding the role of education in a secular life of virtue, see Brinker-von der Heyde, "Durch Bildung."

53. Hamburger, *Rothschild Canticles*, 42. See also Katzenellenbogen, "The Representation," who discusses various contexts in which the seven liberal arts start to appear in the twelfth century.

54. The practice of characterizing the arts by adding distinguished authors or scholars to their visual representation goes back to the twelfth century. See Evans, "Allegorical Women," esp. 310.

55. For descriptions of these images and how they fit into the iconographic tradition of portraying the liberal arts, see Evans, "Allegorical Women," esp. 312. See Thomasin von Zerclaere, *Der Welscher Gast*, ed. von Kries, 4:133–41, for a description of the images in the Gotha manuscript and the variations in the other manuscripts.

56. Evans, "Allegorical Women," 312. As Borst, "Die Naturwissenschaften," esp. 208–11 has pointed out, Thomasin's innovative design of the liberal arts lies in his combination of the allegorical, the historical, and the instrumental, and his reinterpretation of these for a lay audience. Borst writes: "Er verband als erster die alte, allegorische Auffassung der Künste mit der neuen, instrumentalen Ansicht der Wissenschaften, und zwar auf doppelte Weise. Einerseits stellte er die antiken Verfasser von Lehrbüchern gleichberechtigt neben die zeitlosen Frauengestalten der Fächer; diese Anpassung lag zu seiner Zeit schon in der Luft. Andererseits ersetzte er allegorische Attribute, die Zählschnüre, Meßstäbe, Fackeln, Blumenszepter, Vasen, Schriftbänder, durch exakte Zeichnungen, die einzelne Verfahren, Werkzeuge und Ergebnisse der Wissenschaften exemplarisch festhielten; diese Neuerungen verstanden sich noch keineswegs von selbst" (211). See also Tezmen-Siegel, *Die Darstellungen*. See Kronjäger, "Berühmte Griechen," 75–132, for a survey of historical figures in representations of the arts.

57. Stolz, "Text und Bild."

58. Stolz, "Text und Bild" examines the image as it appears in Heidelberg Cpg 389. See also Wenzel, "Artes," 88–90.

59. See Wenzel, "Artes," esp. 81–83, who argues that Thomasin's goal is to incorporate the tradition of learning into aristocratic life. According to Wenzel, Thomasin achieves this by creating a text and image that can be understood on multiple levels by both the literati and illiterati at court.

60. Sears, "'Reading' Images," 2–3.

61. Borst, "Naturwissenschaften," suggests that a lay audience would not have been able to understand the Latin citations, or the instruments, but would have seen in the images a lively interaction between courtly ladies and men, much like those interactions portrayed in the Manesse songbook. Assmann, "Der Wissende," also sees in these illustrations the interaction of two figures whereby "[d]er aktiive Teil liegt beim Manne, der belehrend auf die Frau einzureden scheint" (16). The female figure is the "embodied affirmation of his knowledge." With regard to the attributes, Assmann writes: "Es sind die zur Hieroglyphe geronnenen Axiome, auf denen die jeweiligen Disziplinen als ihren Fundamenten

aufruhen. Was zwischen den beiden Personen steht und von ihnen gemeinsam hochgehalten wird, hat nicht die flüchtige Form des Gesprächs, sondern die verfestigte Form des Bücherwissens. Es ist schriftförmig und in Handbüchern gespeichert; zu ihm tritt die mündliche Lehrsituation ergänzend hinzu, die durch das tête-à-tête der beiden Personen mit angedeutet ist" (16). Assmann thus suggests that, on the representational level, these miniatures depict teachers instructing female students. However, since female students of the seven liberal arts were probably rather uncommon in the thirteenth and fourteenth centuries, I find this reading unconvincing. From the courtly perspective, if the male figures are interpreted as teachers, then the service that they offer to their liege ladies is the transmission of their knowledge, which is made manifest in the instrument held by both figures.

62. Oddly, in the Wolfenbüttel redaction Ptolemy is female.

63. Evans, "Allegorical Women," esp. 312–15. This fluidity in gender is not an oddity of the Wolfenbüttel manuscript but can be found also in other manuscript redactions. In Heidelberg Cpg 320, for example, Music is male, and in Erlangen Ms. B 7 Dialectic is male.

64. Although girls too attended school and received private instruction.

65. While Evans offers several examples of cycles of the liberal arts in which some of the arts are represented as male figures, he locates very few examples in which all of the arts are personified as men. Arithmetic's portrayal as a woman in the Wolfenbüttel redaction may be explained by influence from other secular iconographic traditions (fig. 95). In this version of the image the instrument that the two figures hold has also undergone significant changes. Rather than a triangular shaped chart of proportion, the figures hold a square checkered board resembling a chess board. This image of a man and lady holding a board between them is reminiscent of the image of lovers playing chess that was ubiquitous throughout the high and late Middle Ages. Perhaps this iconographic tradition influenced the artist who decided to portray lovers interacting, rather than produce yet another illustration of two men in scholarly debate. Why Ptolemy appears as a woman in the last image of the Wolfenbüttel series remains a mystery.

66. The Wolfenbüttel version of the illustration originally depicted the knights paying homage to their lords and the subsequent combat on two facing folios, but the manuscript was incorrectly bound so that the knights in combat now appear at the end of the manuscript. Figure 87 depicts the folios side by side as they would have appeared originally.

67. On this inscription, see Wachinger, "Autorschaft," 10; Peters, *Das Ich*, 62–63.

68. See Wenzel, "Der Dichter," esp. 91–92; idem, "Die Beweglichkeit." See also Peters, *Das Ich*, 61–62.

69. Curschmann, "Interdisziplinäre Beweglichkeit," 857–58.

70. See Starkey, "From Symbol to Scene."

FOUR. Image and Elite Self-Fashioning in the Gotha Manuscript

1. The extent to which the *Welscher Gast* is informed by its specific historical and sociological context in the upper Tyrol in 1215 has been much debated. Röcke, *Feudale Anarchie*, attempts to contextualize the poem in the historical reality of Friuli. Cormeau, "Tradierte Verhaltensnormen," examines part 10 on *milte* and comes to the more nuanced conclusion that Thomasin was informed by his particular historical circumstances but that much of his treatise is based on a long tradition of works on the virtues and vices.

2. C. Schneider, *Hovezuht*, 10.

3. In his book on notions of courtly culture at the courts of Prince Albrecht III of Austria and Archbishop Pilgrim II of Salzburg (1365–96), Christian Schneider writes, "In Zentrum dieses Diskurses, der der Regelung höfischen Verhaltens gilt, steht ein Ensemble je spezifischer Verhaltensideale, Werte und Normen, individueller und kollektiver Leitbilder, das in seinen Wurzeln auf antike Formen und Vorstellungen einer idealen Lebensführung zurückgeht und über Renaissance und Humanismus bis in die Moderne hinein fortgewirkt hat" (At the center of this discourse, which essentially addressed the regulation of courtly conduct, is an assemblage of specific ideals of conduct, values, and norms, individual and collective models, that has its roots in antique models and ideas of an ideal life style and continues to be influential throughout the Renaissance and Humanism, and into the modern period; C. Schneider, *Hofezuht*, 10).

4. On the realization of ideas about courtly culture in the medieval German literary tradition, see Bumke, *Höfische Kultur*. On the antique and early medieval traditions that provided the foundation for this thirteenth-century concern with courtliness, see Jaeger, *Origins*. See also the brief synopsis of Jaeger's contribution to the discussion of the development of courtliness and its critique in Schneider, *Hovezuht*, 25–29.

5. See, for example, Jaeger, *Ennobling Love*, and Schultz, *Courtly Love*.

6. Bumke, *Höfische Kultur*.

7. The catalogue appears at 1641–67; 1030–55. The reference to the man who lacks understanding and should therefore read courtly literature appears at 1719–24; 1106–12.

8. There has been much debate about whether Thomasin knew the French or German sources for these stories. See Teske, *Thomasin*, 73–74.

9. On the literary identity and potential sources for these figures see Düwel, "Lesestoff."

10. On this debate, see Huber, "Höfischer Roman," and "Zur mittelalterlichen"; and Haug, "The Truth."

11. Most scholars follow Friedrich von Kries in identifying one hundred and twenty illustrations in the Gotha manuscript. However, Kries's numbering system is misleading as he typically divides large illustrations into smaller units.

His illustrations numbered 4–8, for example, are actually part of a single large illustration (fig. 2). Similarly while the individual miniatures of the seven liberal arts (Kries 101–7) are separated by frames, they arguably comprise a single illustration (fig. 68). The illustrations that Kries numbers 64 and 65 are two halves of the same image divided visually in the manuscript by an architectural element (fig. 38, ill. 59). Finally, like the liberal arts, the virtuous ladies (Kries 115–19) are separated by frames, but they are clearly part of a single larger illustration (figs. 75 and 76, ill. 103). I identify 105 illustrations in the Gotha manuscript.

12. On the discourse on clothing in French medieval literature, see Burns, *Courtly Love*.

13. See Heslop, "Romanesque," who addresses the representation of social distinction in Romanesque art.

14. On the social context for the text see Cormeau, "Tradierte Verhaltensnormen," and Röcke, *Feudale Anarchie*.

15. Cormeau, "Tradierte Verhaltensnormen."

16. The seven illustrations are as follows: (1) the virtuous knights in battle against their unvirtuous counterparts (fig. 2); (2) Diligence driving off Laziness (fig. 3, ill. 4); (3) men greedy for fame who go to hell accompanied by great noise and excitement are juxtaposed with good men whose virtuous deeds speak for themselves and who enter heaven quietly (fig. 38, ill. 61); (4) a man seeking pears in a cherry tree (fig. 39, ill. 61); (5) birds attacking an owl (fig. 57, ill. 83); (6) the virtuous ladies (figs. 75 and 76, ill. 103); (7) the circle of vices (fig. 76, ill. 104). All of these except (4) and (5) emphasize the aristocratic appearance of the figures. A single illustration appears in Heidelberg Cpg 389 but not in the Gotha manuscript. It illustrates the instruction that one's gestures and intent should correspond to one's actions and it depicts the figure of Generosity standing next to a man giving alms (fol. 218v). Curiously this instruction is illustrated twice in the Stuttgart manuscript (fols. 93va, 94ra). The dedication image of the Gotha redaction (fig. 77) is not included in the list of seven addenda above as it is not part of the visual program that generally accompanies the poem.

17. In some of the Gotha illustrations peasants are depicted wearing brightly colored clothing. These illustrations clearly do not represent these peasants in realistically colored garb, but instead the bright colors were probably a means to emphasize the costliness of the manuscript. In images in which peasants do appear in colored attire, however, their clothing style is unambiguously impoverished (e.g., figs. 17; 38, ill. 59). Although the poor man in figure 17 wears red, his beard, bare legs, and the inscription above his head identify him as impoverished. In cases such as this one the vivid pigment contradicts the representational paradigm that is developed in the rest of the image cycle.

18. Piponnier and Mane, *Dress*, 105. On sartorial regulations regarding color for the clergy, see Izbicki, "Forbidden Colors." The regulation of clerical dress offers us some insight into what the clerics' worldly counterparts were wearing.

19. Although class difference is not distinguished so visibly in the illustrations, the Wolfenbüttel manuscript is certainly concerned with affirming its elite patron's social status. For an informative study of manuscripts similar in style and quality to the Wolfenbüttel manuscript, see Saurma-Jeltsch, "Neuzeitliches."

20. Friedrich von Kries argues that the placement of this image in the Gotha manuscript is incorrect; see Thomasin von Zerclaere, *Der welsche Gast*, ed. von Kries, 4:50. There is, in fact, no codicological evidence that the image has been misplaced in the Gotha manuscript. Instead, given the partner image of the virtuous ladies that appears at the end of the poem, the illustration's placement at the beginning seems entirely appropriate.

21. Starkey and Wenzel, "Visuality." On treatises of the virtues and vices see Newhauser, *Treatise*. See also Hourihane, *Virtue and Vice*, 8n8 for a list of important monographs dealing with the virtues and vices.

22. It is not possible to determine which form of dance this might be. It resembles the carole, but according to Mullally's investigation of the carole in French medieval literature and iconography, aristocratic performances of the carole were not accompanied by musical instruments (*The* Carole, 89–90). This image may rather illustrate the *hovetanz*, a dance form distinct from the carole and often accompanied by the shawm (Mullally, *The* Carole, 90).

23. Pastoureau, *The Devil's Cloth*, 13. The figure of "the false man" (*der valsch man*) is also portrayed in particolor (fig. 15).

24. The dancing vices and the virtuous ladies appear also in the Stuttgart manuscript fragment, the images of which are assumed to be roughly contemporaneous to those in the Gotha manuscript. They were therefore probably added to the image cycle prior to the compilation of the Gotha redaction and in any case are not unique to it. Once added to the cycle, however, they became integral to it and are reproduced in some form in almost all of the later illustrated manuscripts.

25. On typical fourteenth-century dress, with special attention paid to the tippet (a decorative tail of fabric that is attached to the sleeve), see Netherton, "The Tippet." The lady in the Gotha manuscript does not wear the tippet, but her overgown does have short sleeves that extend into long tails, which display both her brightly colored undergown and the costly ermine lining of the overgown. According to Netherton, this style was very popular in the mid-fourteenth century when the Gotha manuscript was illustrated (121–22).

26. On the representation of clothing in the twelfth- and thirteenth-century epic, see Brüggen, *Kleidung*.

27. For many examples of the medieval art of love, see Camille, *The Medieval*.

28. That is, they prove "the reality of the text by giving it as a visual confirmation" (Belting, "The New Role," 151).

29. Buettner, in "Profane Illuminations," writes: "Such images ['ancient places and figures (that) were intentionally displaced (i.e., modernized) by medieval representations'] attest to a specific historiographic conception whereby the scenery

of past events was equated with contemporary ones and, by extension, with the world of the onlooker" (81–82).

30. Saurma-Jeltsch, "Neuzeitliches," 105, comes to a similar conclusion specifically with respect to the redactions of manuscripts produced by an urban workshop for vernacular book production, the "Werkstatt von 1418": "Gemeinsam scheint allen diesen Werken die Funktion der Bilder zu sein, einen bestimmten sozialen Habitus, den man mit den Schlagwörtern der höfischen Verhaltensnorm und Herkunft umschreiben könnte, nicht nur zu legitimieren, sondern auch zu beschreiben." Curschmann, "Wort-Schrift-Bild," 730, expands Saurma-Jeltsch's conclusion to generalize about the differences between thirteenth- and fourteenth-century manuscript illustration: "Darin unterscheiden sich die dergestalt gestifteten neues Gruppenidentitäten von denen des 13. Jahrhunderts grundsätzlich: Es geht nicht mehr um Aneignung durch Verarbeitung, sondern um Ablesen und Nachahmung." But it pertains more generally to vernacular book illustration in the fifteenth century. See also Stamm-Saurma, "*Zuht* und *wicze.*"

31. C. Schneider, *Hovezuht*, 226: "Man kann zwar . . . die Vorstellungen von einer idealen Selbst- und Lebensführung sichtbar machen, die offen oder verborgen in der Panegyrik des Wiener Hofdichters Eingang gefunden haben. Aber die Funktion dieser Dichtung besteht in etwas anderem: Sie zielt darauf, die Solidarität, Stabilität und Kohärenz jener höfischen Oberschicht zu beschwören, die ihr Publikum ist, nicht — oder zumindest nicht vorranging — darauf, zu höfischem Verhalten zu erziehen."

32. Several studies of specific late medieval courts have examined late medieval courtly culture from the perspective of their literary culture. See, for example, J.-D. Müller, *Gedechtnus*, on the literary culture at the court of Maximilian I; J.-D. Müller, ed., *Wissen*, Backes, *Das literarische Leben*, and Studt, *Fürstenhof*, on the court at Heidelberg; and C. Schneider, *Hovezuht*, on the courts of Prince Albrecht III of Austria and the Archbishop Pilgrim II of Salzburg. As of yet, there is no comprehensive study of German-speaking late medieval courtly culture. For a comprehensive overview of the German High Middle Ages from the perspective of courtly culture, see Bumke, *Höfische Kultur.* As fascinating and useful as these studies of individual courts may be, they deal with exceptional courts, and their conclusions can probably not be generalized to include less renowned and less well-documented courts.

33. Freed, *Noble Bondsmen.* See also Cormeau and Störmer, *Hartmann,* 40–46, 63–67.

34. As Michael Curschmann succinctly puts it: ministerials were "nobles whose status and land tenure derived from administrative service to a regional overlord . . . , rather than from birth, as was the case with the old and free nobility." Curschmann, "Der aventiure bilde nemen," 221.

35. See Freed, *Noble Bondsmen,* 218–66.

36. Curschmann, in "Der aventiure bilde nemen," 225, speculates that "when Thomasin addresses the German nobility, for whom he wrote his didactic verse

tract in 1215/16, he addresses first of all the German-speaking population directly to the west and northwest [of Aquileia], the very people, in other words, who lived in places like Rodenegg." He further discusses the efforts of ministerials to appropriate the literary material associated with the old nobility in his study of the Iwein mural at Rodenegg: "their particular acts of appropriation in effect recognized the truth of fiction as a means of social identification" (223). On representations of Iwein including the Iwein frescoes at Rodenegg, see Rushing, *Images*.

37. Curschmann, "Der aventiure bilde nehmen," 225.

38. Eisermann, *Die Handschriften*, also available on-line: http://www .manuscripta-mediaevalia.de/hs/projekt-Gotha-pdfs/Memb_I_120.pdf.

39. According to Becker, *Handschriften*, 182, there is little evidence of independent secular workshops that wrote manuscripts in fourteenth-century Germany. Holladay, "Some Arguments," 13–17, however, has found evidence of secular independent workshops that illuminated manuscripts. Great lords also had chanceries where they could have manuscripts copied, or they might pay monastic scriptoria to produce secular manuscripts. Very wealthy patrons might have supported an artist or a writer at court. As Ursula Peters, *Literatur in der Stadt*, reveals, not only rural courts but also towns were important centers for literary production in the fourteenth century. Bishoprics and princely seats in particular offered the kind of political environment and resources necessary for the development of a literary culture: these included wealthy ecclesiastical or secular patrons, monasteries and chanceries. Peters, *Literatur in der Stadt*, 138: "[I]m 14. Jahrhundert konzentriert sich die städtische Literaturproduktion auf Bischofs- und fürstliche Residenzstädte, die durch die jeweiligen geistlichen oder weltlichen Fürsten, durch Domkapitel, adlige Stifter und zahlreiche Klöster, durch die Präsenz fürstlicher Verwaltungsleute und die Städtische Oberschicht die repräsentativen und personellen Voraussetzungen für die Entstehung der verschiedensten Literaturkreise."

40. On the history of Affecking, see Baur, *Am Hochufer*. The entry on the Raidenbuchs is on 57–61.

41. "Seneca dixit. 1574. Si prudens est animus tuus tribus temporibus dispensitur: prœsentia ordina, futura prouide, prœterita recordare. Nit sünd Gott siechts. Hanns Ulrich von Königsfeldt manu propria." Cited in Eisermann, *Die Handschriften*.

42. It is summarized in Eisermann, *Die Handschriften*.

43. Becker, *Handschriften*, 209. For a brief history of the region and an overview of the political situation, see Spindler, ed., *Handbuch*, esp. 161–80.

44. Becker, *Handschriften*, 208: "Franken war im 14. und 15. Jh im Gegensatz zu Bayern territorial außerordentlich zersplittert. Während im Südosten des Reichs die Mehrzahl der alten Grafengeschlechter im Spätmittelalter ausgestorben war, hielten sie sich in Franken in größerer Zahl, die noch durch in landesherrlichen Rang aufsteigende Ministerialsippen erhöht wurde."

45. See Schottenloher, "Schicksale," which is primarily concerned with the loss of books in the peasant wars.

46. Becker, *Handschriften*, 208n30. He writes in reference to the inventories of destroyed books published in Schottenloher, "Schicksale": "Hier sind Inventare von vernichteten Bibliotheken fränkischer Adliger weltlichen und geistlichen Standes abgedruckt; diesen Listen zufolge enthielten allerdings um 1525 selbst Sammlungen bedeutender Familien wie Aufseß und Schaumberg zwar neben deutscher Erbauungs-, Fach- und humanistischer Literatur zahlreiche Historien-bücher, aber keinerlei mhd. Epik." Becker's detailed study on German vernacular epic manuscripts in the thirteenth and fourteenth century provides crucial insight into literary culture in medieval Germany.

47. Becker, *Handschriften*, 209. Becker writes: "Außer diesen wenigen Zeugnissen kann aus einer sozialgeschichtlichen Erscheinung geschlossen werden, daß die traditionelle Adelsethik hochgehalten wurde und die entsprechenden Epen bekannt waren: Ein Charakteristikum Frankens war die zur Reichsunmittelbarkeit aufgestiegene Ritterschaft."

48. Curschmann, "Der aventiure bilde nemen"; Krüger, "Tristan-Love."

49. Curschmann, "Der aventiure bilde nemen"; Rushing, *Images*; Freed, *Noble Bondsmen.*

50. Becker, *Handschriften*, 164.

51. Buettner, "Profane Illuminations," 78; Becker, *Handschriften*, 164.

52. Certain historical texts lent themselves well to these purposes, such as Rudolf von Ems' *Weltchronik*, Der Stricker's *Karlsepik*, and Wolfram's *Willehalm*. See Curschmann, "Wort-Schrift-Bild," 705–6. On the political and dynastic role of *Weltchronik* illustrations, see Ott, "Typen," "Überlieferung," and "Reich und Stadt."

53. Holladay, *Illuminating the Epic.*

54. Buettner, "Profane Illuminations," 76.

55. Buettner, "Profane Illuminations," 76.

FIVE. **Visuality and (Self) Reflection in the Courtier's Mirror**

1. See, for example, Bumke, "Autor und Werk." Studying the specific manuscript witness versus studying a hypothetical edition of a work has become an important area of medieval studies in the past decades, particularly since Stephen G. Nichols's seminal 1990 article on the New Philology ("Introduction") that reintroduced the manuscript as a dynamic focus for the study of medieval literature. This article appeared as the introduction to a special issue of *Speculum* on the New Philology. Germanists responded to the issues raised in this volume with a special edition of the *Zeitschrift für deutsche Philologie* (Helmut Tervooren and Horst Wenzel, eds., *Philologie*).

Whereas traditional editors and philologists, most notably Karl Lachmann, were concerned with reconstructing an original master text from various manuscript versions, proponents of the New Philology recognized the unique qualities

of individual manuscripts and exploited these for what they can tell us about medieval readership, scribal patterns, and cultural context. Michael Camille, in "Philological Iconoclasm," writes that nineteenth-century philologists "erased all aspects of enactment—sound, sight, sense" from poems, making them into "texts" in the modern sense, complete with carefully blocked text, footnotes, and in some cases chapter headings (375).

2. In the introduction to his bilingual translations of early medieval German texts, *Sovereignty and Salvation*, James A. Schultz uses the term "productive reception" for the creative processes that scribes used to make old texts accessible in new contexts of reception.

3. Modern readers usually access medieval texts through editions that often combine manuscript redactions in order to reconstruct a version deemed more "authentic." Although the best editions provide an extensive apparatus in which textual variation is noted, this important information is obscured in many of them, so that the modern reader ends up with a rather misleading impression of a given text. One famous example is Gottfried von Strassburg's *Tristan*. The oldest manuscript redaction is missing the famous extended allegory of the lover's cave, but this scene is considered integral to Gottfried's version of the Tristan story and is therefore included in all of the translations and editions. The edition thus provides yet another contextual layer that interprets a text and influences its reception. Baisch, *Textkritik*, provides a comparative overview of different redactions of Gottfried's *Tristan*.

4. Several important studies, particularly in the areas of Romance and Anglo-Norman studies, have helped to pave the way for studying medieval literature through its material evidence. See, for example, Taylor, *Textual Situations*; Kerby-Fulton and Despres, *Iconography*; Brownrigg, *Medieval Book*; Huot, *From Song to Book*, and *Romance of the Rose*; Hindman, *Sealed in Parchment*; and the collection of essays in Lerer, *Reading from the Margins*; Brownlee and Huot, eds., *Rethinking the Romance de la Rose*. See also Starkey, *Reading*.

5. I have argued elsewhere that this third figure, who is dressed in contrasting colors to the other two boys, has no feet, and holds no banderole, is actually meant to represent the mirror image that the boys are looking at. Starkey, "Thomasins Spiegelphase."

6. Wenzel, *Spiegelungen*, has recently examined visuality and the concept of the mirror in medieval literature in depth. Among many other texts and images he examines the *Welscher Gast* in detail, focusing particularly, but not exclusively, on the oldest Heidelberg redaction. He interprets this image as a visualization of the vice of *superbia*, a vice to which lords might be prone (76–78). More generally he identifies in the images of the *Welscher Gast* four contributions to the medieval discourse on mirrors: the idea that the mirror shows us society's view of us; the reflection of oneself in the mirror is dependent on the interpretation of others; the mirror only shows us an external reflection and not an internal one;

and the literary mirror allows us to see something outside our field of view and thus invites us to engage in self-reflection (79).

7. On the concept of the mirror in the Middle Ages, see Teuber, "Per speculum," esp. 20–24. See also Wenzel, *Spiegelung*, who argues that the text takes on the function of a mirror that reflects an ideal to be emulated by the reader: "Das Buch als Spiegel liefert seinem Gegenüber also nicht etwa ein Abbild wie ein Schminkspiegel aus Metall, sondern das Vor-bild eines Anderen, es fungiert als Medium der Vorbildlichkeit, das als modellierende Vor-schrift das äußere und das innere Auge anspricht, sensorisches und imaginatives Sehen, Fremdwahrnehmung und Eigenwahrnehmung, Beobachtung und Selbstkontrolle miteinander verbindet." (196).

8. Elsewhere I have argued that Thomasin's notion of the transformative power of the mirror image for the child is strikingly similar to the Lacanian mirror stage. Starkey, "Thomasins Spiegelphase."

9. The mirror as a metaphor for self-knowledge has a long tradition. See, for example, Bartsch, "The Philosopher."

10. By invoking beauty the artist further recalls the myth of Narcissus, which was widely known in the Middle Ages but is not mentioned in the text. On the Narcissus myth in the Middle Ages, see Teuber "Per speculum," esp. 24–33.

11. In Starkey, "Thomasins Spiegelphase," I interpret this figure as pointing behind himself. Either reading seems possible.

BIBLIOGRAPHY

Manuscripts

Codex Manesse. Universitätsbibliothek Heidelberg Cpg. 848.

Michael de Leone. *Hausbuch.* Universitätsbibliothek München 2 Cod. ms. 731.

Thomasin von Zerklaere. *Welscher Gast.* Berlin, Staatbibliothek zu Berlin–Preußischer Kulturbesitz, Ms. Hamilton 675.

Thomasin von Zerklaere. *Welscher Gast.* Berlin, Staatsbibliothek zu Berlin–Preußischer Kulturbesitz, Ms. germ. fol. 718.

Thomasin von Zerklaere. *Welscher Gast.* Berlin, Staatsbibliothek zu Berlin–Preußischer Kulturbesitz, Ms. germ. fol. 757.

Thomasin von Zerklaere. *Welscher Gast.* Berlin, Staatsbibliothek zu Berlin–Preußischer Kulturbesitz, Ms. 161.

Thomasin von Zerklaere. *Welscher Gast.* Budapest, Országos Széchényi Könyvtár, Cod. Lat. 210 (destroyed).

Thomasin von Zerklaere. *Welscher Gast.* Büdingen, Fürstlich Ysenburg- und Büdingensche Bibliothek, no shelf mark.

Thomasin von Zerklaere. *Welscher Gast.* Dresden, Sächsische Landesbibliothek–Staats- und Universitätsbibliothek, Mscr. Dresd. M 67.

Thomasin von Zerklaere. *Welscher Gast.* Erlangen, Universitätsbibliothek, Ms. B 7.

Thomasin von Zerklaere. *Welscher Gast.* Gotha, Universitäts- und Forschungsbibliothek Erfurt/Gotha, Memb I 120.

Thomasin von Zerklaere. *Welscher Gast.* Heidelberg, Universitätsbibliothek, Cpg 389.

Thomasin von Zerklaere. *Welscher Gast.* Heidelberg, Universitätsbibliothek, Cpg 330.

Thomasin von Zerklaere. *Welscher Gast.* Heidelberg, Universitätsbibliothek, Cpg 338.

Thomasin von Zerklaere. *Welscher Gast.* Heidelberg, Universitätsbibliothek, Cpg 320.

Thomasin von Zerklaere. *Welscher Gast.* Hermannstadt/Sibiu, Staatsarchiv, Nachlaß Teutsch, Mappe 16, GG 3/X, Tomas A.

Thomasin von Zerklaere. *Welscher Gast.* Karlsruhe, Badische Landesbibliothek, St. Peter pap. 25.

Thomasin von Zerklaere. *Welscher Gast.* Krakow, Biblioteka Jagiellonska, Ms. germ. quart. 978.

Thomasin von Zerklaere. *Welscher Gast.* Munich, Bayerische Staatsbibliothek, Cgm 340.

Thomasin von Zerklaere. *Welscher Gast.* Munich, Bayerische Staatsbibliothek, Cgm 571.

Thomasin von Zerklaere. *Welscher Gast.* New York, The Pierpont Morgan Library, G. 54.

Thomasin von Zerklaere. *Welscher Gast.* Nürnberg, Germanisches Nationalmuseum, Hs 86035.

Thomasin von Zerklaere. *Welscher Gast.* Schlierbach, Stiftsbibliothek, Hs. I 28.

Thomasin von Zerklaere. *Welscher Gast.* Stuttgart, Württembergische Landesbibliothek, Cod. poet. et phil. 2° 1.

Thomasin von Zerklaere. *Welscher Gast.* Watzendorf, Oberfranken, Evangelisch-Lutherisches Pfarramt, no shelf mark.

Thomasin von Zerklaere. *Welscher Gast.* Wolfenbüttel, Herzog August Bibliothek, Cod. Guelf. 404.9 (6) Novi.

Thomasin von Zerklaere. *Welscher Gast.* Wolfenbüttel, Herzog August Bibliothek, Cod. Guelf. 37.19 Aug. 2°.

Wolfram von Eschenbach. *Willehalm.* Kassel Landesbibliothek 2° MS poet. et roman. 1.

Wolfram von Eschenbach. *Willehalm.* Germanisches Nationalmuseum. Nuremberg, Hz 1104–1105.

Wolfram von Eschenbach. *Willehalm.* Bayerische Staatsbibliothek, Munich, Cgm 193, III.

Editions, Translations, and Facsimile Editions

Augustine, St. *The Literal Meaning of Genesis,* vol. 2. Translated by John Hammond Taylor. New York: Newman Press, 1982.

Disanto, Raffaele. *La parola e l'immagine nel ciclo illustrativo del Welscher Gast di Thomasin von Zerklaere.* Triest: Parnaso, 2002.

Herrad of Landsberg and Abbess of Hohenburg, *Hortus deliciarum,* edited by Rosalie Green, T. Julian Brown, and Kenneth Levy. London: Warburg Institute, 1979.

Thomas Aquinas. *Commentary on Aristotle's De anima* Translated by Kenelm Foster and Silvester Humphries. London: Routledge, 1951.

Thomasin von Zerclaere. *Der Welsche Gast.* Edited by Friedrich W. von Kries. 4 vols. Göppingen: Kümmerle, 1984.

———. *Der Welsche Gast*. Selected, introduced, and translated by Eva Willms. Berlin and New York: de Gruyter, 2004.

———. *Der Welsche Gast des Thomasîn von Zerclaere: Codex Palatinus Germanicus 389 der Universitätsbibliothek Heidelberg*. Edited by Ewald M. Vetter and Friedrich Neumann. 2 vols. Wiesbaden: Reichert, 1974–80

———, *Der Wälsche Gast des Thomasin von Zirclaria*. Edited by Heinrich Rückert. Reprinted with an introduction and register by Friedrich Neumann. Berlin: de Gruyter, 1965.

Thomasin von Zerklaere. *Der welsche Gast: Secondo il Cod. Pal. Germ. 389, Heidelberg con le integrazioni di Heinrich Rückert e le varianti del Membr. I 120, Gotha (mit deutscher Einleitung)*. Edited by Raffaele Disanto. Triest: Parnaso, 2002.

Thomasin von Zirclaria. *Der Welsche Gast (The Italian Guest)*. Translated with introduction and notes by Marion Gibbs and Winder McConnell. Medieval German Texts in Bilingual Editions 4. Kalamazoo, MI: Medieval Institute Publications, 2010.

Wolfram von Eschenbach. *Willehalm*. Edited by Joachim Heinzle. Frankfurt am Main: Bibliothek Deutscher Klassiker, 1991.

History and Criticism

Akbari, Suzanne Conklin. *Seeing Through the Veil: Optical Theory and Medieval Allegory*. Toronto: University of Toronto Press, 2004.

Alexander, Jonathan J. G. "Iconography and Ideology: Uncovering Social Meanings in Western Medieval Christian Art." *Studies in Iconography* 15 (1993): 1–44.

Althoff, Gerd. "Demonstration und Inszenierung: Spielregeln der Kommunikation in mittelalterlicher Öffentlichkeit (Gesten, Gebärden, Ritual, Zeremoniell)." *Frühmittelalterliche Studien* 27 (1993): 27–49.

———. "Die Kultur der Zeichen und Symbole." *Frühmittelalterliche Studien* 36 (2002): 1–17.

———. *Spielregeln der Politik im Mittelalter*. Darmstadt: Primus, 1997.

Arn, Mary-Jo. *The Poet's Notebook: The Personal Manuscript of Charles d'Orléans (Paris, BNF MS fr. 25458)*. Turnhout: Brepols, 2008.

Ashley, Kathleen, and Robert L. A. Clark. "Medieval Conduct: Texts, Theories, Practices." Introduction to *Medieval Conduct*, edited by Kathleen Ashley and Robert L. A. Clark, ix–xx. Minneapolis: University of Minnesota Press, 2001.

Assmann, Aleida. "Der Wissende und die Weisheit—Gedanken zu einem ungleichen Paar." In *Allegorien und Geschlechterdifferenz*, edited by Sigrid Schade, Monika Wagner, and Sigrid Weigel, 11–25. Cologne: Böhlau, 1994.

———. *Erinnerungsräume: Formen und Wandlungen des kulturellen Gedächtnisses*. Munich: Beck, 1999.

Auty, Robert, ed. *Lexikon des Mittelalters.* 9 vols. Munich: Artemis Verlag, 1971–99.

Backes, Martina. *Das literarische Leben am kurpfälzischen Hof zu Heidelberg im 15. Jahrhundert: Ein Beitrag zur Gönnerforschung des Spätmittelalters.* Tübingen: Niemeyer, 1992.

———. "Geordnete Texte: Zur Geschichte und Entwicklung von Rubriken in deutschen und französischen Romanen des Mittelalters." *Wolfram-Studien* 19 (2006): 301–15.

Bäuml, Franz H. Review of *Feudale Anarchie und Landesherrschaft: Wirkungsmöglichkeiten didaktischer Literatur; Thomasin von Zerklaere "Der Wälsche Gast,"* by Werner Röcke. *Speculum* 54 (1979): 854–55.

Baisch, Martin. *Textkritik als Problem der Kulturwissenschaft. Tristan-Lektüren.* Berlin: de Gruyter, 2006.

Baisch, Martin, Hendrikje Haufe, Michael Mecklenberg, et al., eds. *Aventiuren des Geschlechts: Modelle Von Männlichkeit in der Literatur des 13. Jahrhunderts.* Göttingen: V & R Unipress, 2003.

Barratt, Alexandra. *Anne Bulkeley and Her Book: Fashioning Female Piety in Early Tudor England.* Turnhout: Brepols, 2008.

———. "Anne Bulkeley and Her Book in Early Tudor England." *Journal of the Early Book Society* 10 (2007): 1–29.

Barthel, Verena. *Empathie, Mitleid, Sympathie: Rezeptionslenkende Strukturen mittelalterlicher Texte in Bearbeitung des Willehalm-Stoffs.* Berlin: de Gruyter, 2008.

Bartsch, Shadi. "The Philosopher as Narcissus: Vision, Sexuality, and Self-Knowledge in Classical Antiquity." In *Visuality Before and Beyond the Renaissance: Seeing as Others Saw,* edited by Robert S. Nelson, 70–97. Cambridge: Cambridge University Press, 2000.

Baskins, Cristelle L. "Gender Trouble in Italian Renaissance Art History: Two Case Studies." *Studies in Iconography* 16 (1994): 1–36.

Baur, Richard. *Am Hochufer der Donau: Hofmark und Pfarrei Affecking; Geschichte eines Kelheimer Stadtteils.* Regensburg: Rotaplan Offset Kammann Druck GmbH, 2000.

Baxandall, Michael. *Painting and Experience in Fifteenth Century Italy: A Primer in the Social History of Pictorial Style.* Oxford: Oxford University Press, 1972.

Becker, Peter Jörg. *Handschriften und Frühdrucke mittelhochdeutscher Epen.* Wiesbaden: Reichert, 1977.

Bejczy, István P., and Cary J. Nederman, eds. *Princely Virtues in the Middle Ages, 1200–1500.* Disputatio 9. Turnhout: Brepols, 2006.

Belting, Hans. *Bildanthropologie: Entwürfe für eine Bildwissenschaft.* Munich: Wilhem Fink, 2001.

———. *Bild und Kult: Eine Geschichte des Bildes vor dem Zeitalter der Kunst.* Munich: C. H. Beck, 1996.

———. *Das Bild und sein Publikum im Mittelalter: Form und Funktion früher Bildtafeln der Passion.* Berlin: Mann, 1981.

————. "The New Role of Narrative in Public Painting of the Trecento: *Historia and Allegoria.*" In *Pictorial Narrative in Antiquity and the Middle Ages,* edited by Herbert L. Kessler and Marianna Shreve Simpson, 151–68. Washington DC: National Gallery of Art, 1985.

Benecke, Georg Friedrich. *Mittelhochdeutsches Wörterbuch Mit Benutzung Des Nachlasses Von George Friedrich Benecke, Ausgearbeitet Von Wilhelm Müller and Friedrich Zarncke.* Edited by Wilhelm Müller and Friedrich Zarncke. Hildesheim: G. Olms, 1963.

Bennewitz, Ingrid. "Der Körper der Dame: Zur Konstruktion von 'Weiblichkeit' in der deutschen Literatur des Mittelalters." In *"Aufführung" und "Schrift" in Mittelalter und Früher Neuzeit,* Germanistisches Symposium, Berichtsbände 17, edited by Jan-Dirk Müller, 222–38. Stuttgart: Metzler, 1996.

————. "Zur Konstruktion von Körper und Geschlecht in der Literatur des Mittelalters." In *Genderdiskurse und Körperbilder im Mittelalter: Eine Bilanzierung nach Butler und Laqueur,* Bamberger Studien zum Mittelalter 1, edited by Ingrid Bennewitz and Ingrid Kasten, 1–10. Münster: Lit, 2002.

Bennewitz, Ingrid, and Ruth Weichselbaumer. "Erziehung zur Differenz: Entwürfe idealer Weiblichkeit und Männlichkeit in der didaktischen Literatur des Mittelalters." *Der Deutschunterricht* 1 (2003): 43–50.

Benson, Peter. "Freud and the Visual." *Representations* 45 (1994): 101–16.

Biernoff, Suzannah. *Sight and Embodiment in the Middle Ages.* New York: Palgrave Macmillan, 2002.

Blaschitz, Gertrud. "Die Frauenkleidung in den Bildinszenierungen des 'Welschen Gastes.'" In *Beweglichkeit der Bilder: Text und Imagination in den illustrierten Handschriften des "Welschen Gastes" von Thomasin von Zerclaere,* edited by Horst Wenzel and Christina Lechtermann, 216–37. Cologne: Böhlau, 2002.

Blume, Dieter. "Körper und Kosmos im Mittelalter." In *Bild und Körper im Mittelalter,* edited by Kristin Marek, Raphaèle Preisinger, Marius Rimmele, and Katrin Kärcher, 225–41. Munich: Fink, 2006.

Boesch, Bruno. *Lehrhafte Literatur: Lehre in der Dichtung und Lehrdichtung im deutschen Mittelalter.* Berlin: E. Schmidt, 1977.

Bogen, Steffen. "Der Körper des Diagramms: Präsentationsfiguren, Mnemonische Hände, Vermessene Menschen." In *Bild und Körper im Mittelalter,* edited by Kristin Marek, Raphaèle Preisinger, Marius Rimmele, and Katrin Kärcher, 61–81. Munich: Fink, 2006.

Borst, Arno. "Die Naturwissenschaften in einer Bilderhandschrift des 13. Jahrhunderts." In *Braunschweigische Wissenschaftliche Gesellschaft. Jahrbuch* (1986): 205–23.

Boshof, Egon, and Fritz Peter Knapp, eds. *Wolfger von Erla.* Germ. Bibliothek Reihe 3, Untersuchungen, N. F. 20. Heidelberg: Winter, 1994.

Brantley, Jessica. *Reading in the Wilderness: Private Devotion and Public Performance in Late Medieval England.* Chicago: University of Chicago Press, 2007.

Bredekamp, Horst. *Repräsentation und Bildmagie der Renaissance als Formproblem.* Munich: Carl Friedrich von Siemens Stiftung, 1995.

Breger, Claudia, and Fritz Breithaupt, eds. *Narrative Empathy.* Special issue of *Deutsche Vierteljahrschrift* 82, no. 3 (September 2008).

Breihaupt, Fritz. *Kulturen der Empathie.* Frankfurt am Main: Suhrkamp Verlag, 2009.

Brinker-von der Heyde, Claudia. "Durch Bildung zur Tugend: Zur Wissenschaftslehre des Thomasin von Zerclære." In *Artes im Mittelalter,* edited by Ursula Schaefer, 34–52. Berlin: Akademie Verlag, 1999.

———. "Der 'Welsche Gast' des Thomasin von Zerclaere: Eine (vor-) Bildgeschichte." In *Beweglichkeit der Bilder: Text und Imagination in den illustrierten Handschriften des Welschen Gast,* edited by Horst Wenzel and Christina Lechtermann, 121–42. Cologne: Böhlau, 2002.

Brownlee, Kevin, and Sylvia Huot, eds. *Rethinking the Romance of the Rose: Text, Image, Reception.* Philadelphia: University of Pennsylvania Press, 1992.

Brownrigg, Linda L., ed. *Medieval Book Production: Assessing the Evidence; Proceedings of the Second Conference of the Seminar in the History of the Book to 1500, Oxford, July 1988.* Los Altos Hills, CA: Anderson-Lovelace, 1990.

Brüggen, Elke. *Kleidung und Mode in der höfischen Epik des 12. und 13. Jahrhunderts.* Heidelberg: Winter, 1989.

Bryson, Norman. "The Gaze in the Expanded Field." In *Vision and Visuality,* Dia Art Foundation: Discussions in Contemporary Culture 2, edited by H. Foster, 87–113. Seattle: Bay Press, 1988.

Buettner, Brigitte. "Past Presents: New Year's Gifts at the Valois Courts, ca. 1400." *The Art Bulletin* 83, no. 4 (2001): 598–625.

———. "Profane Illuminations, Secular Illusions: Manuscripts in Late Medieval Courtly Society." *The Art Bulletin* 74, no. 1 (1992): 75–90.

Bumke, Joachim. "Autor und Werk: Beobachtungen und Überlegungen zur höfischen Epik (ausgehend von der Donaueschinger Parzivalhandschrift G$^{\partial}$)." In *Philologie als Textwissenschaft. Alte und neue Horizonte,* edited by Helmut Tervooren and Horst Wenzel. Special edition of *Zeitschrift für deutsche Philologie* 116 (1997): 87–114.

———. *Courtly culture: Literature and society in the High Middle Ages.* Woodstock, NY: Overlook Press, 2000.

———. "Emotion und Körperzeichen: Beobachtungen zum 'Willehalm' Wolframs von Eschenbach." *Das Mittelalter* 8, no. 1 (2003): 13–32.

———. *Geschichte der deutschen Literatur im hohen Mittelalter.* Vol. 2. Munich: DTV, 1993.

———. *Höfische Kultur: Literatur und Gesellschaft im hohen Mittelalter.* 2 Vols. Munich: DTV, 1986.

———. *Mäzene im Mittelalter: Die Gönner und Auftraggeber der höfischen Literatur in Deutschland 1150–1300.* Munich: Beck, 1979.

————. Review of *Hören und Lesen: Studien zur primären Rezeption der Literatur im 12. und 13. Jahrhundert* by Manfred Günther Scholz. *Anzeiger für deutsches Altertum* 93 (1982): 116–20.

————. Review of *Thomasin von Zerclære, Der Welsche Gast* by Friedrich Wilhem von Kries. *Zeitschrift für deutsches Altertum* 116 (1987): 13–20.

————. "Der unfeste Text: Überlegungen zur Überlieferungsgeschichte und Textkritik der höfischen Epik im 13. Jahrhundert." In *"Aufführung" und "Schrift" in Mittelalter und Früher Neuzeit*, Germanistisches Symposium, Berichtsbände 17, edited by Jan-Dirk Müller, 118–29. Stuttgart: Metzler, 1996.

————. *Die vier Fassungen der Nibelungenklage: Untersuchungen zur Überlieferungsgeschichte und Textkritik der höfischen Epik im 13. Jahrhundert.* New York: Walter de Gruyter, 1996.

Burns, E. Jane. *Courtly Love Undressed: Reading Through Clothes in Medieval French Culture.* Philadelphia: University of Pennsylvania Press, 2002.

Bussmann, Hadumod. "*Das* Genus, *die* Grammatik und—*der* Mensch: Geschlechterdifferenz in der Sprachwissenschaft." In *Genus—Zur Geschlechterdifferenz in den Kulturwissenschaften*, edited by Hadumod Bussmann and Renate Hof, 114–61. Stuttgart: Kröner, 1995.

Butler, Judith. *Gender Trouble.* New York: Routledge, 1990.

Camille, Michael. "Before the Gaze: The Internal Senses and Late Medieval Practices of Seeing." In *Visuality before and beyond the Renaissance: Seeing as Others Saw*, edited by Robert S. Nelson, 197–223. Cambridge: Cambridge University Press, 2000.

————. "The Book of Signs: Writing and Visual Difference in Gothic Manuscript Illuminations." *Word and Image* 1 (1985): 133–48.

————. *The Gothic Idol: Ideology and Image-Making in Medieval Art.* New York: Cambridge University Press, 1989.

————. *The Medieval Art of Love: Objects and Subjects of Desire.* New York: Harry N. Abrams, 1998.

————. *Mirror in Parchment: The Luttrell Psalter and the Making of Medieval England.* Chicago: University of Chicago Press, 1998.

————. "Philological Iconoclasm: Edition and Image in the Vie de Saint Alexis." In *Medievalism and the Modernist Temper*, edited by R. Howard Bloch and Stephen G. Nichols, 371–401. Baltimore: Johns Hopkins University Press, 1996.

————. "Seeing and Reading: Some Visual Implications of Medieval Literacy and Illiteracy." *Art History* 8 (1985): 26–49.

Carroll, William Francis, "'Der Welsche Gast' Thomasins von Zerclaere und 'Der Renner' Hugos von Trimberg: Perspektiven des Fremden in der didaktischen Literatur des 13. Jahrhunderts. In *Fremdes wahrnehmen—fremdes Wahrnehmen: Studien zur Geschichte der Wahrnehmung und zur Begegnung von Kulturen in Mittelalter und früher Neuzeit*, edited by Wolfgang Harms and C. Stephen Jaeger, 137–52. Stuttgart/Leipzig: S. Hirzel, 1997.

Carruthers, Mary. *The Book of Memory: A Study of Memory in Medieval Culture.* New York: Cambridge University Press, 1990.

———. *The Craft of Thought: Meditation, Rhetoric, and the Making of Images, 400–1200.* New York: Cambridge University Press, 1998.

———. "Moving Images in the Mind's Eye." In *The Mind's Eye: Art and Theological Argument in the Middle Ages*, edited by Jeffrey F. Hamburger and Anne-Marie Bouché, 287–305. Princeton, NJ: Department of Art and Archaeology, Princeton University in association with Princeton University Press, 2006.

Carruthers, Mary, and Jan Ziolkowski, eds. *The Medieval Craft of Memory: An Anthology of Texts and Pictures.* Philadelphia: University of Pennsylvania Press, 2002.

Caviness, Madeline. "Images of Divine Order and the Third Mode of Seeing." *Gesta* 22 (1983): 99–120.

———. "'The Simple Perception of Matter' and the Representation of Narrative, ca. 1180–1280." *Gesta* 30, no. 1 (1991): 48–64.

Cerquiglini, Bernard. *Éloge de la variante: Histoire Critique de la Philologie.* Paris: Éditions du Seuil, 1989.

Chartier, Roger, "Die Weltgeschichte der Schrift." *LIBER: Europäische Kulturzeitschrift* 1 (October 1989; Insert, *Frankfurter Allgemeine Zeitung*): 8–9.

Chinca, Mark, and Christopher Young, "Orality and Literacy in the Middle Ages: A Conjunction and its Consequences." In *Orality and Literacy in the Middle Ages: Essays on a Conjunction and Its Consequences in Honour of D. H. Green*, edited by Mark Chinca and Christopher Young, 1–15. Turnhout: Brepols, 2005.

Clover, Carol J. "Regardless of Sex: Men, Women and Power in Early Northern Europe." *Speculum* 68 (1993): 363–87.

Cohen, Jeffrey Jerome, and Bonnie Wheeler, eds. *Becoming Male in the Middle Ages.* New York: Garland, 1997.

Coleman, Joyce. "Aural Illumination: Books and Aurality in the Frontispieces to Bishop Chevrot's Cité de Dieu." In *Orality and Literacy in the Middle Ages: Essays on a Conjunction and Its Consequences in Honour of D. H. Green*, edited by Mark Chinca and Christopher Young, 223–52. Turnhout: Brepols, 2005.

Collins, Christopher. *Reading the Written Image: Verbal Play, Interpretation, and the Roots of Iconophobia.* University Park: Pennsylvania State University Press, 1991.

Cormeau, Christoph. "Thomasin von Zerclaere," *Das Verfasserlexikon—Die deutsche Literatur des Mittelalters*, vol. 9, col. 896–902. Berlin: de Gruyter, 1995.

———. "Tradierte Verhaltensnormen und Realitätserfahrung: Überlegungen zu Thomasins 'Wälschem Gast.'" In *Deutsche Literatur im Mittelalter: Kontakte und Perspektiven. Hugo Kuhn zum Gedenken*, edited by Christoph Cormeau, 276–95. Stuttgart: J. B. Metzlersche Verlagsbuchhandlung, 1979.

Cormeau, Christoph, and Wilhelm Störmer. *Hartmann von Aue: Epoche-Werk-Wirkung.* Munich: Beck, 1985.

Cré, Marleen. *Vernacular Mysticism in the Charterhouse: A Study of BL MS Additional 37790*. Turnhout: Brepols, 2006.

Crosland, Jessie. "Italian Courtesy Books." *The Modern Language Review* 4, no. 5 (1990): 502–4.

Curschmann, Michael. "Der aventiure bilde nemen: The Intellectual and Social Environment of the Iwein Murals at Rodenegg Castle." In *Chrétien de Troyes and the German Middle Ages: Papers from an International Symposium*, edited by Martin H. Jones and Roy Wisbey, 219–28. Rochester, NY: D. S. Brewer, 1993.

———. "Hören-Lesen-Sehen: Buch und Schriftlichkeit im Selbstverständnis der volkssprachlichen literarischen Kultur Deutschlands um 1200." *Beiträge zur Geschichte der deutschen Sprache und Literatur* 106 (1984): 218–57.

———. "Imagined Exegesis: Text and Picture in the Exegetical Works of Rupert of Deutz, Honorius Augustodunensis, and Gerhoch of Reichersberg." *Traditio* 44 (1988): 145–69.

———. "Images of Tristan." In *Gottfried von Strassburg and the Medieval Tristan Legend*, edited by Adrian Stevens and Roy Wisbey, 1–17. Cambridge: Brewer, 1990.

———. "Interdisziplinäre Beweglichkeit—wie weit reicht sie?" Review of *Beweglichkeit der Bilder: Text und Imagination in den illustrierten Handschriften des "Welschen Gastes" von Thomasin von Zerclaere* edited by Horst Wenzel and Christina Lechtermann. *Zeitschrift für deutsche Philologie* 123, no. 1 (2004): 109–17. Reprinted in Michael Curschmann, *Wort—Bild—Text: Studien zur Medialität des Literarischen in Hochmittelalter und früher Neuzeit*, 2: 851–59. Baden-Baden: Valentin Koerner.

———. "'Pictura laicorum litterature?' Überlegungen zum Verhältnis von Bild und volkssprachlicher Schriftlichkeit im Hoch- und Spätmittelalter bis zum Codex Manesse." In *Pragmatische Schriftlichkeit im Mittelalter. Erscheinungsformen und Entwicklungsstufen*, edited by Hagen Keller, Klaus Grubmüller, and Nikolaus Staubach, 211–29. Munich: Fink, 1992.

———. "Volksprache und Bildersprache." In *Literatur und Wandmalerei I. Erscheinungsformen höfischer Kultur und ihre Träger im Mittelalter*, edited by Eckart Conrad Lutz, 9–46. Tübingen: Niemeyer, 2002.

———. "Wort-Schrift-Bild: Zum Verhältnis von volkssprachigem Schrifttum und bildender Kunst vom 12. bis zum 16. Jahrhundert." In *Mittelalter und Frühe Neuzeit: Übergänge, Umbrüche und Neuansätze*, edited by Walter Haug, 378–470. Tübingen: Niemeyer, 1999. Reprinted in Michael Curschmann, *Wort—Bild—Text: Studien zur Medialität des Literarischen in Hochmittelalter und früher Neuzeit*, 2: 661–753. Baden-Baden: Valentin Koerner, 2007.

Dallapiazza, Michael. "Artusromane als Jugendlektüre? Thomasin von Zirklaria und Hugo von Trimberg." In *Thomasin von Zerclaere und die didaktische Literatur des Mittelalters*, edited by Paola Schulze-Belli, 29–38. Trieste: Associazione di Cultura Medioevale, 1995.

de Boor, Helmut. "Fortuna in Mittelhochdeutscher Dichtung, insbesondere in der 'Crône' des Heinrich von dem Türlin." In *Verbum et Signum*, vol. 2, edited by Hans Fromm, Wolfgang Harms, Uwe Ruberg, 311–28. Munich: Fink, 1975.

Diestel, Ludwig. "Der Wälsche Gast und die Moral des 13. Jahrhunderts." *Allgemeine Monatsschrift für Wissenschaft und Literatur* 8 (1852): 687–714.

Dietl, Cora. "Aristoteles und die *sehs dinc*: Zum VIII. Buch des 'Wälschen Gasts.'" In *Thomasin von Zerclaere und die didaktische Literatur des Mittelalters*, edited by Paola Schulze-Belli, 39–61. Trieste: Associazione di Cultura Medioevale, 1995.

Dietrichs, Christof L. "Terribilis est locus iste: Zum Verhältnis des Gläubigen zu Reliquie und Bild im Mittelalter." In *Bild und Körper im Mittelalter*, edited by Kristin Marek, Raphaèle Preisinger, Marius Rimmele, and Katrin Kärcher, 257–71. Munich: Fink, 2006.

Dinges, Martin, ed. *Hausväter, Priester, Kastraten: Zur Konstruktion von Männlichkeit in Spätmittelalter und Früher Neuzeit*. Göttingen: Vandenhoeck & Ruprecht, 1998.

Düwel, Kurt. "Lesestoff für junge Adlige: Lektüreempfehlungen in einer Tugendlehre des 13. Jahrhunderts." *Fabula: Journal of Folktale Studies* 32, no. 1 (1991): 67–93.

Egidi, Margreth. "Minnelied und Sangspruch im Kontext der Überlieferung. Gattungen als Zuschreibungsphänomene." *Wolfram Studien* 29 (2006): 253–67.

Ehrismann, Otfrid. *Ehre und Mut, Âventiure und Minne: Höfische Wortgeschichten aus dem Mittelalter*. Munich: Beck, 1995.

Eisermann, Falk. *Die Handschriften der Forschungsbibliothek Gotha*. Band 2: *Die deutschsprachigen Handschriften des Mittelalters*. Wiesbaden: Harrassowitz Verlag, 2010. Available on-line at http://www.manuscripta-mediaevalia.de/hs/projekt-Gotha-pdfs/Memb_I_120.pdf.

Elias, Norbert. *The Civilizing Process*. Translated by Edmund Jephcott. Cambridge, MA: Blackwell, 1994.

Elsner, Jaś. "Between Mimesis and Divine Power: Visuality in the Graeco-Roman World." In *Visuality before and beyond the Renaissance: Seeing as Others Saw*, edited by Robert S. Nelson, 45–69. Cambridge: Cambridge University Press, 2000.

Evans, Michael. "Allegorical Women and Practical Men: The Iconography of the Arts Reconsidered." In *Medieval Women*, edited by Derek Baker, 305–28. Oxford: Blackwell, 1978.

———. "The Geometry of the Mind." *Architectural Association Quarterly* 12 (1980): 32–55.

Feistner, Edith. "*manlîchiu wîp, wîplîchiu man*: Zum Kleidertausch in der Literatur des Mittelalters." *Beiträge zur Geschichte der deutschen Sprache und Literatur* 119 (1997): 235–60.

Finke, Laurie A. *Feminist Theory, Women's Writing*. Ithaca: Cornell University Press, 1992.

Forer, Rosa Barbara. "Genus und Sexus: Über philosophische und sprachwissenschaftliche Erklärungsversuche zum Zusammenhang von grammatischem und natürlichem Geschlecht." In *Der Widerspenstigen Zähmung*, edited by Sylvia Wallinger and Monika Jonas, 21–41. Innsbruck: Amoe, 1986.

Frank, Barbara. *Die Textgestalt als Zeichen: Lateinische Handschriftentradition und die Verschriftlichung der romanischen Sprachen.* Tübingen: Narr, 1993.

———. "Zur Entwicklung der graphischen Präsentation mittelalterlicher Texte." In *Osnabrücker Beiträge zur Sprachtheorie* 47 (1993): 60–81.

Frank, Georgia. "The Pilgrim's Gaze in the Age before Icons." In *Visuality before and beyond the Renaissance: Seeing as Others Saw*, edited by Robert S. Nelson, 98–115. Cambridge: Cambridge University Press, 2000.

Freed, John B. *Noble Bondsmen: Ministerial Marriages in the Archdiocese of Salzburg, 1100–1343.* Ithaca: Cornell University Press, 1995.

Freedberg, David. *The Power of Images: Studies in the History and Theory of Response.* Chicago: University of Chicago Press, 1989.

Frühmorgen-Voss, Hella. "Mittelhochdeutsche weltliche Literatur und ihre Illustration: Ein Beitrag zur Überlieferungsgeschichte." *Deutsche Vierteljahresschrift für Literaturwissenschaft und Geistesgeschichte* 43 (1969): 24–75.

Gaspary, Adolf. *Geschichte der Italienischen Literatur.* Vol. 1. Berlin: Verlag von Robert Oppenheim, 1885.

Gaunt, Simon. *Gender and Genre in Medieval French Literature.* New York: Cambridge University Press, 1995.

Gehl, Paul F. *A Moral Art: Grammar, Society, and Culture in Trecento Florence.* Ithaca: Cornell University Press, 1993.

Genette, Gérard. *Narrative Discourse: An Essay in Method.* Translated by Jane E. Lewin. Ithaca: Cornell University Press, 1983.

Göttert, Karl-Heinz. "Thomasin von Zerclære und die Tradition der Moralistik. "In *Architectura Poetica: Festschrift für Johannes Rathofer zum 65. Geburtstag*, edited by Ulrich Ernst and Bernhard Sowinski, 179–88. Cologne: Böhlau, 1990.

Grabes, Herbert. *The Mutable Glass: Mirror-Imagery in Titles and Texts of the Middles Ages and English Renaissance.* Translated by Gordon Collier. Cambridge: Cambridge University Press, 1982.

———. *Speculum, Mirror und Looking-Glass: Kontinuität und Originalität der Spiegelmetapher in den Buchtiteln des Mittelalters und der englischen Literatur des 13. bis 17. Jahrhundert.* Tübingen: Niemeyer, 1973.

Green, Dennis H. *Medieval Listening and Reading: The Primary Reception of German Literature, 800–1300.* New York: Cambridge University Press, 1994.

———. "On the Primary Reception of Narrative Literature in Medieval Germany." *Forum for Modern Language Studies* 20 (1984): 289–308.

———. Review of *Die Aufnahme und Verarbeitung des Alanus ab Insulis in mittelhochdeutschen Dichtungen: Untersuchungen zu Thomasin von Zerklaere, Gottfried von Straßburg, Frauenlob, Heinrich von Neustadt, Heinrich von St. Gallen,*

Heinrich von Mügeln und Johannes von Tepl by Christoph Huber. *The Modern Language Review* 85, no. 4 (October 1990): 1020–22.

———. Review of *Thomasin von Zerclaere, Der Welsche Gast* by Friedrich W. von Kries. *The Modern Language Review* 82, no. 2 (April 1987): 509–10.

———. "Terminologische Überlegungen zum Hören und Lesen im Mittelalter." In *Eine Epoche im Umbruch. Volkssprachliche Literalität 1200–1300*, edited by Christa Bertelsmeier-Kierst and Christopher Young, 1–22. Tübingen: Niemeyer, 2003.

———. "*Vrume rîtr und guote vrouwen / und wîse phaffen*: Court Literature and its Audience." In *German Narrative Literature of the Twelfth and Thirteenth Centuries: Studies Presented to Roy Wisbey on his Sixty-Fifth Birthday*, edited by Volker Honemann, Martin H. Jones, Adrian Stevens, and David Wells, 7–26. Tübingen: Max Niemeyer Verlag, 1994.

———. *Women Readers in the Middle Ages*. Cambridge: Cambridge University Press, 2007.

Greenblatt, Stephen. *Renaissance Self-Fashioning: From More to Shakespeare*. Chicago: University of Chicago Press, 1980.

Grubmüller, Klaus. "Gattungskonstitution im Mittelalter." In *Mittelalterliche Literatur und Kunst im Spannungsfeld von Hof und Kloster: Ergebnisse der Berliner Tagung 9.–11. Oktober 1997*, edited by Nigel F. Palmer and Hans-Jochen Schiewer, 193–210. Tübingen: Niemeyer, 1999.

Grundmann, Herbert. "Die Frauen und die Literatur im Mittelalter." *Archiv für Kulturgeschichte* 26 (1936): 129–61.

———. "Litteratus-illiteratus: Der Wandel einer Bildungsnorm vom Altertum zum Mittelalter." *Archiv für Kulturgeschichte* 40 (1958): 1–65.

Haag, Christine. "Das Ideal der männlichen Frau in der Literatur des Mittelalters und seine theoretischen Grundlagen." In *"Manlîchiu wîp, wîplîch man": Zur Konstruktion der Kategorien "Körper" und "Geschlecht" in der deutschen Literatur des Mittelalters*, edited by Ingrid Bennewitz and Helmut Tervooren, 228–48. Berlin: E. Schmidt, 1999.

Hahn, Cynthia. "*Visio Dei*: Changes in Medieval Visuality." In *Visuality before and beyond the Renaissance: Seeing as Others Saw*, edited by Robert S. Nelson, 169–96. Cambridge: Cambridge University Press, 2000.

Hamburger, Jeffrey F. *The "Rothschild Canticles": Art and Mysticism in Flanders and the Rhineland circa 1300*. New Haven: Yale University Press, 1990.

———. *The Visual and the Visionary: Art and Female Spirituality in Late Medieval Germany*. New York: Zone Books, 1998.

Hanna, Ralph. *London Literature, 1300–1380*. Cambridge: Cambridge University Press, 2005.

Harant, Patricia. *Poeta Faber: Der Handwerksdichter bei Frauenlob; Texte, Übersetzungen, Textkritik, Kommentar und Metapherninterpretationen*. Erlangen: Palm & Enke, 1997.

Haug, Walter. "Fiktionalität zwischen Lüge und Wahrheit: Thomasin von Zerklaere und die Integumentum-Lehre." In *Literaturtheorie im deutschen Mittelalter: Von den Anfängen bis zum Ende des 13. Jahrhunderts*, edited by Walter Haug, 228–40. Darmstadt: Wissenschaftliche Buchgesellschaft, 1985.

———. "The Truth of Fiction: Thomasin von Zerklære and *integumentum* Theory." In *Vernacular Theory in the Middle Ages: The German Tradition, 800–1300, in Its European context*. Translated by Joanna M. Catling. New York: Cambridge University Press, 1997.

Heinzle, Joachim, ed. *Wolfram von Eschenbach, Willehalm*. Frankfurt: Bibliothek Deutscher Klassiker, 1991.

Henkel, Nikolaus. *Deutsche Übersetzungen lateinischer Schultexte: Ihre Verbreitung und Funktion im Mittelalter und in der frühen Neuzeit*. Munich: Artemis, 1988.

———. Review of *Hören und Lesen: Studien zur primären Rezeption der Literatur im 12. und 13. Jahrhundert* by Manfred Günther Scholz. *Germanisch-Romanische Monatsschrift* 65 (1984): 215–20.

Heslop, T. Alexander. "Romanesque Painting and Social Distinction: The Magi and the Shepherds." In *England in the Twelfth Century, Proceedings of the 1988 Harlaxton Symposium*, edited by Daniel Williams, 137–52. Wolfeboro, NH: Boydell Press, 1990.

Hindman, Sandra. *Sealed in Parchment: Rereadings of Knighthood in the Illuminated Manuscripts of Chrétien de Troyes*. Chicago: University of Chicago Press, 1994.

Holladay, Joan A. *Illuminating the Epic: The Kassel "Willehalm" Codex and the Landgraves of Hesse in the Early Fourteenth Century*. College Art Association Monograph Series 54. Seattle: University of Washington Press, 1997.

———. "Some Arguments for a Wider View of Cologne Book Painting in the Early Fourteenth Century." *Georges-Bloch-Jahrbuch des Kunstgeschichtlichen Seminars der Universität Zürich* 4 (1997): 5–21.

Holsinger, Bruce H. "Analytical Survey 6: Medieval Literature and Cultures of Performance." In *New Medieval Literatures*, vol. 6, edited by David Lawton, Rita Copeland, and Wendy Scase, 271–311. Oxford: Oxford University Press, 2003.

Hotchkiss, Valerie R. *Clothes Make the Man: Female Cross Dressing in Medieval Europe*. New York: Garland, 1996.

Hourihane, Colum, ed. *Virtue and Vice: The Personifications in the Index of Christian Art*. Princeton, NJ: Index of Christian Art, Department of Art and Archaeology, Princeton University in association with Princeton University Press, 2000.

Huber, Christoph. *Die Aufnahme und Verarbeitung des Alanus ab Insulis in mittelhochdeutschen Dichtungen: Untersuchungen zu Thomasin von Zerklaere, Gottfried von Straßburg, Frauenlob, Heinrich von Neustadt, Heinrich von St. Gallen, Heinrich von Mügeln und Johannes von Tepl*. Münchner Texte und Untersuchungen zur deutschen Literatur des Mittelalters 89. Munich: Artemis, 1988.

———. "Höfischer Roman als Integumentum? Das Votum Thomasins von Zer-klaere." *Zeitschrift für deutsches Altertum* 115 (1986): 79–100.

———. "Zur mittelalterlichen Roman-Hermeneutik: Noch einmal Thomasin von Zerklaere und das Integumentum." In *German Narrative Literature of the Twelfth and Thirteenth Centuries: Studies Presented to Roy Wisbey on his Sixty-Fifth Birthday*, edited by Volker Honemann, Martin H. Jones, Adrian Stevens, and David Wells, 27–38. Tübingen: Max Niemeyer Verlag, 1994.

Hübner, Gert. *Erzählformen im höfischen Roman: Studien zur Fokalisierung im "Eneas," im "Iwein" und im "Tristan."* Bibliotheca Germanica 44. Tübingen: A. Francke Verlag, 2003.

Huot, Sylvia. *From Song to Book: The Poetics of Writing in Old French Lyric and Lyrical Narrative Poetry.* Ithaca: Cornell University Press, 1987.

———. *The Romance of the Rose and its Medieval Readers: Interpretation, Reception, Manuscript Transmission.* Cambridge Studies in Medieval Literature 1. New York: Cambridge University Press, 1993.

———. "Visualization and Memory: The Illustration of Troubadour Lyric in a Thirteenth-Century Manuscript." *Gesta* 31, no. 1 (1992): 3–14.

Irtenkauf, Wolfgang. *Stuttgarter Zimelien: Württembergische Landesbibliothek. Aus den Schätzen ihrer Handschriftensammlung.* Stuttgart: Die Landesbibliothek, 1985.

Irtenkauf, Wolfgang, Ingeborg Krekler, and Isolde Dumke. *Codices Poetici et Philologici.* Die Handschriften der Württembergischen Landesbibliothek Stuttgart I, 2. Wiesbaden: Harrassowitz, 1981.

Izbicki, Thomas M. "Forbidden Colors in the Regulation of Clerical Dress from the Fourth Lateran Council (1215) to the Time of Nicolas of Cusa (d. 1464)." In *Medieval Clothing and Textiles*, vol. 1, edited by Robin Netherton and Gale R. Owen-Crocker, 105–14. Woodbridge: The Boydell Press, 2005.

Jaeger, C. Stephen. *Ennobling Love: In Search of a Lost Sensibility.* Philadelphia: University of Pennsylvania Press, 1999.

———. *The Origins of Courtliness: Civilizing Trends and the Formation of Courtly Ideals 939–1210.* Philadelphia: University of Pennsylvania Press, 1985.

Jaeger, C. Stephen, and Ingrid Kasten, eds. *Codierungen von Emotionen im Mittelalter.* Berlin: de Gruyter, 2003.

Katzenellenbogen, Adolf. *Allegories of the Virtues and Vices in Medieval Art: From Early Christian Times to the Thirteenth Century.* London: Warburg Institute, 1939.

———. "Die Psychomachie in der Kunst des Mittelalters von den Anfängen bis zum 13. Jahrhundert." PhD diss., Universität Hamburg, 1933.

———. "The Representation of the Seven Liberal Arts." In *Twelfth-Century Europe and the Foundations of Modern Society: Proceedings of a Symposium Sponsored by the Division of Humanities of the University of Wisconsin and the Wisconsin Institute for Medieval and Renaissance Studies November 12–14, 1957*, edited

by Marshall Clagett, Gaines Post, and Robert Reynolds, 39–55. Madison: University of Wisconsin Press, 1961.

Keen, Suzanne. *Empathy and the Novel.* New York: Oxford University Press, 2007.

Kerby-Fulton, Kathryn, and Denise Despres. *Iconography and the Professional Reader: The Politics of Book Production in the Douce Piers Plowman.* Minneapolis: University of Minnesota Press, 1998.

Kerth, Thomas. Review of *Thomasin von Zerclaere, Der Welsche Gast* by F. W. von Kries. *Speculum* 62, no. 2 (April 1987): 484–86.

Kessler, Herbart L. *Spiritual Seeing: Picturing God's Invisibility in Medieval Art.* Philadelphia: University of Philadelphia Press, 2000.

Kirschbaum, Engelbert, et al., eds. *Lexikon der christlichen Ikonographie.* 8 vols. Freiburg: Herder, 1994.

Klapisch-Zuber, Christiane, ed. *Silences of the Middle Ages.* Cambridge, MA: Belknap Press of Harvard University Press, 1992.

Klare, Andreas. "Thomasins *unstete*-Begriff." In *Beweglichkeit der Bilder: Text und Imagination in den illustrierten Handschriften des "Welschen Gastes" von Thomasin von Zerclaere,* edited by Horst Wenzel and Christina Lechtermann, 174–99. Cologne: Böhlau, 2002.

Klinger, Judith. "Gender-Theorien. a)Ältere deutsche Literatur." In *Germanistik als Kulturwissenschaft. Eine Einführung in neue Theoriekonzepte,* edited by Claudia Benthien and Hans Rudolf Velten, 267–97. Hamburg: Rowohlt, 2002.

König, Eberhard. "Buchmalerei—eine narrative Kunst?" In *Mittelalterliche Literatur und Kunst im Spannungsfeld von Hof und Kloster: Ergebnisse der Berliner Tagung, 9.–11. Oktober 1997,* edited by Nigel F. Palmer and Hans-Jochen Schiewer, 141–48. Tübingen: Max Niemeyer Verlag, 1999.

Kolve, V. A. *Chaucer and the Imagery of Narrative: The First Five Canterbury Tales.* Stanford: Stanford University Press, 1984.

Kronjäger, Jochen. "Berühmte Griechen und Römer als Begleiter der Musen und der Artes Liberales in Bildzyklen des 2. bis 14. Jahrhunderts." PhD diss., Universität Marburg, 1973.

Krueger, Roberta L. "Identity Begins at Home: Female Conduct and the Failure of Counsel in Le Menagier de Paris." *Essays in Medieval Studies: Proceedings of the Illinois Medieval Association* 22 (2005): 21–39.

Krüger, Klaus. "Tristan-Love: Elite Self-Fashioning in Italian Frescoes of the Thirteenth and Fourteenth Centuries." In *Visuality and Materiality in the Story of Tristan,* edited by Jutta Eming, Ann Marie Rasmussen, and Kathryn Starkey, 178–200. Notre Dame, IN: University of Notre Dame Press, 2012.

Laqueur, Thomas. *Making Sex: Body and Gender from the Greeks to Freud.* Cambridge, MA: Harvard University Press, 1990.

Lees, Clare A., ed. *Medieval Masculinities: Regarding Men in the Middle Ages.* Medieval Cultures 7. Minneapolis: University of Minnesota Press, 1994.

Lentes, Thomas. "'As far as the eye can see . . .': Rituals of Gazing in the Late Middle Ages." In *The Mind's Eye: Art and Theological Argument in the Middle Ages,* edited by Jeffrey F. Hamburger and Anne-Marie Bouché, 360–73. Princeton, NJ: Department of Art and Archaeology, Princeton University in association with Princeton University Press, 2006.

———. "Inneres Auge, äußerer Blick und heilige Schau: Ein Diskussionsbeitrag zur visuellen Praxis in Frömmigkeit und Moraldidaxe des späten Mittelalters." In *Frömmigkeit im Mittelalter: Politisch-soziale Kontexte, visuelle Praxis, körperliche Ausdrucksformen,* edited by Klaus Schreiner and Marc Müntz, 179–219. Munich: Fink, 2002.

Lerer, Seth. *Reading from the Margins: Textual Studies, Chaucer, and Medieval Literature.* San Marino, CA: Huntington Library, 1996.

Lexer, Matthias. *Mittelhochdeutsches Handwörterbuch: Zugleich als Supplement und alphabetischer Index zum Mittlehochdeutschen Wörterbuch von Benecke-Müller-Zancke.* Stuttgart: S. Hirzel, 1970.

Lindberg, David C. "Alhazen's Theory of Vision and Its Reception in the West." In David C. Lindberg, *Studies in the History of Medieval Optics,* 3:321–41. London: Variorum Reprints, 1983.

———. *Theories of Vision from Al-Kindi to Kepler.* Chicago: University of Chicago Press, 1996.

Lochrie, Karma, Peggy McCracken, and James A. Schultz, eds. *Constructing Medieval Sexuality.* Medieval Cultures 11. Minneapolis: University of Minnesota Press, 1997.

Lohse, Gerhart. "Die Aventiurenüberschriften des *Nibelungenliedes.*" *Beiträge zur Geschichte der deutschen Sprache und Literatur* 102, no. 1 (1980): 19–54.

Luyster, Amanda. "Time, Space, and Mind: Tristan in Three Dimensions in Fourteenth-Century France." In *Visuality and Materiality in the Story of Tristan,* edited by Jutta Eming, Ann Marie Rasmussen, and Kathryn Starkey, 148–77. Notre Dame, IN: University of Notre Dame Press, 2012.

Macho, Thomas. "Narziß und Spiegel: Selbstrepräsentation in der Geschichte der Optik." In *Narcissus. Ein Mythos von der Antike bis zum Cyberspace,* edited by Almut-Barbara Renger, 13–25. Stuttgart/Weimar, 2002.

Manuwald, Henrike. "Der Autor als Erzähler? Das Bild der Ich-Figur in der 'Großen Bilderhandschrift' des *Willehalm* Wolframs von Eschenbach." In *Autorbilder: Zur Medialität literarischer Kommunikation in Mittelalter und Früher Neuzeit,* edited by Gerald Kapfhammer, Wolf-Dietrich Löhr, and Barbara Nitsche, 63–92; figs. 89–101. Münster: Rhema, 2007.

Marchal, Guy P. "Domkapital." *Theologische Realenzyklopädie* 9 (1982): 136–40.

Marek, Kristin, Raphaèle Preisinger, Marius Rimmele, and Katrin Kärcher. "Bild und Körper im Mittelalter: Zur Einführung." In *Bild und Körper im Mittelalter,* edited by Kristin Marek, Raphaèle Preisinger, Marius Rimmele, and Katrin Kärcher, 9–20. Munich: Fink, 2006.

Marek, Kristin, Raphaèle Preisinger, Marius Rimmele, and Katrin Kärcher, eds. *Bild und Körper im Mittelalter*. Munich: Fink, 2006.

McConnell, Winder, and Otfrid Ehrismann. "*stæte*: Der feste Charakter." In *Ehre und Mut, Aventiure und Minne: Höfische Wortgeschichten aus dem Mittelalter*. Munich: Beck, 1995.

Meier, Cristel. "Malerei des Unsichtbaren: Über den Zusammenhang von Erkenntnistheorie und Bildstruktur im Mittelalter." In *Text und Bild: Bild und Text; DFG-Symposion 1988*, edited by Wolfgang Harms, 35–65. Stuttgart: Metzler, 1990.

Mellinkoff, Ruth. *Averting Demons*. Los Angeles: Ruth Mellinkoff Publications, 2004.

———. *Outcasts: Signs of Otherness in Northern European Art of the Late Middle Ages*. Berkeley: University of California Press, 1993.

Meyer, Heinz, and Rudolf Suntrup. *Lexikon der mittelalterlichen Zahlenbedeutungen*. Munich: Wilhelm Fink, 1987.

Mitchell, W. J. T. *Picture Theory: Essays on Verbal and Visual Representation*. Chicago: University of Chicago Press, 1994.

Montandon, Alain. Introduction to *Über die deutsche Höflichkeit: Entwicklung der Kommunikationsvorstellungen in den Schriften über Umgangsformen in den deutschsprachigen Ländern*, edited by Alain Montandon, 5–20. Bern: Peter Lang, 1991.

Mullally, Robert. *The* Carole: *A Study of a Medieval Dance*. Surrey: Ashgate, 2011.

———. "Houes Danses." *Neophilologus* 76 (1992): 29–34.

Müller, Jan-Dirk. "Vorbemerkungen" In *"Aufführung" und "Schrift" in Mittelalter und Früher Neuzeit*, Germanistisches Symposium, Berichtsbände 17, edited by Jan-Dirk Müller, xi–xviii. Stuttgart: Metzler, 1996.

———. *Gedechtnus: Literatur und Hofgesellschaft um Maximilian I*. Munich: Fink, 1982.

———. "Visualität, Geste, Schrift: Zu einem neuen Untersuchungsfeld der Mediävistik." *Zeitschrift für deutsche Philologie* 122 (2003): 118–32.

———. *Wissen für den Hof: Der spätmittelalterliche Verschriftungsprozess am Beispiel Heidelberg im 15. Jahrhundert*. Munich: Fink, 1994.

Nelson, Robert S. "Descartes's Cow and Other Domestications of the Visual." Introduction to *Visuality before and beyond the Renaissance: Seeing as Others Saw*, edited by Robert S. Nelson, 1–21. Cambridge: Cambridge University Press, 2000.

———, ed. *Visuality before and beyond the Renaissance. Seeing as Others Saw*. Cambridge: Cambridge University Press, 2000.

Netherton, Robin. "The Tippet: Accessory after the Fact?" In *Medieval Clothing and Textiles*, vol. 1, edited by Robin Netherton and Gale R. Owen-Crocker, 115–32. Woodbridge: The Boydell Press, 2005.

Neumann, Friedrich. "Einführung in Thomasins Verswerk." In *Der Welsche Gast des Thomasîn von Zerclaere: Cod. Pal. Germ. 389 der Universitätsbibliothek*

Heidelberg, Facsimilia Heidelbergensia, 4, edited by Friedrich Neumann and Ewald Vetter. Wiesbaden: Reichert, 1974.

———. "Einleitung." In *Der Wälsche Gast des Thomasin von Zirclaria: Zum ersten Male herausgegeben mit sprachlichen und geschichtlichen Anmerkungen,* edited by H. Rückert, v–li. Deutsche Neudrucke. 1852. Reprint, Berlin: de Gruyter, 1965.

Newhauser, Richard. *In the Garden of Evil: The Vices and Culture in the Middle Ages.* Toronto: Pontifical Institute of Mediaeval Studies, 2005.

———. *The Treatise on Vices and Virtues in Latin and the Vernacular.* Turnhout, Belgium: Brepols, 1993.

Newman, Barbara. *God and the Goddesses: Vision, Poetry, and Belief in the Middle Ages.* Philadelphia: University of Pennsylvania Press, 2003.

———. "Love's Arrows: Christ as Cupid in Late Medieval Art and Devotion." In *The Mind's Eye: Art and Theological Argument in the Middle Ages,* edited by Jeffrey F. Hamburger and Anne-Marie Bouché, 263–86. Princeton: Department of Art and Archaeology, Princeton University in association with Princeton University Press, 2006.

———. "What Did It Mean to Say I Saw? The Clash between Theory and Practice in Medieval Visionary Culture." *Speculum* 80 (2005): 1–43.

Nichols, Stephen G. "Introduction: Philology in a Manuscript Culture." *Speculum* 65, no. 1 (1990): 1–10.

Noel, William. "The Utrecht Psalter in England: Continuity and Experiment." In *The Utrecht Psalter in Medieval Art: Picturing the Psalms of David,* edited by Koert van der Horst, William Noel, and Wilhelmina C. M. Wüstefeld, 120–65. Westrenen: HES Publishers, 1996.

Nugent, S. Georgia. *Allegory and Poetics: The Structure and Imagery of Prudentius' "Psychomachia."* New York: P. Lang, 1985.

———. "*Virtus* or Virago? The Female Personifications of Prudentius' *Psychomachia.*" In *Virtue and Vice: The Personifications in the Index of Christian Art,* edited by Colum Hourihane, 13–28. Princeton, NJ: Index of Christian Art, Dept. of Art and Archaeology, Princeton University in association with Princeton University Press, 2000.

Obermaier, Sabine. "Der Dichter als Handwerker—Der Handwerker als Dichter. Autorkonzepte zwischen Sangspruchdichtung und Meistersang." In *Neue Forschungen zur mittelhochdeutschen Sangspruchdichtung,* edited by Horst Brunner and Helmut Tervooren. Special edition of *Zeitschrift für deutsche Philologie* 119 (2000): 59–72.

———. *Von Nachtigallen und Handwerkern. Dichtung über Dichtung in Minnesang und Sangspruchdichtung.* Tübingen: Niemeyer, 1995.

Oechelhäuser, Adolf von. *Der Bilderkreis zum Wälschen Gast des Thomasin von Zerclaere.* Heidelberg: Koester, 1890.

Ong, Walter. *Orality and Literacy: The Technologizing of the Word.* New York: Routledge, 2002.

O'Reilly, Jennifer. *Studies in the Iconography of the Virtues and Vices in the Middle Ages*. New York: Garland, 1988.

Ott, Norbert. "Der Körper als konkrete Hülle des Abstrakten: Zum Wandel des Rechtsgebärden im Spätmittelalter." In *Gepeinigt, begehrt, vergessen: Symbolik und Sozialbezug des Körpers im späten Mittelalter und in der frühen Neuzeit*, edited by Klaus Schreiner and Norbert Schnitzler, 223–41. Munich: Fink, 1992.

———. "Literatur in Bildern: Eine Vorbemerkung und sieben Stichworte." In *Literatur und Wandmalerei I: Erscheinungsformen höfischer Kultur und ihre Träger im Mittelalter: Freiburger Colloquium 1998*, edited by Eckart Conrad Lutz, Johanna Thali, and René Wetzel, 153–97. Tübingen: Niemeyer, 2002.

———. "Nonverbale Kommentare: Zur Kommentarfunktion von Illustrationen in mittelalterlichen Handschriften." In *Schrift—Text—Edition: Hans Walter Gabler zum 65. Geburtstag*, edited by Christiane Henkes et al., 113–26. Tübingen: Niemeyer, 2003.

———. "Reich und Stadt: Karl der Große in deutschsprachigen Bilderhandschriften." In *Karl der Große als vielberufener Vorfahr: Sein Bild in der Kunst der Fürsten, Kirchen und Städte*, edited by Lieselotte E. Saurma-Jeltsch, 87–111. Sigmaringen: Jan Thorbecke, 1994.

———. "Texte und Bilder: Beziehungen zwischen den Medien Kunst und Literatur in Mittelalter und Früher Neuzeit." In *Die Verschriftlichung der Welt: Bild, Text, Zahl in der Kultur des Mittelalters und der Frühen Neuzeit*, edited by Horst Wenzel, Wilfried Seipel, and Gotthart Wunberg, 104–43. Vienna: Kunsthistorisches Museum, 2000.

———. "Typen der Weltchronistik-Ikonographie: Bemerkungen zu Illustration, Anspruch und Gebrauchssituation volkssprachlicher Chronistik aus überlieferungsgeschichtlicher Sicht." *Jahrbuch der Oswald von Wolkensteingesellschaft* 1 (1980/81): 29–55.

———. "Überlieferung, Ikonographie—Anspruchsniveau, Gebrauchssituation: Methodisches zum Problem der Beziehungen zwischen Stoffen, Texten und Illustrationen in Handschriften des Spätmittelalters." In *Literatur und Laienbildung im Spätmittelalter und in der Reformationszeit*, edited by Ludger Grenzmann and Karl Stackmann, 356–86. Stuttgart: Metzler, 1984.

Palmer, Nigel F. *German Literary Culture in the Twelfth and Thirteenth Centuries: An Inaugural Lecture Delivered before the University of Oxford on 4 March 1993*. Oxford: Clarendon Press, 1993.

———. "Kapitel und Buch: Zu den Gliederungsprinzipien mittelalterlicher Bücher." *Frühmittelalterliche Studien* 23 (1989): 43–88.

———. "Manuscripts for Reading: The Material Evidence for the Use of Manuscripts Containing Middle High German Narrative Verse." In *Orality and Literacy in the Middle Ages: Essays on a Conjunction and its Consequences in Honour of D. H. Green*, edited by Mark Chinca and Christopher Young, 65–100. Turnhout: Brepols, 2005.

Palmer, Nigel F., and Hans-Jochen Schiewer, eds. *Mittelalterliche Literatur und Kunst im Spannungsfeld von Hof und Kloster: Ergebnisse der Berliner Tagung, 9.–11. Oktober 1997.* Tübingen: Niemeyer, 1999.

Parker, Andrew, and Eve Sedgwick, eds. *Performativity and Performance.* New York: Routledge, 1995.

Parkes, Malcolm B. "The Influence of the Concepts of Ordinatio and Compilatio on the Development of the Book." In *Medieval Learning and Literature,* edited by J. J. G. Alexander and M. T. Gibson, 115–51. Oxford: Clarendon Press, 1976.

Pastoureau, Michel. *The Devil's Cloth: A History of Stripes and Striped Fabric.* Translated by Jody Gladding. New York: Columbia University Press, 2001.

Peters, Ursula. *Das Ich im Bild: Die Figur des Autors in Volkssprachigen Bilderhandschriften des 13. bis 16. Jahrhunderts.* Cologne: Böhlau, 2008.

———. *Literatur in der Stadt: Studien zu den Voraussetzungen und kulturellen Organisationsformen städtischer Literatur im 13. und 14. Jahrhundert.* Tübingen: Max Niemeyer, 1983.

———. "Mittelalterliche Literatur am Hof und im Kloster: Ergebnisse und Perspektiven eines historisch-anthropologischen Verständnisses." In *Mittelalterliche Literatur und Kunst im Spannungsfeld von Hof und Kloster: Ergebnisse der Berliner Tagung, 9.–11. Oktober 1997,* edited by Nigel F. Palmer and Hans-Jochen Schiewer, 167–92. Tübingen: Niemeyer, 1999.

Pfeiffer, Franz. *Freie Forschung: Kleine Schriften zur Geschichte der deutschen Literatur und Sprache.* Vienna: Tendler, 1867.

Philipowski, Silke: "Geste und Inszenierung: Wahrheit und Lesbarkeit von Körpern im höfischen Epos." *Beiträge zur Geschichte der deutschen Sprache und Literatur* 122 (2000): 454–74.

Piponnier, Françoise, and Perrine Mane. *Dress in the Middle Ages.* Translated by Caroline Beamish. New Haven: Yale University Press, 2000.

Poor, Sara S. *Mechthild of Magdeburg and Her Book: Gender and the Making of Textual Authority.* Philadelphia: University of Pennsylvania Press, 2004.

Ranke, Friedrich. *Sprache und Stil im Wälschen Gast des Thomasin von Circlaria.* Palaestra 68. Berlin: Mayer und Müller, 1908.

Rasmussen, Ann Marie, and Sarah Westphal-Wihl. *Ladies, Whores, and Holy Women: A Sourcebook in Courtly, Religious, and Urban Cultures of Late Medieval Germany.* Medieval German Texts in Bilingual Editions 5. Kalamazoo, MI: Medieval Institute Publications, 2010.

Resler, Michael. "Thomasîn von Zerclaere." In *German Writers and Works of the High Middle Ages: 1170–1280,* edited by James Hardin and Will Hasty, 133–40. Detroit: Gale Research, 1994.

Ringbom, Sixten. "Devotional Images and Imaginative Devotions: Notes on the Place of Art in Medieval Private Piety." *Gazette des Beaux-Arts* 73 (1969): 159–70.

Rocher, Daniel. "Die ars oratoria des Thomasin von Zirklaere in seinem, Wälschen Gast." In *Thomasin von Zerclaere und die didaktische Literatur des Mittelal-*

ters, edited by Paola Schulze-Belli, 63–77. Trieste: Associazione di Cultura Medioevale, 1995.

———. "Thomasin von Zerklaere, 'Der wälsche Gast' (1215–1216)." PhD diss., Université de Lille III, Paris, 1977.

Röcke, Werner. *Feudale Anarchie und Landesherrschaft: Wirkungsmöglichkeiten didaktischer Literatur; Thomasin von Zerclaere "Der Welsche Gast."* Bern: Lang, 1978.

Roth, Gunhild. "Spiegelliteratur." In *Lexikon des Mittelalters,* vol. 7, edited by Norbert Angermann et al., cols. 2101–4. Munich: Artemis, 1995.

Rouse, Mary A., and Richard H. Rouse. "The Development of Research Tools in the Thirteenth Century." In *Authentic Witnesses: Approaches to Medieval Texts and Manuscripts,* edited by Mary A. Rouse and Richard H. Rouse, 221–55. Notre Dame, IN: University of Notre Dame Press, 1991.

———. *Preachers, Florilegia and Sermons: Studies on the "Manipulus florum" of Thomas of Ireland.* Toronto: Pontifical Institute of Mediaeval Studies, 1979.

———. "*Statim Invenire*: Schools, Preachers, and New Attitudes to the Page." In *Renaissance and Renewal in the Twelfth Century,* edited by Robert L. Benson and Giles Constable, 201–25. Cambridge, MA: Harvard University Press, 1982.

Rosenwein, Barbara H. *Anger's Past: The Social Uses of an Emotion in the Middle Ages.* Ithaca: Cornell University Press, 1998.

———. "Worrying about Emotions in History." *The American Historical Review* 107, no. 3 (2002): 821–45.

Rücker, Helmut. *Mâze und ihre Wortfamilie in der deutschen Literatur bis um 1220.* Göppingen: A. Kümmerle, 1975.

Ruff, Ernst Johann Friedrich. *Der Wälsche Gast des Thomasin von Zerklaere: Untersuchungen zu Gehalt und Bedeutung einer mittelhochdeutschen Morallehre.* Erlangen: Palm & Enke, 1982.

Rushing, James A., Jr. *Images of Adventure: Ywain in the Visual Arts.* Philadelphia: University of Pennsylvania Press, 1995.

Rust, Martha. *Imaginary Worlds in Medieval Books: Exploring the Manuscript Matrix.* New York: Palgrave, 2007.

Saenger, Paul. "Silent Reading: Its Impact on Late Medieval Script and Society." *Viator* 13 (1982): 367–414.

Saurma-Jeltsch, Lieselotte E. "Bildverfremdung gegen Bildverehrung: Zu einigen Darstellungsstrategien in der nördlichen Tafelmalerei des Spätmittelalters." In *"Aufführung" und "Schrift" in Mittelalter und Früher Neuzeit,* Germanistisches Symposium, Berichtsbände 17, edited by Jan-Dirk Müller, 406–28. Stuttgart: Metzler, 1996.

———. "Neuzeitliches in einer mittelalterlichen Gattung: Zum Wandel der illustrierten Handschrift." In *Hours in a Library,* Mitteilungen/Beiheft 1, edited by Wolfgang Liebenwein, 70–112. Frankfurt am Main: Zentrum zur Erforschung der frühen Neuzeit der Johann Wolfgang Goethe-Universität Frankfurt am Main, 1994.

———. "Textaneignung in der Bildersprache: Zum Verhältnis von Bild und Text am Beispiel spätmittelalterlicher Buchillustration." *Wiener Jahrbuch für Kunstgeschichte* 41 (1988): 41–59.

———. "Zum Wandel der Erzählweise am Beispiel der illustrierten deutschen 'Parzival'-Handschriften." *Wolfram-Studien* 12 (1992): 124–52.

Scala, Elizabeth. *Absent Narratives, Manuscript Textuality, and Literary Structure in Late Medieval England.* New York: Palgrave, 2002.

Scalon, Cesare. *Necrologium Aquileiense.* Udine: Istituto Pio Paschini, 1982.

Schade, Herbert. *Dämonen und Monstren: Gestaltungen des Bösen in der Kunst des frühen Mittelalters.* Regensburg: F. Pustet, 1962.

Schleusner-Eichholz, Gudrun. *Das Auge im Mittelalter.* Munich: W. Fink, 1985.

Schmidt, Hans-Joachim. "Spätmittelalterliche Fürstenspiegel und ihr Gebrauch in unterschiedlichen Kontexten." *Wolfram-Studien* 19 (2006): 377–97.

Schneider, Christian. *Hovezuht: Literarische Hofkultur und höfisches Lebensideal um Herzog Albrecht III. von Österreich und Erzbischof Pilgrim II. von Salzburg (1365–1396).* Heidelberg: Winter, 2008.

Schneider, Karin. *Gotische Schriften in deutscher Sprache, I. Vom späten 12. Jahrhundert bis um 1300.* Wiesbaden: Reichert, 1987.

Scholz, Manfred Günter. *Hören und Lesen: Studien zur primären Rezeption der Literatur im 12. und 13. Jahrhundert.* Wiesbaden: F. Steiner, 1980.

Schottenloher, Karl. "Schicksale von Büchern und Bibliotheken im Bauernkrieg." *Zeitschrift für Bücherfreunde* 12, no. 2 (1908/09): 396–408.

Schreiner, Klaus. "Soziale, visuelle und körperliche Dimensionen mittelalterlicher Frömmigkeit." In *Frömmigkeit im Mittelalter. Politisch-soziale Kontexte, visuelle Praxis, körperliche Ausdrucksformen*, edited by Klaus Schreiner and Marc Müntz, 9–38. Munich: Fink, 2002.

Schultz, James A., ed. *Courtly Love, the Love of Courtliness, and the History of Sexuality.* Chicago: University of Chicago Press, 2006.

———. *Sovereignty and Salvation in the Vernacular, 1050–1150: Das Ezzolied, Das Annolied, Die Kaiserchronik, vv. 247–667, Das Lob Salomons, Historia Judith.* Medieval German Text in Bilingual Editions 1. Kalamazoo, MI: Medieval Institute Publications, 2000.

Schumacher, Meinolf. "Gefangensein—waz wirret daz? Ein Theodizee-Argument des 'Welschen Gastes' im Horizont europäischer Gefängnis-Literatur von Boetheus bis Vladimir Nabokov." In *Beweglichkeit der Bilder: Text und Imagination in den illustrierten Handschriften des Welschen Gast*, edited by Horst Wenzel and Christina Lechtermann, 238–55. Cologne: Böhlau, 2002.

Schüppert, Helga. "Bildschichten und ihre Funktion im 'Wälschen Gast.'" In *Thomasin von Zerclaere und die didaktische Literatur des Mittelalters*, edited by Paola Schulze-Belli, 7–28. Trieste: Associazione di Cultura Medioevale, 1995.

Schwarz, Michael Victor. *Visuelle Medien im christlichen Kult: Fallstudien aus dem 13. bis 16. Jahrhundert.* Vienna: Böhlau, 2002.

Schiewer, Hans-Jochen. "Thomasin von Zerklaere." In *Lexikon des Mittelalters* VIII.4, col. 727–28. Munich: LexMA-Verlag, 1996.

Sears, Elizabeth. "'Reading' Images." Introduction to *Reading Medieval Images: The Art Historian and the Object*, edited by Elizabeth Sears and Thelma K. Thomas, 1–7. Ann Arbor: University of Michigan Press, 2002.

Sekules, Veronica. *Medieval Art*. New York: Oxford University Press, 2001.

Simon, Gérard. *Der Blick, das Sein und die Erscheinung in der antiken Optik: Mit einem Anhang; Die Wissenschaft vom Sehen und die Darstellung des Sichtbaren*. Munich: Wilhelm Fink, 1992.

Simons, Walter. "Reading a Saint's Body: Rapture and Bodily Movement in the *Vitae* of Thirteenth-Century Beguines." In *Framing Medieval Bodies*, edited by Sarah Kay and Miri Rubin, 10–23. New York: Saint Martin's Press, 1994.

Solterer, Helen. "Figures of Female Militancy in Medieval France." *Signs: Journal of Women in Culture and Society* 16 (1991): 522–49.

Sowinski, Bernhard. *Lehrhafte Dichtung des Mittelalters*. Stuttgart: Metzler, 1971.

Spindler, Max, ed. *Handbuch der Bayerischen Geschichte: Dritter Band; Franken, Schwaben, Oberpfalz bis zum Ausgang des 18. Jahrhunderts, erster Teilband*. Munich: Beck, 1971.

Stamm-Saurma (Saurma-Jeltsch), Lieselotte. "*Zuht* und *wicze*: Zum Bildgehalt spätmittelalterlicher Epenhandschriften." *Zeitschrift des Deutschen Vereins für Kunstwissenschaft* 41 (1987): 42–70.

Stammler, Wolfgang. *Frau Welt: Eine mittelalterliche Allegorie*. Freiburg in der Schweiz: Universitätsverlag, 1959.

Stammler, Wolfgang, and Karl Langosch, eds. *Die deutsche Literatur des Mittelalters: Verfasserlexikon*, 2nd ed. 14 vols. Berlin: de Gruyter, 1994.

Starkey, Kathryn. "Affektives Sehen und die Visualisierungsstrategien in den Illustrationen zu Thomasins *Welschem Gast*." In *Machtvolle Gefühle*, edited by Ingrid Kasten, 167–88. Berlin: de Gruyter, 2010.

———. "From Symbol to Scene: Changing Models of Representation in Thomasin von Zerclaere's *Welsche Gast*." In *Beweglichkeit der Bilder: Text und Imagination in den illustrierten Handschriften des Welschen Gast*, edited by Horst Wenzel and Christina Lechtermann, 121–42. Cologne: Böhlau, 2002.

———. "The Question of Reading and the Medieval Book: Reception and Manuscript Variation of Thomasin's *Welscher Gast*." In *Literary Studies and the Question of Reading*, edited by Eric S. Downing, Jonathan M. Hess, and Richard V. Benson, 40–67. Rochester, NY: Camden House, 2012.

———. *Reading the Medieval Book: Word, Image, and Performance in Wolfram von Eschenbach's "Willehalm."* Notre Dame, IN: University of Notre Dame Press, 2004.

———. "Thomasins Spiegelphase: (Selbst)Reflexion und Bildfunktion bei der Formierung des höfischen Subjekts." In *Inszenierung von Subjektivität in der Literatur des Mittelalters*, edited by Martin Baisch, Jutta Eming, Hendrikje Haufe, and Andrea Sieber, 230–48. Berlin: Ulrike Helmer, 2005.

———. "Das unfeste Geschlecht: Überlegungen zur Entwicklung einer volks- sprachlichen Ikonographie am Beispiel des *Welschen Gastes.*" In *Visualisie- rungsstrategien in mittelalterlichen Bildern und Texten,* edited by Horst Wenzel and C. Stephen Jaeger, 99–138. Berlin: Erich Schmidt, 2006.

———. "Visual Culture and the German Middle Ages," in *Visual Culture and the German Middle Ages,* edited by Kathryn Starkey and Horst Wenzel, 1–12. New York: Palgrave Press, 2005.

Starkey, Kathryn, and Horst Wenzel. "Visuality in German Courtly Literature." *Oxford German Studies* 37, no. 2 (2008): 130–59.

———, eds. *Visual Culture and the German Middle Ages.* New York: Palgrave Macmillan, 2005.

Stolz, Michael. "Text und Bild im Widerspruch? Der Artes-Zyklus in Thomasins *Welschem Gast* als Zeugnis mittelalterlicher Memorialkultur." *Wolfram- Studien* 15 (1998): 344–72.

Studt, Birgit. *Fürstenhof und Geschichte. Legitimation durch Überlieferung.* Cologne: Böhlau, 1992.

Tachau, Katherine H. "Seeing as Action and Passion in the Thirteenth and Four- teenth Centuries." In *The Mind's Eye: Art and Theological Argument in the Middle Ages,* edited by Jeffrey F. Hamburger and Anne-Marie Bouché, 336–59. Princeton, NJ: Department of Art and Archaeology, Princeton University in association with Princeton University Press, 2006.

Taylor, Andrew. *Textual Situations: Three Medieval Manuscripts and their Readers.* Philadelphia: University of Pennsylvania Press, 2003.

Tervooren, Helmut, and Horst Wenzel, eds. *Philologie als Textwissenschaft: Alte und neue Horizonte.* Special edition of *Zeitschrift für deutsche Philologie* 116 (1997).

Teske, Hans. *Thomasin von Zerclaere, der Mann und sein Werk.* Heidelberg: C. Win- ter, 1933.

Teuber, Bernhard. "Per speculum in aenigmate: Medialität und Anthropologie des Spiegels vom Mittelalter zur frühen Neuzeit." In *Vom Flugblatt zum Feuilleton. Mediengebrauch und ästhetische Anthropologie in historischer Per- spektive,* edited by Wolfram Nitsch and Bernhard Teuber, 13–33. Tübingen: Narr, 2002.

Tezmen-Siegel, Jutta. *Die Darstellungen der septem artes liberales in der Bildenden Kunst als Rezeption der Lehrplangeschichte.* Munich: Tuduv-Verlagsgesellschaft, 1985.

Traub, Gerhard. *Studien zum Einfluß Ciceros auf die höfische Moral.* Greifswald: L. Bamberg, 1933.

Trokhimenko, Olga V. "Keeping up Appearances: Women's Laughter and the Per- formance of Virtue in Medieval German Discourse." PhD diss., Duke Uni- versity, 2006.

Turner, Ralph V. "The *Miles Literatus* in Twelfth- and Thirteenth-Century England: How Rare a Phenomenon?" *American Historical Review* 83 (1978): 928–45.

Vetter, Ewald M., and Friedrich Neumann. *"Der Welsche Gast" des Thomasîn von Zerclaere: Cod. Pal. Germ. 389 der Universitätsbibliothek Heidelberg: Einführung in Thomasins Verswerk.* Facsimilia Heidelbergensia 4. Wiesbaden: Reichert, 1974.

Vetter, Ewald M. "Die Handschrift und ihre Bilder." In *Der Welsche Gast des Thomasîn von Zerclaere: Codex Palatinus Germanicus 389 der Universitätsbibliothek Heidelberg,* edited by Ewald M. Vetter and Friedrich Neumann, vol. 1. Wiesbaden: Reichert, 1974–80.

von Ems, Rudolf. *Alexander: Ein höfischer Versroman des 13. Jahrhunderts,* 2 Bände. Edited by Victor Junk. Darmstadt: Wissenschaftliche. Buchgesellschaft, 1970.

von Kries, Friedrich W. *Textkritische Studien zum Welschen Gast Thomasins von Zerclaere.* Berlin: de Gruyter, 1967.

Wachinger, Burghardt. "Autorschaft und Überlieferung." In *Autorentypen,* edited by Walter Haug and Burghardt Wachinger, 1–28. Tübingen: M. Niemeyer, 1991.

Wandhoff, Haiko. "*bilde* und *schrift, volgen* und *versten*: Medienorientiertes Lernen im 'Welschen Gast' am Beispiel des Lektürekatalogs." In *Beweglichkeit der Bilder. Text und Imagination in den illustrierten Handschriften des "Welschen Gastes" von Thomasin von Zerclaere,* edited by Horst Wenzel and Christina Lechtermann, 586–97. Cologne: Böhlau, 2002.

———. *Ekphrasis: Kunstbeschreibungen und virtuelle Räume in der Literatur des Mittelalters.* Berlin: de Gruyter, 2003.

———. *Der epische Blick: Eine mediengeschichtliche Studie zur höfischen Literatur.* Philologische Studien und Quellen 41. Berlin: Erich Schmidt Verlag, 1996.

Weichselbaumer, Ruth. *Der Konstruierte Mann: Repräsentation, Aktion und Disziplinierung in der didaktischen Literatur des Mittelalters.* Bamberger Studien zum Mittelalter 2. Münster: LIT-Verlag, 2003.

———. "Normierte Männlichkeit: Verhaltenslehren aus dem Welschen Gast Thomasins von Zerclaere." In *Genderdiskurse und Körperbilder im Mittelalter: Eine Bilanzierung nach Butler und Laqueur,* Bamberger Studien zum Mittelalter 1, edited by Ingrid Bennewitz and Ingrid Kasten, 157–77. Hamburg: LIT-Verlag, 2002.

Wenzel, Horst. "Antizipation unbekannter Räume: Phantastische Explorationen vor dem Zeitalter der Messung." In *(Auslassungen): Leerstellen als Movens der Kulturwissenschaft,* edited by Natascha Adamowsky and Peter Matussek, 123–33. Würzburg: Königshausen & Neumann, 2004.

———. "Artes und Repräsentation: Zur doppelten Lesbarkeit volkssprachlicher Lehrdichtung im Spannungsverhältnis von Mündlichkeit und Schriftlichkeit." *Das Mittelalter: Perspektiven mediävistischer Forschung. Zeitschrift des Mediävistenverbandes* 3, no. 1 *Artes im Medienwechsel* (1998): 73–94.

———. "Audiovisualität im Mittelalter." In *Literatur im Informationszeitalter,* edited by Dirk Matejovski and Friedrich Kittler, 50–70. New York: Campus Verlag, 1996.

———. "Autobiographie." In *Die Literatur im Übergang vom Mittelalter zur Neuzeit*, edited by Werner Röcke and Marina Münkler, 572–95. Munich: Hanser, 2004.

———. "Die Beweglichkeit der Bilder: Zur Relation von Text und Bild in den illuminierten Handschriften des 'Welschen Gastes.'" In *Philologie als Textwissenschaft: Alte und neue Horizonte*, special issue of *Zeitschrift für deutsche Philologie*, edited by Helmut Tervooren and Horst Wenzel, 224–52. Berlin: Erich Schmidt, 1997.

———. "Der Dichter und der Bote: Zu den Illustrationen der Vorrede in den Bilderhandschriften des 'Welschen Gastes' von Thomasin von Zerclaere." In *Beweglichkeit der Bilder: Text und Imagination in den illustrierten Handschriften des "Welschen Gastes" von Thomasin von Zerclaere*, edited by Horst Wenzel and Christina Lechtermann, 82–103. Cologne: Böhlau, 2002.

———. *Hören und Sehen—Schrift und Bild: Kultur und Gedächtnis im Mittelalter*. Munich: C. H. Beck, 1995.

———. "Schrift und Bild: Zur Repräsentation der audiovisuelle Wahrnehmung im Mittelalter." In *Vorträge des Augsburger Germanistentags: Kultureller Wandel und die Germanisitik in der Bundesrepublik, Band 3, Methodenkonkurrenz in der germanistischen Praxis*, edited by Johanes Janota, 101–20. Tübingen: Niemeyer, 1993.

———. *Spiegelungen: Zur Kultur der Visualität im Mittelalter*. Berlin: Erich Schmidt, 2009.

———. "Systole—Diastole: Mediävistik zwischen Textphilologie und Kulturwissenschaft." *Jahrbuch der deutschen Schillergesellschaft* 43 (1999): 479–87.

———. "Visualität: Sichtbarkeit und Imagination im Medienwandel." *Zeitschrift für Germanistik* 9, no. 3 (1999): 549–673.

Wenzel, Horst, and C. Stephen Jaeger, eds. *Visualisierungsstrategien in mittelalterlichen Bildern und Texten*. Berlin: Erich Schmidt, 2006.

Wenzel, Horst, and Christina Lechtermann, eds. *Beweglichkeit der Bilder: Text und Imagination in den illustrierten Handschriften des "Welschen Gastes" von Thomasin von Zerclaere*. Cologne: Böhlau, 2002.

Wenzel, Horst, and Haiko Wandhoff, and Rainmar S. Zons, eds. *Räume der Wahrnehmung*. Paderborn: Fink, 2004.

Westphal, Sarah. *Textual Poetics of German Manuscripts, 1300–1500*. Columbia, SC: Camden House, 1993.

Winer, Gerald A., and Jane E. Cottrell. "Does Anything Leave the Eye When We See? Extramission Beliefs of Children and Adults." *Current Directions in Psychological Science* 5, no. 5 (October 1996): 137–42.

Wirth, Karl-August. "Von mittelalterlichen Bildern und Lehrfiguren im Dienste der Schule und des Unterrichts." In *Studien zum städtischen Bildungswesen des späten Mittelalters und der frühen Neuzeit. Bericht über Kolloquien der Kommission zur Erforschung der Kultur des Spätmittelalters 1978 bis 1981*, ed-

ited by Bernd Moeller, Hans Patze, and Karl Stackmann, 256–370. Göttingen: Vandenhoeck & Ruprecht, 1983.

Wurzer, Bernhard. *Die deutschen Sprachinseln in Oberitalien.* Bozen: Verlagsanstalt Athesia, 1998.

Zumthor, Paul. *Oral Poetry: An Introduction.* Translated by Kathryn Murphy-Judy. Minneapolis: University of Minnesota Press, 1990.

———. "The Text and the Voice." Translated by Marilyn C. Engelhardt. *New Literary History: A Journal of Theory and Interpretation* 16, no. 1 (Fall 1984): 67–92.

INDEX

Adam and Eve, 73, 81
Ad Herennium, 65
aesthetic issues, 99
affective viewing, 61–62, 65–66
Alan of Lille, 26, 95
 Anticlaudianus, 384n.62
Albrecht III of Austria, Prince, 131,
 403n.3, 406n.32
Albrecht von Johannsdorf, 24
Alexander, Jonathan J. G., 393nn.50, 52
allegory, 77, 79, 86, 120, 378n.3, 380n.21
 personifications as allegorical, 15, 56,
 63–64, 68, 69, 70–71, 76, 82, 85,
 87–88, 96, 100, 101, 102, 110, 111,
 112–14, 115, 118, 126, 127,
 394n.62
Ambrose of Milan, 26, 384n.61
Andreas Capellanus, 397n.18
anger, 80, 97, 100, 306
 as personified, 109, 214, 238, 340
Aquileia, 382n.50, 383n.55
Aquinas, Thomas: on sense of sight,
 391n.11
Architrenius, 52
Aristotle, 26
 and Dialectic, 111, 332
 Nicomachean Ethics, 384n.61
arrogance. *See* pride/arrogance
Assmann, Aleida, 401n.61
audiences, 10, 11–14, 21, 25, 27, 36–43,
 82–83, 118, 119, 120, 139,
 378nn.3, 6, 385n.4, 406n.36
 changes in, 3–5, 16, 17, 18, 19, 20,
 55–56, 89, 140

children, 11, 89–90
clerics, 1, 2, 11, 22, 34, 40, 41, 132,
 396n.11
 directly addressed, 36–37, 38–41,
 122
 of Gotha manuscript, 5, 111–13, 119,
 131–32, 133, 134–36
 of Heidelberg manuscript (Cpg 389),
 57, 65
 knights, 1, 2, 11, 22, 34, 40, 41, 132,
 396n.11
 ladies, 1, 2, 11, 15, 22, 25, 34, 40, 41,
 57, 132, 396n.11
 ministerials, 4, 9, 21, 132–33, 134–36
 Thomasin on, 12, 34, 39, 40, 41, 132,
 133
 urban burghers, 3, 4
 See also reception
Augustine, St., 26, 384n.61
aurality, 33, 34, 41, 42, 43, 46–47, 53,
 382n.39, 386n.15
avarice, 80, 97, 316, 320, 328
 as personified, 103, 200, 208, 248,
 250, 268, 348, 399n.38

Baisch, Martin, 409n.3
Bamberg cathedral's Fürstenportal, 73
Bartsch, Shadi, 410n.9
Baskins, Cristelle L., 393n.56
Bäuml, Franz H., 9
Becker, Peter Jörg, 407nn.39, 44,
 408nn.46, 47
Belting, Hans, 61, 405n.28
Benedictine abbey Mosach, 378n.6

438

Bennewitz, Ingrid, 90, 397n.20
 on didactic texts for women,
 397n.17
Berlin manuscript Hamilton 675,
 378n.6
Berthold von Regensburg, 395n.74
Bible, the, 26, 384n.61
boasting (*ruom*), 49, 97, 228, 328
 as personified, 72–73, 75–76, 109,
 206, 348, 394nn.60, 61
 relationship to reputation, 393n.59
Boccaccio, Giovanni: tale of Nastaglio,
 393n.56
Boethius, 26, 384n.61
Boncompagno da Signa, 24
Boner, Ulrich: *Edelstein*, 389n.62
Borst, Arno, 401n.61
Brüggen, Elke, 398n.30
Buettner, Brigitte, 394n.67, 405n.29
 on art works as status symbols, 137
 on memory and images, 62
 on visual narrative, 380n.21
Bumke, Joachim, 29, 382n.39, 384n.66,
 406n.32
burghers, 3, 4, 53
Butler, Judith: *Gender Trouble*, 395n.1

Caesar, Julius, 15, 264
Camille, Michael, 408n.1
 on intromission model of seeing,
 59–60, 71
 Mirror in Parchment, 391n.12
Carrol, William F., 22
Carruthers, Mary, 65
 The Book of Memory, 391n.12,
 395n.74
 The Craft of Thought, 391n.12
Castiglione, Baldassare, 7–8
Cathedral of Naumburg: sculpture of
 Reglindis in, 74
Cerquiglini, Bernard
 Éloge, 382n.38
 on *variance*/textual variation, 17,
 382n.38
Chartier, Roger: on meaning and
 layout, 35

children, 12, 100, 120, 212
 as audience of *Welscher Gast*, 11,
 89–90
 education of, 13–14, 41, 89–95, 208,
 210, 222, 314
 image of children gazing in mirror,
 141–45
chivalry, 25
Chrétien de Troyes, 397n.19
Cicero, Marcus Tullius, 26, 65
 De officiis, 384n.61
 and Rhetoric, 111, 332
Cividale, 25, 383n.55
class differentiation, 99, 103–4, 105,
 121–24, 129, 132, 136, 395n.1,
 398n.30, 399n.40, 400n.42,
 405n.19
clerics, 4, 8, 33, 86–87, 126, 146, 246,
 378n.3
 attitude regarding colored clothing,
 74, 128, 404n.18
 as audience of *Welscher Gast*, 1, 2, 11,
 22, 34, 40, 41, 57, 132, 396n.11
 clerical literature, 9, 26
 Thomasin as cleric, 1, 2, 22, 24, 67,
 383nn.55, 56
Clover, Carol J., 398n.26
Coleman, Joyce: *Public Reading*,
 389n.58
Collins, Christopher, 392n.29
compilations, 54, 389n.62
constancy (*stete*), 2, 3, 6, 62, 63, 97, 117,
 133, 236, 384n.61
 of the cosmos, 64, 242, 246
 as personified, 106–8, 126–27, 200,
 288
constellation of figures, 16
Cormeau, Christoph, 378n.2, 381n.29
courtliness, 49, 97, 108, 118, 119–21,
 128–31, 135, 141, 208, 340
 as personified, 103, 278, 346
courtly culture, 1, 115, 403n.3, 406n.32
 courtly epics vs. *Welscher Gast*, 1, 8,
 388n.34
 courtly love, 6, 21, 25, 86, 105, 118,
 121, 128–31, 137

courtly culture (*cont.*)
 courtly romances vs. *Welscher Gast*,
 6, 7, 27–28, 108, 119–20, 121,
 127, 132, 133, 141, 386n.12
 courtly virtues, 2, 106, 117, 126–27,
 133
 dancing, 108–9, 125, 127–28,
 400n.47, 405n.22
 etiquette, 4, 6, 10, 89–95
 literary patronage, 33
 rituals, 121, 125–28
 tournaments, 121, 125, 128, 274
courtship, 4, 94, 125
cowardice, 93, 97
 as personified, 320
Cramer, Thomas, 392n.43
Crosland, Jessie, 383n.58
crusades, 23, 24, 338
cultural stereotypes, 99, 100, 114
Curschmann, Michael
 on audiovisual poetic, 11
 on manuscript illustration, 406n.30
 on ministerials vs. free nobility,
 406nn.34, 36
 on viewing manuscripts, 57
 on visual context, 390n.4
 on women patrons, 114

dancing, 108–9, 125, 127–28, 336,
 400n.47, 405n.22
decorated initials, 35, 43, 47, 51, 197, 198
Der Stricker
 Daniel von dem blühenden Tal, 127
 Karlsepik, 408n.52
desire, 278, 282, 286
 as one of six qualities, 78, 80, 81, 98,
 284, 306, 316
 as vice, 97, 98
dialogue, 88
didactic literature, 131, 383n.57
 gender in, 87, 89
 medieval behavior in, 7–8
 as pragmatic, 7, 8, 12, 27, 88
 in Provençal, 22–23
 Welscher Gast as, 1, 2, 6–9, 25, 26, 27,
 34, 36, 53–54, 87, 89, 119, 125,
 141, 387n.24

Diestel, Ludwig, 379n.8, 384n.61
Dietl, Cora, 384n.61, 395n.72
diligence, 97
 personification of, 123, 202, 404n.16
Disanto, Raffaele, 30, 197
Disticha Catonis, 7
dreams, 13
Dresden manuscript
 vs. Heidelberg Cpg 330 (1420), 113
 vs. Heidelberg Cpg 389 (1256), 28,
 70–72, 113
 illustrations in, 30, 70–72
 image of Inconstancy in, 70–72
drunkenness, 97, 284, 316
 as personified, 99–100, 340, 348

editorial history, 21–22, 27–31
education
 of children, 13–14, 41, 89–95, 143,
 210, 222, 314
 seven liberal arts, 1, 110–15, 197, 332,
 346, 401nn.54–56, 61, 402n.65
 of women, 91–92, 397n.17, 401n.61,
 402n.64
Ehrismann, Otfrid, 398n.28
Eike von Repgow: *Sachsenspiegel*,
 380n.22
Eisermann, Falk, 133, 134, 196n.,
 386n.12
ekphrasis, 10, 58
Elias, Norbert
 The Civilizing Process, 7–8
 on Middle Ages vs. Renaissance, 7–8
Elisabeth of Volkensdorff, 378n.6
elite secular identity
 in Gotha manuscript, 86, 104, 105,
 108, 121, 122–23, 128, 131, 135,
 137, 141, 145, 146
 role of gender in, 20–21, 83, 85,
 86–87, 88, 89, 90, 94, 104, 105, 108
 self-recognition, 21, 57, 77, 82–83,
 115, 143–44, 146
 self-representation, 1, 2, 9, 10, 18, 57,
 77, 82, 85, 88, 90, 122, 131–32, 133
 See also courtly culture; estate (social
 status); self-fashioning/identity
 construction

Elsner, Jaś
 on frontal gaze, 66
 on mimetic vs. iconic visualities,
 66
ensenhamen, 25
Erasmus, Desiderius, 7–8
estate (social status), 2, 5, 12, 16, 21,
 117, 118, 125–28, 256, 312
 vs. gender, 105
 visual markers of, 99, 103–4, 105,
 121–24, 129, 132, 136, 395n.1,
 398n.30, 399n.40, 400n.42,
 405n.19
 See also elite secular identity
etiquette, 4, 6, 10, 89–95
Euclid and Geometry, 111, 332
Evans, Michael, 111, 113, 401nn.54–56,
 402n.65
exempla, 10, 62, 380n.21

faithlessness, 226
feasts, 121, 125, 127
Finke, Laurie A.: on gendered identity,
 86–87
flattery, 142, 254, 268, 270, 272, 308
Flore und Blanschflur, 397n.19
format
 changes in, 34–35, 140, 141, 145,
 146
 of Gotha manuscript, 19, 20, 35–36,
 48–50, 51–52, 53, 54, 118, 119,
 128, 131, 141, 145, 146, 196–97,
 386n.11
 of Heidelberg Cpg 389 (1256), 35,
 45–46, 47, 48–49, 51–52, 53, 54,
 118, 386n.11, 388n.35
 in Latin tradition, 51–52, 54,
 389n.53
 relationship to reading practices,
 388n.35
four elements, 64–65, 70, 244
Frank, Barbara, 44, 388nn.37, 46
Freed, John, 132
Freidank, 390n.62
French language, 22, 25
Friuli, 23, 24, 25, 378n.2, 403n.1
frontal gaze, 66–71, 72, 75

gambling, 49, 214, 278
Gehl, Paul, 388n.36
gender
 differentiation in illustrations, 99,
 103–4, 105, 136, 395n.1, 398n.30,
 399n.40, 400n.42
 gender roles, 5, 85, 87, 88, 89–95,
 104, 107–8, 109–10, 112–13, 115,
 125, 127
 gender-specific instructions, 85,
 89–95, 100
 grammatical gender, 18, 21, 86, 88,
 89, 94–104, 105, 109, 115, 118,
 396nn.7, 11, 398n.23
 male-female interaction, 4, 72, 86,
 94, 102, 104, 108–9, 112, 114,
 115, 125, 206, 218, 220, 224,
 280, 397n.20, 401n.61, 402n.65
 manly women, 107, 400n.46
 models of, 88–89
 of personifications, 18, 21, 63–64,
 85–86, 87–88, 89, 95–104,
 105–15, 118, 126–27, 396n.7,
 397n.12, 398n.24, 399nn.35, 37,
 38, 401n.63
 relationship to reading practices,
 385n.4
 in religious context, 86–87
 role in elite identity construction, 20,
 83, 85, 86–87, 88, 89, 94, 104, 105,
 108, 127
 role in elite secular identity, 20–21,
 83, 85, 86–87, 88, 89, 90, 94, 104,
 105, 108, 127
 vs. sex, 395n.1
 social gender, 86–87, 89, 96, 100, 101,
 105, 107–8, 114
generosity (*milte*), 2, 3, 8, 79–80, 93, 94,
 95, 97, 117, 133, 306, 328, 384n.61,
 403n.1
 as personified, 106–8, 126–27, 200,
 288, 328, 342, 348, 404n.16
Genette, Gérard
 Narrative Discourse, 390n.7
 on narrative vs. story, 390n.7
gestures, 15, 74–75
Gibbs, Marion, 30, 378n.1

glory
 as one of six qualities, 78, 79–80, 81,
 98, 284, 306, 316
 as personified, 103, 78, 284
 as vice, 97, 98
gluttony, 49, 208, 282, 316
God
 and cosmic order, 64
 grace of, 324
 judgment of, 324
 permission of, 298
 and salvation, 300
good sense, 97, 218
 as personified, 104, 214, 258
Gotha manuscript
 audience of, 5, 111–13, 119, 131–32,
 133, 134–36
 vs. courtly romances, 119–20, 127,
 141, 386n.12
 decorated initials in, 47, 197, 198
 edition of von Kries, 29–30, 197,
 381n.30, 384n.64, 388n.42,
 397n.19, 401n.55
 elite identity construction in, 4–5,
 86, 104, 105, 108, 121, 122–23,
 128, 131, 135, 137, 141, 145, 146
 format of, 19, 20, 35–36, 48–50,
 51–52, 53, 54, 118, 119, 128, 131,
 141, 145, 146, 196–97, 386n.11
 gender in, 21, 86, 88, 89, 96–98, 99,
 100, 102–4, 105–10, 112–13,
 114–15, 125, 127, 136, 399n.38
 vs. Heidelberg Cpg 320 (1460), 81,
 109
 vs. Heidelberg Cpg 330 (1420), 113
 vs. Heidelberg Cpg 389 (1256), 5, 18,
 19, 20, 29, 30–31, 35–36, 46, 47,
 48–49, 50, 51–53, 54, 67–68,
 80–81, 88–89, 96, 99, 100, 103,
 104, 105, 112, 113, 114, 118–19,
 121, 122, 123, 125, 141, 144–45,
 200, 252, 316, 328, 381n.30,
 384n.64, 385n.6, 386n.11, 388n.45,
 397n.19, 404n.16
 historical context of, 21, 29, 119,
 131–37

indexing system, 5, 20, 35, 47–48,
 49, 50–51, 52, 53, 118, 137,
 196–97
vs. Kassel manuscript, 136, 137
vs. Latin manuscripts, 52
layout of, 19, 20, 35–36, 46, 47–48,
 52–53, 54, 196
vs. Manesse codex, 130–31, 137,
 401n.61
metrical structure in, 46
patron of, 54, 118–19, 121, 128–37
prose foreword, 5, 20, 28, 30, 35,
 47–48, 49, 50, 53, 118, 196, 198,
 381n.30, 384n.64, 388n.42
Raidenbuch arms in, 130, 134
and reading practices, 19, 35–36,
 389n.58
rhymed couplets in, 46, 50, 52–53,
 384n.64
rubrication in, 47, 137, 196–97
scribe of, 133–34, 196
size of, 386n.12
as status symbol, 136
and story telling, 57–58
vs. Stuttgart manuscript fragment,
 53–54, 81, 99, 109, 390n.63,
 393n.53, 400n.50, 405n.24
subdivisions in, 48–50, 52, 196–97
vs. Wolfenbüttel manuscript, 5, 18,
 19, 28, 81, 88–89, 96, 113, 114,
 123–24, 141
vs. Wolfram von Eschenbach's
 Willehalm, 107–8
Gotha manuscript, illustrations in,
 4–6, 15, 20, 21, 29–30, 53–54,
 57–58, 105–15, 125–31, 144–46,
 384n.64, 399n.38, 401nn.55, 56,
 61, 403nn.16, 17, 405nn.24, 25,
 410n.11
 class differentiation in, 121–24
 vs. illustrations in Heidelberg Cpg
 389 (1256), 18, 19, 50, 67–68,
 88–89, 96, 99, 100, 102–4, 112,
 113, 114, 118–19, 121, 122, 123,
 125, 141, 144–45, 200, 252, 316,
 328, 384n.64

vs. illustrations in Wolfenbüttel manuscript, 18, 19, 88–89, 96, 113, 114, 123–24, 141
large-format illustrations, 88, 102–3, 105–10, 113, 114, 125–28, 137, 400n.50, 405n.20
nakedness in, 75, 81, 109
number of, 197, 403n.11
Gotha manuscript, images in
Anger, 348
Avarice, 103, 208, 248, 250, 268, 348
Betrayal, 348
Blame, 103
Boasting, 109, 348
Chain of Vices, 103, 284, 316
children gazing at mirror, 141, 144–45, 270, 410n.11
Constancy, 106, 200, 288, 346
Courtliness, 103
courtly rituals, 121, 125–28, 141
Critical Judgment, 214, 258
dedication image, 128–31, 136, 137, 196, 197, 350, 404n.16, 405n.25
Deed, 214
Dishonor, 104
Dishonorable Man, 104
Drunkenness, 100, 284, 348
Faithfulness, 334
Faithlessness, 226
False Women, 220
Fear, 248
Generosity, 103, 106, 200, 346
German language, 114, 202
Gluttony, 208
Good Conduct, 210
Goodness, 220
Good Sense, 104, 214, 258
Grammar, 111, 112, 113
Greed, 248, 250, 268, 284, 348
Hatred, 348
Heaven, 272, 304, 306
Hell, 272, 290, 304, 306, 324, 328
Honor, 104, 222
Idle Man, 104, 326
Idle Thought, 103, 104, 326
Immoderation, 334, 348

Inconstancy, 67–68, 200, 232, 236, 238, 268, 276, 348, 399n.38
Injustice, 348
Intention, 214
Joylessness, 103
Justice, 103, 106, 200, 346
Lady Virtue, 106, 126–27, 288, 346
Lechery, 284
Lying, 206, 276, 284, 348
Moderation, 106, 200, 334, 346
Nobility, 103
Poor Judgment, 218
Pride, 348
Righteous Man, 103, 202, 310
the scoundrel, 122, 124, 202, 232, 310
seven liberal arts, 110–15, 197, 346, 401nn.55, 56, 61, 403n.11
Thievery in, 348
Treachery, 103, 202, 204, 276
Unhappiness, 103
Usury, 348
Vice, 109, 232, 284, 308, 348
vices' dance, 108–9, 127–28, 348, 405nn.22, 24
Violence, 348
virtuous ladies, 106, 109, 126–27, 128, 197, 400n.50, 403n.11, 404n.16, 405nn.20, 24
Whoring, 100, 284, 348
Wicked Man, 122, 294
Wickedness, 103
Wise Man, 103, 212, 224, 312
Gottfried von Strassburg, 22
 Tristan, 6, 28, 74, 399n.33, 409n.3
Grabes, Herbert, 380n.23
greed, 97, 252, 260, 262, 272, 274, 306, 340
 as personified, 214, 248, 250, 256, 268, 284, 314, 320, 328, 348, 399n.38
Greenblatt, Stephen: *Renaissance Self-Fashioning*, 379n.7
Green, Dennis H.: on court audience, 3
Gregory I, 26, 95, 384n.61
Grundmann, Herbert, 385n.5

Haag, Christine, 400n.46
Hamburger, Jeffrey: *Rothschild*, 395n.71
Hans Ulrich von Königsfeld, 134, 407n.41
Harrad of Hohenbourg: *Hortus deliciarum*, 395n.71
Hartmann von Aue
 Erec, 6, 127
 Iwein, 108, 406n.36
Haug, Walter, 378n.3
Hector, 264
Heidelberg Cpg 320 (1460)
 vs. Dresden manuscript, 70
 vs. Heidelberg Cpg 389 (1256), 70–71
 illustrations in, 69, 76–77, 81, 109, 112, 113–14, 402n.63
 image of Inconstancy in, 69
 image of seven liberal arts in, 113–14
 image of vices' dance in, 109
 images of heaven and hell, 81
 ladders of vice and virtue in, 81
 vs. Wolfenbüttel manuscript, 81, 113–14, 402n.63
Heidelberg Cpg 330 (1420)
 vs. Dresden manuscript, 113
 vs. Gotha manuscript, 113
 vs. Heidelberg Cpg 389 (1256), 69, 75–76, 113
 illustrations in, 68–69, 75–76
 image of Inconstancy in, 68–69
 vs. Wolfenbüttel manuscript, 68–69
Heidelberg Cpg 338 (1420), 393n.55
Heidelberg Cpg 389 (1256)
 audience of, 57, 65
 vs. courtly epics, 388n.34
 decorated initials in, 43
 Disanto edition, 30, 197
 vs. Dresden manuscript, 28, 70–72, 113
 format of, 35, 45–46, 47, 48–49, 51–52, 53, 54, 118, 386n.11, 388n.35
 gender in, 88–89, 96, 99–102, 103, 113, 114, 399n.35

 vs. Gotha manuscript, 5, 18, 19, 20, 29, 30–31, 35–36, 46, 47, 48–49, 50, 51–53, 54, 67–68, 80–81, 88–89, 96, 99, 100, 103, 104, 105, 112, 113, 114, 118–19, 121, 122, 123, 125, 141, 144–45, 200, 252, 316, 328, 381n.30, 384n.64, 385n.6, 386n.11, 388n.45, 397n.19, 404n.16
 vs. Heidelberg Cpg 320 (1460), 70–71
 vs. Heidelberg Cpg 330 (1420), 69, 75–76, 113
 layout of, 45, 46, 52–53, 388nn.36, 37
 vs. *Nibelungenlied*, 44
 and orality, 44, 46, 47, 54
 rubrication in, 43–44, 47, 48–49, 387n.30
 Rückert edition, 28–29, 30, 197
 size of, 386n.11
 vs. Stuttgart manuscript fragment, 53, 81, 99, 404n.16
 subdivisions in, 43–44, 46–47, 48–49
 vs. Wolfenbüttel manuscript, 56, 68, 81, 124, 141
Heidelberg Cpg 389 (1256), illustrations in, 6, 30, 51, 53, 99–102, 399nn.35, 37, 38, 404n.16
 and contemplation, 56–57
 vs. illustrations in Gotha manuscript, 18, 19, 50, 67–68, 88–89, 96, 99, 100, 102–4, 112, 113, 114, 118–19, 121, 122, 123, 125, 141, 144–45, 200, 252, 316, 328, 384n.64
 and religious iconography, 67, 72–75
Heidelberg Cpg 389 (1256), images in
 children gazing at mirror, 141–45, 409n.5
Courtliness, 103
Dishonor, 104
Dishonorable Man, 104
Drunkenness, 99–100
Good Sense, 104
heaven and hell, 81
Honor, 104
Idle Man, 101, 104
Idleness, 101, 104